AMERICA IN SPACE

NASA'S FIRST FIFTY YEARS

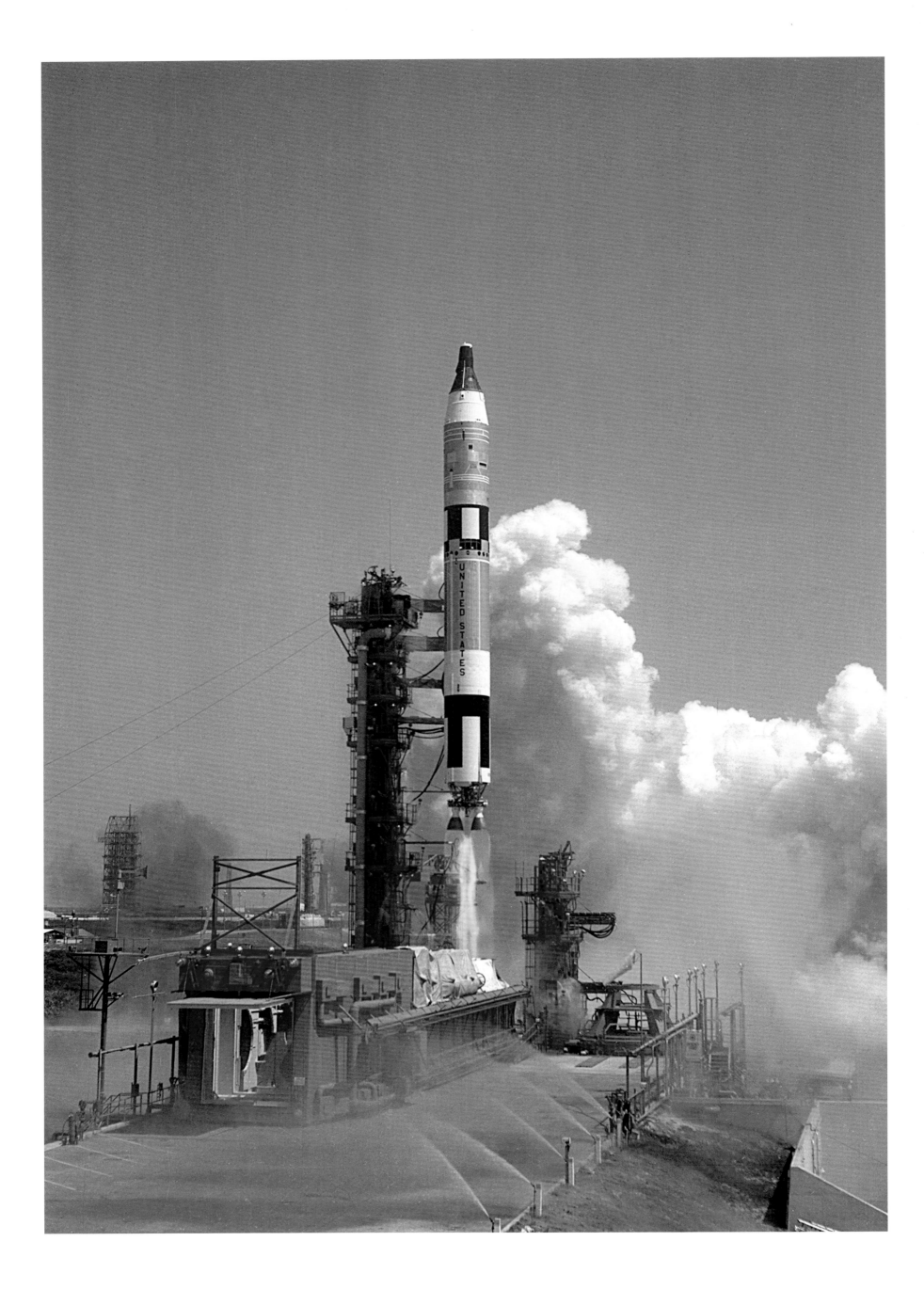

AMERICA IN SPACE

NASA'S FIRST FIFTY YEARS

FOREWORD BY NEIL ARMSTRONG

EDITED BY STEVEN J. DICK, ROBERT JACOBS, CONSTANCE MOORE, ANTHONY M. SPRINGER, AND BERTRAM ULRICH

WITH THE ASSISTANCE OF THE NASA CHIEF HISTORIAN'S OFFICE AND THE NASA PHOTO DEPARTMENTS

ABRAMS, NEW YORK

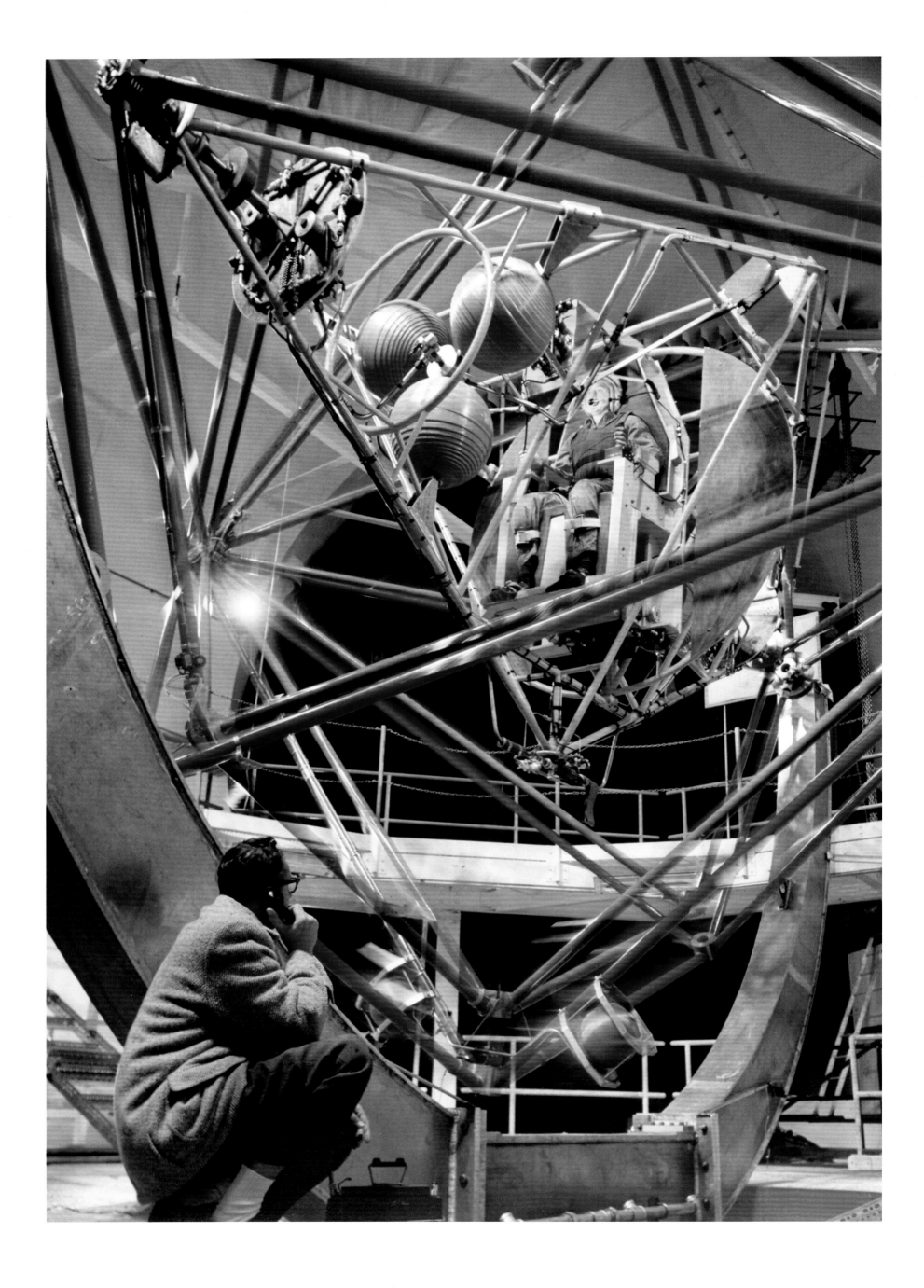

CONTENTS

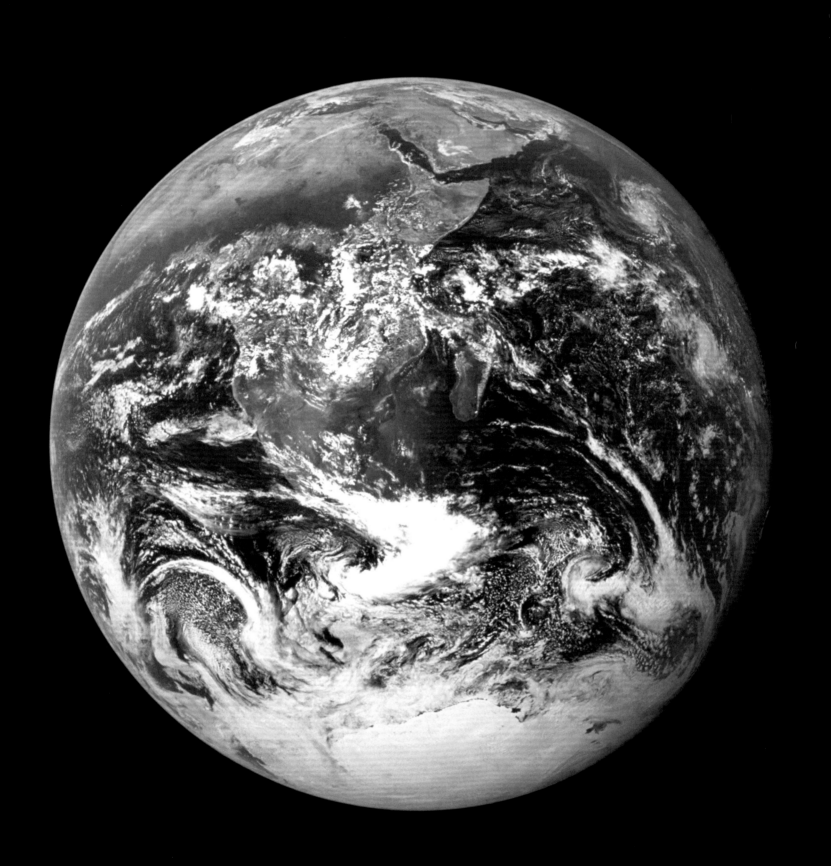

FOREWORD

New transportation systems have always caused very large societal changes in surprisingly short time periods. In the thirteenth and fourteenth centuries a popular Mediterranean coastal fishing vessel was called the caravel. It was said to be the first ship that could effectively sail against the wind. In the fifteenth century, the Portuguese modified and enlarged the caravel for ocean sailing. Within a span of thirty years, using the new type caravel, Vasco da Gama had sailed around the Cape of Good Hope to India, Christopher Columbus had crossed the Atlantic and discovered the New World, and the expedition of Ferdinand Magellan circled the globe. Sea power was born in this short period, and remained the dominant world influence in international affairs for the next four centuries.

In 1830, a ship delivered a new locomotive to Charleston, South Carolina. Built at the West Point foundry in New York, it was named "The Best Friend." It began the first regular train service in the United States. By 1835, two hundred railroads were chartered in eleven states with more than one thousand miles of track. The Golden Spike was driven in 1869, providing transcontinental service. The Pacific coast could be reached in days rather than weeks or months. The great expansion had taken place in only thirty-nine years.

The Air Age developed even faster, with only sixteen years elapsing between the first flight of the Wright Brothers in 1903 and scheduled airline service. World War I found thousands of airplanes being used in aerial combat. Our planet was circumnavigated by air just twenty-one years after that first flight.

History repeated itself in the Space Age, with only eleven years passing between the flight of the first man-made artificial satellite, the Soviet *Sputnik*, and the human circumnavigation of the Moon.

The cost of developing a transportation system has always been high. The Spanish treasury could not afford the Columbus expedition. Ships at that time were so expensive that it was thought they could not be commercially profitable unless they were carrying gold, gems, or spices. The cost of developing the US railroad system was approximately the same as that required for the US space program.

The risks accompanying transportation development have always been substantial. Columbus ran the Santa Maria aground in Haiti. Magellan was killed by natives in the Philippines. Only 18 of his original 249 men completed the round the world voyage. That first American locomotive, "The Best Friend," exploded several months after it began service. The early years of any transportation system are fraught with uncertainty. It took the Wrights five years to convince the United States government that their flying machine might, with improvement, be of some use to the Army.

History tells us that transportation developments are complex, expensive, and unpredictable. But history also tells us that transportation developments change the way people live. They affect how much we can accomplish in our lives and our expectations for the future.

One year after *Sputnik*, the United States Congress created the National Aeronautics and Space Administration. Under the Space Act of 1958, NASA's mandate included "the expansion of human knowledge of phenomena in the atmosphere and space"; "the improvement of the usefulness, performance, speed, safety, and efficiency of aeronautical and space vehicles"; "the development and operation of vehicles capable of carrying instruments, equipment, supplies and living organisms through space"; and "the establishment of long-range studies of the potential benefits to be gained from . . . the utilization of aeronautical and space activities for peaceful and scientific purposes."

Within a dozen years, humans had become travelers in space; satellites had been sent into orbit to monitor weather and provide wide-area communications; manned craft had rendezvoused and docked with other craft; unmanned probes had studied the Earth's Moon, Venus, and Mars; and humans had visited the surface of the Moon.

The remainder of the first half-century of the Space Age brought an unending series of remarkable astronautical advances. Space stations with scientists aboard were put into orbit. Probes explored planets throughout the solar system and beyond. Asteroids and comets were visited and examined. Our knowledge of our small sector of the universe increased a thousandfold. *America in Space* chronicles the remarkable first half-century of progress in the conquest of space with a thoughtful retrospective and a remarkable collection of photographs. I believe you will enjoy it.

—Neil Armstrong

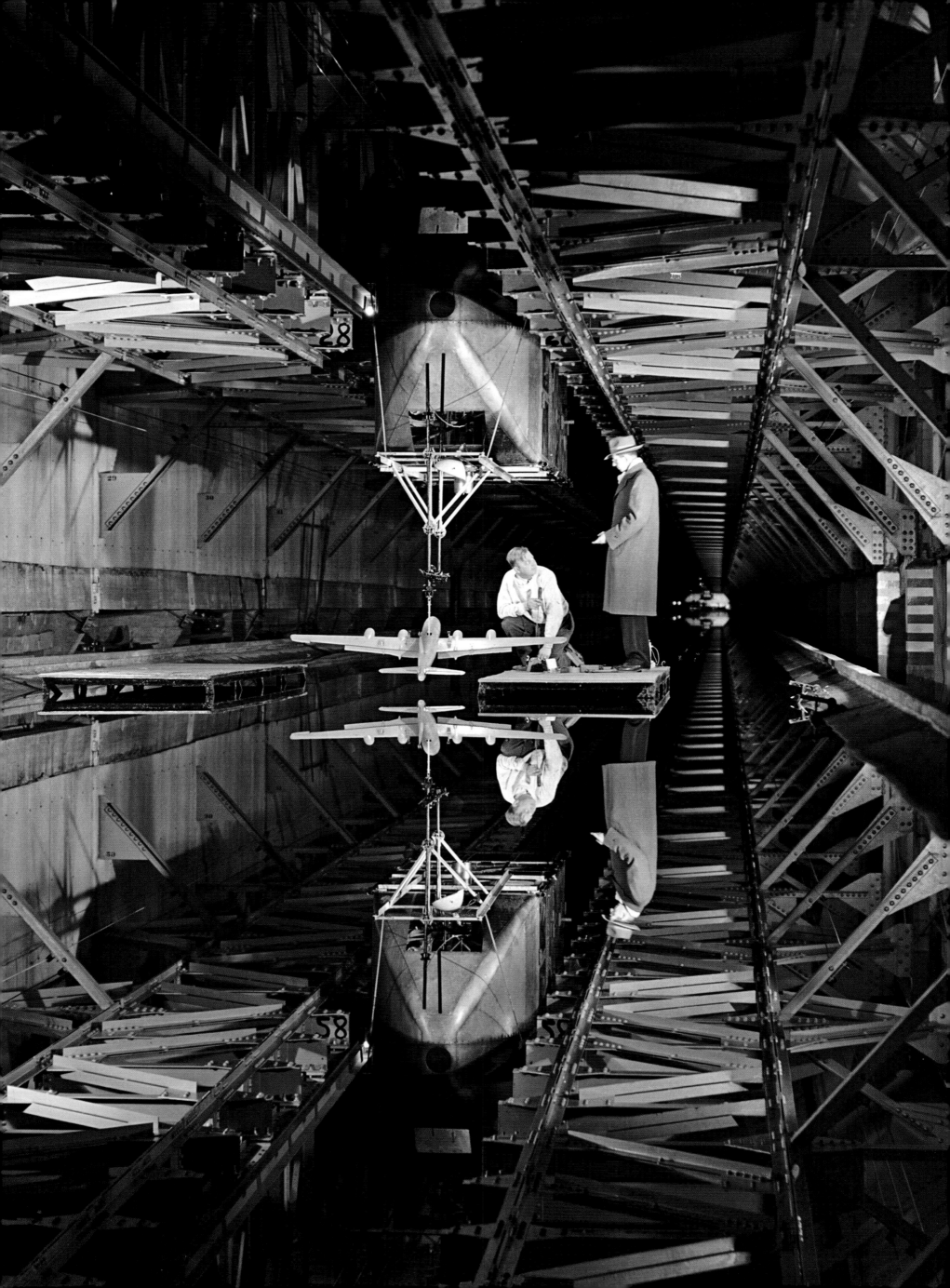

1

IN THE BEGINNING

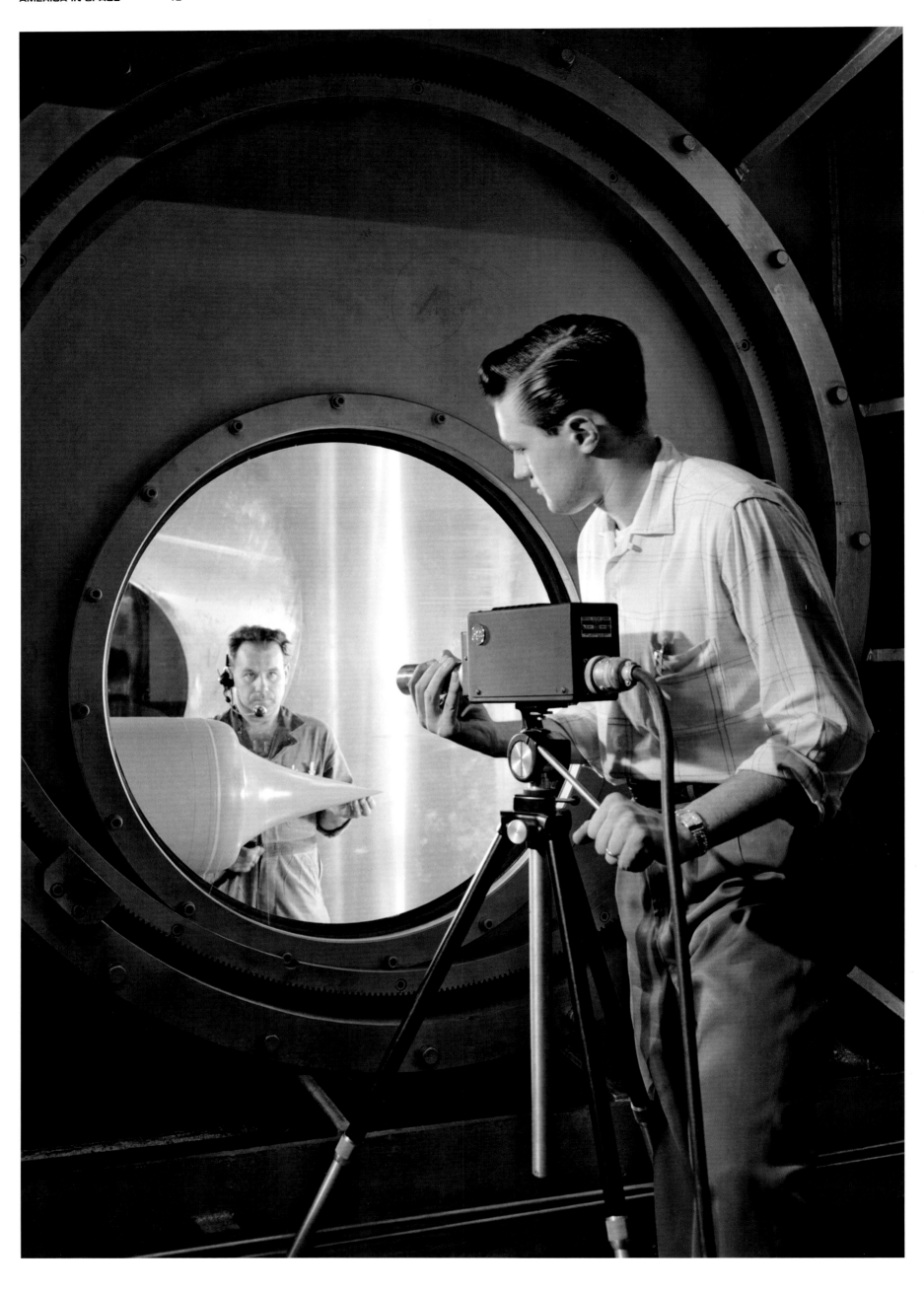

IN THE BEGINNING

The idea of an American national space agency, impossible at the beginning of the twentieth century, was ripe for implementation by the late 1950s. The advancement of rocket technology was a necessary condition, but the reasons for the founding of NASA, as with other space agencies, can only be understood in the geopolitical context of the times. After World War II the Cold War between the United States and the Soviet Union was the great fact of life on planet Earth. NASA's birth was directly related to the Soviet Union's launch of *Sputnik* on October 4, 1957. As part of its participation in the International Geophysical Year (1957–1958), the United States had already proposed to launch a satellite into Earth orbit, and in September 1955 the government had chosen the Navy rather than the Army to do so. The Navy's first attempt in December 1957 failed, and thus it was the Army that answered for the United States when its Army Ballistic Missile Agency launched *Explorer 1* on January 31, 1958. *Explorer 1* detected what became known as the Van Allen radiation belt, launching the beginnings of space science. *Explorer 1* was followed by the Navy's launch of *Vanguard 1* on March 17, 1958.

Despite these military successes, and mindful of the peaceful uses of outer space, two weeks before *Vanguard*'s launch President Dwight D. Eisenhower ordered that a bill be drafted to create a civilian space agency. The bill was sent to Congress on April 2 and was passed after lengthy congressional debate and signed into law July 29, 1958. When NASA began operations on October 1, 1958, no one could have foreseen the full scope of the adventures, the triumphs, and the tragedies that would occur under its auspices over the next fifty years.

Before the adventures it was necessary to organize for exploration, no small feat in itself. The National Aeronautics and Space Act of 1958 provided for research into the problems of flight, both within the Earth's atmosphere and in space. NASA began by absorbing the earlier National Advisory Committee for Aeronautics (NACA, established in 1915), including its eight thousand employees, an annual budget of $100 million, three major research laboratories—Langley Aeronautical Laboratory, Ames Aeronautical Laboratory, and Lewis Flight Propulsion Laboratory—and two smaller test facilities. It quickly incorporated other organizations, or parts of them, notably the space science group of the Naval Research Laboratory that formed the core of the new Goddard Space Flight Center; the Jet Propulsion Laboratory managed by the California Institute of Technology for the Army; and the Army Ballistic Missile Agency in Huntsville, Alabama, where Wernher von Braun's team of engineers was developing large rockets. Over the next fifty years each of these NASA Centers—as well as the Kennedy Space Center, Dryden Flight Research Center, Johnson Space Center, and Stennis Space Center—would bring their own expertise to NASA projects, whether in aeronautics, rocket technology, launch facilities, space science or human spaceflight.

With its early facilities in hand, and its first Administrator Keith Glennan at the helm, NASA set about a great variety of activities, ranging from aeronautics to human and robotic space exploration. Early in NASA's history, the practical use of space was dramatically proven. *Tiros 1,* launched April 1, 1960, began a series of weather satellites that continues to the present day in ever more sophisticated form. *Echo 1,* a passive communications satellite launched August 12 of the same year, eventually gave way to the complex active communications satellites so essential today. In conjunction with the military, NASA demonstrated the importance of space for navigation, reconnaissance, and surveying Earth resources.

It was spaceflight beyond the Earth that most captured the public imagination. Even before President John F. Kennedy set the Moon as a goal for humans, robotic reconnaissance was necessary, and it was carried out in the midst of a geopolitical environment that fostered intense competition between two superpowers, the United States and the Soviet Union. The United States made the first lunar orbit attempt on August 17, 1958, six weeks before NASA was founded, under the auspices of the Air Force. *Able 1* lasted only 77 seconds when the first stage exploded at an altitude of 9.3 miles. Eight weeks later *Able 2* reached an altitude of 71,400 miles, and returned useful information about the Van Allen radiation belt before falling back to Earth. Meanwhile, the Soviets had launched their first entry (unnamed) in the lunar sweepstakes. Several Russian attempts failed before *Luna 2* made the first lunar impact near the Sea of Serenity in September 1959, depositing Soviet emblems. *Luna 3* succeeded in the first lunar flyby the following month, and returned the first photos of the lunar far side. These far-side images showed fewer of the smooth maria features than were evident on the visible side, and allowed the Soviets to confer on surface features names like Tsiolkovsky, Lomonosov, and the Sea of Moscow.

Meanwhile, the United States Army and Air Force had tried two more Moon launches in 1958, and NASA attempted its first lunar launch in 1959 with *Pioneer 4.* The latter failed in its lunar flyby objective, but became the first American spacecraft to enter orbit around the Sun. It was with the Ranger series of spacecraft in 1961 that the Americans would prove they were serious about lunar exploration.

With all this in the background, the stage was set. President Kennedy's decision in May 1961 to land a man on the Moon by the end of the decade gave great impetus to the American space program, and scientists already looked outward to the nearest planets—Venus and Mars.

Opposite At the Lewis Flight Propulsion Laboratory (now the Glenn Research Center), a technician aims a television camera at a ramjet engine model through the windows of a supersonic wind tunnel on August 21, 1957. Closed-circuit television enabled aeronautical research scientists to view the ramjet in the wind tunnel, which operated at speeds from 1,500 to 2,500 mph.

Below Thirty-three years later, on April 1, 1980, an engineer at the Marshall Space Flight Center in Huntsville, Alabama, observes the testing of a small space shuttle orbiter model in a trisonic wind tunnel, which is capable of running subsonic, transonic, and supersonic. It is used to test the integrity of rockets and launch vehicles in launch and reentry environments.

Above The NACA, created by Woodrow Wilson, first convened on April 23, 1915. The committee, which included representatives of the military, the US Weather Bureau, and academia, focused on research to advance American aeronautics. **Below** Its last meeting took place on August 21, 1958, a few months before the National Aeronautics and Space Administration became operational on October 1.

Opposite Some of the great scientific minds of the German "brain drain" are photographed in 1956 at the newly created Ballistic Missile Agency in Huntsville, Alabama. The scientists and engineers include Hermann Oberth (foreground), Ernst Stuhlinger (seated left), Wernher von Braun, later to become director of the Marshall Space Flight Center, which took over the installation (seated right), and Eberhard Rees (background right). American General H. N. Toftoy (background left, standing) managed "Project Paperclip," which enabled German scientists and engineers after World War II to be employed by the American military.

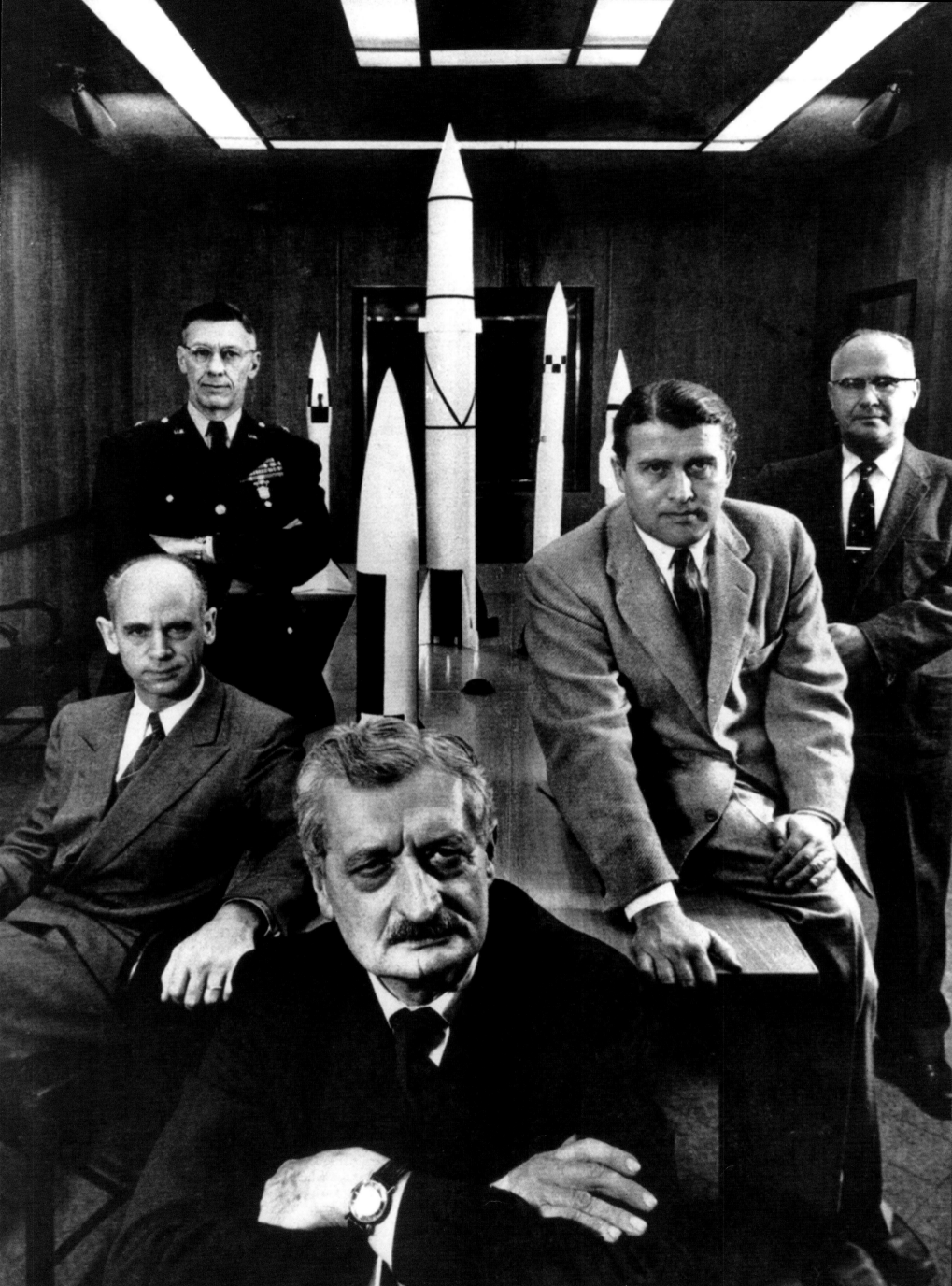

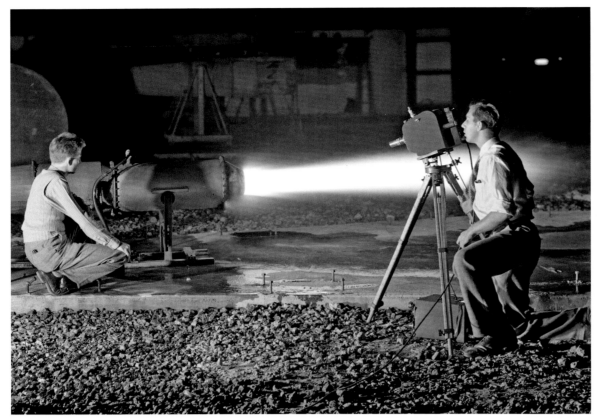

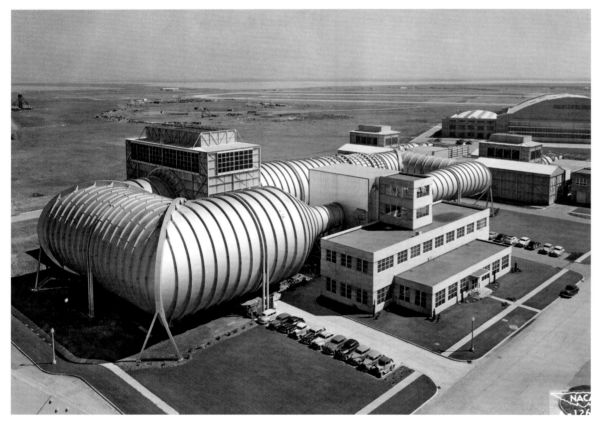

Top The laboratories managed by NACA were at the forefront of the development of reliable high-performance jets. In this 1946 test, engineers at the Flight Propulsion Research Laboratory in Cleveland take motion pictures of exhaust gases being discharged from a burner used for studying thrust augmentation in jet-propulsion engines. As is often the case in aerospace engineering studies, the camera is an essential tool for recording data for analysis.

Above As aircraft became larger and more powerful, the facilities required to test their design underwent a parallel development. The sixteen-foot high-speed wind tunnel at Ames Aeronautical Laboratory (now the Ames Research Center) in Moffett Field, California, was completed in December 1941, and was the testing ground for models of many classic World War II planes, some of which were pushing toward the sound barrier. **Overleaf** In the largest wind tunnel at Ames actual aircraft could be subjected to 230 mph winds in a space 40 feet high by 80 feet wide. This low-speed tunnel, covering eight acres, was useful for testing takeoff and landing characteristics.

Right Test pilots Mel Gough, Herb Hoover, Jack Reeder, Steve Cavallo, and Bill Gray stand in front of a P-47 Thunderbolt Fighter at Langley Field in Hampton Roads, Virginia, in 1945. This was the year Gough, the chief test pilot, was quoted as saying of the rocket-powered X-1, "No NACA pilot will ever be permitted to fly an airplane powered by a damned firecracker." Although the NACA was established as a civilian entity, it was closely associated with the military, especially during wartime. Like the NACA, NASA would have to integrate the worlds of the technicians and the test pilots.

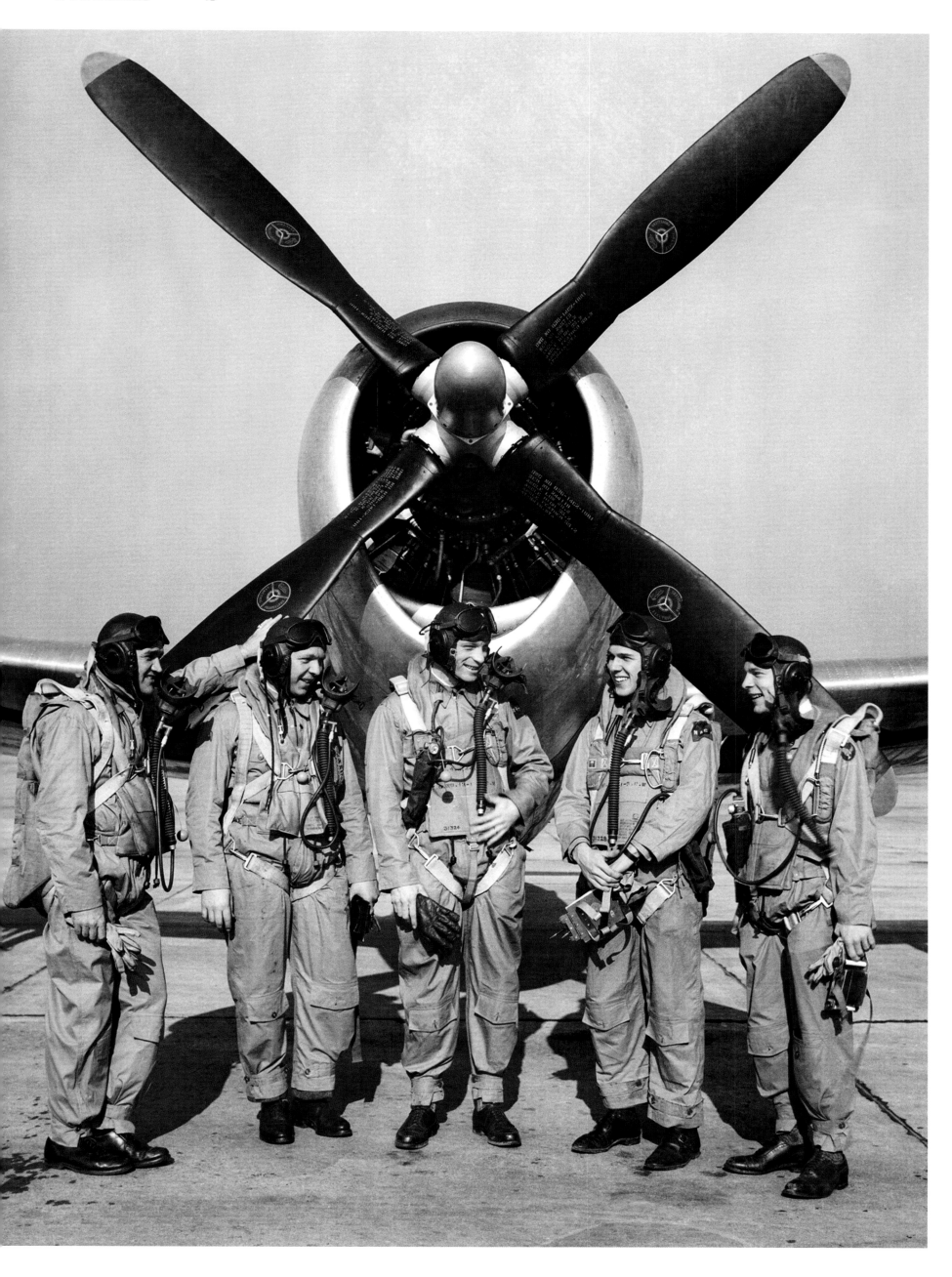

Experimental aircraft were a hallmark of the NACA. The High Speed Flight Station (now the Dryden Flight Research Center) in Edwards, California, became a testing facility for reaching higher and going faster. **Below** In January 1952, the fleet of NACA test aircraft was assembled with personnel and test pilots for a traditional "group portrait." Included are the Douglas Aircraft D-558-2 Skyrocket in the foreground and the P2B-1 Superfortress behind it, which carried the D-558-2 under its fuselage. To the front left and right of the D-558-2 are North American F-86 Sabre chase aircraft. **Opposite bottom** A similar view from 1988 includes too many aircraft to list in a brief caption. **Opposite top** A look into Hangar 4802 on August 10, 1966, reveals three lifting bodies—essential to the early development of concepts for the space shuttle—and the X-15, which pioneered high-speed high-altitude flight.

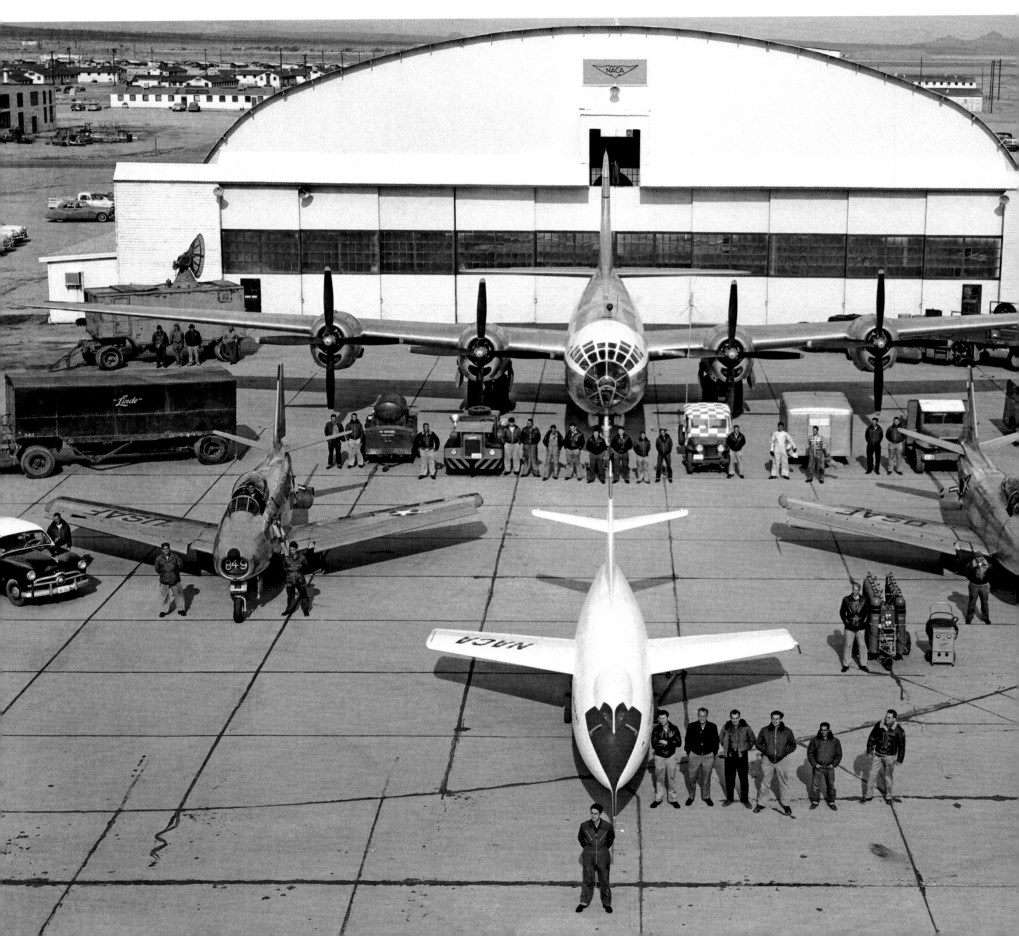

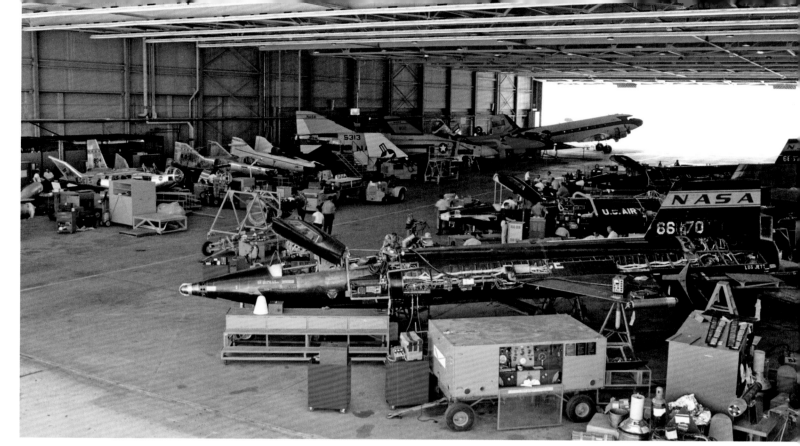

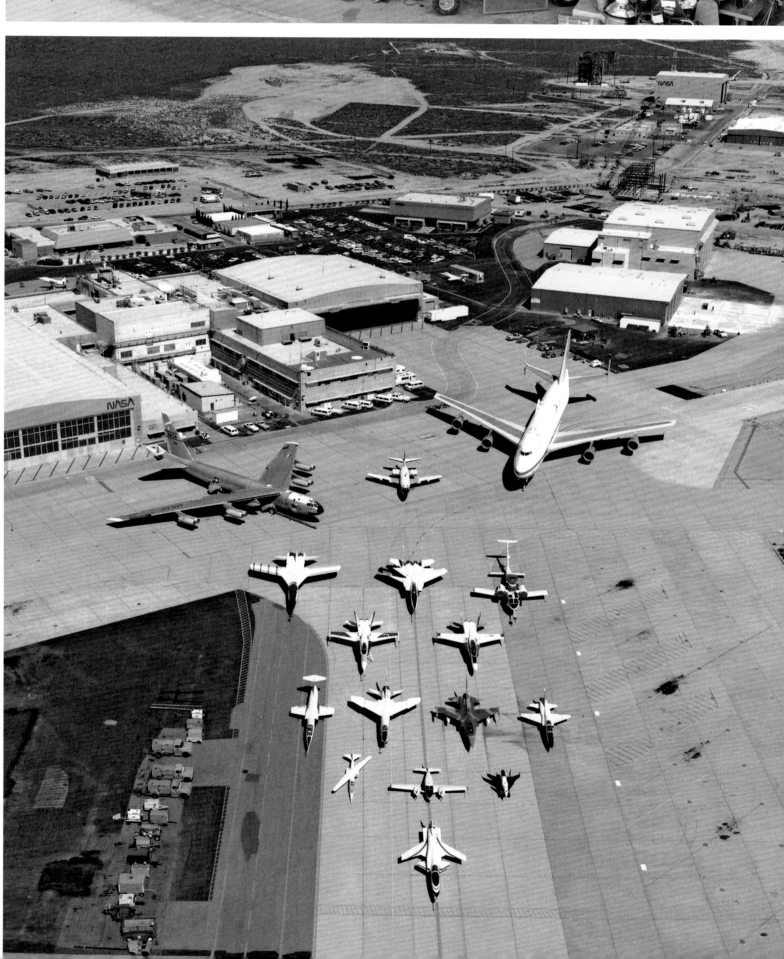

By the 1950s, research at the Lewis Flight Propulsion Research Laboratory had expanded to embrace not only aircraft-engine technology but also propulsion systems. It would soon become one of the leading centers for propulsion research in the nation. **Below left** A technician operates a rig used for studying film-cooling of combustors in 1952. **Right** In 1957, another works on a 20,000-pound rocket test stand and engine installation.

In response to the successful launch of the Russian satellite *Sputnik* on October 4, 1957, the United States raced to catch up. **Opposite** *Explorer 1*, officially known as Satellite 1958 Alpha, was the first US satellite to orbit the Earth. Designed and built by the Jet Propulsion Laboratory in Pasadena, California, *Explorer 1* was launched from Cape Canaveral, Florida, on January 31, 1958, aboard a US Army Jupiter-C vehicle. Based on *Explorer 1*'s data and confirmed by later missions, James Van Allen theorized the existence of a belt of charged particles trapped in space by the Earth's magnetic field, which became known as the Van Allen radiation belt. **Below right** A month before the successful launch of *Explorer 1*, on December 6, 1957, the US Navy had attempted to launch a satellite into Earth orbit: after two seconds, the *Vanguard 1A* launch vehicle lost thrust and exploded at Cape Canaveral.

Overleaf The *Vanguard 1* **(right)** and *Vanguard 2* **(left)** satellites were designed to provide data about the atmosphere and the shape of the Earth. When the *Vanguard 1* satellite did finally launch on March 17, 1958, it would become the second US satellite to reach Earth orbit and the third ever to reach orbit worldwide. It still orbits Earth today.

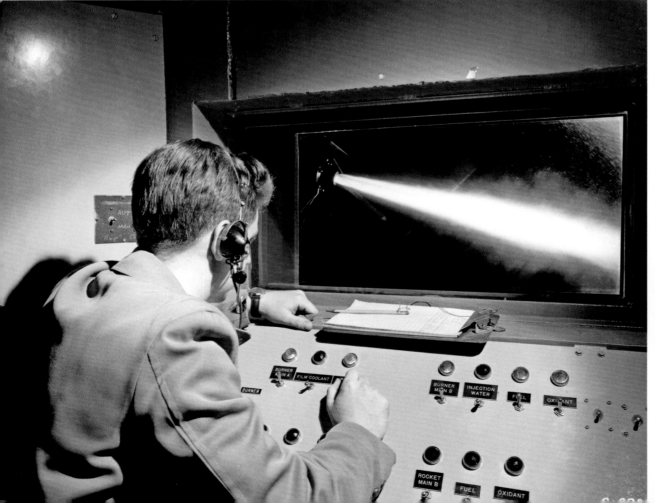

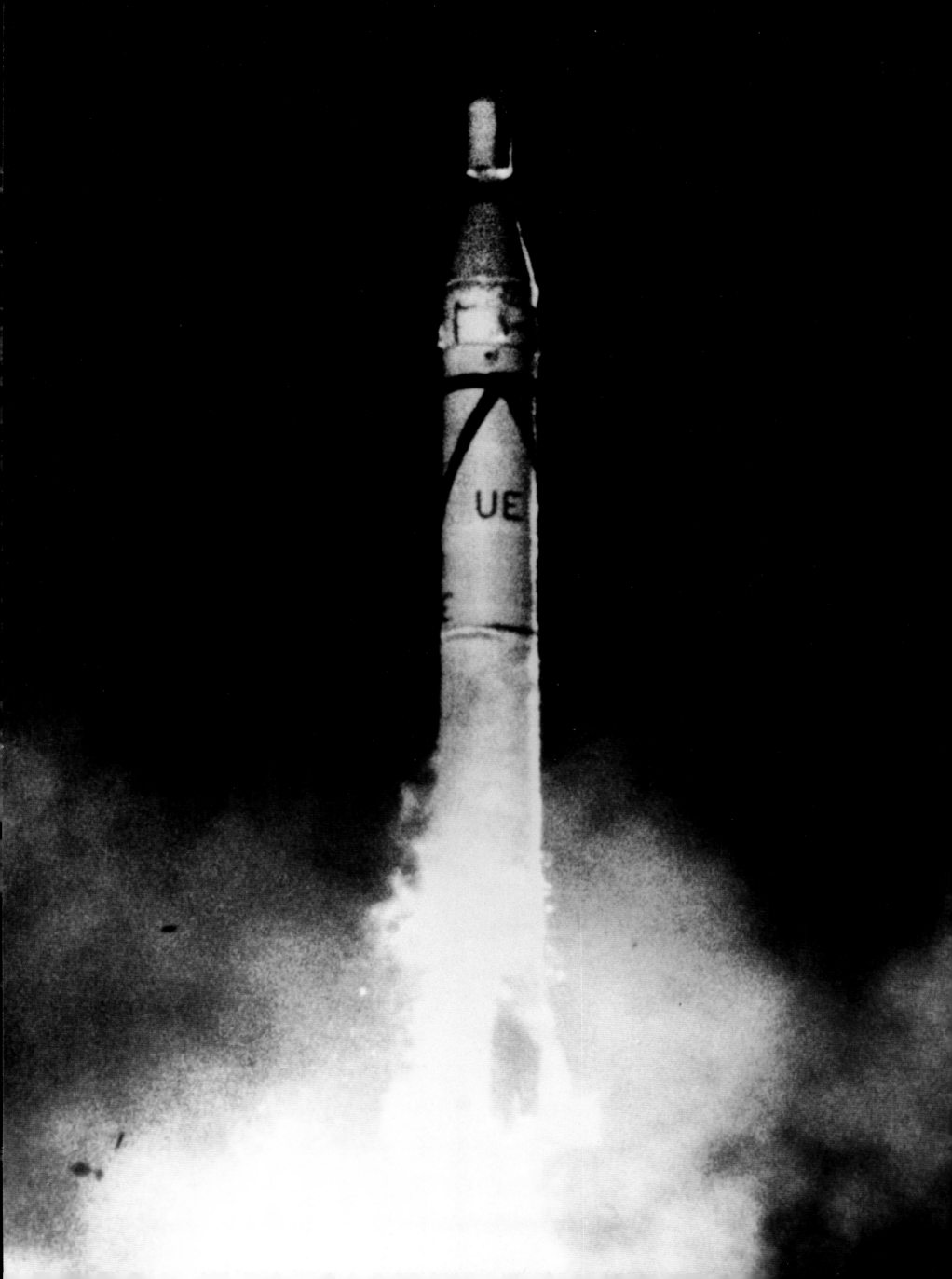

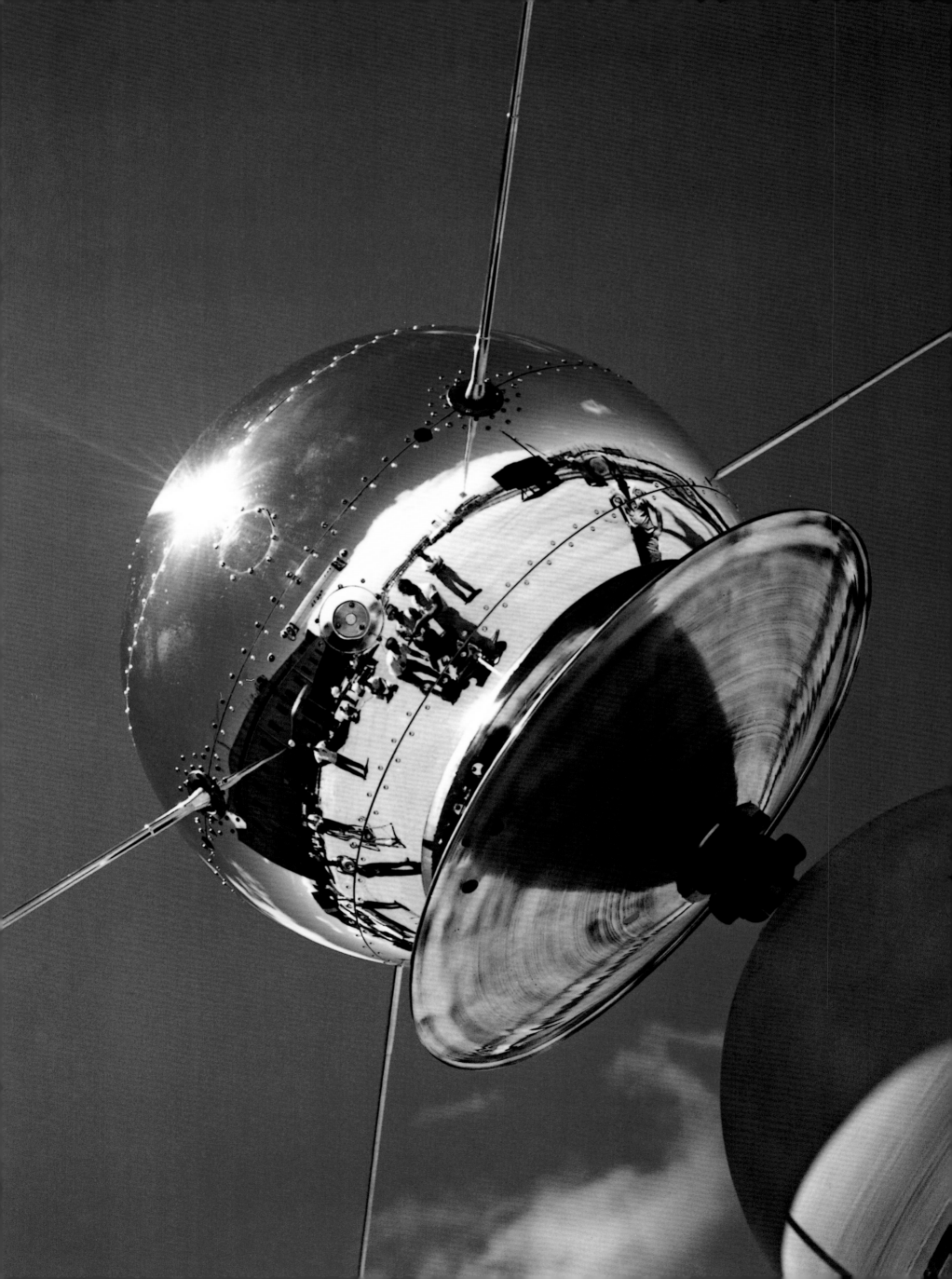

NASA swiftly entered the satellite race. The agency launched America's first weather satellite, *TIROS-1* on April 1, 1960, from Cape Canaveral. **Below** *TIROS-1* is being prepared by a group of engineers. Created by the Goddard Space Flight Center in Greenbelt, Maryland, *TIROS-1* carried two television cameras, a magnetic tape recorder, timer systems, transmitters, and a power supply. It provided new information on cloud systems. **Left** A few months later, on August 12, *Echo 1*, NASA's first communications satellite, was launched from Cape Canaveral. The Echo mission included a number of communications experiments and research on atmospheric density and solar pressure. *Echo 1* was essentially a balloon one-hundred feet in diameter made of aluminized polyester. Once in orbit, it could be seen by the naked eye from the ground because of its reflective surface.

Overleaf Molded astronaut couches line the Langley Research Center's model-shop wall in 1959. The names of test subjects (Langley employees) are written on the back. The couches were similar to those made for Mercury astronauts for manned spaceflight. In the late 1950s, NASA had already begun serious research and development to propel humans into space.

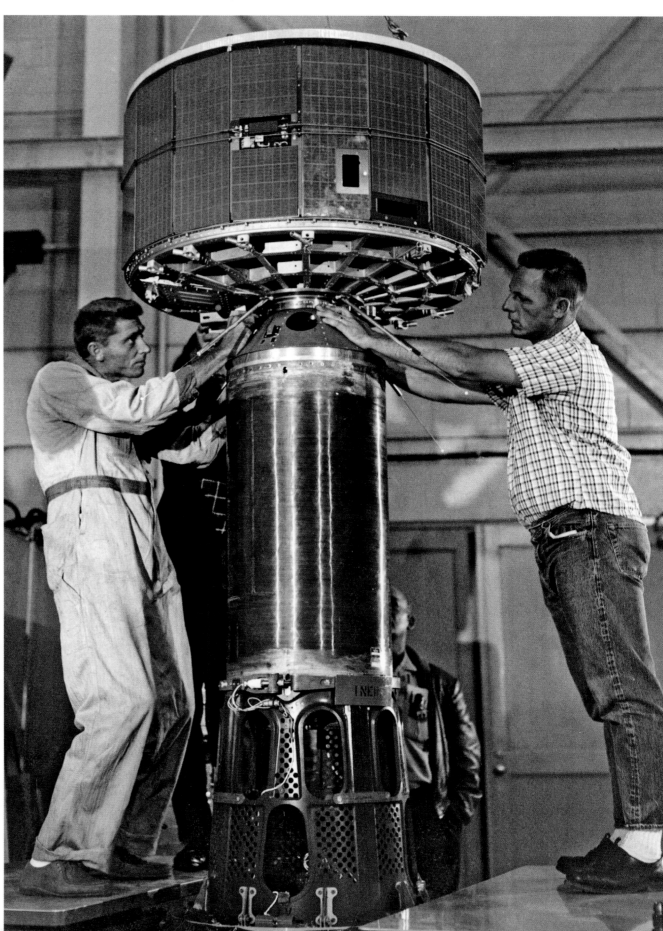

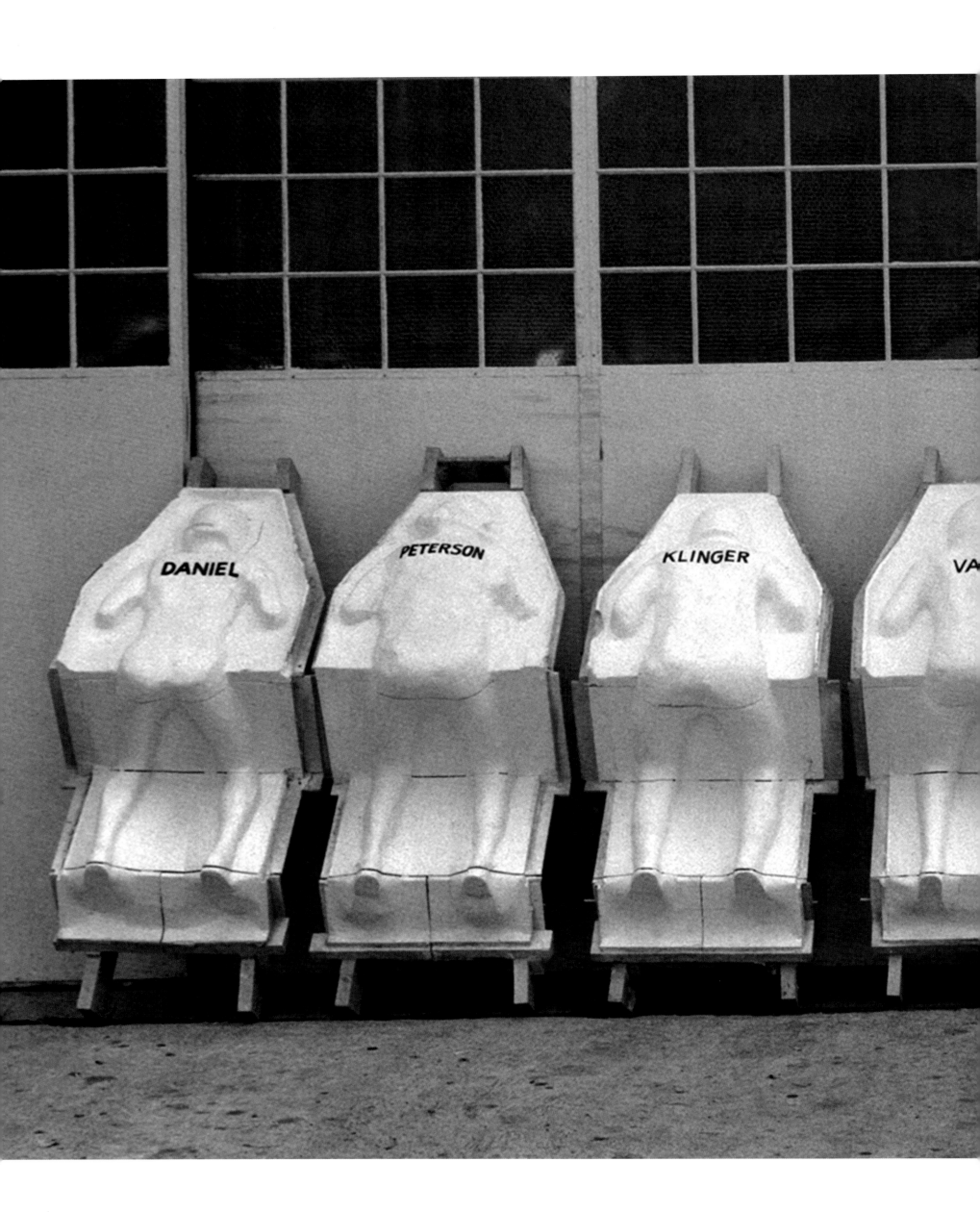

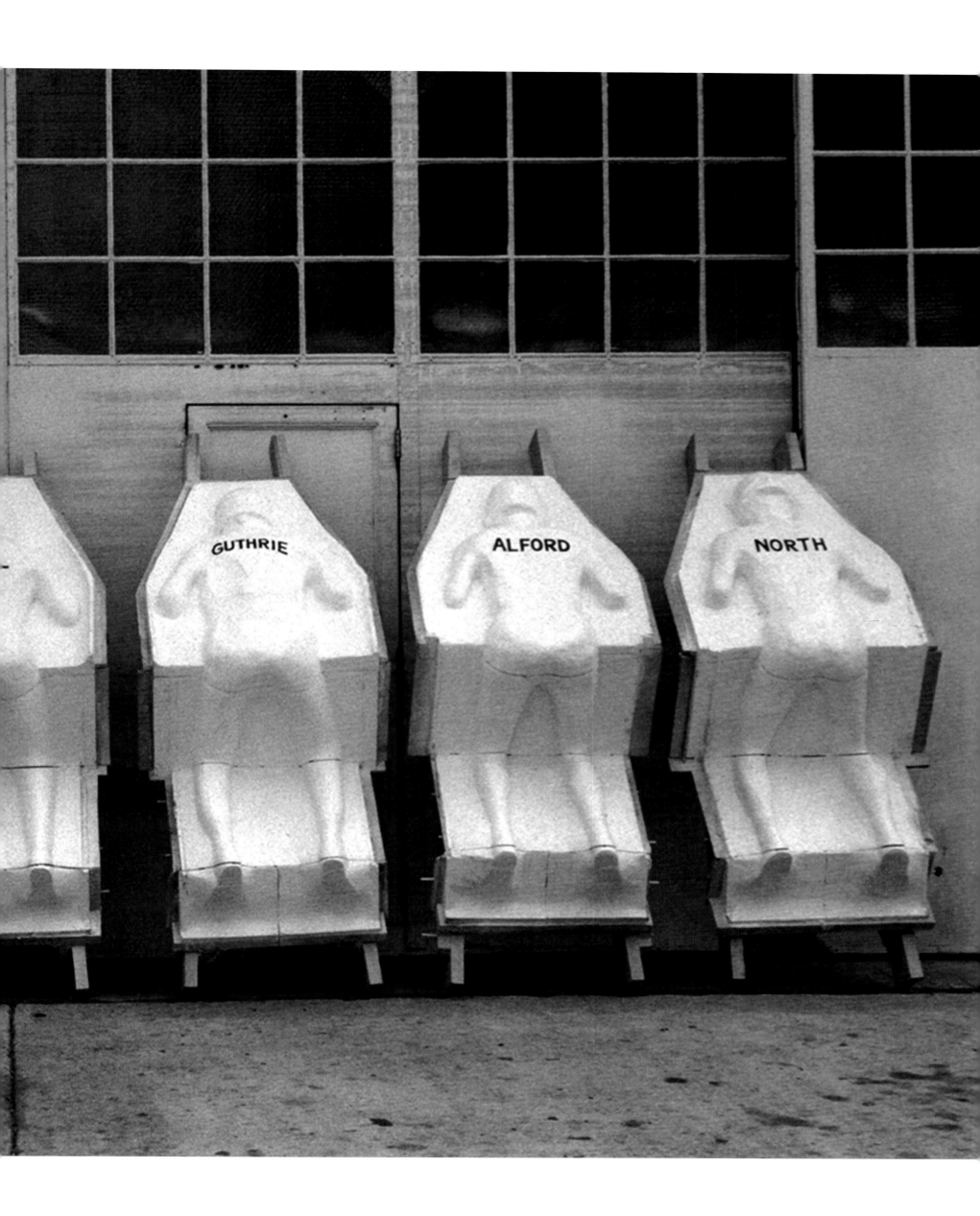

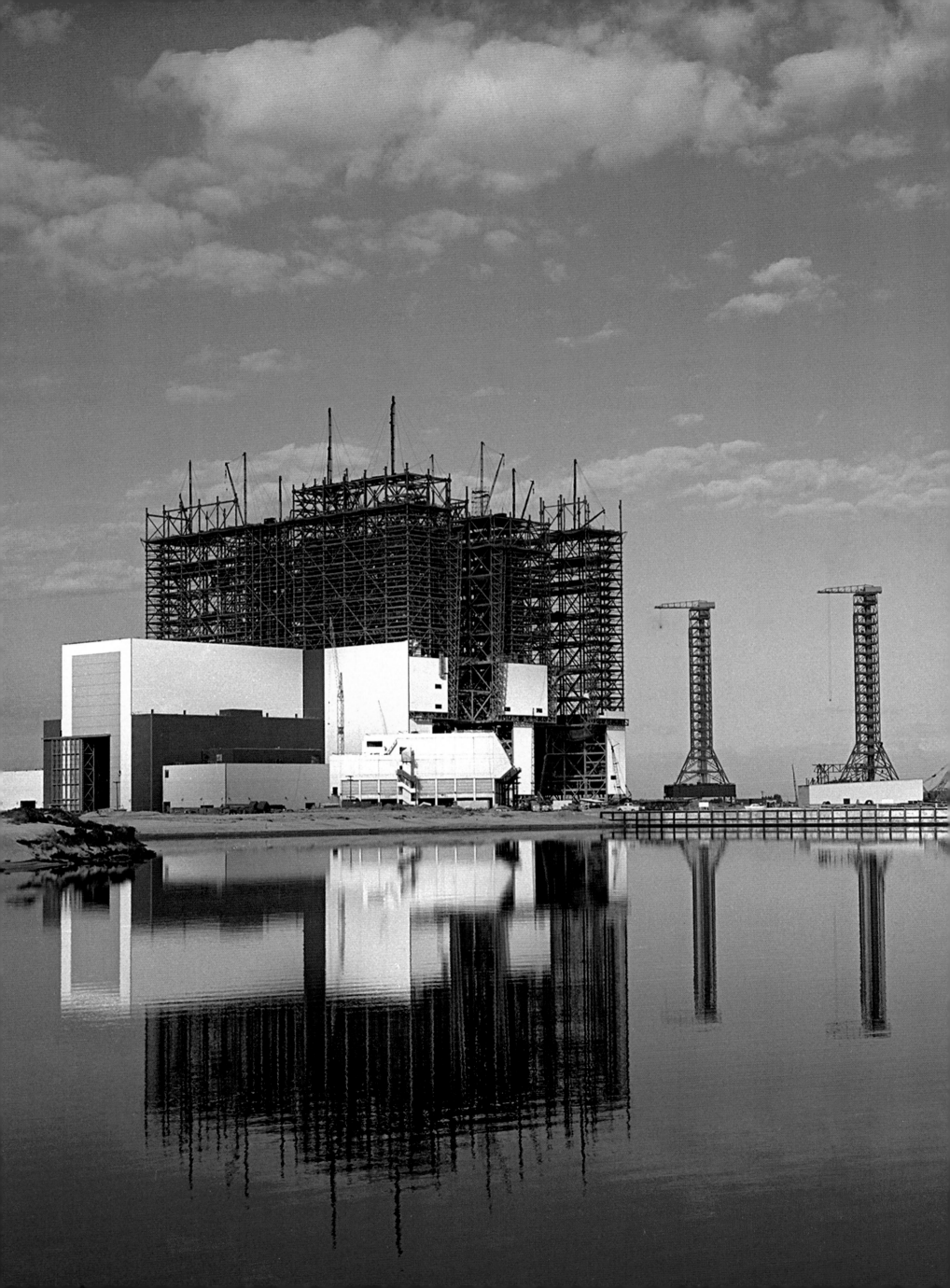

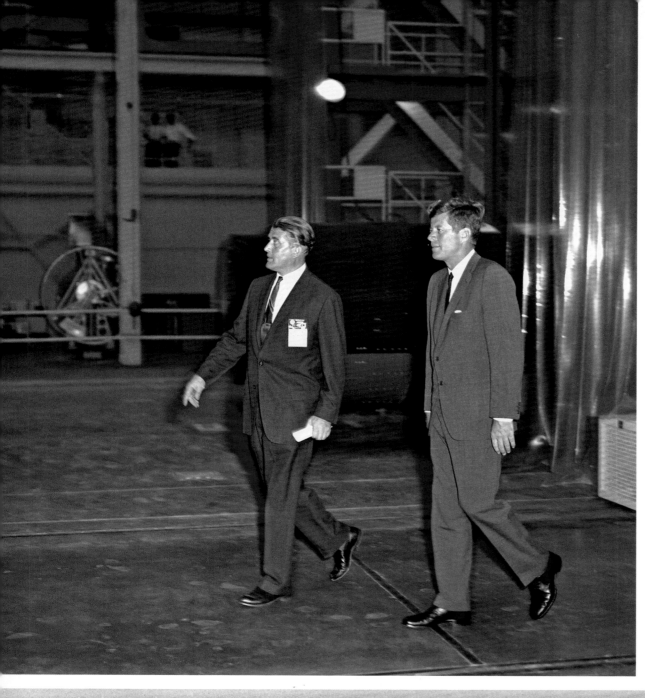

Left On September 11, 1962, President John F. Kennedy visited Marshall Space Flight Center, where he toured one of the laboratories with Wernher von Braun, Marshall director and rocket pioneer. On the very next day, Kennedy gave his famous "We choose to go to the Moon" speech at Rice Stadium in Houston, Texas. By then, NASA was already building the massive infrastructure that would be required for the effort.

Below An aerial view of "Missile Row" at Cape Canaveral Air Force Station in Florida in November 1964 shows the launch complexes where Mercury and Gemini missions originated. In the far distance, across the Banana River, the steel framework of the unfinished Vehicle Assembly Building (VAB) at Kennedy Space Center is just visible.

Opposite By 1965 the voluminous VAB is half finished. The service towers of Launch Complex 39 used for Apollo missions (and later for the space shuttle) can be seen in the distance. Completed in 1966, the VAB—525 feet tall by 716 feet long by 518 feet wide and equal in volume to more than three Empire State Buildings—would become renowned for the construction and maintenance of both the Saturn V rocket and the space shuttle.

Overleaf An aerial view of the Apollo 11 rollout on May 20, 1969, shows gigantic feats of human ingenuity. In the foreground is the Launch Control Center, with its firing rooms where launches are supervised. The Saturn V rocket, von Braun's legacy, stands 363 feet tall atop the crawler-transporter—with a platform the size of a baseball infield—that will carry it from the VAB to Launch Complex 39.

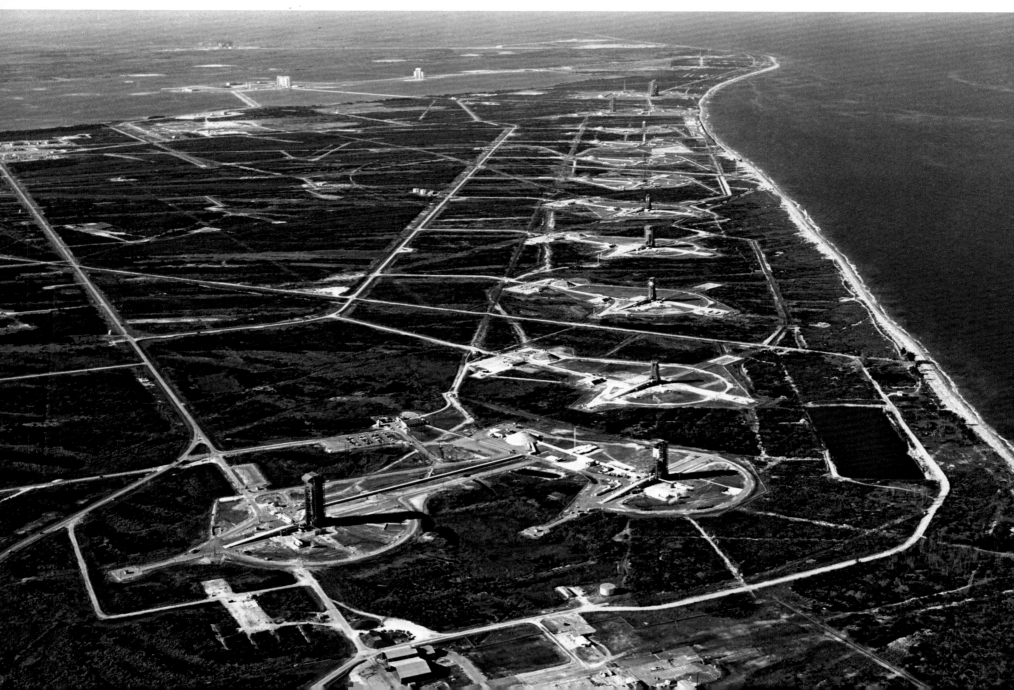

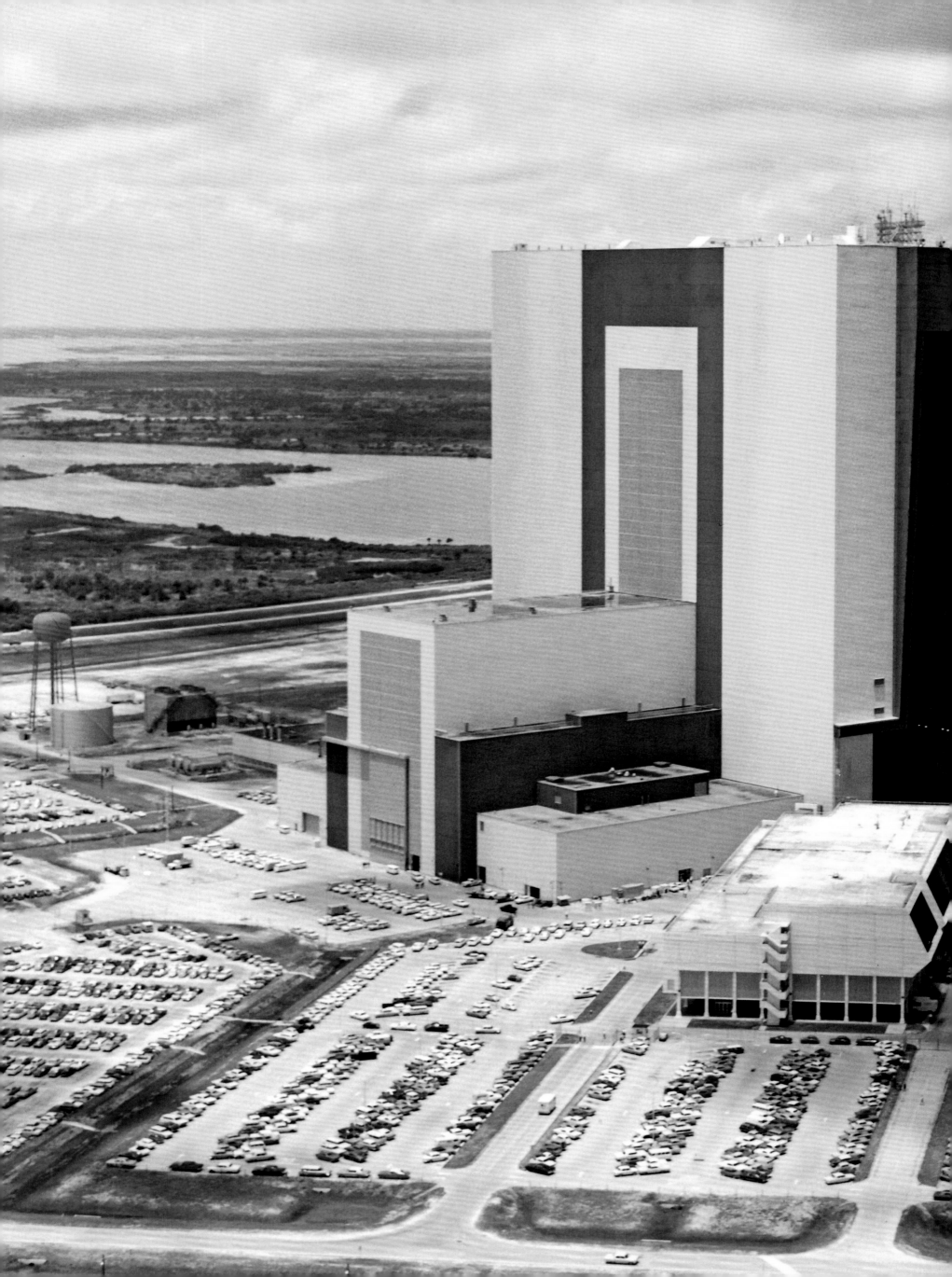

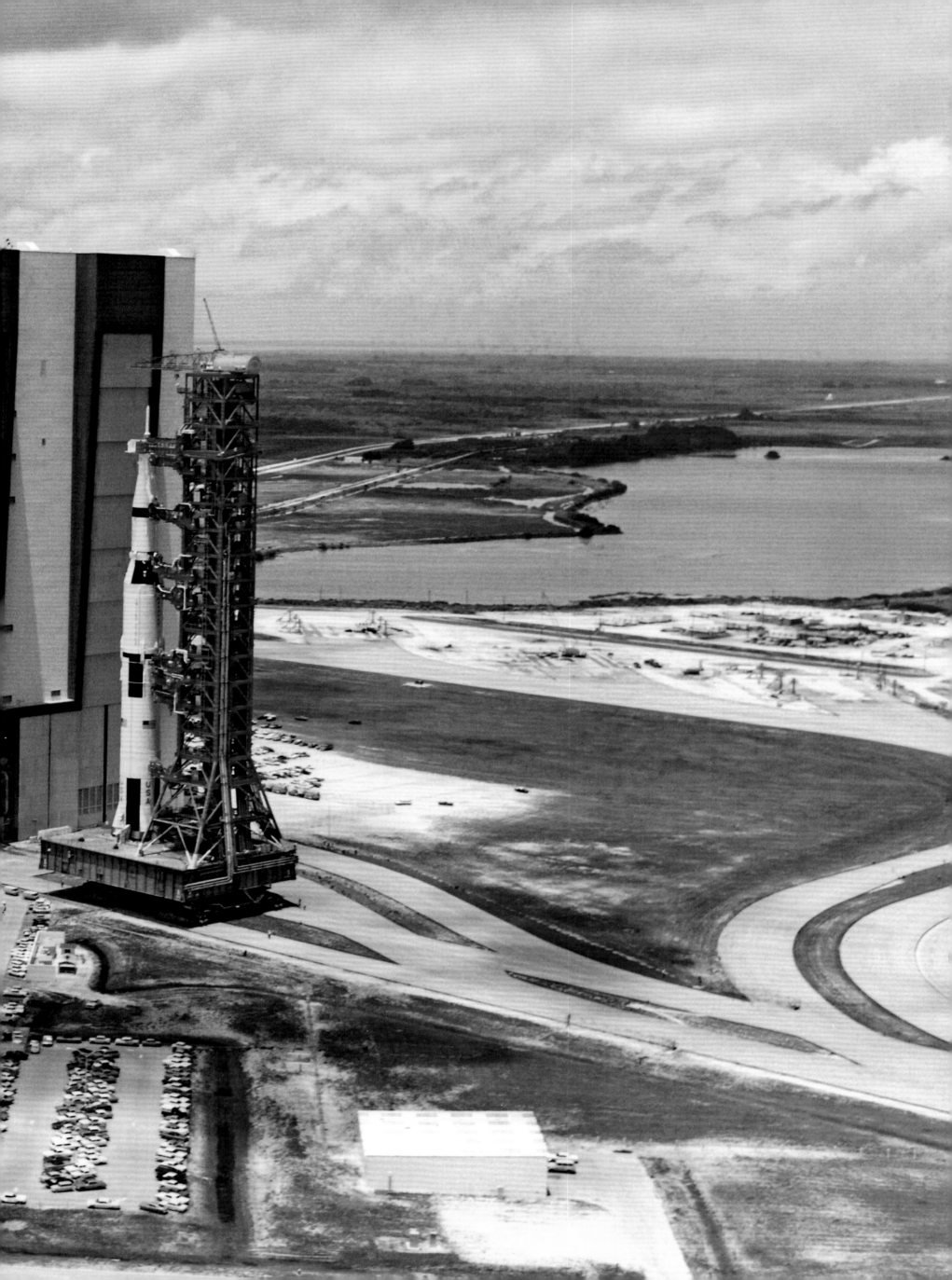

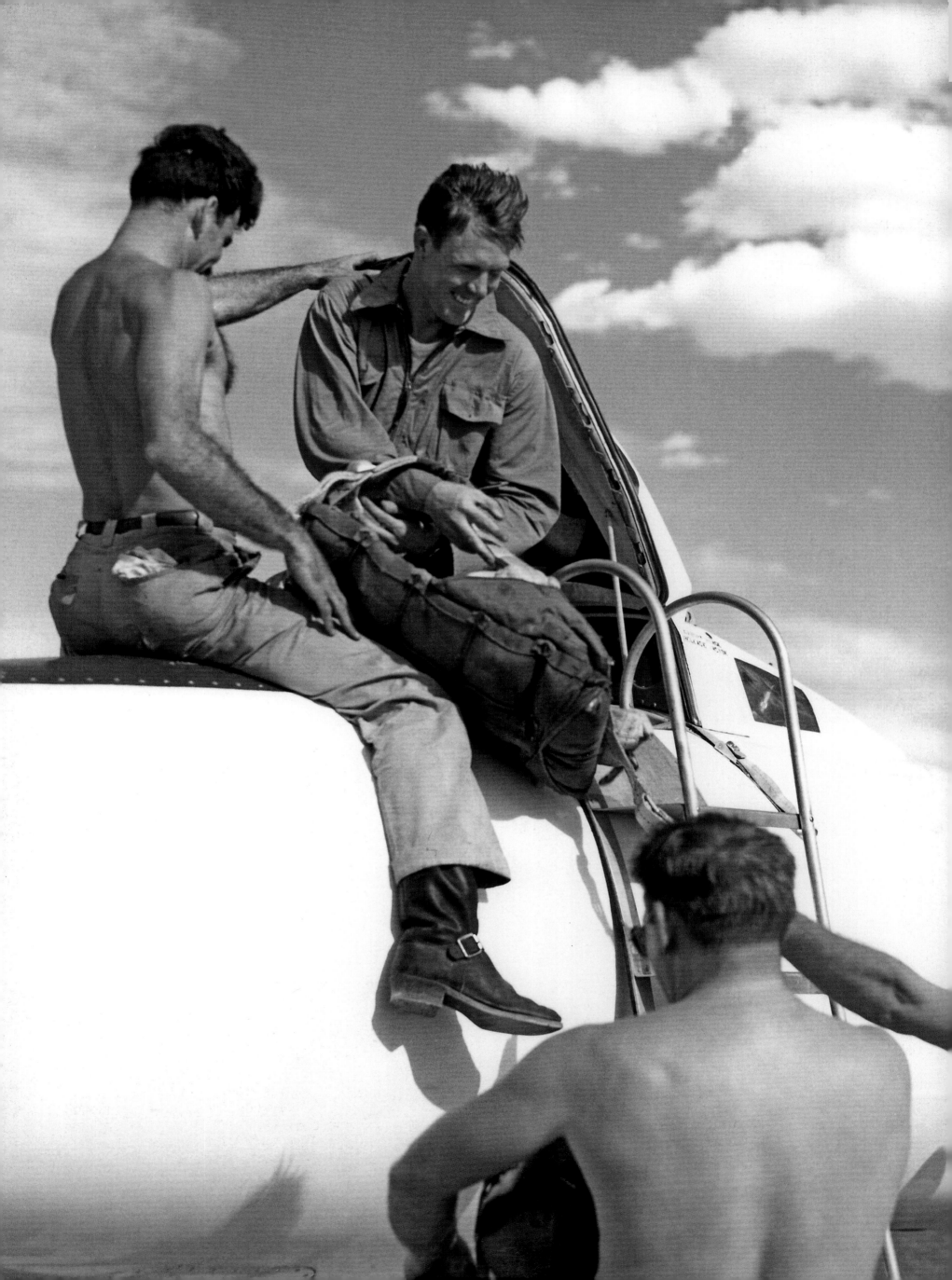

2

THE FIRST "A" IN NASA

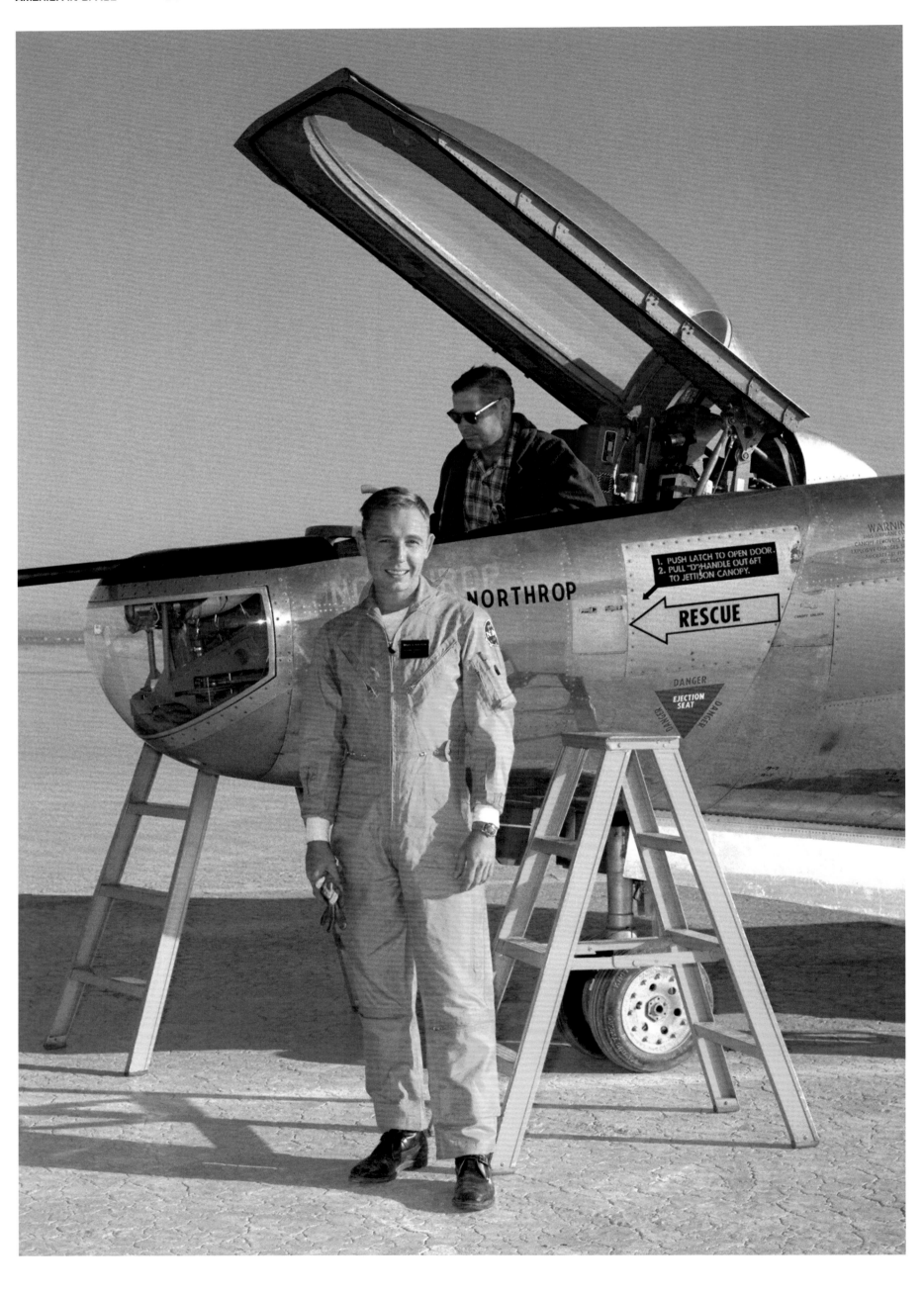

THE FIRST "A" IN NASA

NASA's first "A" is sometimes downplayed in the midst of its spectacular space achievements. But building on its roots in the National Advisory Committee for Aeronautics (NACA), NASA from its beginnings conducted research on aerodynamics, structures, controls, flight safety, and other important topics using wind tunnels, flight testing, and computer simulations.

Wind tunnels, though not the most glamorous technology, are essential to relatively low-cost testing of aircraft performance before the aircraft are actually built. NASA inherited a variety of wind-tunnel facilities from the NACA, many of them constructed during World War II at Ames, Lewis, and Langley. Each wind tunnel had its own characteristics, depending on the size of the aircraft or models being tested, and whether they were being tested at subsonic, transonic, and supersonic speeds. By the dawn of the Space Age, hypersonic tunnels were constructed with their own unique characteristics and capabilities. Wind tunnels were also used to determine the aerodynamics of the Mercury, Gemini, and Apollo capsules, and eventually the space shuttle for ascent and entry. They continue to be a vital tool for aeronautics research.

In the area of flight testing, from its beginning NASA assumed joint responsibility with the Air Force for testing the X-15 hypersonic aircraft, capable of speeds exceeding Mach 6 (4,500 miles per hour) at altitudes of sixty-seven miles, reaching the very edge of space. Between 1959 and 1968, three X-15 aircraft completed 199 flights, and contributed greatly to knowledge about hypersonic aerodynamics and structures eventually needed for spaceflight, including the space shuttle. The X-15 was air-launched from a B-52. Its "control room," located at the NASA (now Dryden) Flight Research Center in the California desert, advanced from a portable van to a more formal permanent room that later served as the model for the famous mission control at Johnson Space Center. Synergies between aeronautics and human spaceflight also appeared in other ways; today it is a little-known fact that Neil Armstrong was an X-15 pilot working for NACA, and that eight other X-15 pilots flew high enough to be qualified as astronauts according to US standards (fifty miles). Many other astronauts were research or test pilots on other high-performance research aircraft. NASA also cooperated with the Air Force in the 1960s on the X-20 Dyna-Soar program, which was designed to fly humans into orbit. The program was eventually cancelled, but the ideal of winged spacecraft never died.

NASA also conducted significant research on aircraft flight efficiency, maneuverability, and safety over all speed ranges. NASA scientist Richard Whitcomb invented the "supercritical wing," specially shaped to delay and lessen the impact of shock waves on performance aircraft. It had a significant impact on civil aircraft design. From 1963 to 1975, NASA conducted a series of research programs on "lifting bodies," or aircraft without wings. During the 1970s NASA undertook a variety of aeronautics research using the SR-71 Blackbird in the Mach 3 range.

During the 1980s NASA and the Department of Defense began the development of a hypersonic National Aerospace Plane known as the X-30, and later worked on the X-33 hypersonic flight demonstrator project. For a variety of reasons these never reached production. In 2004, the hypersonic X-43A aircraft used innovative scramjet technology to fly at 7,000 miles per hour, almost ten times the speed of sound, setting a world's record for air-breathing aircraft.

In addition to its better-known spaceflight achievements, during its first fifty years NASA continued in the forefront of flight, carrying on from the humble beginnings of the Wright brothers at Kitty Hawk. As thousands of pilots over the last century can attest, flight through the atmosphere has a magic all its own. Despite the high-technology nature of its work,

NASA's aeronautical research still embodies the tradition captured by John Gillespie Magee, an American Royal Canadian Air Force pilot who wrote these words before his death during World War II at age nineteen:

> Oh! I have slipped the surly bonds of earth
> And danced the skies on laughter-silvered wings;
> Sunward I've climbed and joined the tumbling mirth
> Of sun-split clouds—and done a hundred things
> You have not dreamed of—wheeled and soared and swung
> High in the sunlit silence. Hov'ring there,
> I've chased the shouting wind along, and flung
> My eager craft through footless falls of air.
> Up, up the long, delirious burning blue
> I've topped the wind-swept heights with easy grace
> Where never lark, nor even eagle flew.
> And, while with silent, lifting mind I've trod
> The high untrespassed sanctity of space,
> Put out my hand, and touched the face of God.

As test pilot and Apollo 11 astronaut Michael Collins reminded us in his book *Carrying the Fire*, these words retain their meaning in the Space Age, built as it is on the expertise of test pilots who often displayed Magee's "High Flight" sonnet in their cockpits. Collins had it with him in his Gemini 10 spacecraft. And on the day of the space shuttle *Challenger* accident twenty years later, President Reagan eulogized the astronauts by saying "We will never forget them this morning as they prepared for their journey and waved goodbye and slipped the surly bonds of earth to touch the face of God." Aeronautics and spaceflight have much in common technologically, and even more in spirit.

Page 32 Test pilot Robert Champine is seen in the cockpit of a D-558-1 Skystreak with the ground crew in 1949. The Douglas D-558 series of aircraft were a joint Navy/NACA program beginning in 1945 to perform transonic (D-558-1) and later supersonic (D-558-2) flight research. The D-558-1 Skystreak was turbojet powered, while the D-558-2 Skyrocket was air-launched and rocket powered. On November 20, 1953, a D-558-2 Skyrocket with Scott Crossfield at the controls was the first aircraft to exceed Mach 2.

Opposite Test pilot Bruce Peterson stands beside the M2-F2 lifting body on Rogers Dry Lake near the Flight Research Center in Edwards, California. On May 10, 1967, Peterson crashed the M2-F2 on the lakebed and survived. The crash, used in the opening sequence of *The Six Million Dollar Man* television program, was seen by millions.

Overleaf The Bell Aircraft Corporation X-1E is mated to the belly of a Boeing B-29 mother ship in 1955. The B-29 will carry it to an altitude of approximately 25,000 feet before releasing it; the pilot will then activate the XLR-11 rocket engine for the research flight and glide to a landing on Rogers Dry Lake. The X-1 series of rocket planes was used for research into supersonic flight; Air Force Captain Chuck Yeager first broke the sound barrier in a Bell X-1 on October 14, 1947.

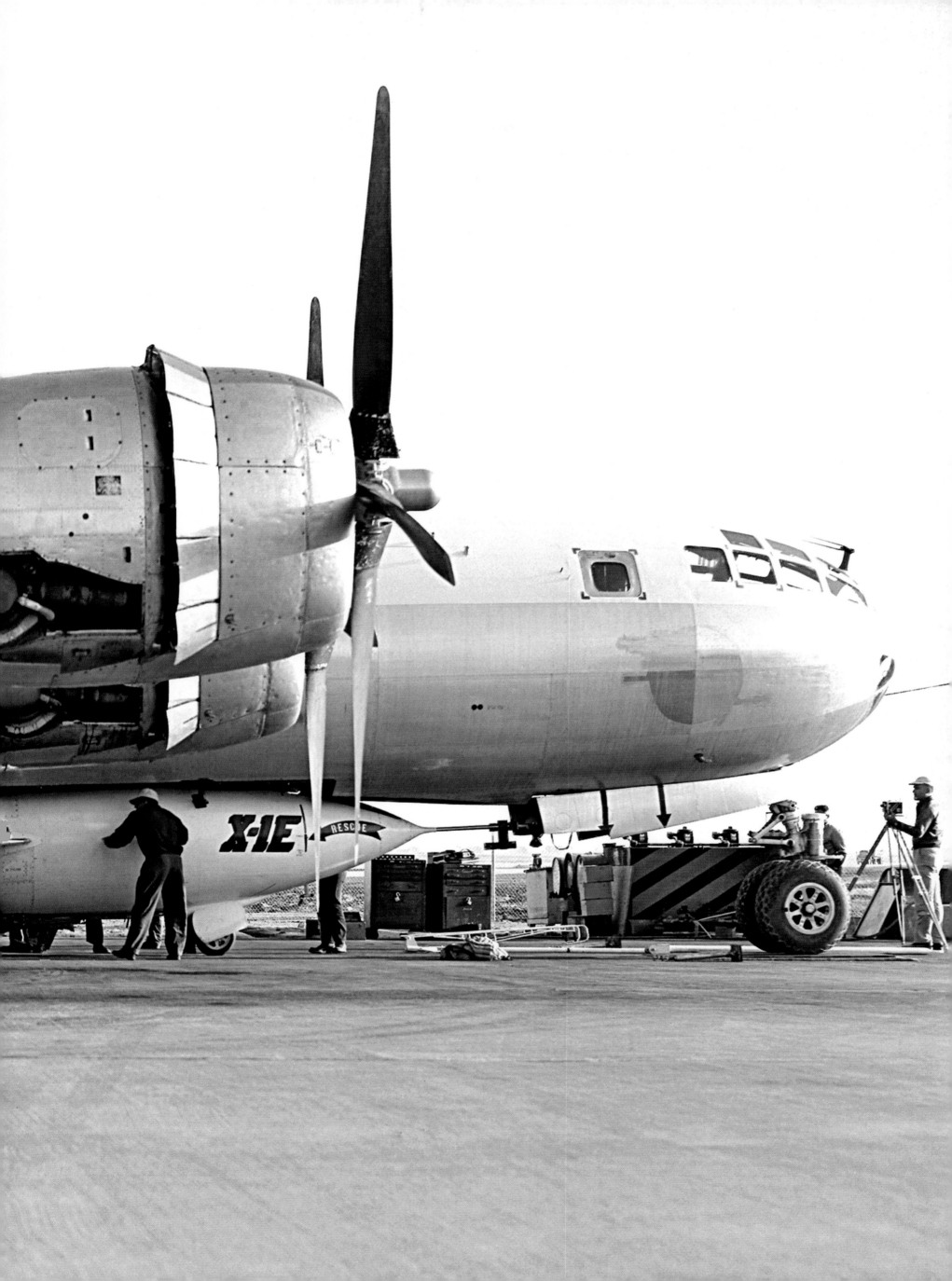

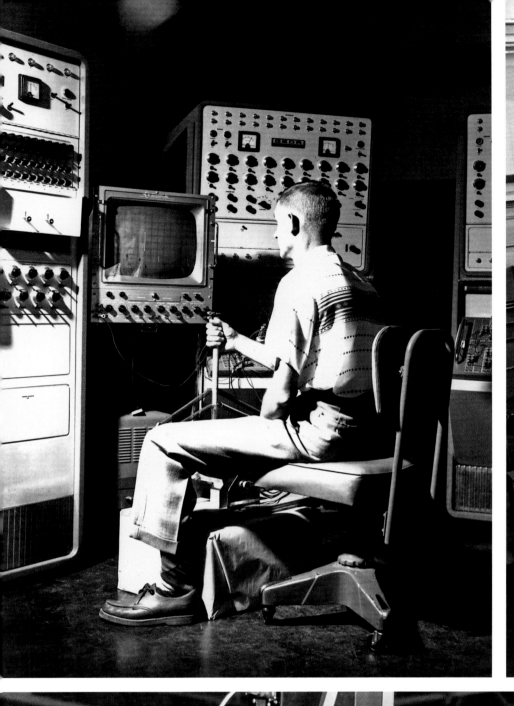

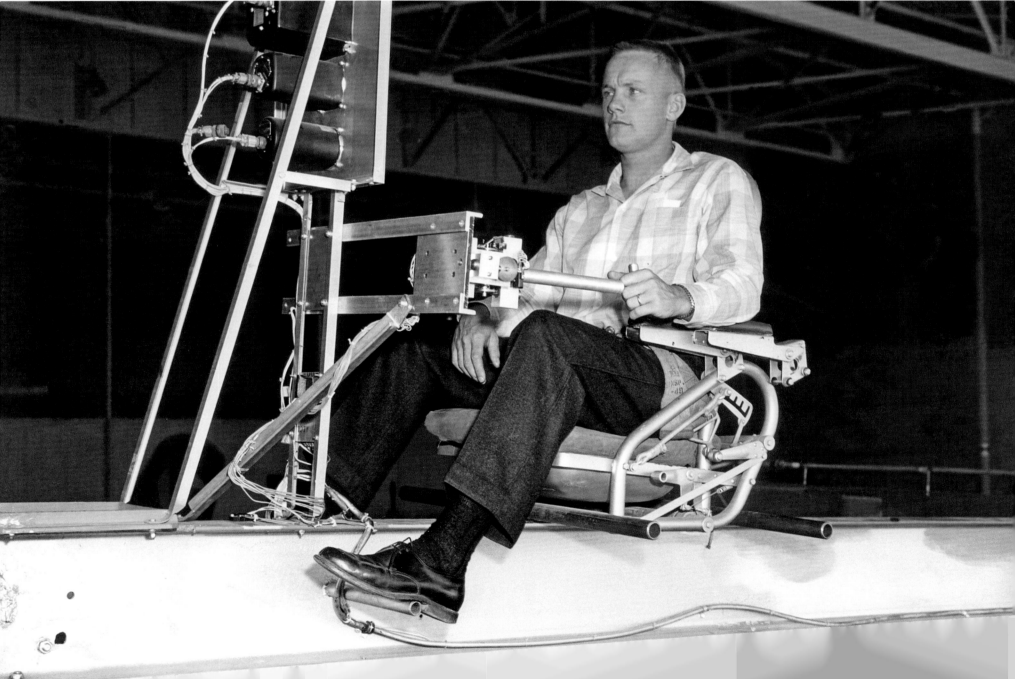

One of the major advances in pilot training and mission planning for research-flight activities in the 1950s and 1960s was the use of simulators. **Far left** NACA engineer Richard Day is testing out the Air Force's General Electric differential analyzer (an analog computer) fitted with an airplane stick and controls to create a simulator of the X-2 aircraft in 1955. **Below left** Test pilot Neil Armstrong is operating a device used to simulate the reaction-control system of the X-15 at high altitudes in 1956. **Left** Five years later, NASA's X-15 flight simulator has a more sophisticated computer programmed with the flight characteristics of the aircraft, so that pilots can "fly" a mission on it before the real flight. The generators used in the X-15 simulator had hundreds of fuses, amplifiers, and potentiometers without any surge protection. After the simulator was started on a Monday morning, it would be noon before it had warmed up and stabilized.

Below The X-15 was intended to be air launched from a B-52, and testing was necessary to determine if this was feasible. A one-twentieth-scale model of the X-15 is being released, or dropped, from beneath the wing of the B-52 mother ship in the Langley high-speed seven-by-ten-foot wind tunnel. From these and other tests it was determined that it was safe to air-launch the X-15 from the B-52.

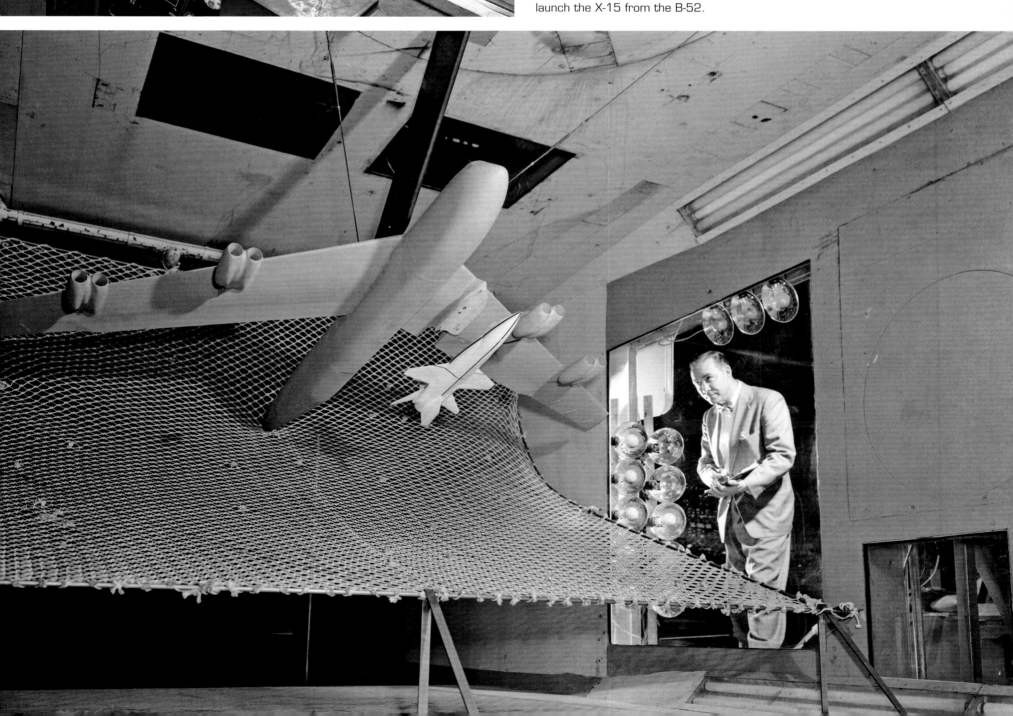

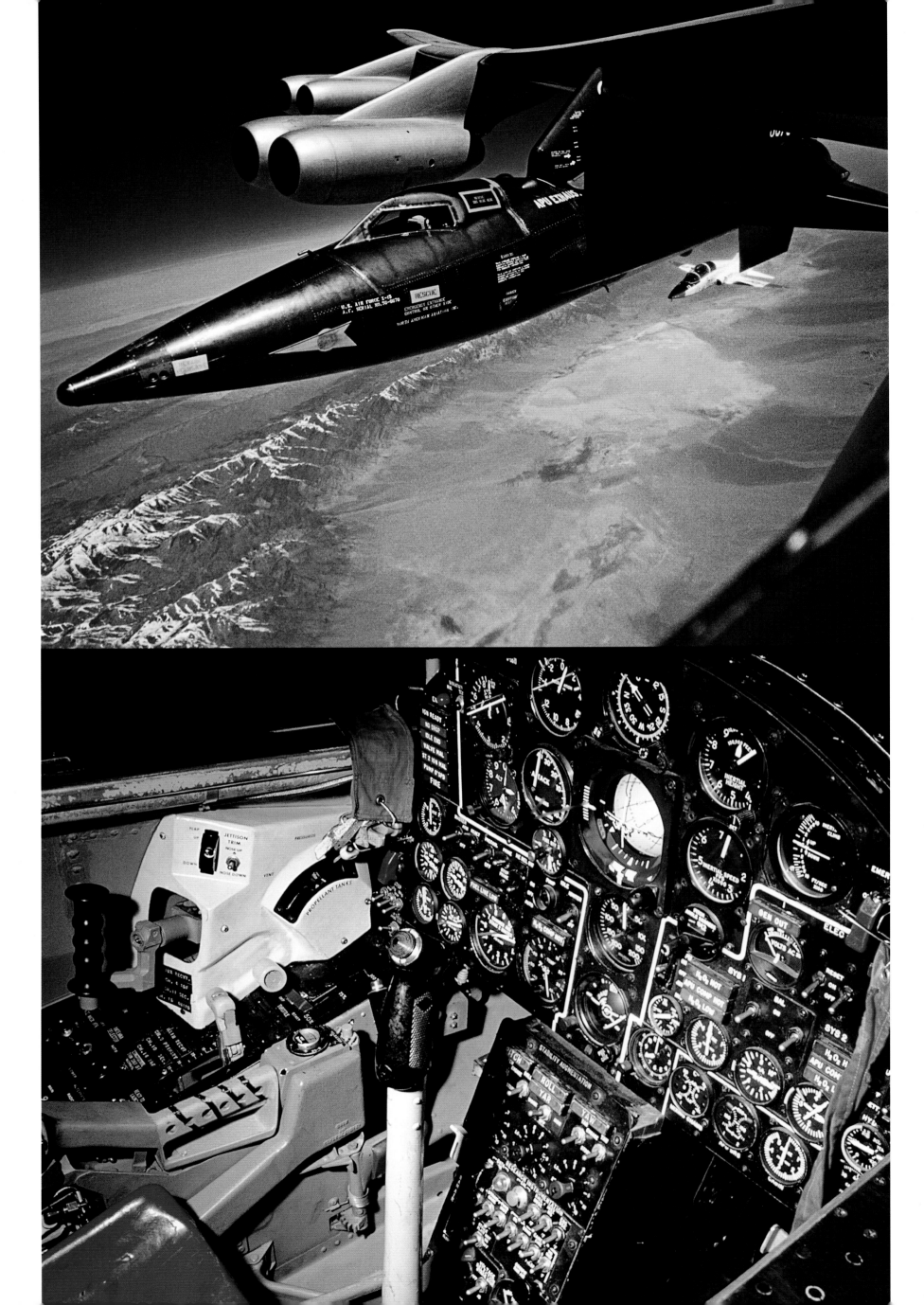

Opposite top An X-15 research aircraft is carried to its launch altitude of 45,000 feet on the wing of a NASA NB-52 "008" or "balls eight" aircraft. Below and behind the X-15 is one of the chase aircraft used to monitor the flight. The North American X-15 series of rocket planes was one of NASA's premier aeronautics programs in its early years. X-15s reached an altitude of 354,200 feet (67.08 miles) and a speed of 4,520 mph (Mach 6.7) during their highly successful 199 flights from 1959 to 1968. These speed and altitude records for winged aircraft would remain unbroken until the space shuttle first returned from Earth orbit in 1981. The original program provided data on aerodynamics, structures, flight controls, and the physiological aspects of high-speed, high-altitude flight. A follow-on program used the X-15 aircraft as testbeds to carry various scientific experiments beyond the Earth's atmosphere.

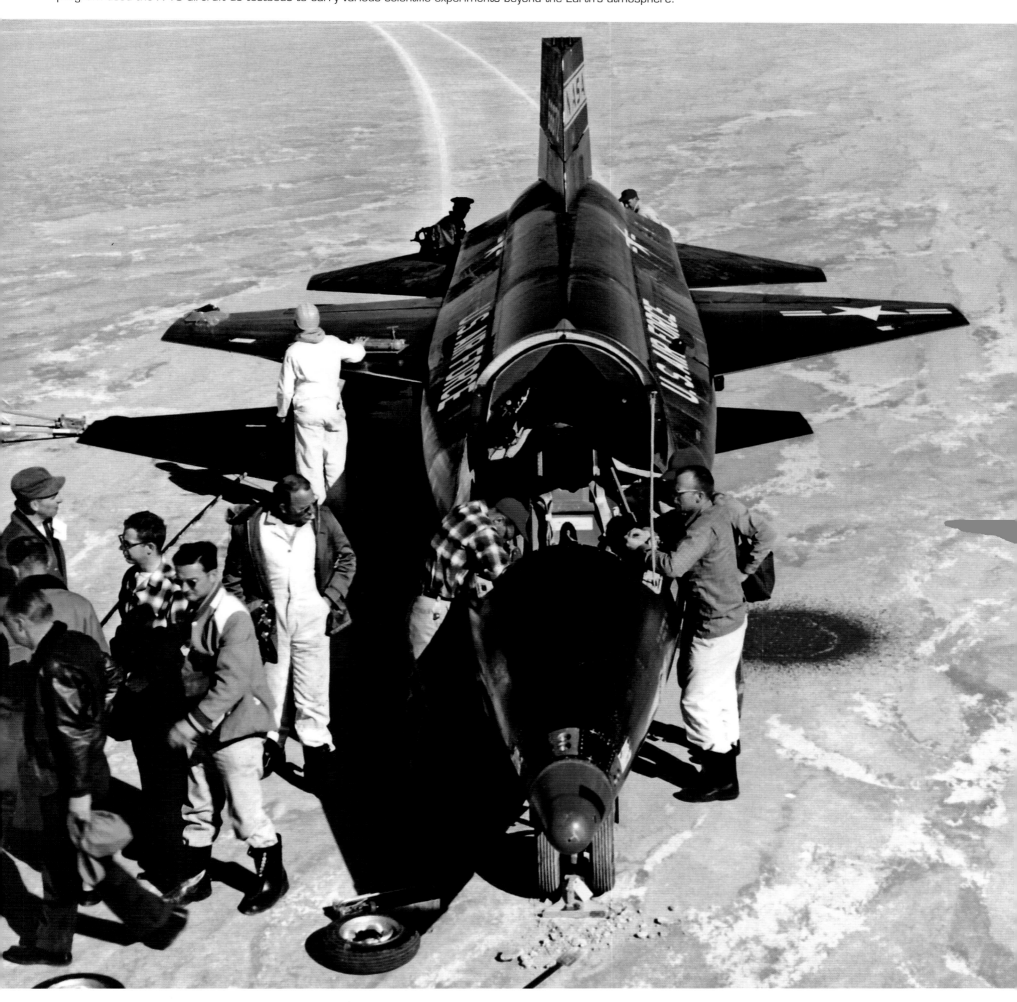

Above X-15-3 is secured by ground crew after landing on Rogers Dry Lakebed.

Opposite bottom The cockpit of the X-15 was crowded with instruments and controls, including the standard stick and rudder pedals for conventional flying and a side-stick multi-axis controller for the reaction-control system used at the edge of space where the aerodynamic control surfaces would not function. The X-15 was the first vehicle to use multiple systems for control through various flight regimes.

Below The X-15 test pilots are photographed in 1966 in front of X-15-2. From left to right: Air Force Captain Joseph Engle, Air Force Major Robert Rushworth, NASA pilot Jack McKay, Air Force Major Pete Knight, NASA pilot Milt Thompson, and NASA pilot Bill Dana. These six pilots made 125 of the 199 total flights in the X-15. **Opposite** While preparations for each research flight and the flights themselves were serious affairs, the pilots found time to clown around during this photo op. Eight of the X-15 pilots would earn astronaut wings for their flights, although none before Alan Shepard's first Mercury mission in 1961. The Air Force defined the qualification for astronaut wings as flight above fifty statute miles altitude. Five Air Force pilots qualified; Adams (posthumously), Engle, Knight, Rushworth, and White. The qualifying civilian NASA pilots, Dana, McKay, and Walker, were not recognized with astronaut wings until 2005.

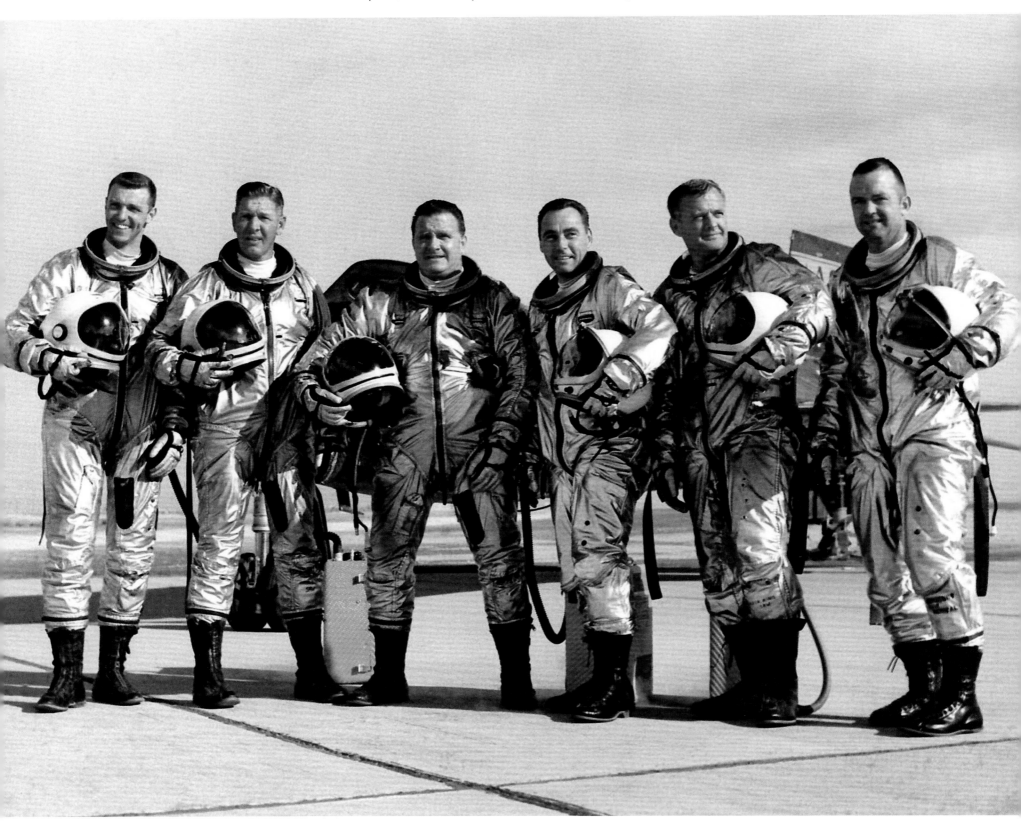

Overleaf Nearly a decade before his journey to the Moon's surface, test pilot Neil Armstrong poses in front of X-15-1. Armstrong made his first of seven X-15 flights on November 30, 1960, in this aircraft. The X-15 employed a non-standard landing gear. It had a nose gear with a wheel and tire, with skids mounted at the rear of the vehicle. In the photo, the left skid is visible, as are marks on the lakebed from both skids. Because of the skids, the rocket-powered aircraft could only land on the dry lakebed, not on a concrete runway.

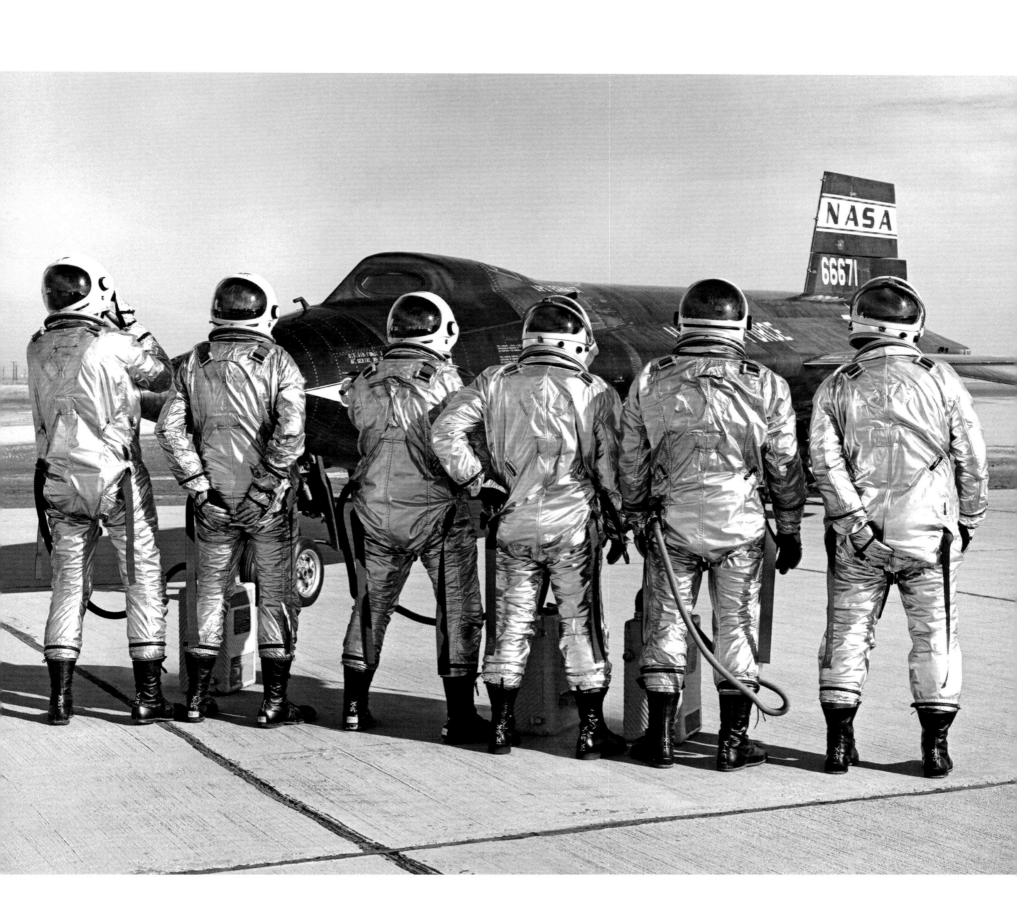

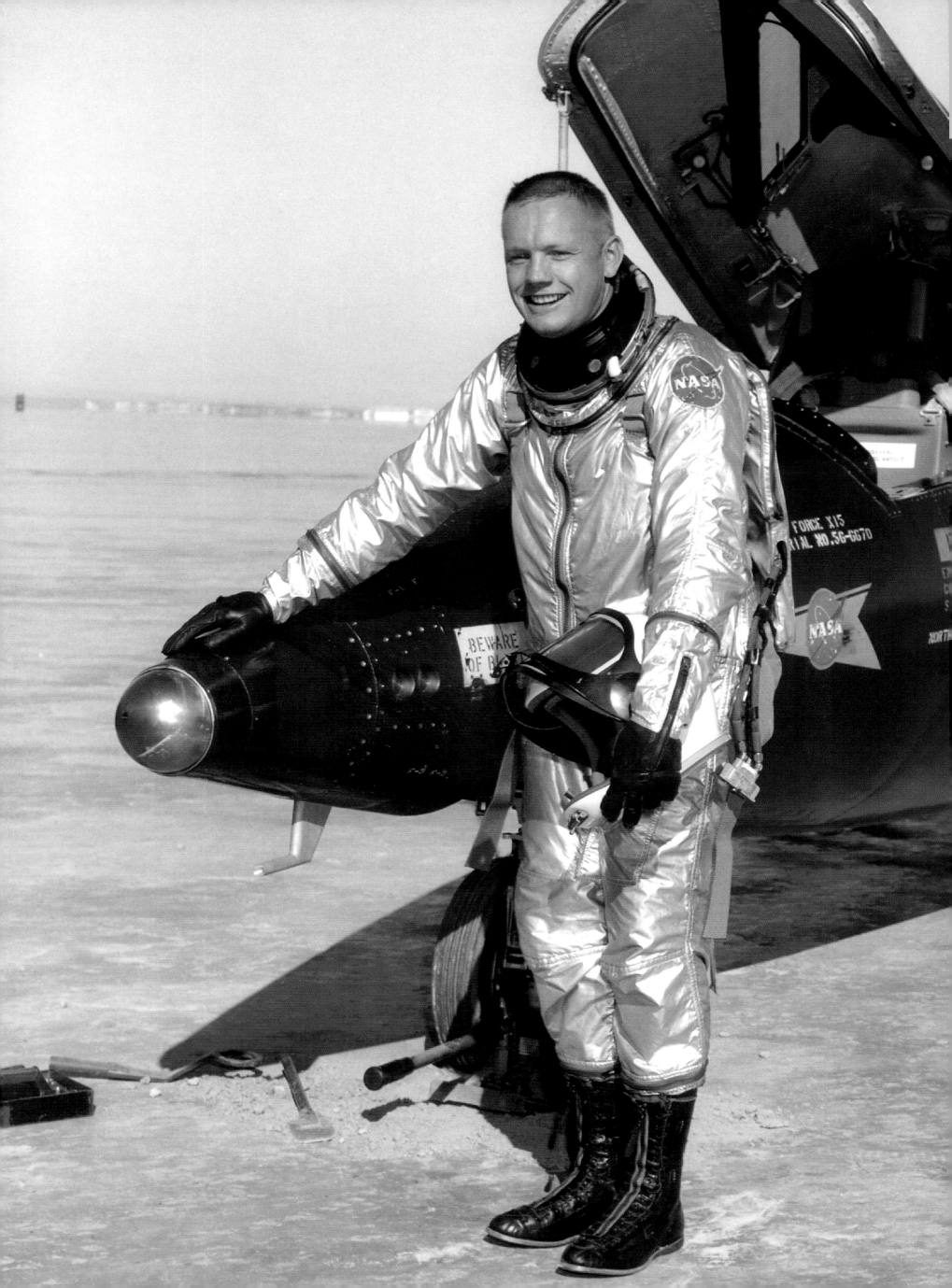

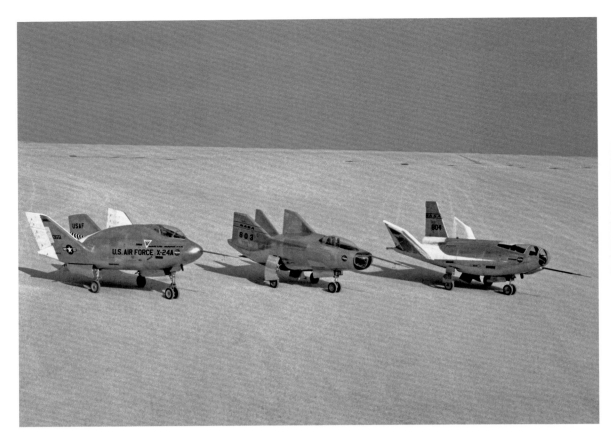

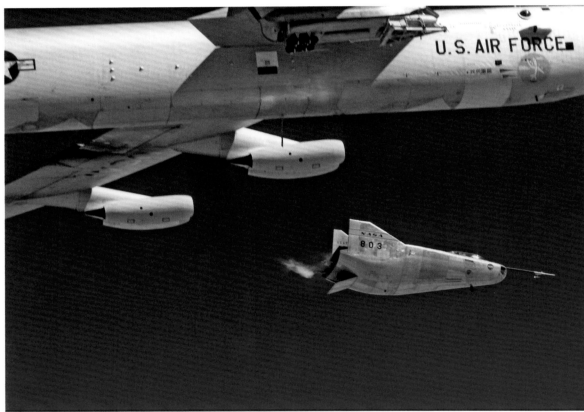

At the dawn of the space age, NASA explored different concepts for safely returning humans back to Earth from space. A capsule was chosen for the Mercury, Gemini, and Apollo programs due to a number of constraints, including time and weight. A concept that offered greater cross-range flexibility was the lifting body; an aircraft that uses its body instead of wings to generate the lift necessary to remain aloft. Between 1963 and 1975, six lifting-body designs were tested at Dryden. **Previous spread** An engineer mounts a model of the M-1 lifting body in the test section of the 3.5-foot hypersonic tunnel at Ames Research Center to determine the vehicle's aerodynamic characteristics at speeds above Mach 5 in 1964. **Top** Three of the series (X-24A, M2-F3, HL-10) pose on Rogers Dry Lake, December 18, 1969. **Opposite** Test pilot Milt Thompson (on the ladder) is assisted into the cockpit of the M2-F2 before it is carried aloft by the B-52 mother ship in 1966. **Above** After it crashed in 1967, the M2-F2 was reconfigured for greater stability as the M2-F3, seen here being launched in 1971.

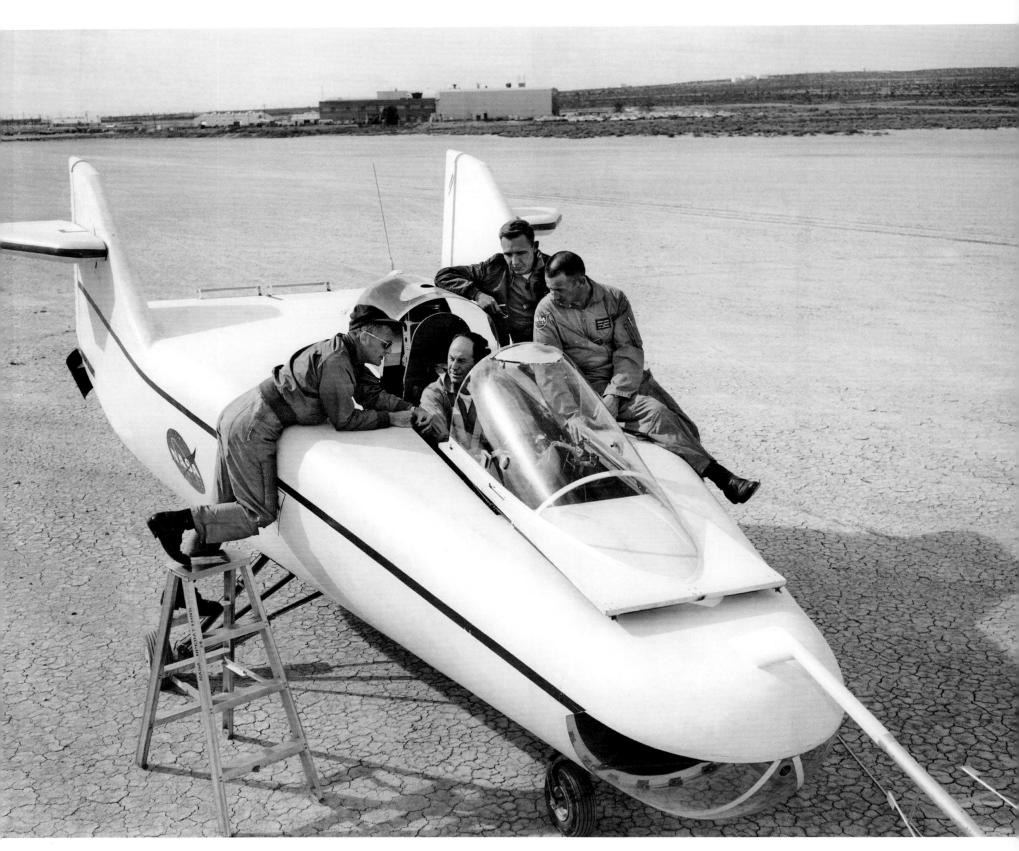

The first lifting body was the M2-F1, and it was initially tested in tow behind a souped-up Pontiac convertible. Eventually, M2-F1 was towed by a C-47 transport plane and released at about 12,000 feet to glide back to Earth. **Above** Colonel Chuck Yeager, then commandant of the Air Force's Aerospace Research Pilots School, checks out the aircraft in 1963 for possible use as a trainer. Yeager (seated in the cockpit) is surrounded by NASA project pilots Bruce Peterson and Milt Thompson, along with backup pilot Don Mallick.

In February 1970, the HL-10 attained speed (Mach 1.86, with Air Force test pilot Peter Hoag in the cockpit) and altitude (90,030 feet, piloted by NASA's Bill Dana) records for the lifting-body program. **Opposite** NASA test pilot John Manke confers with crew chief Charles Russell across the HL-10. **Overleaf** Dana takes a moment to watch NASA's NB-52B aircraft cruise overhead after landing the HL-10 on Rogers Dry Lake in 1969.

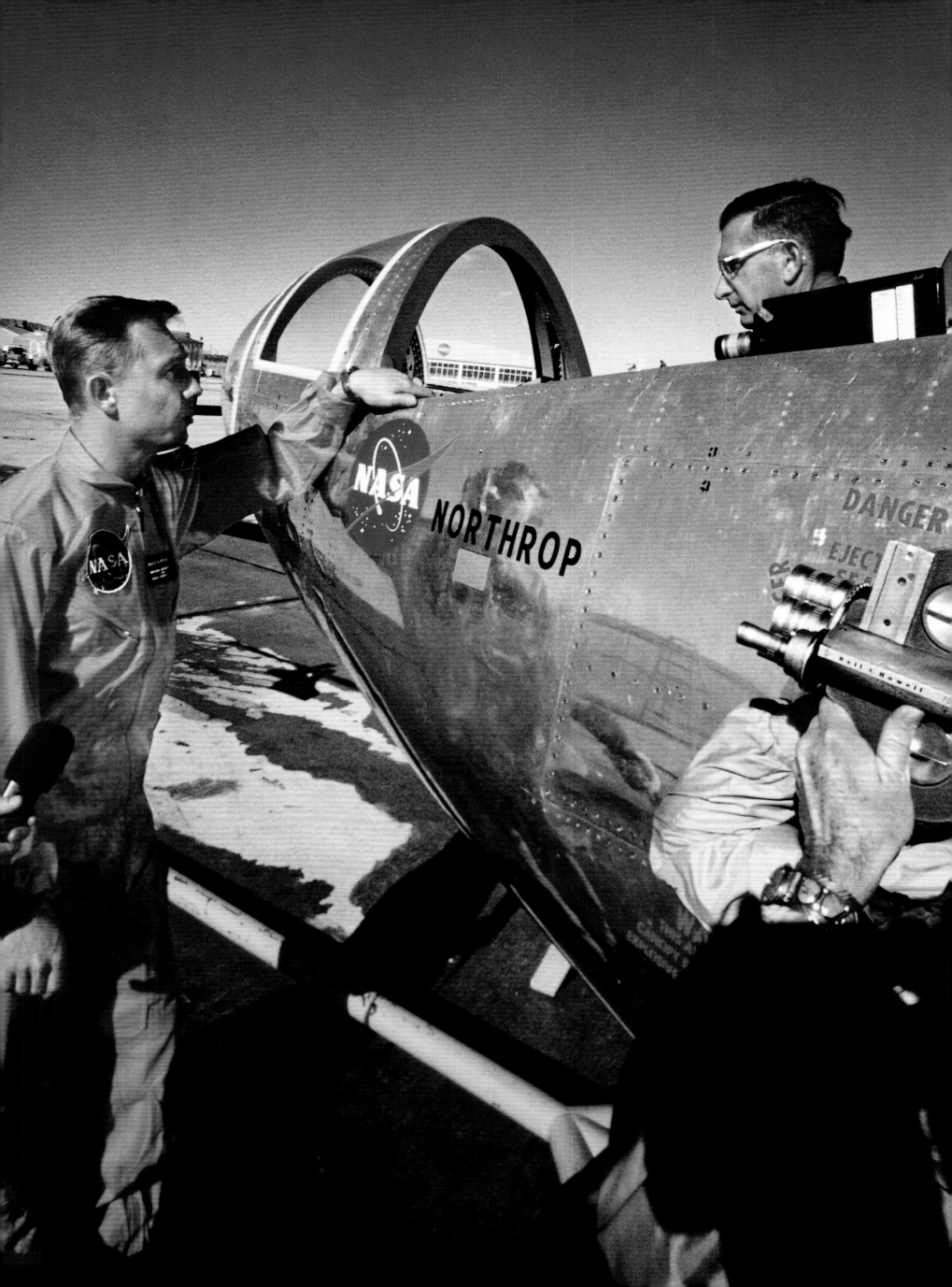

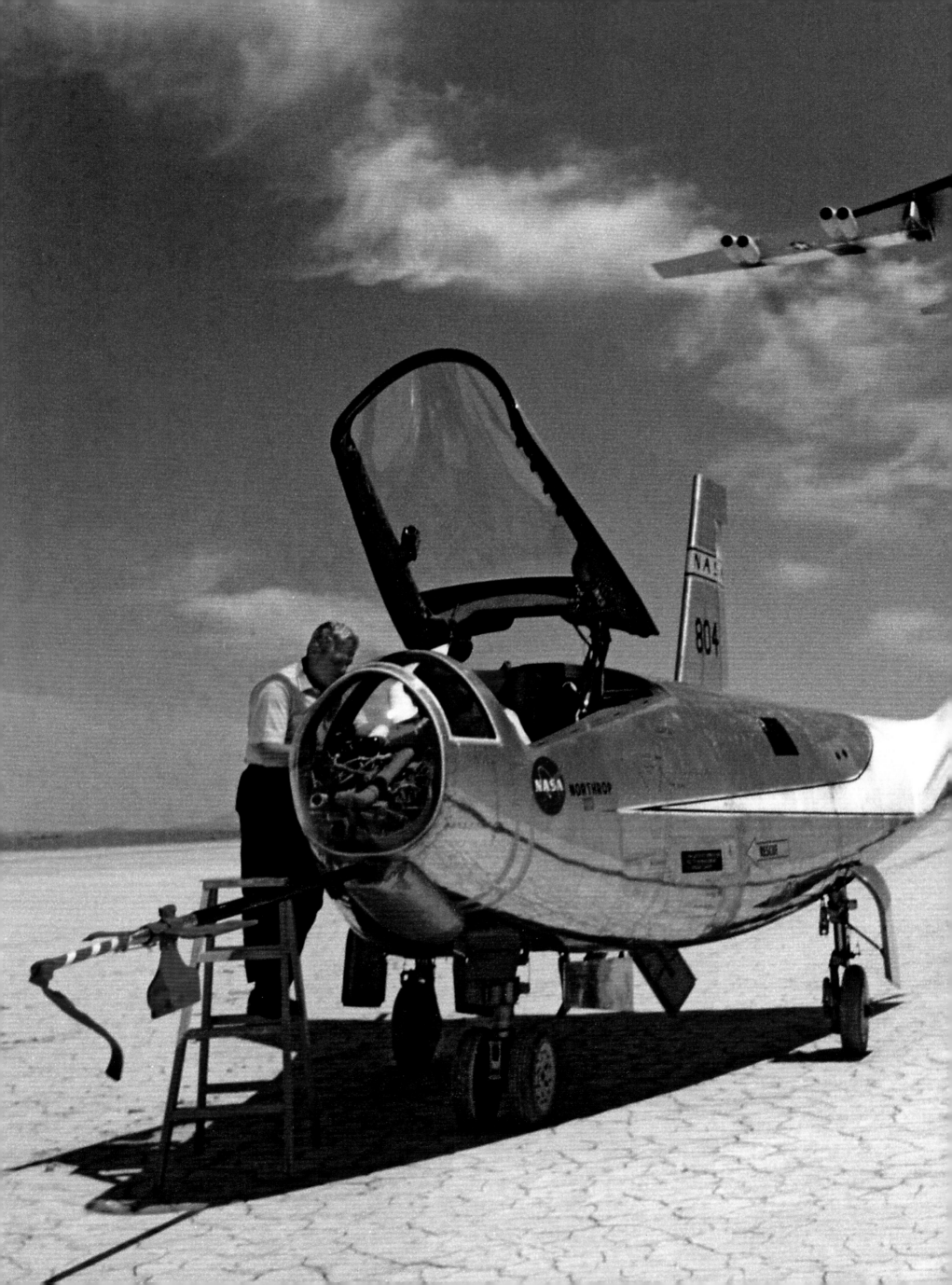

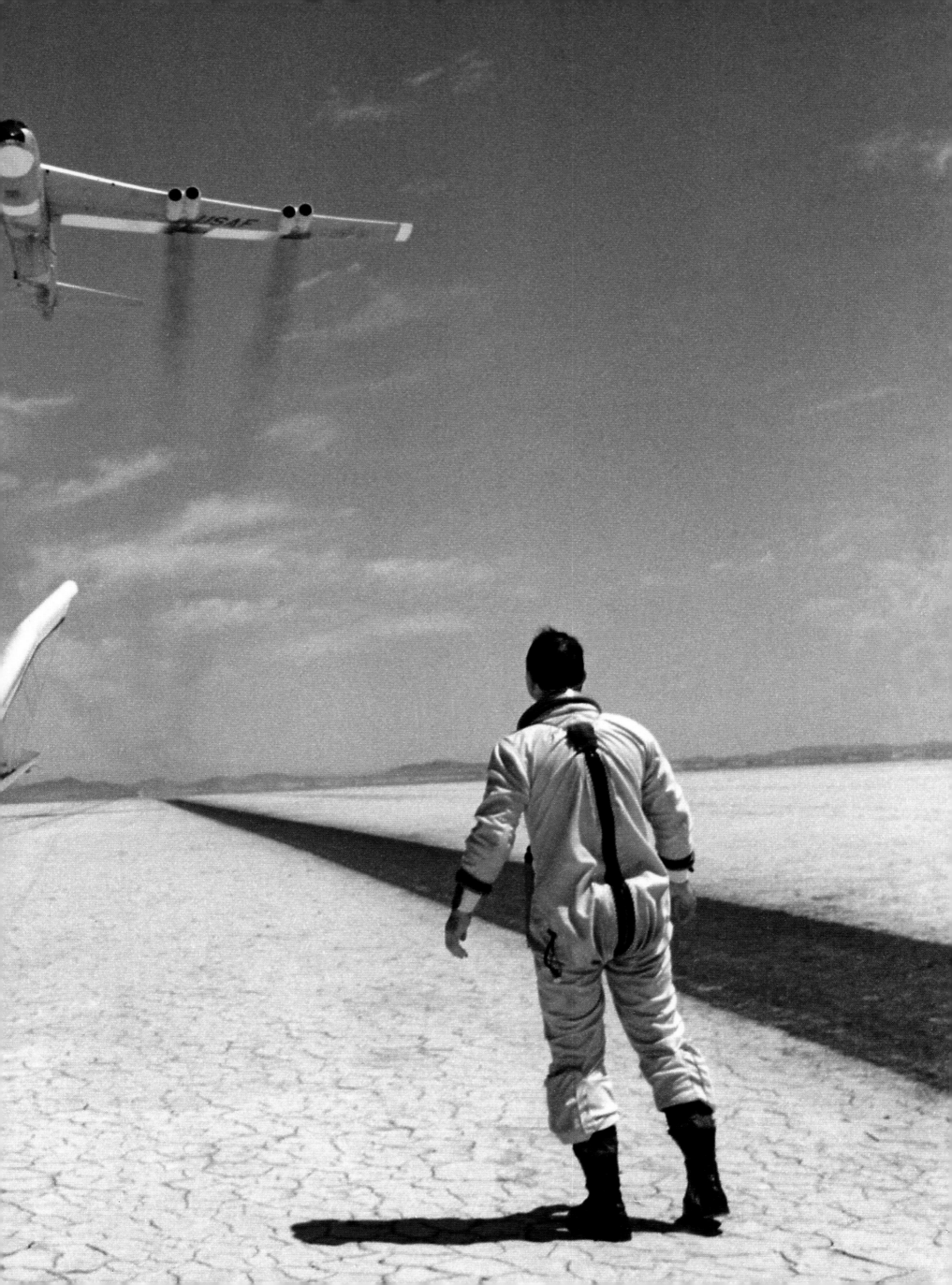

Below A variable-sweep wing, supersonic transport configuration is being tested in the Langley seven-by-ten-foot high-speed wind tunnel in the 1963. On and off from the 1950s through the 1990s, NASA joined the aerospace industry and other government agencies in researching supersonic transports; none of these efforts resulted in viable production models.

Opposite top A Vought F-8A Crusader with an experimental supercritical wing in place of the conventional wing is tested in 1973. Based on studies by NASA scientist Richard Whitcomb, the supercritical wing increases the wing's critical Mach number—the Match number at which flow over the wing goes sonic—thus reducing drag. Today supercritical airfoils derived from NASA's research and verified by flight tests are used on most commercial and military aircraft.

Opposite bottom Four of NASA's T-38's are shown flying in formation in a photo taken in 1970. NASA keeps a fleet of Northrop T-38 Talon supersonic jets, which were produced for the US Air Force between 1961 and 1972, for astronaut training and proficiency flights and for use as chase planes for the space shuttle. **Overleaf** Astronaut and former Air Force test pilot Deke Slayton straps himself into a T-38 to practice maneuvers and sharpen flying skills for the Apollo-Soyuz Test Project mission in 1975. All the early astronauts were military test pilots.

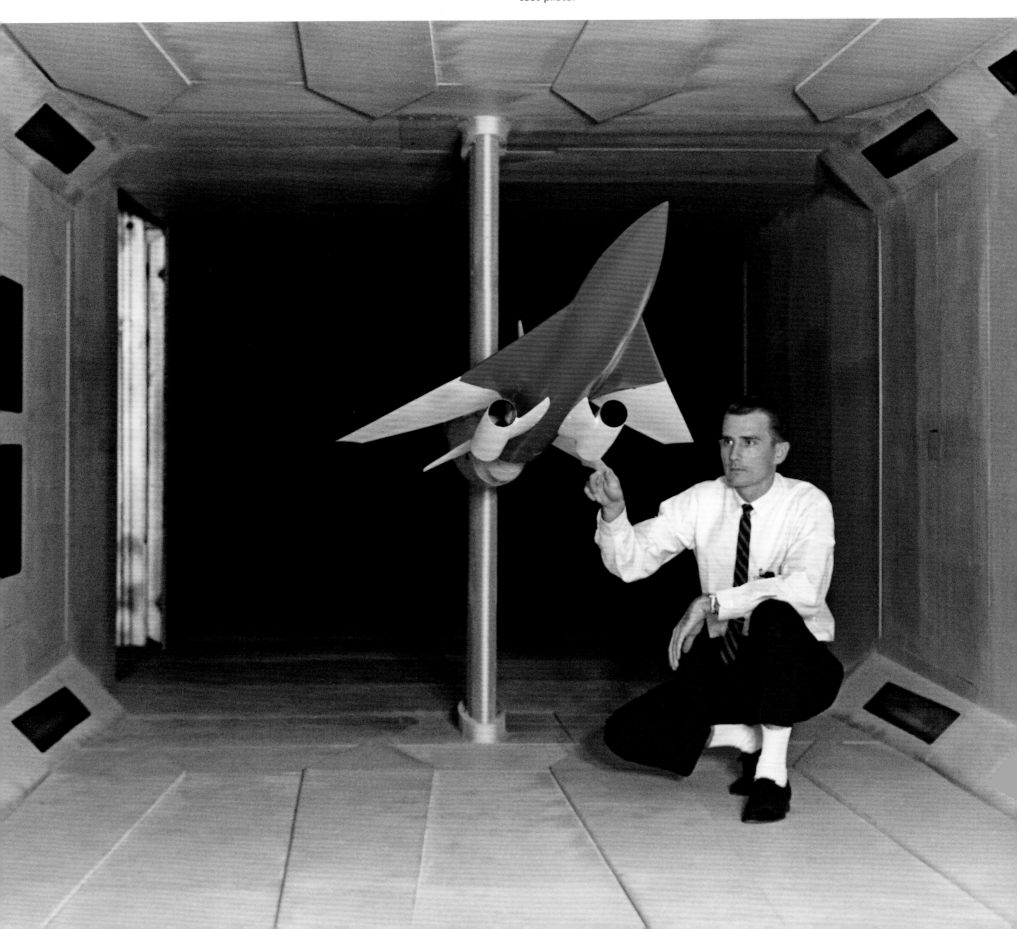

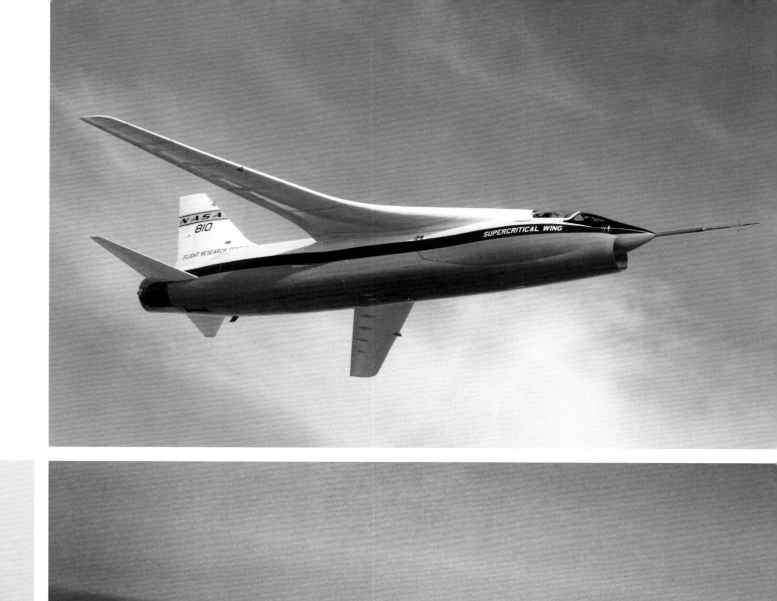

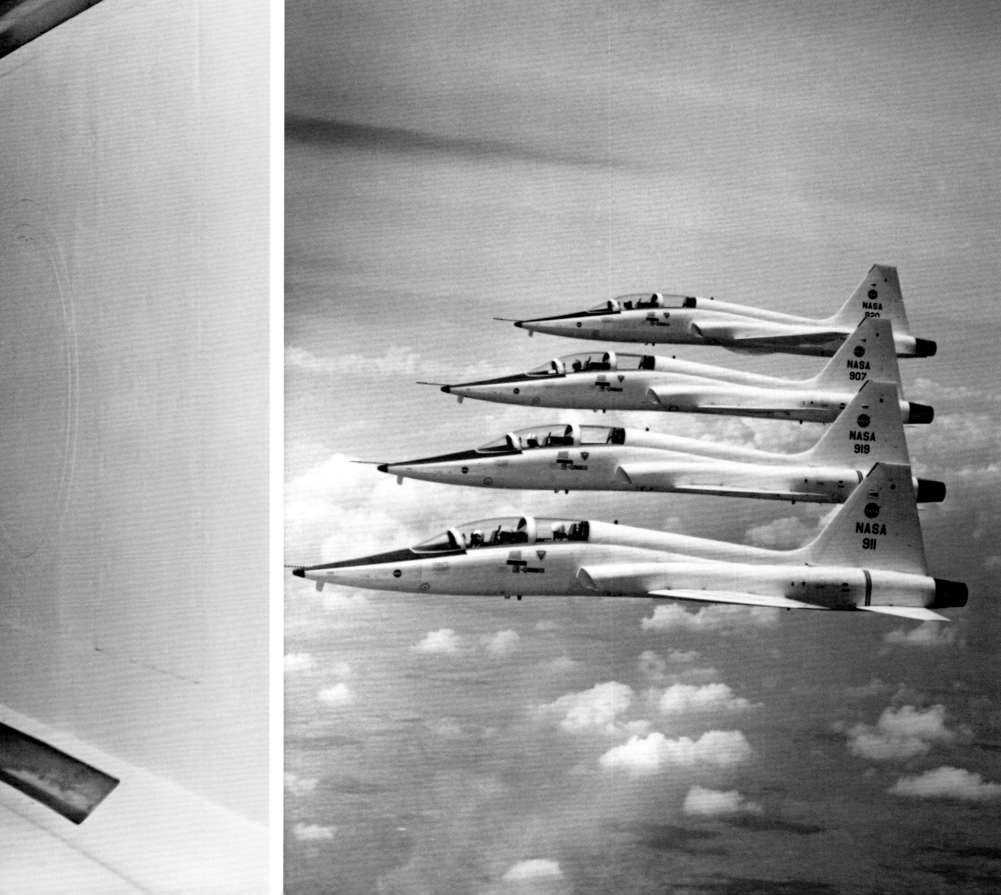

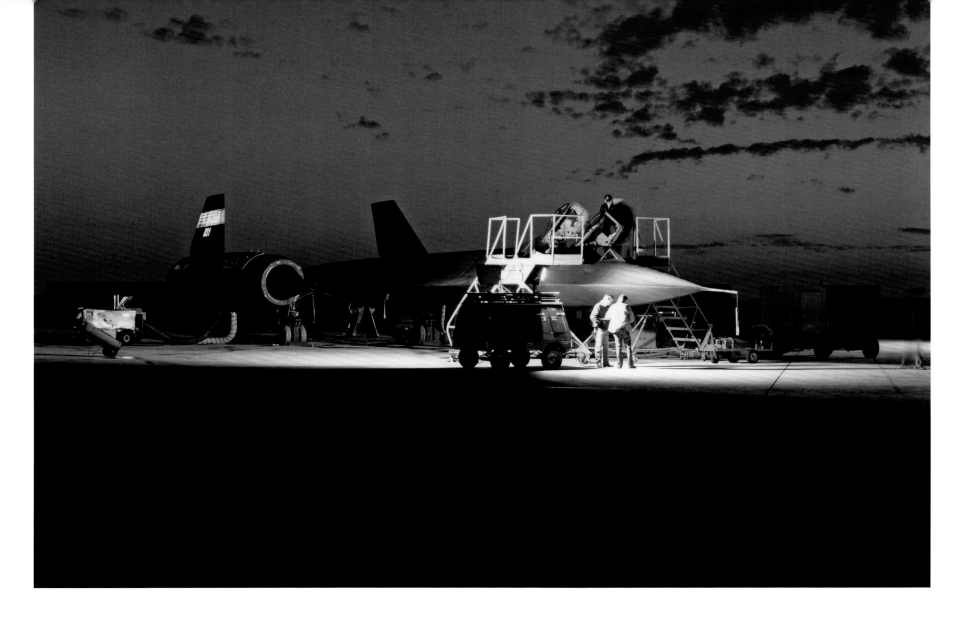

The dramatic "Blackbird" family of jet aircraft—designated A-12, YF-12, and SR-71—reached speeds in excess of Mach 3 and altitudes above 85,000 feet. Manufactured in the 1960s, these planes were used as testbeds for high-speed and high-altitude aeronautical research and pilot training until the final SR-71's retirement in 2000. **Above** As the first traces of dawn light the eastern sky, Dryden technicians work to prepare NASA's SR-71B, on loan by the US Air Force in 1991-97, for a research flight in 1992. **Below** The same aircraft slices across the snow-covered southern Sierra Nevada Mountains of California after being refueled by an Air Force tanker during a December 1994 flight. **Opposite** Helmeted crew members are visible through the cockpit windows in this photo taken from the tanker: they were required to wear full pressure suits similar to space suits in case of emergency.

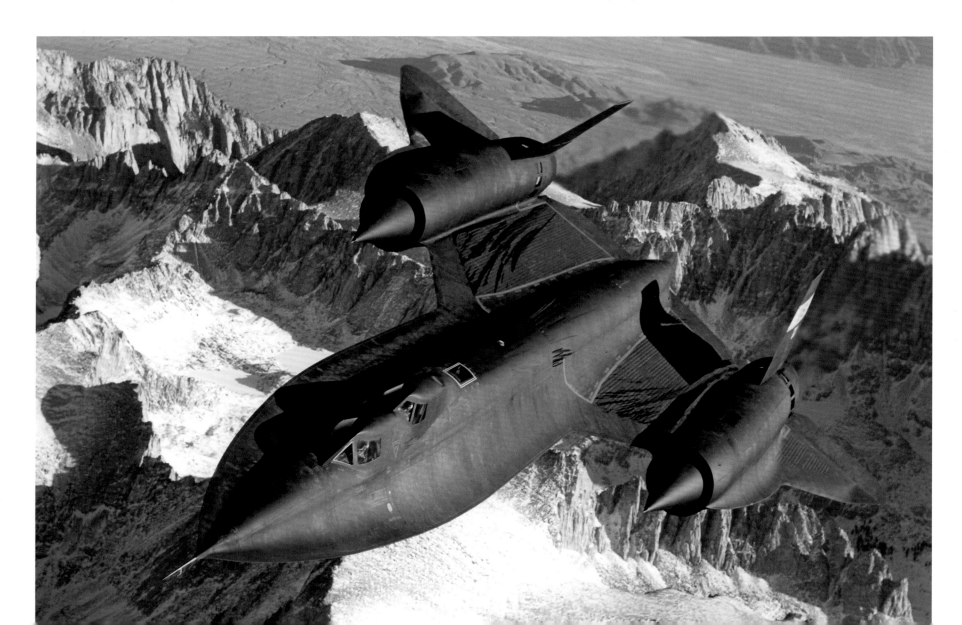

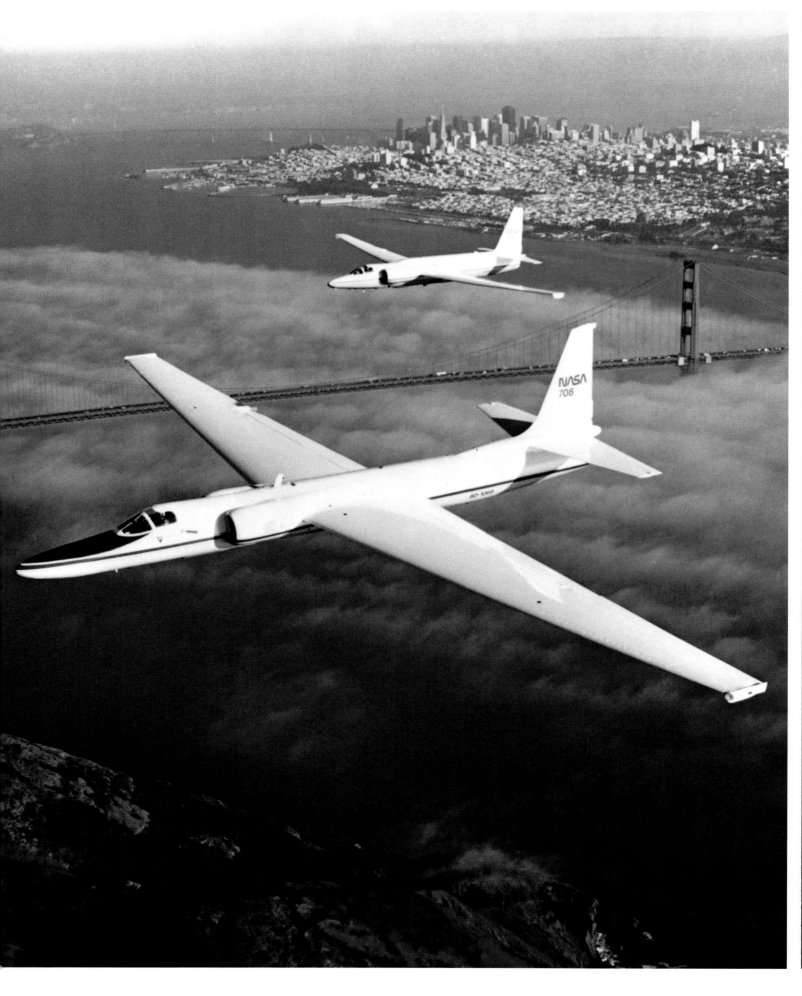

Opposite NASA U-2C and ER-2 aircraft fly by the Golden Gate Bridge in San Francisco in December 1988. The Lockheed U-2 "spy plane" served as a research aircraft for NASA. Two U-2Cs on loan to NASA from the Air Force in 1971 were used for Earth observation and atmospheric studies until the last one was retired in April 1989. Two ER-2s, demilitarized versions of the TR-1A aircraft, a follow-on to the U-2 capable of greater payload and range, replaced the U-2Cs.

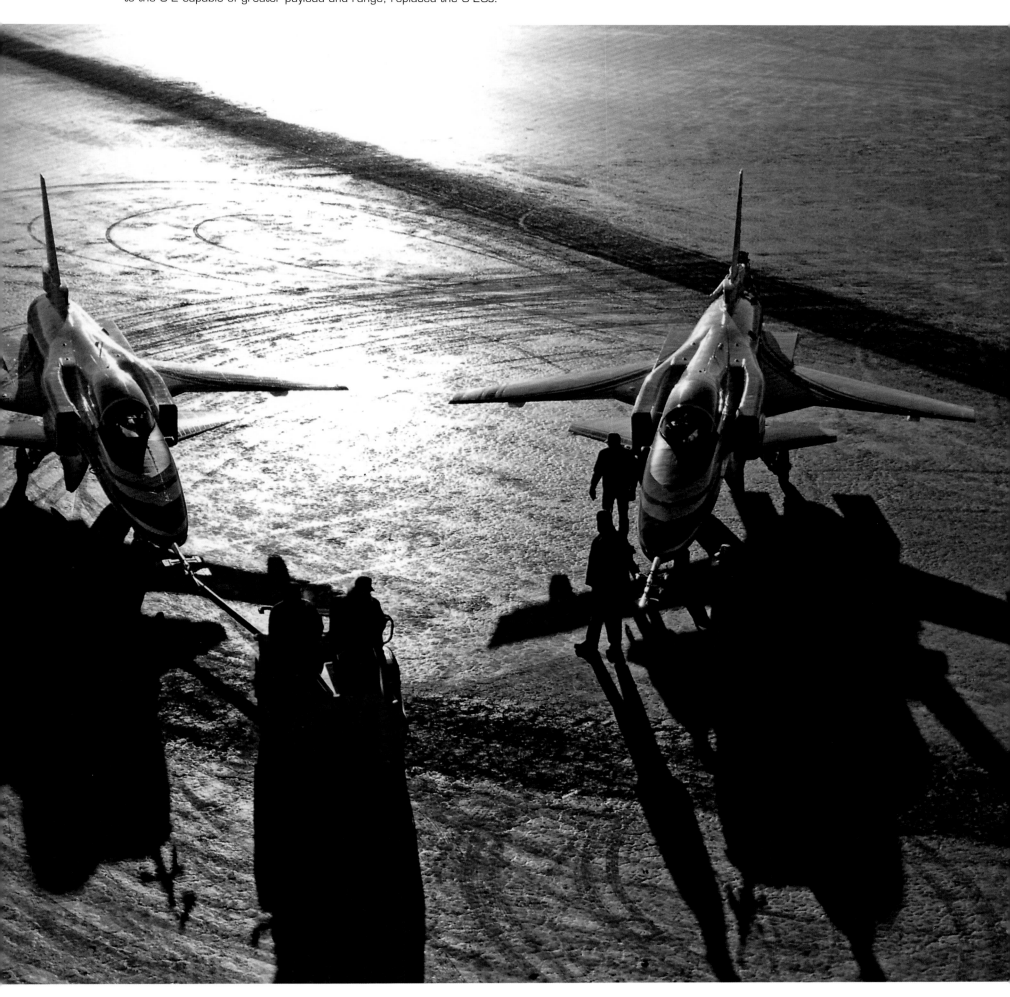

Above Both of NASA's X-29s bask in early morning sun on Rogers Dry Lake, 1990. The Grumman X-29 was an unusual aircraft design, with its forward-swept wing and canards. Two were produced. The first flew from 1984 to 1988, probing general handling qualities, performance issues, and systems integration of the curious jet. The fact that it was inherently aerodynamically unstable made it an ideal testbed for computerized "fly-by-wire" flight-control systems: it required up to forty automatic corrections per second just to remain aloft. The second flew from 1989 until 1992 in a program to investigate high angle-of-attack characteristics. Angle of attack (AOA) refers to the angle of an aircraft's body and wings relative to its actual flight path.

Right Three of NASA's F-18s are being serviced in the Walter C. Williams Research Aircraft Integration Facility at Dryden, circa 1995. The Systems Research Aircraft at the far left is a testbed for advanced system technologies. In the middle is the F-18 Iron Bird, used for full-scale, so-called "hardware-in-the-loop" simulations that can test the behavior of highly complex systems in real time. On the right is the F-18 High Angle-of-Attack Research Vehicle, used for research into better control and maneuverability in high-performance aircraft.

Overleaf In a return to the lifting-body aircraft design, NASA developed a series of unmanned X-38 prototypes for a "lifeboat" for the International Space Station beginning in 1999. The proposed lifeboat, later cancelled, would have accommodated seven astronauts; the Russian Soyuz spacecraft permanently docked at the station for emergency use only carries three. The second free-flight test of the aircraft, seen here, took place July 10, 2001. The X-38 was released from NASA's NB-52 mother ship over the Mojave Desert. Shortly after the photo was taken, a sequenced deployment of a drogue parachute followed by a large parafoil fabric wing slowed the X-38, and it landed safely on Rogers Dry Lake.

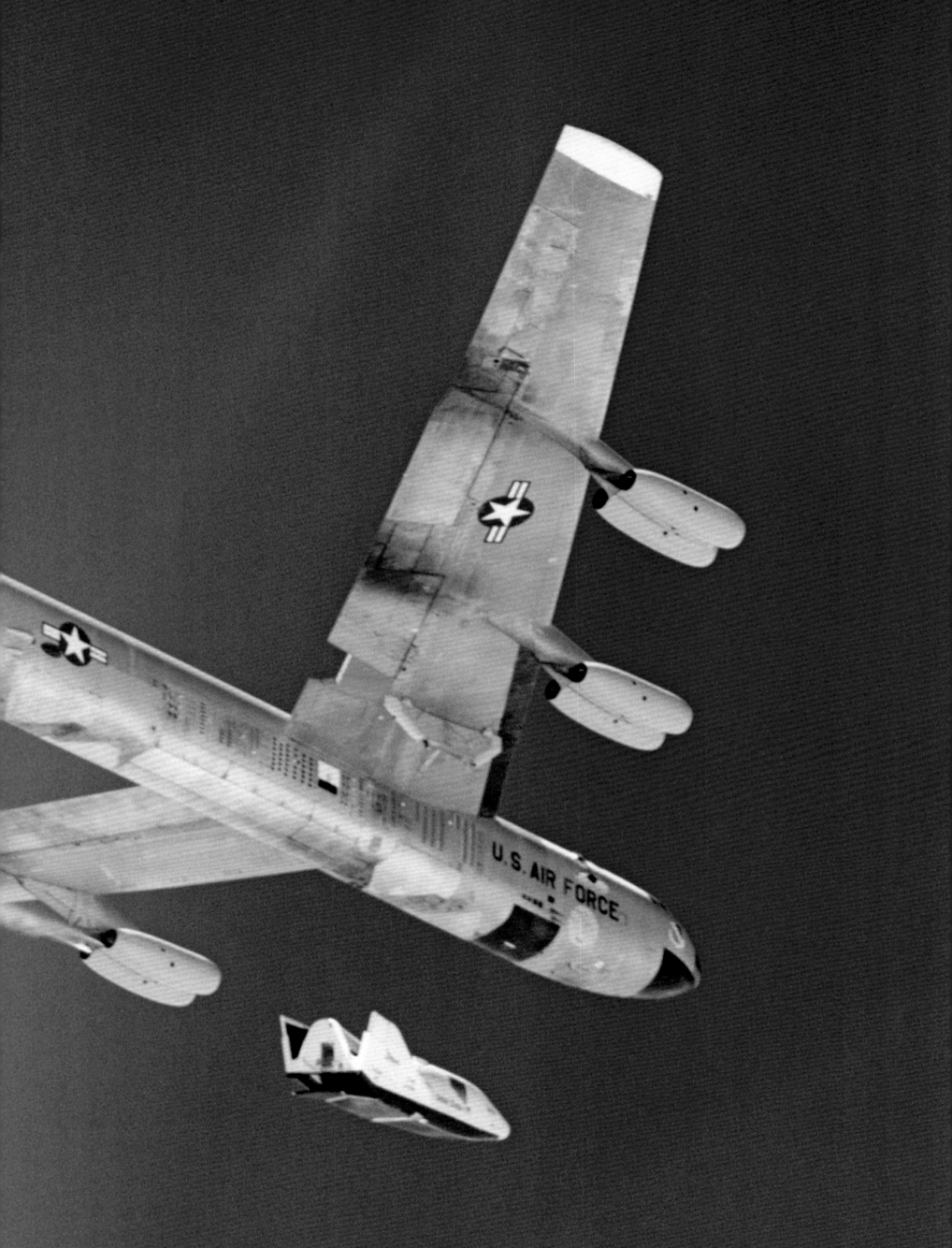

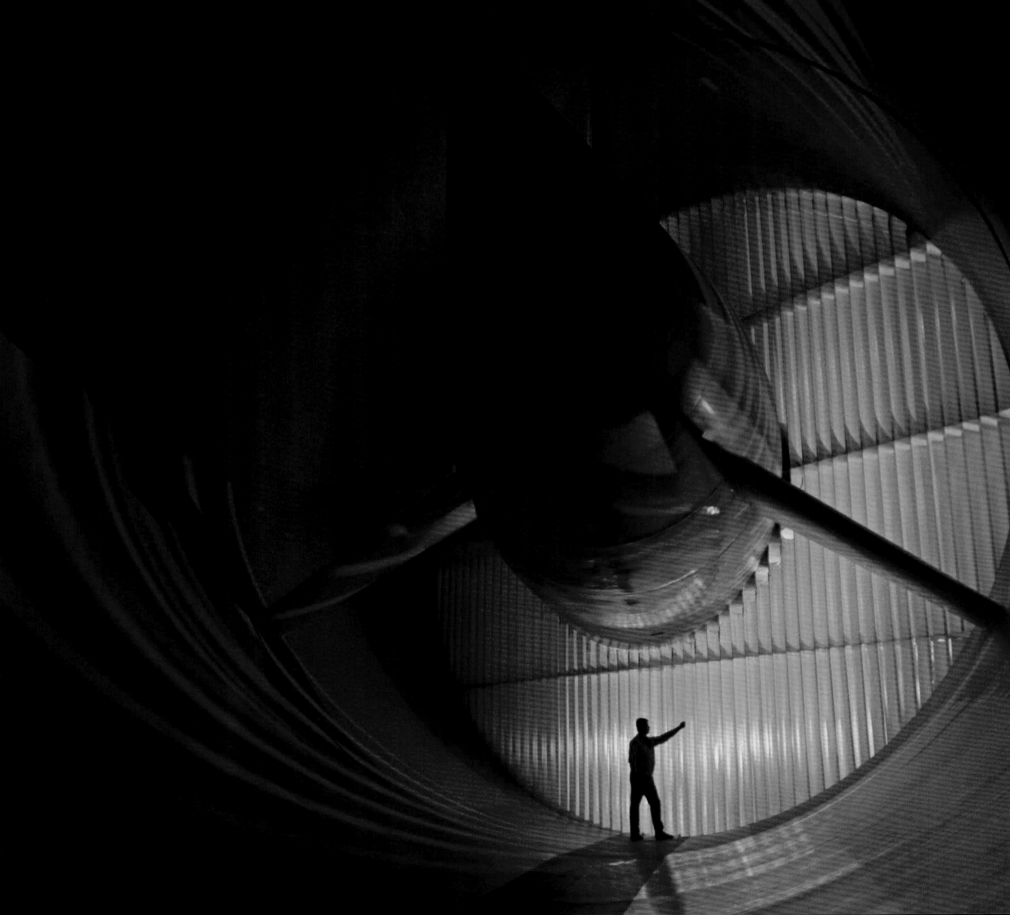

Left The X-43A Hypersonic Experimental (Hyper-X) Vehicle hangs suspended in the cavernous Benefield Aenechoic Facility at Edwards Air Force Base during radio frequency tests in January 2000. The air-launched unpiloted demonstrator was used to demonstrate and test a scramjet propulsion system in flight. Scramjets, or supersonic combustion ramjets, are air-breathing engines that capture their oxygen from the atmosphere. Current spacecraft, such as the space shuttle, are rocket powered, so they must carry both fuel and oxygen for propulsion. Without the need to carry oxygen, future hypersonic vehicles could be able to carry heavier payloads. During the program's three flights, a world record speed of Mach 9.6 was achieved for an air-breathing aircraft on November 16, 2004, more than tripling the top speed of the fastest air-breathing manned vehicle, the SR-71.

Below left A technician inspects the guide vanes in the sixteen-foot transonic wind tunnel at Langley Research Center, originally built in 1939 and modified a number of times, most recently in 1990 when this picture was taken.

Below Researchers at Langley test a twenty-one-foot wingspan, 8.5-percent scale prototype of a blended wing body aircraft, the X-48B, in the historic full-scale wind tunnel in May 2006 (this same wind tunnel can be seen in the upper left photograph on page 76). This advanced concept for a long-range, high-capacity military transport aircraft—under the joint development of NASA, Boeing Phantom Works, and the Air Force Research Laboratory—is a cross between a conventional plane and a flying wing.

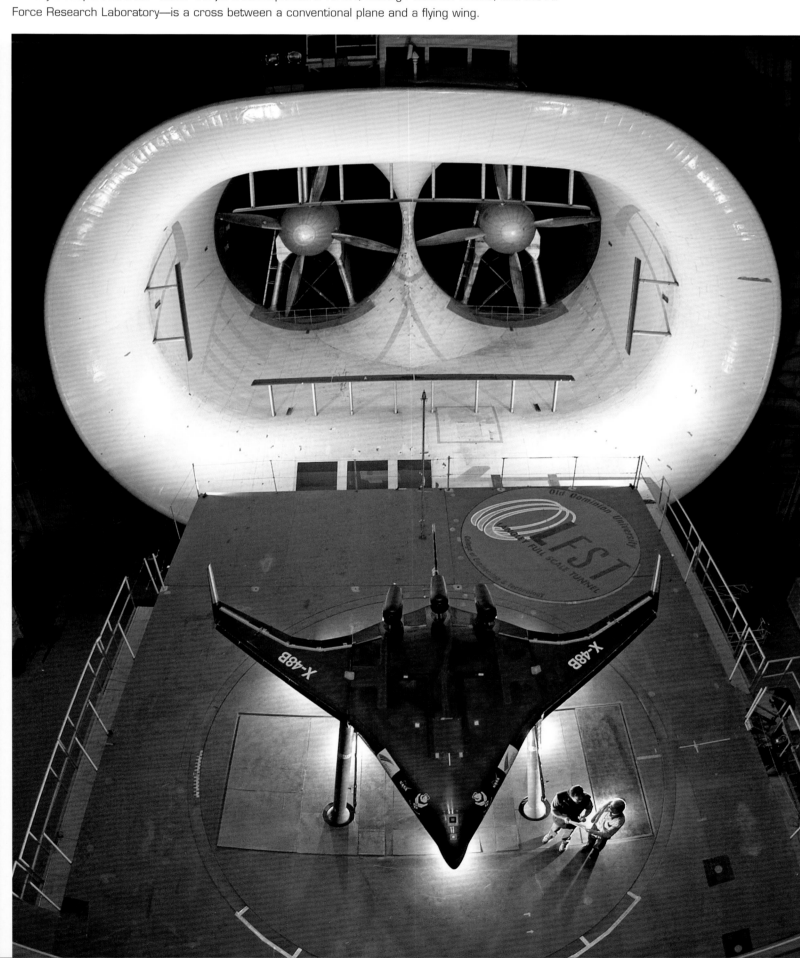

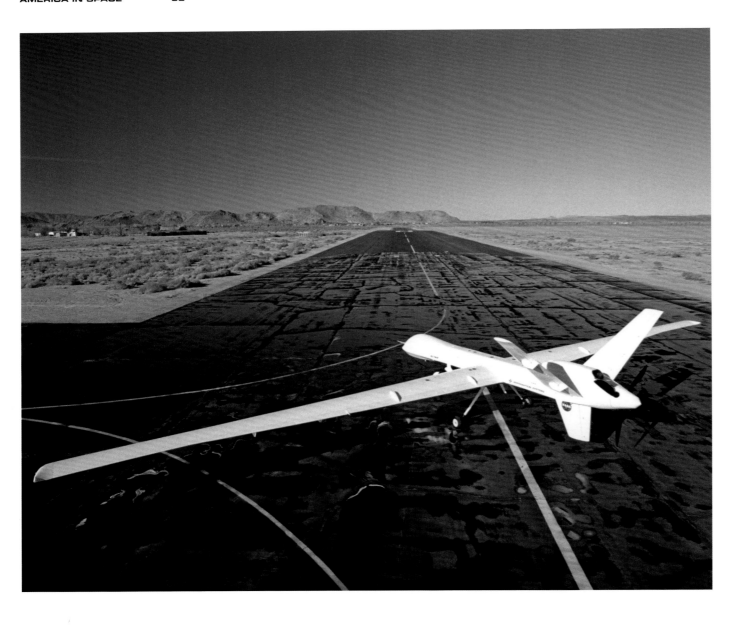

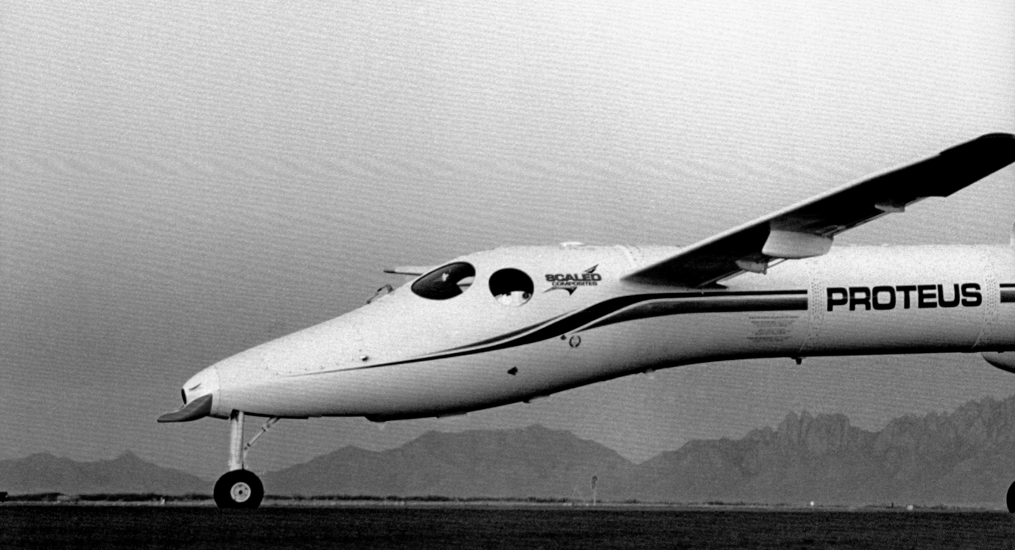

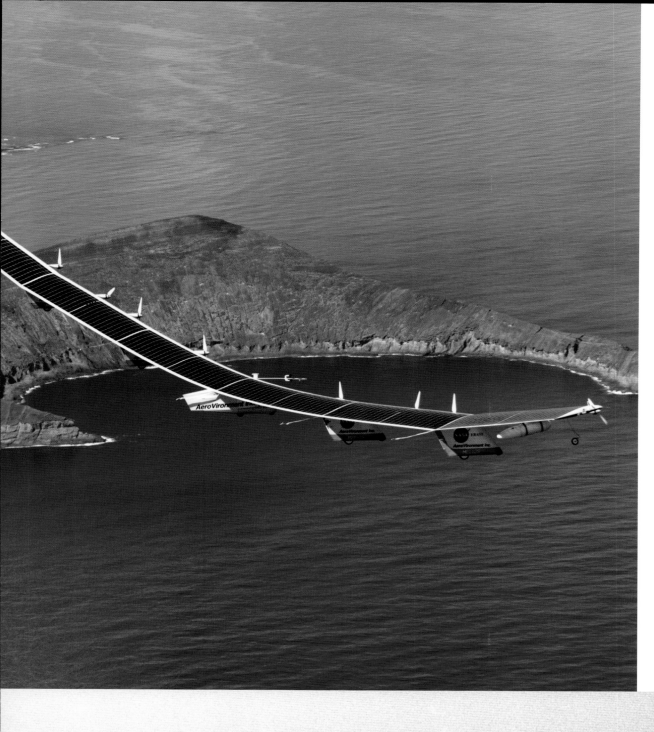

Far left The long, narrow wings of NASA's Altair, undergoing testing in 2003, have been designed to allow the unmanned aerial vehicle to maintain long-duration flight at high altitudes.

Left Designed as a forerunner to high-altitude, long-endurance unmanned aerial vehicles that could undertake environmental science or telecommunications relay missions lasting for weeks or months without using consumable fuels or emitting airborne pollutants, the solar-electric Helios Prototype flying wing is shown over the Pacific Ocean during its first test flight from the US Navy's Pacific Missile Range Facility on Kauai, Hawaii, July 14, 2001. On August 13, 2001, the Helios prototype flew to the world-record altitude of 96,863 feet for a non-rocket powered aircraft. On a later test flight in June 2003 the prototype crashed into the Pacific Ocean.

Below The Proteus aircraft, photographed in the Mojave Desert in March 2002, was designed by Burt Rutan of Scaled Composites to cruise over major cities at high altitudes for up to eighteen hours, relaying broadband telecommunications data. The "optionally piloted" aircraft, ordinarily flown by two pilots in a pressurized cabin, was built for extreme reliability and low operating costs, and to operate out of general aviation airports with minimal support. However, it also has the capability to perform its missions semi-autonomously or be flown remotely from the ground. NASA assisted Scaled Composites in developing a sophisticated autopilot system for Proteus, and is using the aircraft as a testbed to develop technologies for unmanned air vehicles that could execute atmospheric sampling and Earth-monitoring science missions.

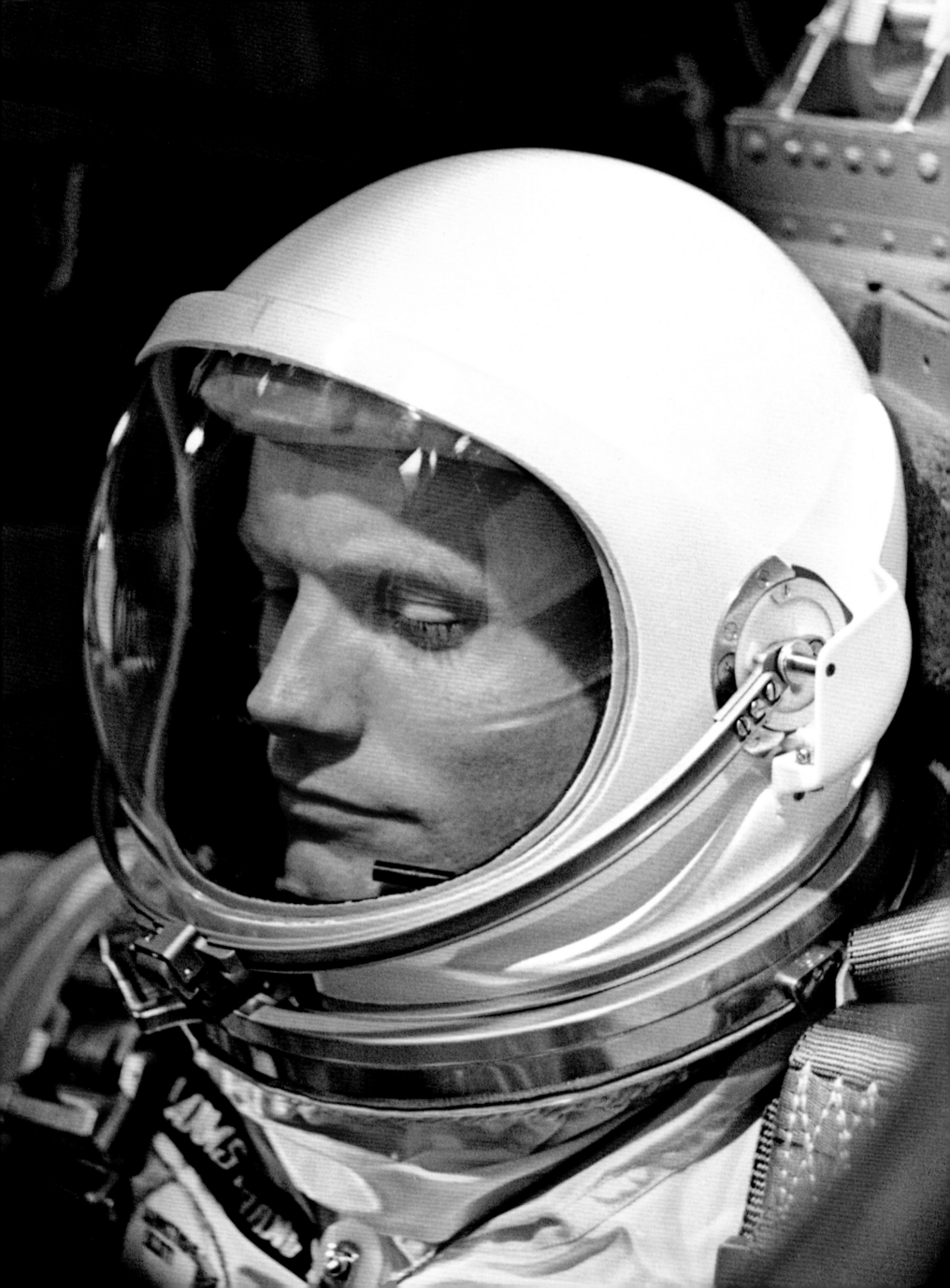

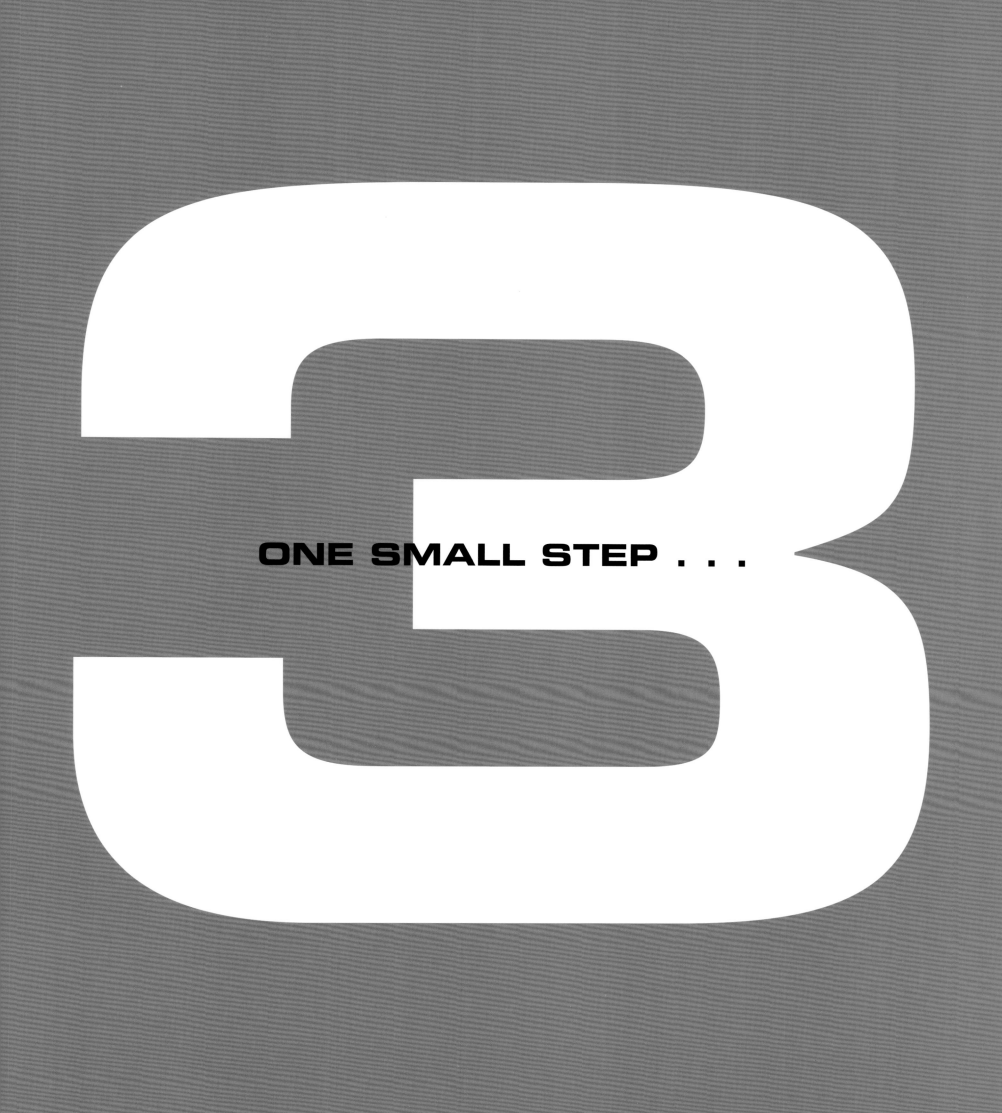

ONE SMALL STEP . . .

One Small Step . . .

The epic human voyages into space constitute one highlight of NASA's first fifty years. The Apollo era (1961–1975), the space shuttle era (1972–), and the International Space Station era (1984–) each mark an extended high technology effort, begun with a Presidential commitment and carried through by NASA in conjunction with thousands of contractors in the aerospace industry. In 2004, another Presidential directive launched NASA on its fourth human spaceflight era, setting its sights first on the Moon and then the ever-mysterious red planet Mars.

Geopolitics, in the form of international rivalry with the Soviet Union, propelled the first human voyages to the Moon. On May 25, 1961, six weeks after Yuri Gagarin's first human orbital flight on April 12, President John F. Kennedy declared that the United States would land a man on the Moon and return him safely to Earth "before this decade is out." The larger objective was for the nation "to take a clearly leading role in space achievement which in many ways may hold the key to our future on Earth. . . . No single space project in this period will be more exciting or more impressive to mankind, or more important for the long-range exploration of space; and none will be so difficult or expensive to accomplish."

Project Mercury, a single-astronaut program to ascertain if humans could survive in space, was already well underway when Kennedy laid down his challenge. Alan Shephard had made the first suborbital flight twenty days before, and his was to be followed by five single-astronaut Mercury flights, ending two years after Kennedy's declaration, that proved humans could not only survive, but also perform well in space. Project Gemini (flights during 1965–66) proceeded with two astronauts to practice space operations, especially rendezvous and docking of spacecraft and extravehicular activity (EVA). In short, Gemini taught astronauts how to fly in space, an essential skill for the Moon program.

Words can hardly do justice to the events that then took place between 1968 and 1972, four years that, as time passes, seem all the more remarkable for human history. During those years twenty-four men went to the Moon, three of them (James Lovell, Eugene Cernan, and John Young) twice. Twelve of them orbited silently above the bleak lunar landscape, and three others were whipped around the Moon in a "free-return trajectory" in a desperate attempt to return to Earth after an explosion aboard their spacecraft. Twelve of the twenty-four lunar voyagers actually landed, spending in total some three hundred hours on the surface, of which eighty hours were outside the lunar module with "boots on the ground" or actually driving around the spacecraft environs.

When the Apollo 11 crew landed on the Sea of Tranquility on July 20, 1969, they stayed a little less than a day, and Neil Armstrong and Edwin "Buzz" Aldrin traveled less than a half mile on foot. The last crew on Apollo 17 landed on the Taurus-Littrow highlands on December 11, 1972, and stayed for three days during which Harrison Schmitt and Eugene Cernan traveled some nineteen miles in the lunar roving vehicle. In between four other spacecraft landed on the Moon as part of the Apollo program, each with its own accomplishments and adventures. One mission, Apollo 13, suffered an explosion aboard the spacecraft, and made it home only after heroic efforts on the Earth and in space. Aside from the geopolitical goals of the Apollo program, a considerable amount of science was returned from the Moon. Almost five thousand pounds of experimental equipment were landed on the Moon, including the Apollo Lunar Surface Experiments Package on each of the last five Apollo missions. Eight hundred and forty pounds of lunar material were returned and analyzed. Sixty-five miles were traversed on foot or in the lunar rover in support of field geology and geophysical studies. And during the last three missions detailed data were collected from the orbiting command and service modules. The overall result was a much better understanding of the nature and origin of the Moon and its relation to Earth.

Hundreds of subcontractors, thousands of engineers, tens of thousands of workers and many unsung heroes played their roles in sending Americans to the Moon. It was not only a matter of creating complex hardware and software. It was also a question of managing the largest technological system ever devised. Despite NASA's first taste of tragedy— the fire that killed three astronauts in their capsule during a ground test in 1967—all the Apollo astronauts were returned safely to Earth, even with the harrowing experience of Apollo 13.

With the Moon race won, political interest in the space program waned. Nevertheless, two subsequent projects are closely associated with the Moon race era. Skylab, the orbiting space station that made use of hardware in the aftermath of the Apollo program, operated for eight months beginning in May 1973. The Apollo telescope mount, the most important of a variety of scientific instruments aboard Skylab, was an innovative program for astronauts to observe the Sun. Unhampered by the limits of telemetry, the astronauts brought solar photographs back to Earth, including X-ray observations of solar flares, coronal holes, and the corona itself. In 1975, the United States cooperated with the Soviet Union to achieve the first international human spaceflight, the Apollo-Soyuz Test Project. The famous "handshake in space" between American astronaut Tom Stafford and Soviet cosmonaut Aleksey Leonov provided one of the iconic, and ironic, images of the Space Age in the midst of the Cold War.

After the 1975 handshake, American astronauts awaited the space shuttle. The shuttle had been approved by President Nixon in 1972, and the shuttle era began in earnest with the first flight of *Columbia* in April, 1981. While many people would associate the shuttle era's most memorable moments with the searing images of the *Challenger* accident in 1986 and the *Columbia* accident in 2003, those events should not obscure the accomplishments of a technological marvel—the only functional winged space vehicle ever to fly. While the shuttle goals of low cost and routine frequent access to space were not met, its numerous flights did transport payloads up to fifty-five thousand pounds into low Earth orbit—the only reusable system capable of doing so. Among its accomplishments were the twenty-four commercial satellites deployed prior to the *Challenger* accident; major scientific missions including *Galileo*, *Magellan*, Chandra, and the launching and servicing missions of the Hubble Space Telescope; Spacelab and Spacehab missions with their material, microgravity, and life sciences experiments; deployment of the Tracking and Data Relay System constellation; and numerous flights in support of the Mir and International Space Stations.

The space station era was the result of another Presidential decision, announced in Ronald Reagan's State of the Union address in January 1984. Its mature accomplishments remain to be seen, but one achievement not to be underestimated was international cooperation. Originally dubbed Freedom, over the years it became the International Space Station, encompassing sixteen partners. The first elements of the space station were launched in 1998, and assembly was about 40 percent complete prior to the *Columbia* accident in 2003. The remaining shuttle flights will be used to complete the International Space Station by 2010. Whatever the scientific outcome, the international cooperation fostered during construction and operations was no small achievement in itself.

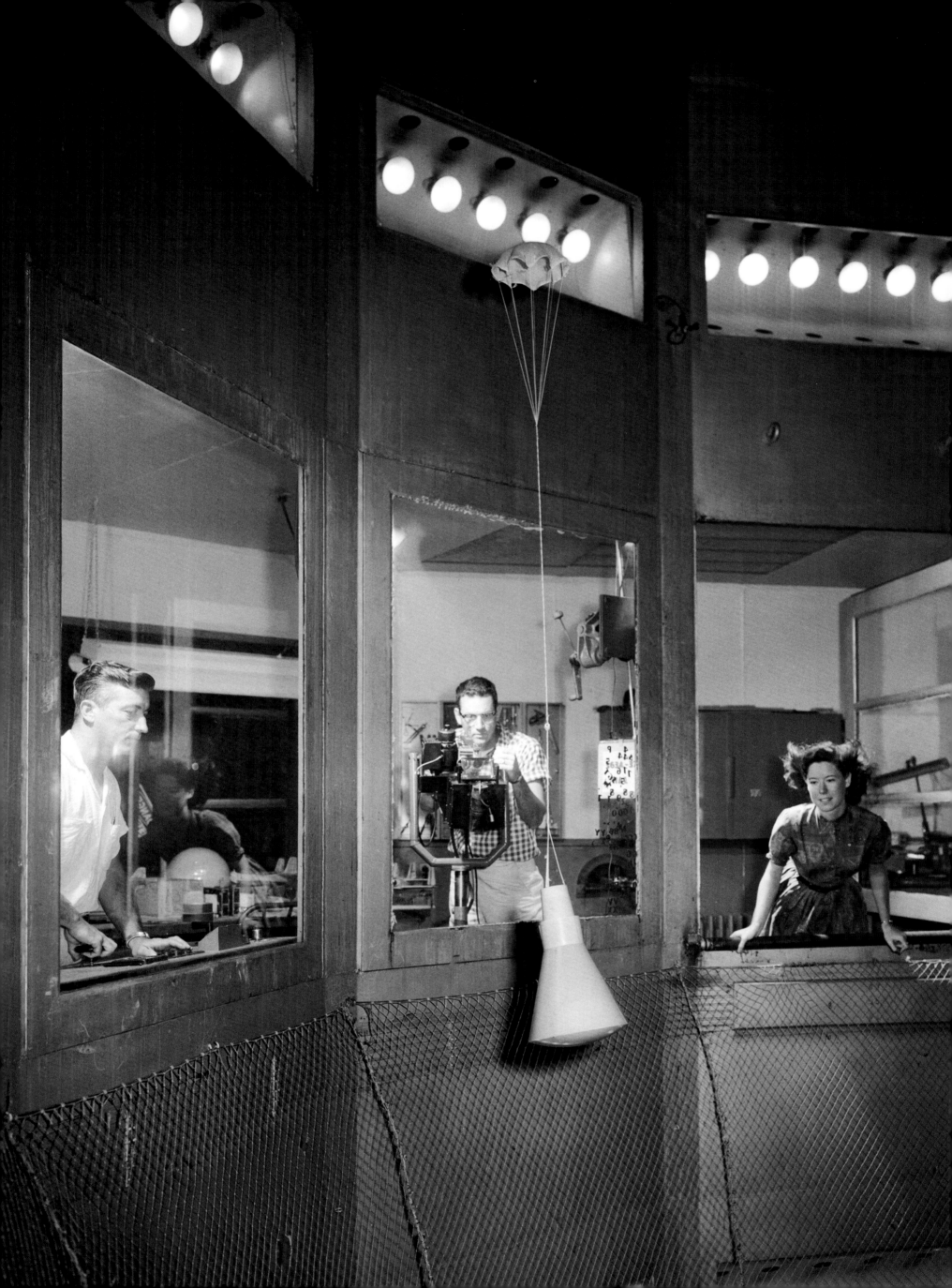

PROJECT MERCURY

On October 7, 1958, only one week after the agency became operational, NASA announced its first human space program. It was designated "Project Mercury" on November 26. The objectives were to place a spacecraft in orbit around Earth, observe human performance, and return the human and spacecraft safely to Earth. Whether a human could function in the harsh conditions of weightless spaceflight was still unknown, and NASA quickly decided that the pool of astronauts should come from military test pilots. On April 9, 1959 NASA introduced its first astronauts, the "Mercury Seven": Scott Carpenter, Gordon Cooper, John Glenn, Gus Grissom, Wally Schirra, Alan Shepard, and Deke Slayton.

After several test flights, including the monkey Miss Sam in January 1960 and the chimpanzee Ham a year later, on May 5, 1961 a Mercury Redstone rocket launched Alan Shepard and his *Freedom 7* spacecraft on a fifteen-minute suborbital flight. On July 21 Gus Grissom was launched on a second fifteen-minute suborbital flight in the *Liberty Bell 7.*

Orbital flights required a larger launch vehicle, and after a test of the Mercury Atlas launcher with the chimp Enos, on February 20, 1962, John Glenn made three successful orbits of the Earth in his *Friendship 7* spacecraft. This mission was followed in May by Scott Carpenter's three orbits in *Aurora 7*, and by Wally Schirra's six orbits in October in *Sigma 7.* The Mercury program ended on May 15, 1963, with Gordon Cooper's twenty-two orbits of the Earth (*Faith 7*) lasting thirty-four hours and twenty minutes.

Less than five years after the announcement of the Mercury program, and over a span of two years and six human flights, the goals of the program were fully met. Brief as they were, the pioneering Mercury flights were full of anxiety and adventure. Grissom's capsule sank when the hatch blew off and it filled with water before it could be recovered; Glenn's reentry into Earth's atmosphere was marked with tension because of a signal that his heat shield had come loose; and Carpenter's capsule landed more than two hundred miles off course, causing anxious moments until it could be located and recovered.

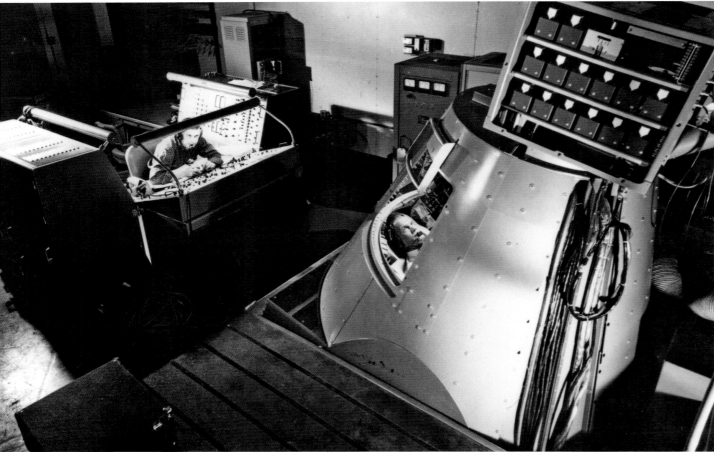

Right Technicians at Langley work on boilerplate Mercury capsules, designed to test launch escape systems, in 1959. A boilerplate model is a full-size mock-up of the same weight and size as a final production model. The launch escape system was a rocket mounted atop the Mercury or Gemini capsule that would theoretically boost it out of harm's way in case of an imminent explosion—none was ever used in practice. The capsule with its escape tower seen here would be broken down for shipping and then reassembled for launching at Wallops Island, Virginia, 1959. **Top** A Mercury space capsule undergoes testing in Langley's full-scale wind tunnel, January 1959. **Above** Astronaut John Glenn runs through a training exercise in the Mercury Procedures Trainer at Langley in 1960. This sophisticated computer-controlled simulator allowed the trainee to activate all of the twenty-two possible combinations of manual and/or automatic attitude controls that were provided in the Mercury spacecraft.

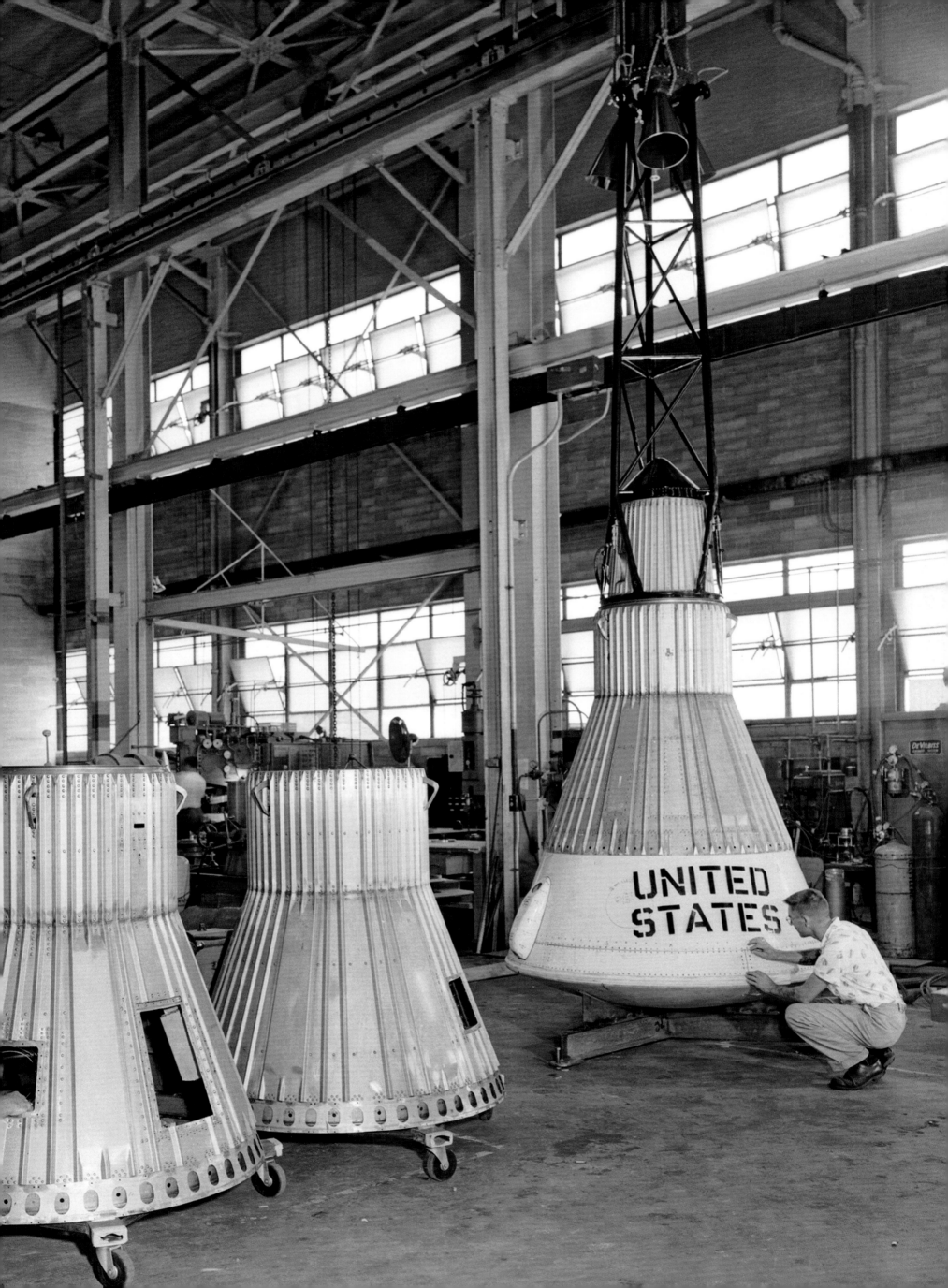

Left Technicians inside Langley's nine-by-six-foot thermal structures tunnel prepare materials that will be heated to the temperature they would have to endure at escape-velocity speeds in August 1962. The need to design spacecraft that could protect astronauts from the enormous heat generated by friction upon reentering the Earth's atmosphere led to pioneering advances in materials science.

Overleaf Engineers at Langley crawl through a Plexiglas tunnel to determine astronauts' ability to move through an airlock with the added bulk of a pressurized suit in 1966. Mercury and Gemini capsules did not have airlocks (when the hatch of a Gemini capsule was opened in space, the whole craft had to be depressurized first), but the more sophisticated spacecraft envisioned for the future would need them to prevent artificial atmosphere loss when an astronaut entered or exited in space.

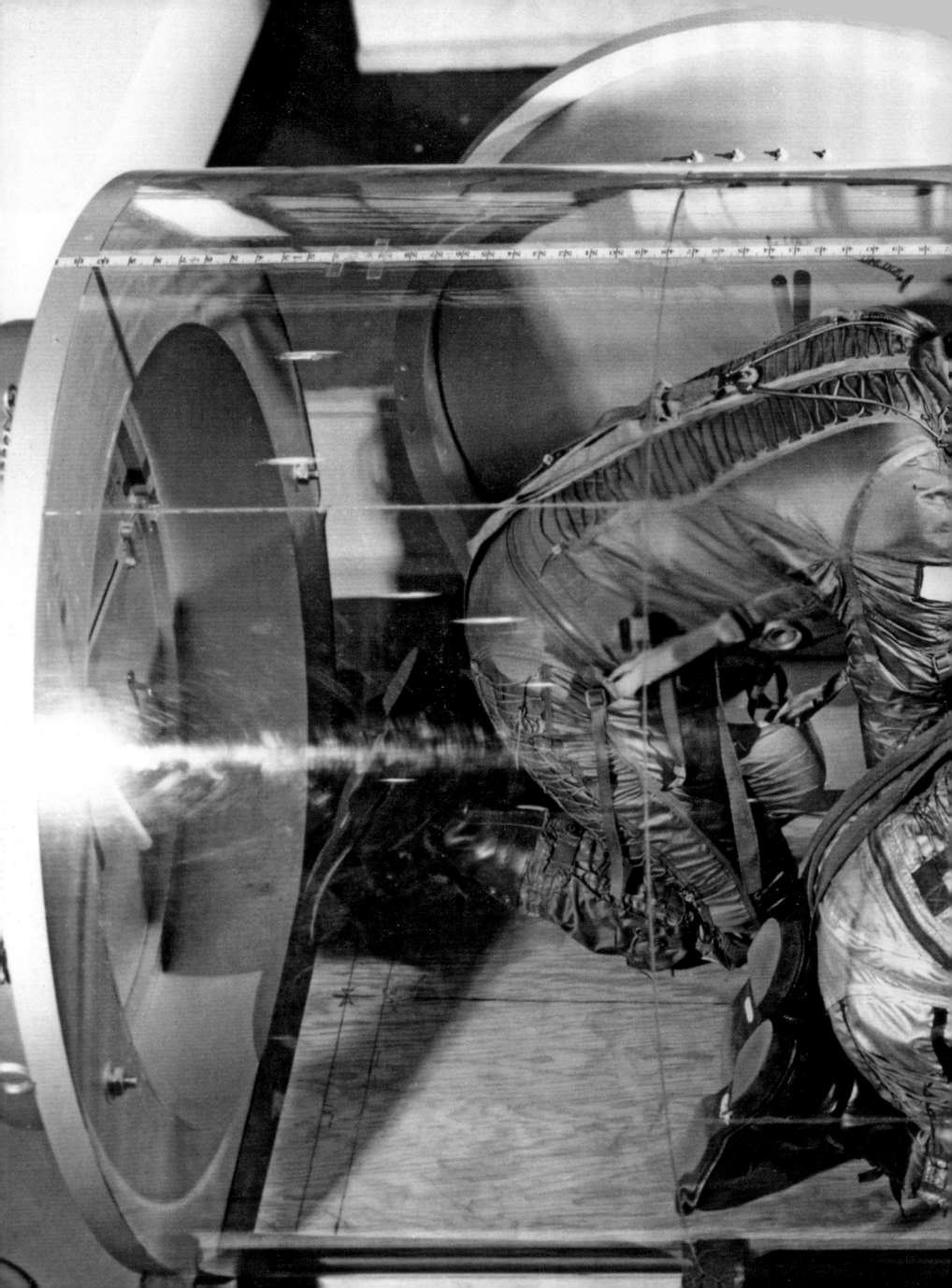

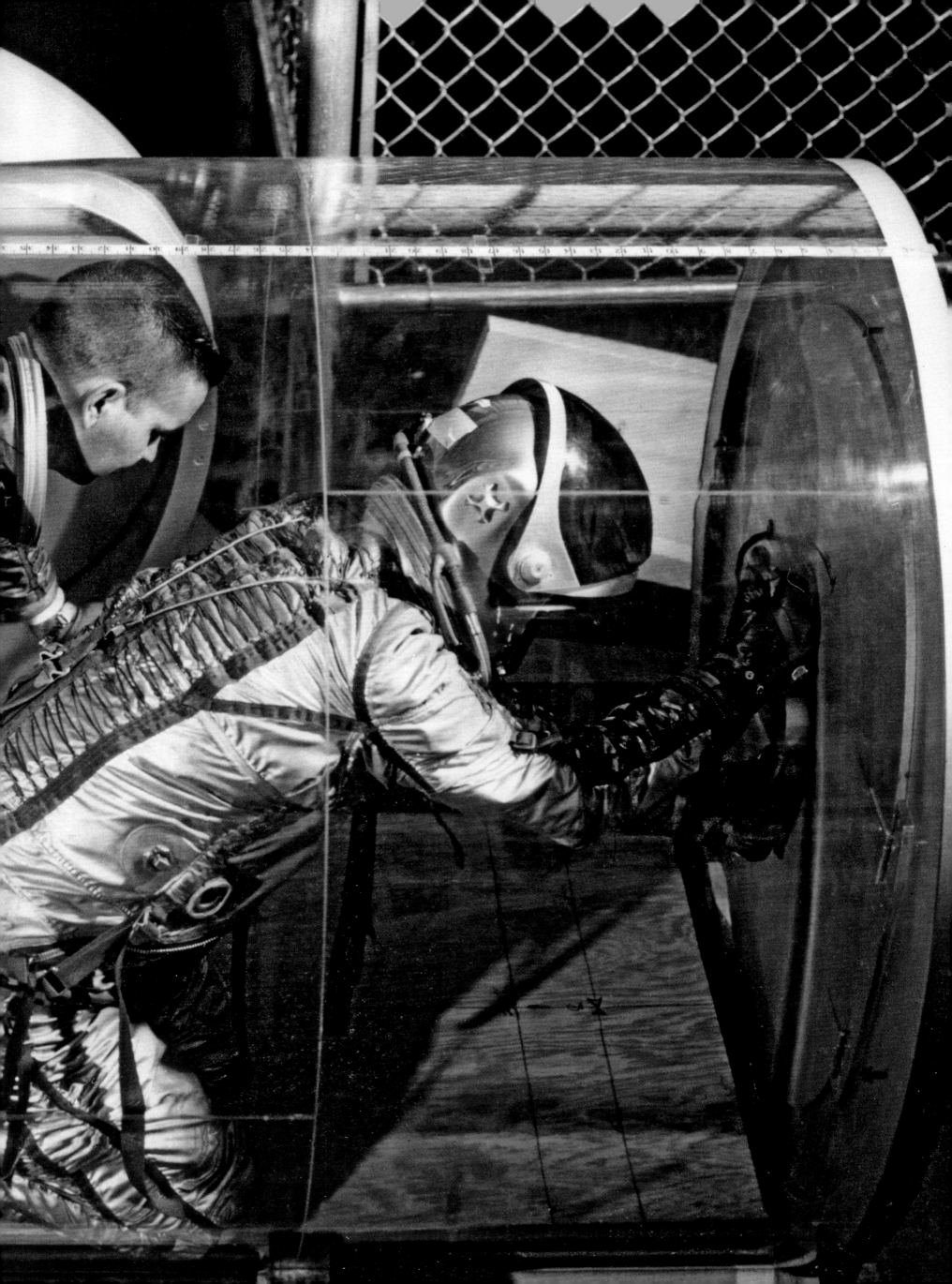

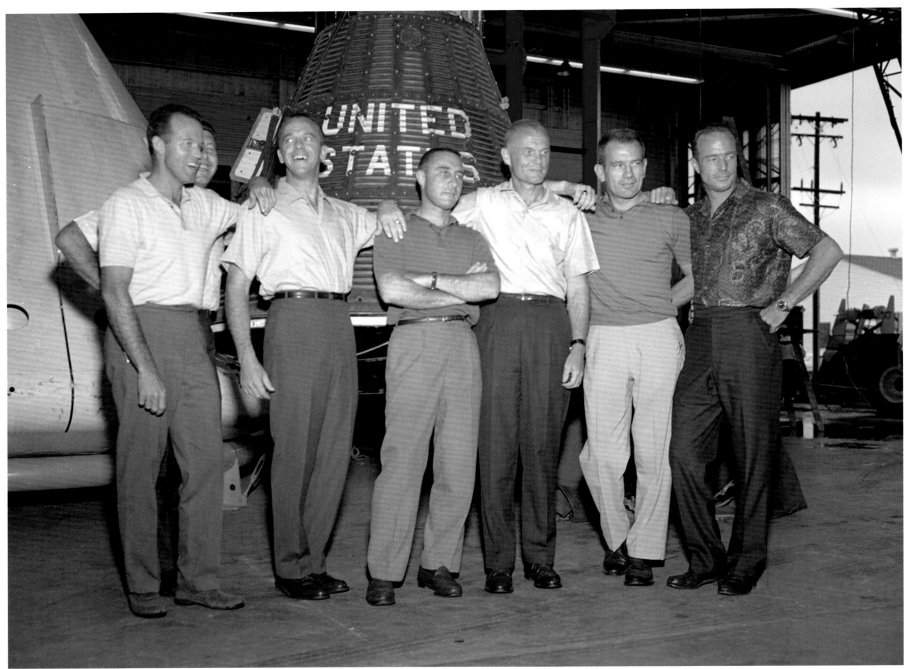

Opposite NASA introduced its first seven astronauts to the public at a press conference on April 9, 1959, only six months after the agency was established. The Mercury astronauts were proven test pilots, selected from more than five hundred applicants. Between January and April 1, when the seven were chosen, the process ground on, as more and more men were eliminated while the remainder was subjected to stringent tests and examinations. The Mercury 7 posed for a widely reproduced group portrait at Langley on April 27. In the front row, left to right, are Wally Schirra, Deke Slayton, John Glenn, and Scott Carpenter; standing behind them are Alan Shepard, Gus Grissom, and Gordon Cooper. Slayton and Glenn are wearing spray-painted work boots.

Above A candid shot of the Mercury 7 shows Cooper, Schirra, Shepard, Grissom, Glenn, Slayton, and Carpenter at the Manned Spacecraft Center (now the Johnson Space Center), in Houston, Texas. When this photo was taken on October 21, 1963, during *Look* magazine's coverage of the award of the prestigious Robert J. Collier Trophy in aeronautics and astronautics for 1962, all but Slayton had flown in the project.

Right Beginning in 1948, NASA used monkeys and chimpanzees to assess the biological impact of space flight. Ham, a chimpanzee, is seated in the couch to be used for a sixteen-minute ballistic flight from Cape Canaveral, Florida, in January 1961. Ham died in 1983.

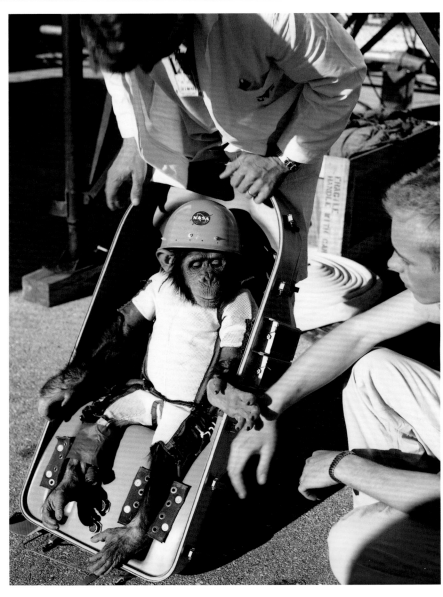

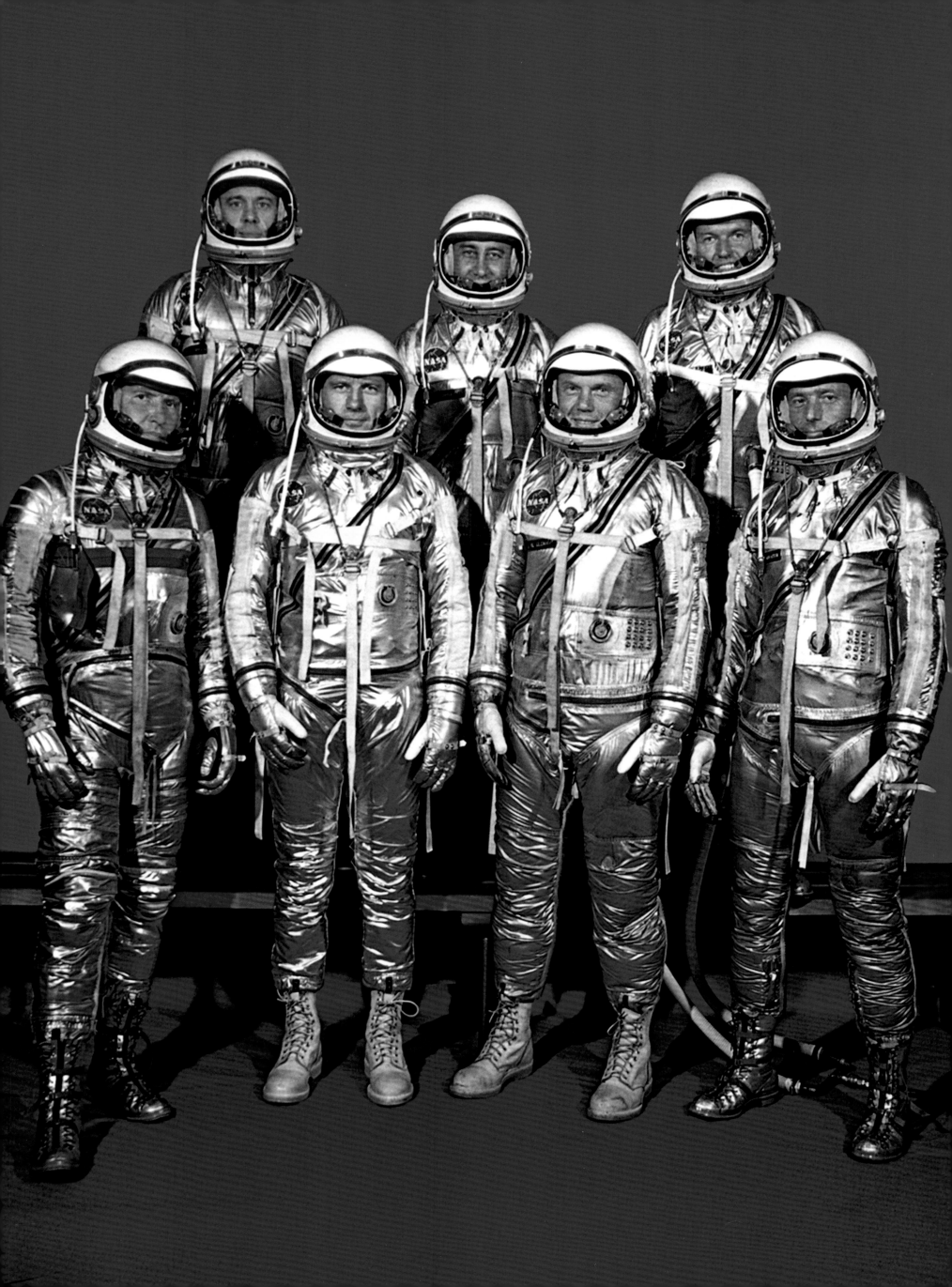

Below During training, the Mercury astronauts, looking like the test pilots they were, pose beside an Air Force F-106 Delta Dart jet at Langley. From left to right: Carpenter, Cooper, Glenn, Grissom, Schirra, Shepard, and Slayton.

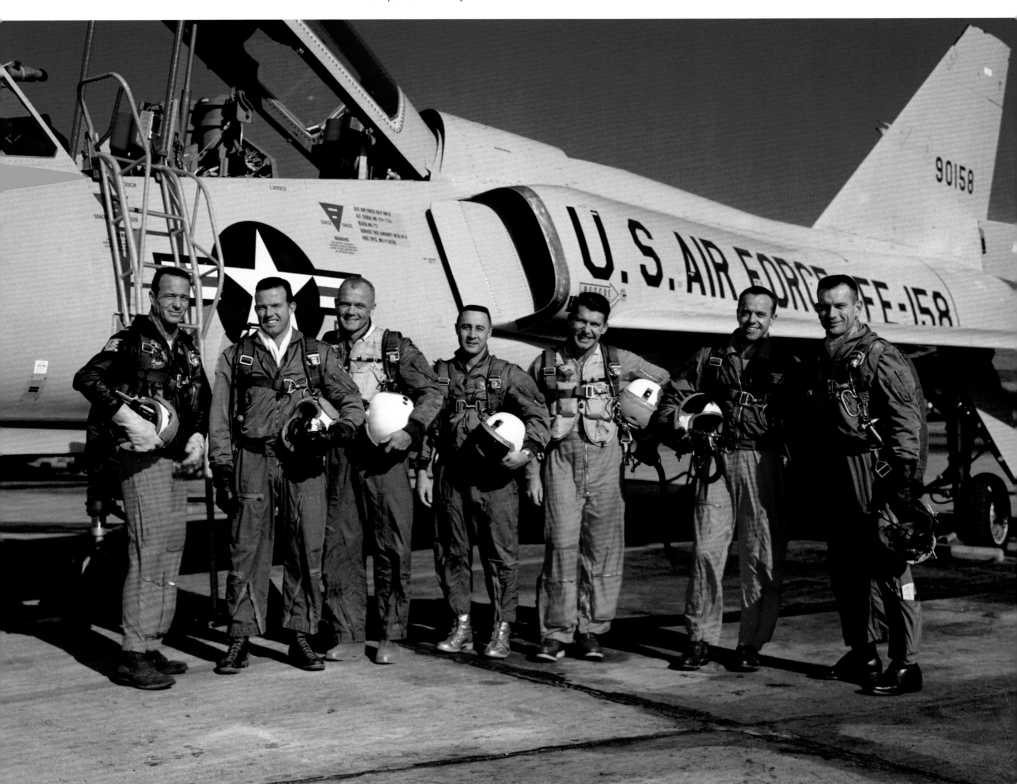

Opposite Astronaut Group 2, or the New Nine, was selected in September 1962. This photo, taken in August 1963 at Stead Air Force Base in Nevada six months after *Laurence of Arabia* swept the Academy Awards, includes the New Nine plus Slayton, who would finally fly in Gemini, wearing outfits they fabricated for desert survival. Survival training at Stead was required of all Air Force flight personnel, any one of whom could potentially end up in a tight spot somewhere on Earth, and NASA required it of astronauts for the same reason. Front row, left to right: Frank Borman, James Lovell, John Young, Pete Conrad, James McDivitt, and Edward White; back row, left to right: Ray Zedehar (astronaut training officer), Thomas Stafford, Deke Slayton, Neil Armstrong, and Elliot See.

Overleaf Astronauts honed their survival skills not only in the desert but also in the jungle. **Top left** David Scott, from Astronaut Group 3, strikes a pose in his survival gear, June 1964. **Bottom left** H. Morgan Smith instructs astronauts on tropical survival methods in the jungle at Albrook Air Force Base, Canal Zone, June 1963. **Right** John Glenn and Neil Armstrong take a break in a jungle dwelling, June 1963.

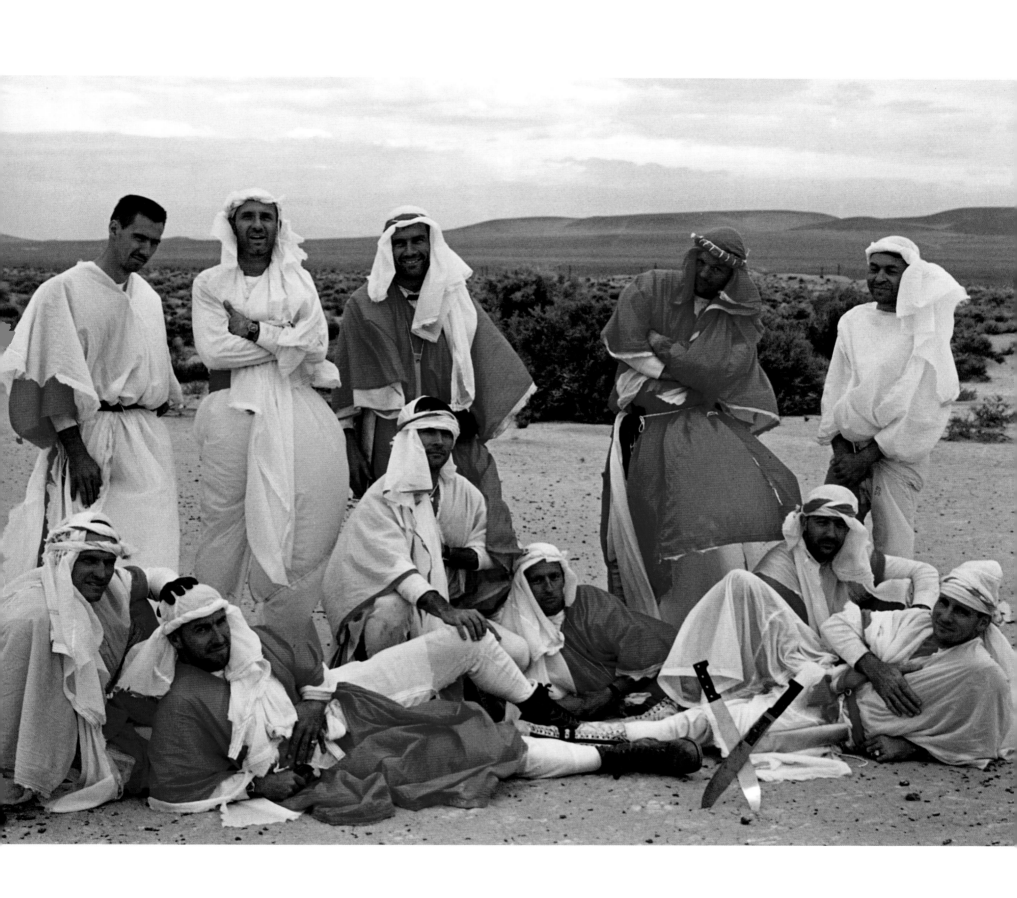

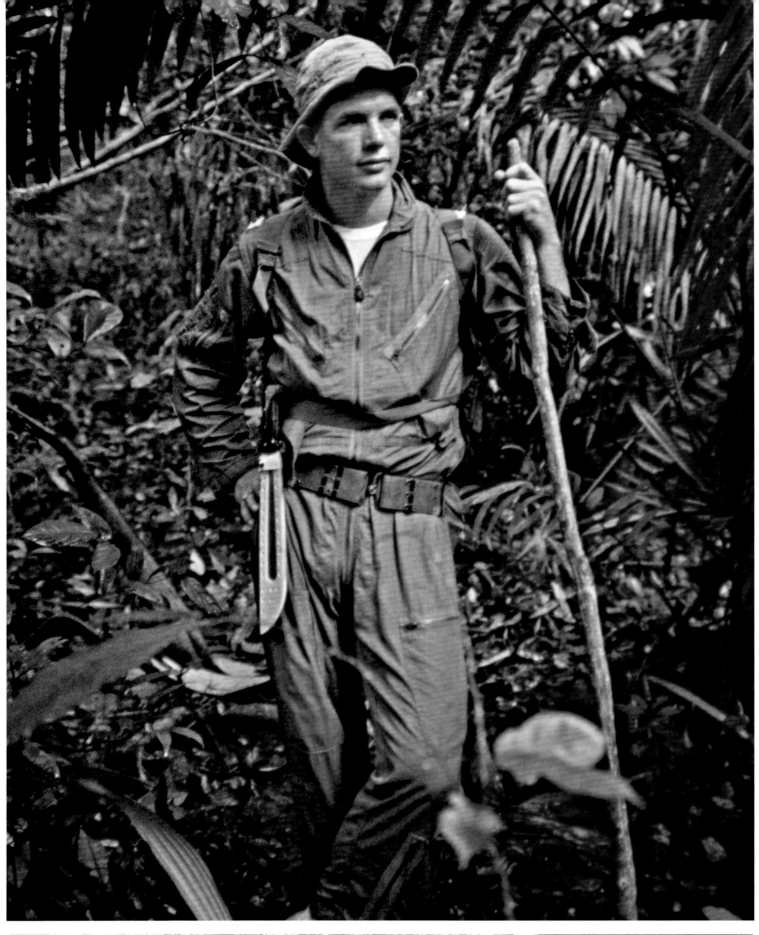
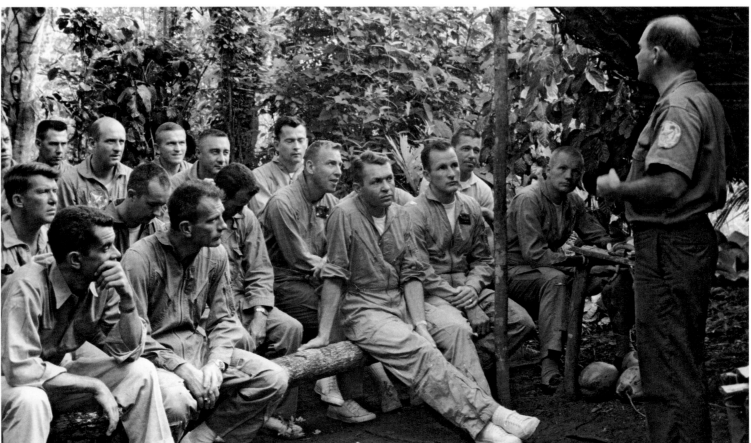

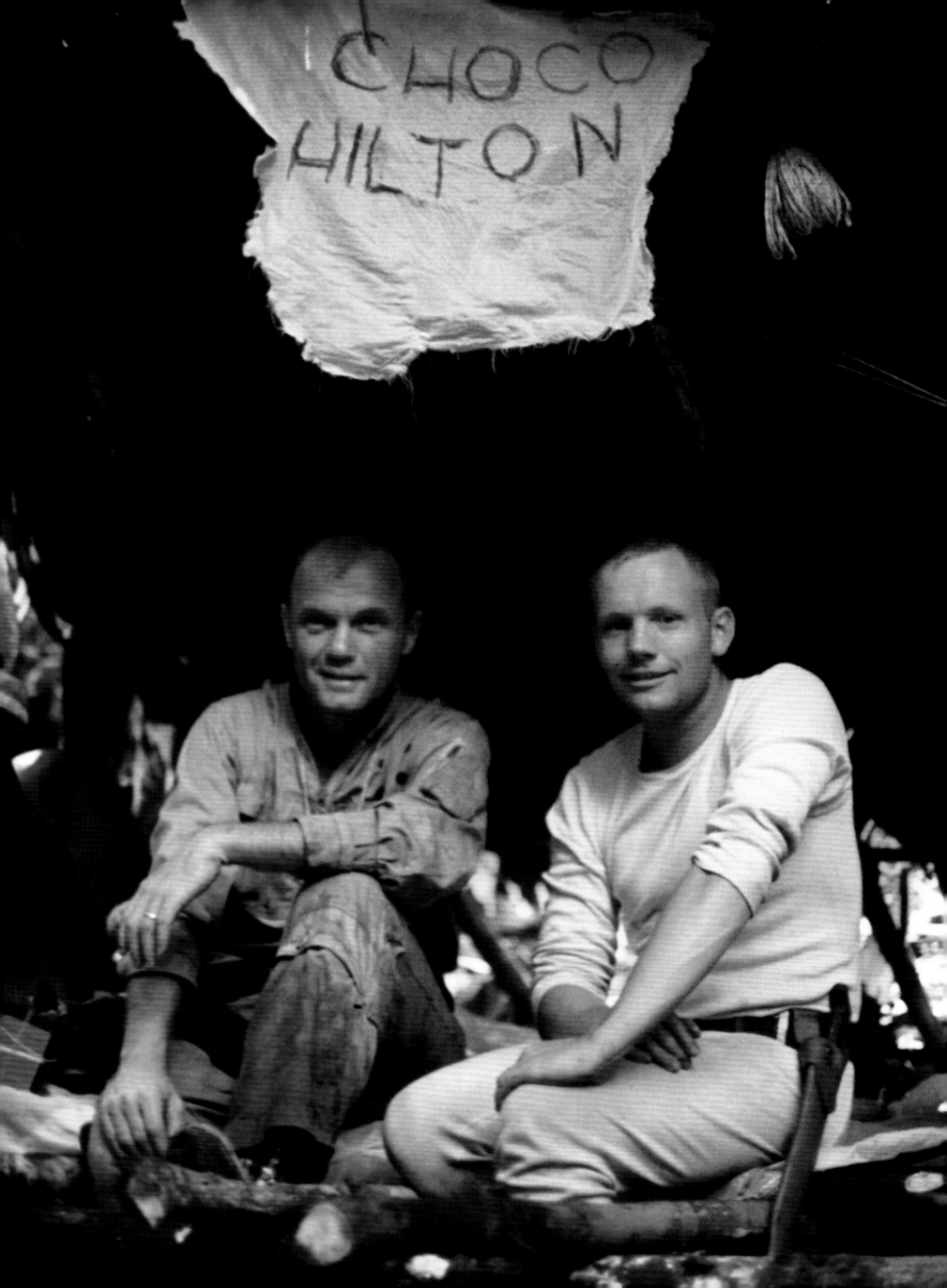

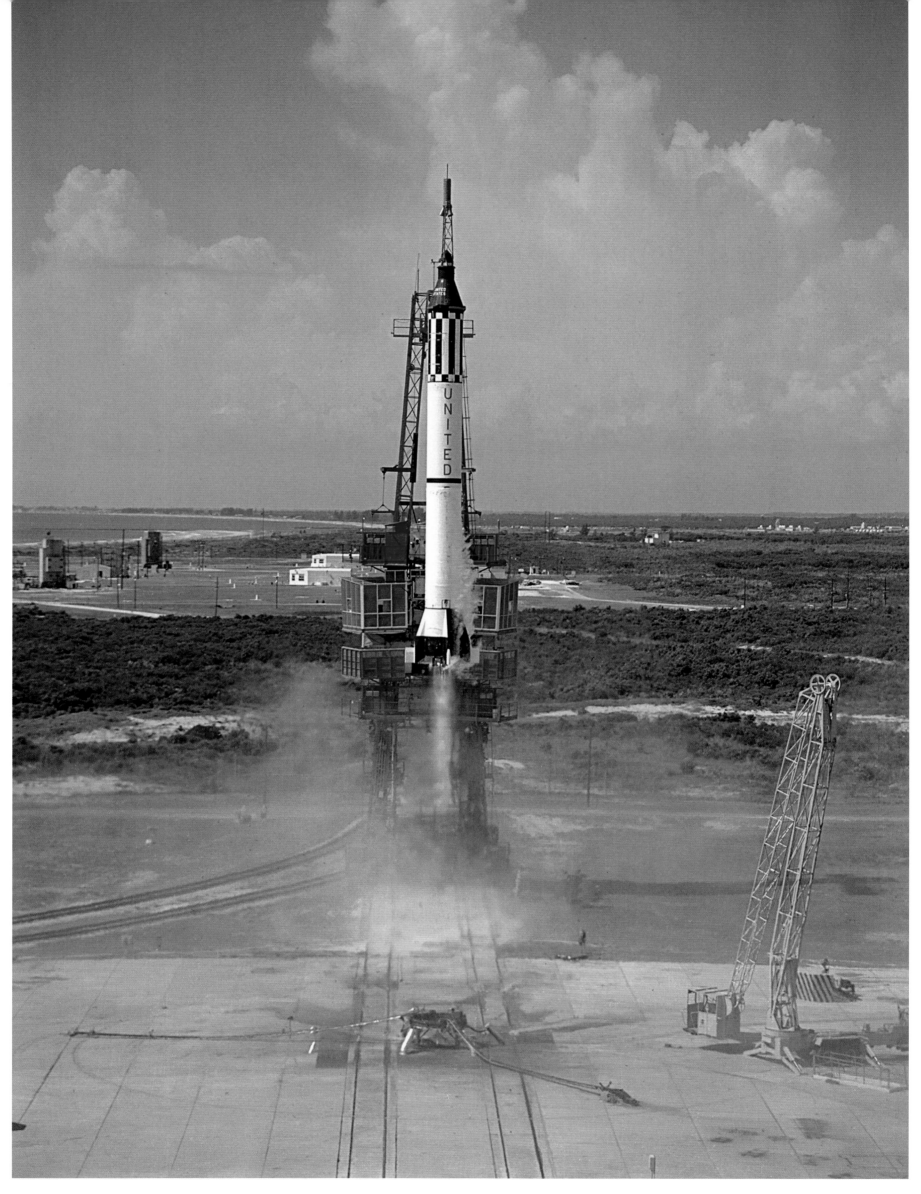

On May 5, 1961, at 9:34 am, millions of Americans turned on their television sets to watch Alan Shepard make history aboard the Mercury spacecraft *Freedom 7*. Launched on a Redstone rocket from Cape Canaveral, Florida, Shepard reached an altitude of 115 miles during his fifteen-minute suborbital flight. The first manned mission was designated Mercury-Redstone 3, and the series counted up from there. Meanwhile, each capsule was named by its astronaut, with the number 7 appended in recognition of the original seven Mercury astronauts, although in the case of *Freedom 7* it also stood for the spacecraft's production number.

Shepard poses in his Mercury spacesuit, whose design was based on the Goodrich/US Navy Mark IV high-altitude jet-aircraft pressure suit. It consisted of an inner layer of Neoprene-coated nylon fabric and an outer layer of aluminized nylon that gave the suit its silvery sheen. The spacesuit was worn "soft" or unpressurized, and served only as a backup in the unlikely chance of a loss in spacecraft cabin pressure.

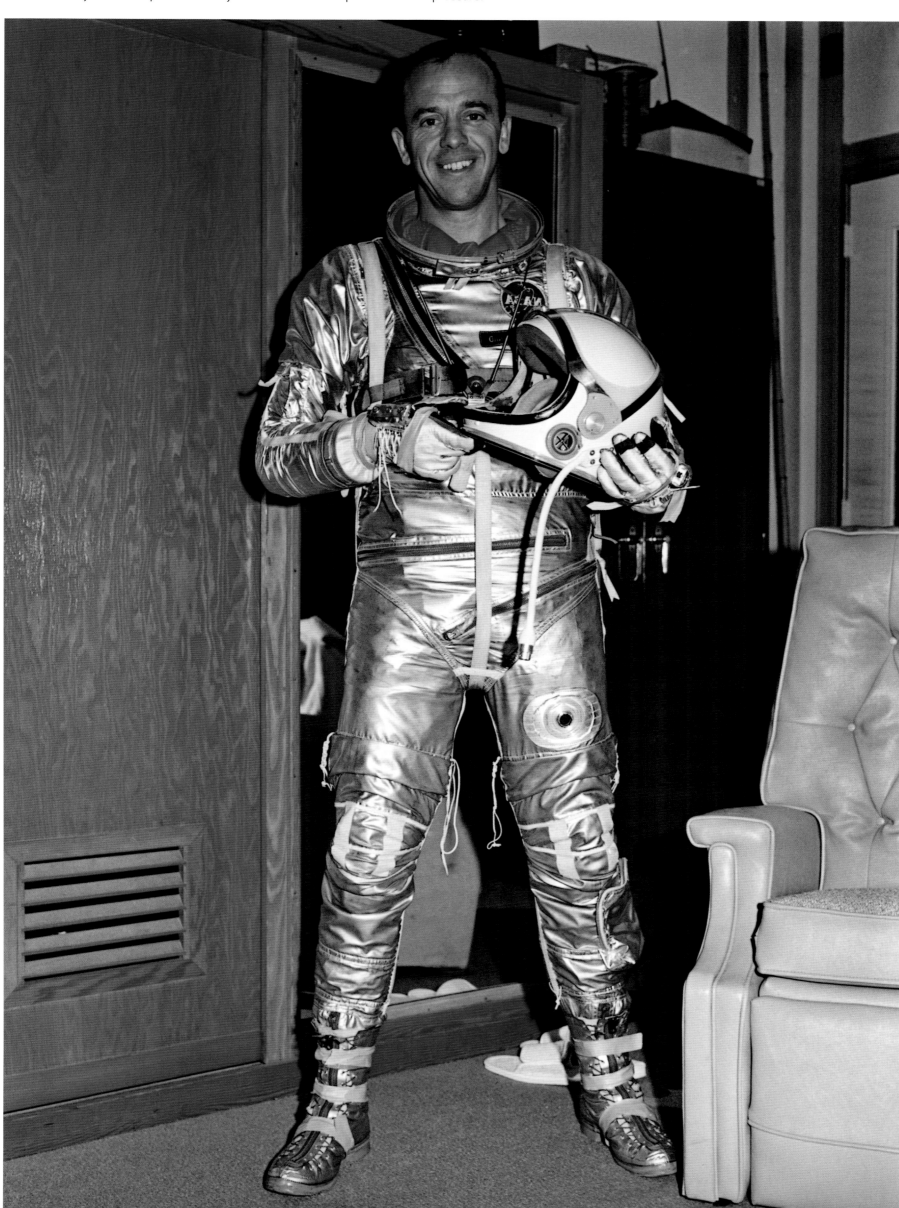

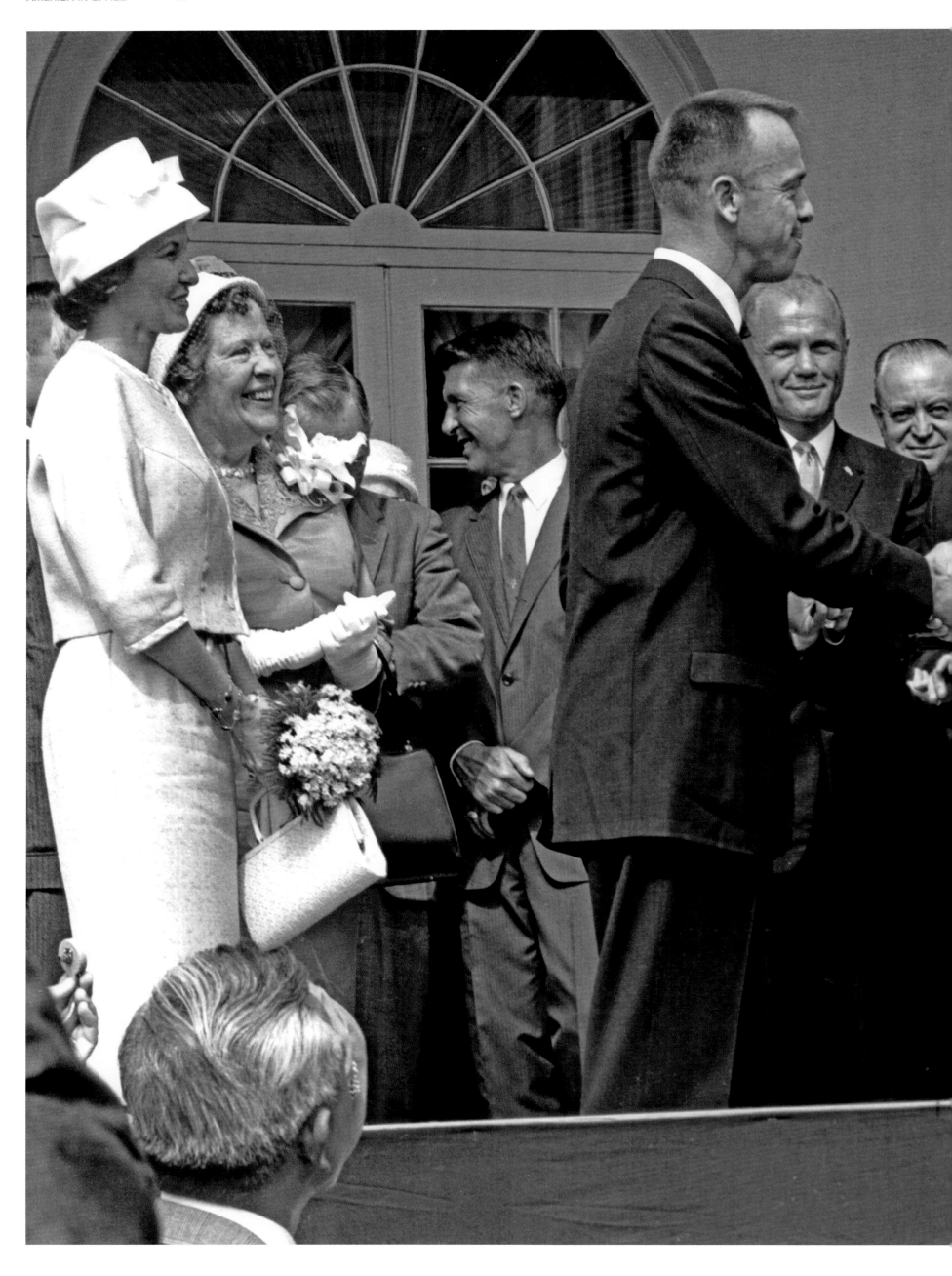

Left President John F. Kennedy congratulates Alan Shepard on his successful mission and confers NASA's Distinguished Service Medal on May 8, 1961. The President made the point that "this flight was made out in the open with all the possibilities of failure, which would have been damaging to our country's prestige. Because great risks were taken in that regard, it seems to me that we have some right to claim that this open society of ours which risked much, gained much." The other six Mercury astronauts were also in attendance during the medal ceremony on the White House lawn, which was followed by a parade on Pennsylvania Avenue.

Overleaf On July 21, 1961, Gus Grissom completed a fifteen-minute, thirty-seven-second suborbital space flight in *Liberty Bell 7* for the Mercury-Redstone 4 mission. After splashdown, the capsule sank when the explosive bolts on a faulty side-egress hatch blew prematurely and it was flooded. Grissom barely escaped and was fished out of the sea. **Right** Flanked by medical officers, he crosses the deck of the recovery ship USS *Randolph*. **Left** A last view of the foundering capsule, not to be seen again until it was salvaged in 1999.

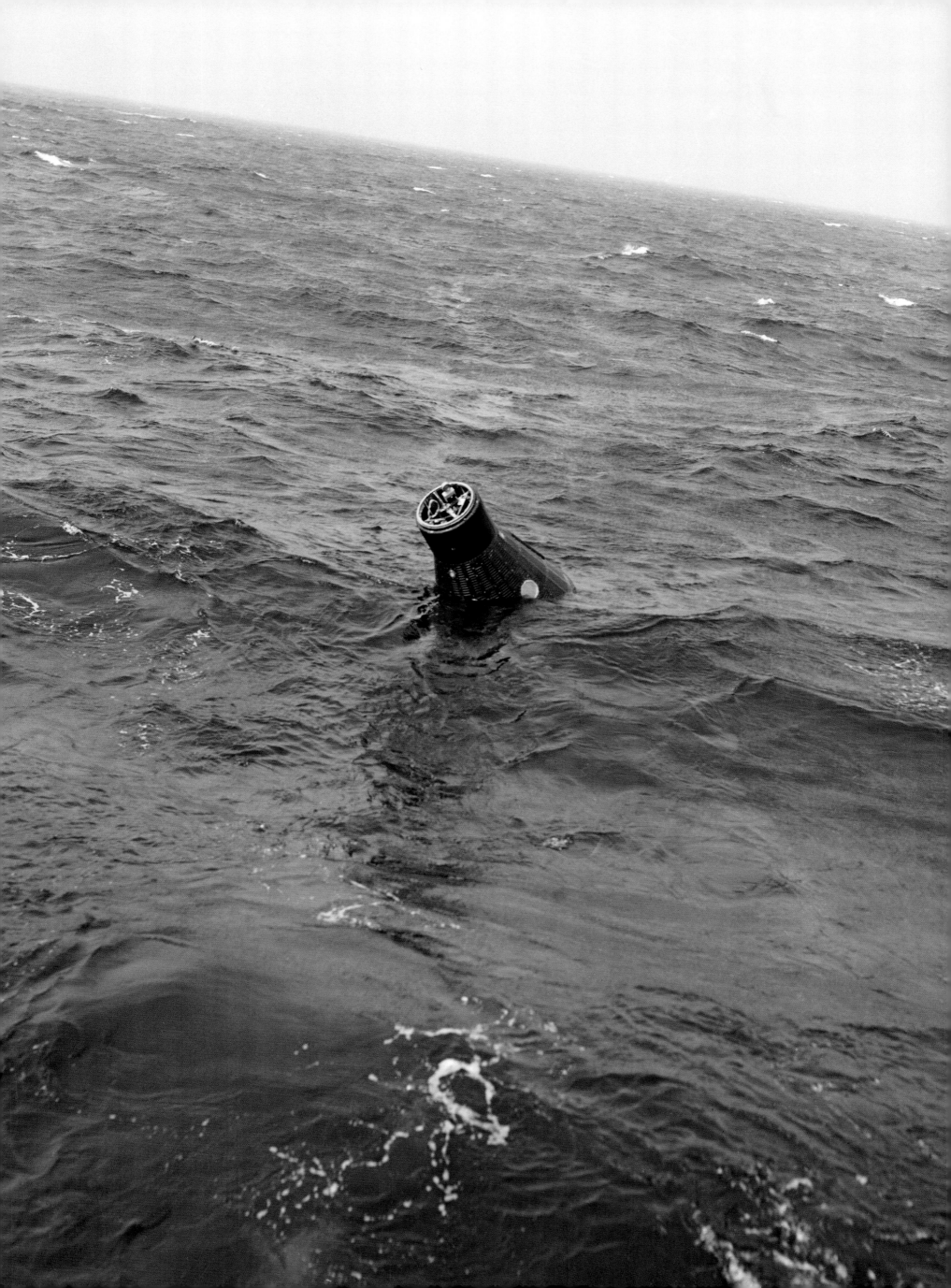

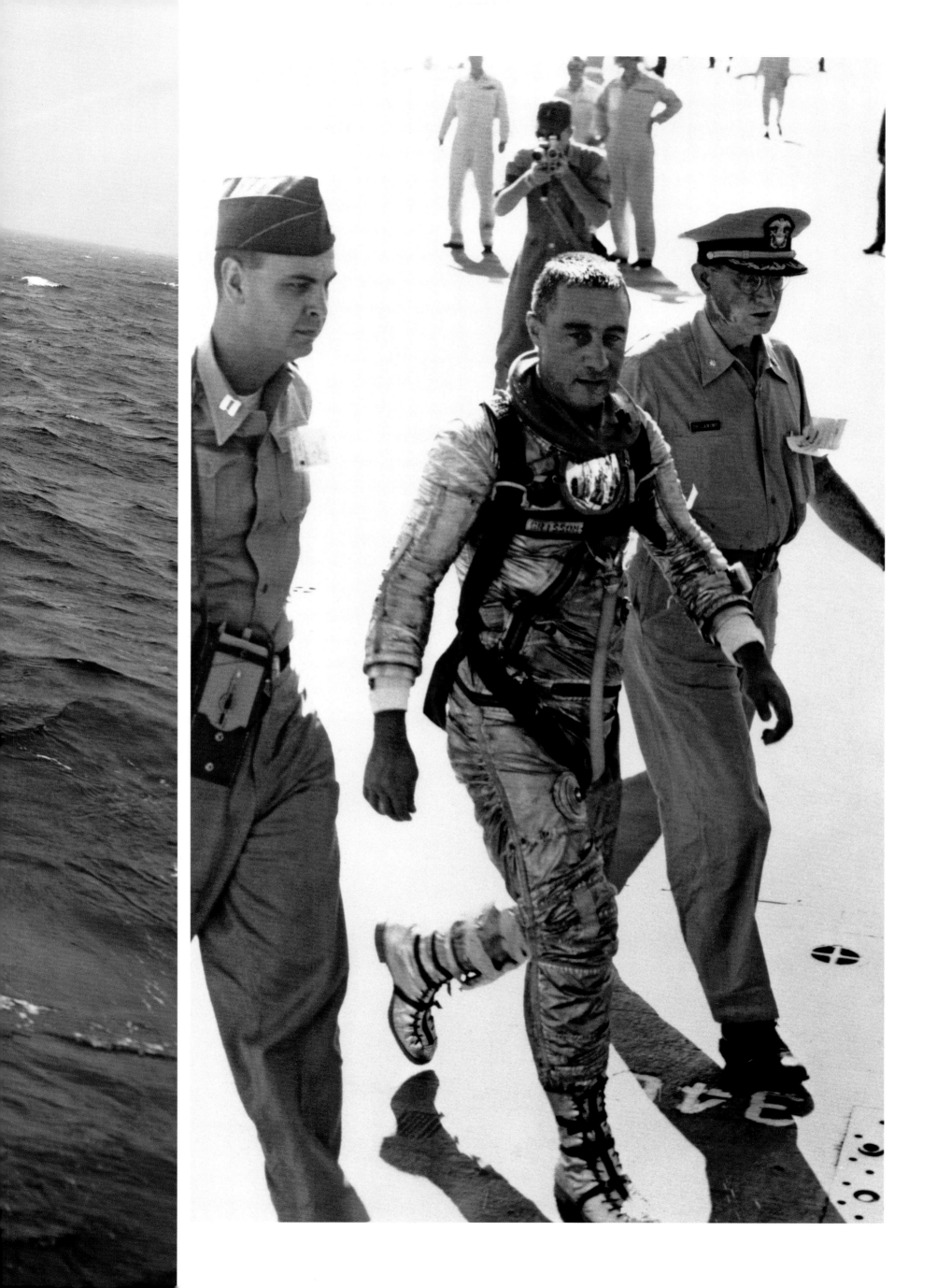

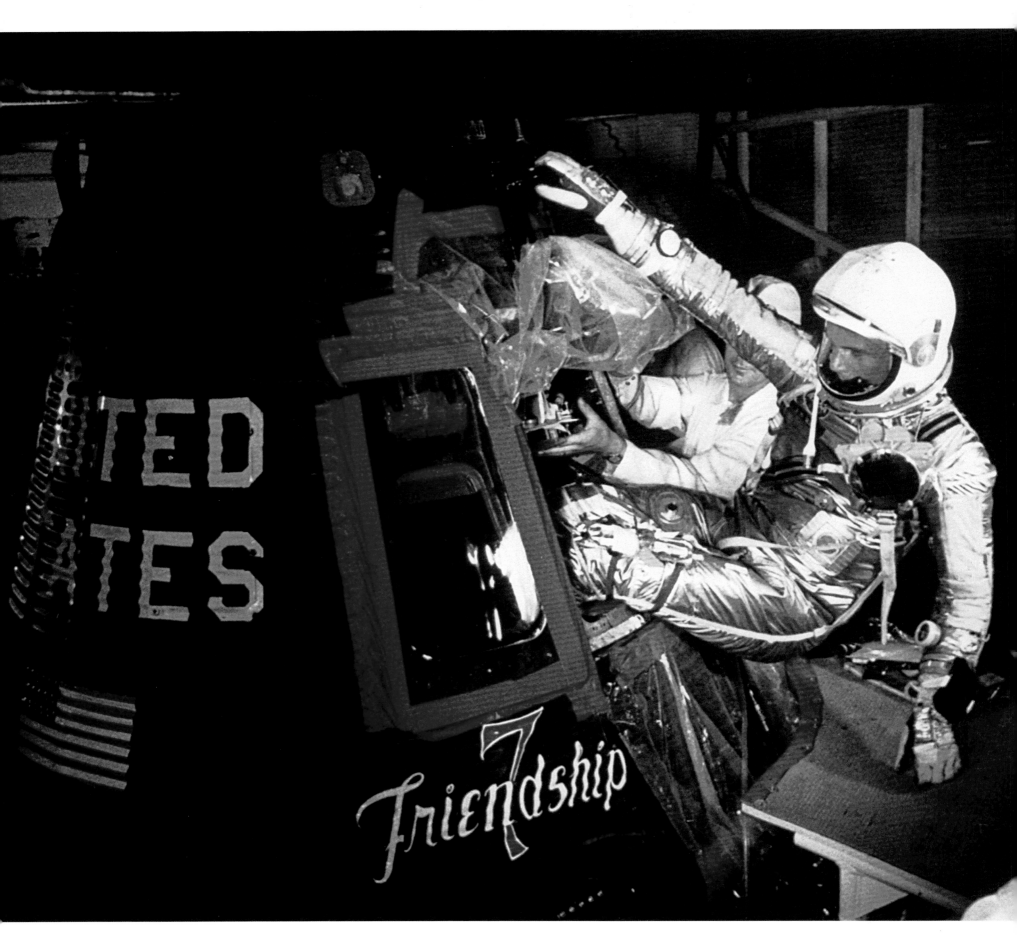

John Glenn became the first American astronaut to orbit the Earth on February 20, 1962. **Above** Glenn hoists himself into the *Friendship 7* spacecraft on launch day. He had ridden the elevator to the top of the gantry several times already, as his mission was scrubbed ten times before it finally launched. **Opposite** *Friendship 7* was boosted by a Mercury-Atlas rocket, a modified Atlas Intercontinental Ballistic Missile. **Overleaf** Glenn was photographed by an automatic-sequence motion-picture camera during his flight. He was in a state of weightlessness, traveling at 17,500 mph, as the pictures were taken. Looking down at the Earth, he exclaimed, "Oh, that view is tremendous." After his third orbit, Glenn experienced a harrowing reentry. A faulty sensor mistakenly indicated that the heat shield of his capsule was not locked in place and ground control decided that he should not jettison the retro pack that covered it. As a result, the pack burned up during reentry, engulfing the capsule in flames. The mission lasted four hours and fifty-five minutes.

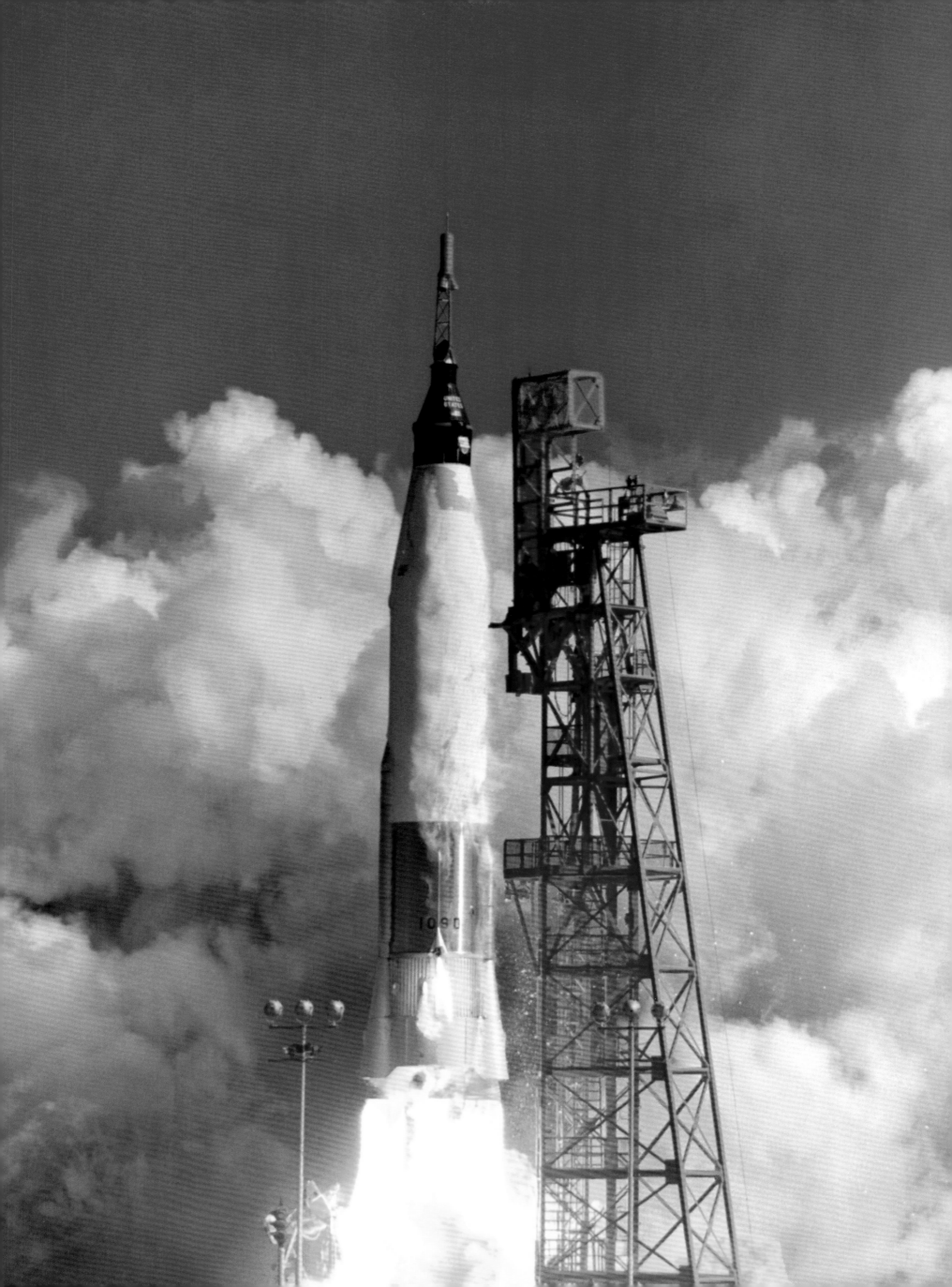

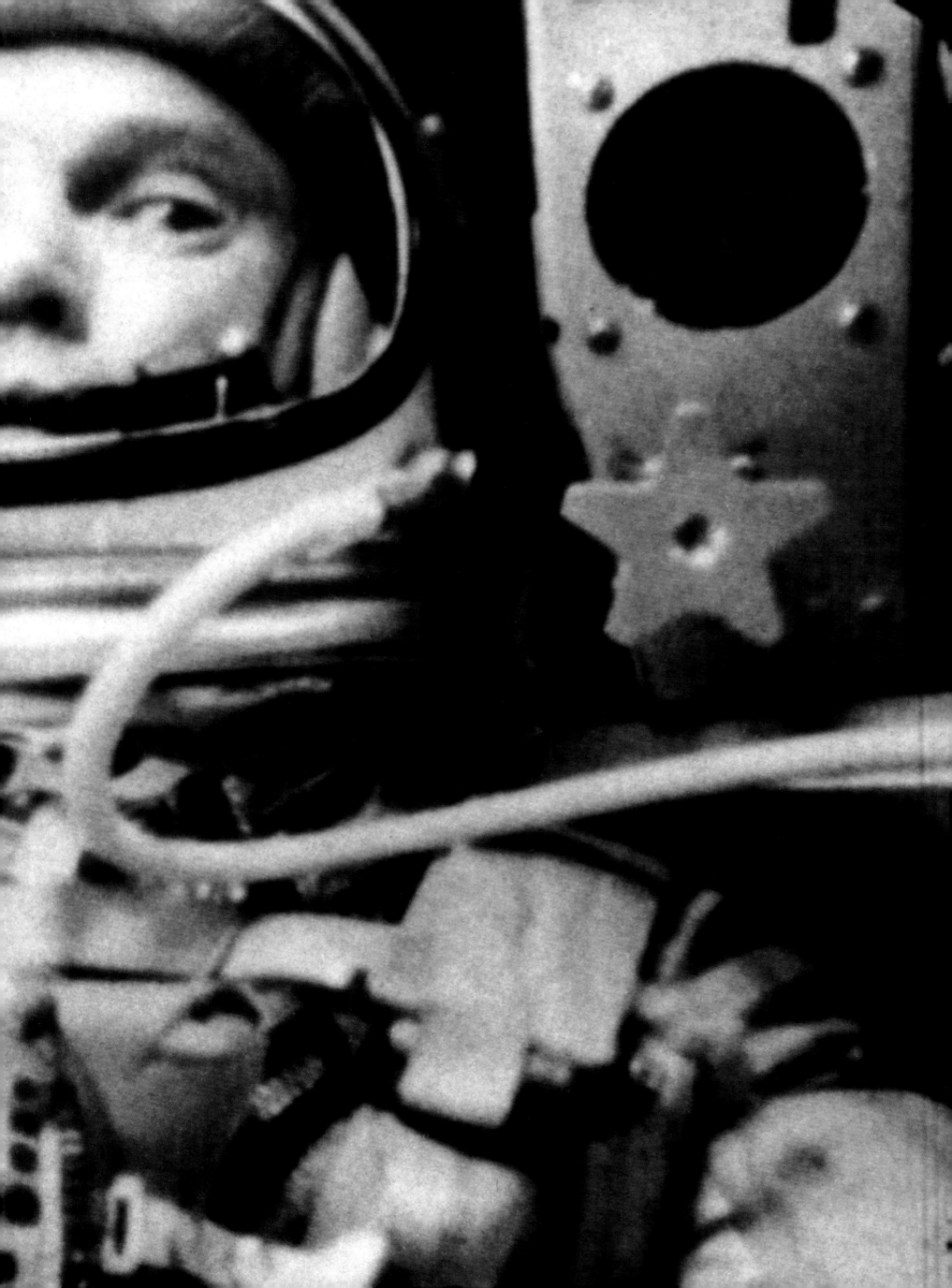

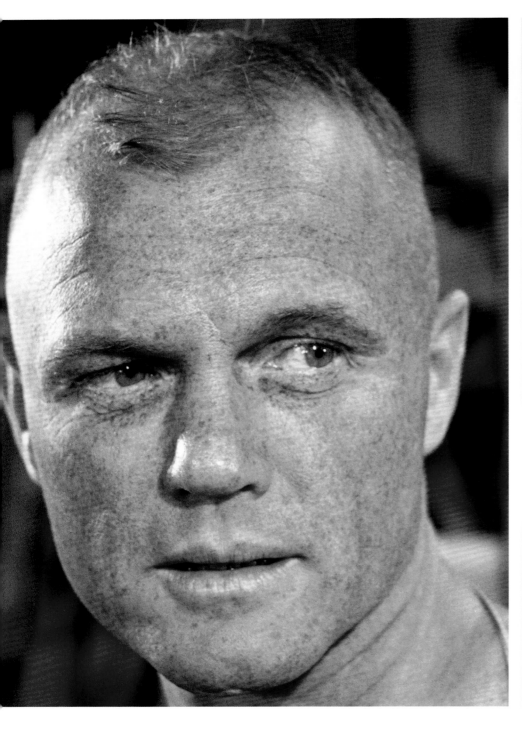

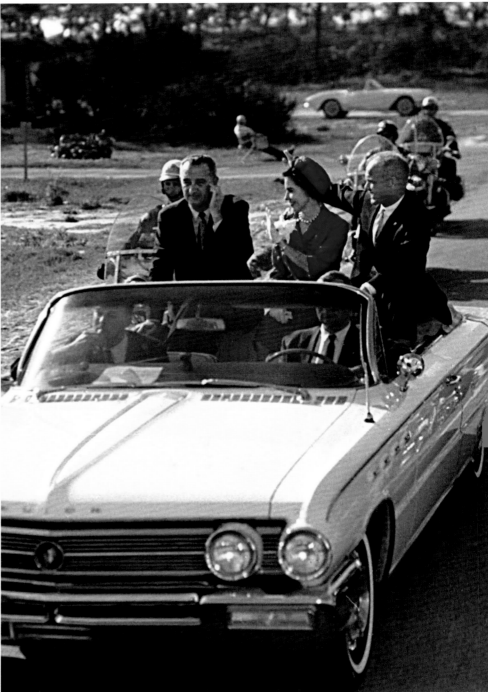

Above left *Friendship 7*, with Glenn still inside, was recovered by the destroyer USS *Noa* near Grand Turk Island in the Atlantic Ocean, forty miles short of the predicted landing site. The astronaut looks composed and alert in this photograph taken aboard the destroyer, where he spent only three hours before being transferred to the USS *Randolph*.

Above and opposite Three days after the mission, Vice President Lyndon Johnson escorted Glenn on a flight from Grand Turk Island to Patrick Air Force Base in Florida, where his family was waiting. The Glenn family, accompanied by the Vice President and other Mercury 7 astronauts, then traveled up the coast to Cape Canaveral for a meeting with President Kennedy. The eighteen-mile road trip turned into a parade as thousands of people gathered along the highway to greet the astronaut.

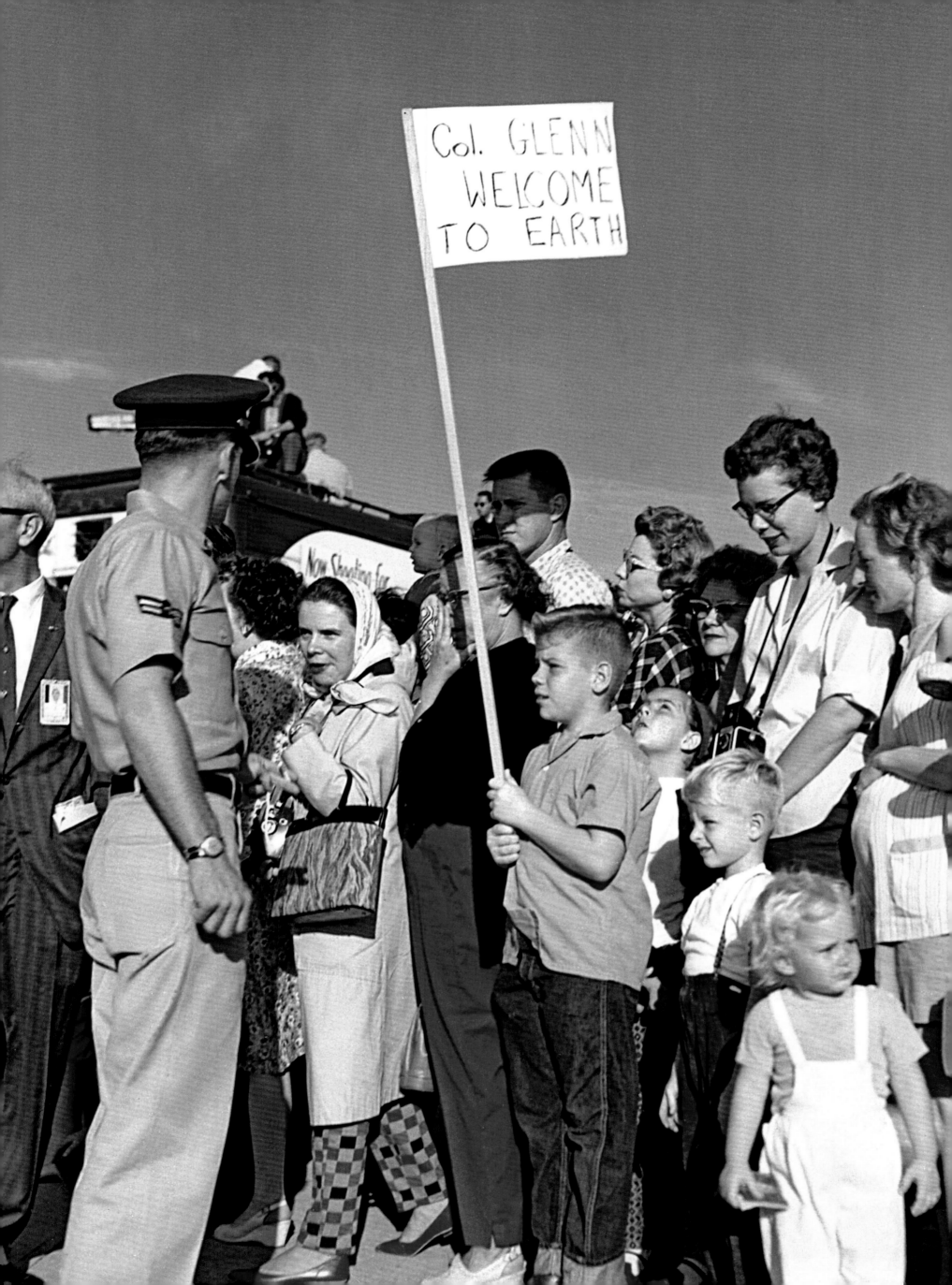

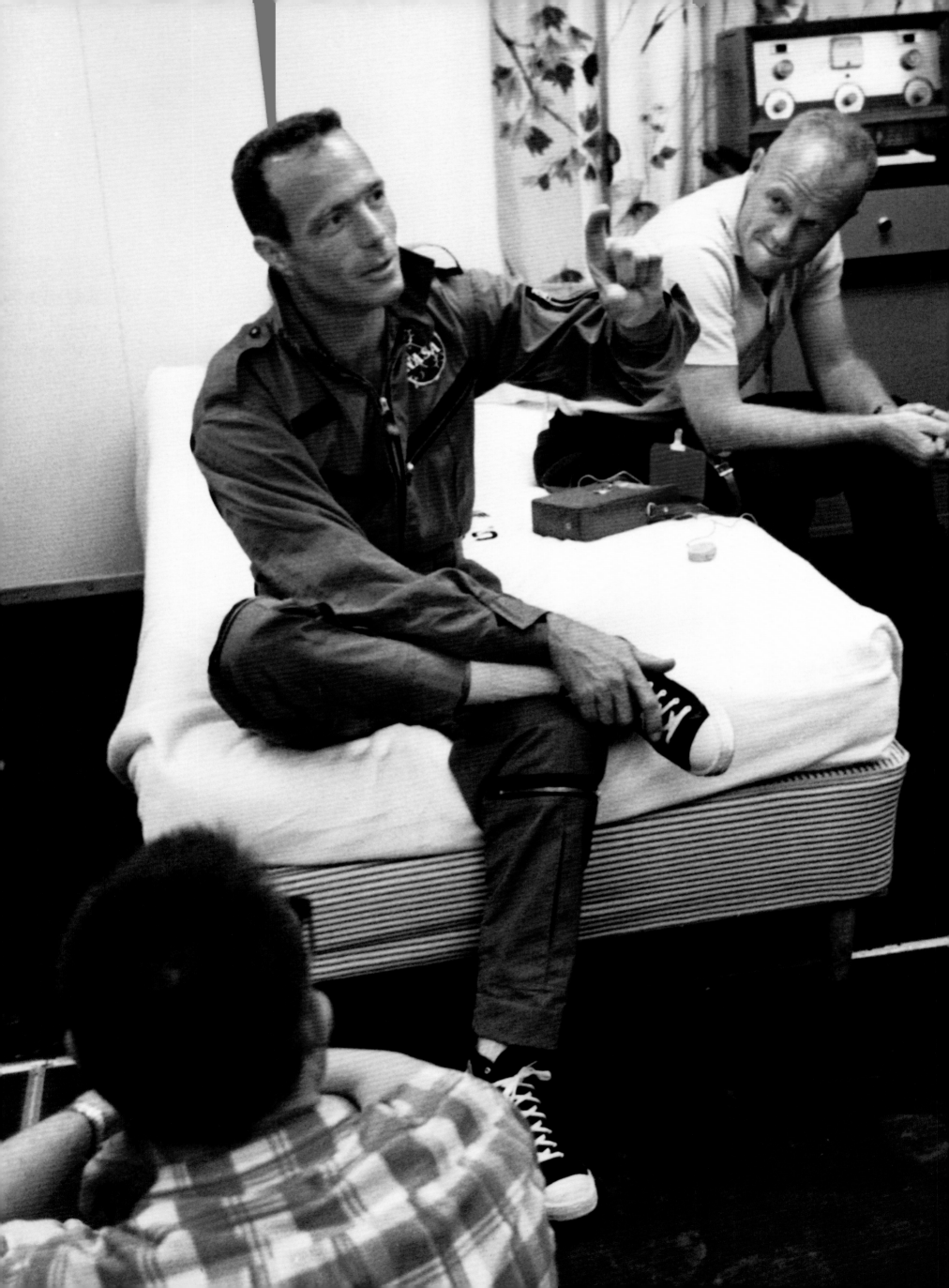

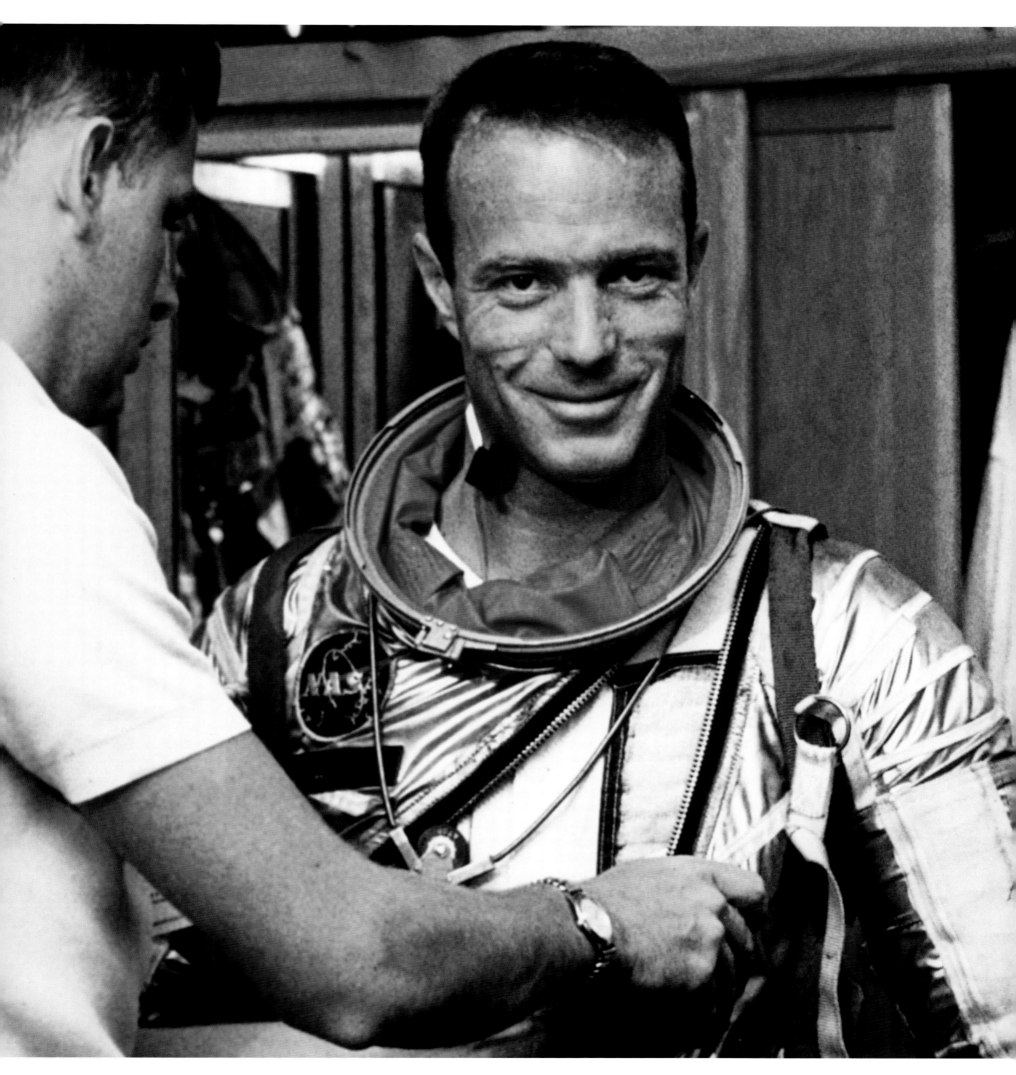

Above A technician adjusts Scott Carpenter's spacesuit before the Mercury-Atlas 7 launch on May 24, 1962. Carpenter named his spacecraft *Aurora 7* and, like Glenn, orbited three times around the Earth during his four-hour, fifty-six-minute flight. **Opposite** After the flight, Carpenter makes a point as Glenn listens. Deke Slayton was slated to fly this mission, until he was found to have cardiac arrhythmia; he remained with NASA in the important job of selecting crews for the Gemini and Apollo missions. He was returned to full flight status in 1973.

Opposite Wally Schirra undergoes a test to measure the effect of a disturbance of the semi-circular canal in the ear—which regulates balance—on eye motions, and thereby vision. Assessing the impact of microgravity on the human body, and especially performance, was a priority for NASA. A similar experiment from the space-shuttle era can be seen on pages 282-283.

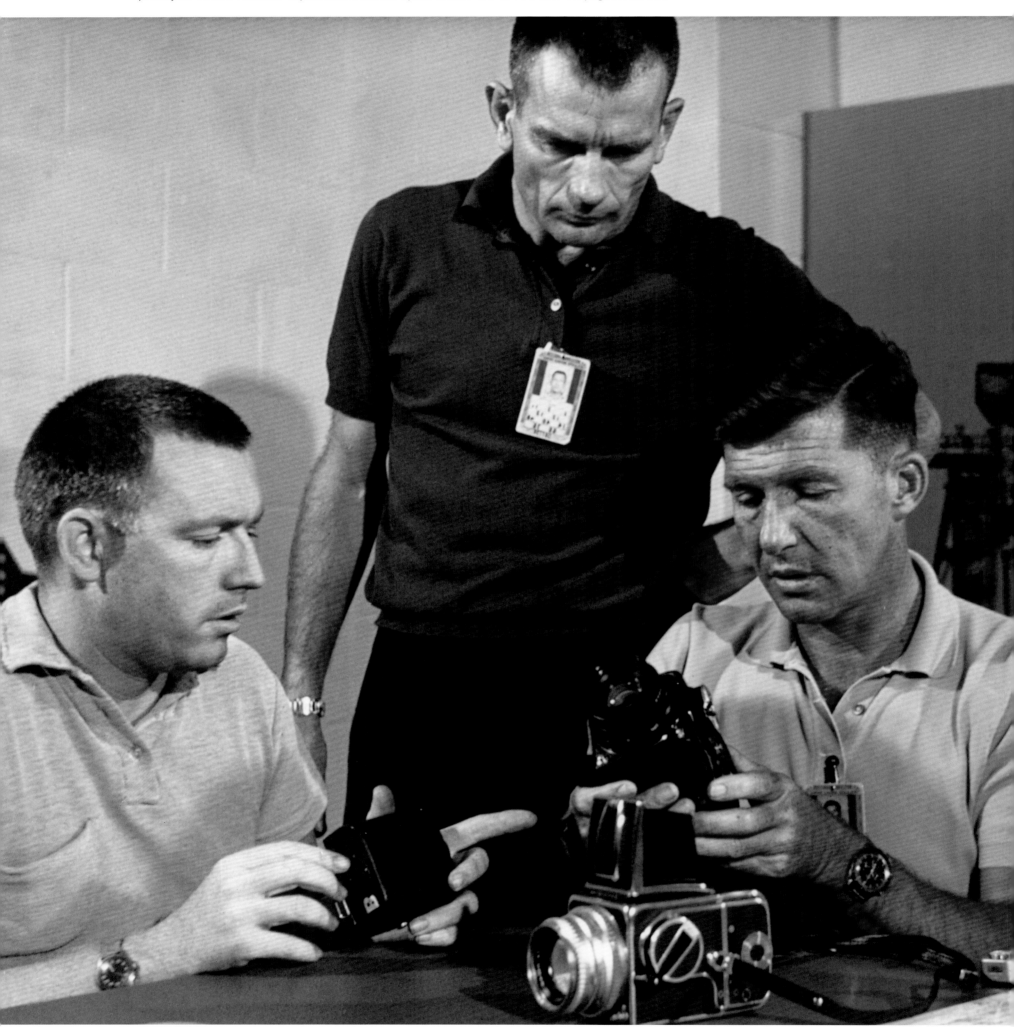

Above Wally Schirra (holding camera) and Deke Slayton (standing) are briefed on the use of a Hasselblad camera that Schirra would use on the Mercury-Atlas 8 mission. Photography was not a priority for NASA in the beginning; Glenn famously bought a cheap 35mm camera at a Florida drug store on his own and used it to take some black-and-white snaps of the Earth below. By the time it was Schirra's turn, mission planners were able to think about photography. The versatile Hasselblad would prove invaluable through the Apollo missions and beyond. Schirra spent nine hours and eleven minutes aboard *Sigma 7* on October 3, 1962, and his color photos of the Earth set a precedent for future missions.

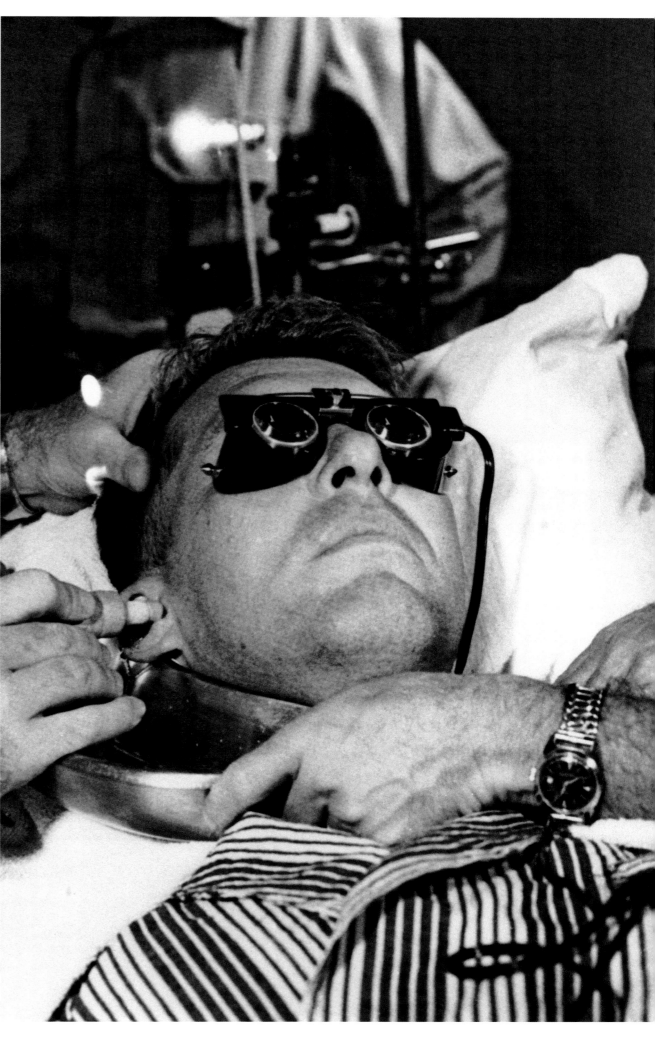

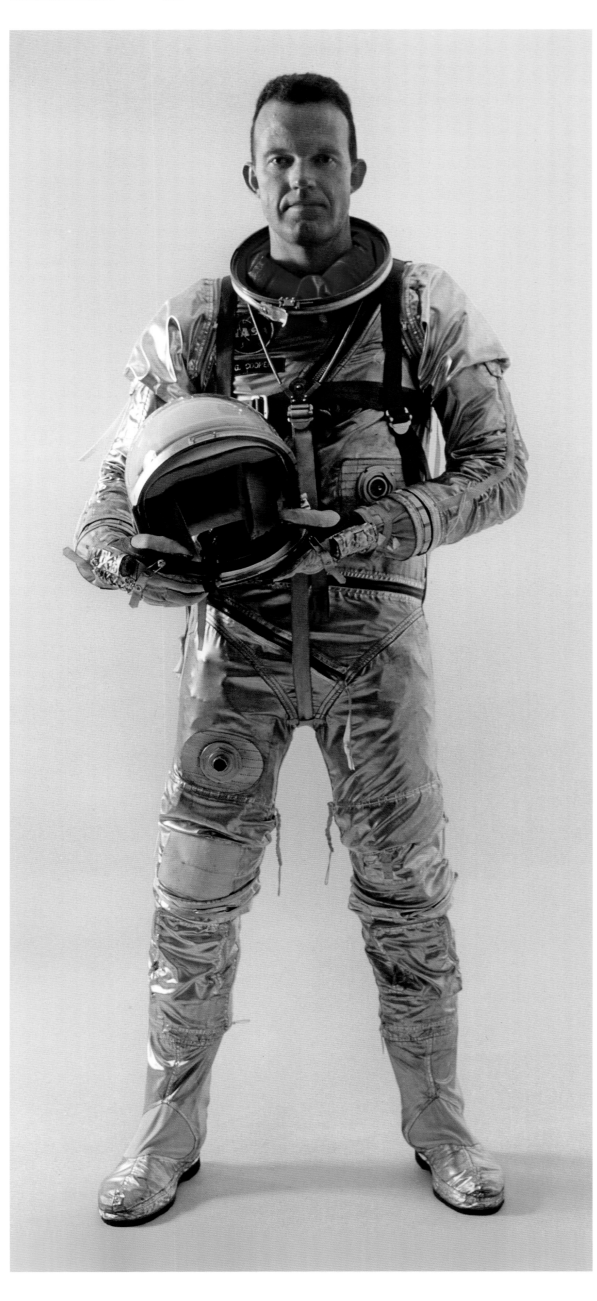

Left Astronaut Gordon Cooper poses for an atypical official portrait without props or flag in February 1963.

Opposite On May 15, Cooper walks from the transfer van toward the service-tower elevator of Launch Complex 14 at Cape Canaveral, to the applause of the assembled launch technicians.

Overleaf Cooper completes an altitude-chamber test in the capsule, in a photograph that captures its claustrophobic dimensions. Mercury astronauts had to get used to cramped spaces: the spacecraft was approximately seven feet long by six feet in diameter. Inside it was crammed with one hundred dials and controls. One goal of Cooper's Mercury-Atlas 9 mission was to demonstrate that it was possible to keep a man in space for more than twenty-four hours. Cooper spent thirty-four hours and nineteen minutes in his *Faith 7* capsule, through twenty-two orbits of the Earth, and some of its automatic systems did begin to degrade toward the end of the mission.

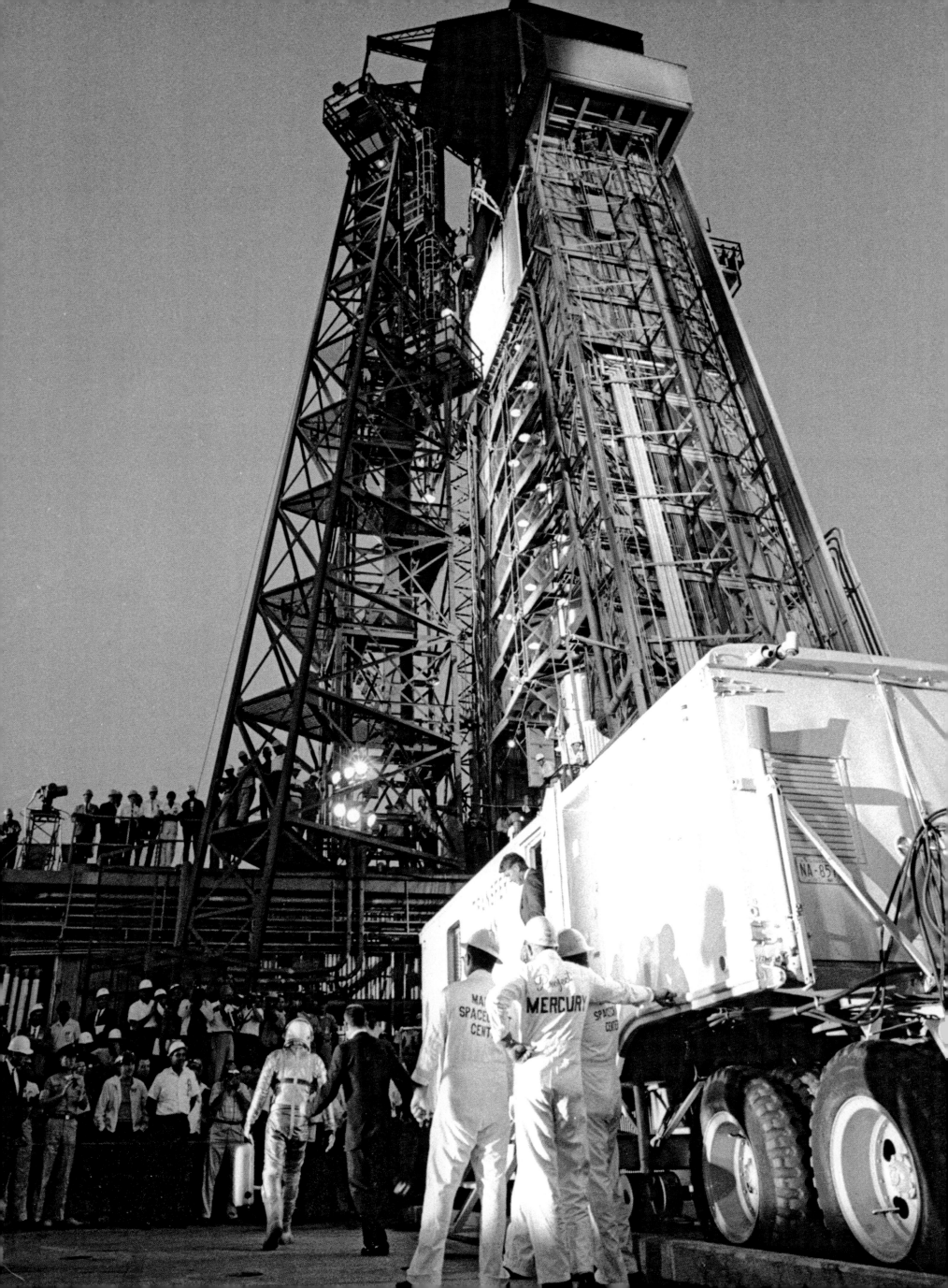

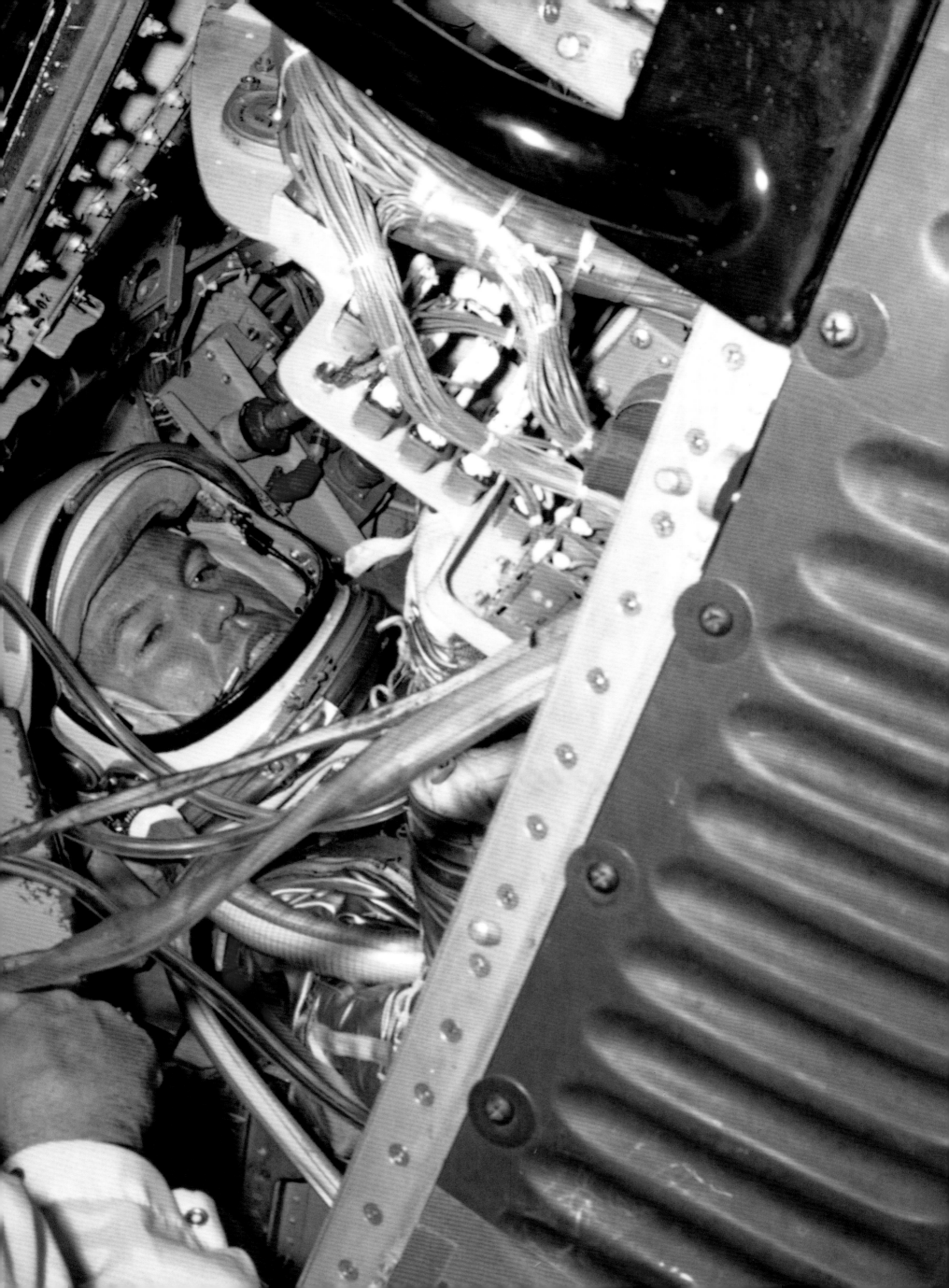

The aircraft carrier USS *Kearsarge* recovered the last two Mercury missions. **Right** An aerial view of Wally Schirra's *Sigma 7* capsule, with Schirra still inside, being lowered onto a deck of the carrier on October 3, 1962. **Below** The crew spells out "Mercury 9" on the flight deck for Gordon Cooper seven months later, on May 16, 1963. **Below right** A visibly stiff Cooper emerges from the *Faith 7* spacecraft at the end of his mission. Like Schirra, he elected to remain in the capsule until it was safely aboard ship. Mercury-Atlas 9 marked the end of the nearly five-year-long Project Mercury, which demonstrated that humans could function in space and introduced the public to a cast of brave pioneers.

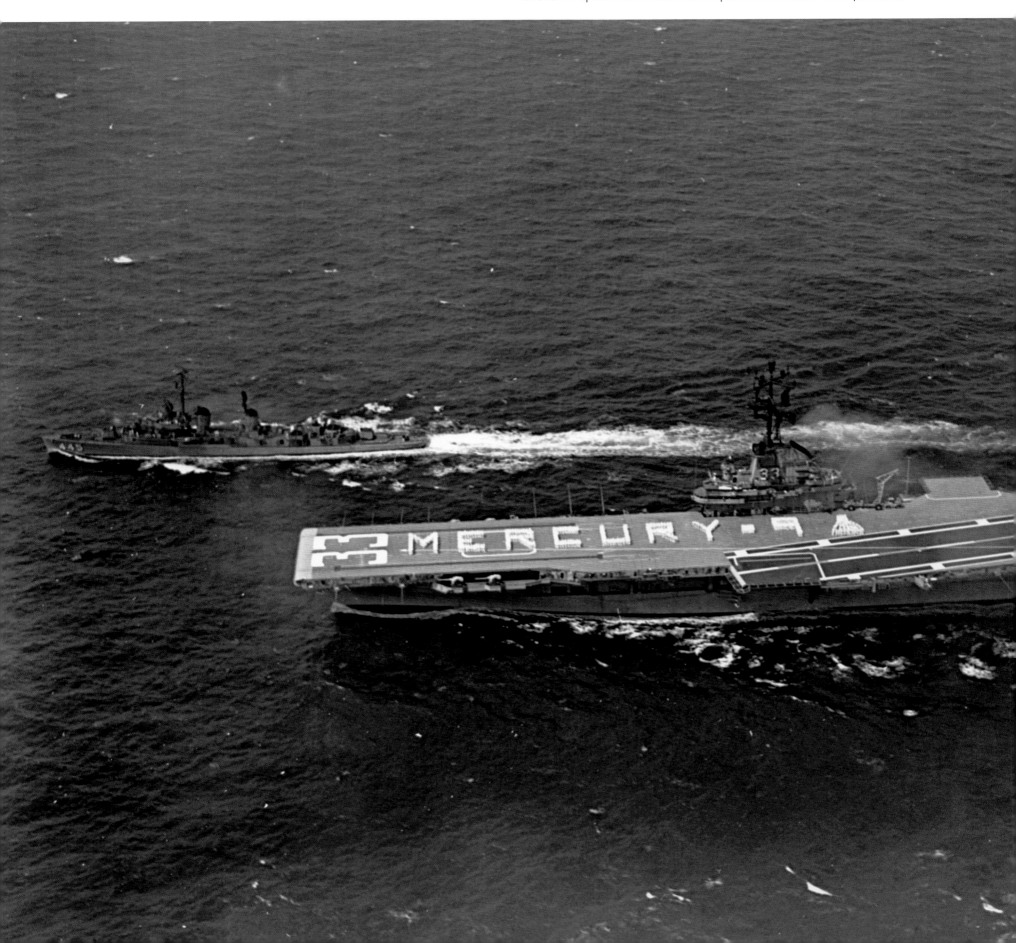

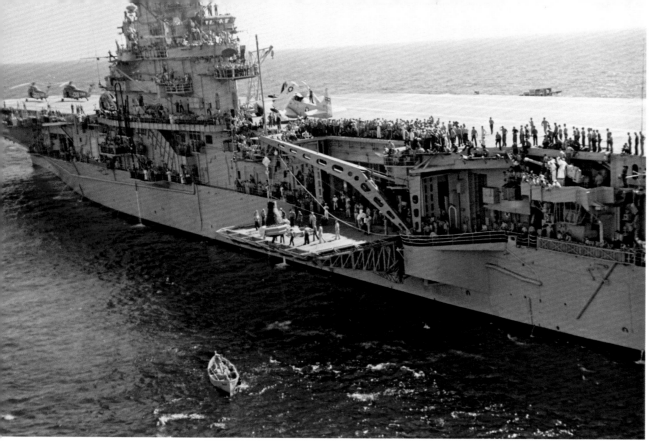

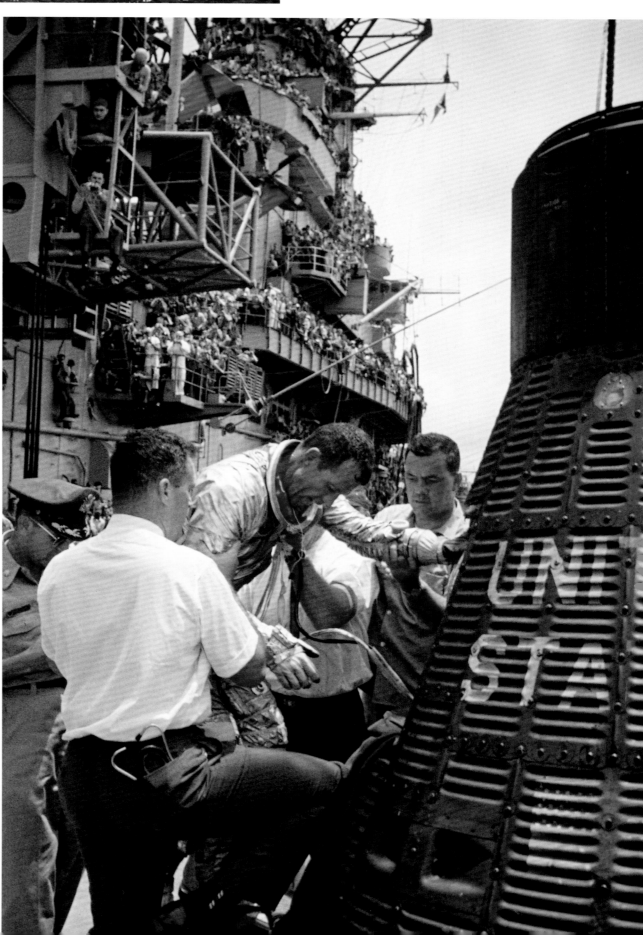

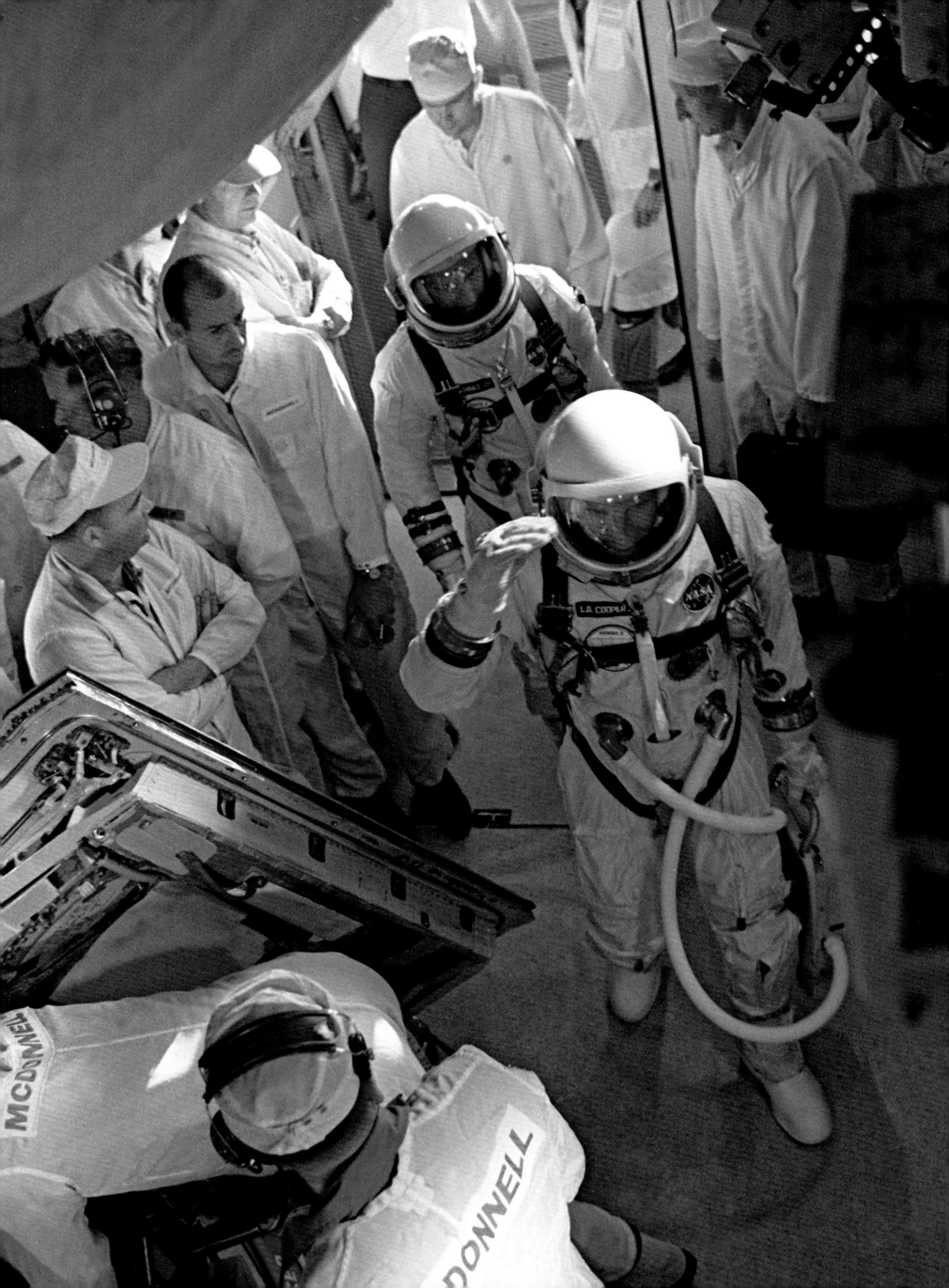

PROJECT GEMINI

NASA announced plans for a two-man spacecraft on December 7, 1961, even before Glenn's orbital flight. The following month it was officially designated the Gemini program, named after the constellation with its twin stars, Castor and Pollux. The program was conceived as an intermediate step between Project Mercury and Apollo. Its major objectives were to subject humans to spaceflight for up to two weeks, to rendezvous and dock with orbiting vehicles, and to perfect methods of entering the atmosphere and landing.

Gemini consisted of twelve flights, including two unmanned flight tests in April 1964 and January 1965. The first manned Gemini flight was Gemini 3, launched March 23, 1965, with Gus Grissom and John Young aboard. Grissom nicknamed the spacecraft "Molly Brown," in reference to his first spacecraft that sank, unlike the unsinkable Molly Brown of Titanic legend. Young, representing a new class of astronauts, would go on to fly in the Apollo and shuttle programs. The three-orbit Gemini 3 lasted almost five hours. It was followed by flights of increasing duration and difficulty: 62 orbits for Gemini IV (Roman numeral designations began with this flight), 120 for Gemini V, and 206 orbits for Gemini VII.

The Gemini program saw many firsts, had its share of exciting moments, and was a training ground for many of the astronauts who would go on to the Moon in the Apollo program. Gemini 4 saw the first American Extravehicular Activity (EVA), a twenty-two minute spacewalk carried out by Edward White, later killed in the Apollo 1 fire. Gemini V saw the first use of fuel cells for electrical power, and evaluated the guidance and navigation system for future rendezvous missions. Gemini VII not only showed that humans could live in space for fourteen days, it was also the first rendezvous in space. Launched on December 4, 1965, on December 15 it rendezvoused with Gemini VI-A, station-keeping for over five hours at distances from 1 to 295 feet. Gemini VIII accomplished the first docking with another space vehicle, an unmanned Agena stage. When a malfunction caused uncontrollable spinning of the craft, the crew undocked and effected the first emergency landing of a manned US space mission. Neil Armstrong's impressive actions on this flight later helped win him the Apollo 11 landing slot. Four more Gemini flights during 1966 perfected rendezvous and docking procedures, including the final flight Gemini XII. Gemini XII rendezvoused and docked with its target Agena and kept station with it during EVA. Buzz Aldrin set an EVA record of five hours, thirty minutes for one spacewalk and two stand-up exercises.

The success of the Mercury and Gemini flights meant the United States was on target in reaching its goal of a lunar landing by the end of the decade.

Opposite Command Pilot Gordon Cooper (foreground) and Pilot Pete Conrad cross the white room (the structure atop the gantry that gave astronauts and technicians access to the Gemini capsule) through a crowd of McDonnell and NASA technicians during the Gemini V countdown at Cape Kennedy, August 21, 1965. Cooper appears to be saluting as he approaches the capsule.

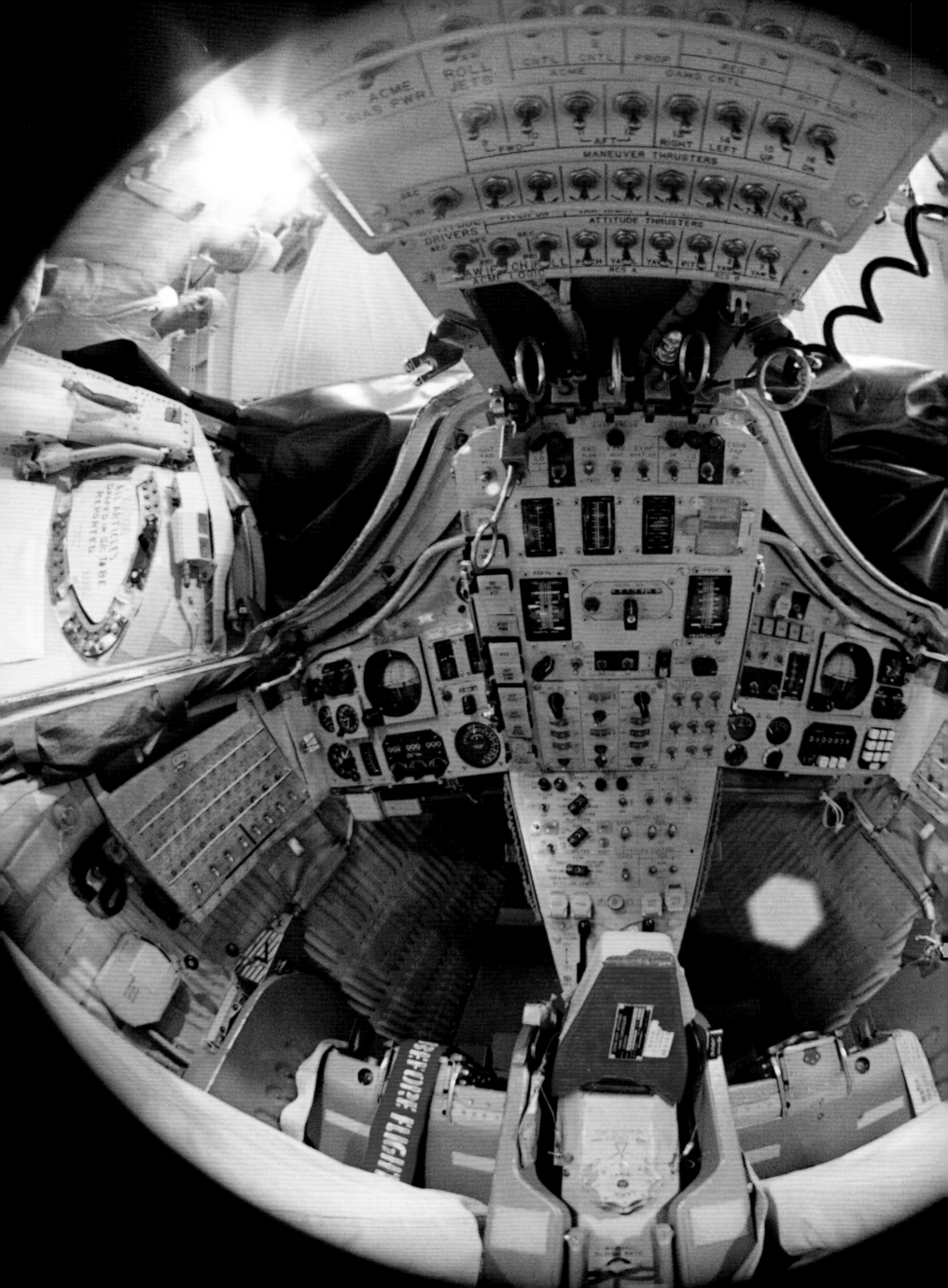

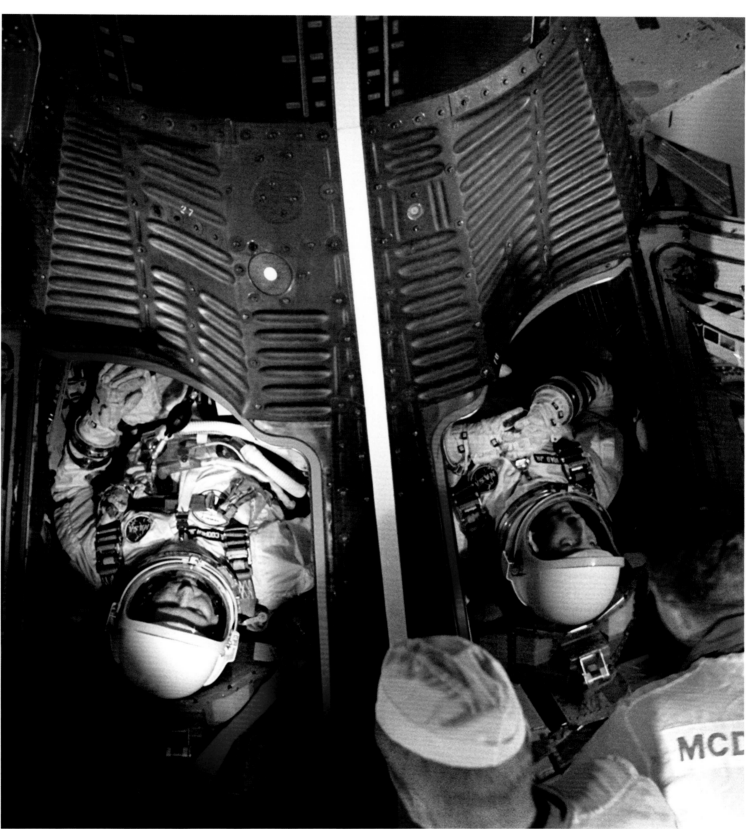

Above Cooper (left) and Conrad have been inserted in the capsule.

Opposite A fish-eye view of the interior of Gemini VI spacecraft gives the astronauts' eye-view. The two-seater spacecraft was nineteen feet long by ten feet wide, considerably more spacious than the Mercury capsule, and it was technically more sophisticated. For one thing, because it was designed to rendezvous and dock with other spacecraft, it was far more maneuverable in space, thanks in part to an on-board guidance computer.

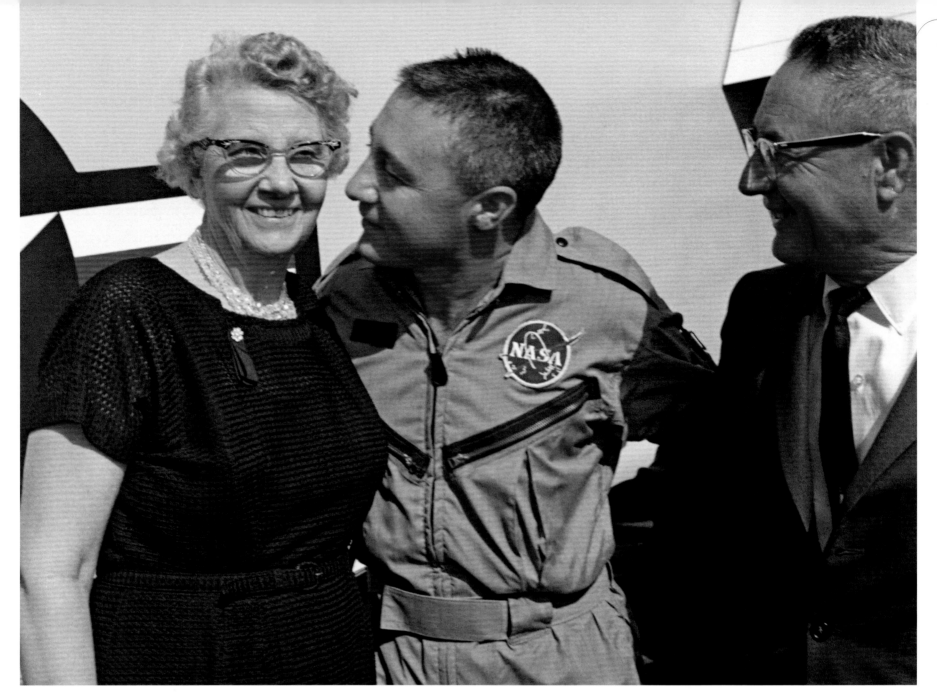

Opposite Command Pilot Gus Grissom and Pilot John Young pose during training for the first manned Gemini mission. Designated Gemini 3, it launched on March 23, 1965, and flew three orbits.

Above Grissom shares a quiet moment with his parents. Grissom was the first astronaut to fly into space twice and he was deeply involved with the McDonnell engineers who designed the Gemini spacecraft. He "unofficially" named the capsule *Molly Brown* after the Broadway hit *The Unsinkable Molly Brown*. Some at NASA did not appreciate Grissom's backhanded salute to his sunken Mercury *Liberty 7* capsule, but the mission crew loved it and used the name at every opportunity. Spacecraft names were abandoned for the remainder of the Gemini program (whose missions were henceforth designated with roman numerals) and then reinstated in the course of Apollo.

Overleaf left waving to well-wishers, Command Pilot James McDivitt (left) and Pilot Edward White walk up the ramp on their way to the elevator that would deliver them to their spacecraft for the Gemini IV mission on June 3, 1965.

Overleaf right McDivitt (foreground) and White were photographed a few minutes before the hatches were secured and they were launched on their sixty-six-orbit, four-day mission.

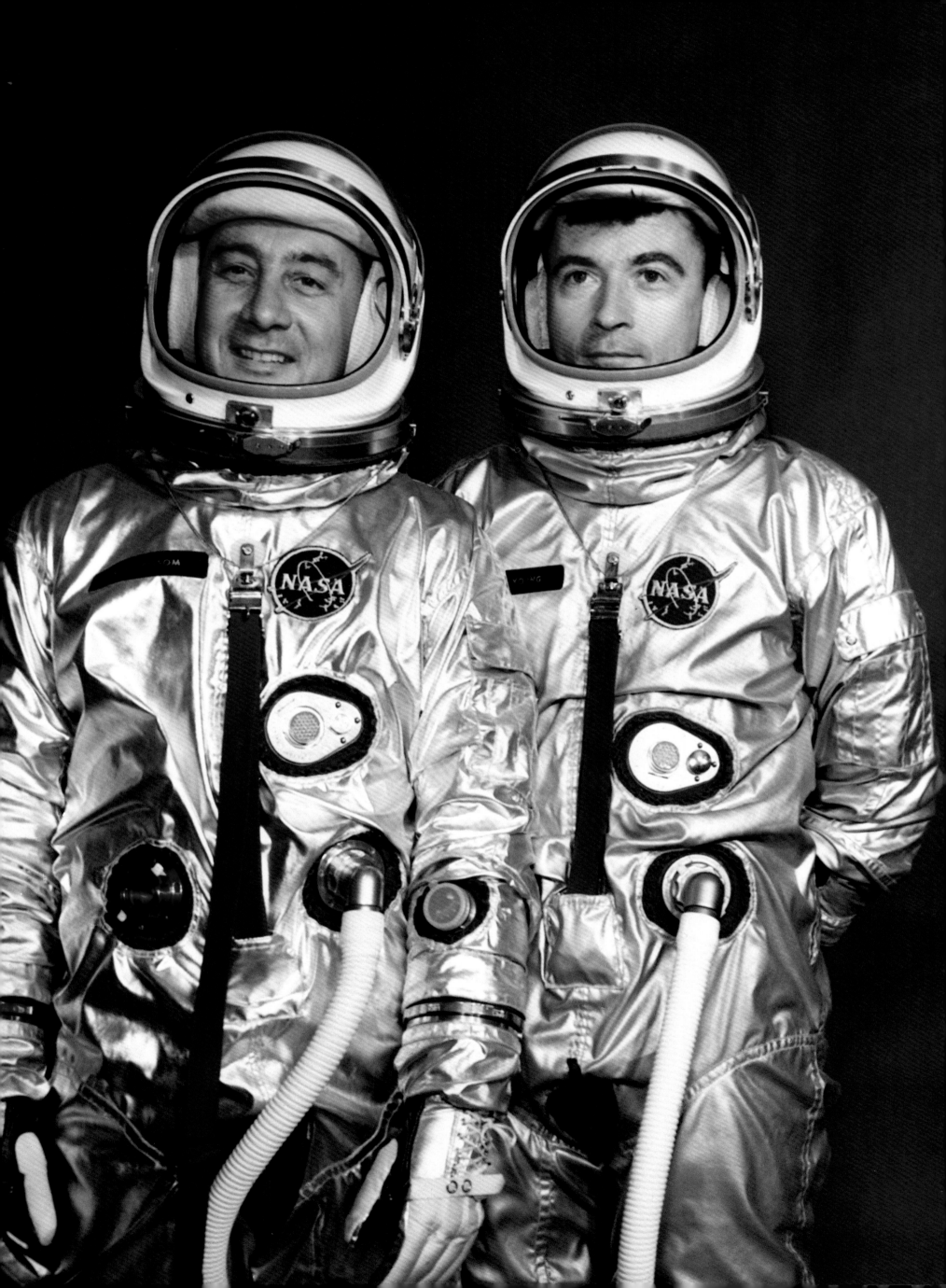

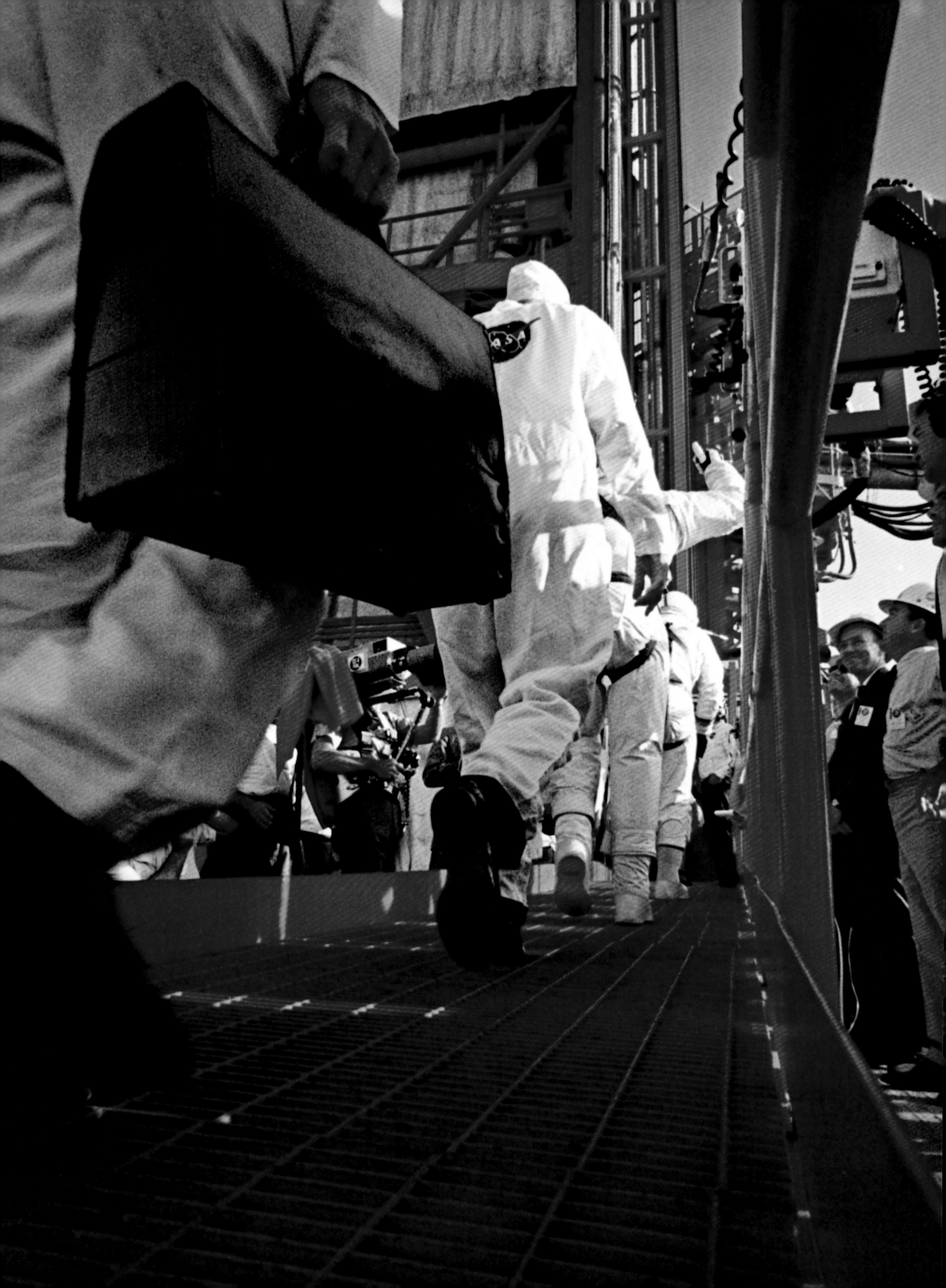

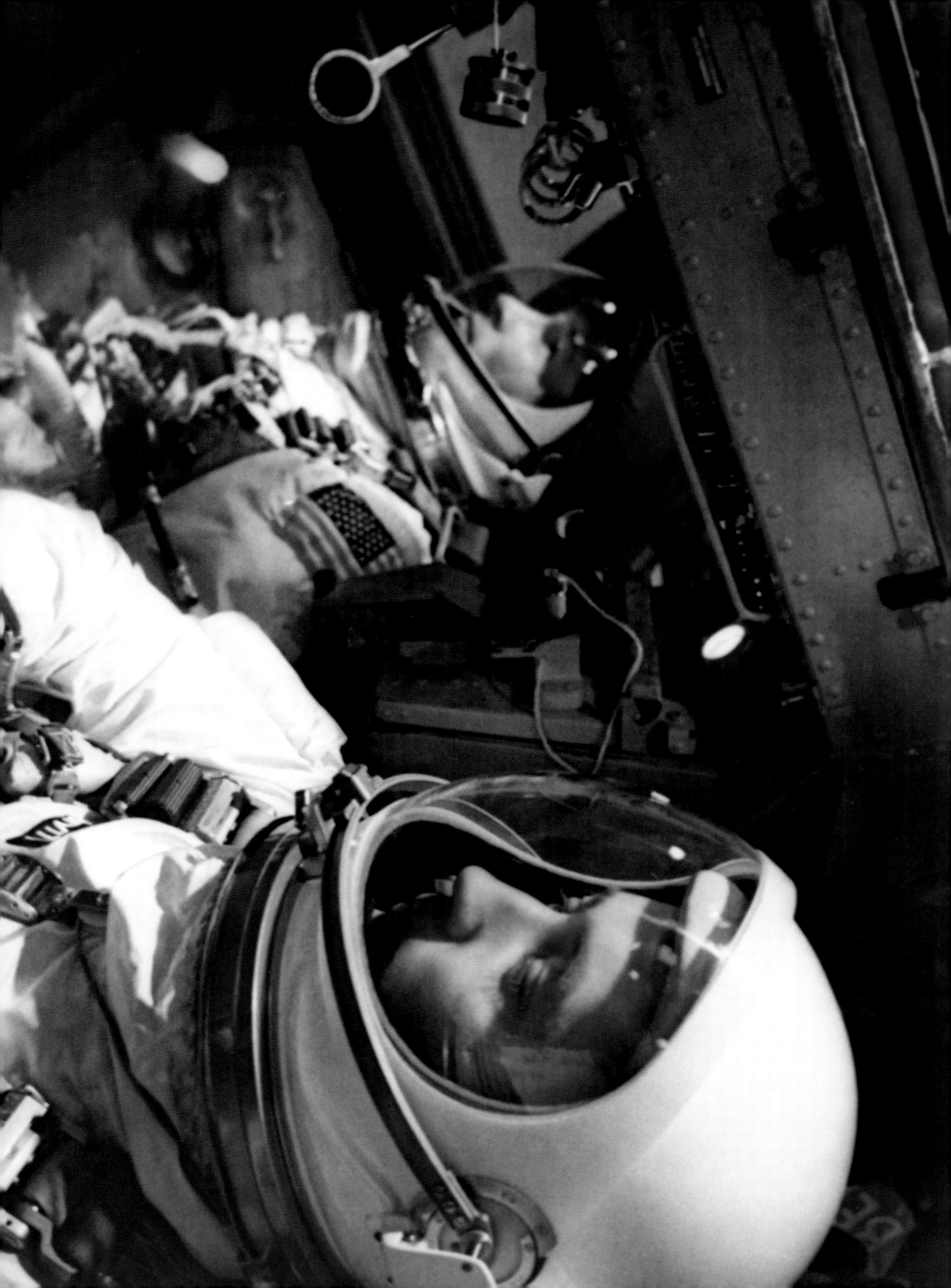

Below Flight controllers are monitoring the flight of Gemini V in August 1965 in the new Mission Control Center (MCC) at the Manned Space Center in Houston. Prior to Gemini IV, all manned missions were controlled from Cape Canaveral. The MCC, which is familiar from innumerable TV broadcasts and is now on the National Register of Historic Places, controlled manned missions until 1998. **Right** Flight Director Christopher Kraft monitors his console during Gemini IV. Kraft was a key figure in planning and running Mission Control, and was on duty for many of the significant moments in the Mercury and Gemini missions. **Below right** The families of McDivitt and White visited the MCC during the Gemini IV mission and talked with the astronauts as they passed over the United States.

Far right Gemini IV is best known for Edward White's spacewalk. On June 3, the astronaut became the first American to leave his spacecraft on extravehicular activity (EVA). White wore an oxygen-supply chest pack and a hand-held self-maneuvering unit and was secured to the spacecraft by a twenty-five-foot tether. After fifteen minutes and forty seconds, Kraft told McDivitt to get White back inside the capsule. White dallied, but finally obeyed, muttering, "It's the saddest moment of my life."

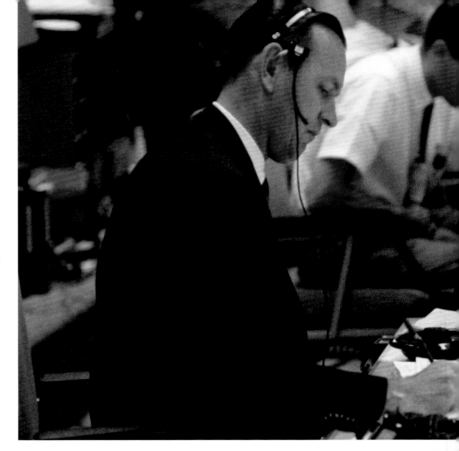

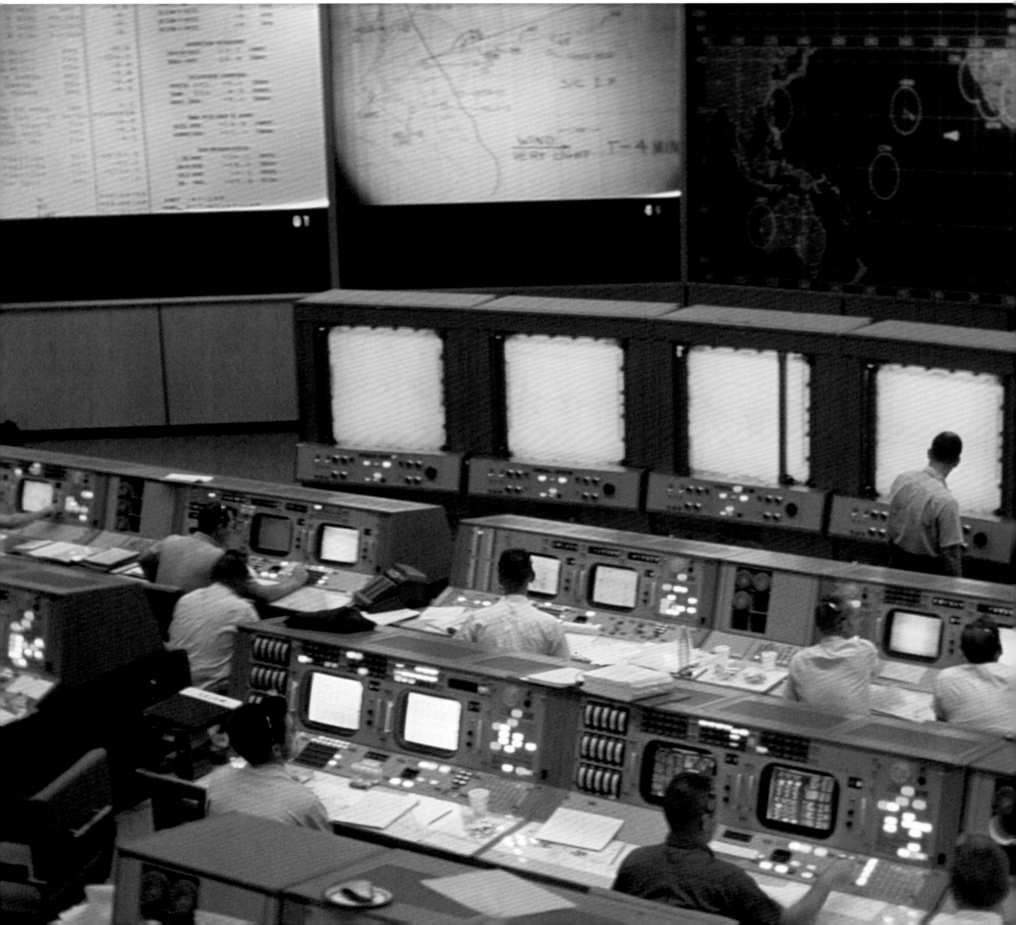

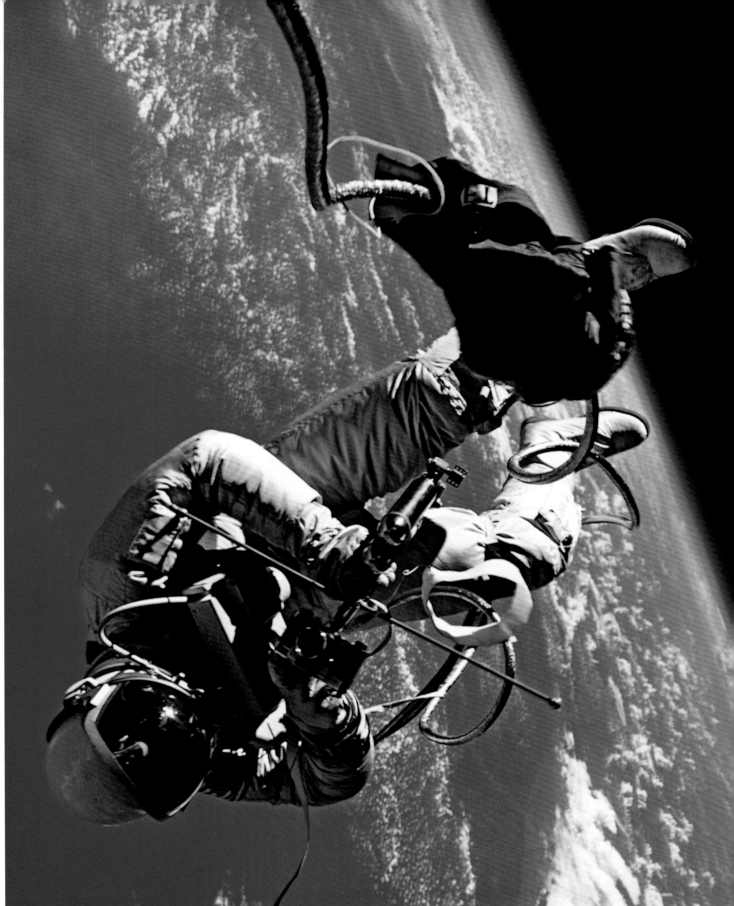

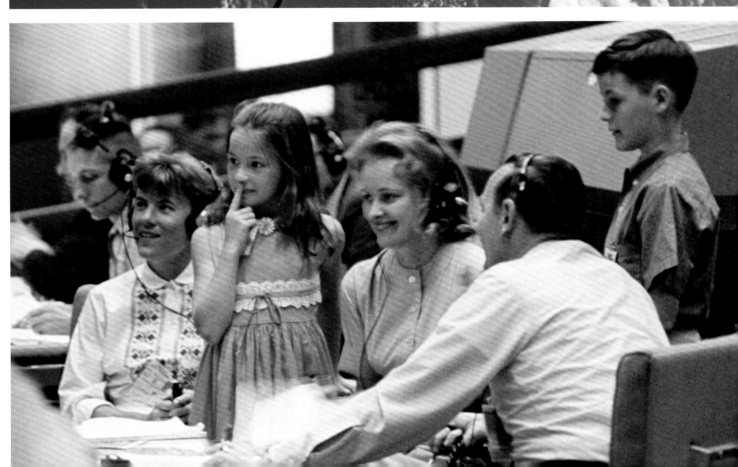

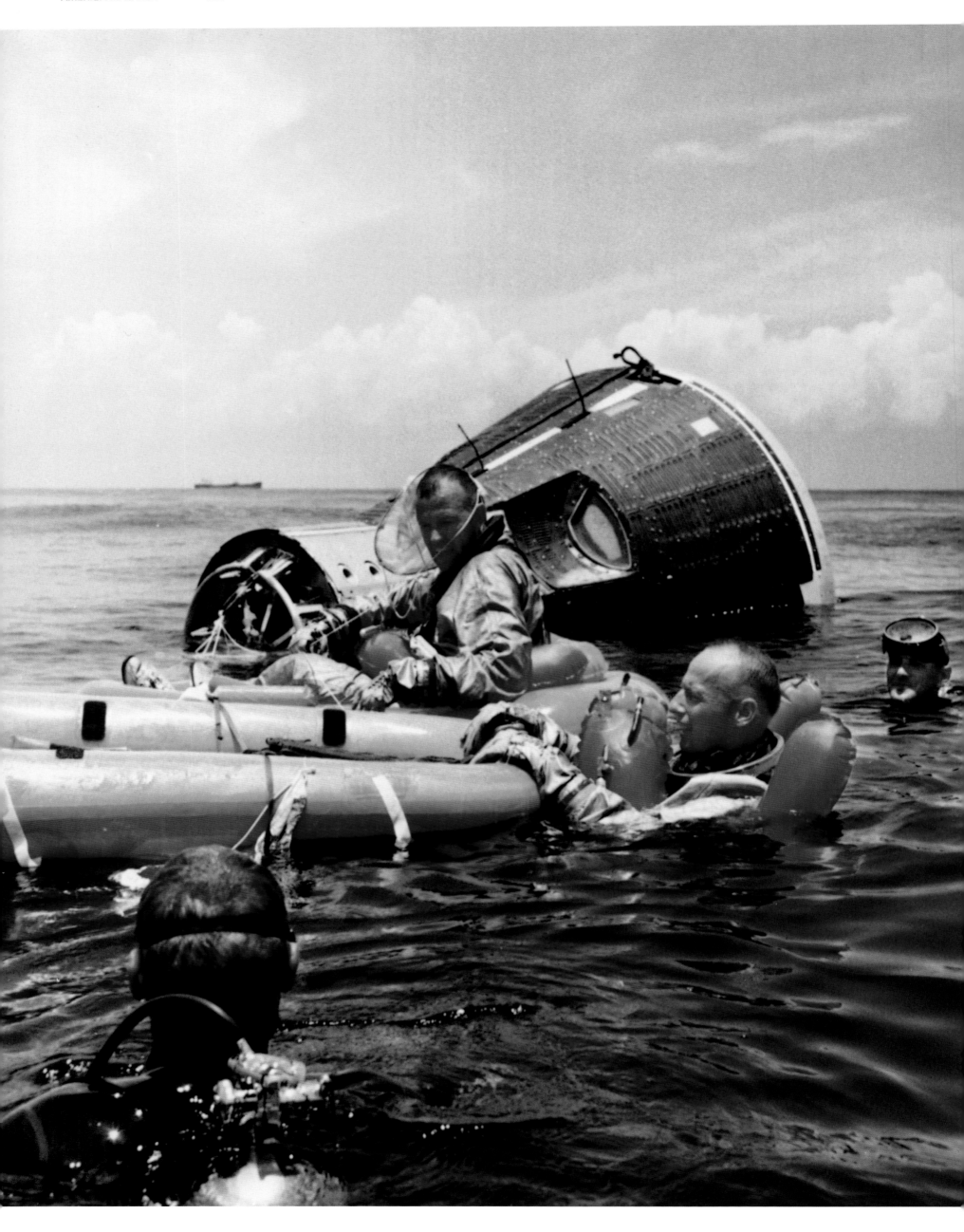

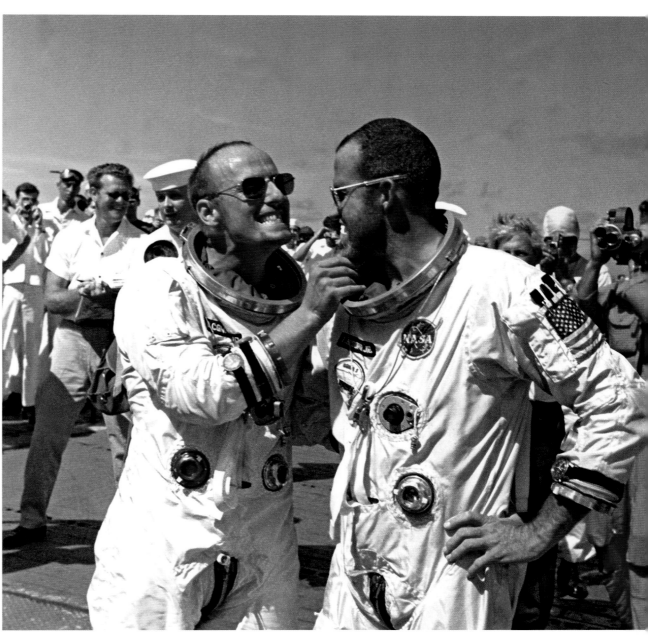

Left Command Pilot Gordon Cooper (in the raft) and Pilot Pete Conrad (in the water) work with Navy frogmen during recovery training for Gemini V. The mission lasted nearly eight days, roughly the amount of time it would take a spacecraft to reach the Moon, and was the first to use fuel cells instead of shorter-lasting batteries to generate electricity to power on-board systems, another necessity for a lunar voyage. Without enough to occupy the astronauts, the mission seemed endless: Conrad described it as "eight days in a garbage can."

Above right After the real recovery and safely aboard the USS *Lake Champlain* on August 29, 1965, Conrad tweaks Cooper's eight-day growth of beard. **Right** They celebrate their return from space by cutting a cake on board the aircraft carrier.

Overleaf NASA successfully completed the first space rendezvous mission with two Gemini spacecraft, Gemini VI-A and Gemini VII, on December 15, 1965, at an altitude of approximately 160 miles above the Earth. The main purpose of Gemini VI-A, crewed by Command Pilot Wally Schirra and Pilot Thomas Stafford, was the rendezvous with Gemini VII. Gemini VII, on the other hand, was planned to study the effects of long-duration space flight, and Command Pilot Frank Borman and Pilot Jim Lovell remained in space for fourteen days. **Left** The Gemini VII spacecraft photographed through the hatch window of the Gemini VI-A spacecraft. **Right** The Gemini VI-A spacecraft photographed through the hatch window of the Gemini VII spacecraft.

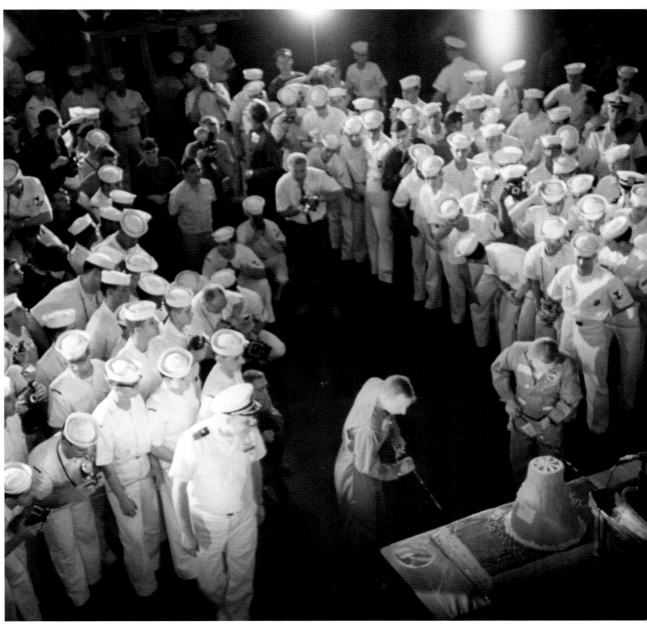

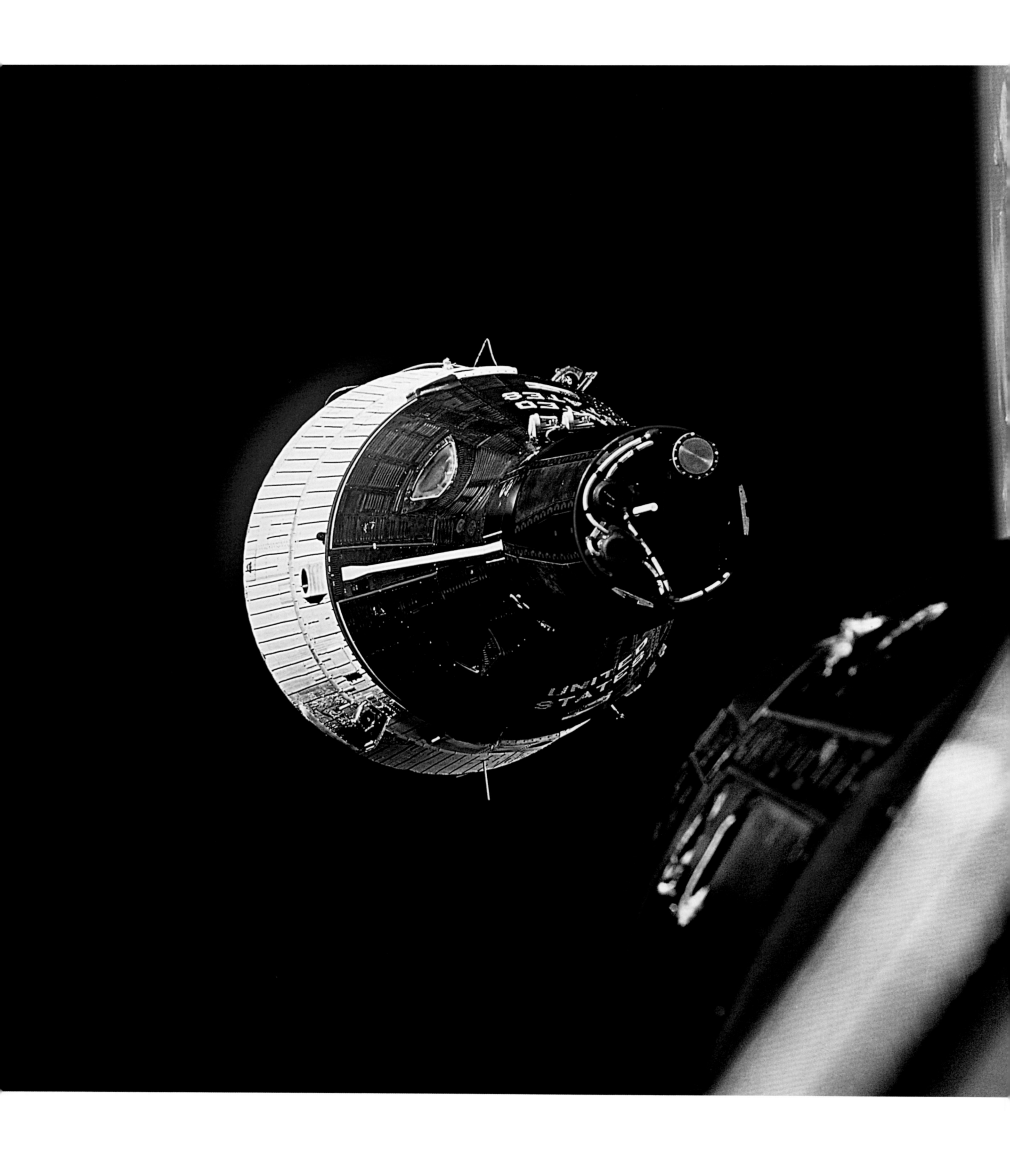

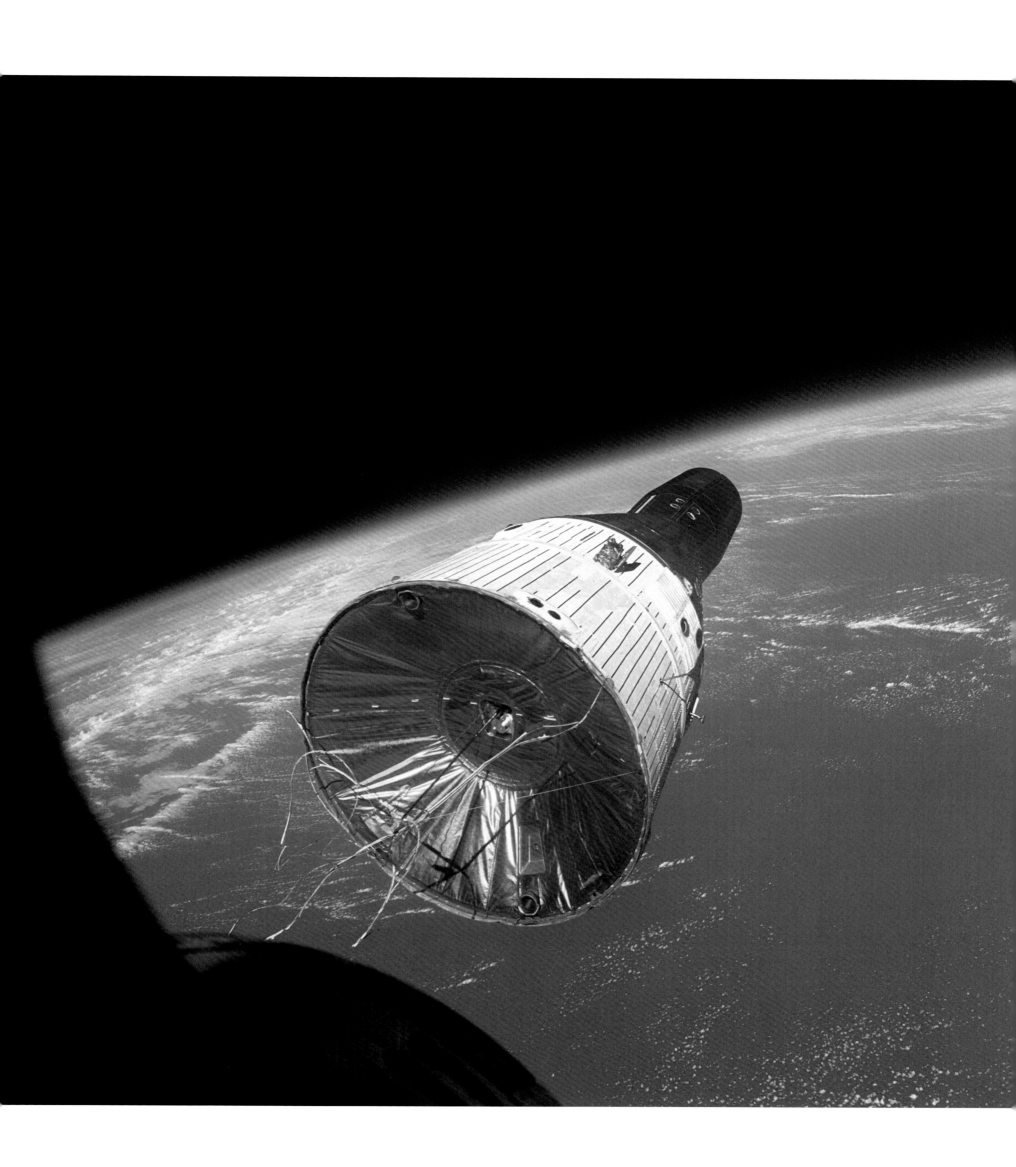

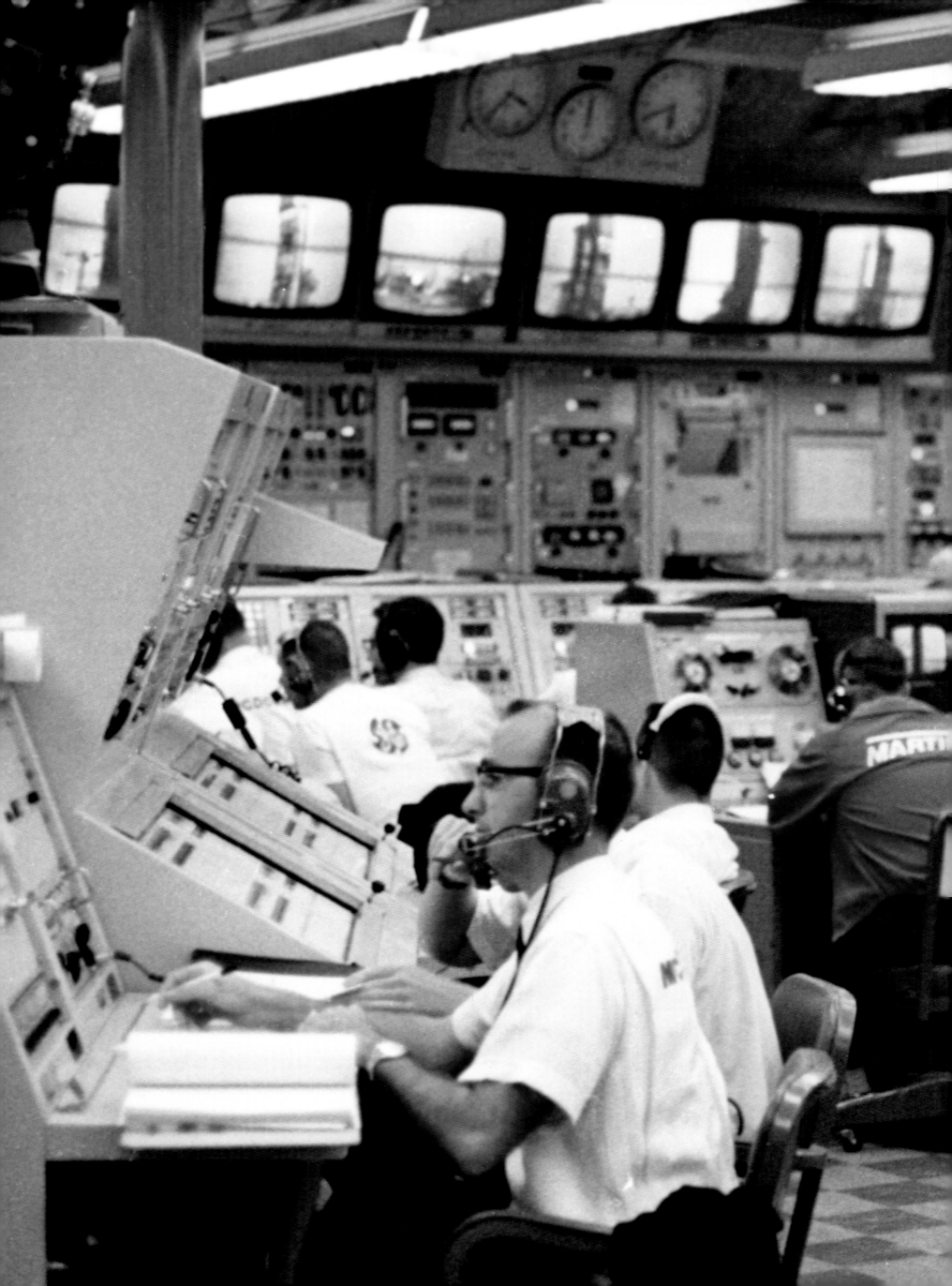

Left In the blockhouse in Launch Complex 19, technicians are preparing to launch Gemini VIII, which carried Command Pilot Neil Armstrong and Pilot David Scott into space on March 16, 1966. Gemini VIII successfully docked with a Gemini Agena target vehicle, another first, but when an electrical short in the control system caused increasingly dangerous yaw and roll rates, the mission was suddenly in crisis. The crew stabilized the capsule, which was rotating at a rate of one revolution per second, and returned it safely to Earth ten hours after launch.

Overleaf After their splashdown to Earth and recovery from the nausea produced by their harrowing escape, Neil Armstrong (center) and David Scott arrive at Hickam Field, Hawaii, on their way from Naha, Okinawa, to Cape Kennedy, Florida. Wally Schirra is walking next to Armstrong.

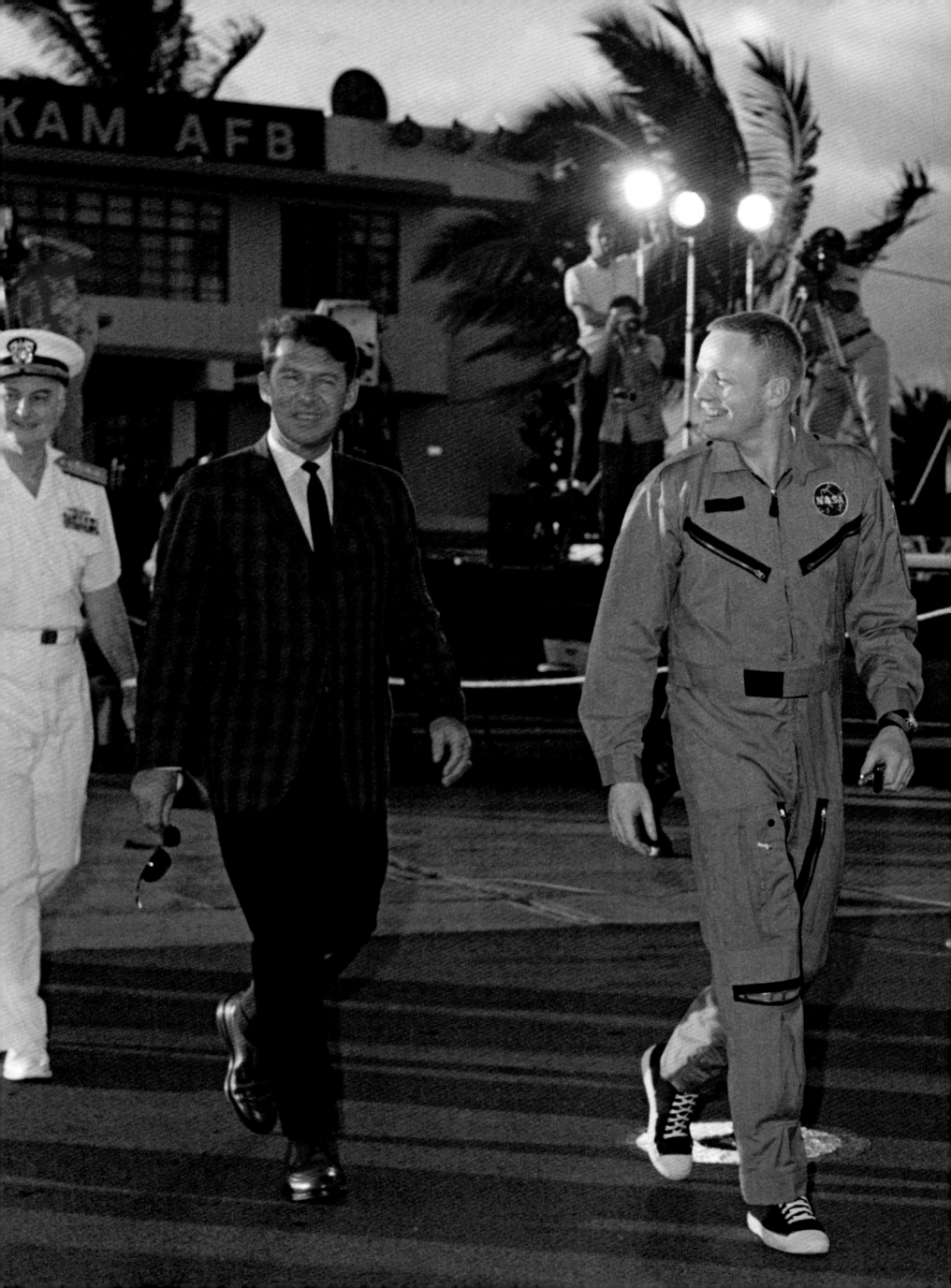

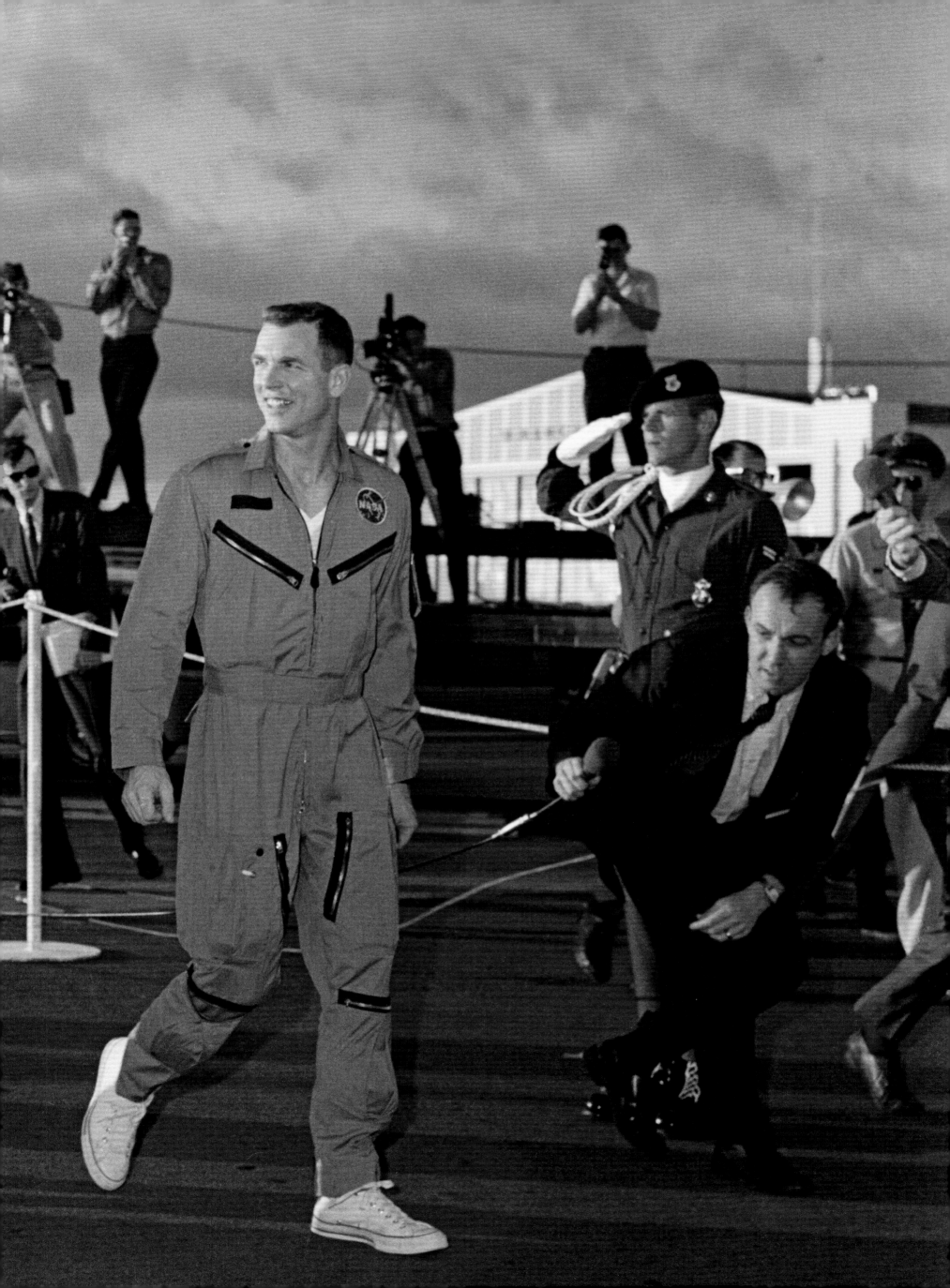

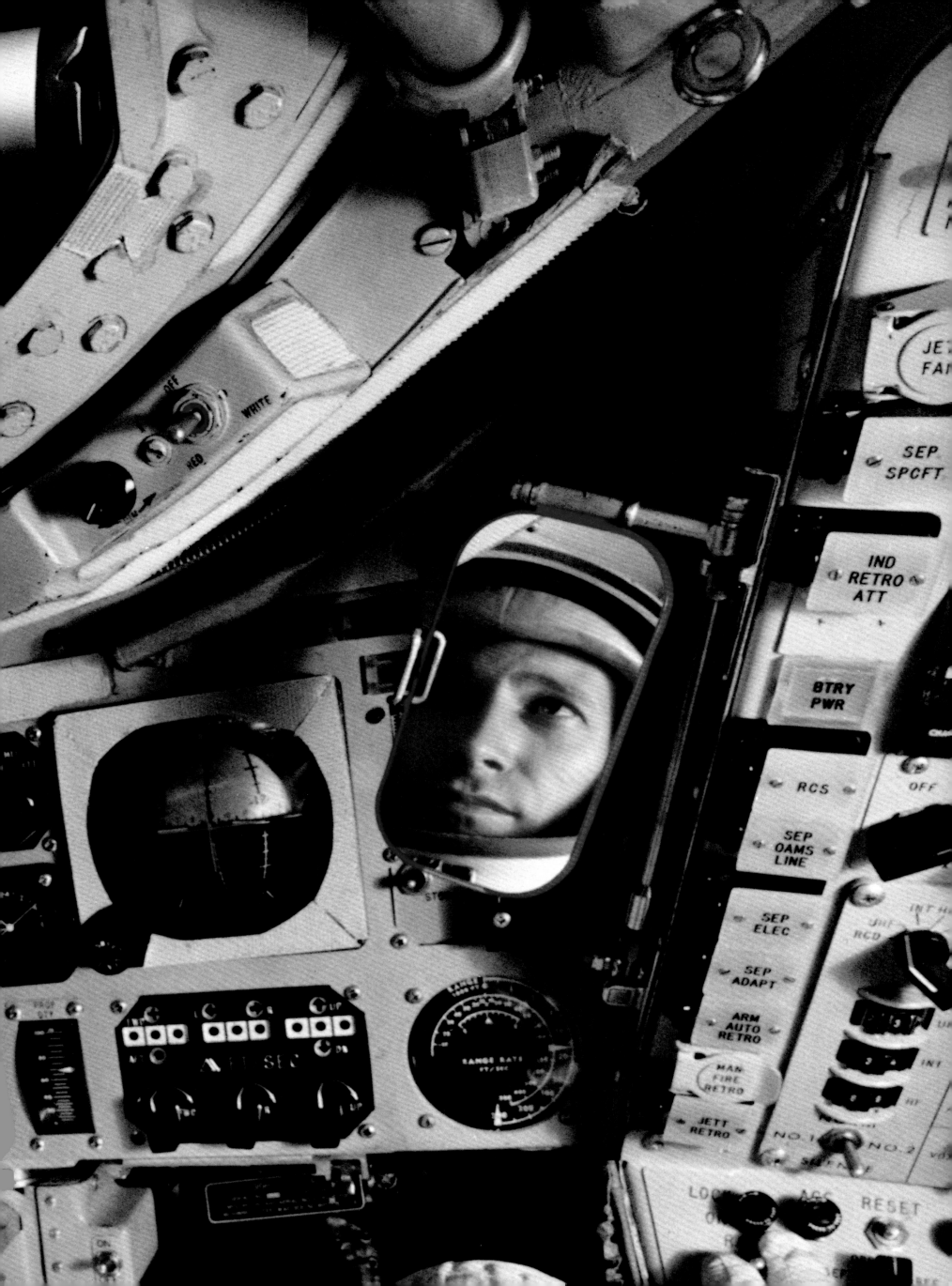

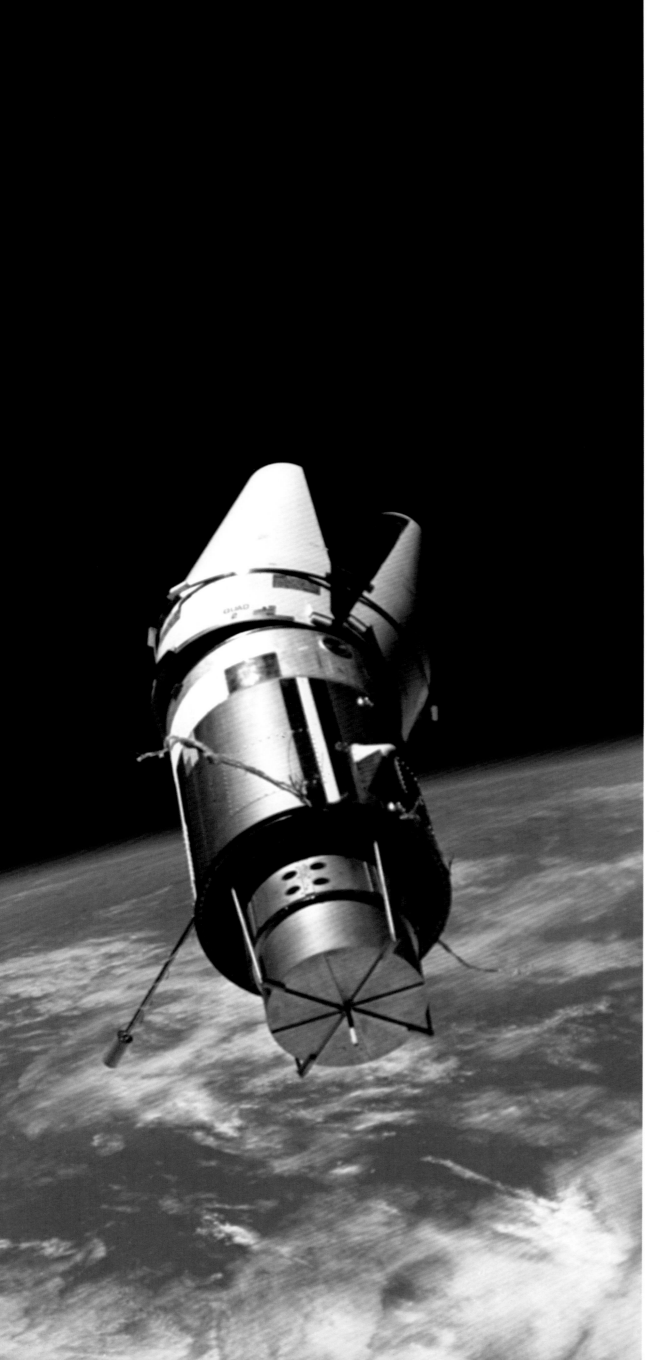

Previous spread A technical engineer practices rendezvous and docking with an Agena target vehicle in the McDonnell simulator for Gemini IX. The original Gemini IX crew of Elliott See and Charles Bassett were tragically killed en route to practice on the simulator when their jet trainer accidentally hit the corner of the building where their Gemini IX capsule was under construction at Lambert Field in St. Louis on February 28, 1966. Gemini IX-A launched on June 3, 1966, and the back-up crew of Command Pilot Thomas Stafford and Pilot Eugene Cernan encountered obstacles not of their own making on both of their main assignments.

Left When the Agena target vehicle failed to launch, NASA managed to get an augmented target docking adapter into space instead. However, its protective covering got stuck in place, dooming the docking portion of the exercise anyway. The crew named the malfunctioning target the "angry alligator," for obvious reasons.

Opposite Cernan (seen here in a photo taken by Stafford during the mission) was scheduled for an EVA with an overly ambitious menu of activities that turned into a two-hour ordeal after his suit overheated and his visor fogged.

Overleaf After splashdown on June 6, the weary Stafford and Cernan, accompanied by alert Navy frogmen, wait to be transported to the recovery ship USS *Wasp*, visible in the distance.

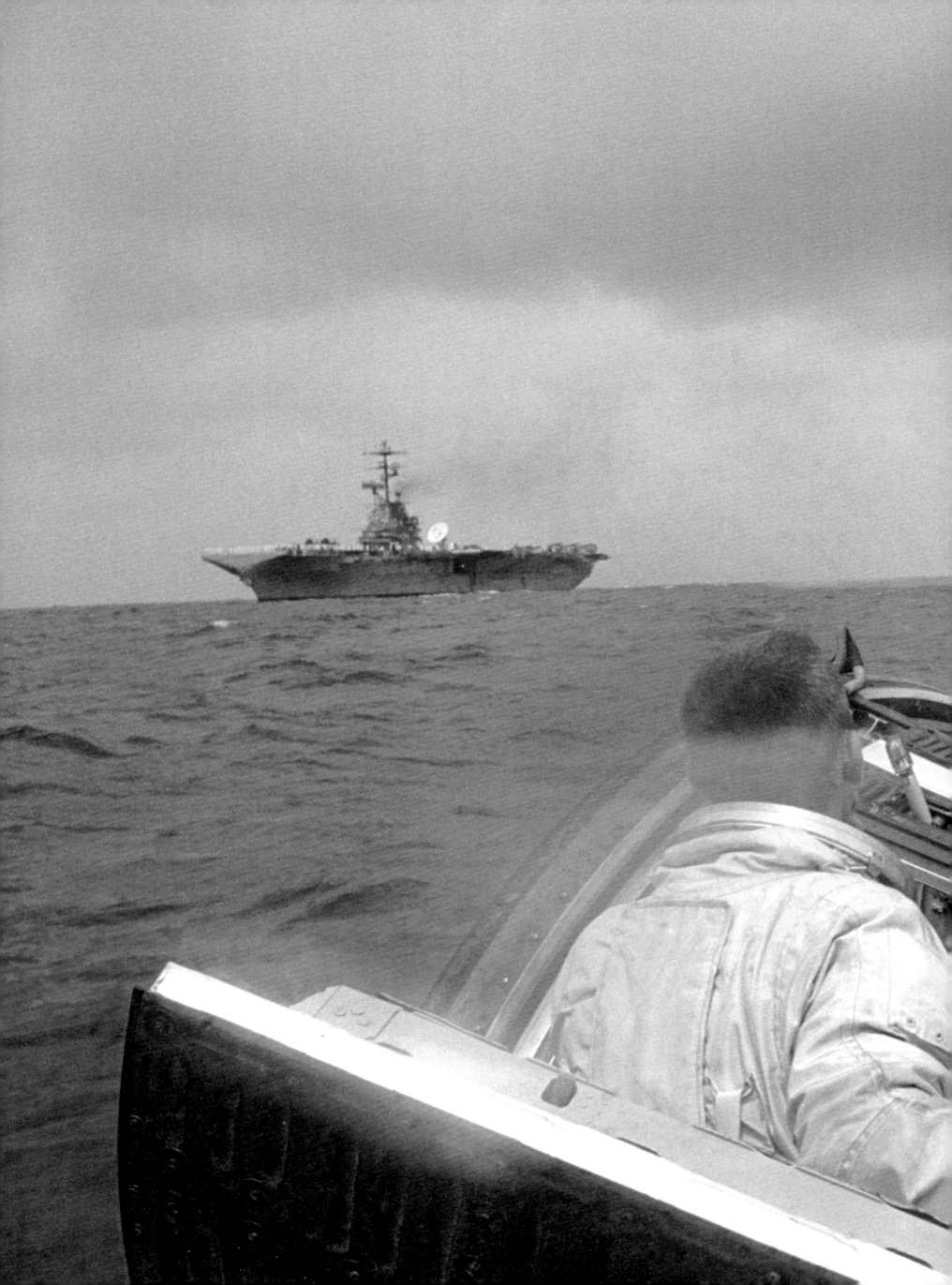

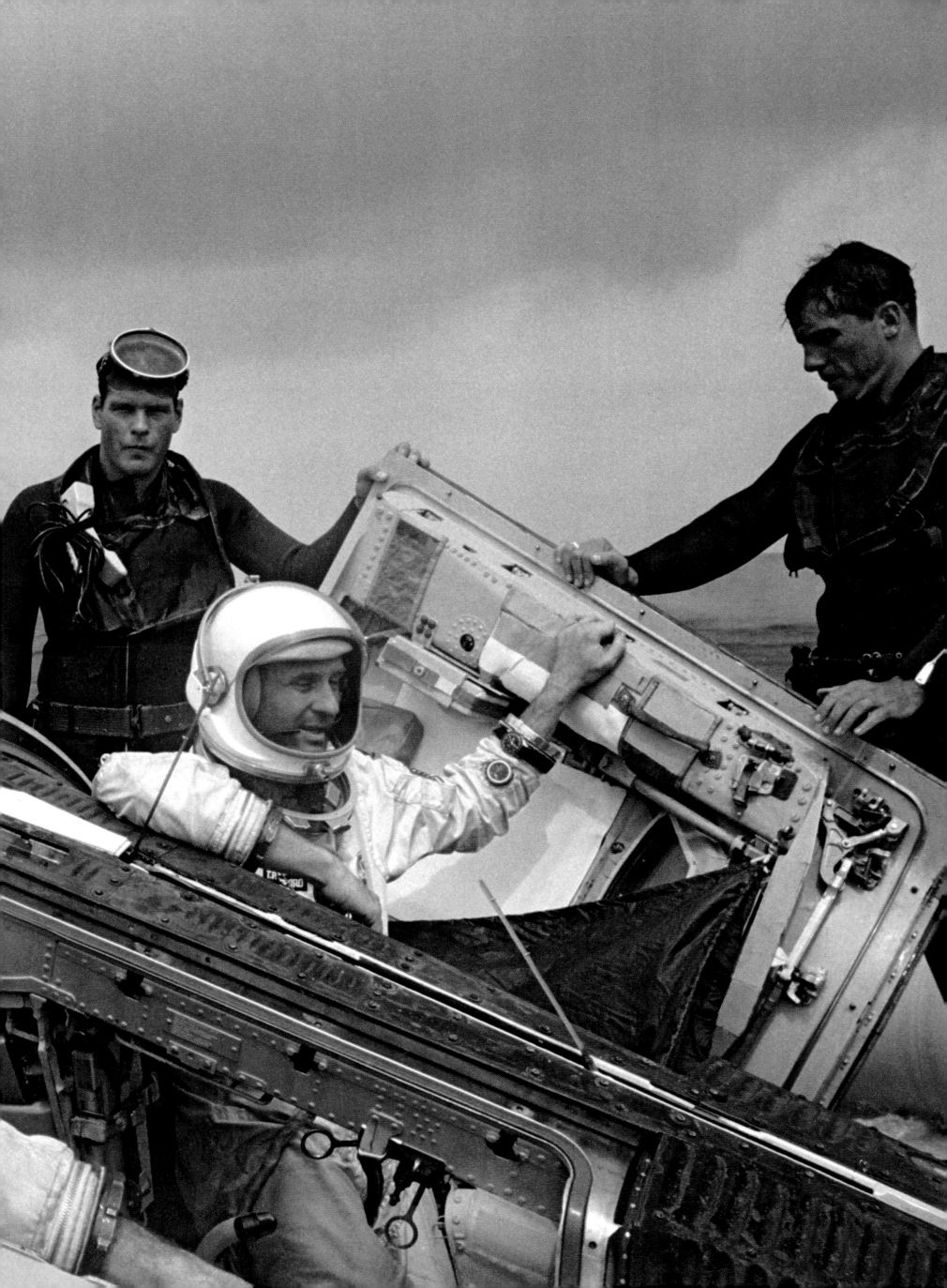

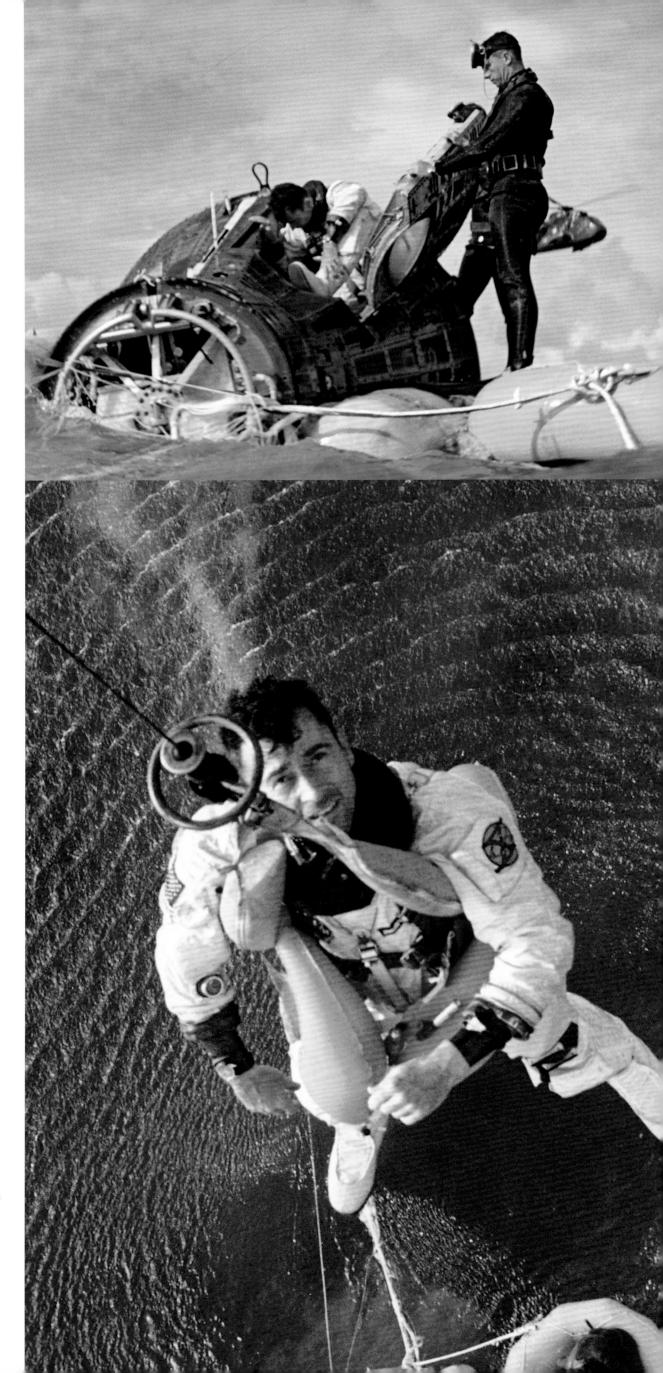

Right top and bottom On July 21, 1966, after almost three days in space, Gemini X Command Pilot John Young climbs out of the spacecraft and is hoisted into a helicopter that will deliver the crew to the recovery ship USS *Guadalcanal*. Note the green marker dye used as a locating aid for the recovery team. Gemini X successfully executed the docking tasks that had been plagued by mishaps on Gemini VIII and IX, although Pilot Michael Collins's two EVAs were still more difficult than NASA had anticipated.

Opposite Young (left) and Collins are photographed on the deck of the carrier.

Overleaf The later Gemini missions were planned as rehearsals for specific challenges facing the Apollo planners, beginning with the rendezvous and docking of two spacecraft. Gemini XI was taxed with this task almost immediately upon entering orbit. **Left** Command Pilot Pete Conrad (foreground), and Pilot Richard Gordon wait in the white room while engineers attempt to repair the autopilot on the Atlas launch vehicle that will launch their Agena target vehicle, September 10, 1966. **Right** The Agena target launch vehicle finally lifts off two days later. It would be followed about an hour and a half later by Gemini XI. Within eighty-five minutes, the rendezvous and docking was achieved.

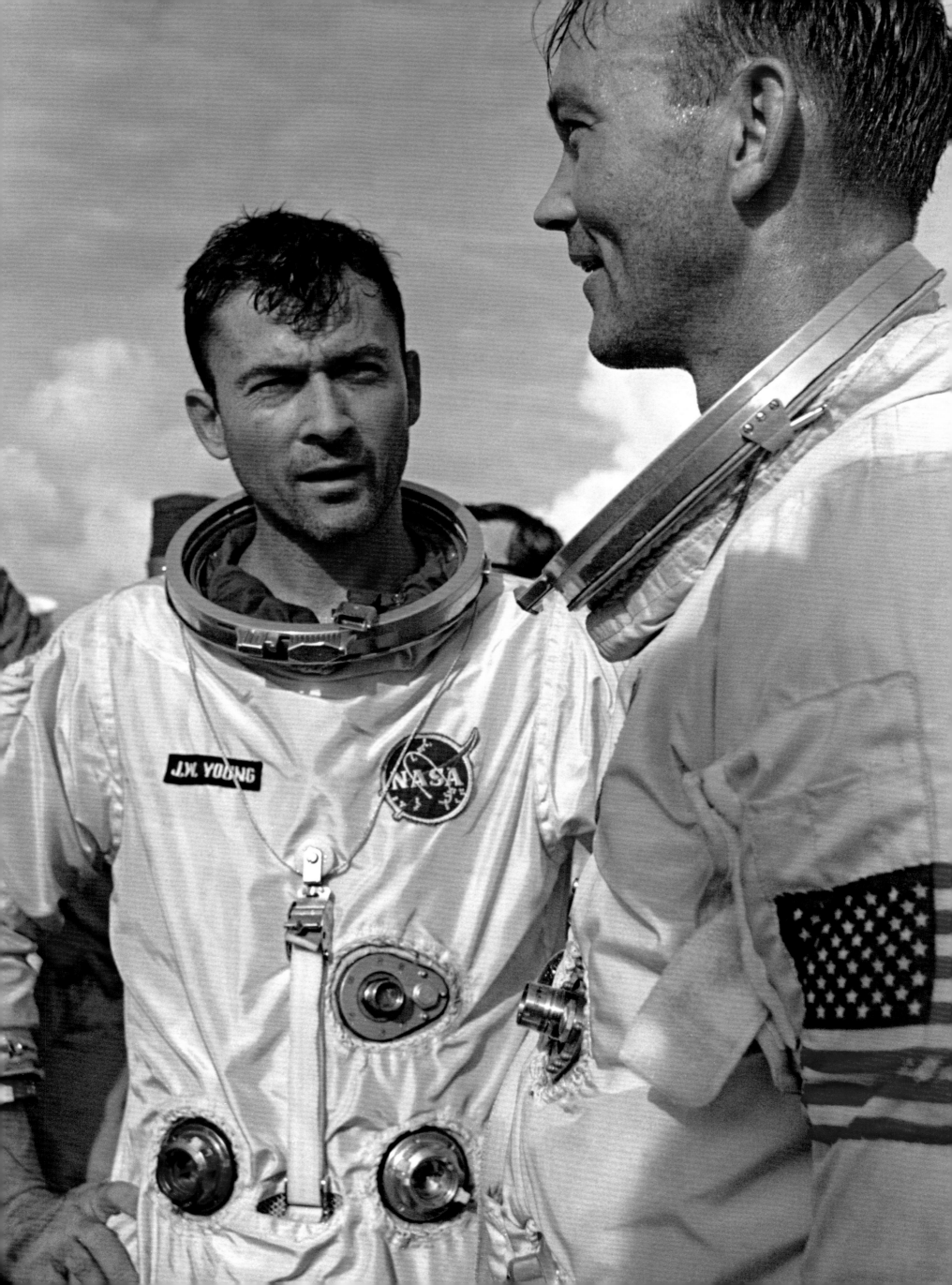

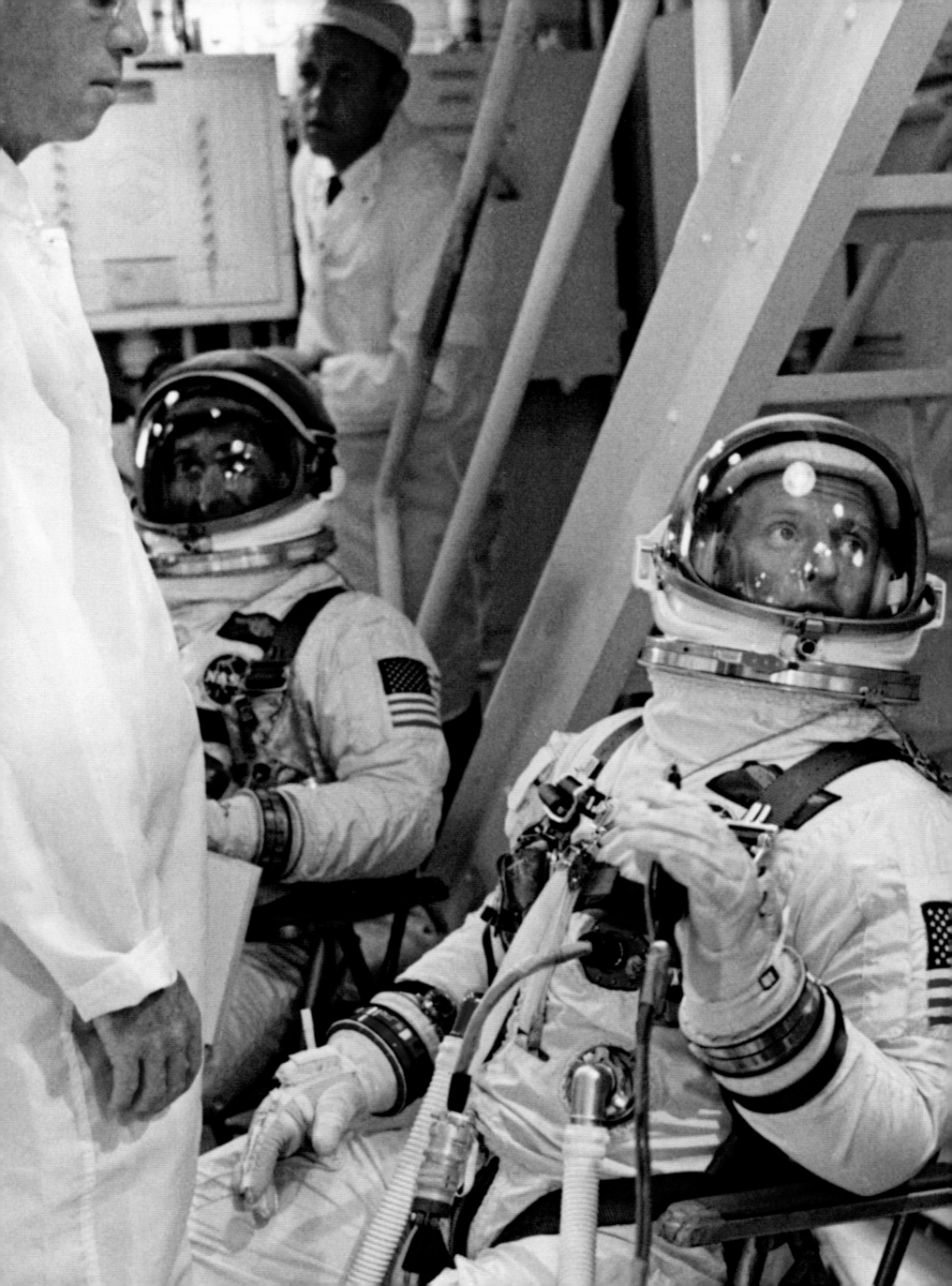

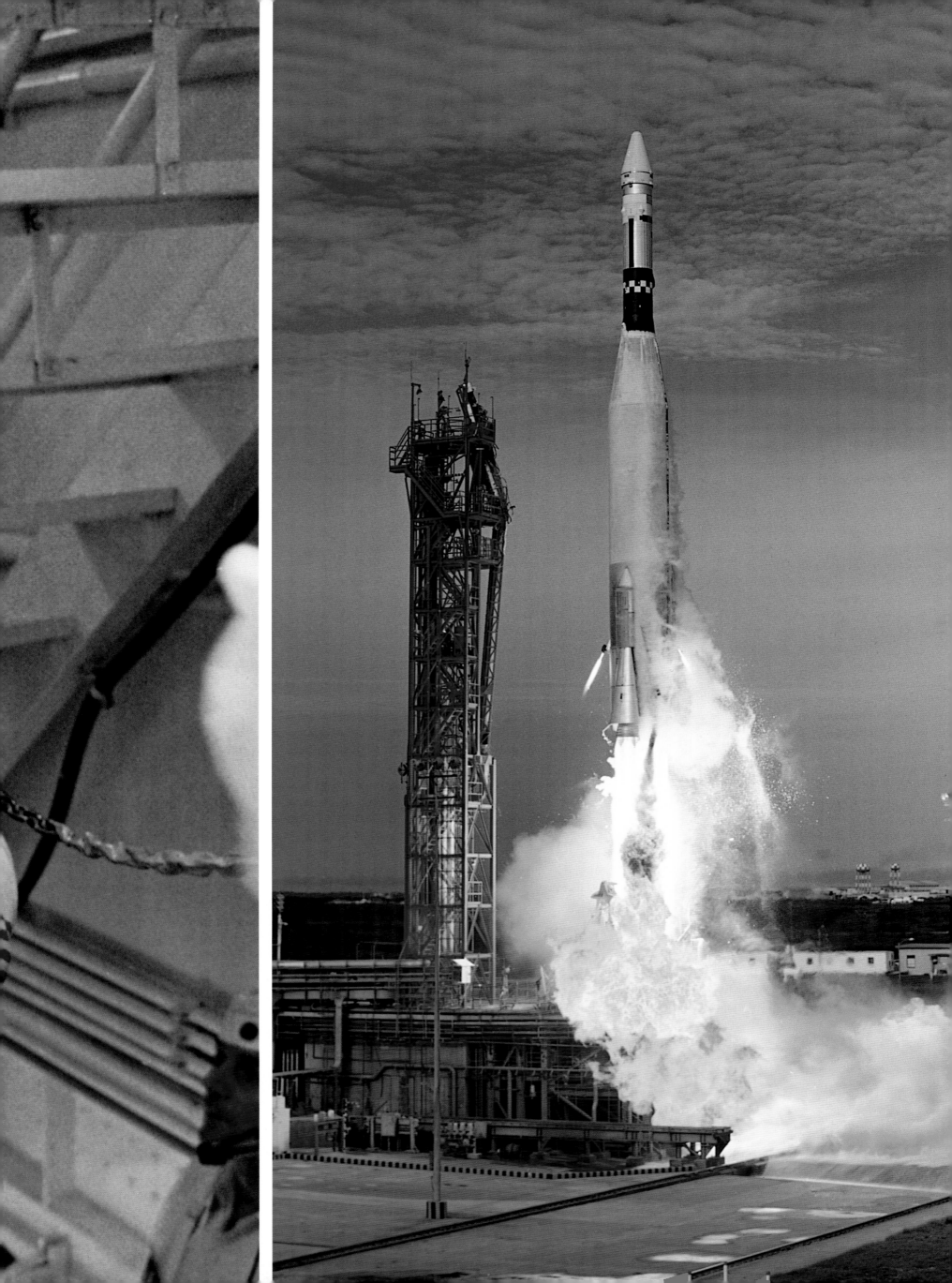

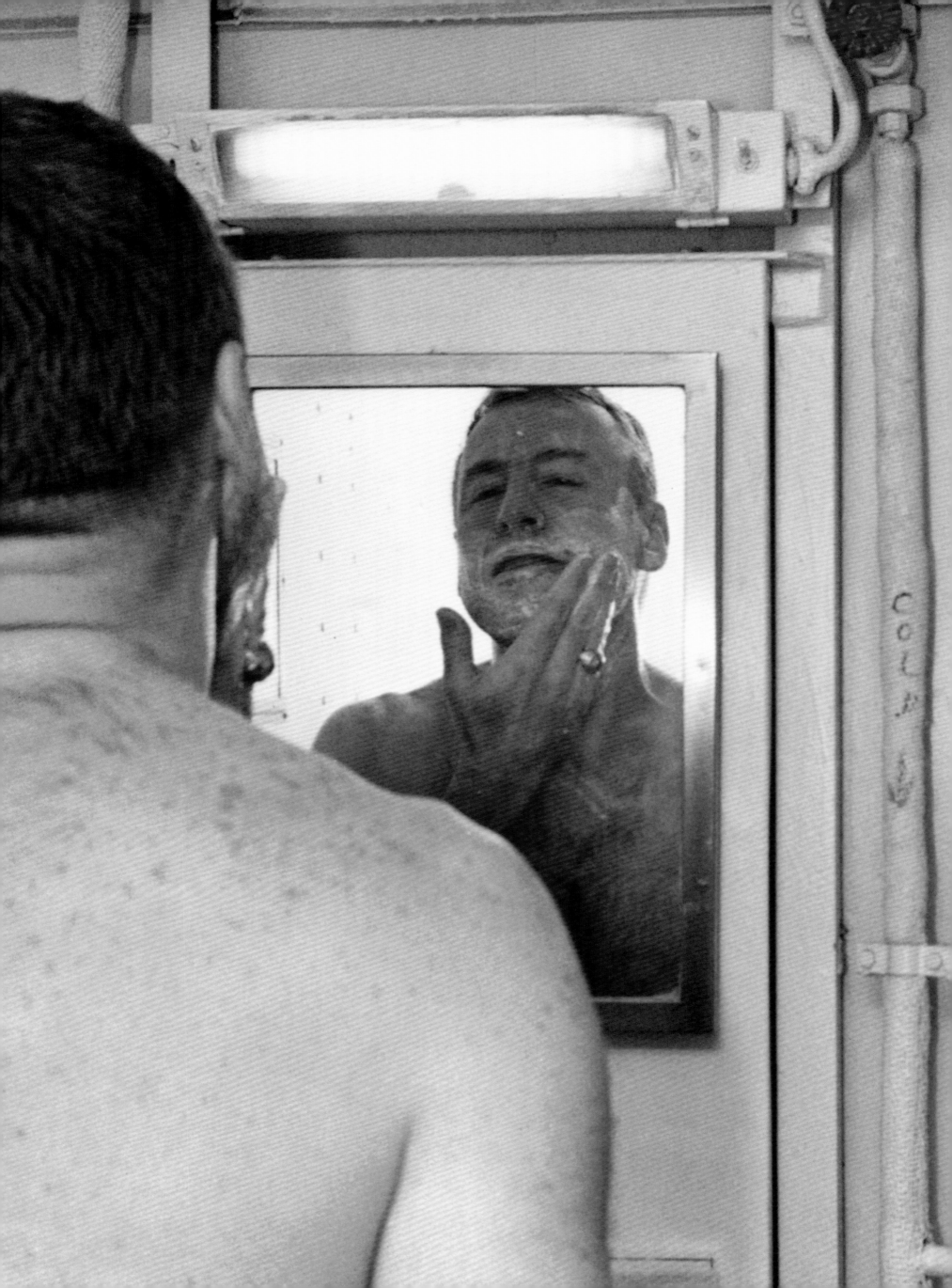

Left Many of the Mercury and Gemini astronauts became seasoned astronauts with an unquenchable desire to return to space. Their spirit is captured in this shot of astronaut James Lovell giving himself a shave on board ship, after casually hanging his spacesuit on a drainpipe next to the sink. Lovell flew on the Gemini VII and XII missions and later on Apollo 8 and 13. Of the thirty-three astronauts who went on the eleven Apollo missions, fourteen flew first aboard Mercury and/or Gemini missions.

Overleaf left Pilot Buzz Aldrin awaits the final minutes of the Gemini XII pre-launch countdown in the spacecraft on November 11, 1966. Lovell was the Command Pilot.

Overleaf right one of the main goals of Gemini XII was to improve the effectiveness and endurance of astronauts going on EVA. To that end, ergonomic improvements were made to the exterior of the capsule, and underwater training prior to the mission was inaugurated. Here, Aldrin performs one of his three EVAs during the four-day mission that set to rest concerns about the feasibility of spacewalks.

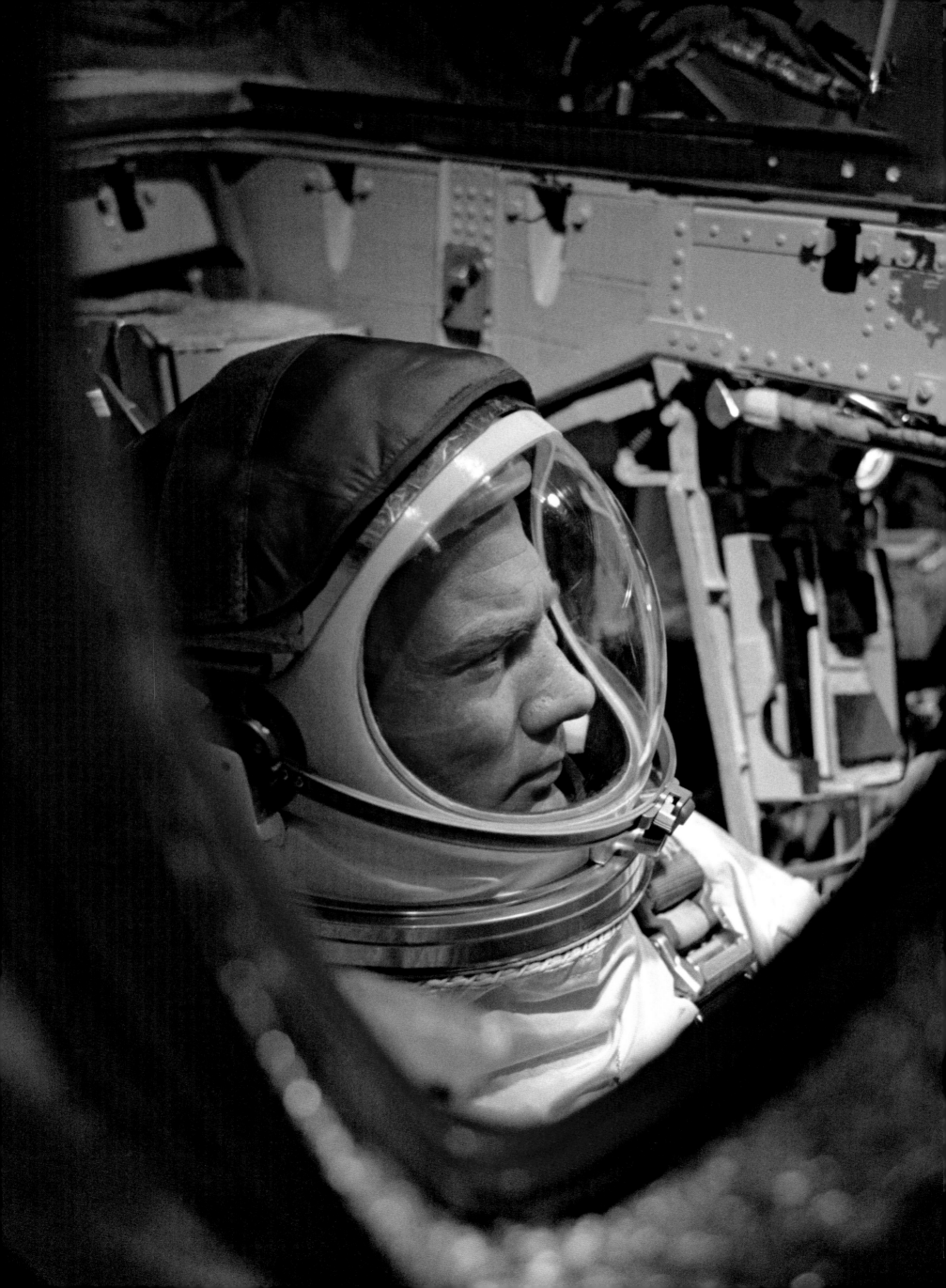

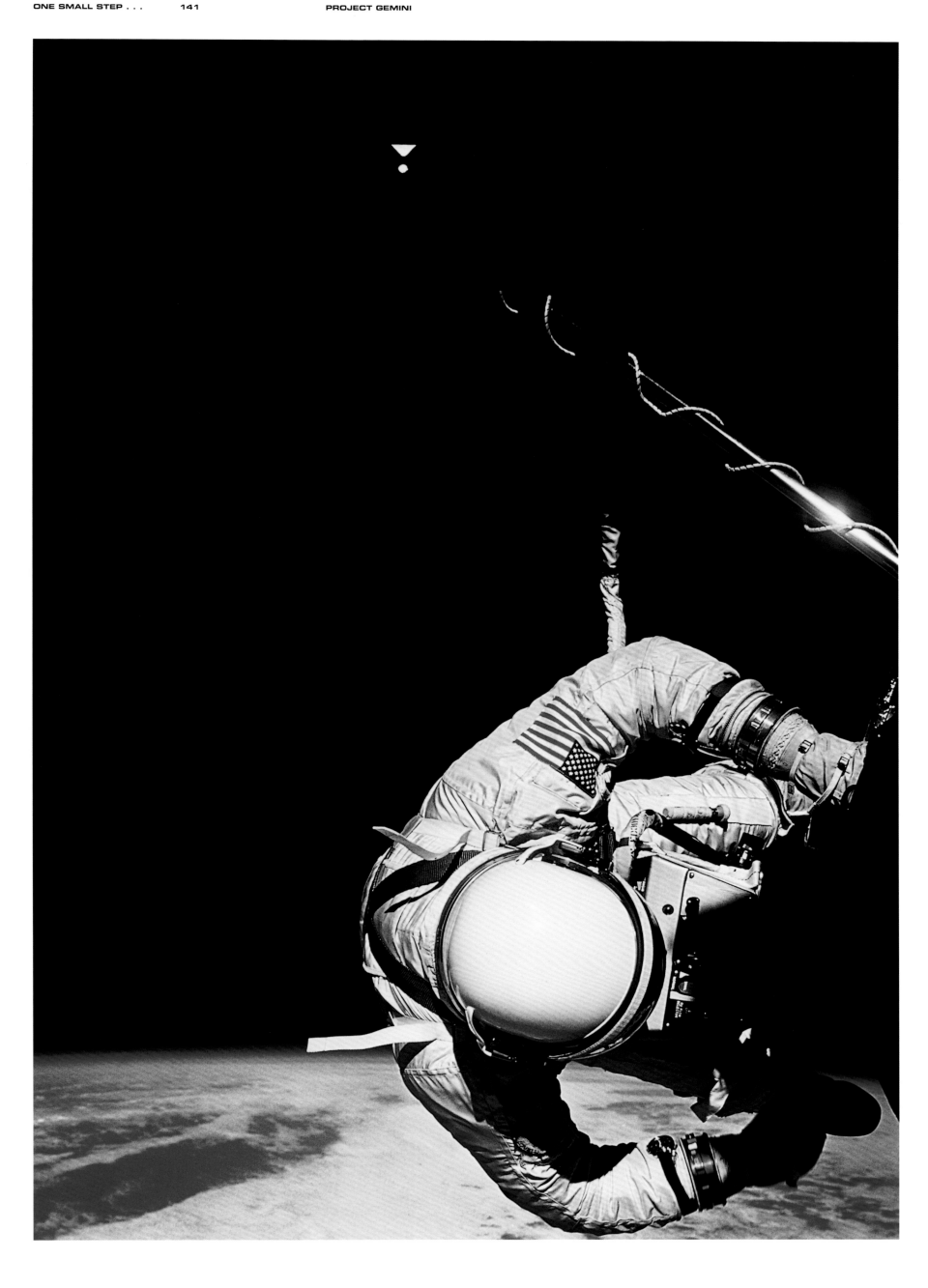

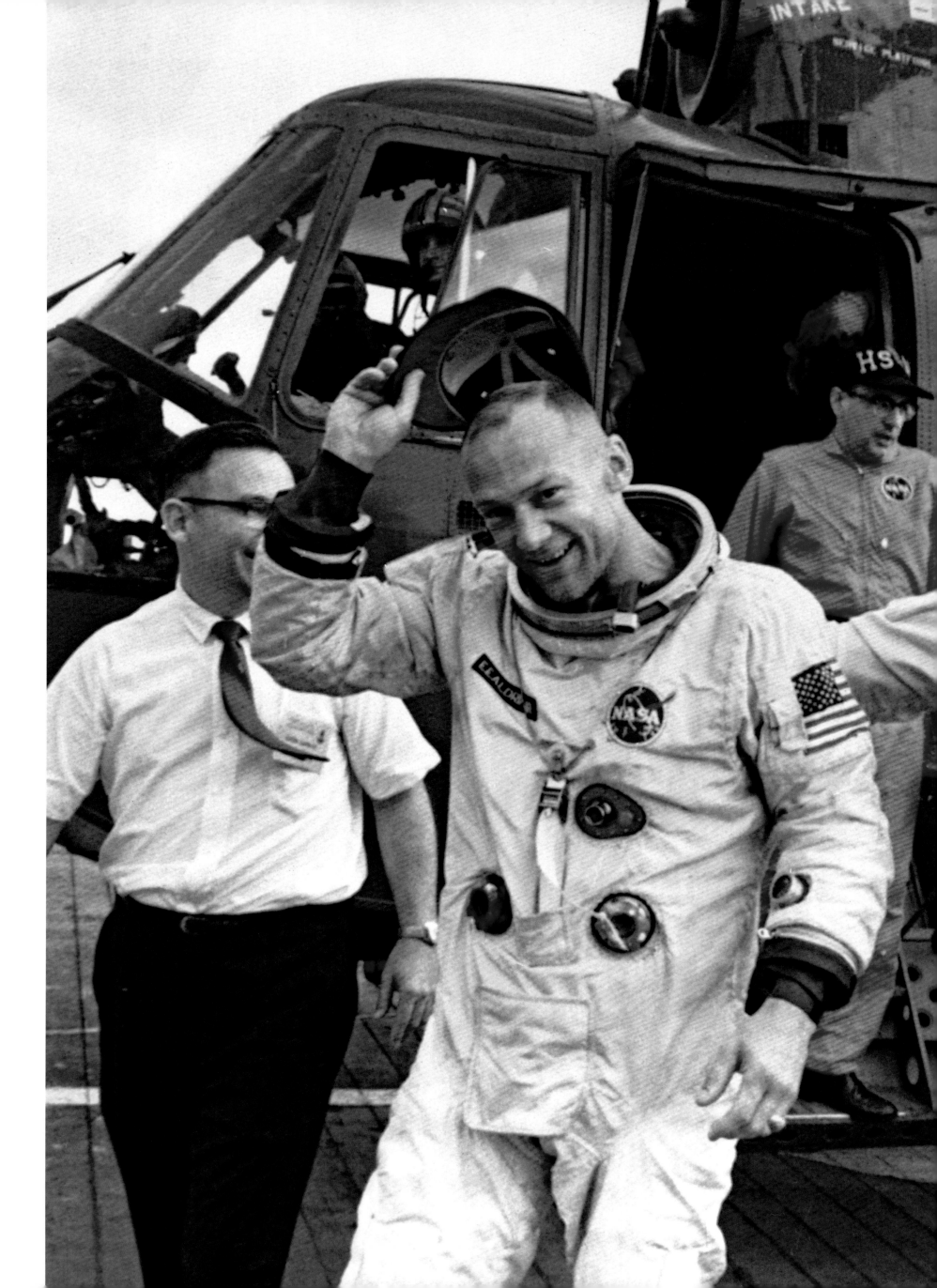

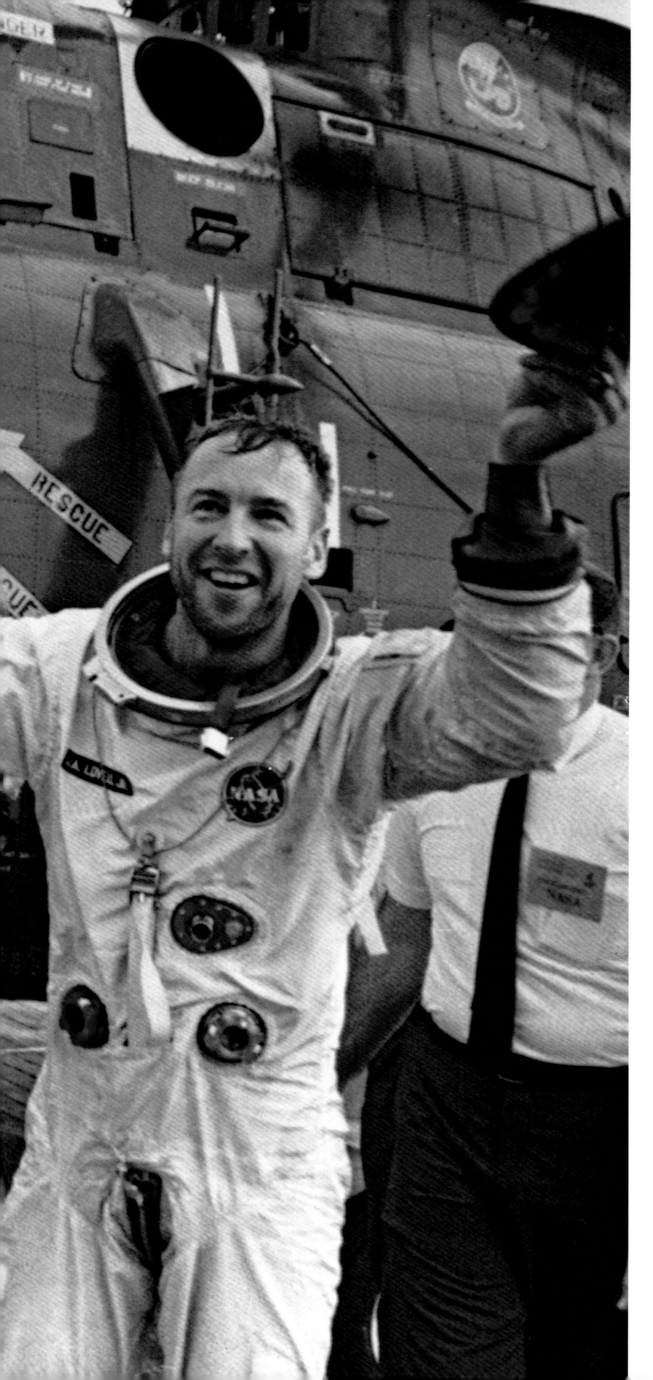

Stepping onto the deck of the USS *Wasp* on November 15, Aldrin (left) and Lovell tip their caps to a crowd of welcoming sailors. Gemini XII marked the end of the Gemini Program. In fact, on launch day, Lovell and Aldrin each wore a sign as he walked toward the spacecraft, one reading "The" and the other "End." However, in reality, the space program was just revving up: the Apollo era was about to begin.

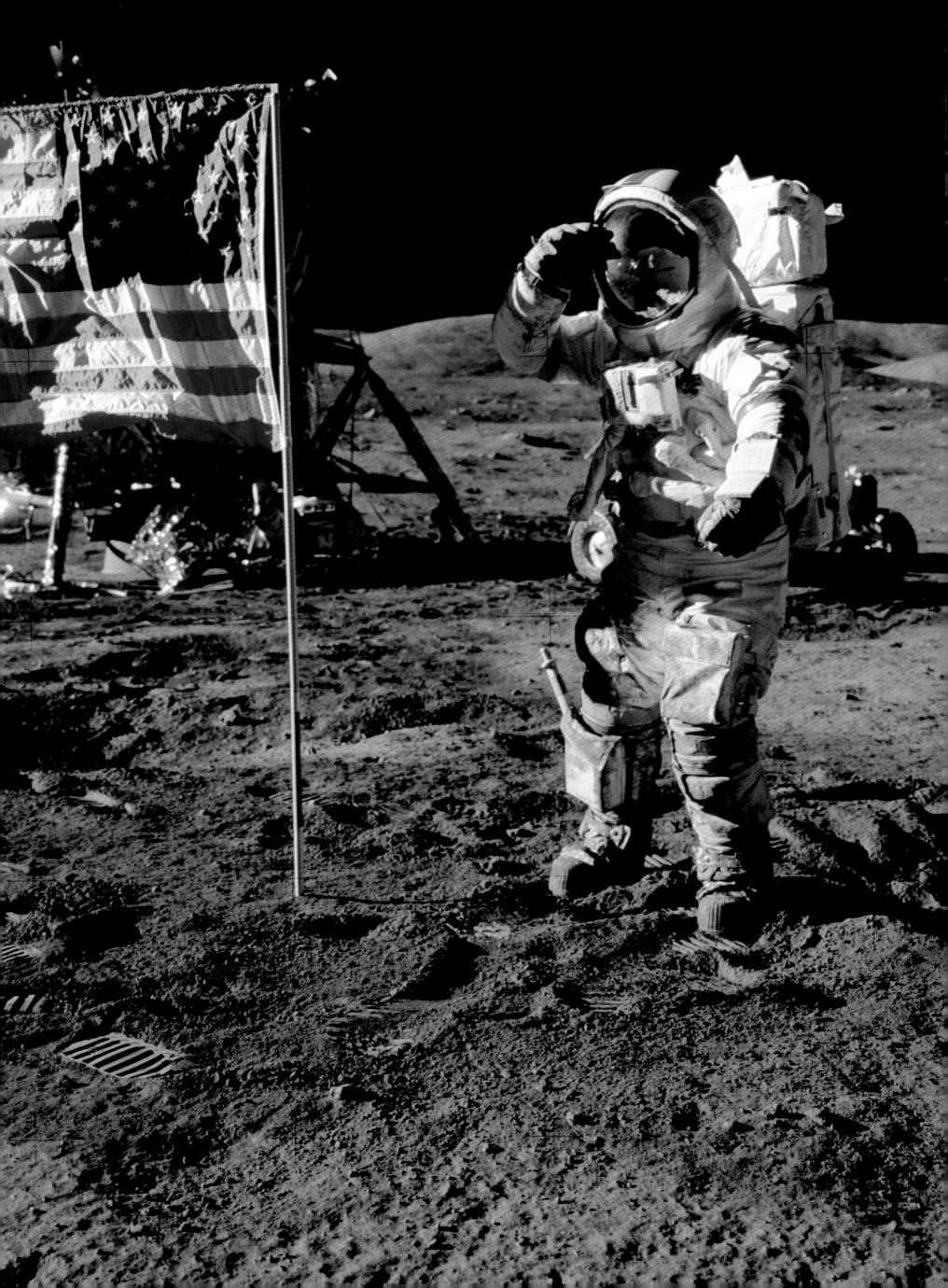

PROJECT APOLLO

The Apollo program (excluding the follow-up Apollo-Soyuz Test Project and Skylab programs) consisted of eleven manned flights that took place between 1968 and 1972. Two of the flights (Apollo 7 and 9) were Earth-orbit tests, two (Apollo 8 and 10) were circumlunar, and one (Apollo 13) was aborted midway to the Moon. Six flights (Apollo 11, 12, 14, 15, 16, and 17) succeeded in landing men on the Moon. None of this could have happened without the magnificent Saturn rockets, developed through the work of Wernher von Braun and a team of thousands. And all of it happened after the tragic fire of January 27, 1967, that killed Gus Grissom, Edward White, and Roger Chaffee as they sat in their Apollo 1 capsule on the launch pad undergoing tests.

The Apollo manned flights began in October 1968, when Wally Schirra (a veteran of Mercury and Gemini flights), Donn Eisele, and Walter Cunningham tested the command and service modules in Earth orbit over a period of almost eleven days during the Apollo 7 mission. After this one test flight, and with its eye still on the goal of a lunar landing by the end of the decade, NASA made the bold decision to send Apollo 8 to the Moon. Apollo 8 orbited the Moon ten times, and made a now-legendary transmission on Christmas Eve, citing passages from Genesis. The six-day mission proved the spacecraft could traverse the Earth-Moon distance safely, enter lunar orbit, and return to Earth. But it did not yet prove that a lunar landing was possible.

An actual lunar landing required two more flights in preparation. In early March 1969, Apollo 9 tested the entire Apollo spacecraft in Earth orbit, including the rendezvous maneuvers between the command module and the lunar module that would descend to the lunar surface. Over ten days Apollo 9 proved this sequence could be done. Only two months later Apollo 10 performed a full-dress rehearsal for the lunar landing. During two-and-a-half days in lunar orbit, the lunar module descended within 50,000 feet of the lunar surface, re-docked with the command module, and returned safely to Earth, setting the stage for the first manned lunar landing in history.

Apollo 11 was commanded by Neil Armstrong, with Michael Collins as the command module pilot and Buzz Aldrin as the lunar module pilot. Launch took place on July 16, 1969, with landing on July 20 on the Sea of Tranquillity. Six hours later, Armstrong took his famous "one giant leap for mankind." Aldrin joined him, and the two spent two-and-a-half hours drilling core samples, taking photographs, and collecting rocks. After more than twenty-one hours on the lunar surface, they returned to the *Columbia* command module, bringing 47.7 pounds of lunar samples with them. The two Moon-walkers had left behind scientific instruments, an American flag, and other mementos, including a plaque bearing the inscription: "Here Men From Planet Earth First Set Foot Upon The Moon. July 1969 A.D. We Came In Peace For All Mankind." They returned to Earth on July 24, surely the conclusion of eight of the most historic days ever recorded.

Apollo 12 touched down on the lunar surface only four months later, on the Ocean of Storms near the unmanned *Surveyor 3* probe. Astronauts Pete Conrad and Alan Bean took two Moonwalks lasting just under four hours each. They collected rocks and set up experiments that measured the Moon's earthquakes, magnetic field, and the wind from the Sun. A few months later Apollo 13 was on its way to the Moon when an oxygen tank in the service module exploded. The crew (James Lovell, John Swigert, and Fred Haise) aborted their planned landing, swung around the Moon, and returned on a trajectory back to Earth, using the lunar module *Aquarius* as a lifeboat.

Following the near disastrous Apollo 13, Alan Shepard, Stuart Roosa, and Edgar Mitchell achieved the third lunar landing on February 5, 1971. After touching down in the Fra Mauro region, Shepard and Mitchell took two Moonwalks, adding new seismic studies to the Apollo experiment package, and used a "lunar rickshaw" pull-cart to carry their equipment. This was also the flight where Shepard made his famous long golf shot. On the way back to Earth, the crew conducted the first US materials-processing experiments in space. The Apollo 14 astronauts were the last lunar explorers to be quarantined on their return from the Moon.

The last three Apollo missions, from July 1971 to December 1972, were characterized by much longer excursions from the lunar lander, up to tens of miles, made possible by the lunar roving vehicle. The Apollo 15 astronauts explored the area known as Hadley Rille, while Apollo 16 explored the Descartes highlands. The last lunar expedition, Apollo 17, landed in an area known as Taurus-Littrow. Here astronaut Eugene Cernan and geologist Harrison Schmitt conducted the longest lunar exploration of the Apollo program. The crew roamed for twenty-one miles through the Taurus-Littrow valley in their rover, discovered orange-colored soil, and left behind a plaque attached to their lander *Challenger*, which read: "Here Man completed his first exploration of the Moon, December 1972 A.D. May the spirit of peace in which we came be reflected in the lives of all mankind." The Apollo lunar program had ended.

Opposite Commander Eugene Cernan of Apollo 17, the last lunar landing mission, salutes the flag on December 14, 1972. Each Apollo mission that landed on the Moon raised an American flag. The astronauts were following a tradition that went all the way back to Columbus, who came ashore in the New World in 1492, "proclaiming heralds and flying standards." What the Apollo astronauts did not do was claim the Moon for the United States, and in this they broke away from the customs of the great explorers of the past. By treaty and convention, the Moon belongs to humankind, as Neil Armstrong implicitly suggested in his famous first utterance upon it.

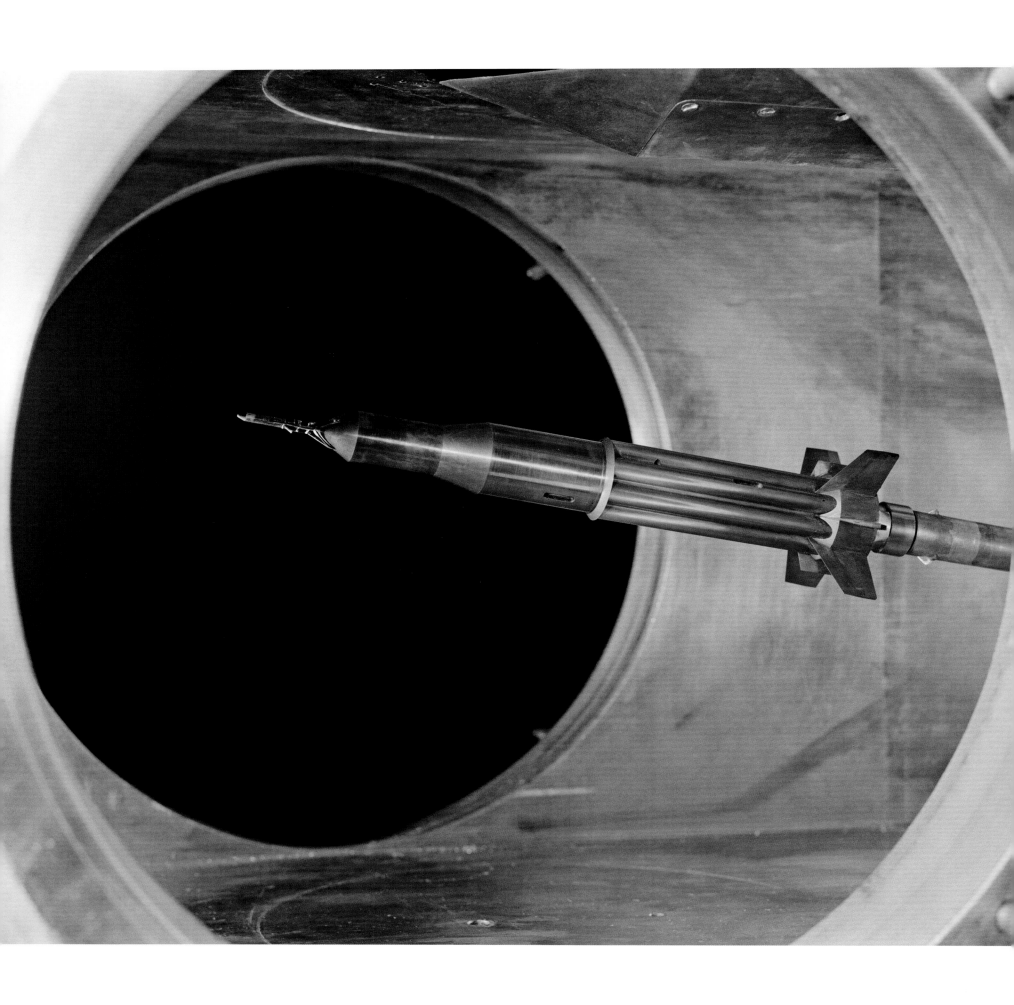

Opposite Several possible mission modes, featuring various rocket-spacecraft launch configurations and rendezvous options, were originally discussed by NASA officials looking to meet Kennedy's goal of having a man on the Moon by the end of the decade. After much debate, NASA settled on the "lunar orbit rendezvous" mode in 1962. Here, the basic aerodynamic integrity of the chosen Saturn-Apollo launch configuration is tested in a wind tunnel at Langley Research Center on March 19, 1962.

Below The initial challenge for the Apollo missions would be to develop a rocket powerful enough to propel the spacecraft into Earth orbit and then to the Moon. NASA's answer was the Saturn V. The men responsible for building the rocket, including (left to right) Kurt Debus (pointing), Hans Gruene (foreground), Wernher von Braun (behind Gruene), and Eberhard Rees (leaning in) observe a launch of the Saturn SA-8 rocket, a precursor to the Saturn V, at Cape Canaveral on May 25, 1965.

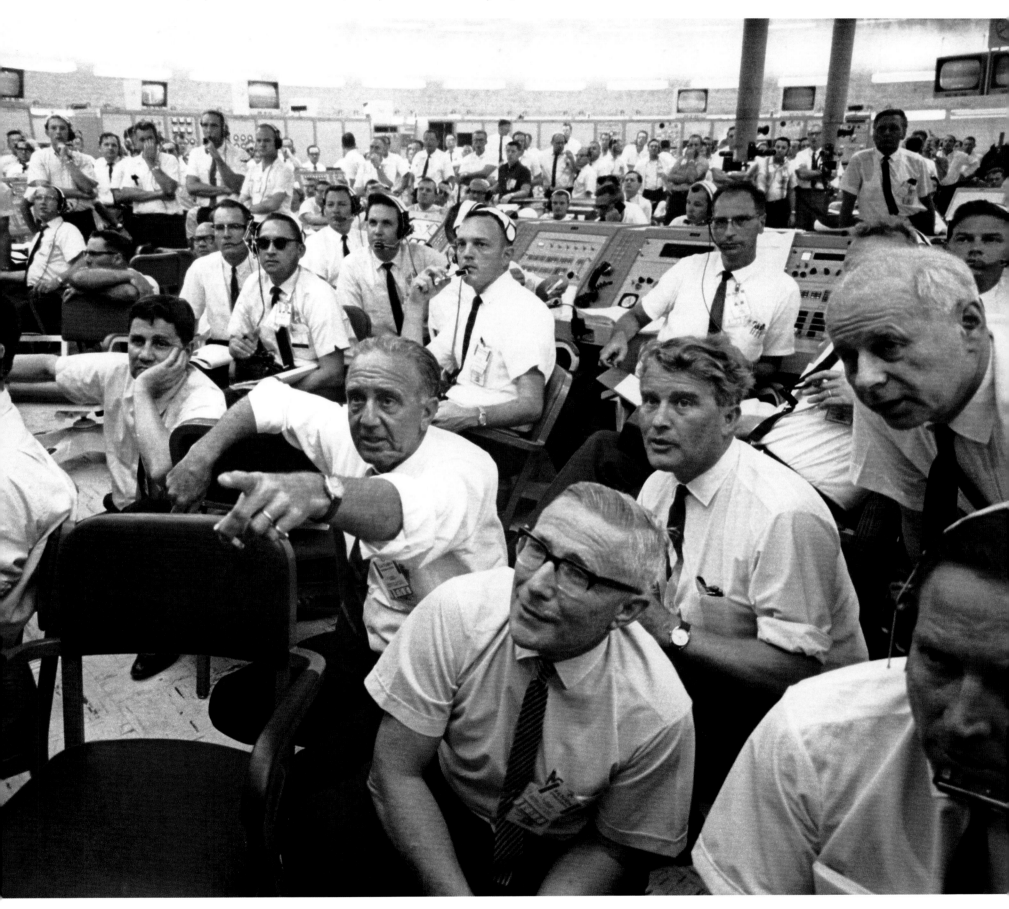

Overleaf People living fifty miles away felt the Earth tremble when the Saturn engines were tested. **Left** In an aerial photo from 1964, an enormous crater marks the site where the A-2 test stand is being constructed at the Mississippi Test Facility, now the Stennis Space Center. This was the second largest construction project in the US at the time. **Right** On New Year's Day, 1967, the S-II stage of the Saturn V rocket is hoisted onto a test stand at the Mississippi Test Facility. Powered by five J-2 engines, this second stage of the three-stage rocket has one million pounds of thrust, or the equivalent of 21 million horsepower. Stennis became NASA's primary center for testing and certifying rocket propulsions systems, including the space shuttle main engines.

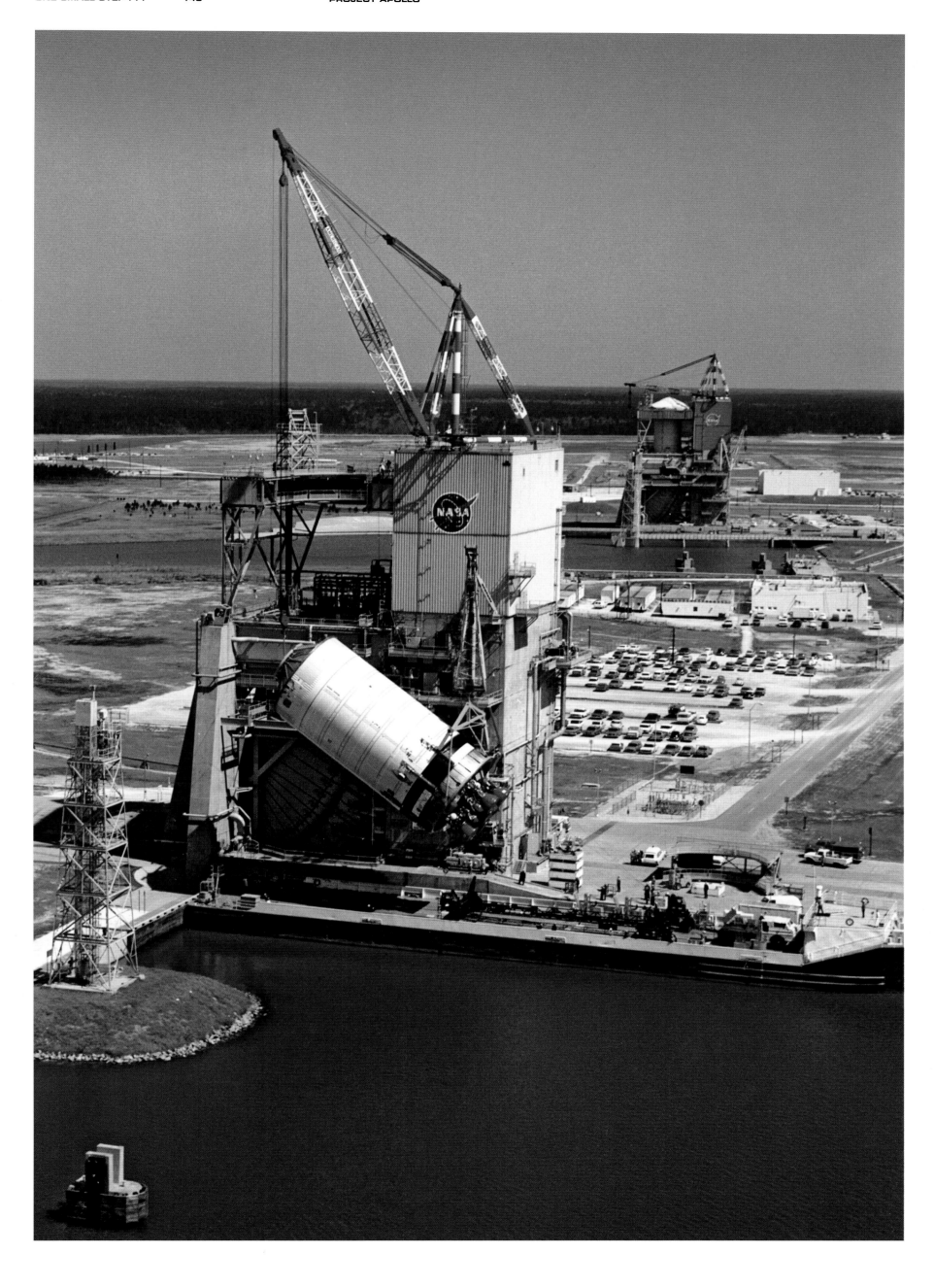

To prepare for Apollo, astronauts had to be trained and vehicles had to be tested under the conditions they would encounter on the Moon, where gravity was one-sixth of the Earth's. **Below** As early as December 1963, researchers were using the reduced-gravity walking simulator at Langley Research Center to study the fatigue limit, energy expenditure, and speed of locomotion of astronauts walking on the Moon. **Right** Once astronauts made it to the Moon, they would need special lunar vehicles to traverse it. While the lunar bicycle being tested in lunar gravity aboard a KC-135 aircraft in August 1969 never made the trip, it was a precursor to the four-wheeled LRVs astronauts would drive on the final Apollo missions. **Below right** Apollo pilots had to be trained, on Earth, to pilot lunar landers on the Moon. Three concepts to fill this need emerged: an electronic simulator, a tethered device, and a free-flying vehicle. All became serious projects, but the last was the most significant. This May 1963 photograph shows a prototype of a free-flying lunar-landing trainer developed by Bell Aerosystems.

Overleaf Astronauts in fully pressurized suits conduct EVA training in the neutral buoyancy simulator at Marshall Space Center in 1968. Water is an excellent medium for simulating the experience of maneuvering in microgravity, as Buzz Aldrin demonstrated during his training for Gemini XII.

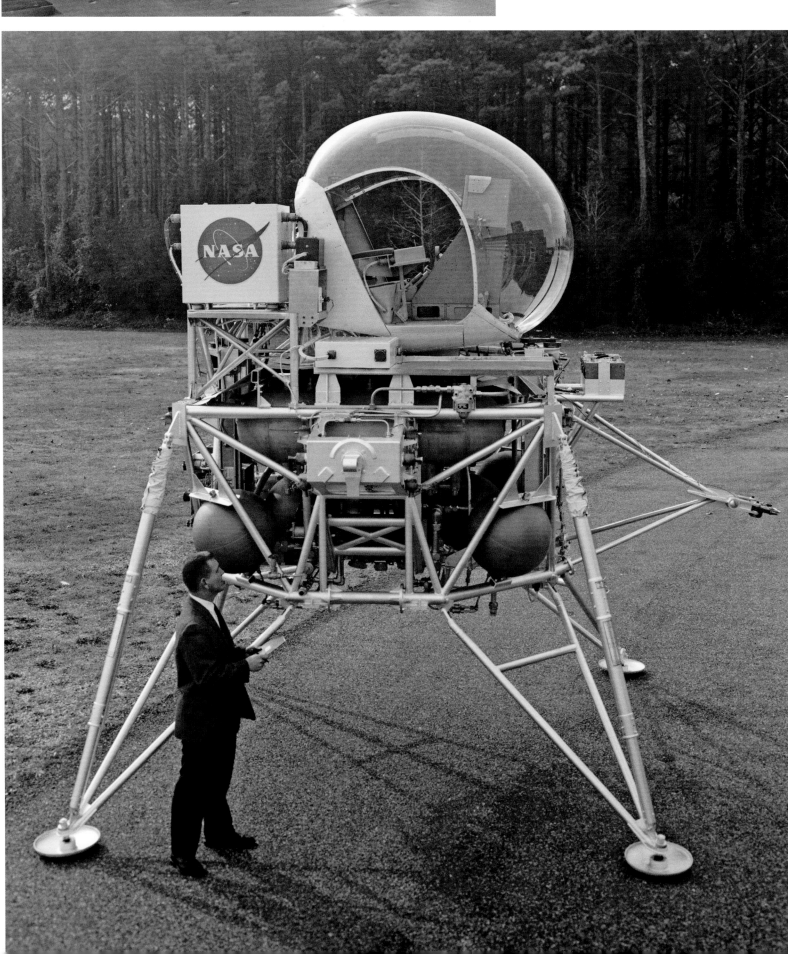

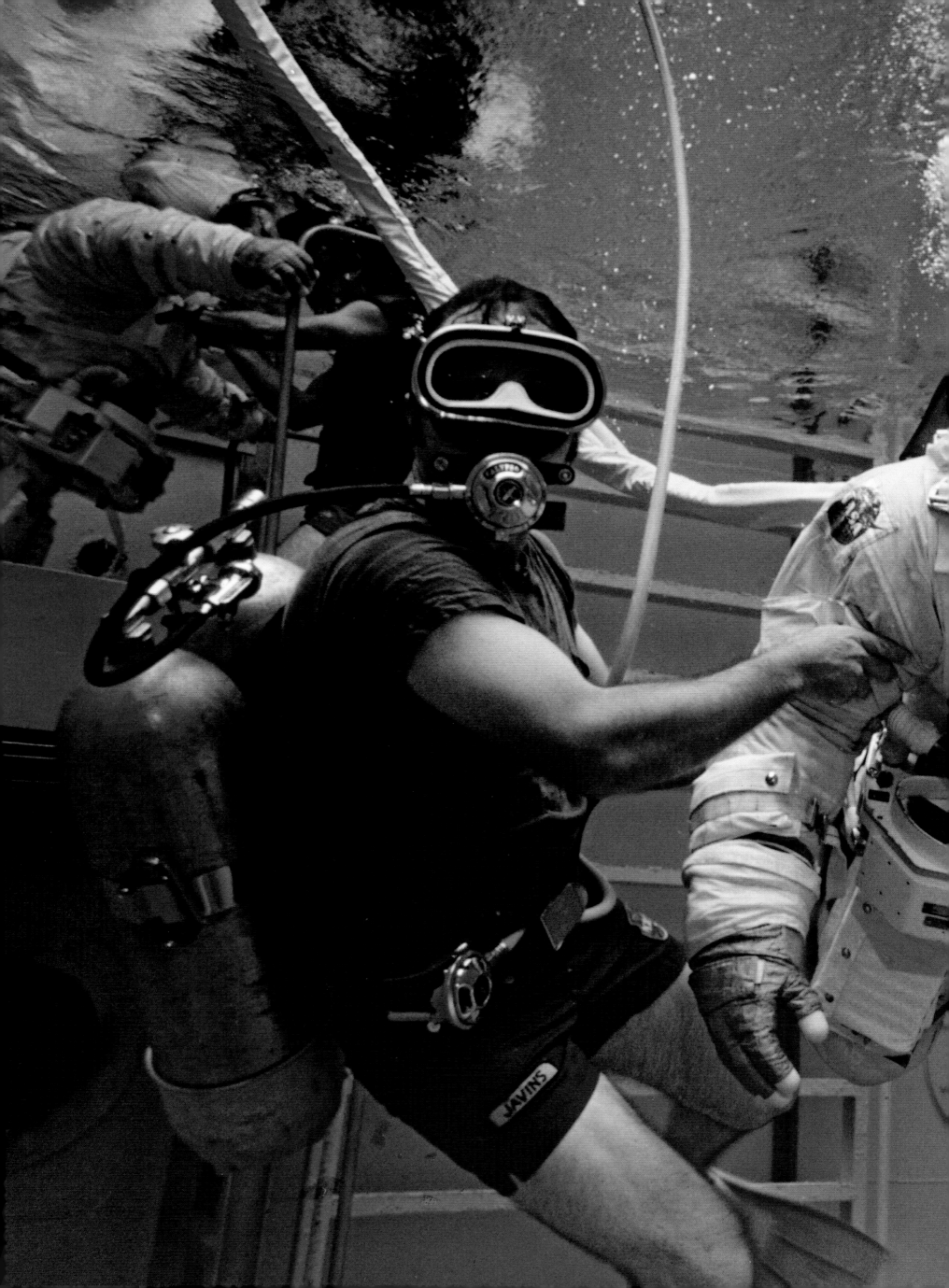

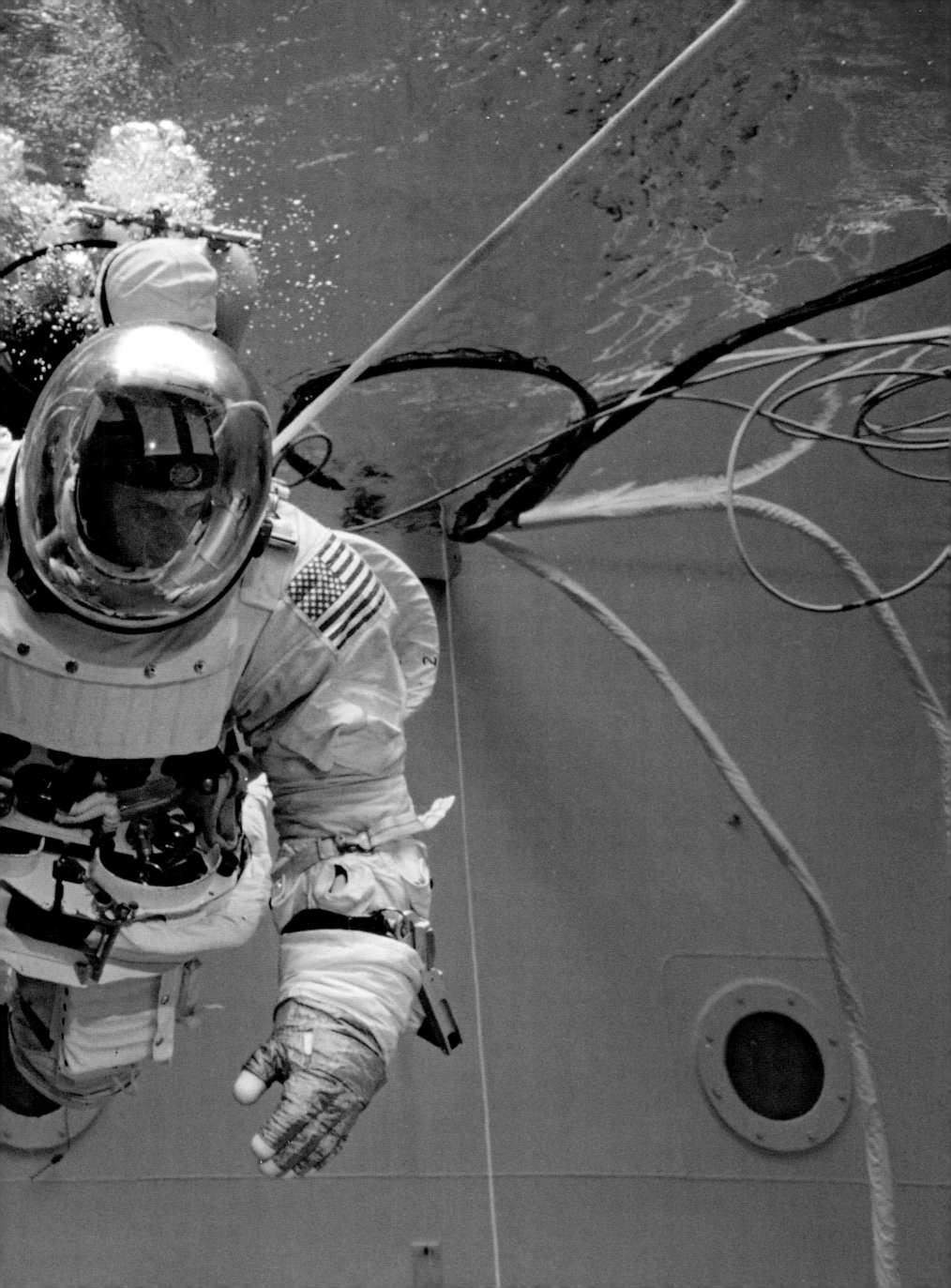

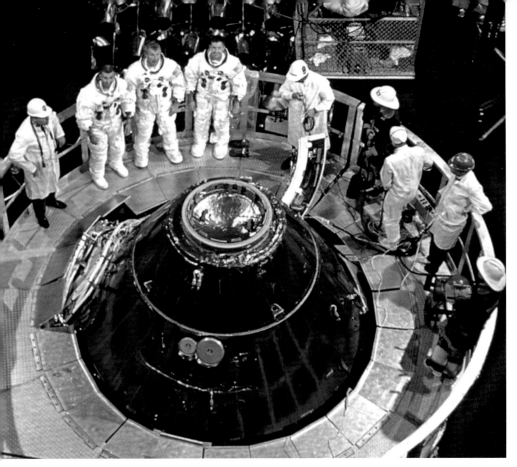

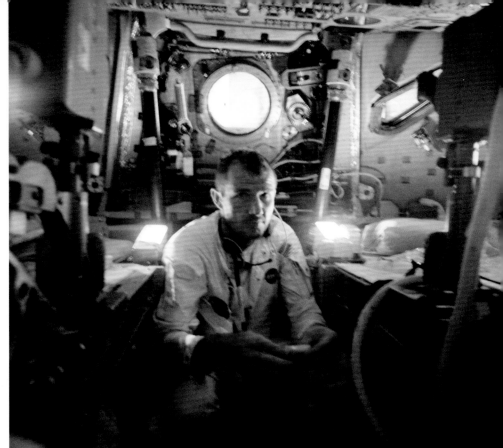

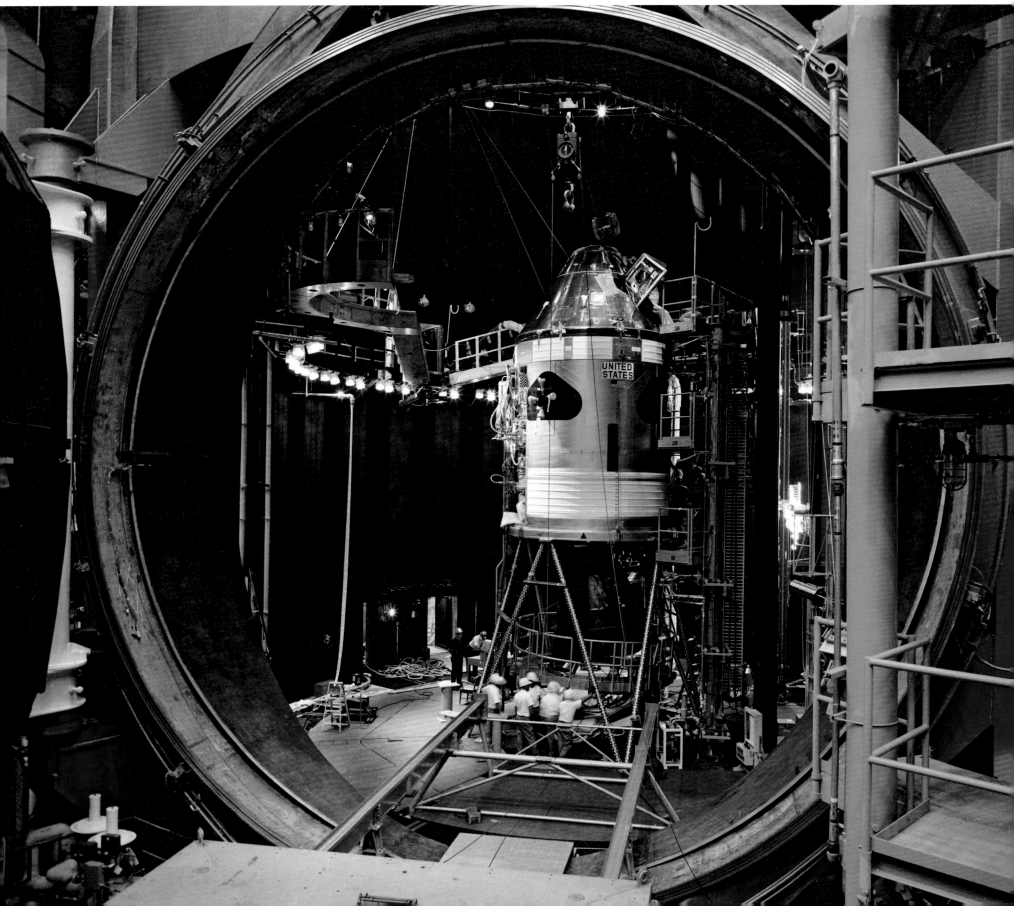

The Apollo spacecraft consisted of the command module (CM), which acted as the brain of the ship; the service module (SM), which housed the astronauts' equipment; and the lunar module (LM), which was the only portion of the spacecraft that would actually land on and blast off from the Moon. The service module propelled the spacecraft back from the Moon and was jettisoned before reentry. **Opposite bottom** NASA tested full-scale command and lunar module designs at the Manned Spacecraft Center in vacuum chambers that simulate the airlessness of space. For example, after the terrible Apollo 1 fire in 1967, NASA decreed that the next-generation command module incorporating fireproof materials and a new cabin atmosphere would have to undergo unusually rigorous testing in the three-story vacuum chamber before being cleared for flight. During this "mission," which was designated 2TV-1 (after the production number of the command module being tested), three crewmen spent 177 hours inside the command module following the timeline of a lunar mission. **Opposite top left** The crew is about to enter the spacecraft. **Opposite top right** CM Pilot Vance Brand was one of three who crewed the test spacecraft. The hours he spent in 2TV-1 were not counted in the 746 hours Brand eventually logged in real space, on four missions.

Below Bell Aerosystems delivered two lunar-landing trainers to NASA in April 1964; three more followed. This 1967 shot of one of them in flight at Edwards Air Force Base gives a clear view of the pilot's platform, with its restricted view, just like in the real lunar module. Astronauts jokingly referred to the vehicles as "flying bedsteads," but they served their purpose.

Overleaf left Various stages of lunar module construction.

Overleaf right An astronaut uses an early LM mockup during EVA simulation, in a photograph that Norman Rockwell used for his painting *Apollo and Beyond,* which was commissioned by *Look* magazine in 1969 on the occasion of Apollo 11. During the course of the Apollo program, twelve astronauts spent some three hundred hours on the lunar surface, of which eighty were outside with "boots on the ground."

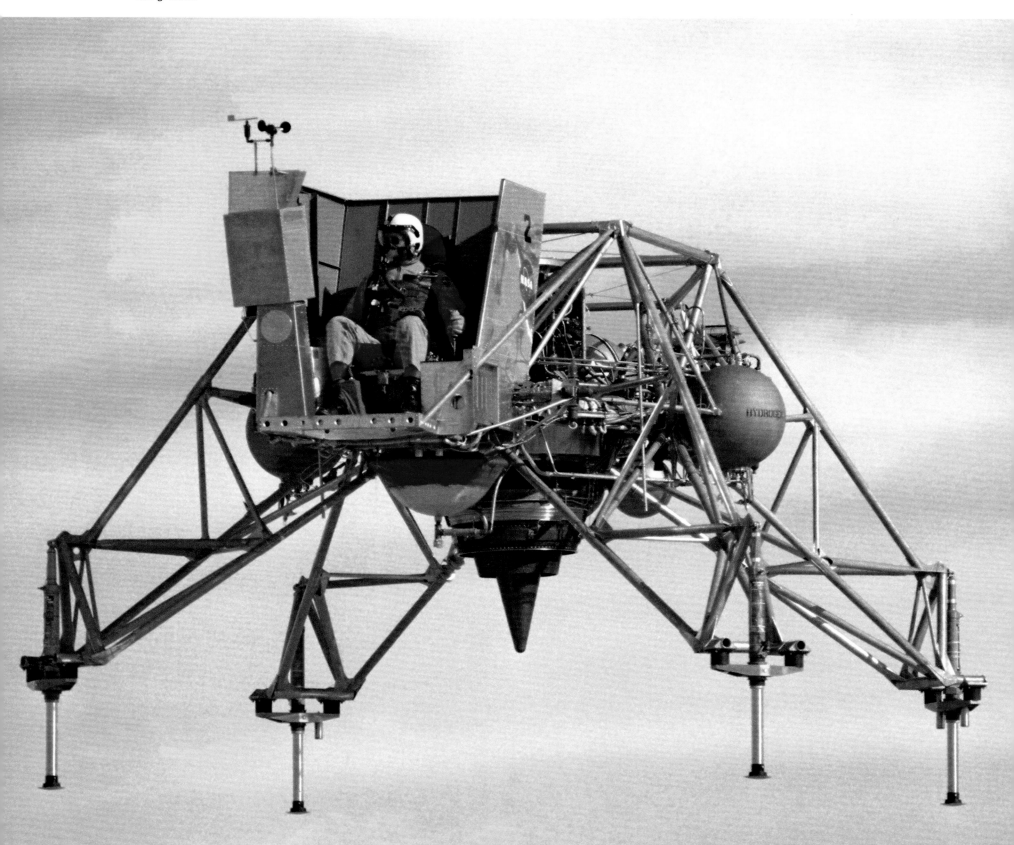

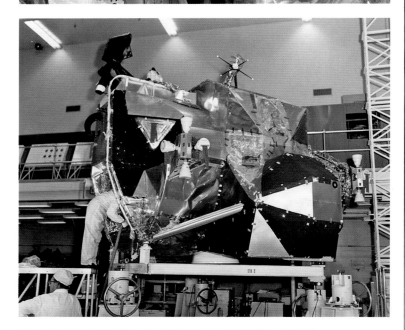

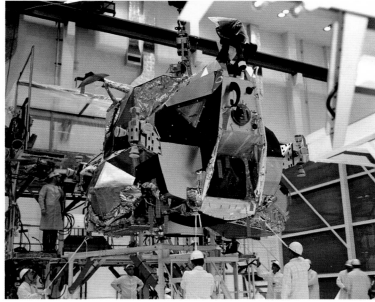

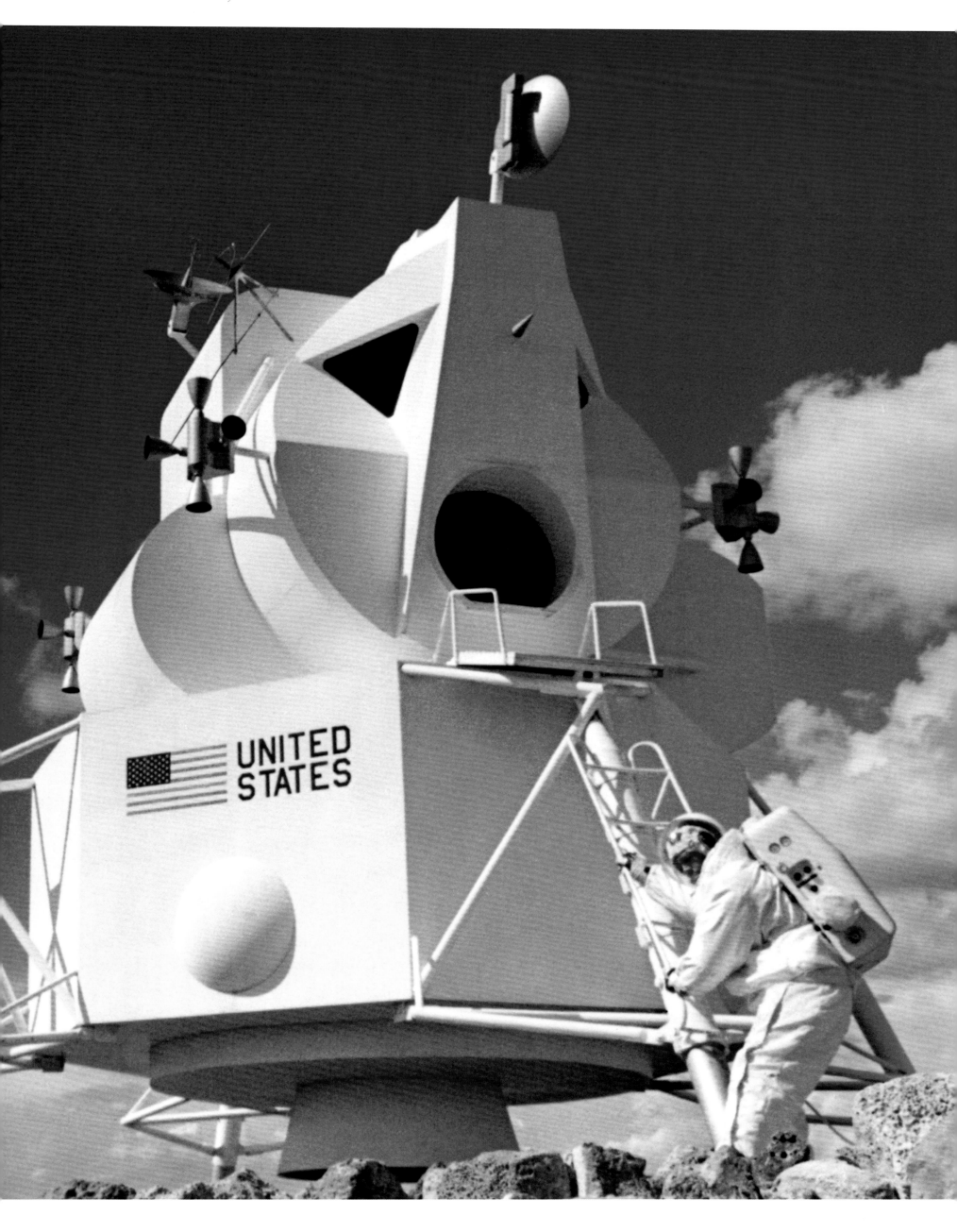

Below First stages of the Saturn IB wait the final assembly area of Michoud Assembly Facility, Eastern New Orleans, in 1967. The Saturn family of rockets culminated in the Saturn V, which was in height, weight, and payload capacity the champ of all launch vehicles produced for NASA. It had three stages: Boeing's S-IC powered the spacecraft through the first thirty-eight miles of ascent; North American Aviation's S-II propelled it through the Earth's upper atmosphere; and Douglas Aircraft's S-IVB, which fired twice, the first time for Earth-orbit insertion and then again for the translunar injection burn that sent the spacecraft to the Moon. A second variant, the Saturn IB, could place the Apollo spacecraft into Earth orbit and was used for the Apollo 7, Skylab, and Apollo-Soyuz Test Project flights.

Opposite Components of the Apollo spacecraft were assembled for missions in the Kennedy Space Center's Manned Spacecraft Operations Building. A January 31, 1969, photo shows Spacecraft 107, flown on Apollo 11, being moved from its workstand for mating to the spacecraft lunar module adapter, which carried the LM.

Overleaf left The complete Apollo spacecraft was then moved to the VAB, where it was mated with the Saturn rocket, a procedure seen in this photo from November 1968 of the preparations for Apollo 8.

Overleaf right A top-to-bottom view of the thirty-six-story Apollo/Saturn space vehicle used for Apollo 4, an unmanned mission, in High Bay No. 1 of the VAB, on May 25, 1967.

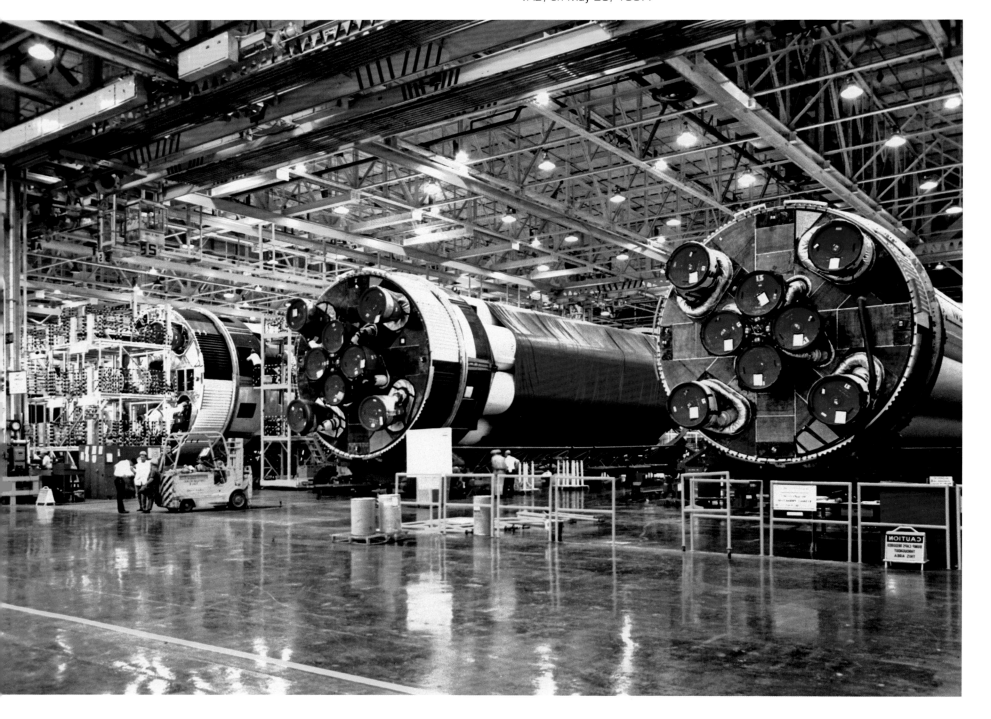

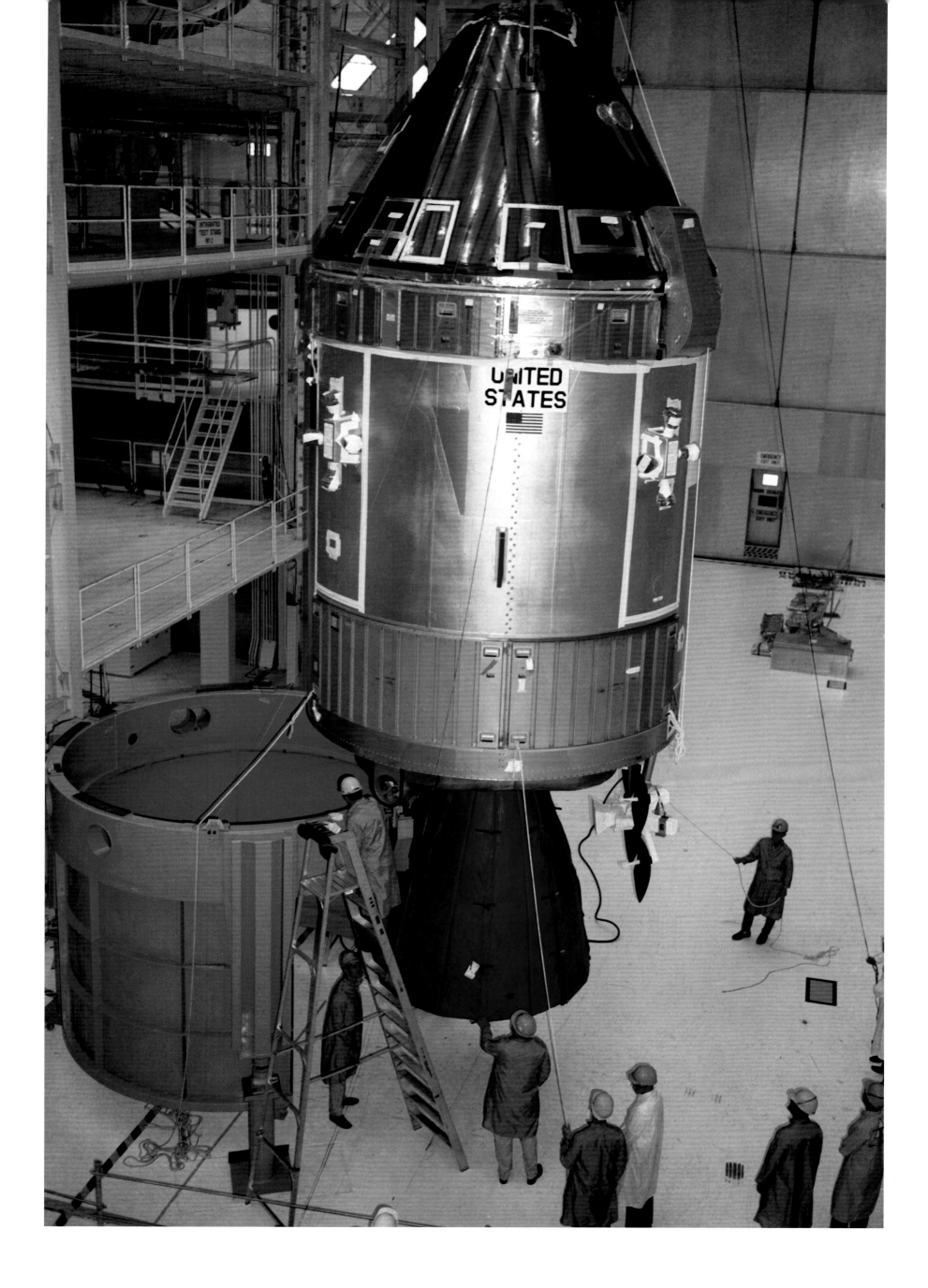

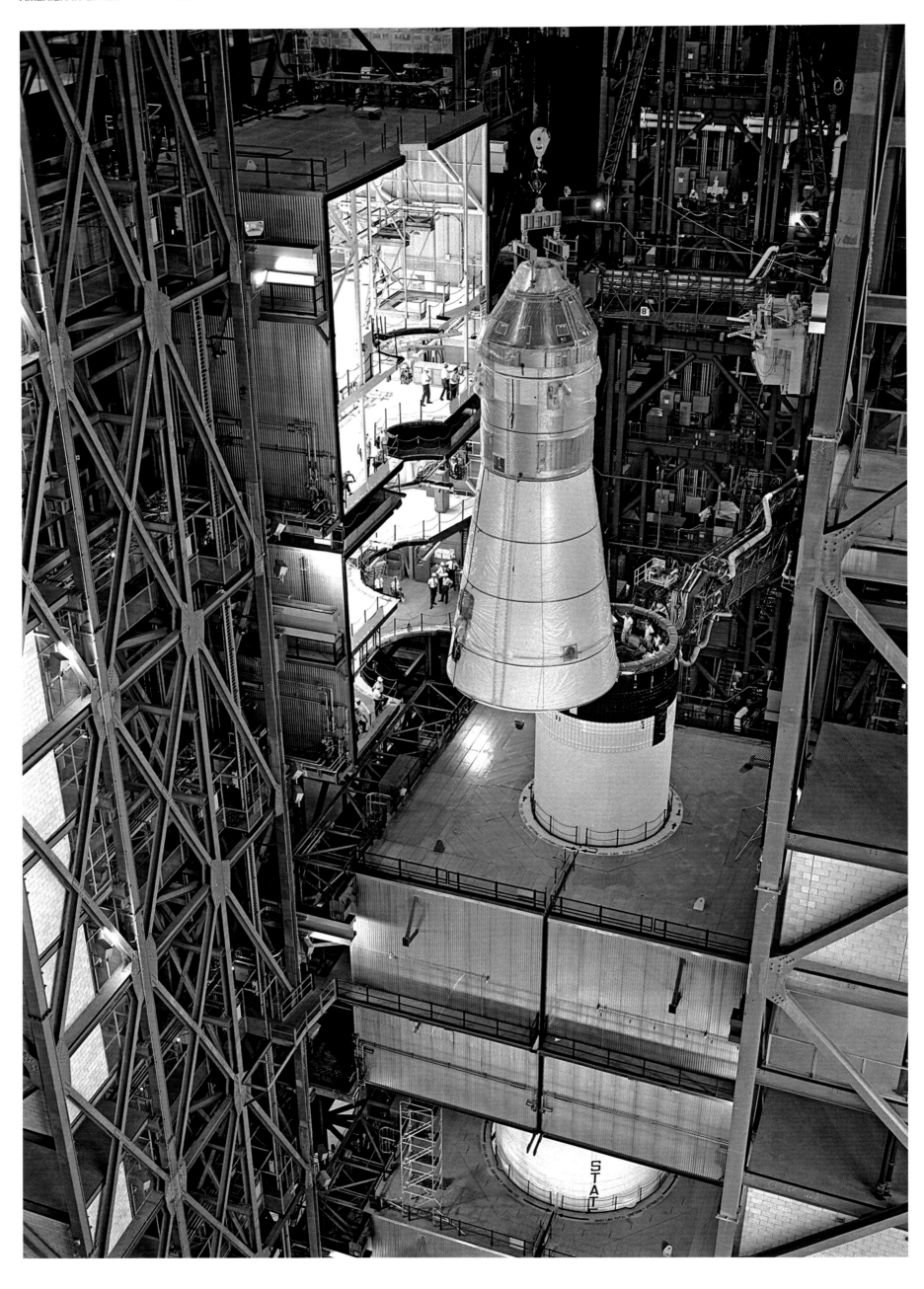

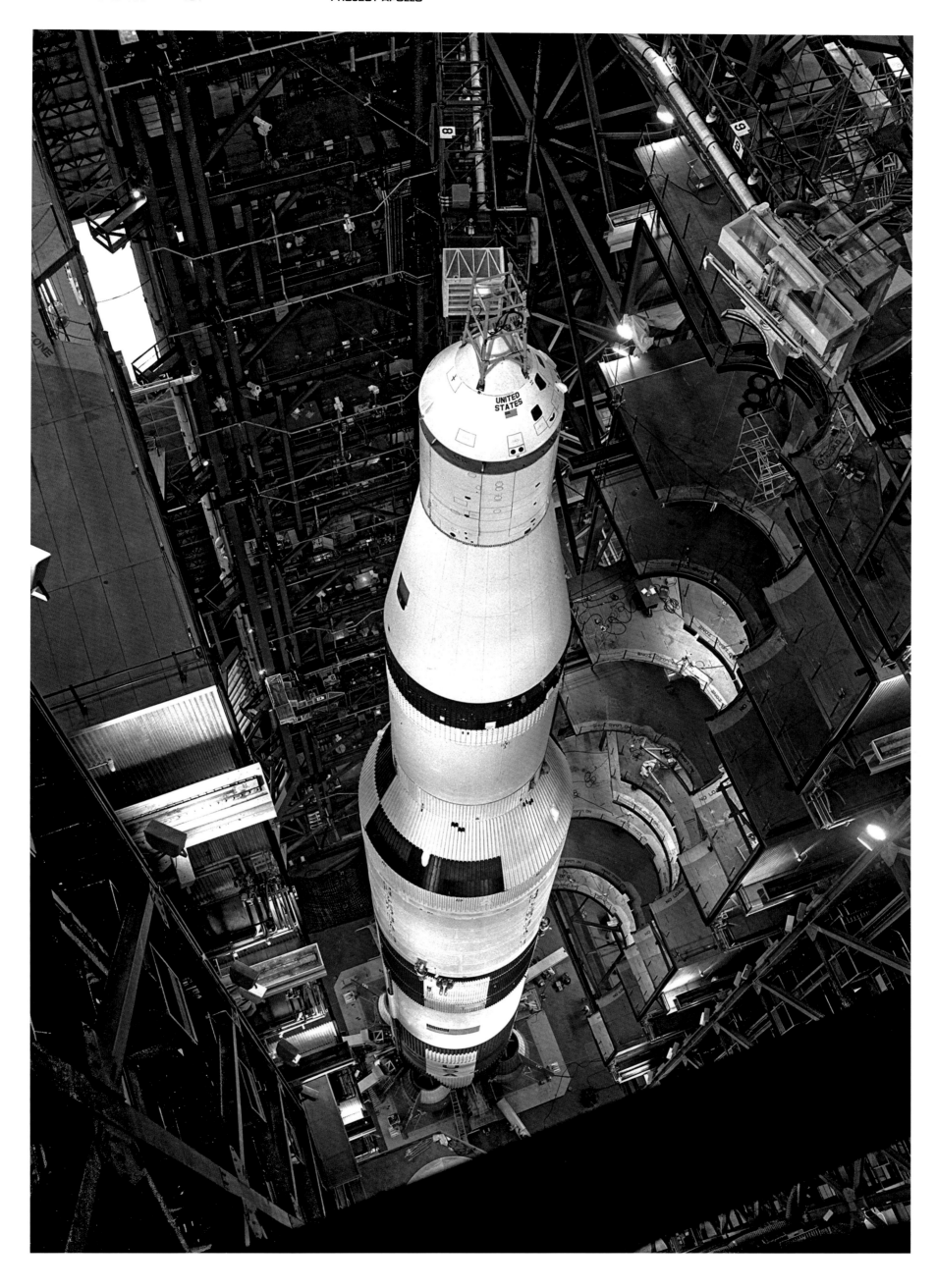

On January 27, 1967, during a launch simulation for what was to be Apollo's first manned mission, the program faced its darkest moment. **Opposite top** The mission's three astronauts (left to right), Command Pilot Gus Grissom, Senior Pilot Edward White, and Pilot Roger Chaffee, were killed when their spacecraft caught fire on the launch pad. The tragedy, marking the first and only fatalities of the Apollo program, was a reminder that winning the space race might come at great cost. **Below** The crew of Apollo 204 (later renamed Apollo 1) crosses an access arm to the command module before the fateful training exercise. **Opposite bottom** Fire damage can be seen on the exterior of the spacecraft. Investigators believed a short circuit in the electrical system sparked the fire, while the pure oxygen environment inside the craft caused it to rage out of control in just seconds. The program's launch schedule was halted while NASA investigated and the CM was redesigned, making a lunar landing before the end of the decade seem even more unlikely.

Overleaf The Apollo 7 Saturn IB rocket waits on the pad at Complex 34, Cape Canaveral Air Force Station, during a countdown demonstration test. Launched on October 11, 1968, Apollo 7 was the program's first manned mission. Its success was a much-needed confidence boost after the Apollo 1 tragedy.

Pages 166–67 Apollo 7 Commander Wally Schirra (left), CM Pilot Donn Eisele, and LM Pilot Walter Cunningham (right) tested the improved command module in Earth orbit. The mission lasted almost eleven days, long enough for colds and cramped living conditions to frustrate the crew.

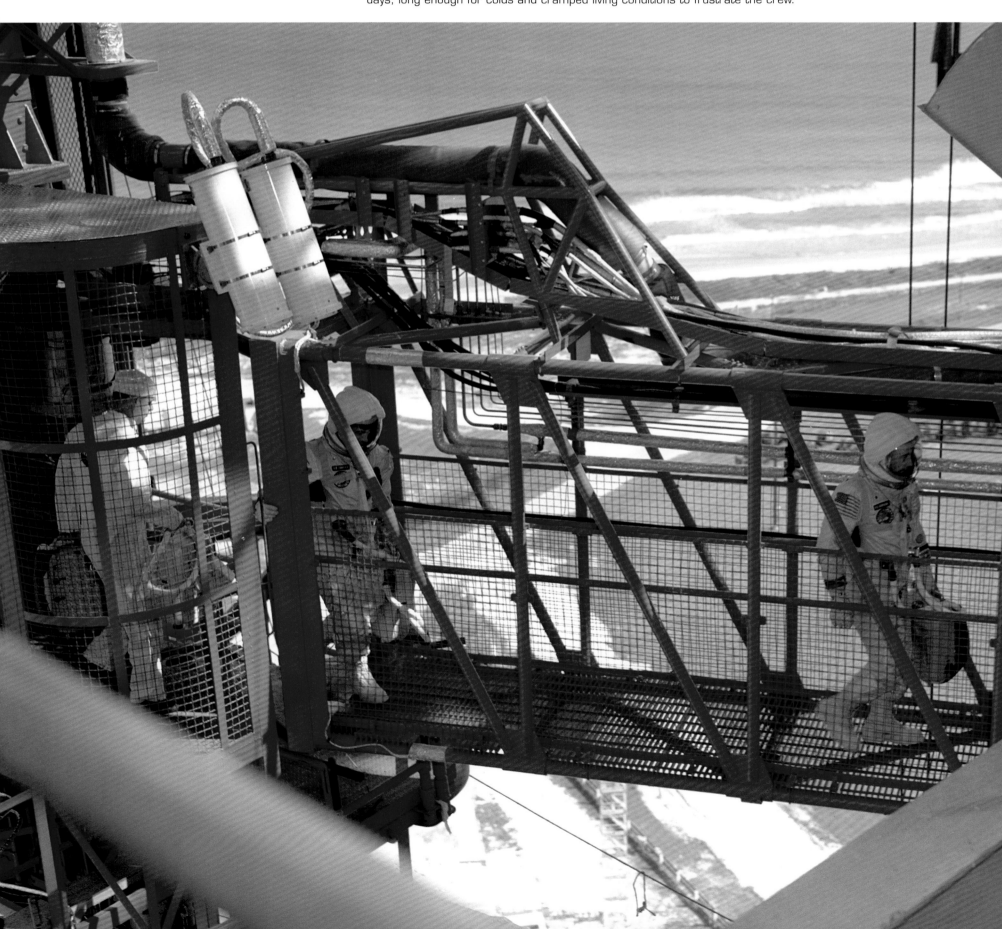

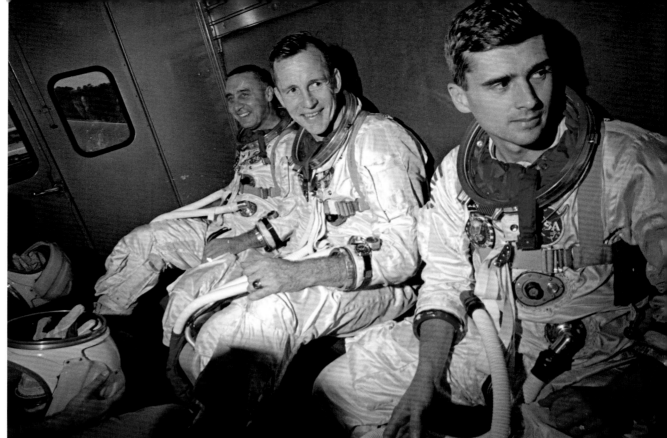

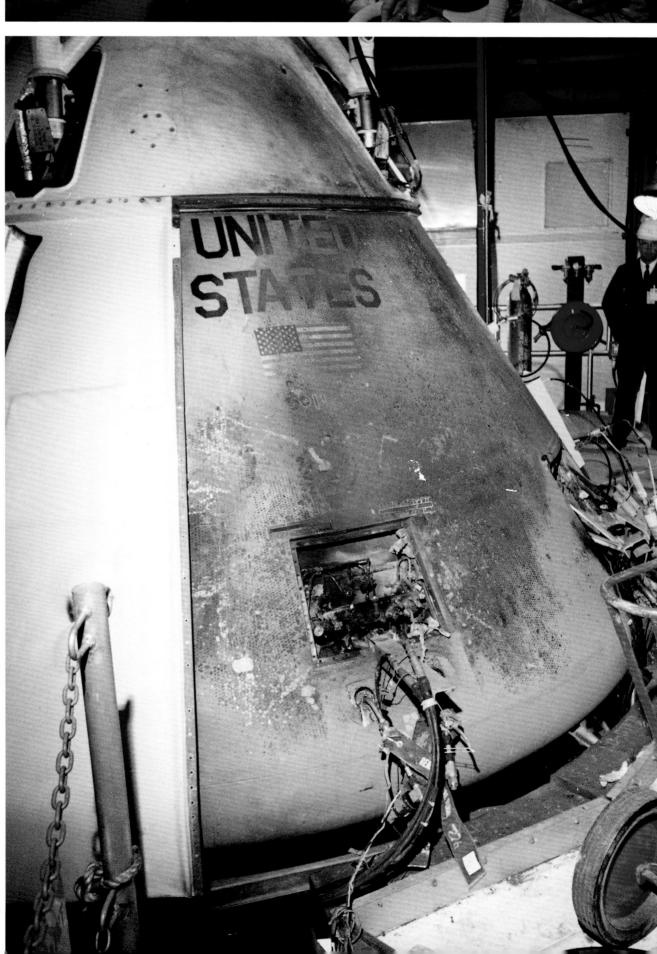

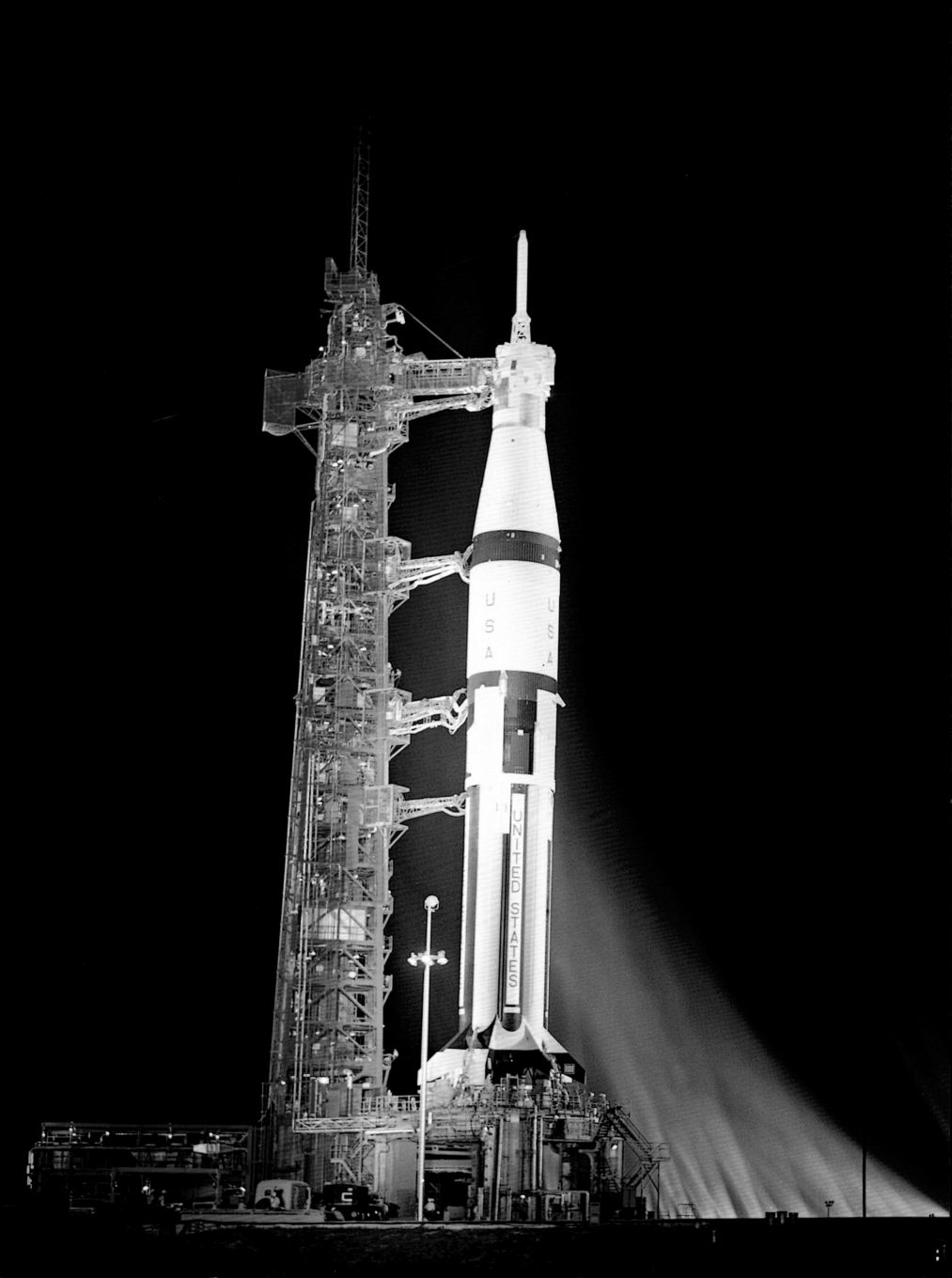

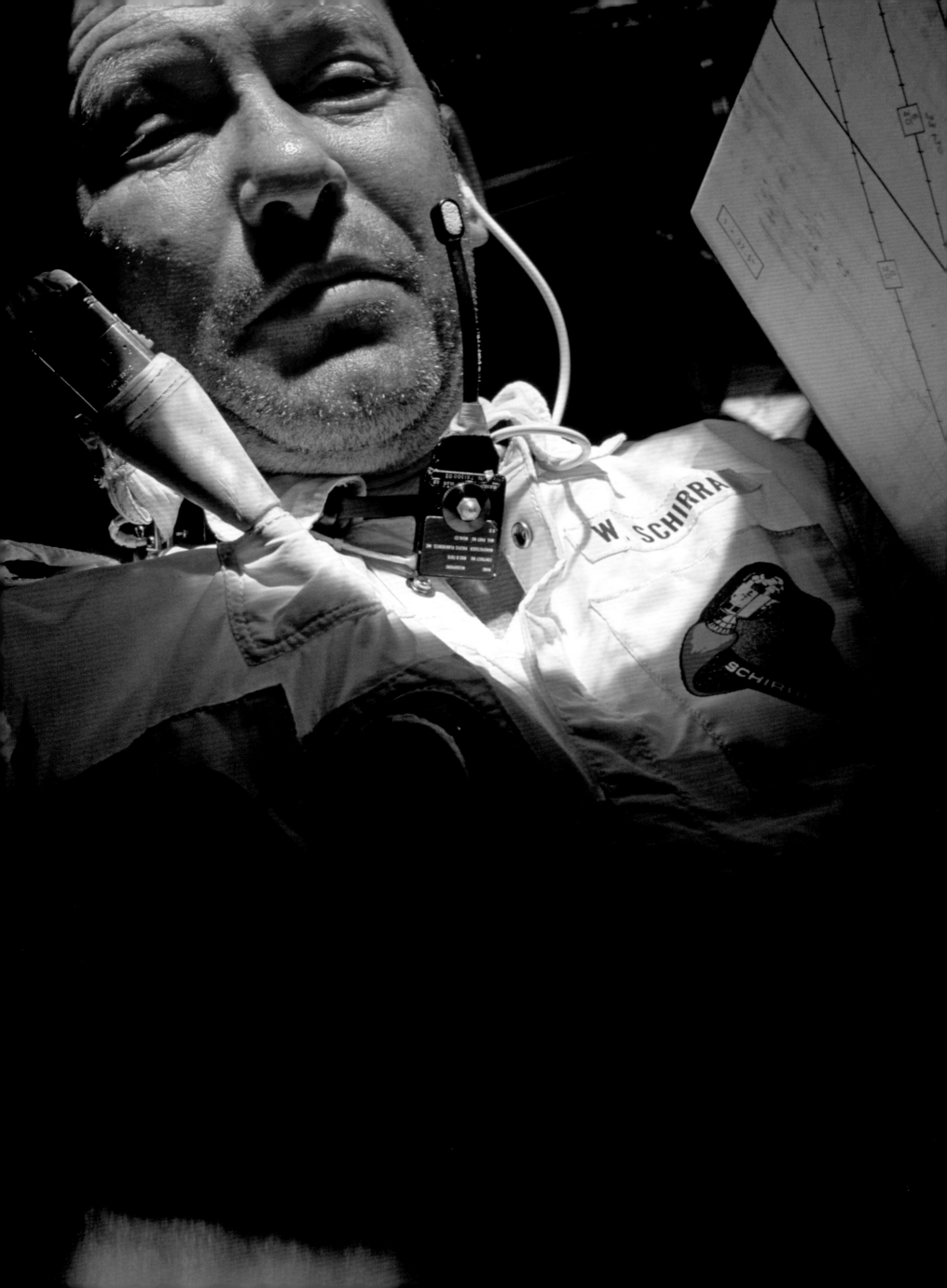

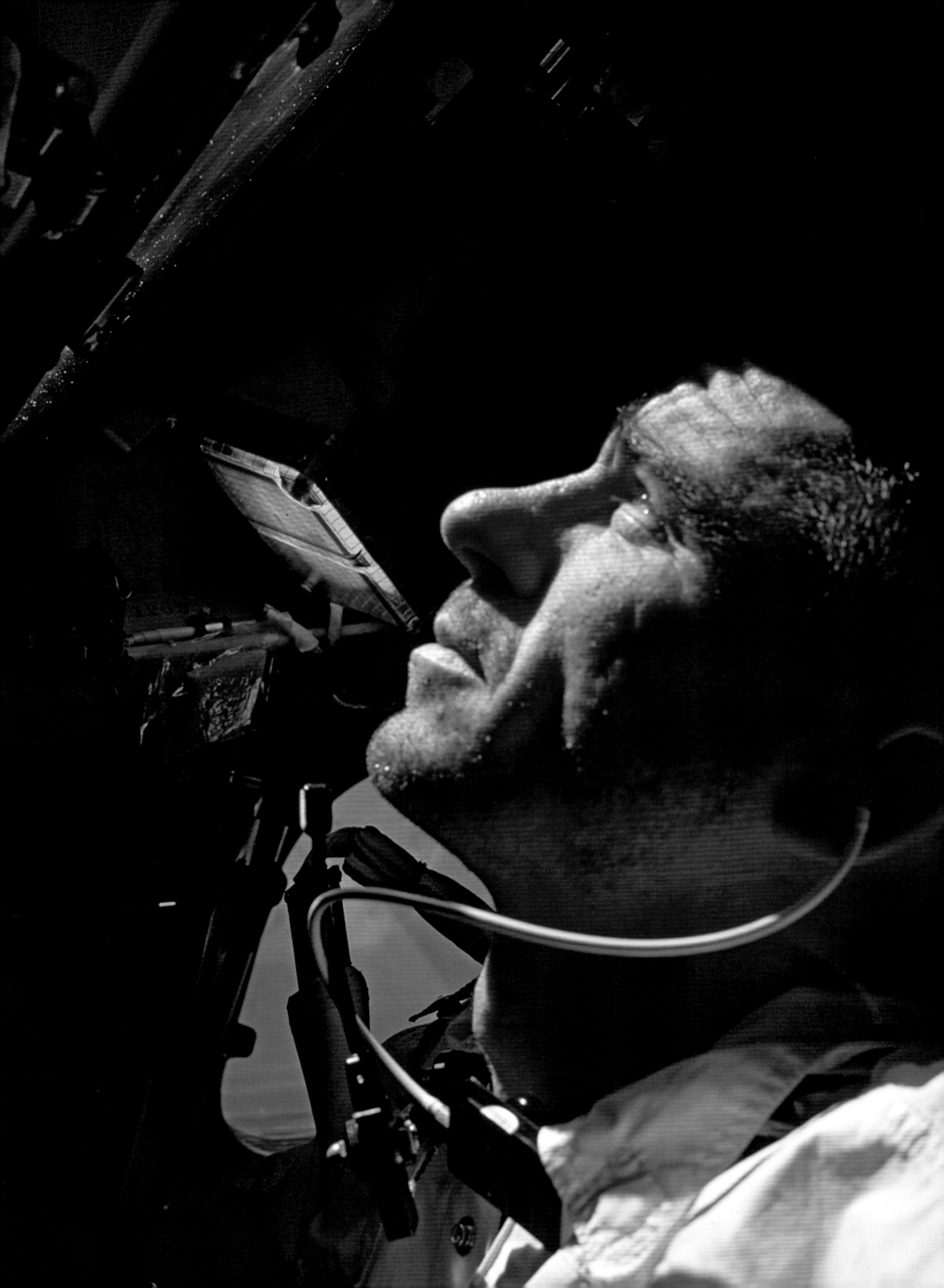

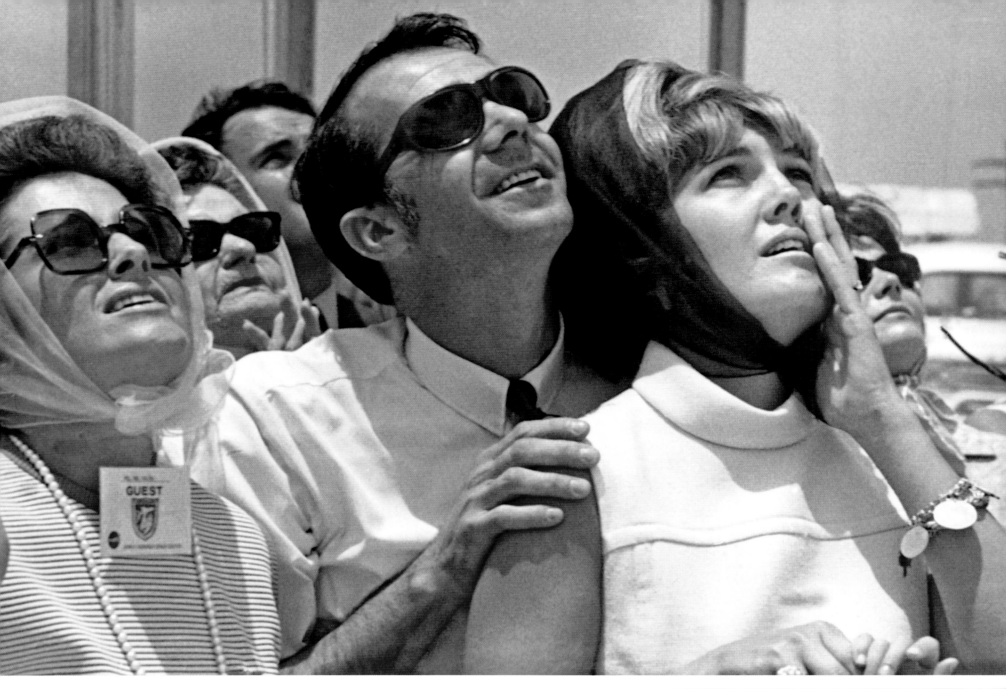

Above and right The Saturn launches were something to see. All eyes and cameras follow the lift-off of the Saturn V rocket carrying the crew of Apollo 8—Commander Frank Borman, CM Pilot James Lovell, and LM Pilot William Anders—on their six-day lunar orbital voyage on December 21, 1968. This was the first launch from Kennedy Space Center's Launch Complex 39A. The mission captured the public's imagination when the astronauts transmitted live black-and-white television images of the Moon up close. In a second famous transmission on Christmas Eve, they showed the Earth rising over the Moon (see page 321) as they recited verses from the Book of Genesis. Apollo 8 remained in lunar orbit for just over twenty hours. **Above right** About five months later, family and friends of LM Pilot Eugene Cernan look up in anticipation as Apollo 10 lifts off on May 18, 1969.

Overleaf Back on Earth on December 27, 1968, the Apollo 8 crew of Anders, Borman, and Lovell speak to President Lyndon Johnson from the carrier USS *Yorktown.* "You have made us feel kin to those Europeans five centuries ago who first heard news of the New World," Johnson told the astronauts.

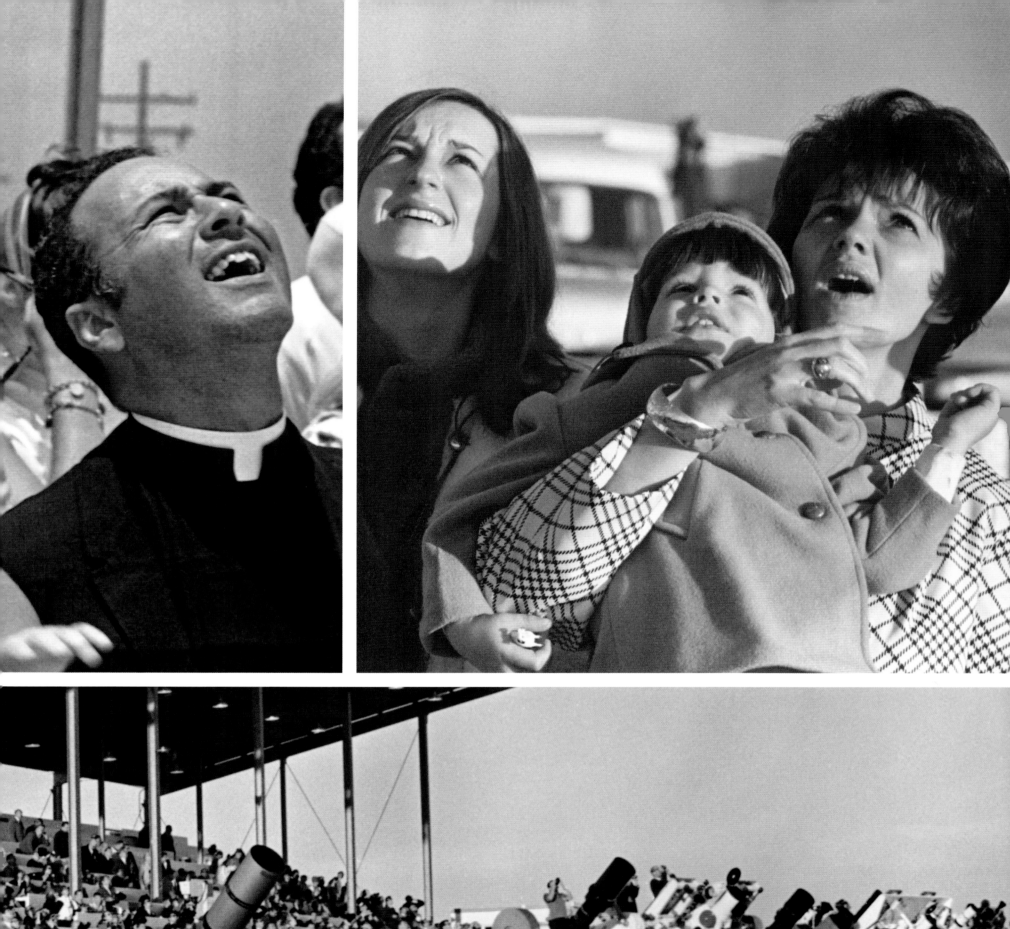
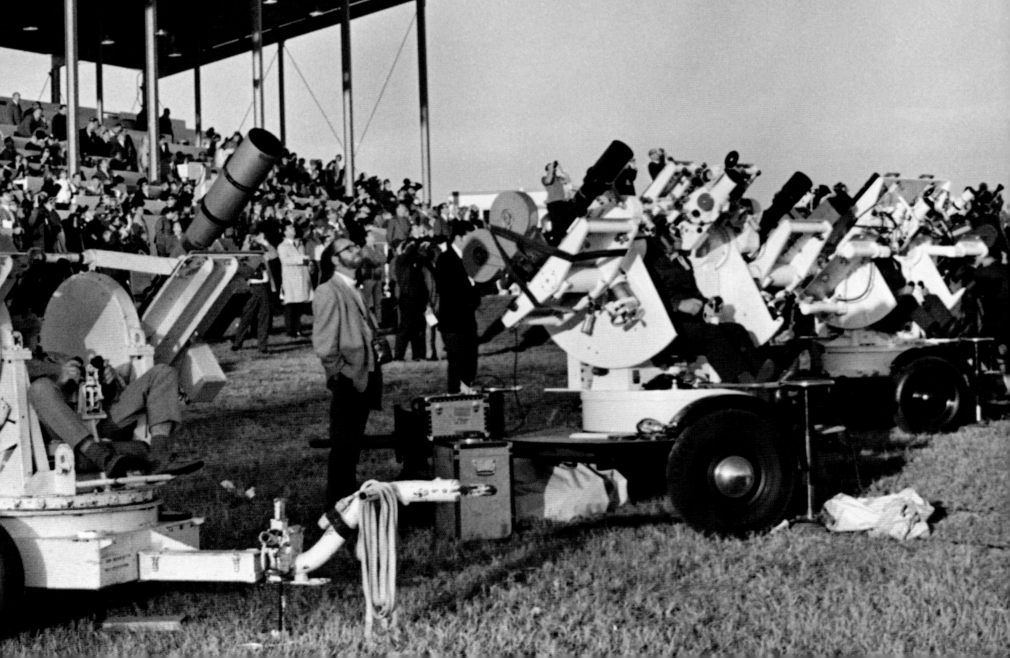

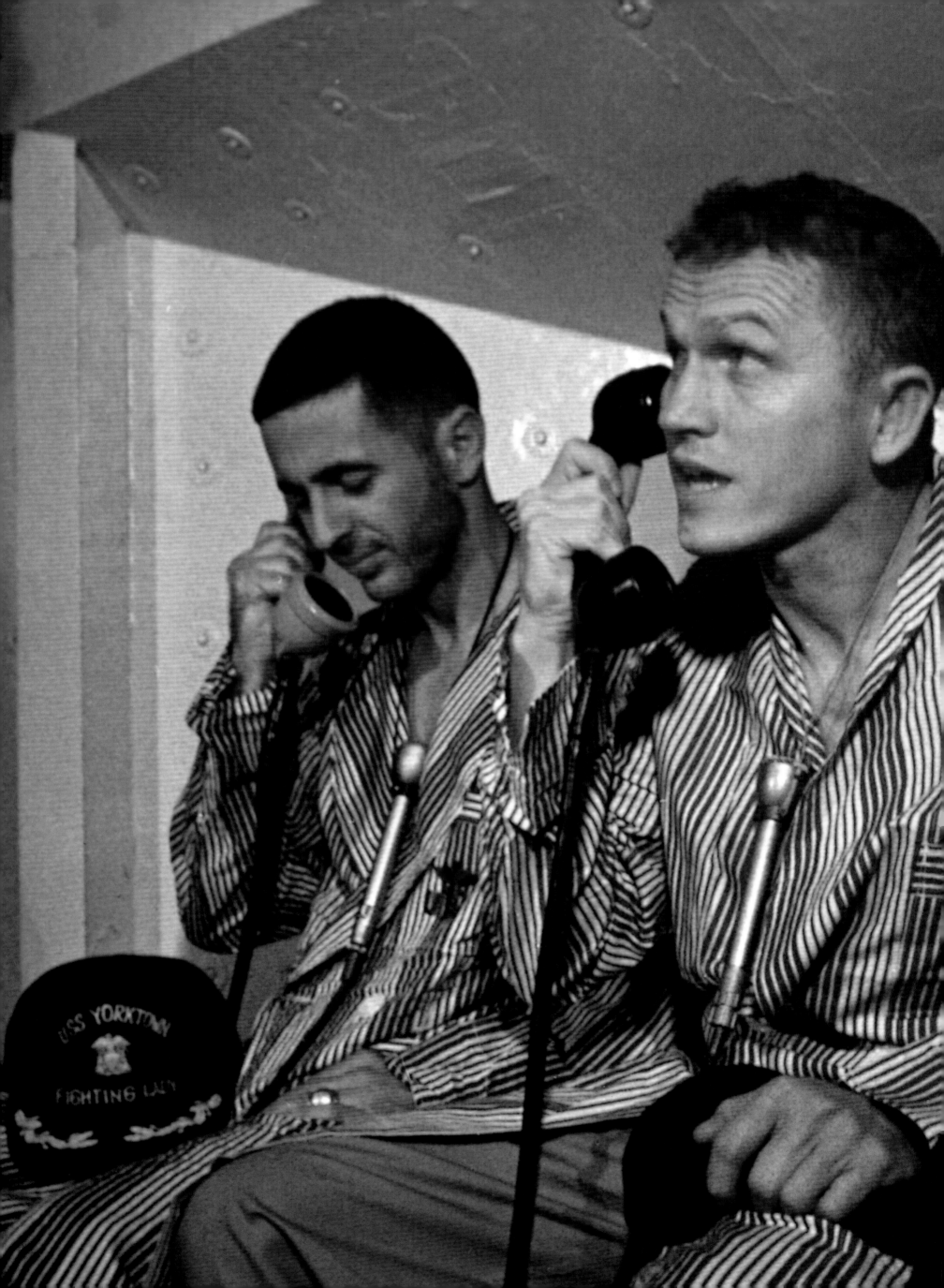

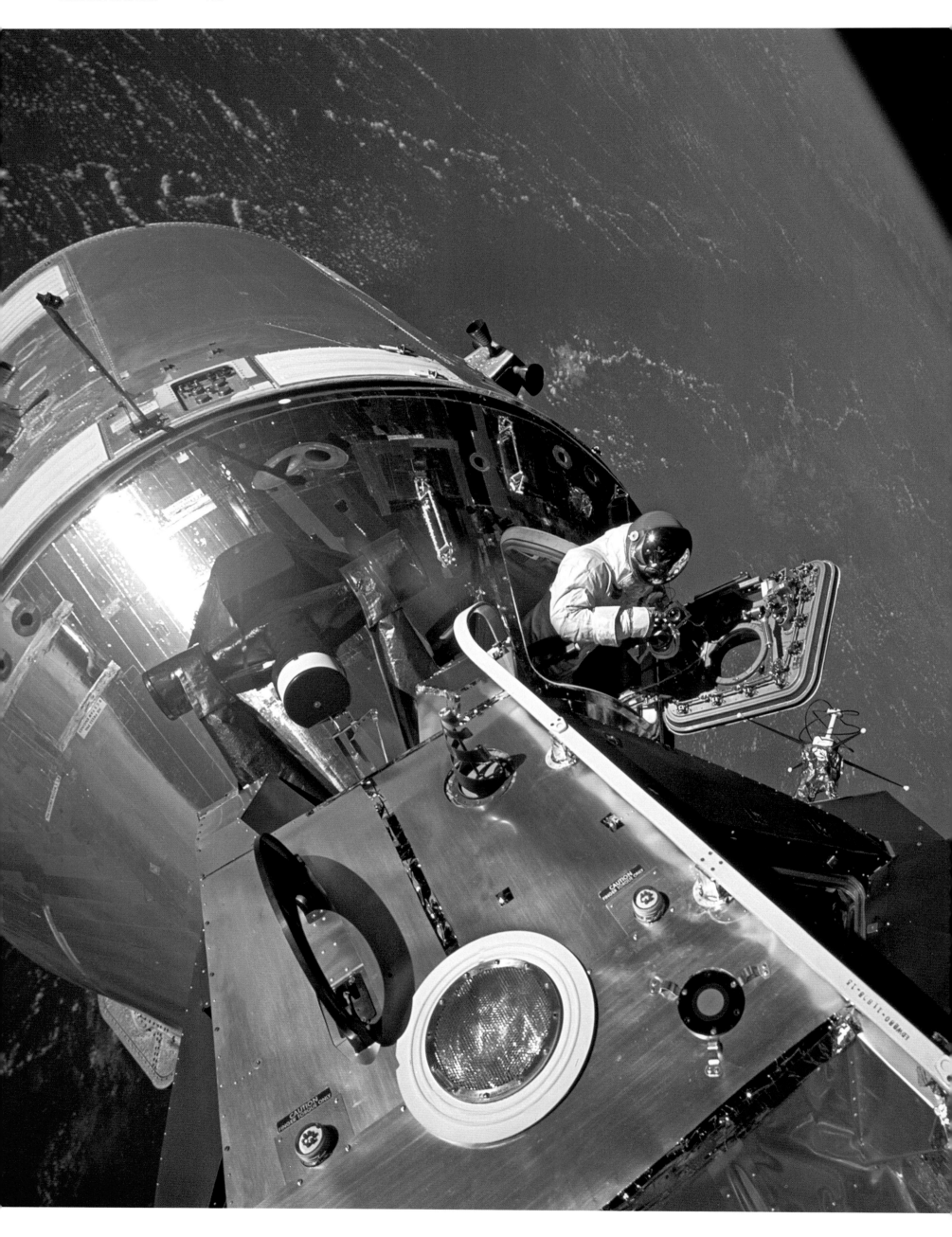

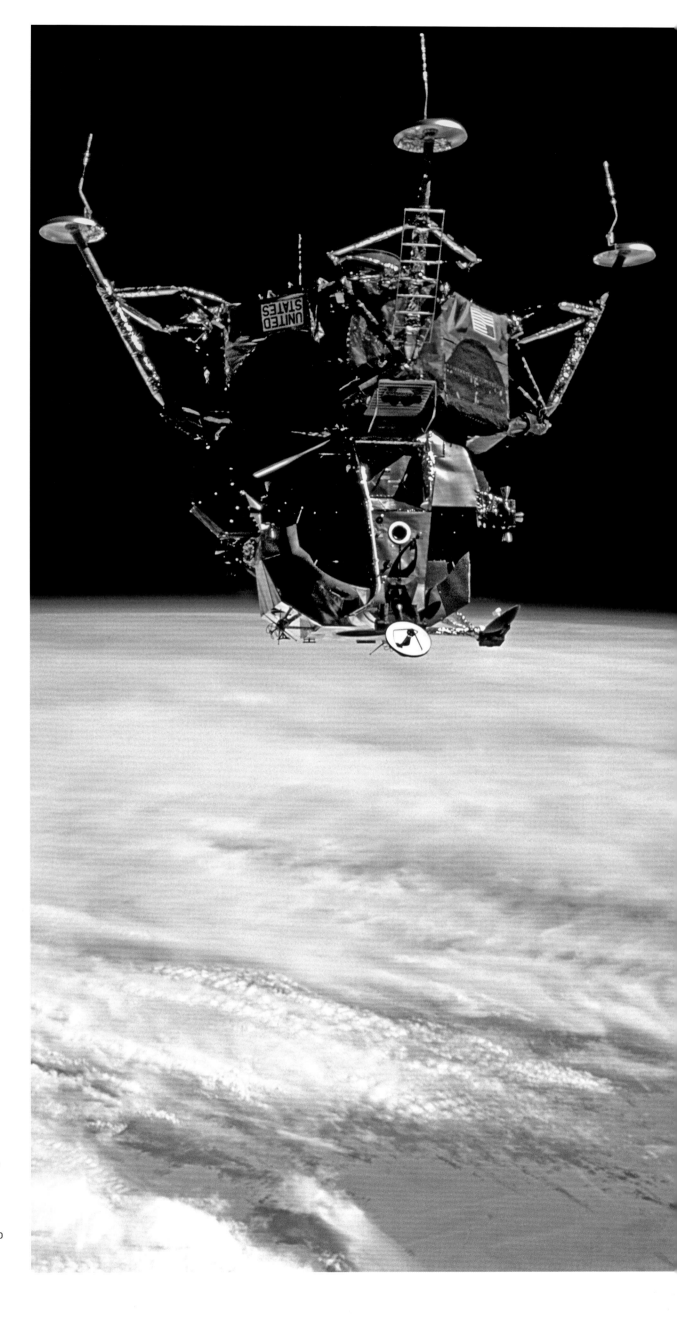

Left Apollo 9 tested out the docking and undocking of the lunar module in Earth orbit. CM Pilot David Scott performs an EVA from the open hatch of the command module, named "Gumdrop" by the astronauts, which is docked with the lunar module, called "Spider," in the foreground.

Right *Spider* flies in lunar landing configuration, photographed by Scott from inside the command module on March 7, 1969. *Spider*'s landing gear has been deployed, and lunar surface probes extend out from the footpads. Inside *Spider* are Commander James McDivitt and LM Pilot Russell Schweickart.

Overleaf Crowds on Eleuthera Island, Bahamas, greet the Apollo 9 crew during a stopover en route to Cape Kennedy. The crew splashed down east of the Bahamas on March 13, 1969, after a ten-day trip.

Right Apollo 10 Commander Thomas Stafford is seen in a screen shot of the first live color-television transmission from space on May 18, 1969. NASA's decision to report on its missions in real time kept public support for the space program high. A timeline of American television firsts in space would also include Gordon Cooper's transmission of still TV images (one frame every two seconds) on Mercury 9 and the first black-and-white live broadcast from Apollo 7.

Below A Navy frogman carrying a camera captures an anxious moment aboard the rubber life raft as the crew of Apollo 10, (from left to right) CM Pilot John Young, LM Pilot Eugene Cernan, and Commander Stafford, wait for a helicopter to transport them to the USS *Princeton* off the coast of Hawaii on May 26, 1969.

Opposite Crew members on the flight deck of the carrier greet the astronauts later that day. The eight-day dress rehearsal for lunar landing was a success: the astronauts had brought the lunar module within 9.7 miles of the Moon's surface.

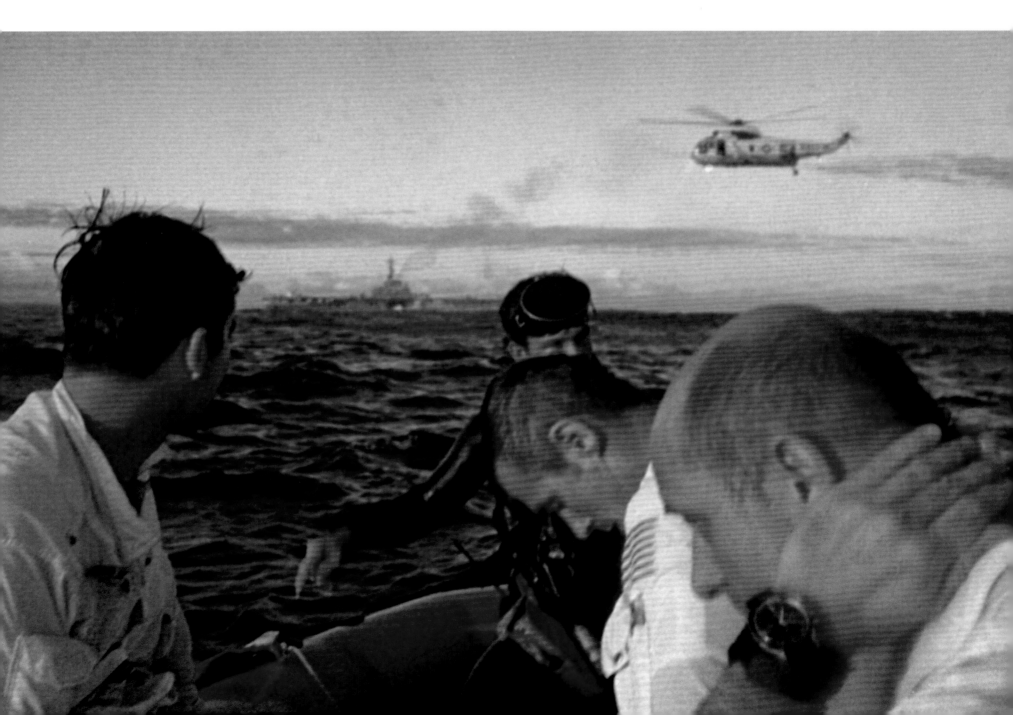

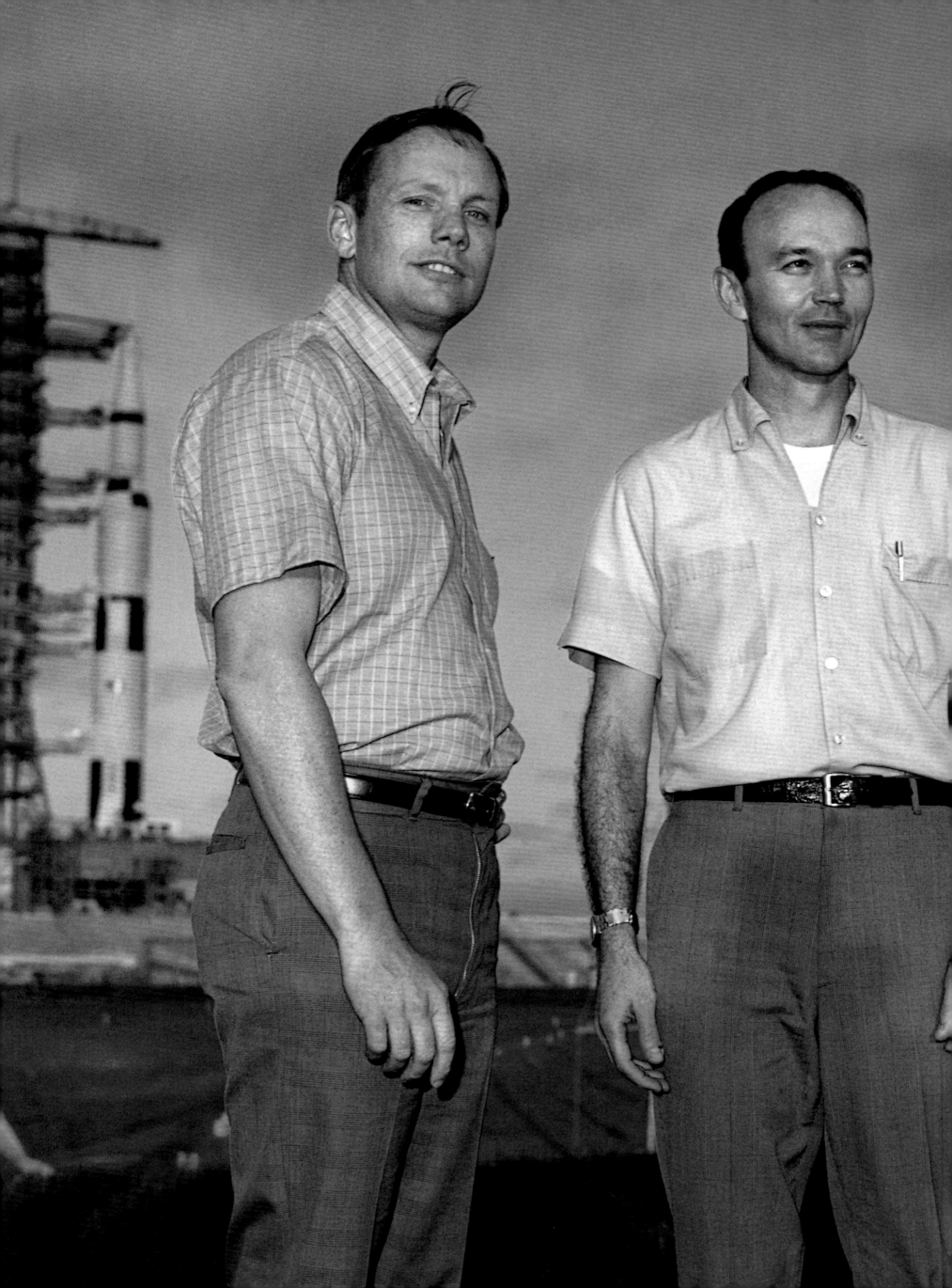

On July 20, 1969, after eight years in development, the Apollo program landed two astronauts on the Moon, just five months shy of President Kennedy's deadline. In this pre-flight publicity photo, the Apollo 11 crew—Commander Neil Armstrong, CM Pilot Mike Collins, and LM Pilot Buzz Aldrin—stands in front of the Saturn V rocket that will transport them on their historic journey.

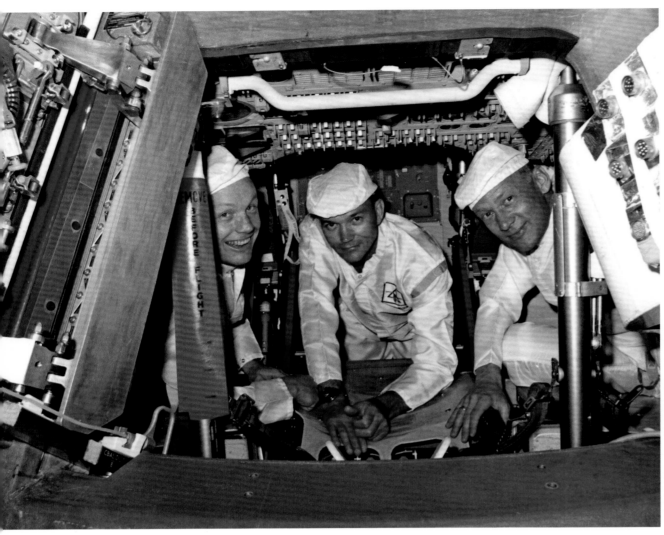

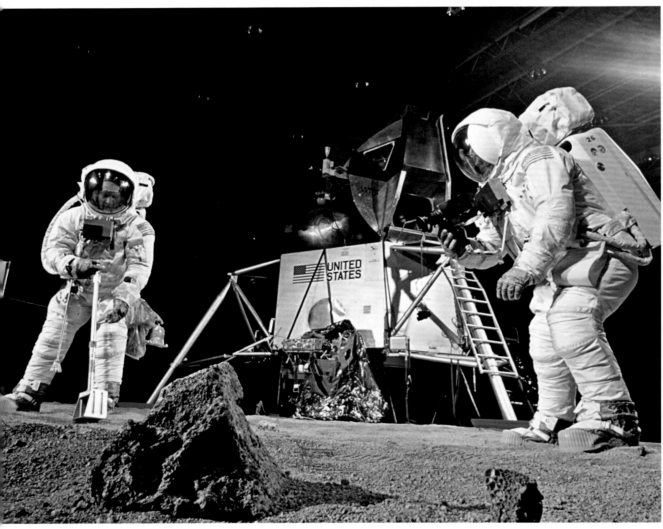

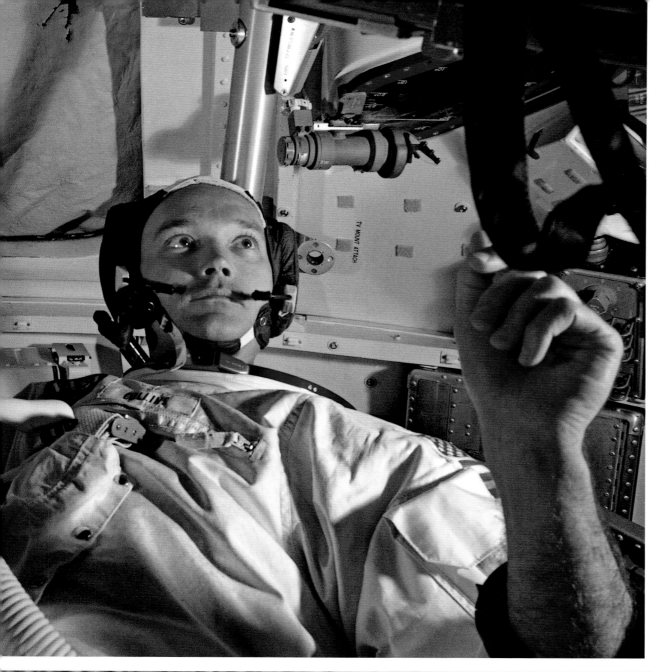

NASA photographers documented the preparations for Apollo 11 with great care, and the images on this spread are culled from hundreds that exist. **Top left** Armstrong, Collins, and Aldrin check out their spacecraft in an exercise that turned into a photo op. **Left** Collins, who spent much of his training time in the CM simulator, practices a rendezvous and docking maneuver in June 1969. **Below left** Armstrong and Aldrin rehearse a lunar EVA in the Houston thermovacuum chamber in April 1969. The chamber was not big enough for the astronauts to move as far away from the lunar module as they planned to do on the Moon, but the engineers did provide the correct lighting and temperature range. During one of these sessions, Armstrong reported from the LM: "Mission Control this is Apollo 11, we can't get the hatch open." **Below** On the day of the launch, the crew eats the traditional steak-and-eggs breakfast. Back-up CM Pilot William Anders is at left and astronaut crew chief Deke Slayton is on the right. At the meal, NASA Administrator Thomas Paine told the astronauts that the primary concern must be their own safety, assuring them that if the mission were aborted, they would be granted spots on the next attempted landing.

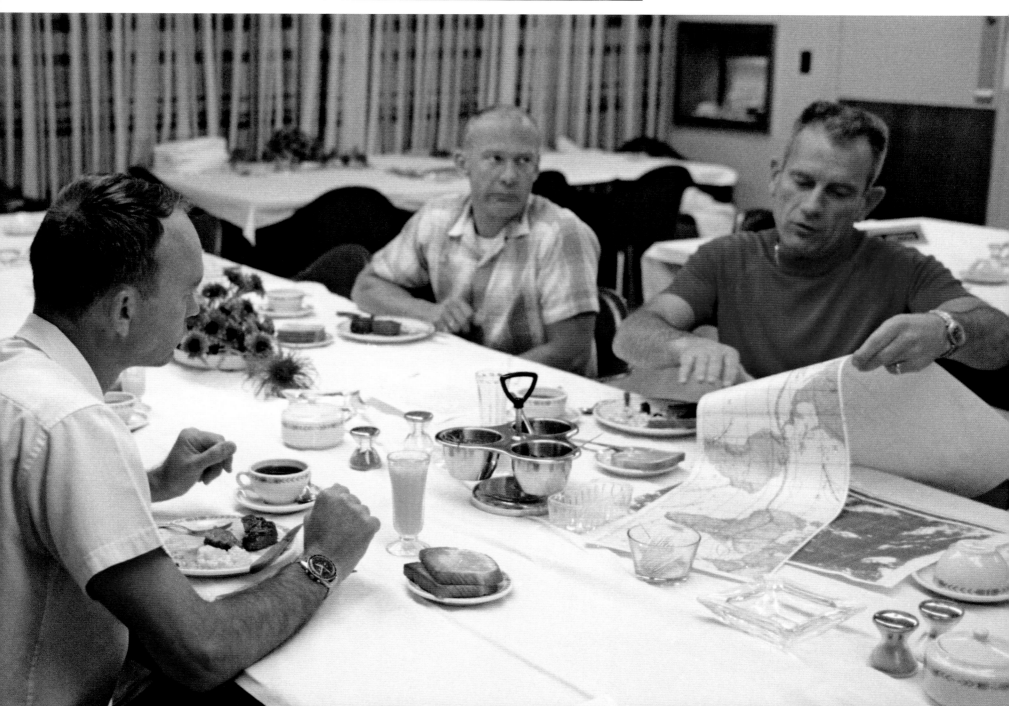

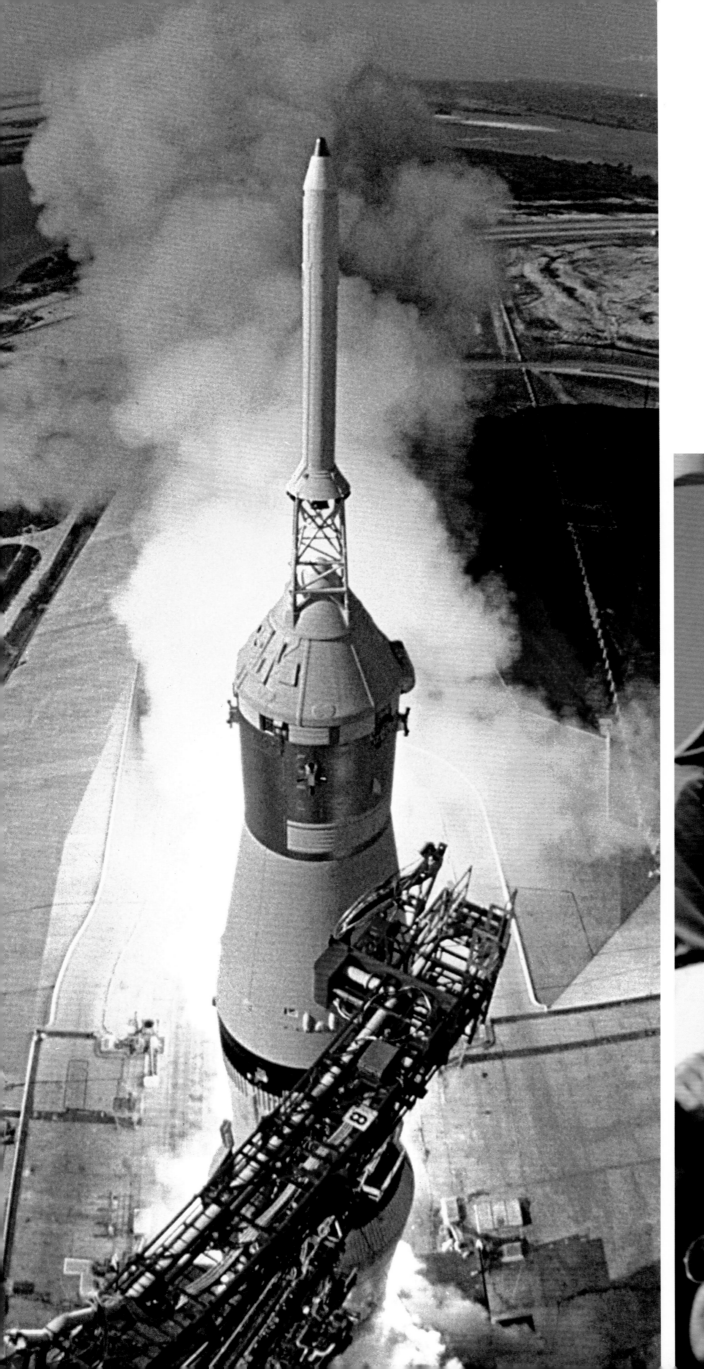

Opposite July 16, 13:32:00 UTC: the six million-pound Saturn V rocket lifts off, beginning Apollo 11's historic mission. Later, Collins would compare the experience to the launch of Gemini 10: "I am just as tense this time, but the tenseness comes mostly from an appreciation of the enormity of our undertaking. . . . I wouldn't give better than even odds on a successful landing and return." **Below** Witnessing this key moment in the Apollo program he was instrumental in spearheading, former-President Lyndon Johnson (middle) is flanked by his daughter, Lynda, and Vice President Spiro Agnew.

Overleaf July 20, 20:17:40 UTC: the lunar module *Eagle* carrying Armstrong and Aldrin touched down on the Moon. "Houston, Tranquility Base here, the *Eagle* has landed," Armstrong informed mission control. Stepping onto the surface, he made his famous declaration: "One small step for a man, one giant leap for mankind" (recent analysis of the transmission suggests that the much-argued-about "a" was spoken). Armstrong was carrying a Hasselblad 500EL camera modified with a transparent Reseau plate engraved with a grid of crosses. These crosses are visible in the photographs, and they make it possible to calibrate the distance and size of objects. **Left** The first photograph taken by a human on the Moon shows one leg of the LM and a jettison bag full of stuff the astronauts won't need to bring back to Earth. **Right** A sequence of images shot by a 16mm Maurer motion-picture film camera mounted in a window of the LM shows Armstrong (top) and Aldrin (bottom) kangaroo-hopping across the lunar surface, and Armstrong photographing Aldrin as he salutes the American flag they planted (middle).

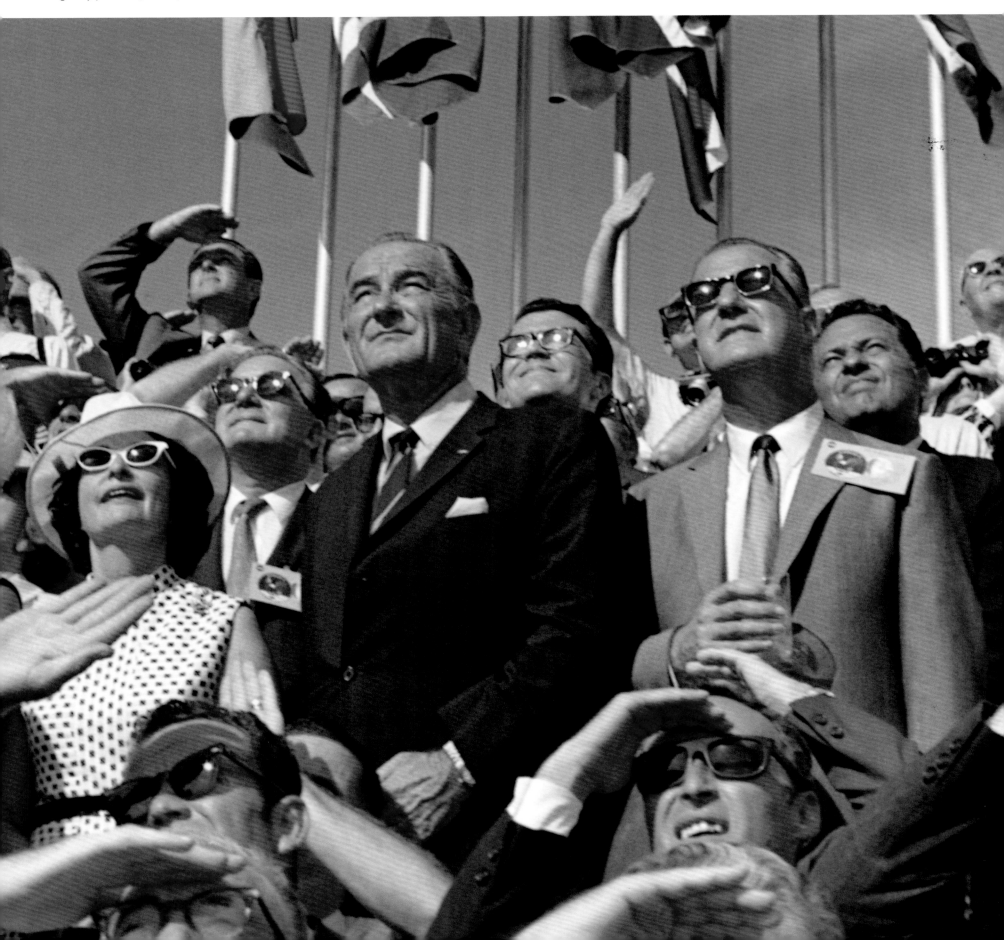

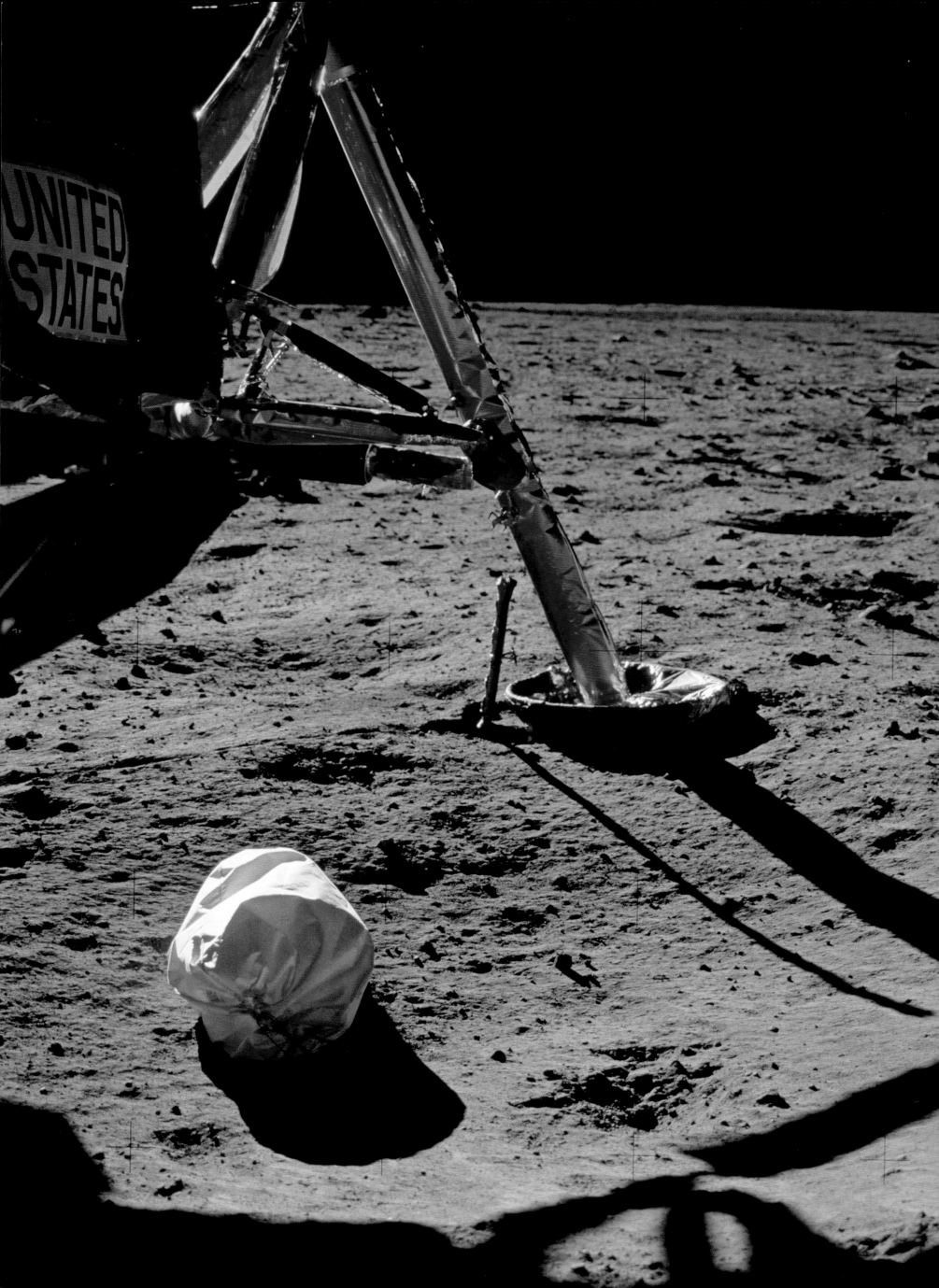

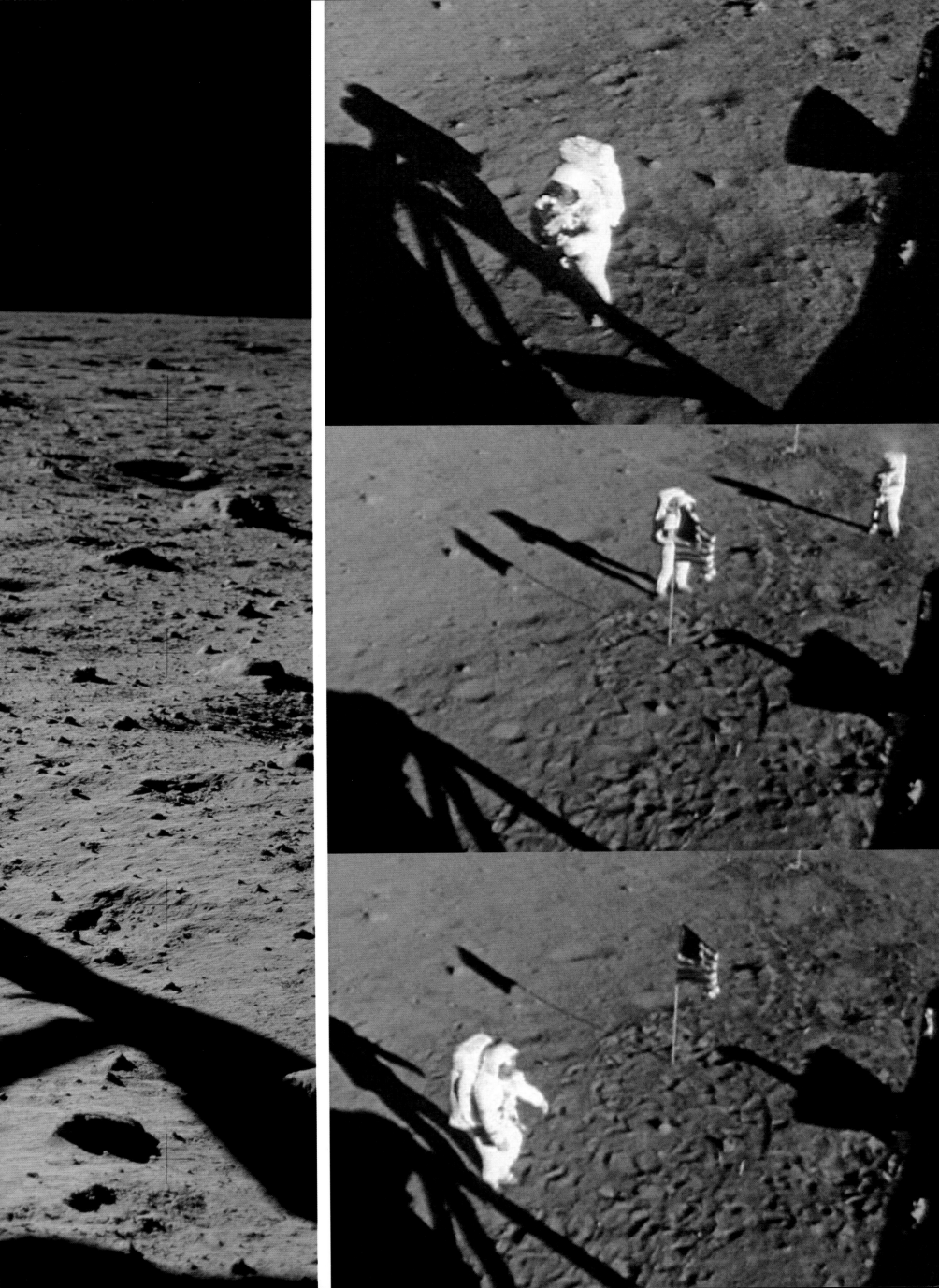

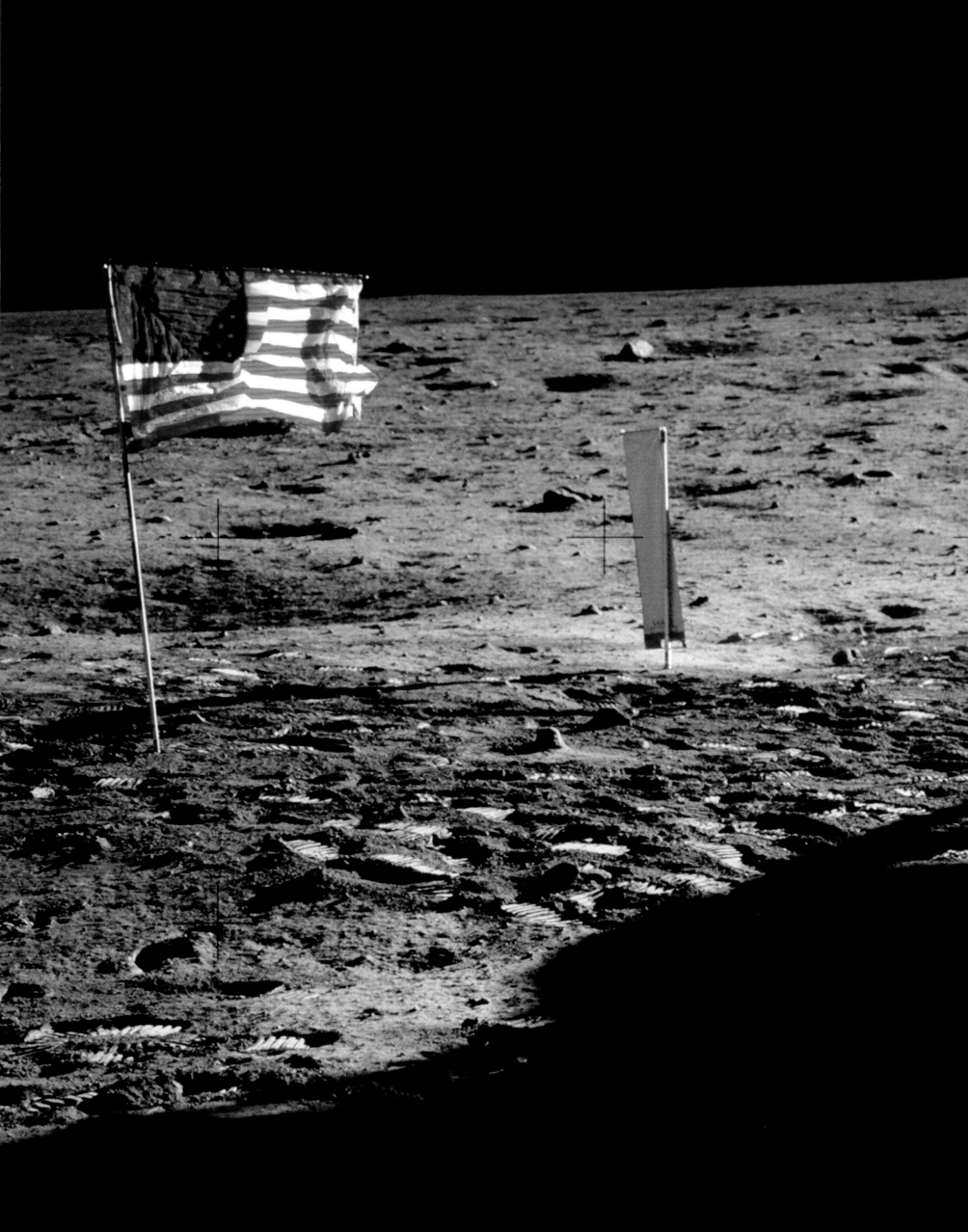

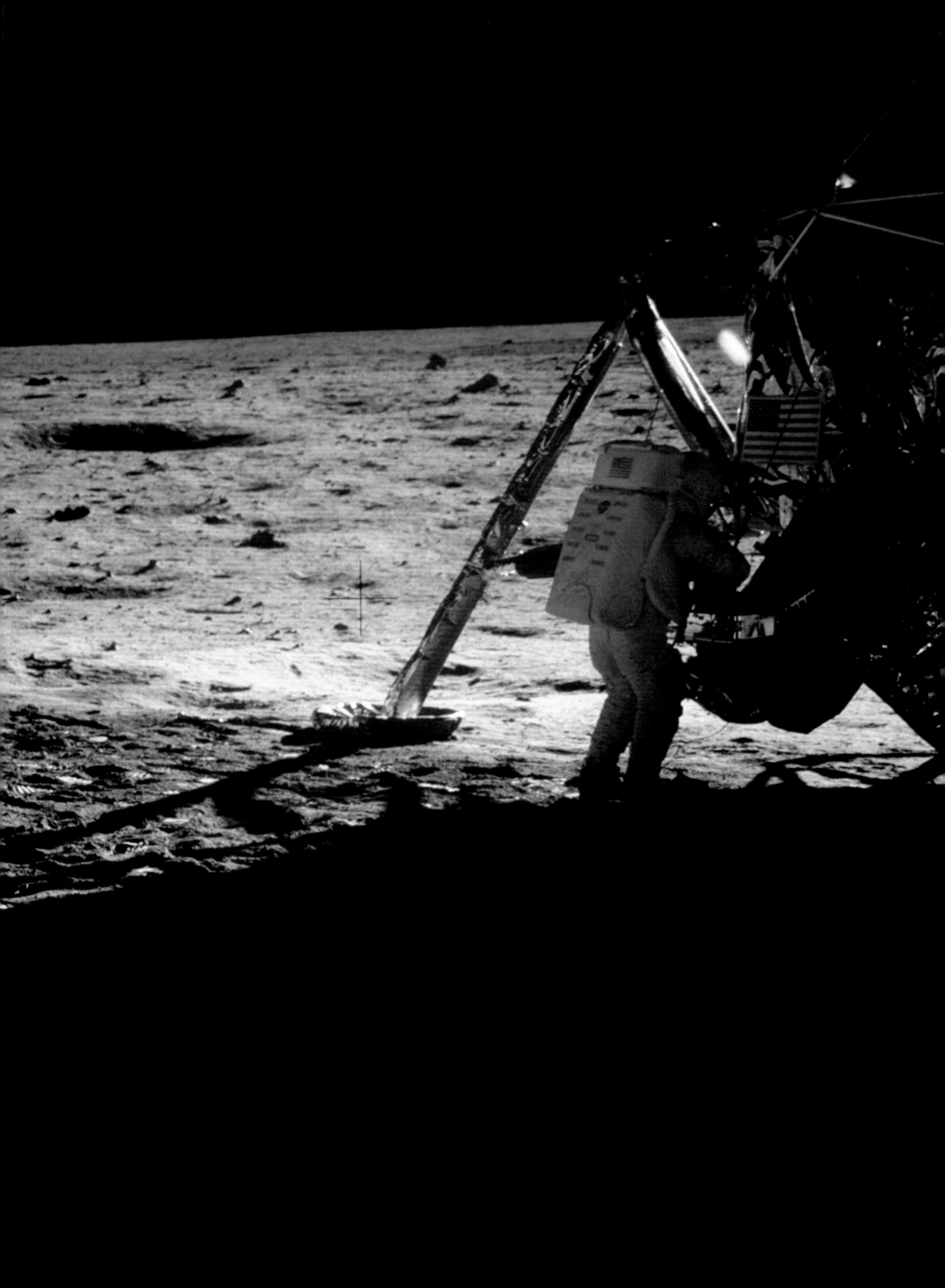

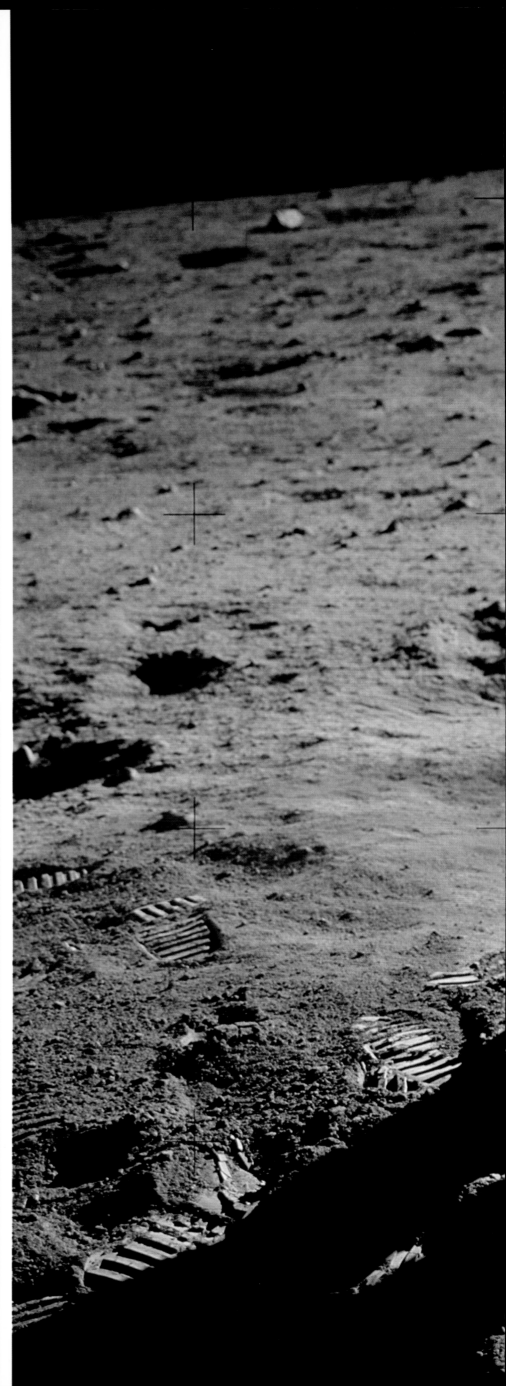
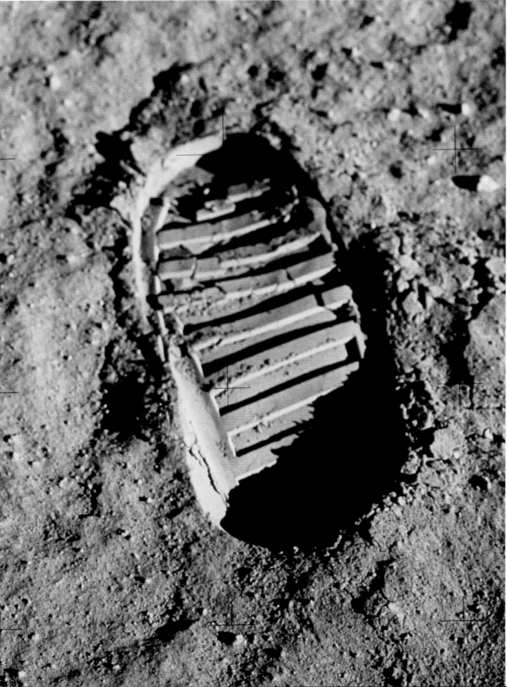
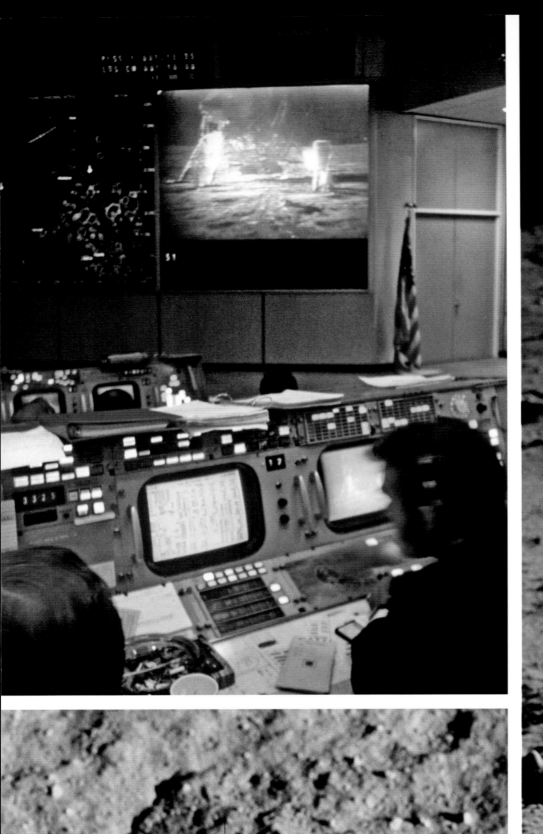

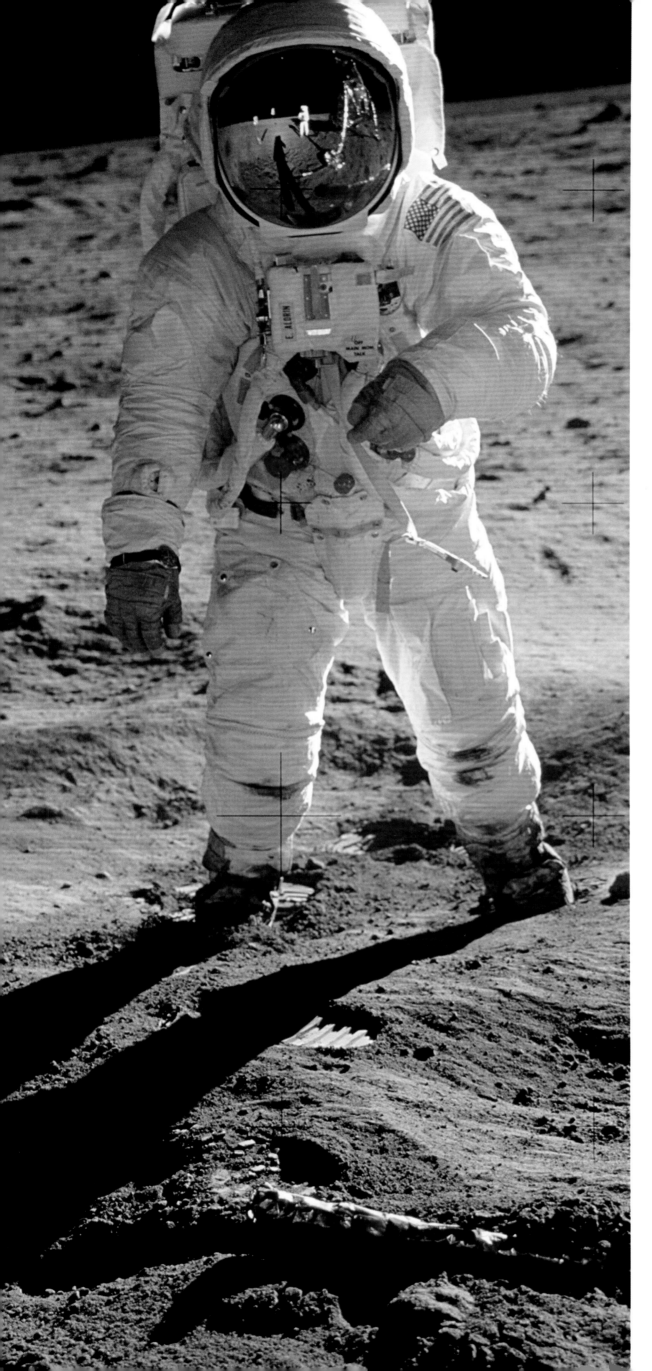

Top left Half a billion people across the world tuned in to watch the moonwalk on television, via a black-and-white TV camera; technicians at Mission Control got the same video feed. It was only later, when NASA officials were reviewing the Apollo 11 film, that they discovered they couldn't identify a photo of the first man on the Moon. A selection of Armstrong's shots of Aldrin was made for release to the press. Much later, they realized that Aldrin did have the camera for a time during the first moonwalk.

Previous spread A photograph of Armstrong taken by Aldrin during the first moonwalk.

Near left This remarkable shot of Aldrin, with Armstrong and Tranquility Base reflected in his gold-coated visor, became the iconic image of the mission. From his point of view, Aldrin described the panorama as "magnificent desolation."

Bottom left Aldrin's photo of his bootprint in the lunar dust also has great symbolic meaning for many.

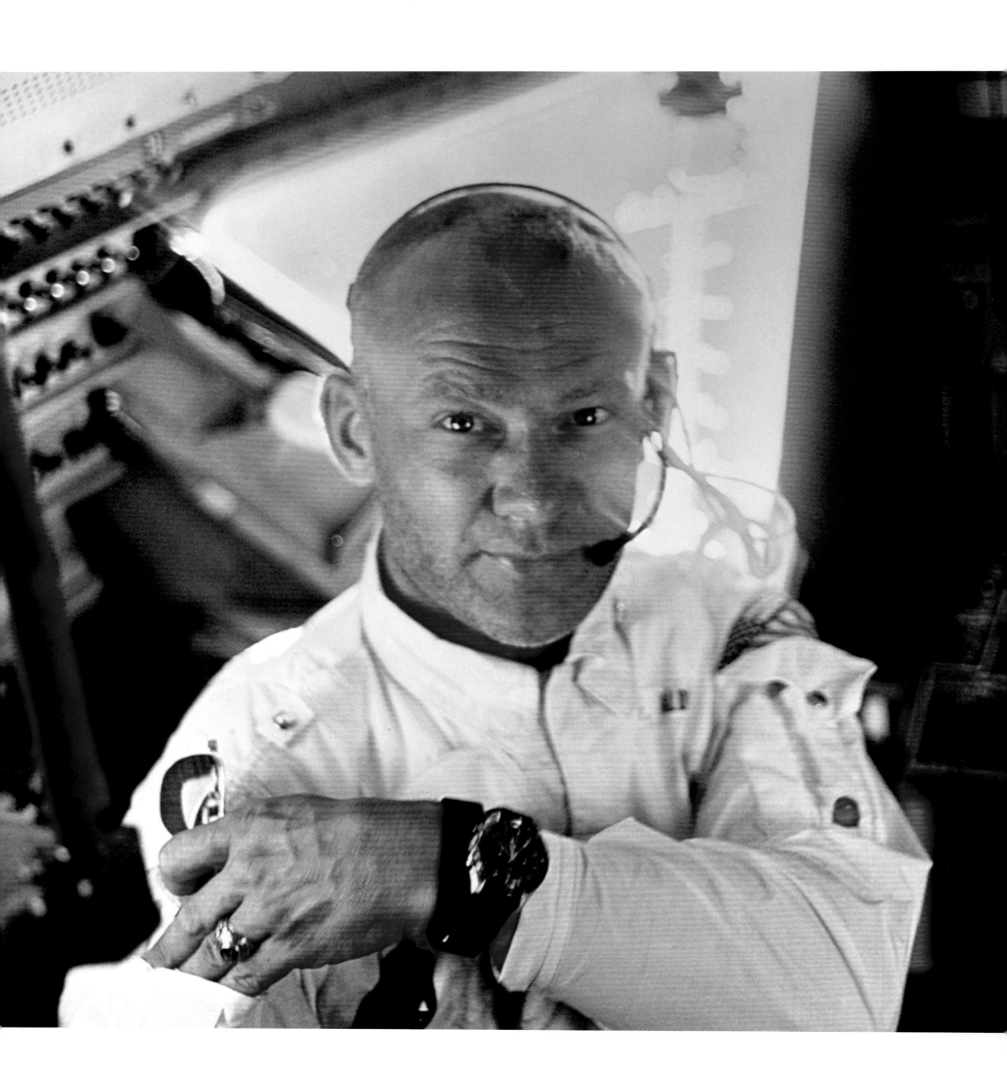

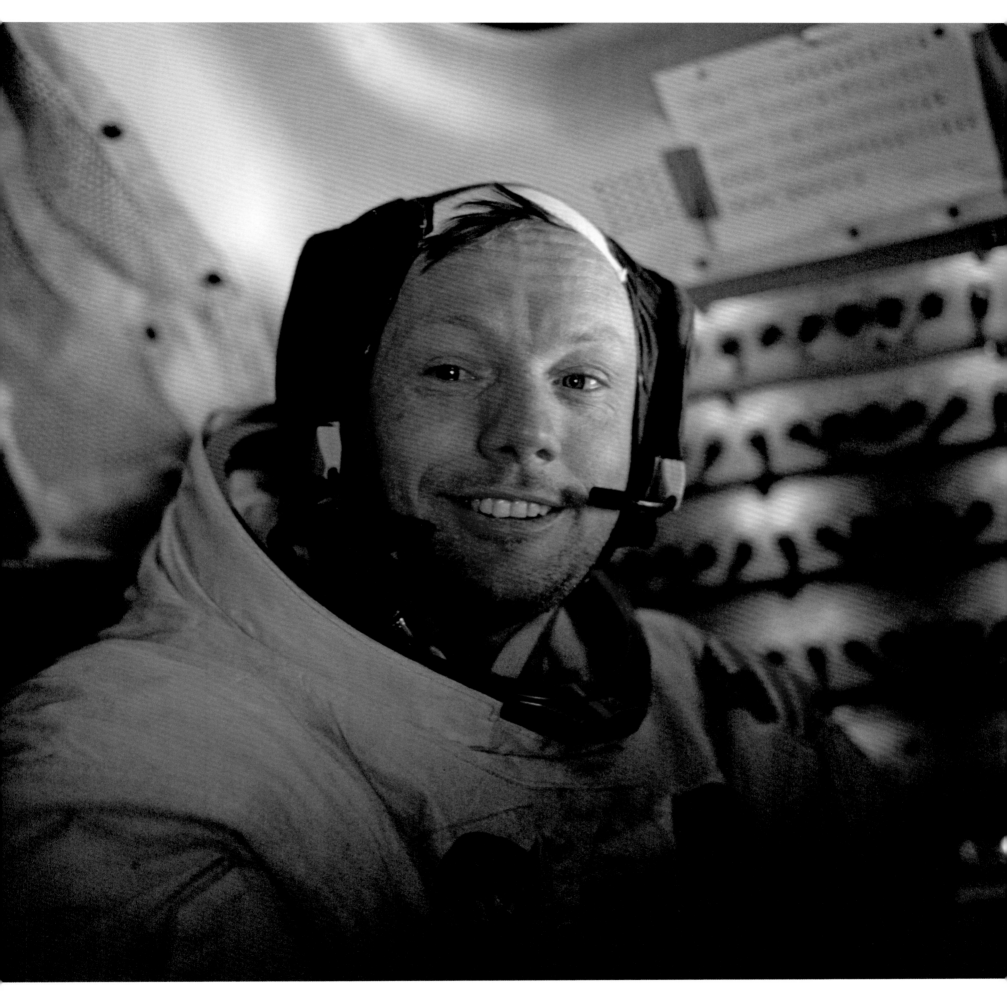

Opposite and above Aldrin (left) and Armstrong (right) pose for each other in the LM after their two-and-a-half-hour EVA. Armstrong said the moonwalk was like being a "five-year-old boy in a candy store." The astronauts left behind a number of symbolic items, including a patch from Apollo 1, two Soviet medals honoring killed cosmonauts, a silicon disk with messages from world leaders, and a golden olive branch carried for their wives. Twenty-one and a half hours after landing on the Moon, they lifted off in *Eagle's* ascent stage to return to the command module *Columbia*.

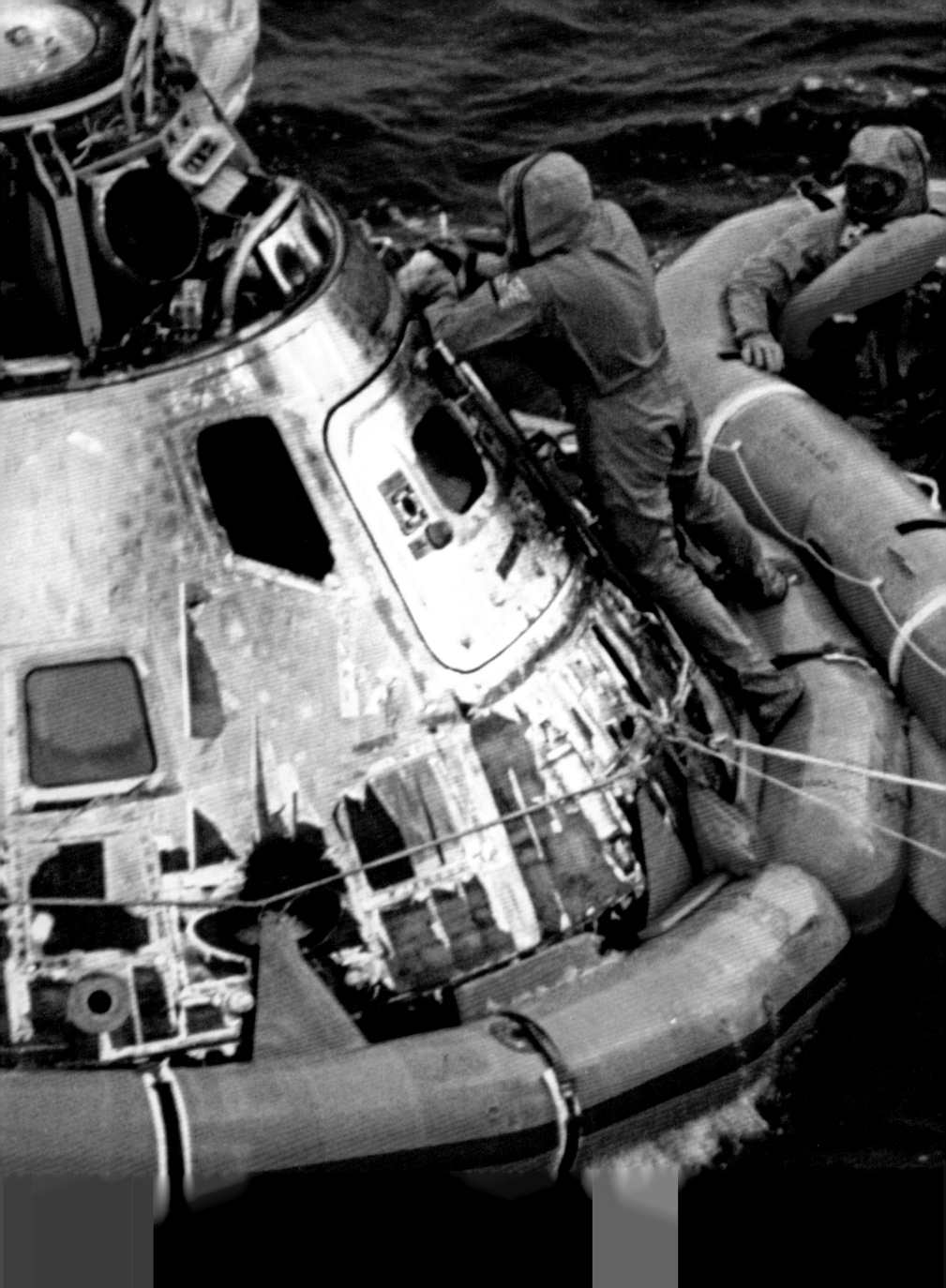

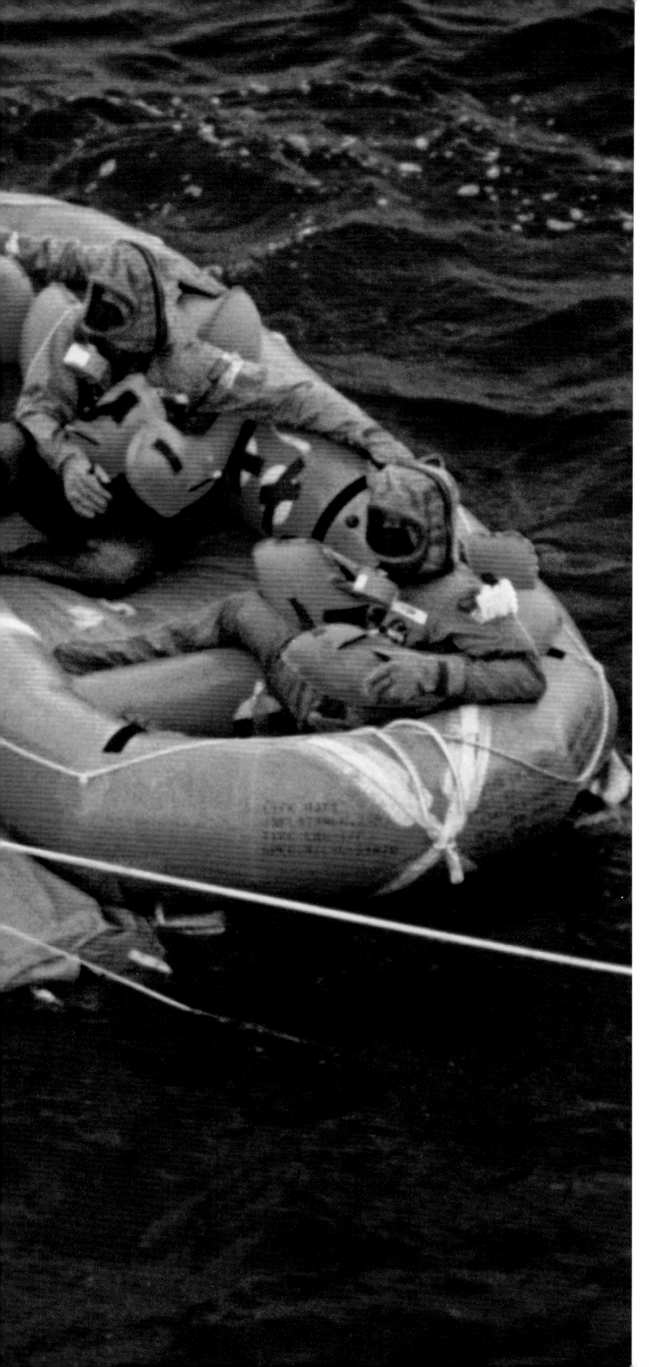

Left July 24, 16:50:35 UTC: splashdown, nine hundred miles southwest of Hawaii. Pararescueman Lt. Clancy Hatleberg closes the Apollo 11 spacecraft hatch as the astronauts, dressed in biological isolation garments, await helicopter pickup from their life raft.

Overleaf Once aboard the USS *Hornet*, the crew was placed inside a mobile quarantine facility designed to prevent any possible "moonbugs" from contaminating Earth. NASA dispensed with the quarantines following Apollo 14, after scientists were sufficiently convinced there were no microorganisms, harmful or otherwise, coming back from the lunar surface. President Richard Nixon was waiting on the *Hornet* to greet the astronauts and spoke and joked with them through the glass window of the quarantine van. This was the occasion upon which he made his oft-quoted comment, "this is the greatest week in the history of the world since the Creation."

Pages 196-99 On August 13, 1969, the Apollo 11 crew receives a hero's welcome with a ticker-tape parade through downtown New York City, at the time, the largest parade in the city's history. Apollo 11 would be the final space flight for all of them.

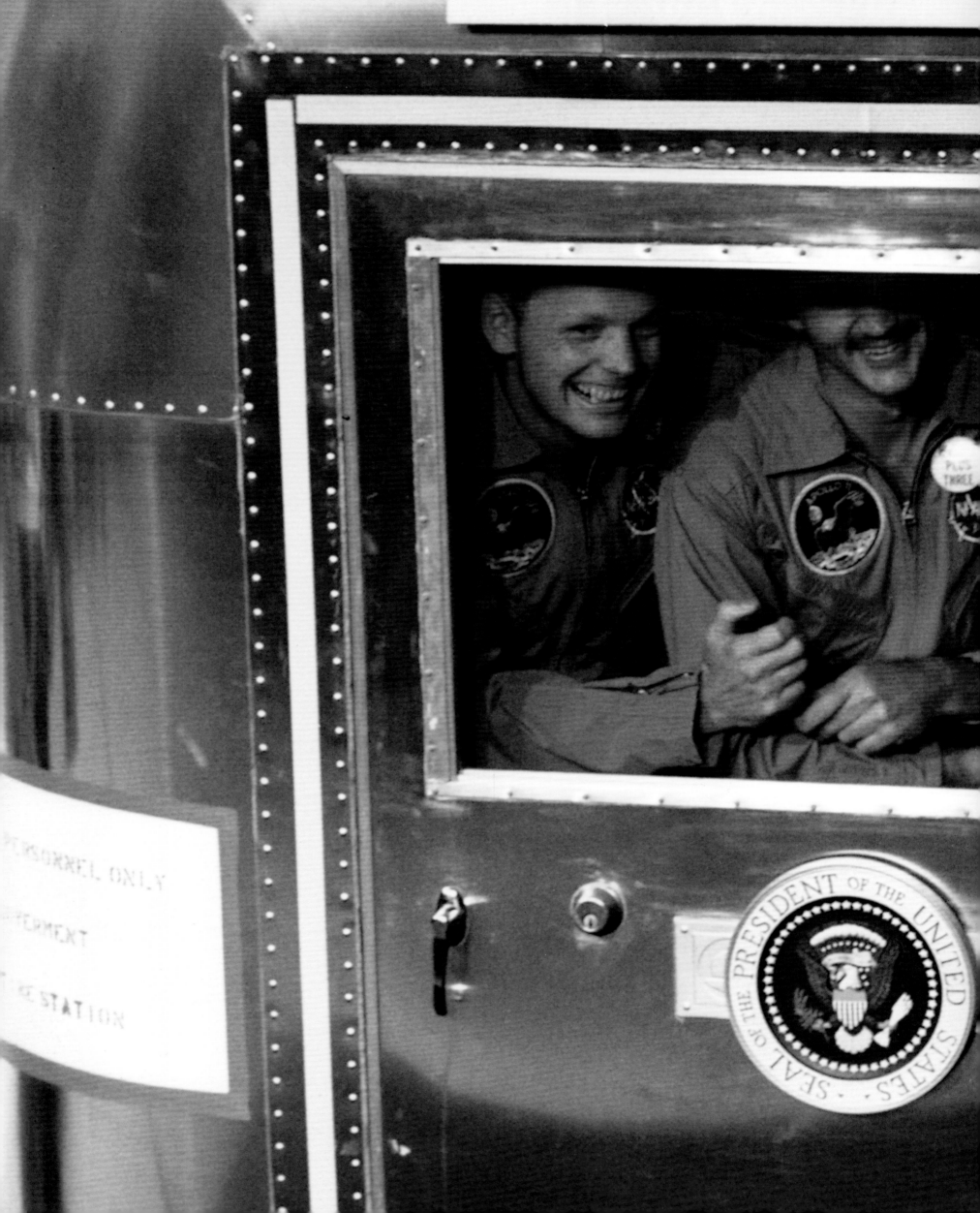

HORNET +

PERSONNEL ONLY

FERMENT

STATION

SEAL OF THE PRESIDENT OF THE UNITED STATES

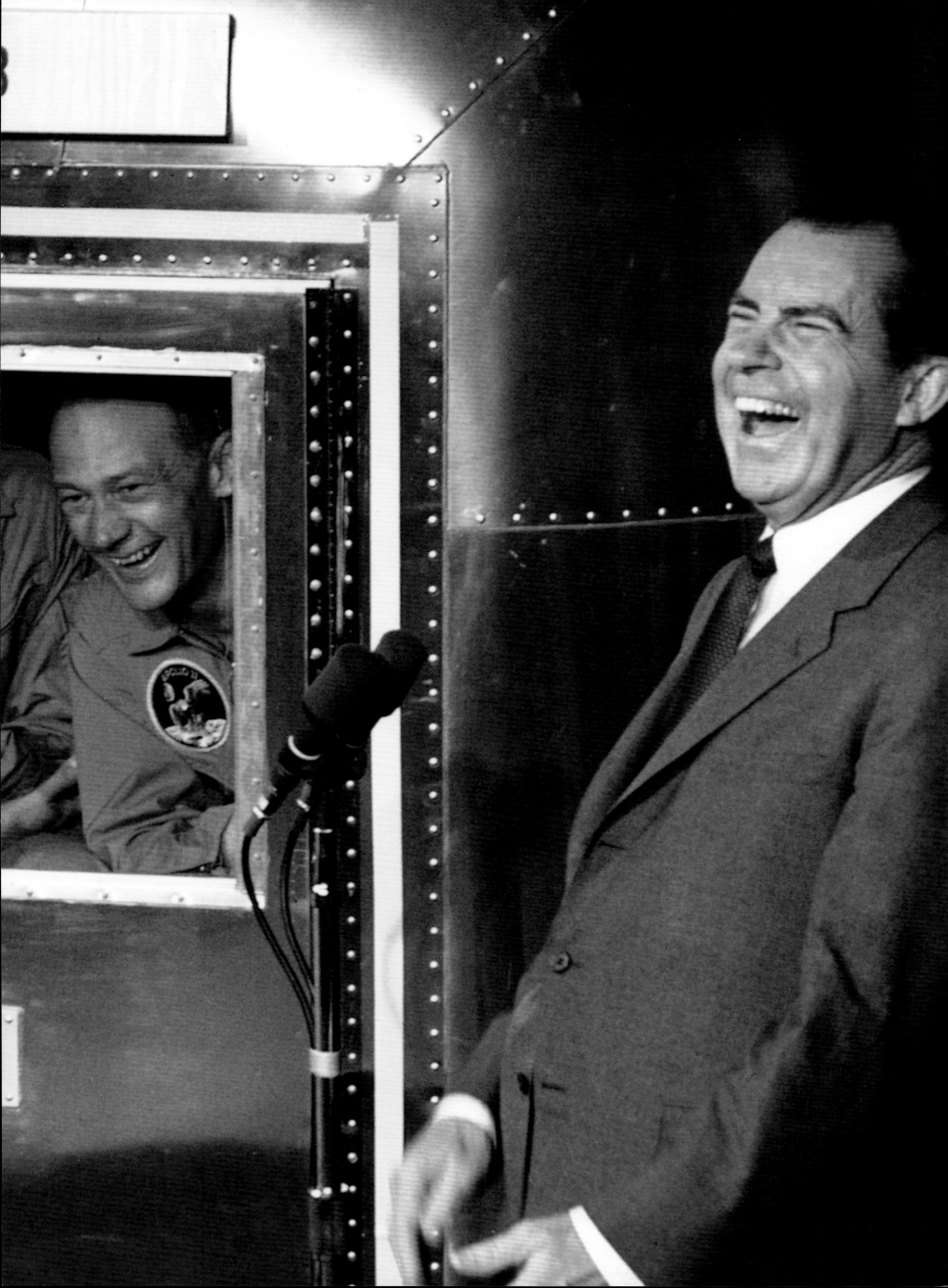

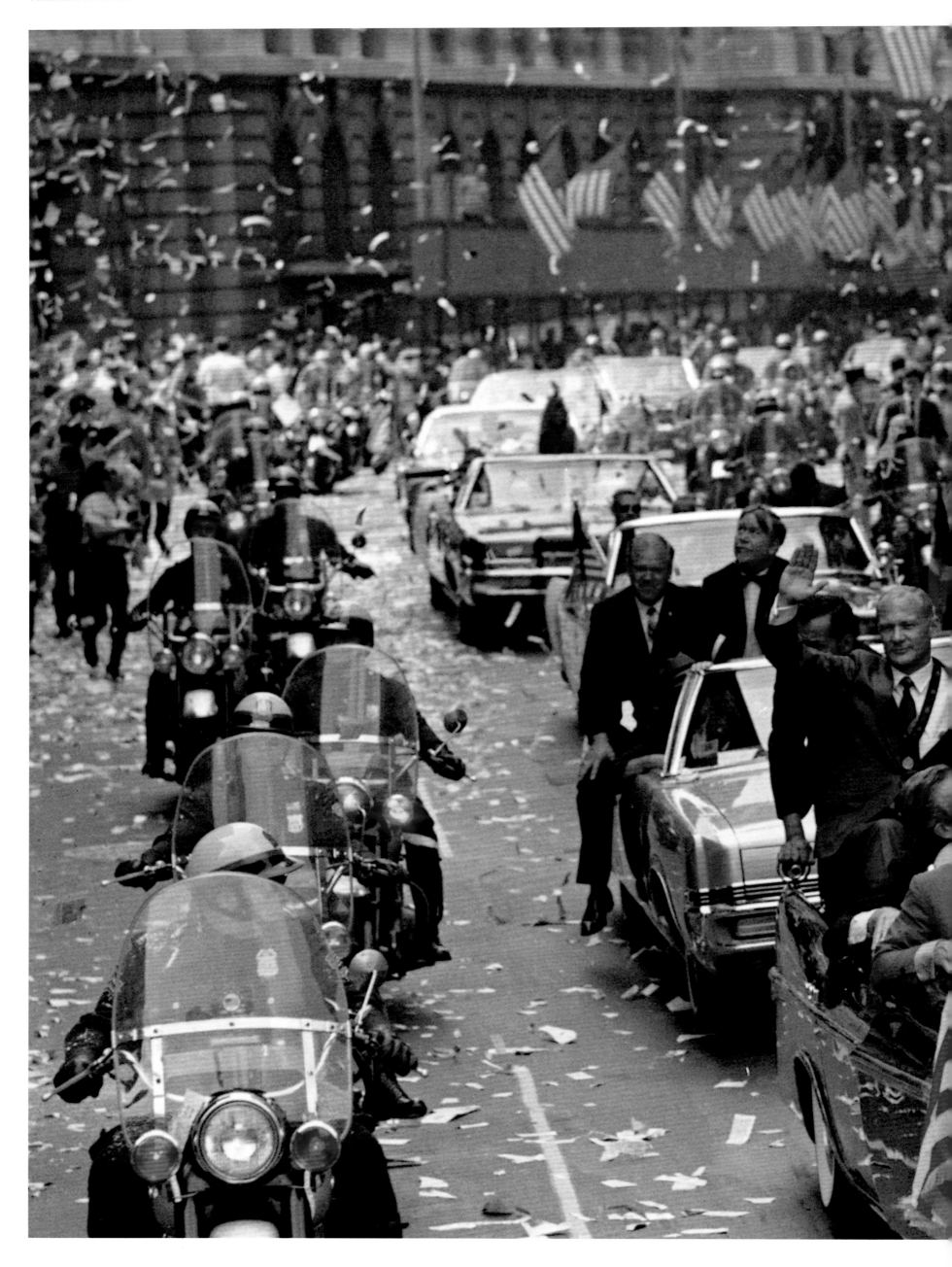

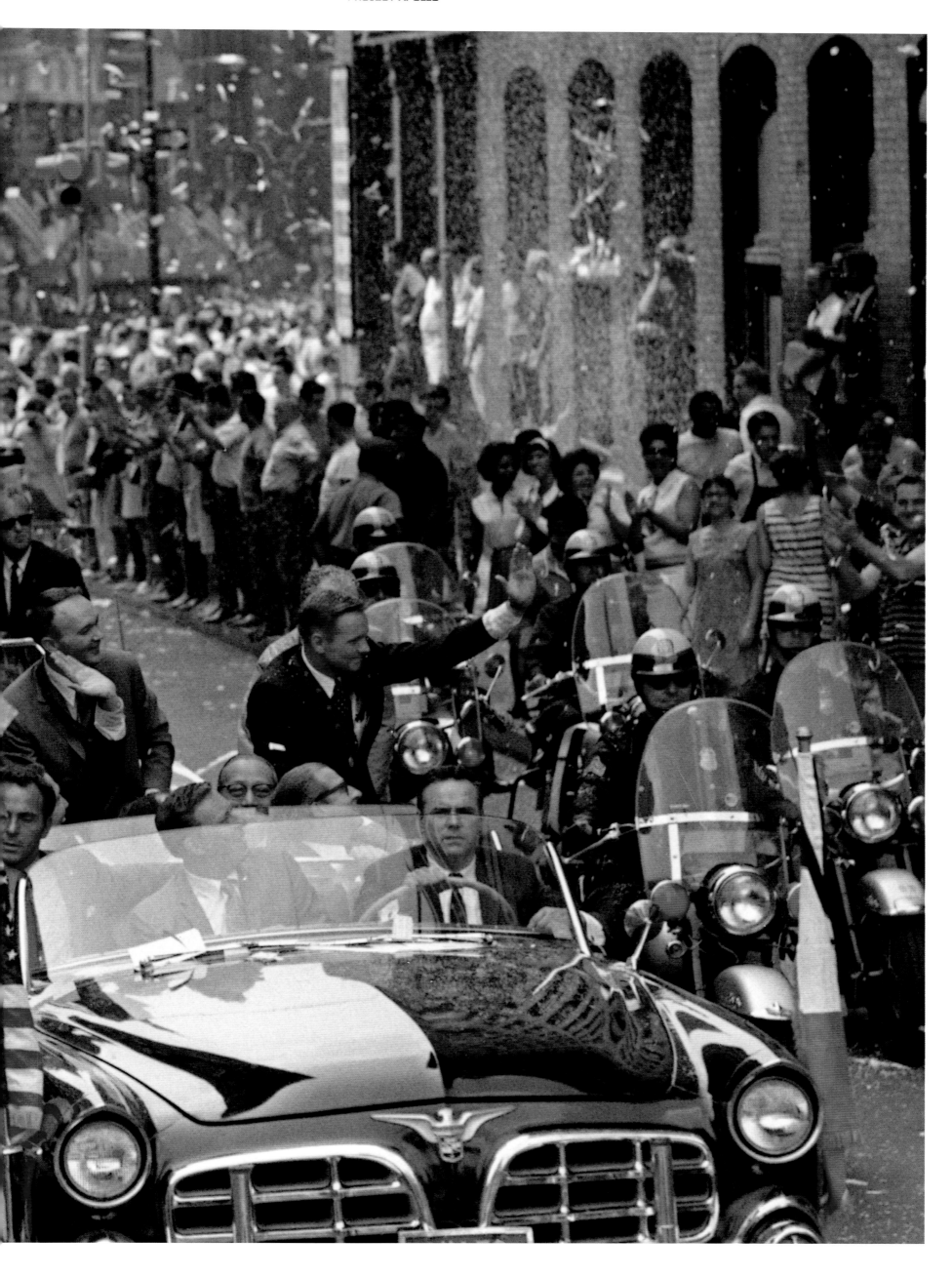

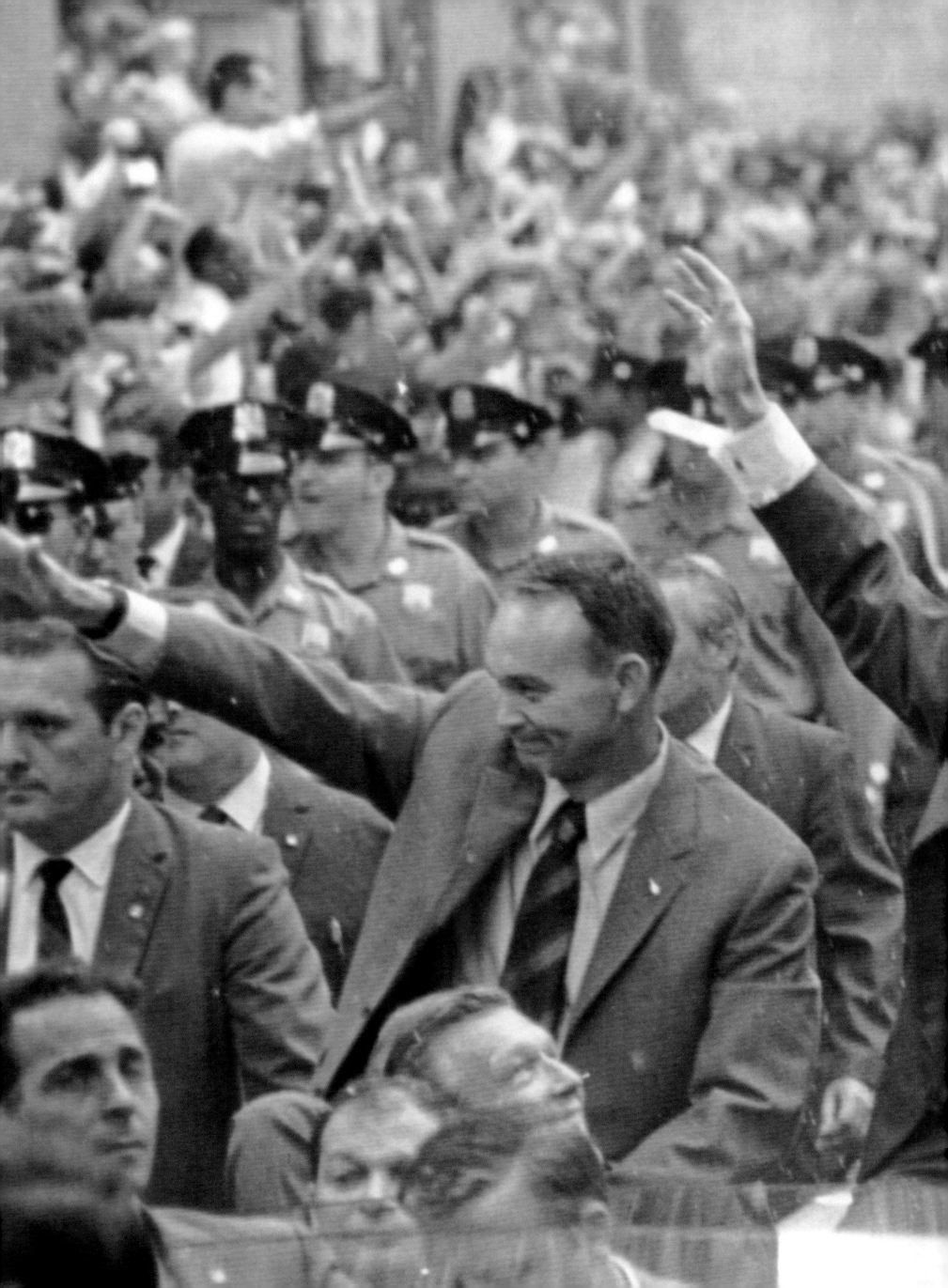

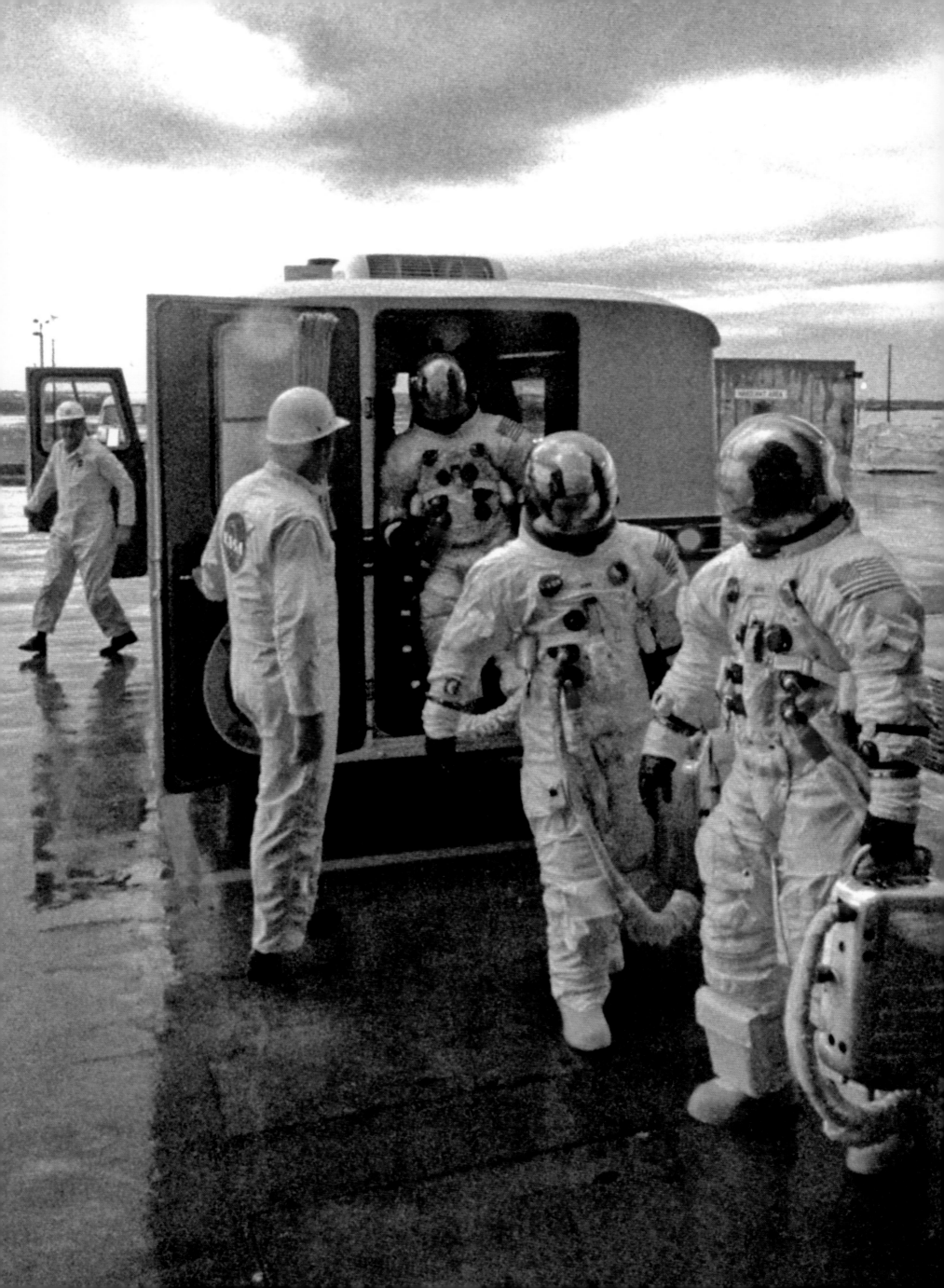

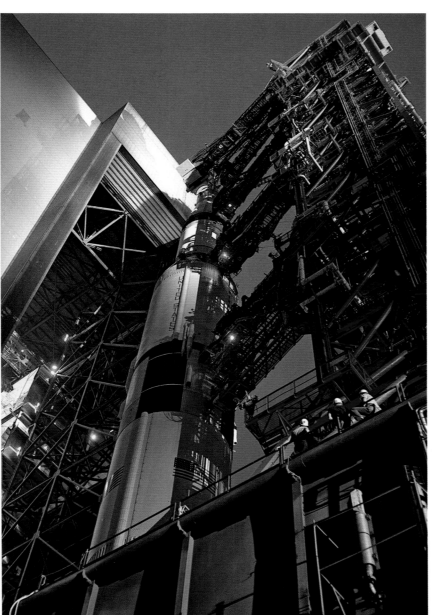

Left The crawler-transporter carrying the Apollo 12 Saturn V rocket begins its three-and-a-half mile, snail-paced journey from the VAB to Launch Complex 39A.

Below A view of Firing Room #2 in the Launch Control Center during a countdown demonstration test for Apollo 12 on October 28, 1969.

Far left Commander Pete Conrad, CM Pilot Richard Gordon, and LM Pilot Alan Bean leave the transfer van at the pad prior to launch on November 14, 1969. The rainy weather resulted in a lightning discharge that traveled down the spacecraft's exhaust plume shortly after lift-off, temporarily garbling its telemetry feeds. Thanks to quick thinking and Bean's memory of a similar training incident, the feeds were restored and the mission didn't have to be aborted.

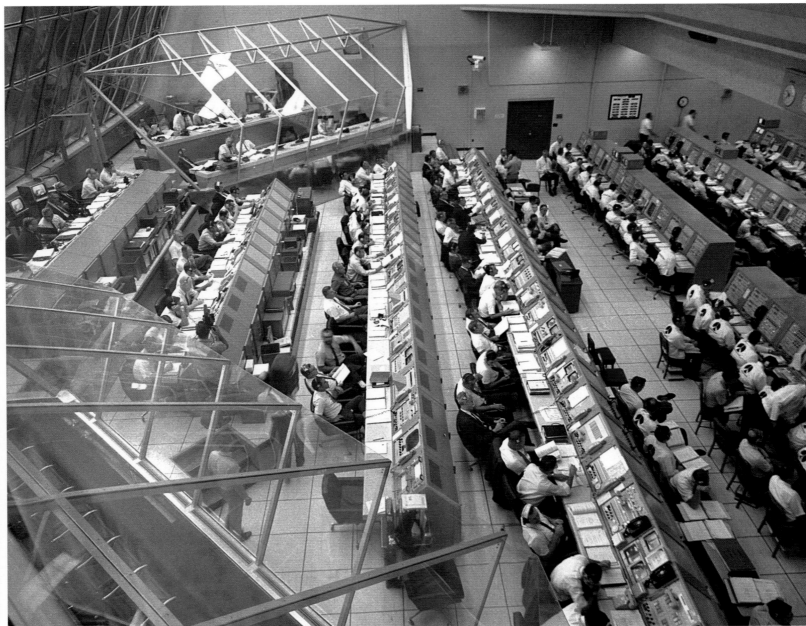

Right After Apollo 11 proved a lunar landing and safe return possible, the missions began to call for more extensive exploration and experimentation. Here, Gordon attaches a telephoto lens to a camera during simulation training for Apollo 12 in October 1969. Among many other duties, Gordon was tasked with photographing the lunar surface from the command module as Conrad and Bean explored.

Overleaf bottom Gordon photographed the lunar module *Intrepid* from the command module *Yankee Clipper* (both named in homage to the crew's Navy background) as it descended toward the Moon.

Overleaf top left Conrad becomes the third man to step onto the lunar surface on November 19, 1969.

Overleaf top center Conrad photographed Bean as he set up the Apollo Lunar Surface Experiments Package (ALSEP), which included a seismometer, magnetometer, and sensors for the study of moonquakes and solar wind. Conrad and Bean collected 75.7 pounds of rocks over the course of two moonwalks that together lasted almost eight hours.

Overleaf top right One of Apollo 12's challenges was to land *Intrepid* within walking distance of the *Surveyor 3* probe that had come to rest in the Ocean of Storms on April 20, 1967 (see page 320). The astronauts had to travel no more than 600 feet to reach *Surveyor 3*, where Bean photographed Conrad. *Intrepid* is visible on the horizon.

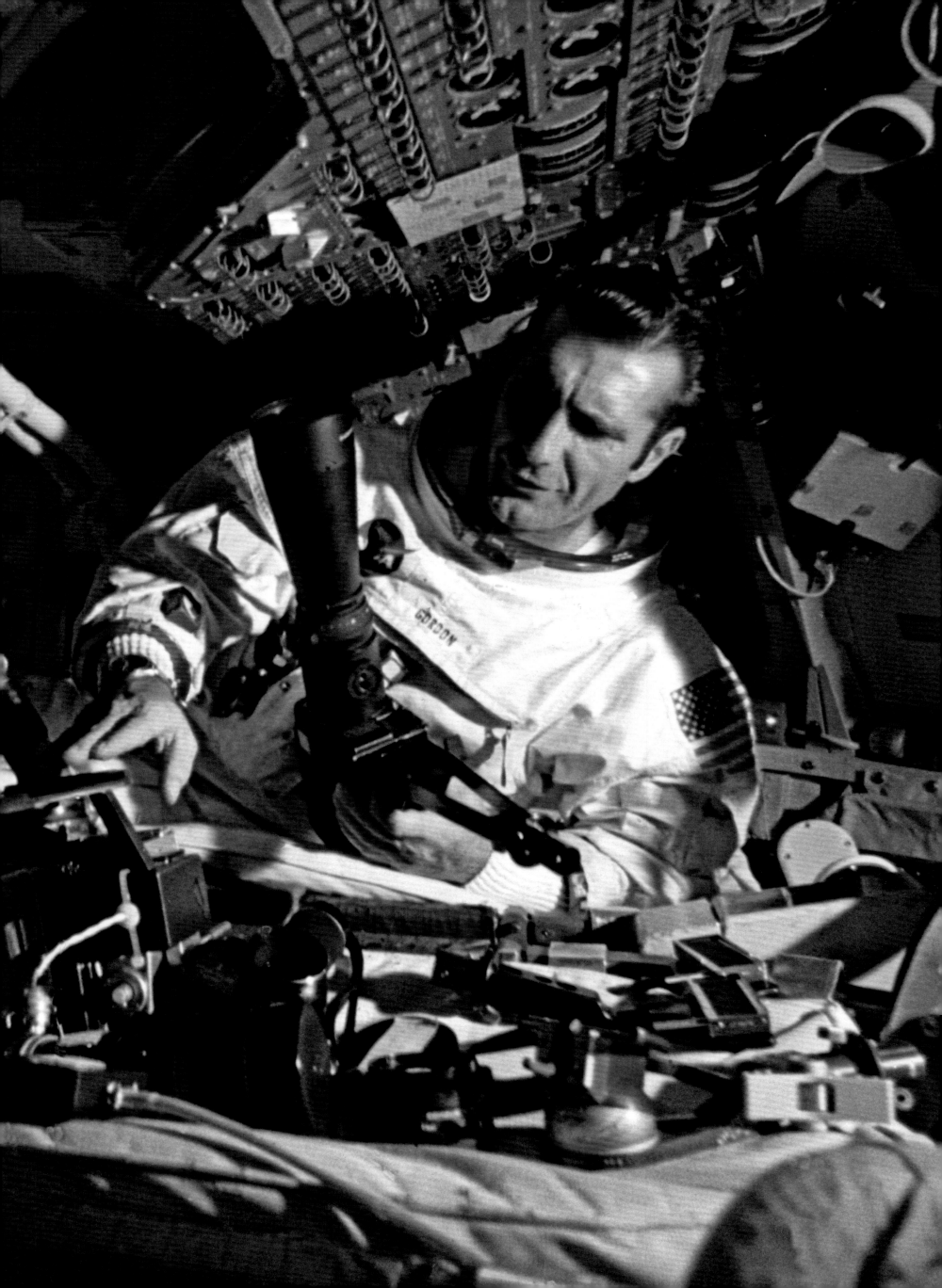

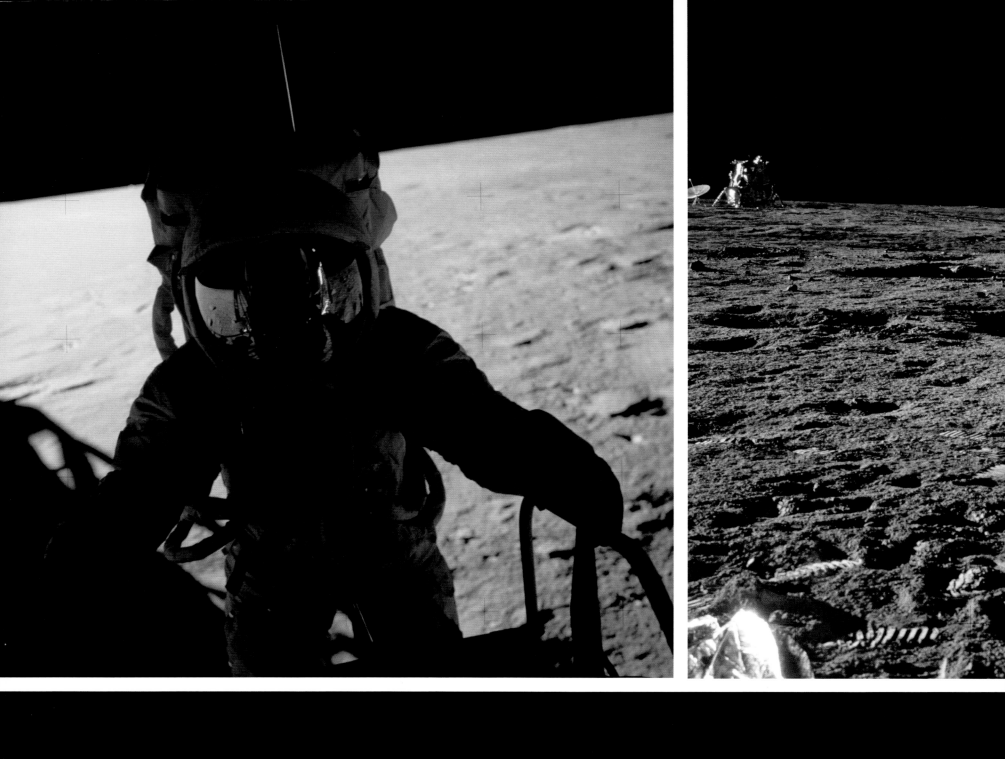
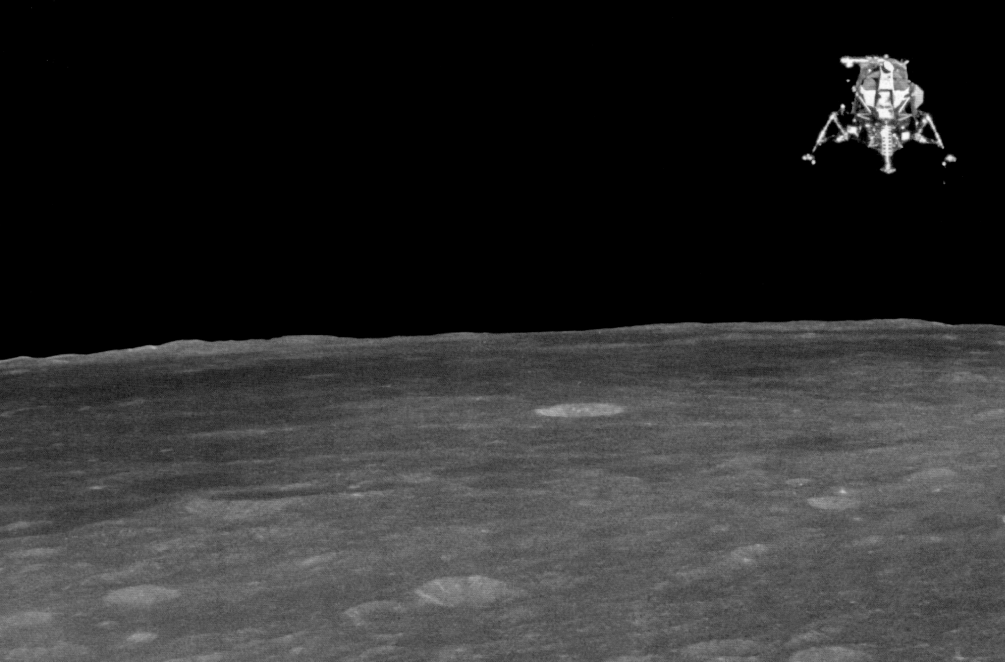

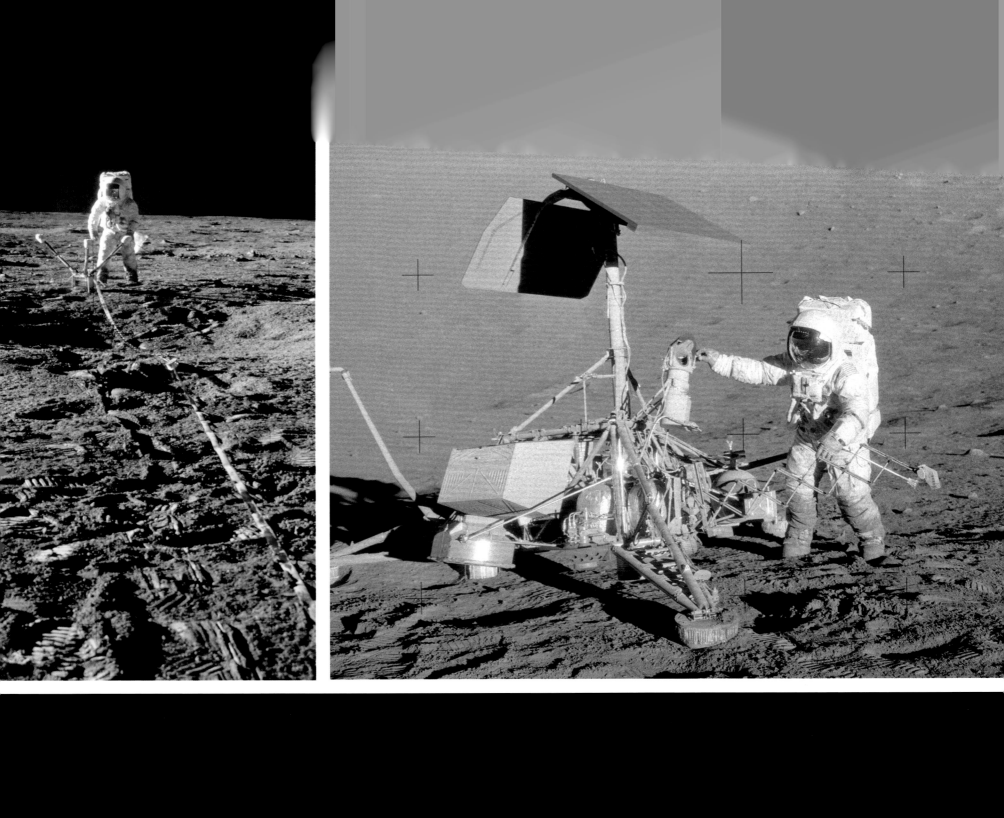

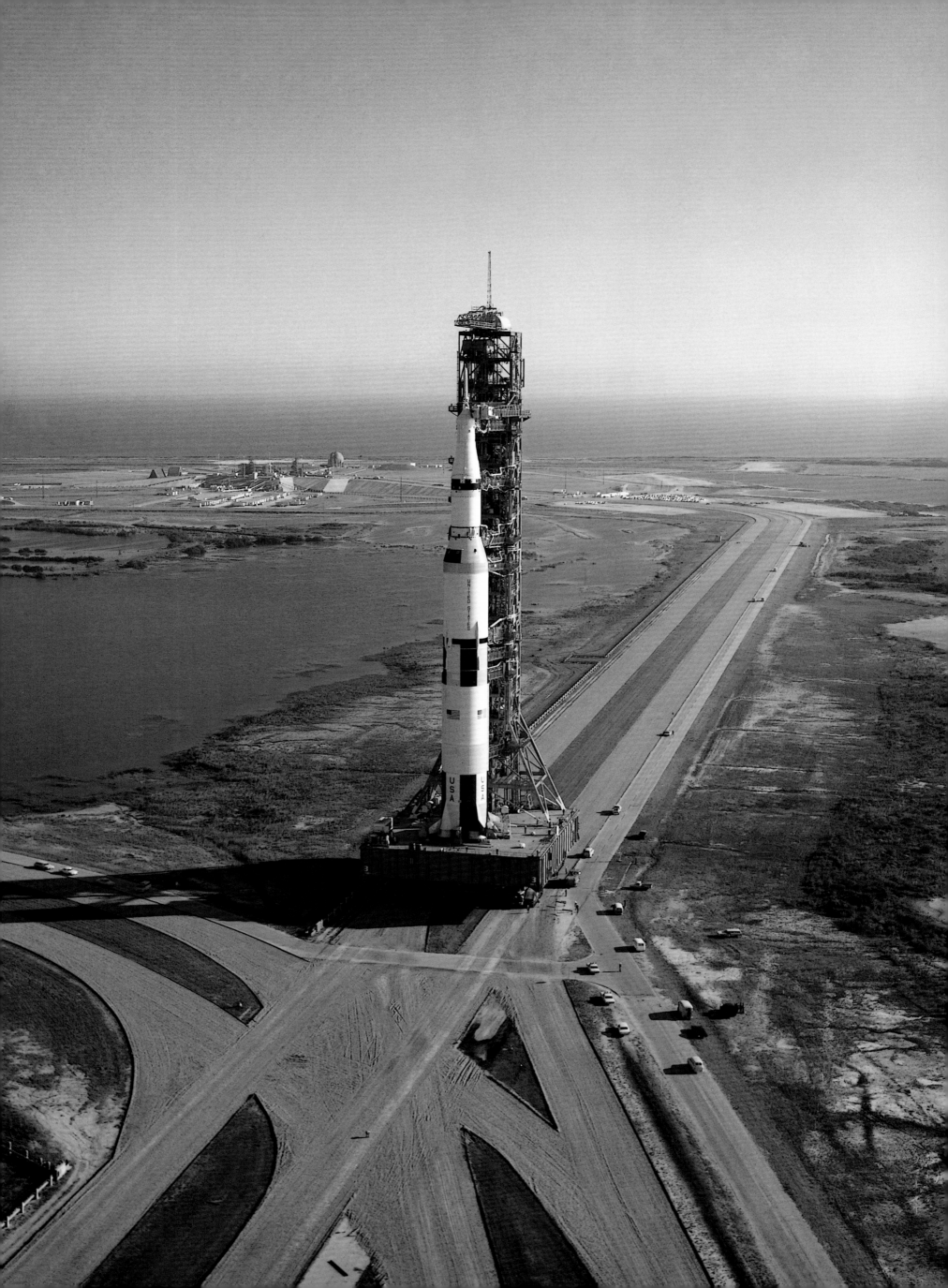

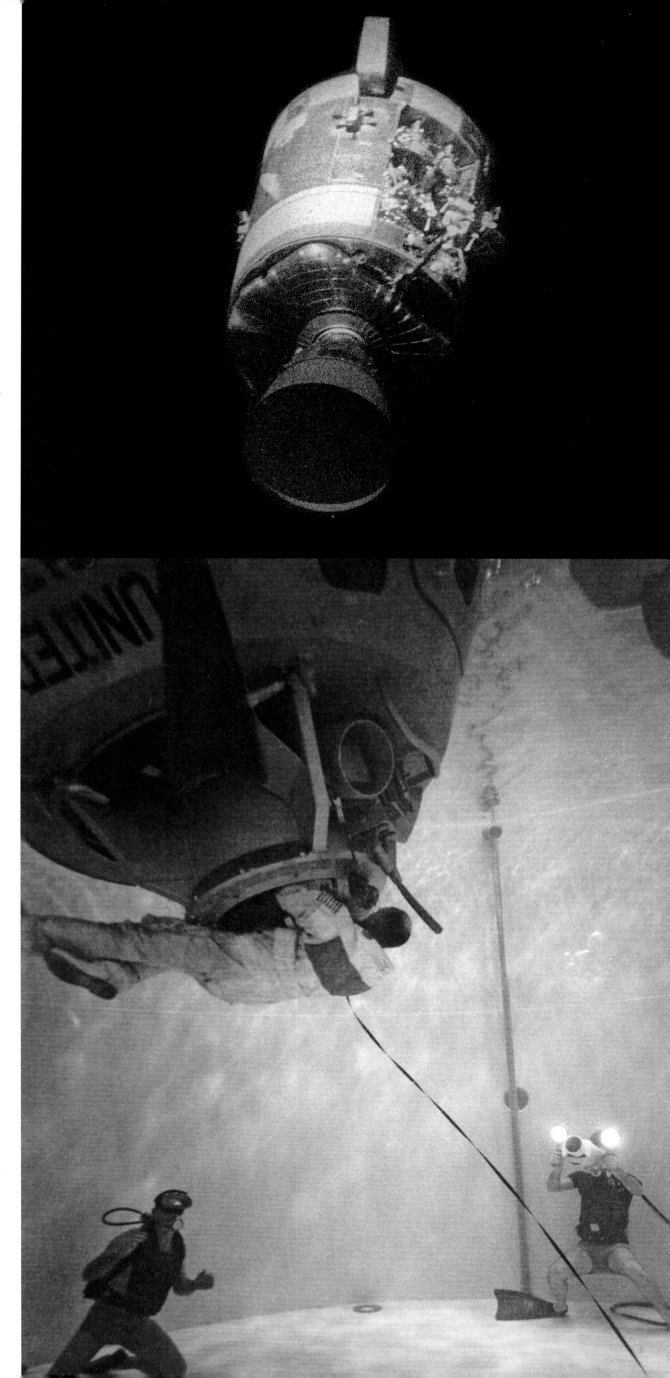

Opposite The Apollo 13 Saturn V is seen midpoint in its journey on the crawler-transporter to Launch Complex 39A. The ill-fated mission carrying Commander James Lovell, CM Pilot John Swigert, and LM Pilot Fred Haise was launched on April 11, 1970. Two days after launch, the explosion of an oxygen tank in the service module caused the command/service module to lose both oxygen tanks and two of the three fuel cells that powered its electrical systems, forcing the astronauts to use the lunar module *Aquarius* as a "lifeboat" for an emergency return to Earth.

Above right When the service module was later jettisoned before reentry, the crew photographed it; they saw that the access panel covering the oxygen tanks and fuel cells had been blown off by the force of the explosion.

Right Astronaut Thomas Mattingly, seen here during water-egress training at Johnson Space Center in January 1970, was slated to be the CM pilot for Apollo 13. When he was exposed to the measles two days before launch, back-up crewman John Swigert took his place. Mattingly proved to be key to the rescue effort, testing new procedures to cope with the emergency in the simulator before passing them to the crew in the LM.

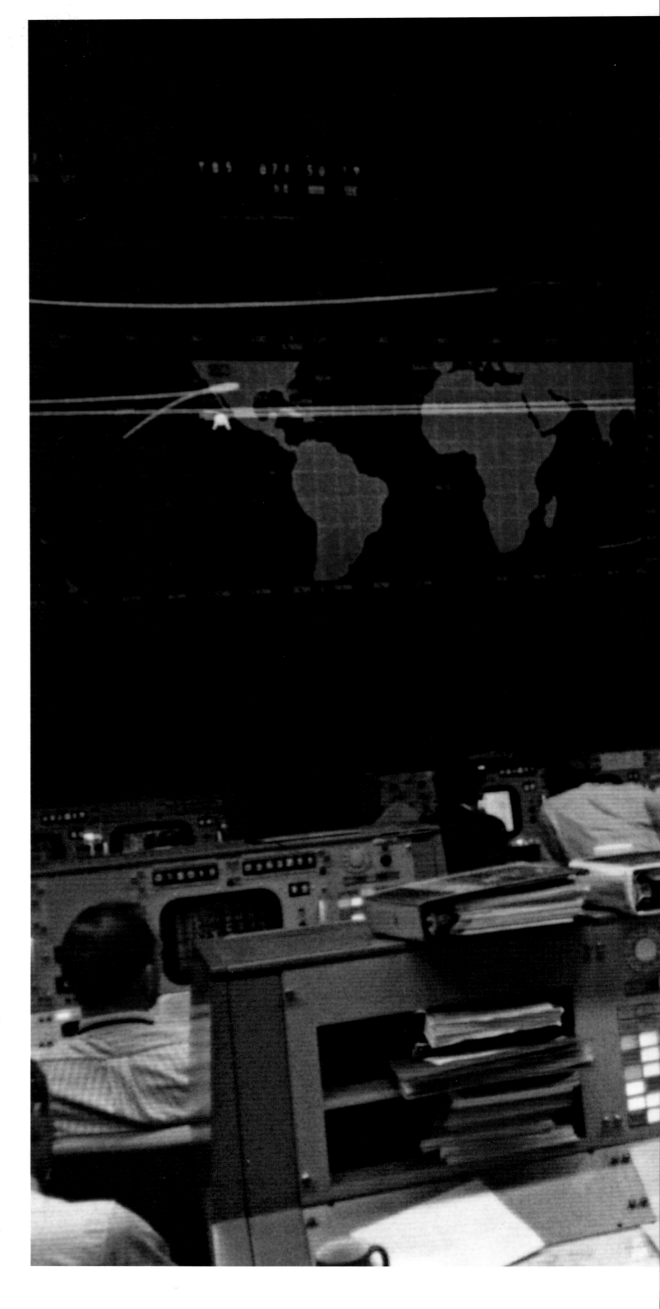

"Houston, we've had a problem" were the immortalized words of Swigert when the service module's oxygen tank blew. **Right** In the Mission Control Center, Flight Director Eugene Kranz (foreground, back to camera) watches Haise during the fourth television transmission from Apollo 13 on April 13, 1970, the day of the explosion. Among the many problems that would need to be solved, Houston focused first on the most obvious: how to retrieve a spacecraft with limited propulsion and maneuverability that was racing away from Earth. The solution was to use the Moon as a slingshot, meaning that the craft would be captured by the gravitational force of the Moon, whip around behind it, and come racing back toward Earth. Meanwhile, the lunar module was equipped for forty-five hours of operation with two men; the rescue plan called for *Aquarius* to harbor three men over nearly four days. There was enough oxygen; all non-essential functions were shut off to conserve power; and water had to be conserved to cool the spacecraft, resulting in the severe dehydration of the crew. Carbon dioxide removal soon emerged as the toughest challenge, and the one whose solution was to become a watchword in creative engineering. The problem was simple enough. The CO_2 that is a byproduct of respiration is unbreathable, and would have to be scrubbed from the air in *Aquarius* if the men were to survive. This would require an adequate supply of the chemical lithium hydroxide, which was stored in canisters in the command module *Odyssey*. However, these canisters were not mechanically compatible with the CO_2 scrubbers in the lunar module.

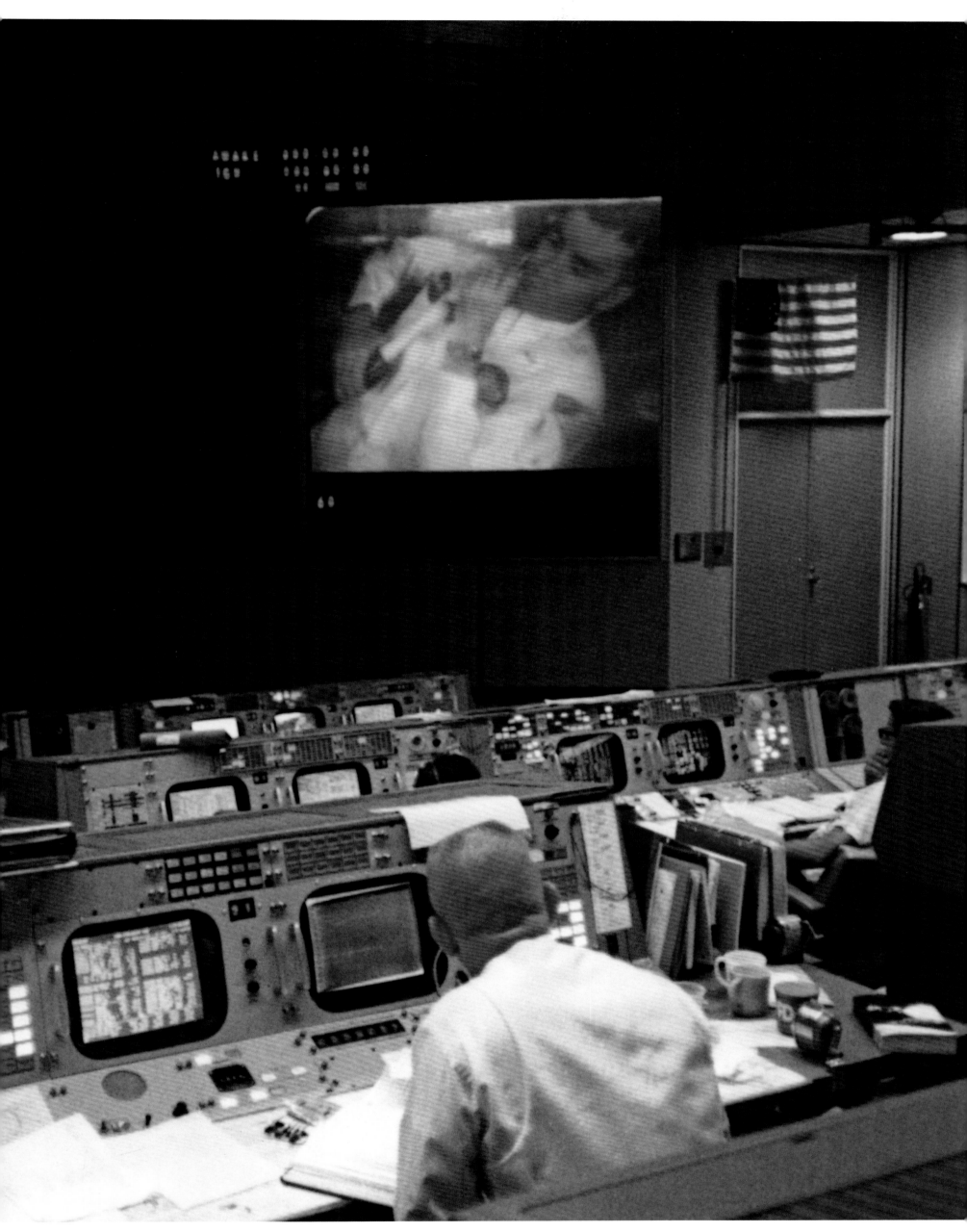

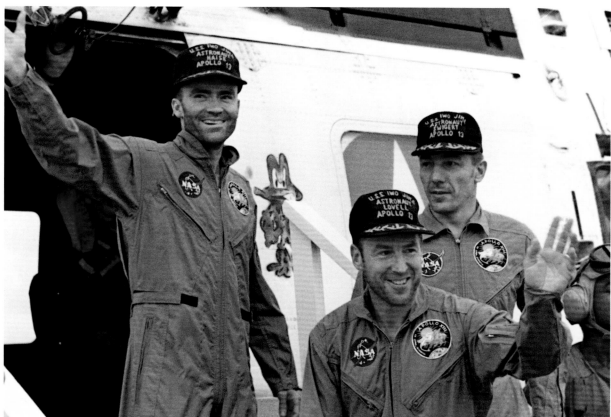

Left Anticipating that the scrubbers in the lunar module would run out of lithium hydroxide much too soon, Houston quickly designed and tested a contraption using materials available to the astronauts (parts cannibalized from a spacesuit, tape, cardboard, and plastic bags) to adapt *Odyssey's* canisters and purge the poisonous gas from *Aquarius*. Swigert (right) and Haise (left) hold some of the improvised life-support apparatus that saved their lives. To Swigert's right, wrapped in tape, is one of the lithium hydroxide canisters.

Almost six days after launch, the crew returned to *Odyssey* for reentry, jettisoning both the damaged supply module and *Aquarius*, their refuge for the long journey. **Top** After splashdown in the Pacific, Haise, Swigert, and Lovell step onto the deck of the recovery ship, USS *Iwo Jima*, on the morning of April 17. **Above** Later that day, Lovell is photographed aboard ship reading about his amazing experience in a late edition of the *Honolulu Star-Bulletin*, whose front page is illustrated with the photo taken that morning.

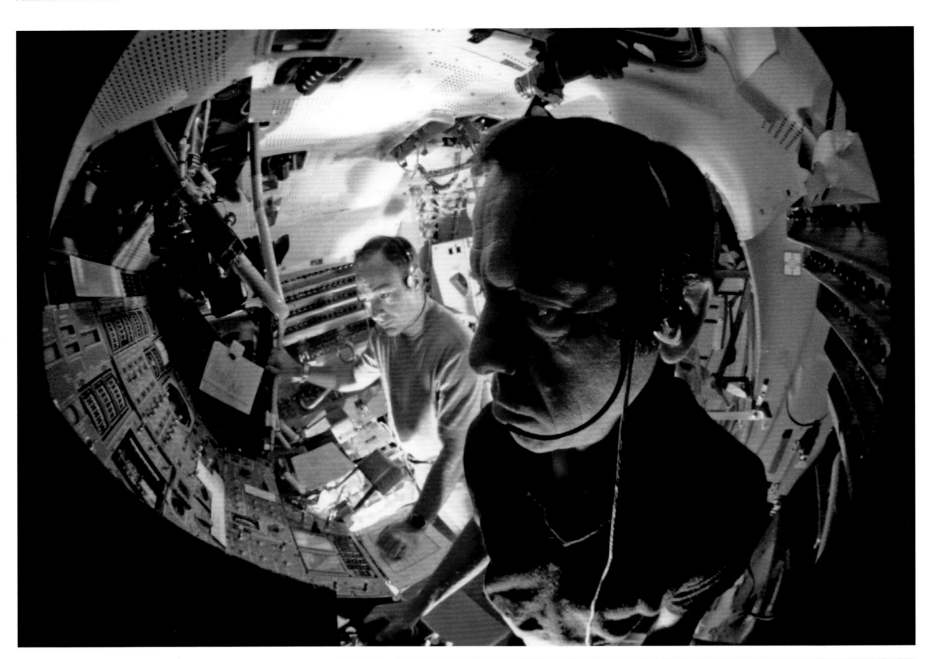

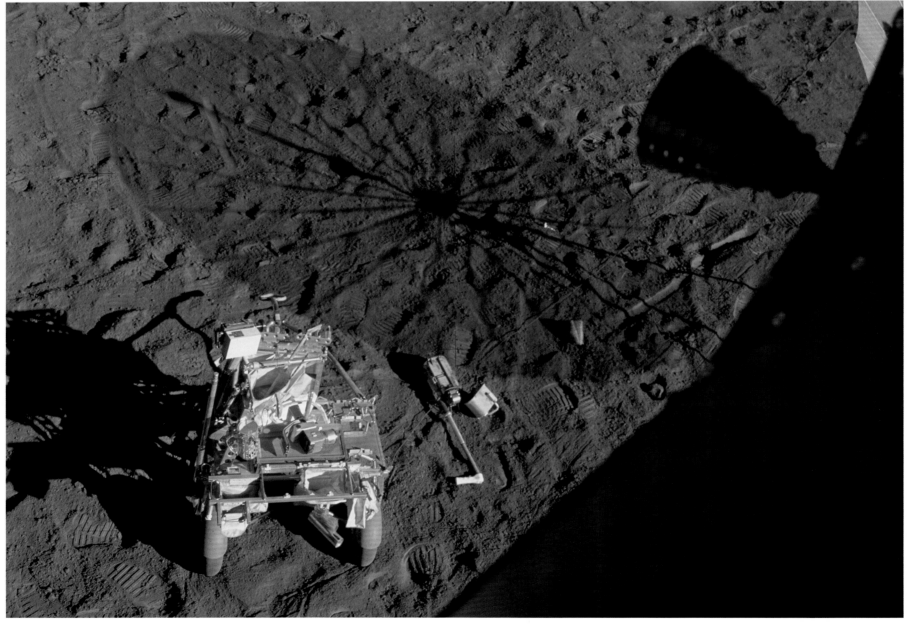

Opposite top A fish-eye lens captures Commander Alan Shepard and LM Pilot Edgar Mitchell of Apollo 14 in the lunar module simulator at Kennedy Space Center in July 1970 (CM Pilot Stuart Roosa was the third member of the crew). Apollo 14 launched on January 31, 1971. Shepard, the first American in space, was the only one of the Mercury 7 to visit the Moon. He was also, famously, the first to hit a golf ball in space.

Right With each mission, EVAs were extended to accommodate more surface research and further exploration. On their second EVA on February 6, Shepard and Mitchell searched for four-and-a-half hours for the rim of the geologically significant Cone Crater, coming within sixty-six feet but missing it due to the difficulty of determining their exact location. Shepard photographed Mitchell examining a map. Lunar dust can be seen clinging to the boots and legs of his space suit.

Opposite bottom Apollo 14 was the first and only time the modular equipment transporter (MET) was used. The MET was a two-wheeled, rickshaw-like vehicle with pneumatic tires used to carry instruments, geological tools, and photographic equipment. On previous missions, astronauts were limited to what they could carry and hoist, but the MET enabled Shepard and Mitchell to gather 93.2 pounds of lunar samples. It was made obsolete, however, with the arrival of the lunar roving vehicle on Apollo 15.

Overleaf left The unoccupied Apollo 14 spacecraft is hoisted aboard the USS *New Orleans* after splashdown on February 9, 1971. It is now on display at the Kennedy Space Center's Astronaut Hall of Fame. The command modules that went into space are usually on public exhibition in the US, except for *Charlie Brown*, from Apollo 10, which is in the Science Museum, London.

Overleaf right Meanwhile Apollo astronauts were also sought after. Roosa, Mitchell, and Shepard appear on the NBC *Tonight Show* on March 8, 1971, flanked by Ed McMahon (left) and Joey Bishop (right), sitting in for Johnny Carson that night.

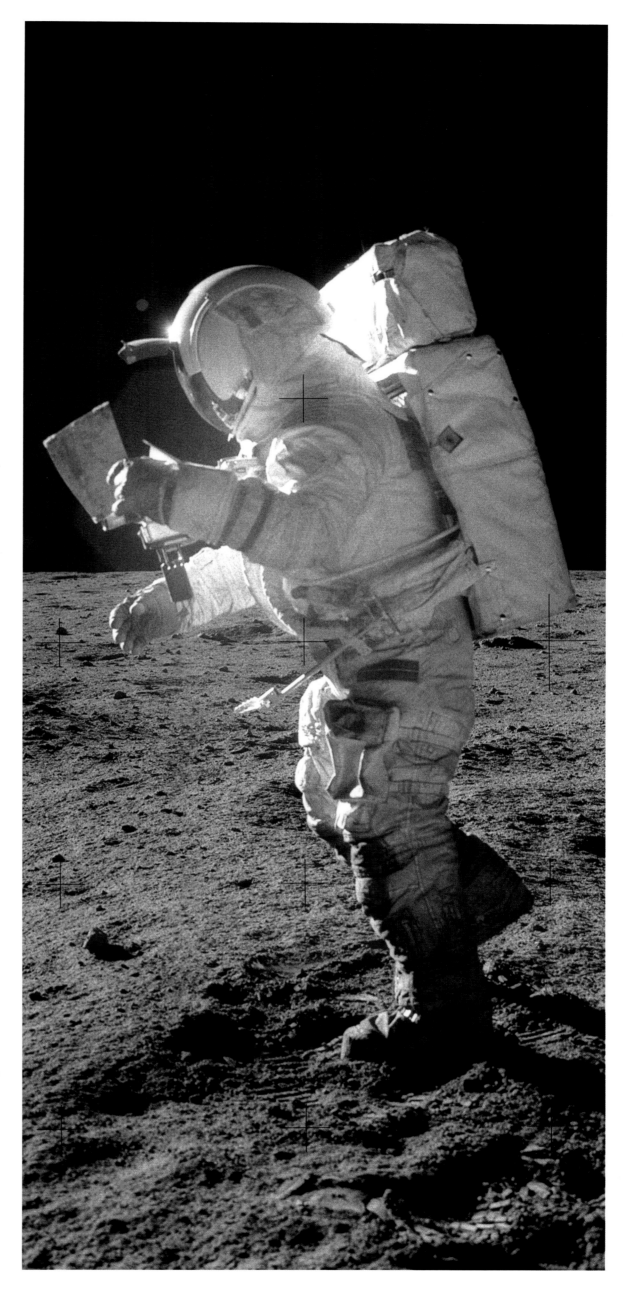

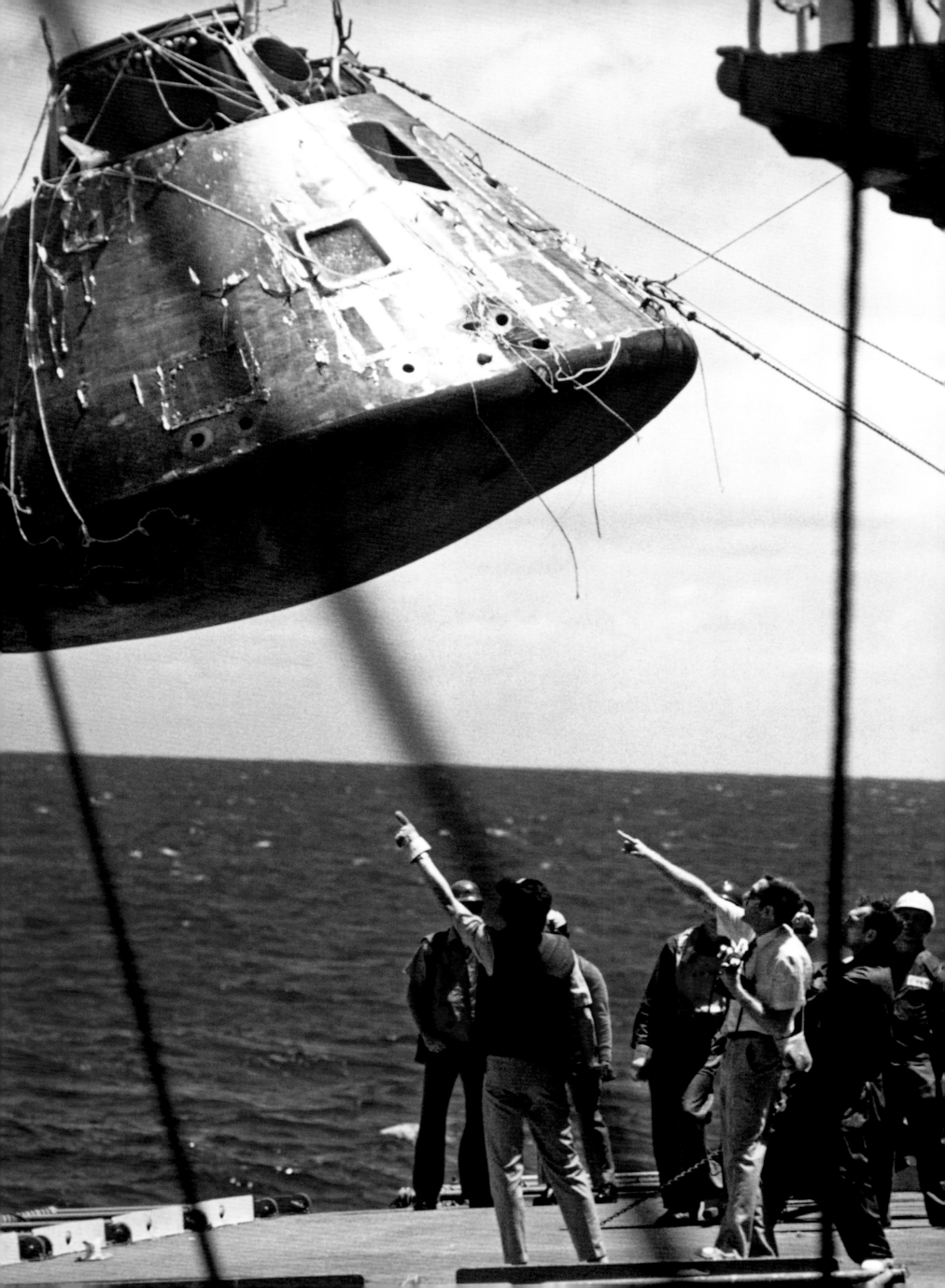

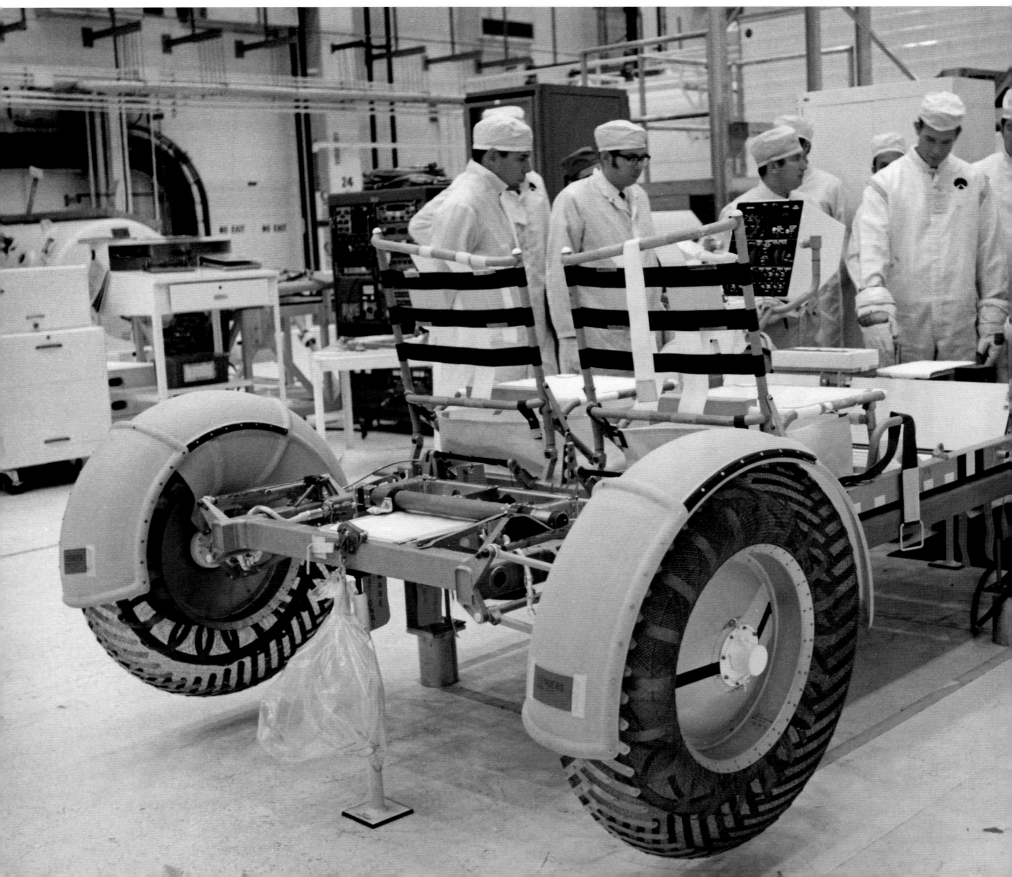

Internally at NASA, the lunar missions were separated into three groups. Apollo 8-11 were considered test missions; Apollo 12-14 were designated "H-class" missions, intended to show that astronauts could work effectively in the lunar environment; Apollo 15-17 were "J-class" missions, true voyages of scientific exploration. To be wide-ranging explorers, the astronauts needed wheels, hence the lunar roving vehicle (LRV), built by Boeing. **Left** Apollo 15 Commander David Scott and LM Pilot James Irwin drive the lunar rover training vehicle in Taos, New Mexico in March 1971. **Below left** They inspect gear on the front end of the LRV they will drive on the Moon at the Manned Spacecraft Operations Building a month later. Able to carry 1,080 pounds in lunar gravity, operate 78 hours, and travel up to 40 miles, the LRV greatly extended the range of astronaut exploration. It was cleverly designed to fold up into the lunar module until deployment. **Below** The Apollo 15 LRV and LM during simulations at Kennedy Space Center in April.

Overleaf During an Apollo 15 pre-launch activity, NASA Administrator James Fletcher (hand extended) makes a point to Deputy Administrator George Low (to his right) and Wernher von Braun (to his left).

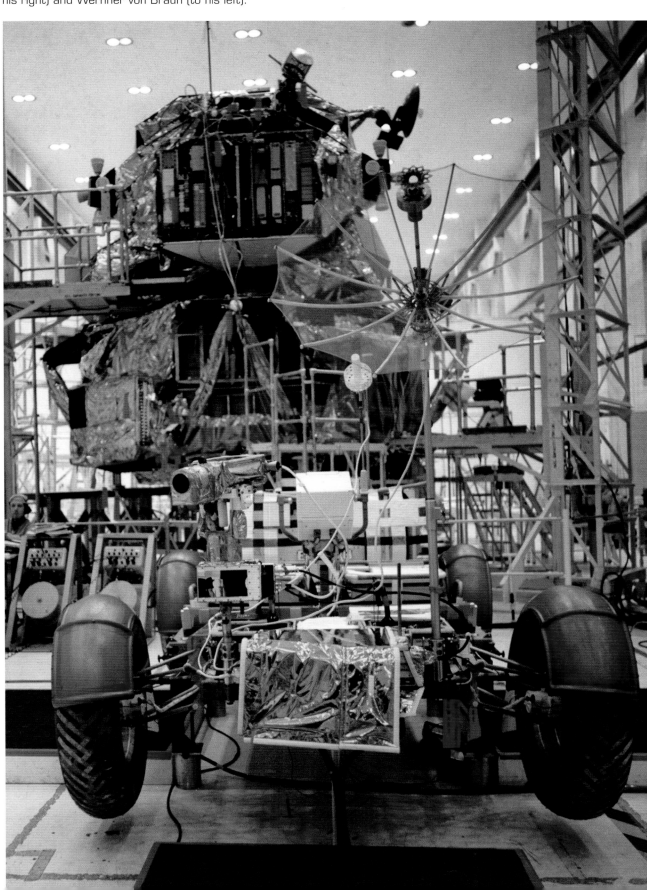

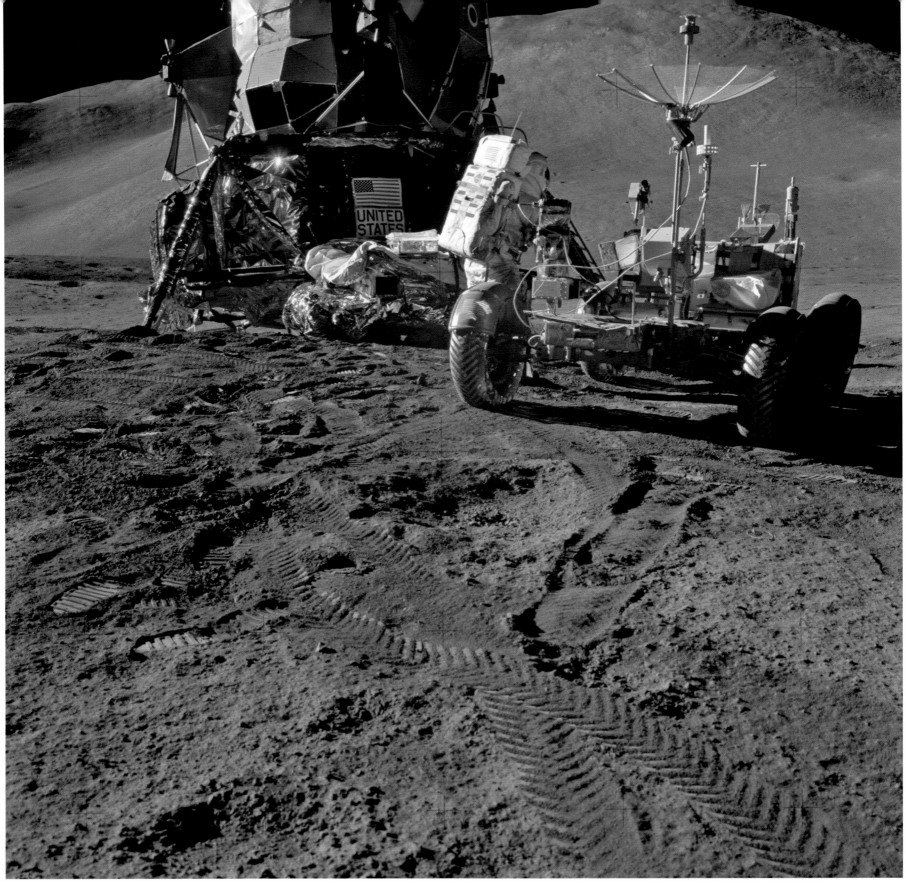

Scott and Irwin touched down on July 30, 1961, near the base of Mount Hadley in the Apennine Mountains. This was the most rugged and dramatic landing site so far. **Above** The LRV is parked next to lunar module *Falcon*. **Opposite** The following day, Scott photographed Irwin at the LRV with Mount Hadley in the background. Meanwhile, CM Pilot Alfred Worden was busy surveying the lunar surface from orbit, compiling data for an accurate, detailed topographical map of the Moon. **Right** On his last EVA, Scott conducted an experiment that warmed the hearts of science teachers everywhere, dropping a falcon feather and his geological hammer from the same height; the two objects underwent the same acceleration and landed simultaneously.

Overleaf After a frightening incident where one of the capsule's (luckily redundant) parachutes failed during reentry, the crew of Apollo 15 successfully splashed down on August 1, 1971, eliciting smiles from the astronauts and the Navy divers who recovered them. Flight controllers Gerald Griffin, Eugene Kranz, and Glynn Lunny break out cigars and wave American flags.

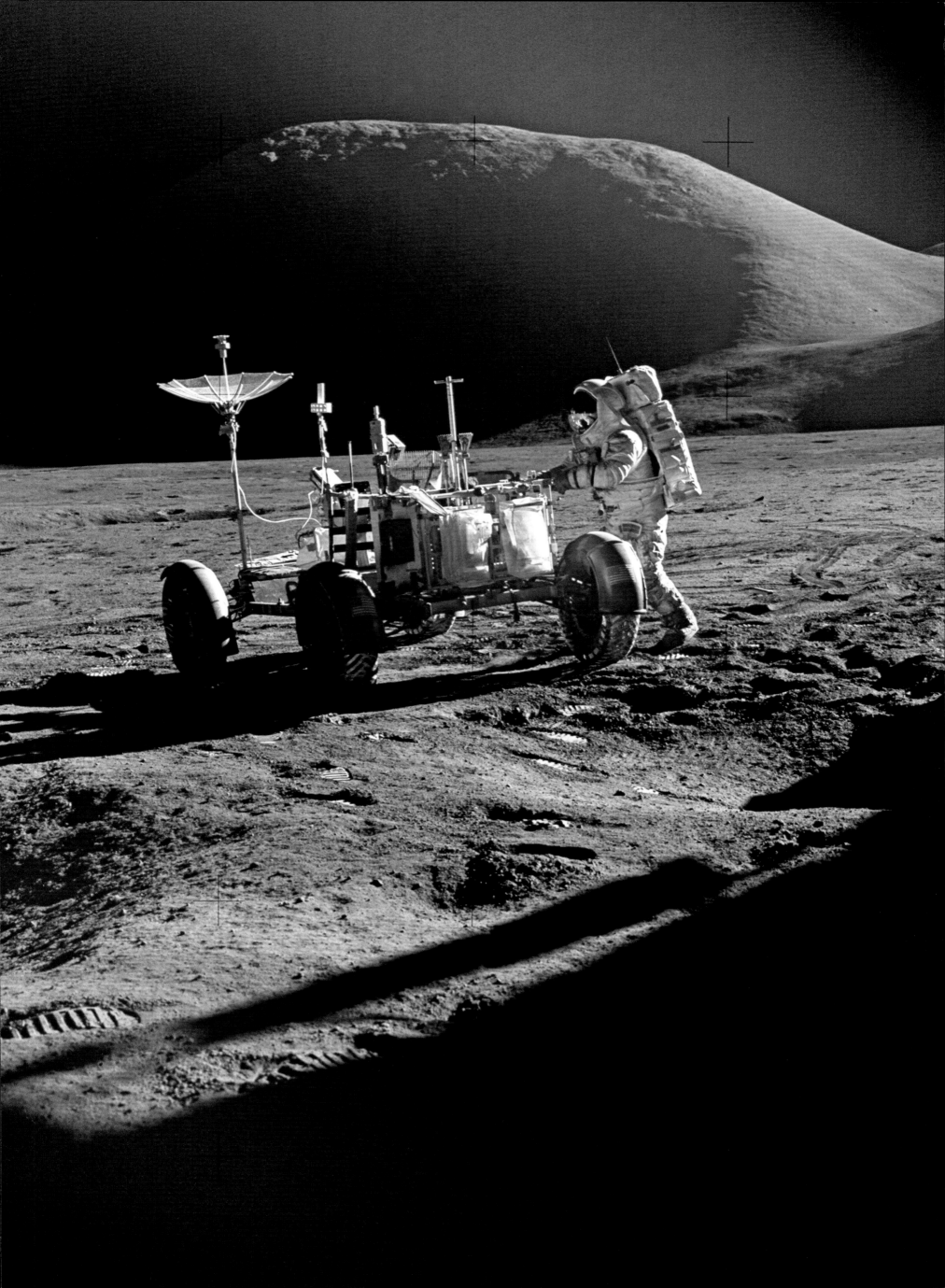

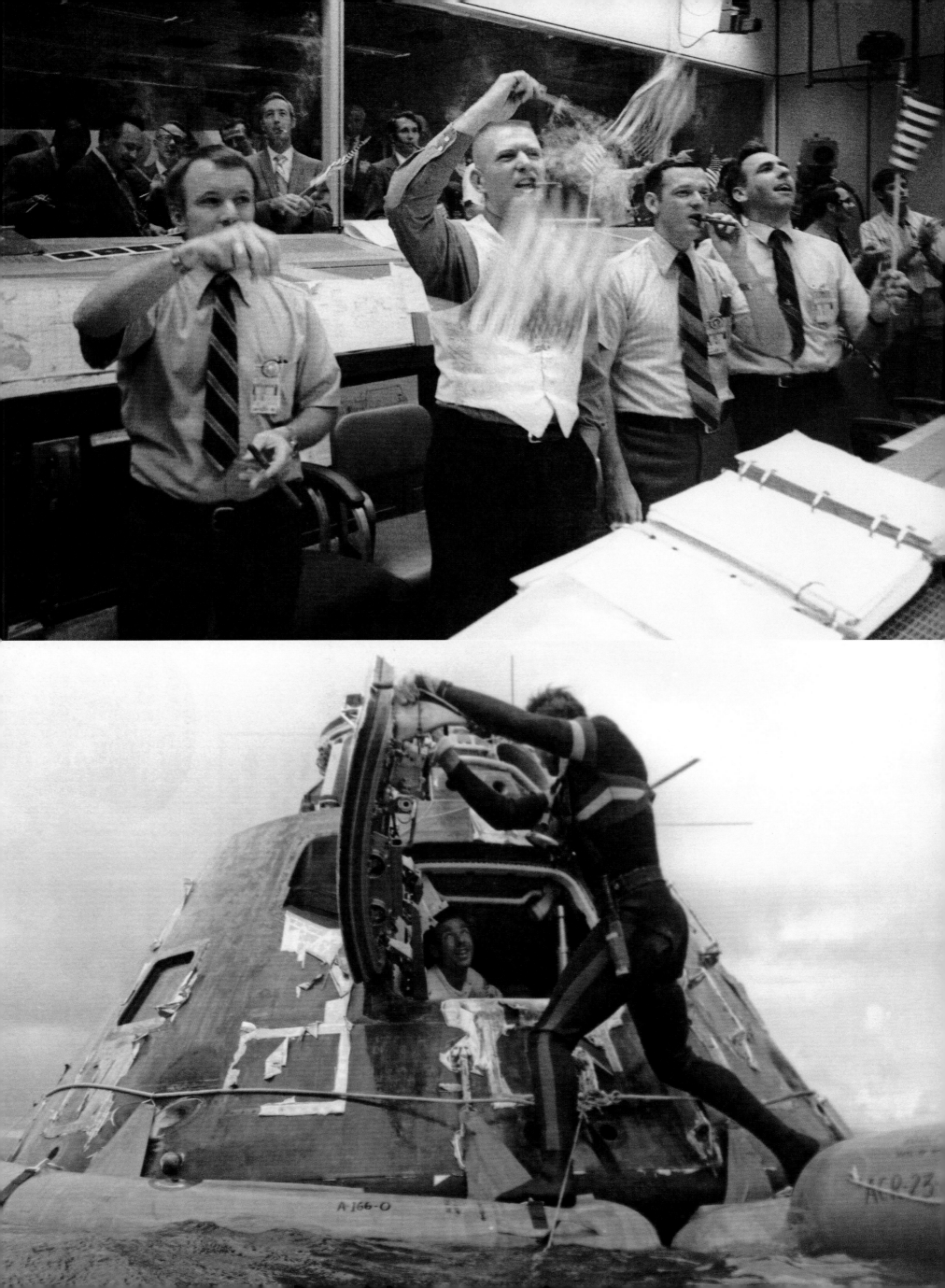

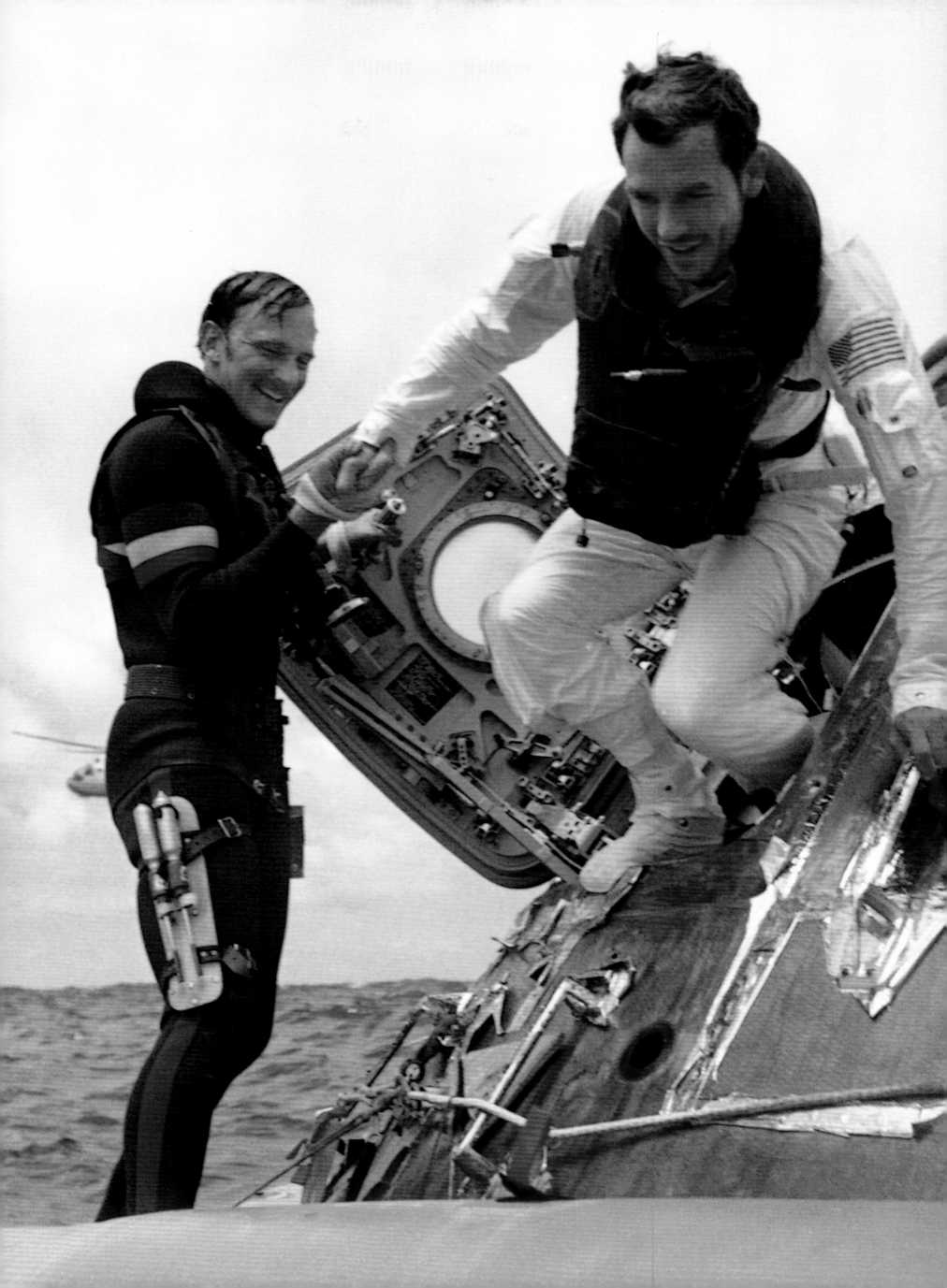

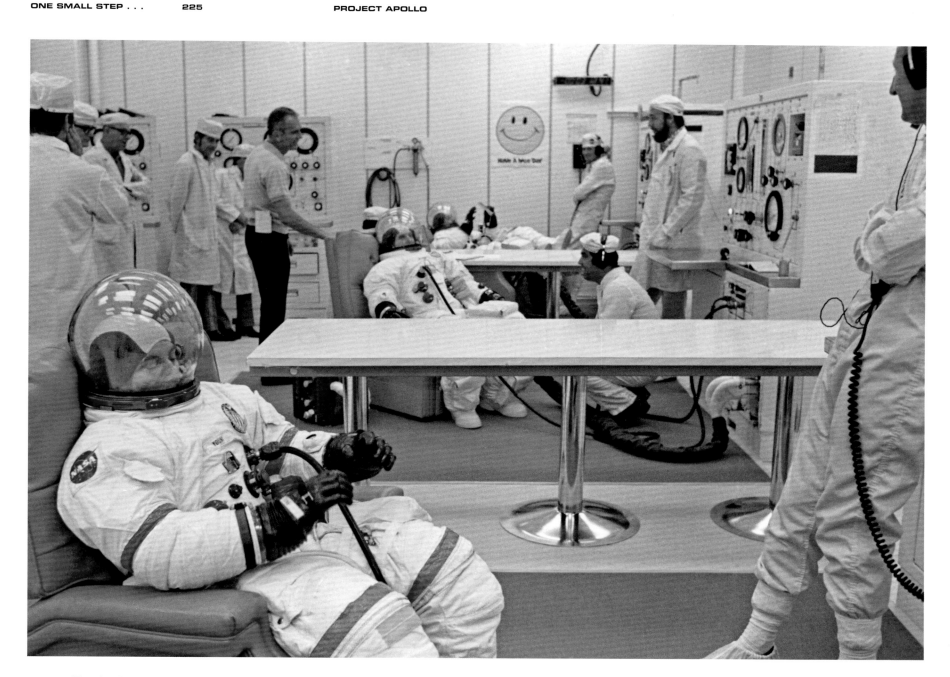

Above The Apollo 16 astronauts undergo pre-launch spacesuit pressure checks in the Manned Spacecraft Operations Building at Kennedy Space Center in April 1972. The red stripes on the commander's spacesuit—in this case it is John Young—made it easier to identify him in photographs and videos taken on the Moon. Behind Young are CM Pilot Thomas Mattingly and LM Pilot Charles Duke. Deke Slayton is at the back of the room in a blue shirt.

Opposite The Apollo astronauts were given extensive geological field training, especially for the later missions. They were sent to survey sites on Earth selected for surface features similar to what they might find on the Moon; wearing simulated life-support packs, they would relay their findings via radio to a "CapCom" crew set up nearby. Young (left) and Duke (right) prepare to explore Rio Grande Canyon, New Mexico, in September 1971. This was one of eighteen field trips made by the two in the year and a half preceding their mission. The rock samples they would collect on the Moon and bring back to Earth would be crucial for scientists' understanding of the Moon's geological formation. In turn, these discoveries offered clues to Earth's own history.

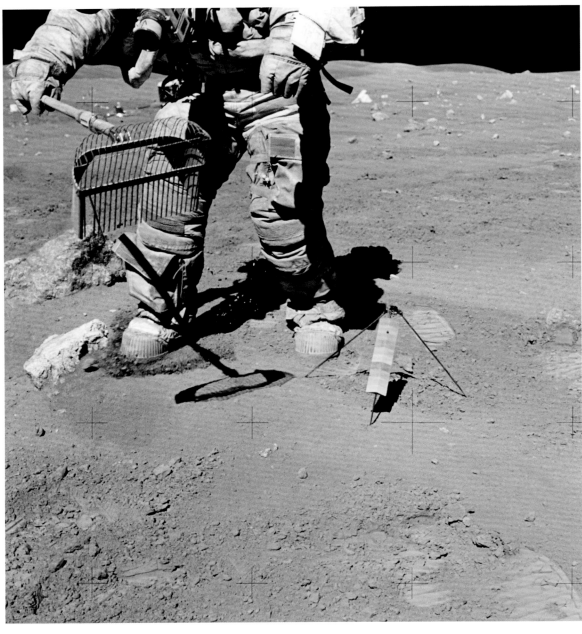

Above left Commander Young wields a rake used to collect rock samples. Apollo 16 set down in the Descartes Highlands on April 21, 1972, where Young and Duke spent almost three days on the surface collecting 208 pounds of lunar samples, including a twenty-five-pound rock that was the record for the program.

Left Duke placed a photograph of his family on the Moon's surface during his final EVA on April 23, 1972.

Opposite After the mission, Duke (center) and Young (right) inspect some of their lunar samples at the Lunar Receiving Laboratory in Houston. The Apollo samples are mostly basalt, solidified molten lava from volcanism, or breccia, more complex rocks formed when the pressure and heat of a meteorite impact fragments older rocks and then fuses the tiny fragments together. The samples range from 3.2 to 4.6 billion years old. Most of the lunar rock samples collected on Apollo missions remain at the Johnson Space Center in Houston.

Overleaf left Eugene Cernan, posing here with family and a family friend during EVA training at Kennedy Space Center in August 1972 would be the last American on the Moon.

Overleaf right In this official portrait for Apollo 17, Commander Cernan is seated in an LRV with LM Pilot Harrison Schmitt and CM Pilot Ronald Evans standing behind him, as they pose in front of Launch Complex 39-A and the spacecraft that would take them to the Moon on December 7, 1972.

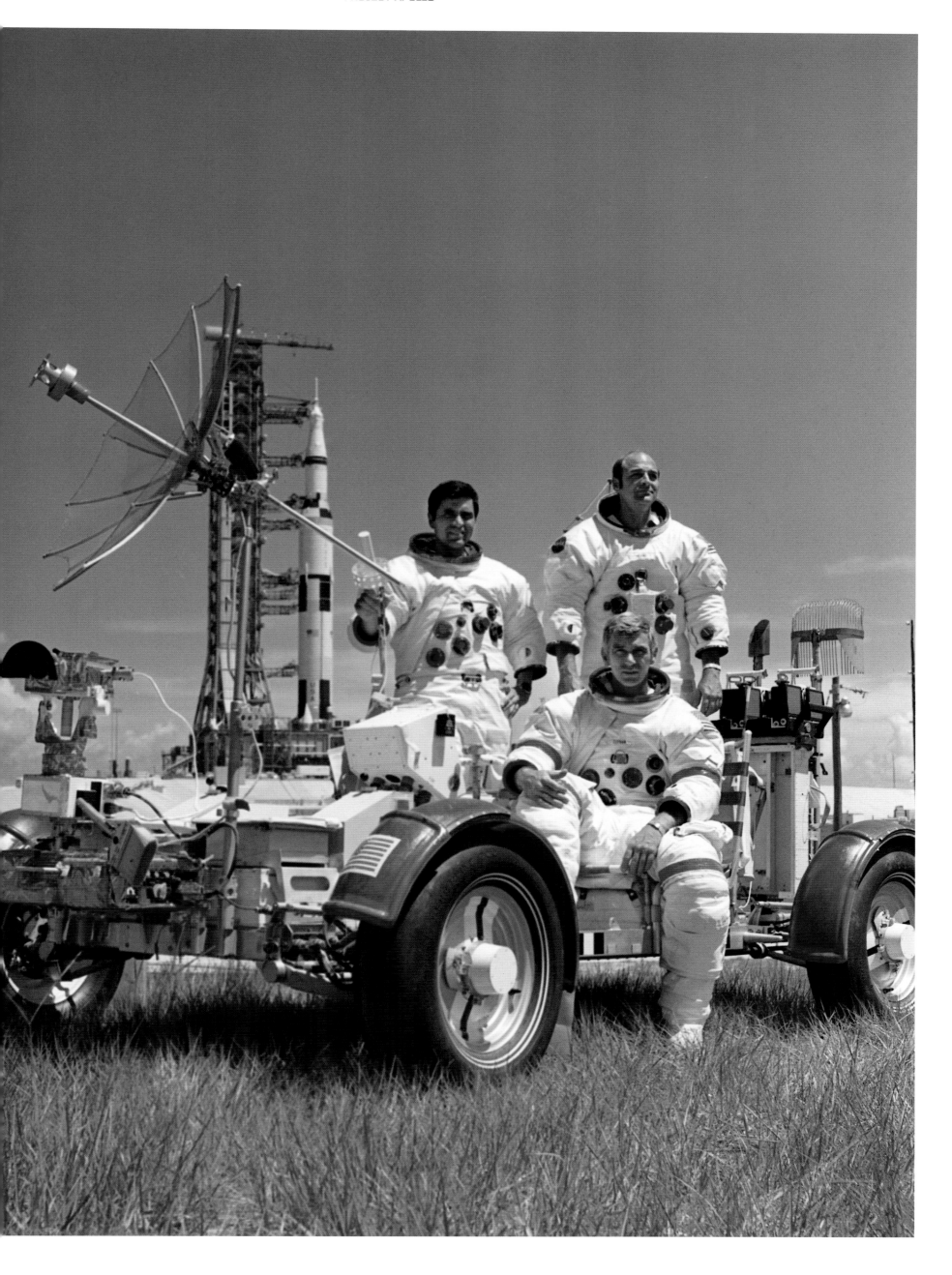

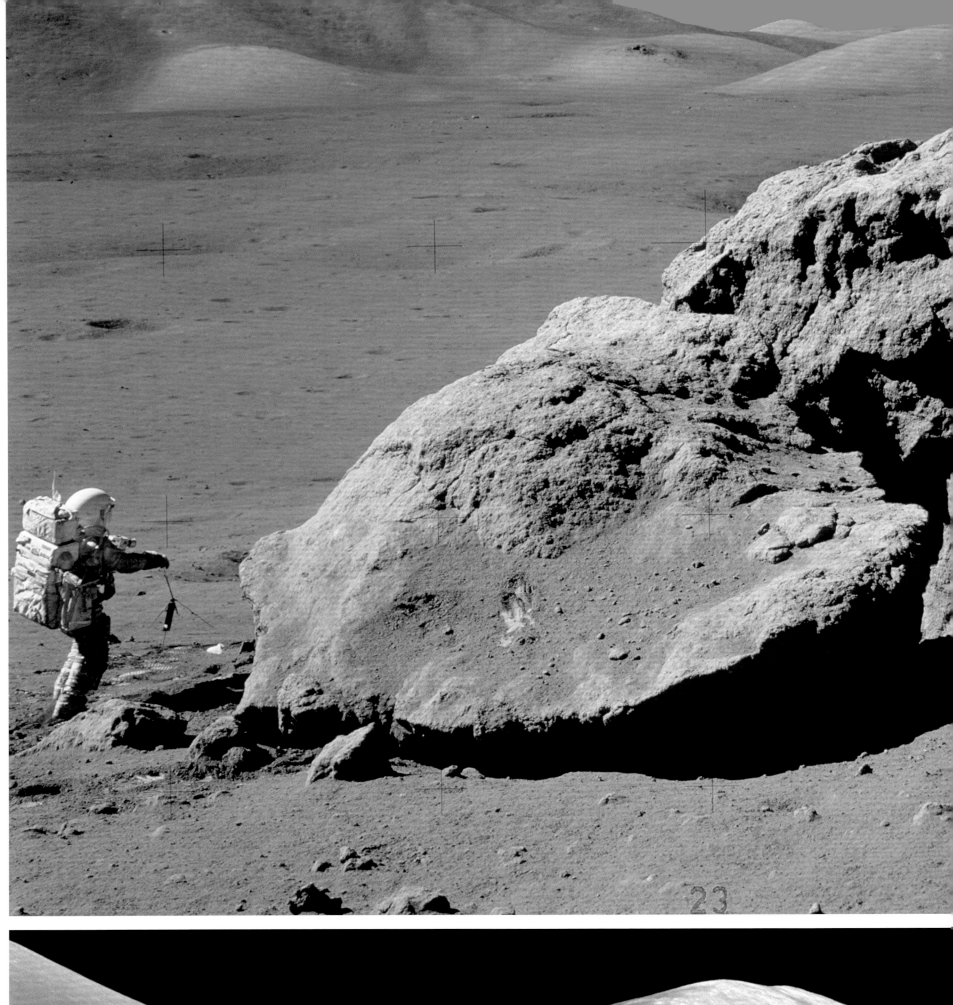

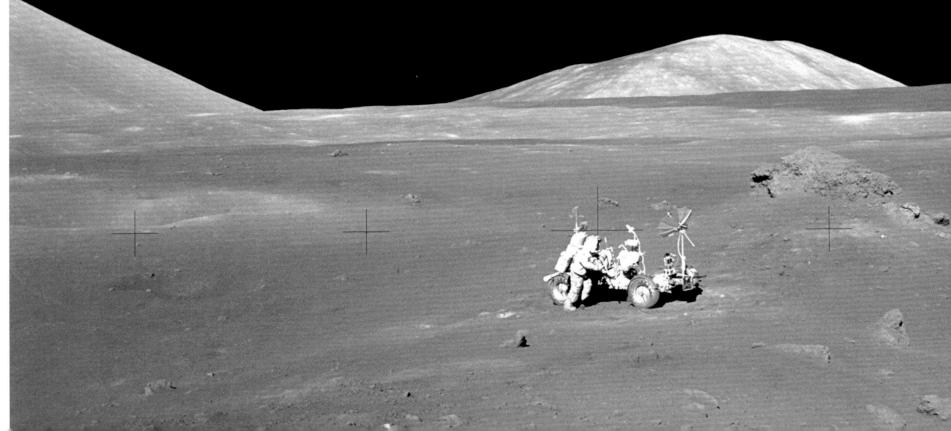

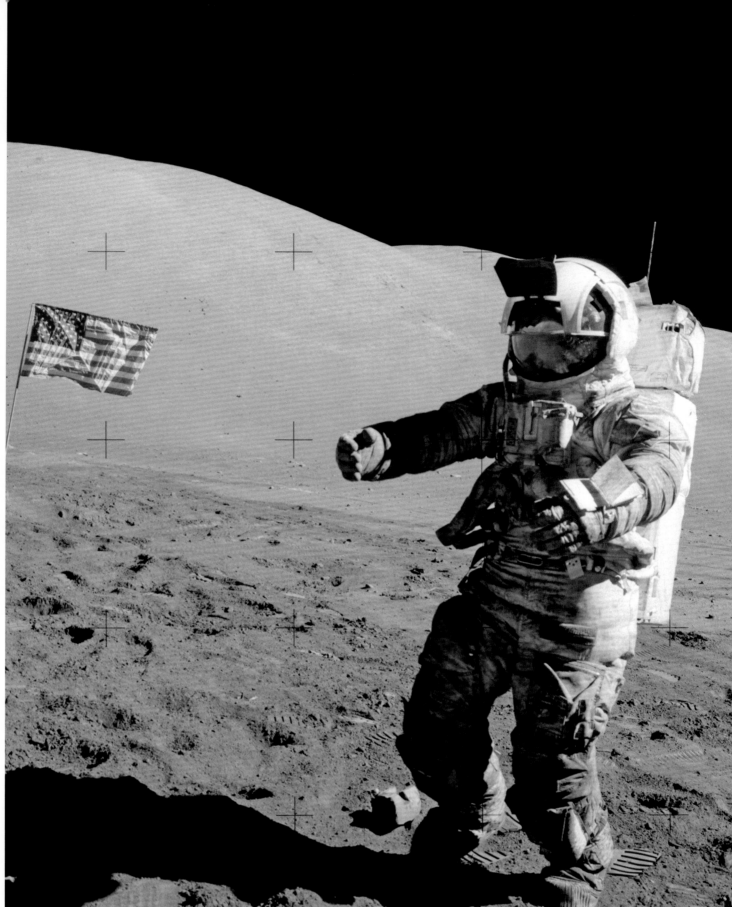

Apollo 17 landed in the Taurus-Littrow valley, a plain surrounded by high massifs and filled with signs of geological activity. Cernan was accompanied by astronaut-geologist Harrison Schmitt, the first scientist to fly for NASA. Together, the two explorers gathered 243 pounds of rock, and the mission set several Apollo duration records. **Left** Schmitt is dwarfed by a extraordinary lunar panorama while working at the LRV on December 12, 1972. Family Mountain (center) and a portion of South Massif (left) are visible on the horizon. This is the area where he spotted curious orange soil, actually fine particles of volcanic glass high in titanium, iron oxide, and zinc. **Above left** Schmitt stands beside a huge boulder near the landing site. Inside the fraternity of Apollo astronauts, the boulder became known as "Tracy's Rock" after Cernan's daughter. **Above** Schmitt stands near the American flag in what is likely the last photograph of an astronaut on the Moon.

Overleaf left An overhead view taken by a recovery aircraft of Apollo 16 seconds before splashdown. People around the world who watched the Apollo missions on TV or read about them in magazines or newspapers would have many striking images to remember, but undoubtedly one of the most compelling was the sight of the spacecraft descending on three cheerful red-and-white striped parachutes and splashing into the sea, signaling a safe return from the mission. **Overleaf right** Ronald Evans is hoisted aboard a helicopter in the final moments of Apollo 17.

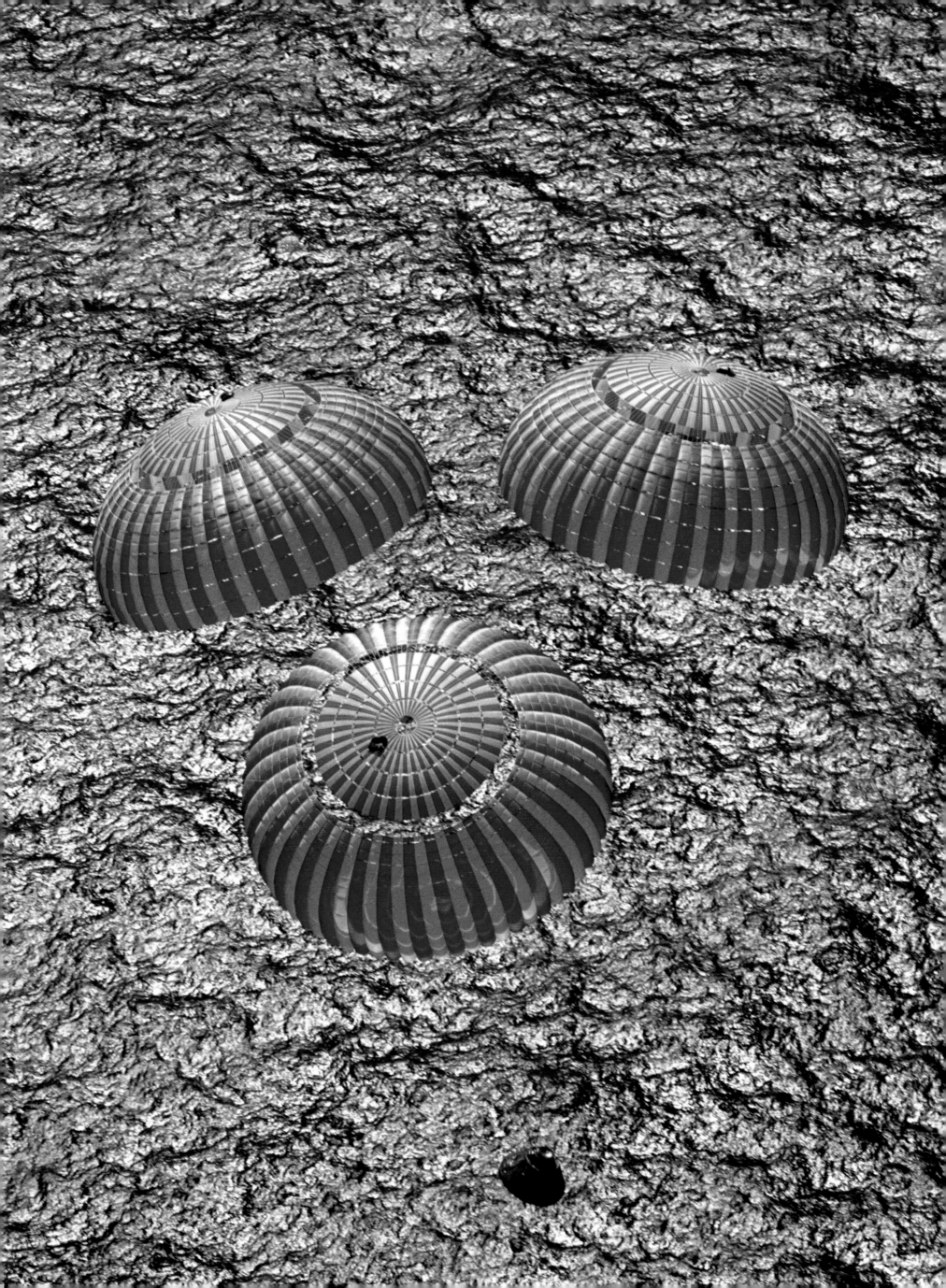

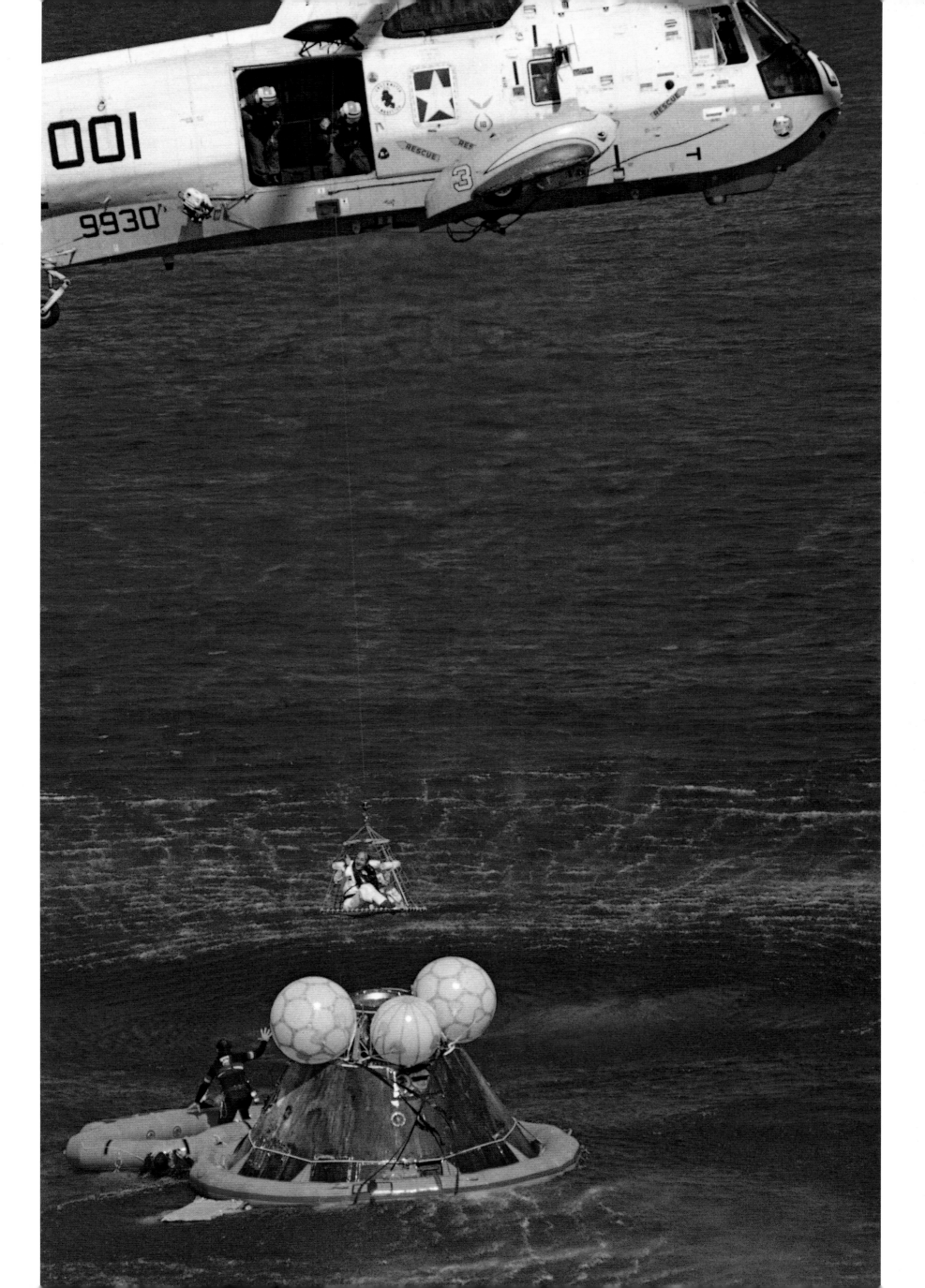

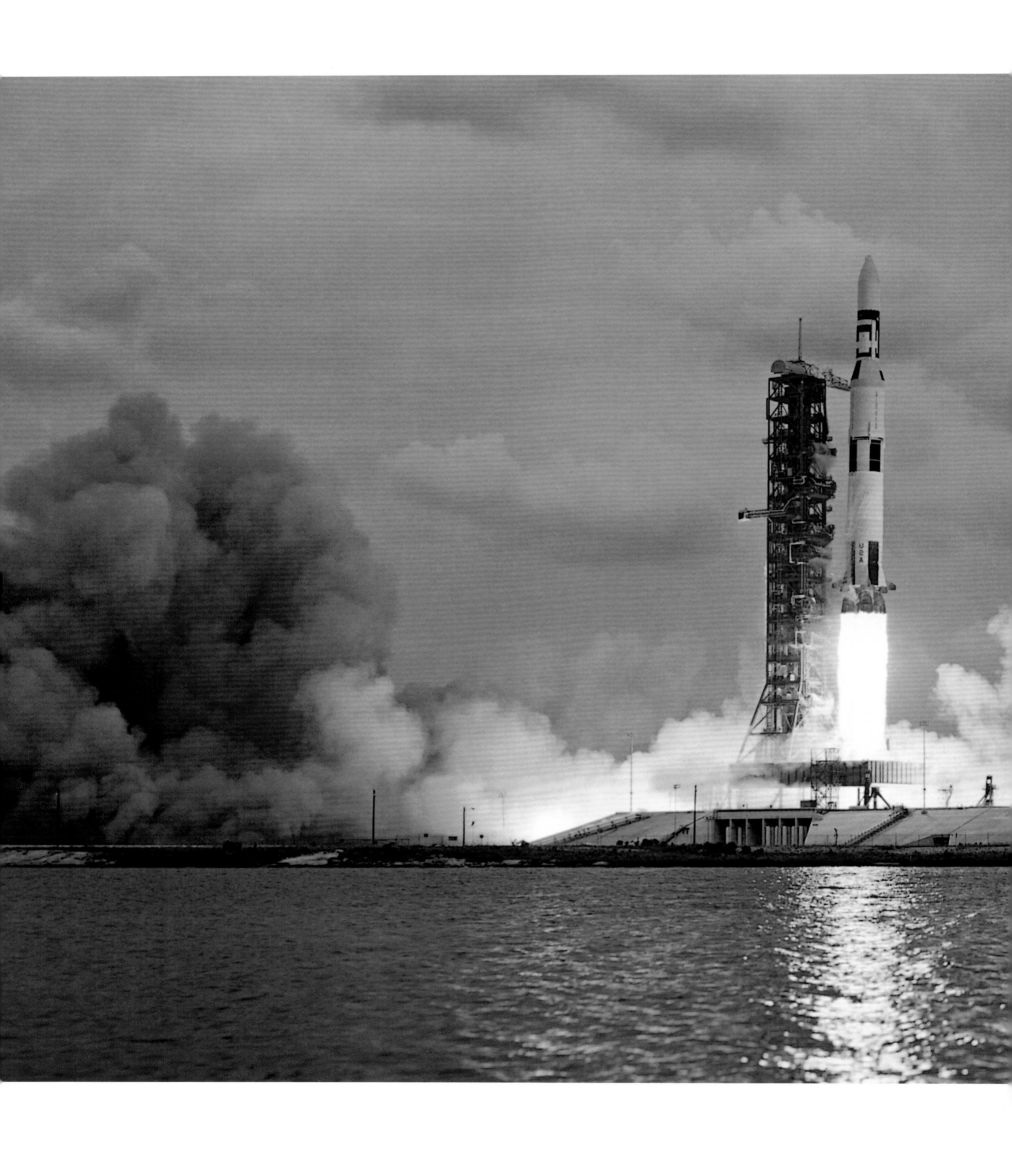

To meet their mandates, both the American and Russian space programs recognized the need for more or less permanent manned research platforms in space. As early as 1964, NASA began exploring ways to repurpose existing Apollo hardware for long-term use, and the eventual result was Skylab. Both the Soviet Salyut 1, which was occupied for 23 days in 1971, and Skylab, which was home to three crews for 171 days, were experiments that led to more permanent stations in the following decades. **Above** Skylab 1 carries the Skylab space station into orbit on May 14, 1973. Crews to man the station would follow.

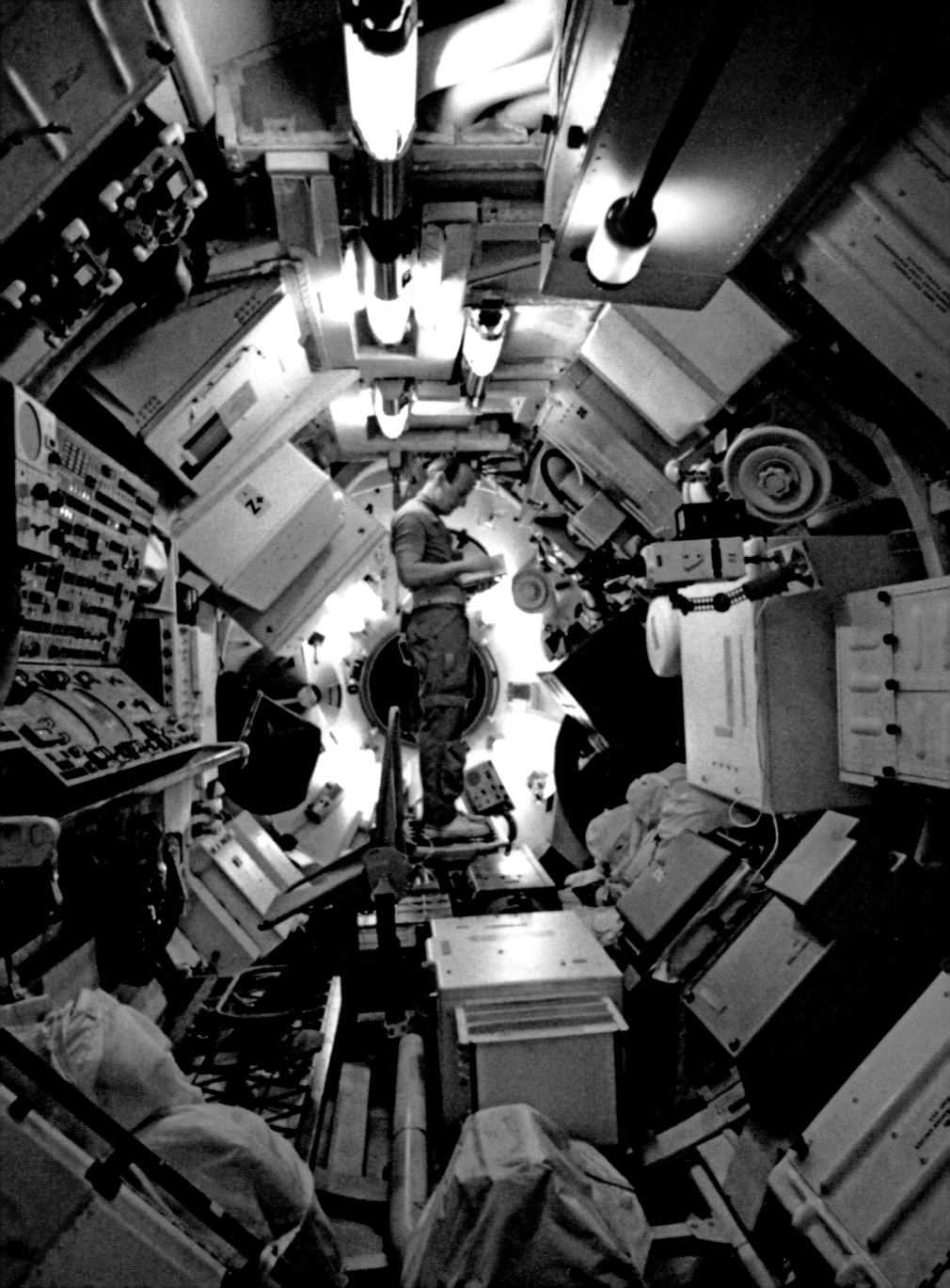

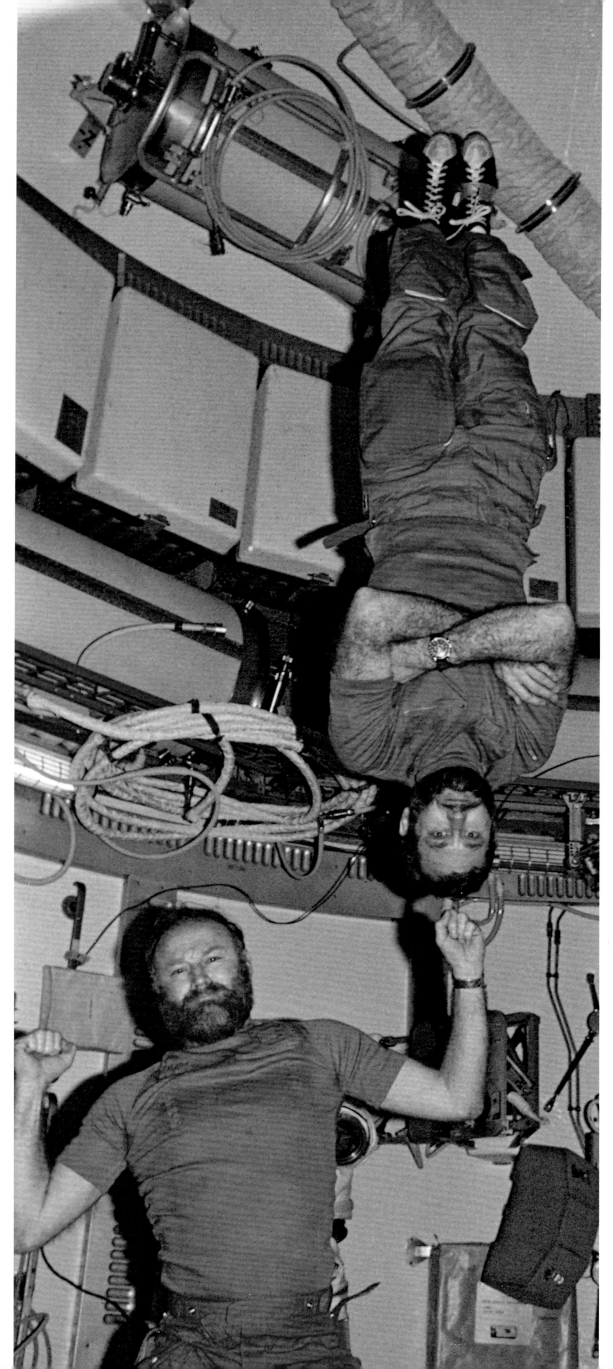

Opposite A view of Skylab 2 Commander Pete Conrad in the Skylab training facility at Johnson Space Center in March 1973 is reminiscent of the movie *2001: A Space Odyssey*. The Skylab 2 mission lasted twenty-eight days in May-June 1973.

Left Commander Gerald Carr and Pilot William Pogue of Skylab 4—eighty-four days in space from November 16, 1973, to February 8, 1974—doing what most people would probably do in zero-G: have fun. Given that Skylab was a first attempt, the most pressing experiment aboard the station was everyday life itself, which crews reported as being relatively normal, if a little cramped. Some astronauts got so accustomed to living in microgravity, in fact, that after returning to Earth, they reported that they were dropping things that they expected would "float."

Overleaf left A photo taken from the Skylab 3 spacecraft gives a good view of the station: the "hole" at the front is the docking bay for the CM; the structure on top is the Apollo Telescope Mount, used for making solar observations; the laboratory and living quarters are in the cylinder—actually the refitted second stage of a leftover Apollo Saturn 1B rocket—attached to the docking module.

Overleaf right Nearly three hundred experiments were performed on Skylab. Skylab 3 Science Pilot Owen Garriott deploys the Skylab Particle Collection experiment on August 6, 1973, during the fifty-nine day mission.

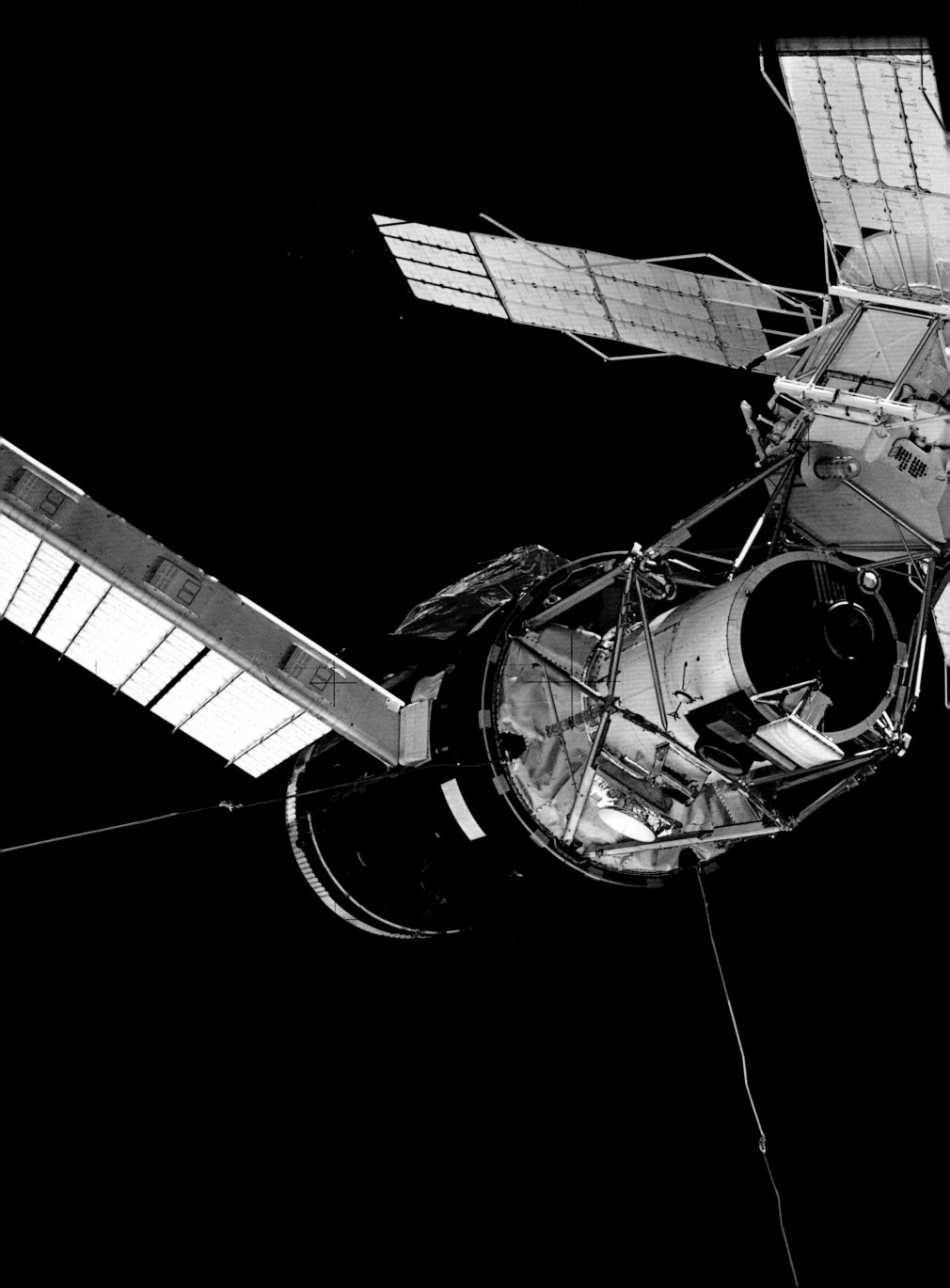

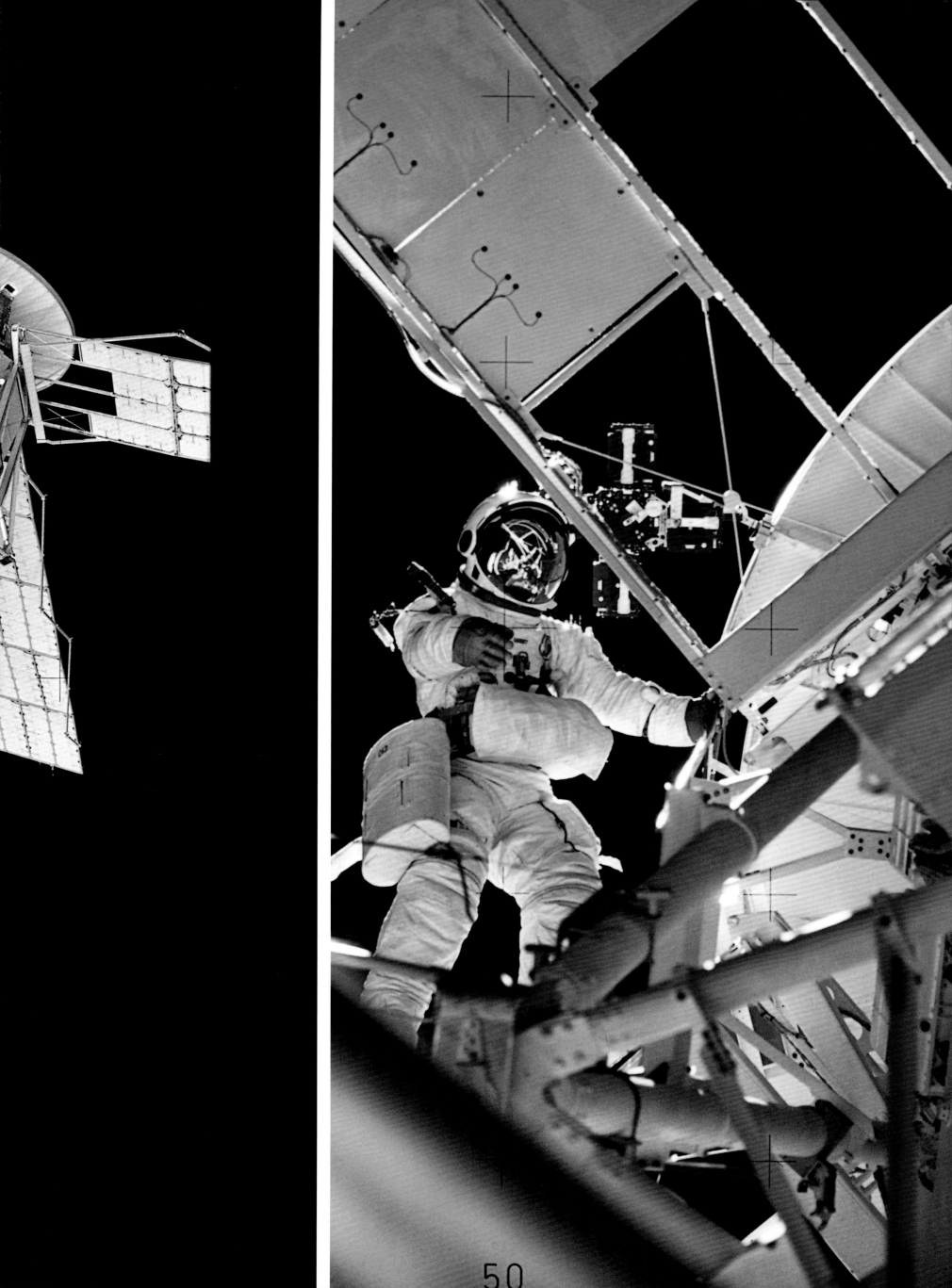

50

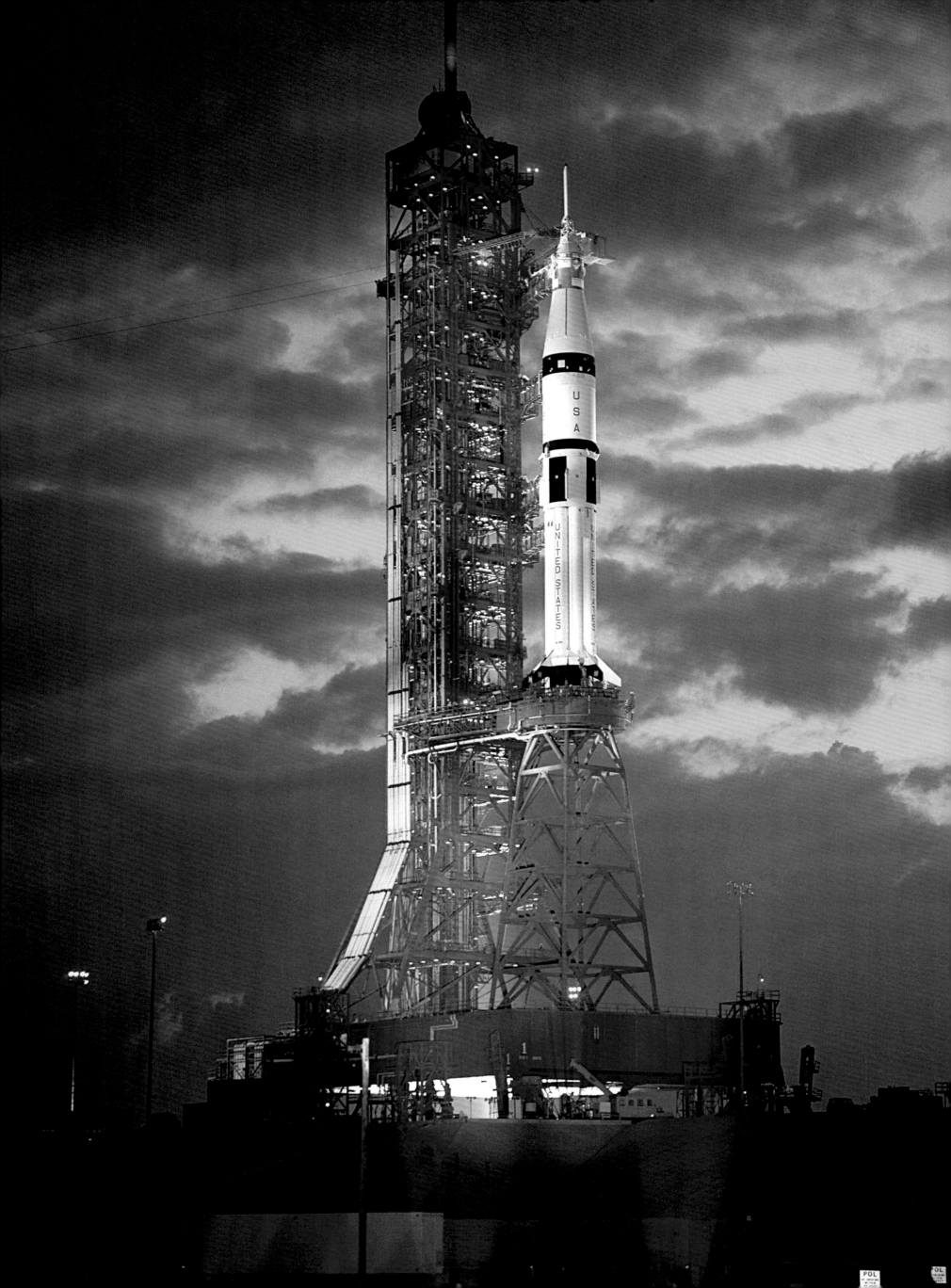

After almost twenty years of competition in space, the United States and the Soviet Union took a first step in cooperative space exploration in 1975. The Apollo-Soyuz Test Project (ASTP), a docking mission involving spacecraft from both countries, was the final flight of the Apollo program and the first manned international space flight. **Opposite** Dawn breaks behind the ASTP Saturn IB launch vehicle during a countdown demonstration test, two weeks before lift-off. Because the Saturn IB rocket was considerably shorter than the Saturn V, a platform had to be built so it could reach the top of the gantry at Launch Complex 39A; technicians called it the "milkstand."

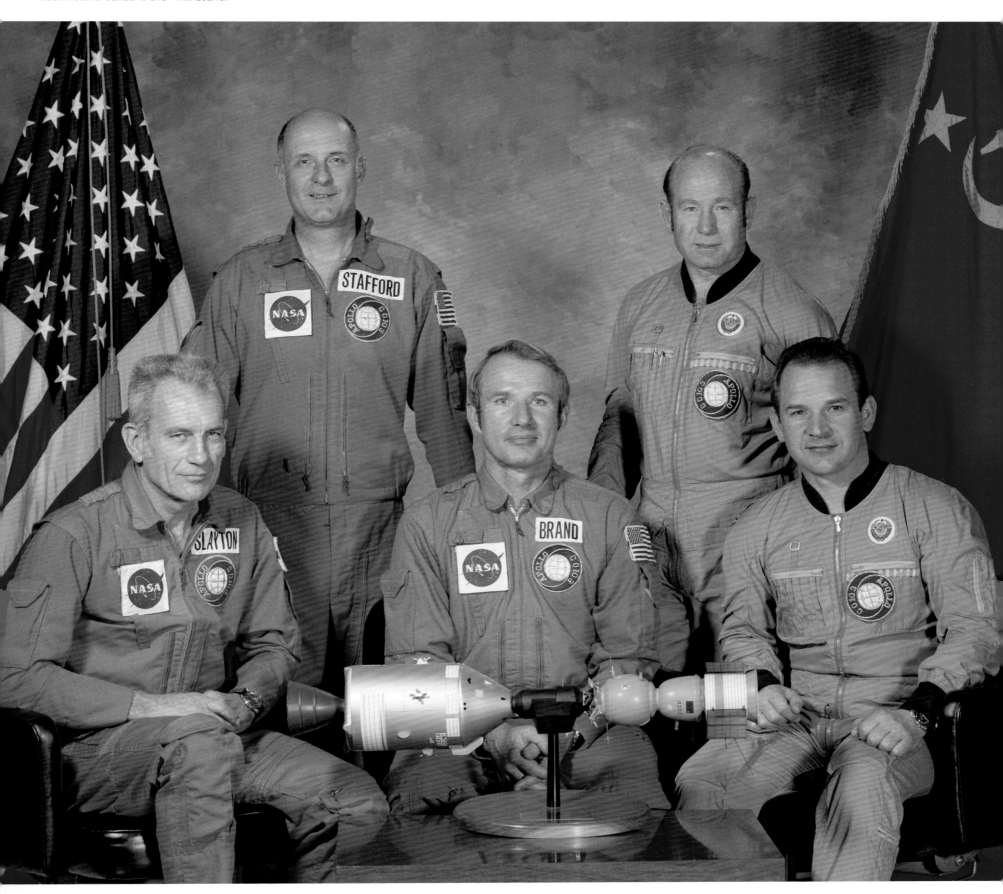

Above The American crew—(left to right) Docking Module Pilot Deke Slayton, Commander Thomas Stafford, and Command Module Pilot Vance Brand—would rendezvous with the Russian spacecraft manned by Soyuz 19 Commander Aleksey Leonov (standing) and Soyuz 19 Engineer Valery Kubasov (seated) in Earth orbit. A model showing the two spacecraft connected by the docking module where the meeting would take place sits on the table in front of the men.

Overleaf The Americans launched on July 15, 1975, seven hours after the Russians. Two days later, Stafford (above) and Leonov (below) shook hands in space. Stafford greeted Leonov (the first human to walk in space) in Russian while Leonov greeted Stafford in English. The Apollo Era was ending.

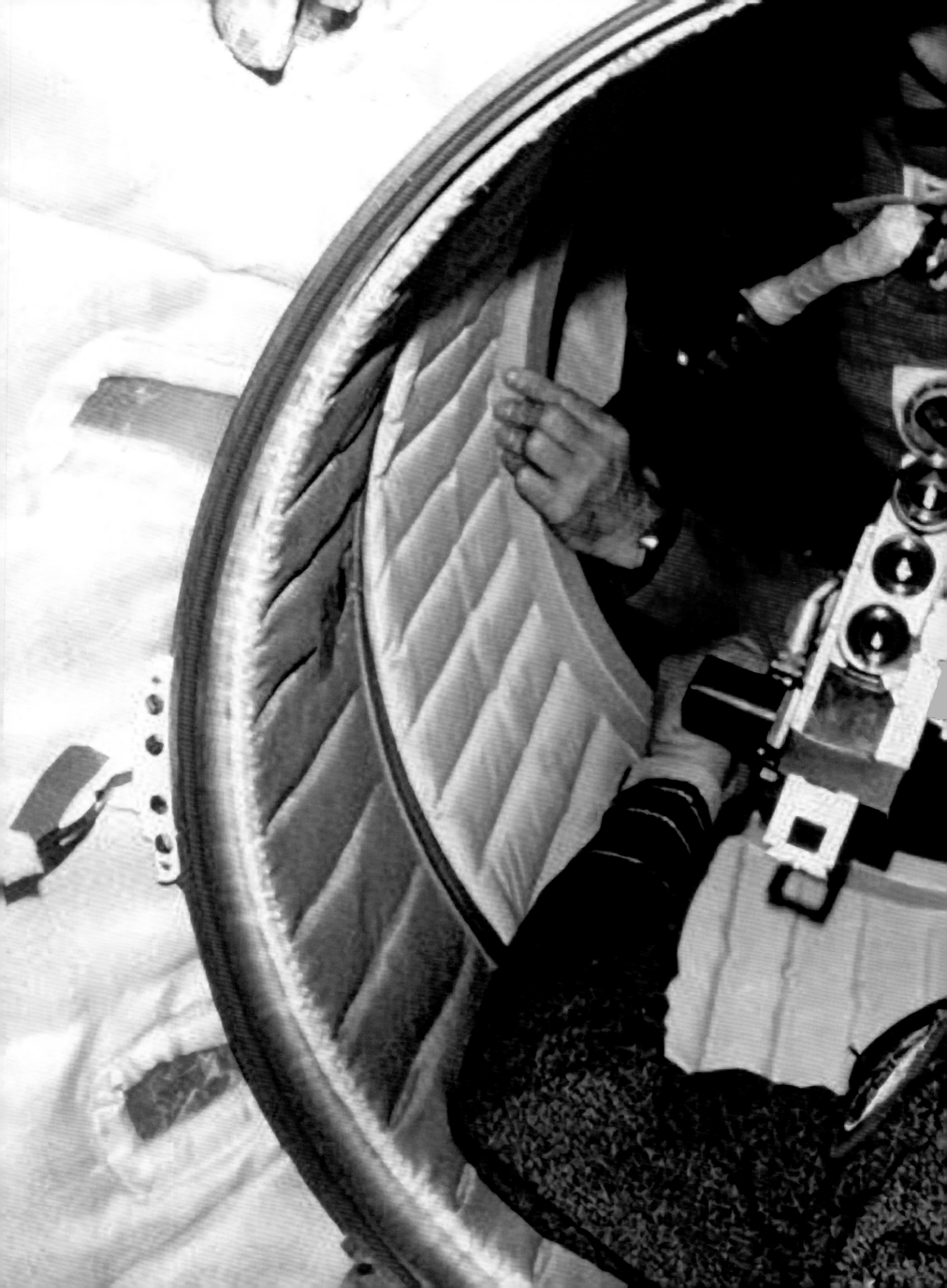

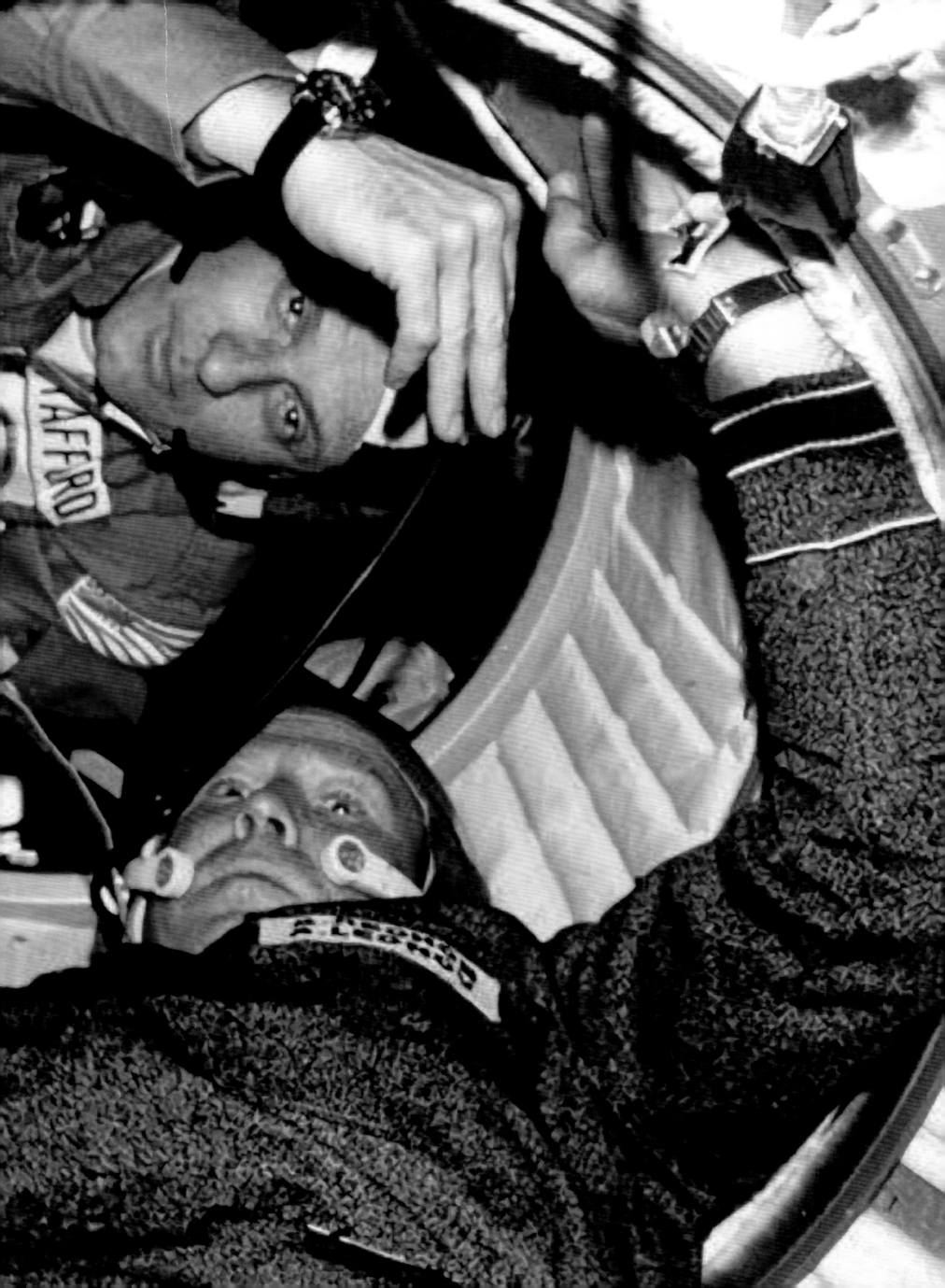

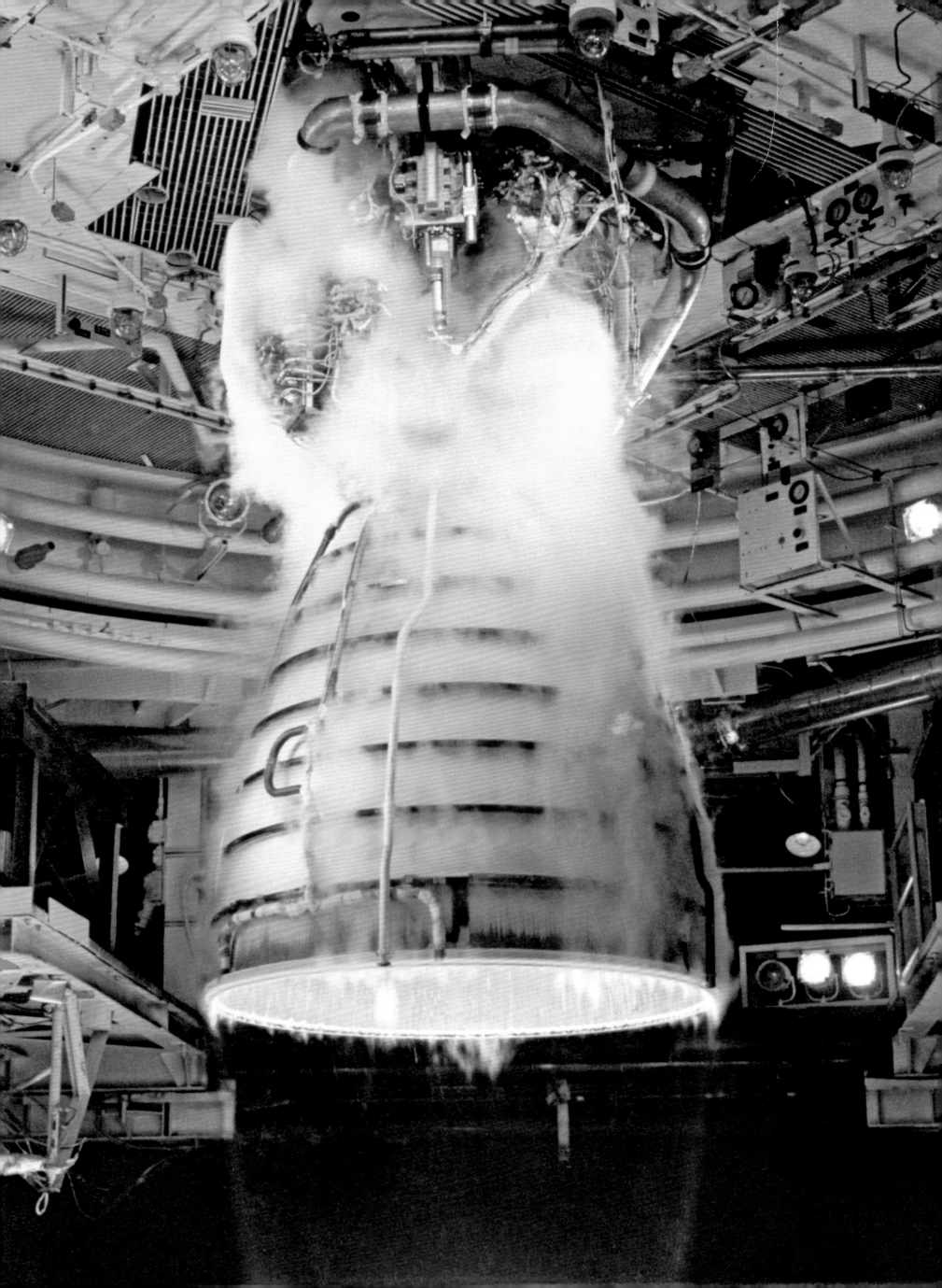

SPACE SHUTTLE

The space shuttle consists of four main components: the orbiter in which the astronauts and payloads reside, the external tank carrying more than a half million gallons of liquid hydrogen and liquid oxygen, the space shuttle main engines fed by the fuels from the external tank, and two solid rocket boosters that provide 3.3 million pounds of thrust at lift-off. All components except the external tank are reusable, making the space shuttle the first reusable launch vehicle, in contrast to expendable launch vehicles.

Aside from the *Enterprise*, a test shuttle now at the National Air and Space Museum, five space shuttle orbiters have operated since 1981: *Columbia, Challenger, Discovery, Atlantis*, and *Endeavour*. The latter is a replacement for the *Challenger*, destroyed on launch in 1986. The *Columbia*, destroyed on reentry in 2003, has not been replaced. *Challenger* had only ten flights and sixty-two flight days during its brief lifetime, while *Columbia* at the time of its demise held the shuttle record with three hundred flight days during twenty-eight flights.

During 117 flights in its first twenty-five years (1981–2006), the space shuttle could boast at variety of accomplishments carried out by 813 astronauts. For fifteen years beginning with STS-9 in 1983, fifteen flights carried Spacelab, a laboratory module for microgravity experiments. In 1990 STS-31 launched the Hubble Space Telescope, and four subsequent flights serviced it, an invaluable activity without which the telescope could not have operated. Altogether shuttle astronauts deployed sixty-six satellites, some of them major satellites for communications and science.

Between 1995 and 1998 nine flights docked with the Russian Mir space station as part of what became known as the "Shuttle-Mir" program. The first components of Mir were launched in February, 1986, one month after the *Challenger* accident. Beginning in 1995 seven astronauts spent a total of twenty-eight months on Mir, often undergoing unexpected adventures. Jerry Linenger was onboard when a fire broke out in February, 1997, and the following June Michael Foale and his Russian colleagues survived a collision of the Mir station with an unmanned *Progress* spacecraft. Mir was de-orbited March 23, 2001.

Between 1998 and 2006 twenty space shuttle flights went toward construction of the International Space Station (ISS), orbiting at an altitude of 230 miles. The ISS is an international venture involving sixteen countries, five space agencies (from the United States, Canada, Europe, Russia, and Japan) and more than one hundred thousand people around the world. The ISS, powered by enormous solar arrays, will consist of ten pressurized modules from a variety of countries. Two Russian modules (Zarya and Zvezda) and two US modules (Destiny and Node 1) are now in place. ISS now holds a crew of three, which will increase to six in 2009. When completed the ISS will be about four times the size of Mir, five times larger than Skylab, and will weigh 925,000 pounds. In addition to the space shuttle, ISS is serviced by the manned Soyuz spacecraft and the unmanned Progress spacecraft. In the future supply missions will also be undertaken by the European Automated Transfer Vehicle (ATV), Japan's H-II Transfer Vehicle (HTV), and the US Crew Exploration Vehicle (CEV).

The space shuttle program is scheduled to be phased out in 2010. Until then fourteen more shuttle missions are planned, including thirteen to the International Space Station and one final servicing mission for the Hubble Space Telescope. The space shuttle will be replaced by a new launch vehicle known as Ares, capable of boosting humans to the Moon and Mars in the CEV.

Opposite The space shuttle orbiters have three reusable main engines that, along with solid rocket boosters, provide power during ascent. Thanks to the longevity of the shuttle program, these are among the most thoroughly tested large rocket engines ever built. Each weighs one-seventh as much as a train engine but delivers the horsepower of thirty-nine locomotives. This photograph records a test-firing of a space shuttle main engine at the Stennis Space Center in Mississippi in May 1981.

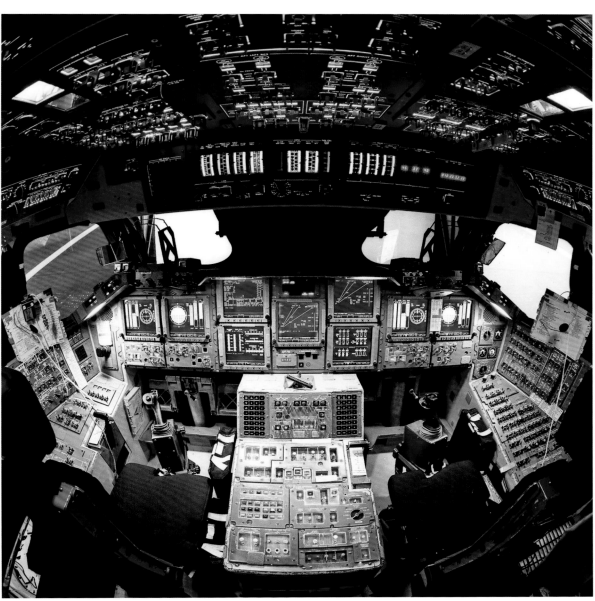

Above The cockpit of the space shuttle orbiters is complex, given that it must be operational in both the microgravity of space and the Earth's atmosphere. Originally, shuttle cockpits had mechanical gauges and cathode-ray-tube displays. This fish-eye view shows an orbiter simulator at the Johnson Space Center's Mission Simulation and Training Facility outfitted with NASA's newer multifunction electronic display subsystem, otherwise known as the glass cockpit, which uses the LCD displays common on many commercial airliners, in January 1999.

Left A NASA technician painstakingly installs tiles on the belly of space shuttle *Endeavour* at Rockwell's Palmdale, California assembly facility in September 1989. The tiles that protect the space shuttle orbiters from the heat of reentry are made of silica fibers derived from sand. These small tiles reach temperatures of 2,300 degrees Fahrenheit.

Overleaf The space shuttle *Endeavour* receives a high-flying salute from its sister *Columbia*, one day after landing at Edwards Air Force Base in California, to complete mission STS-68 (STS is an acronym for Space Transportation System) on October 11, 1994. *Columbia* was being ferried from the Kennedy Space Center, Florida, to Palmdale, California, for refurbishment. *Endeavour* is surrounded by the ground-support convoy that services the space vehicles as soon as they land.

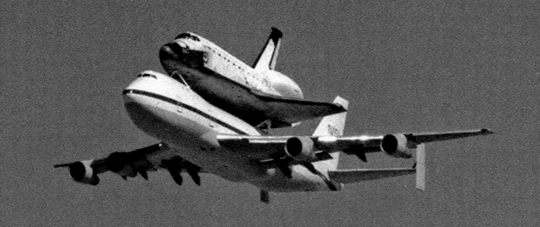

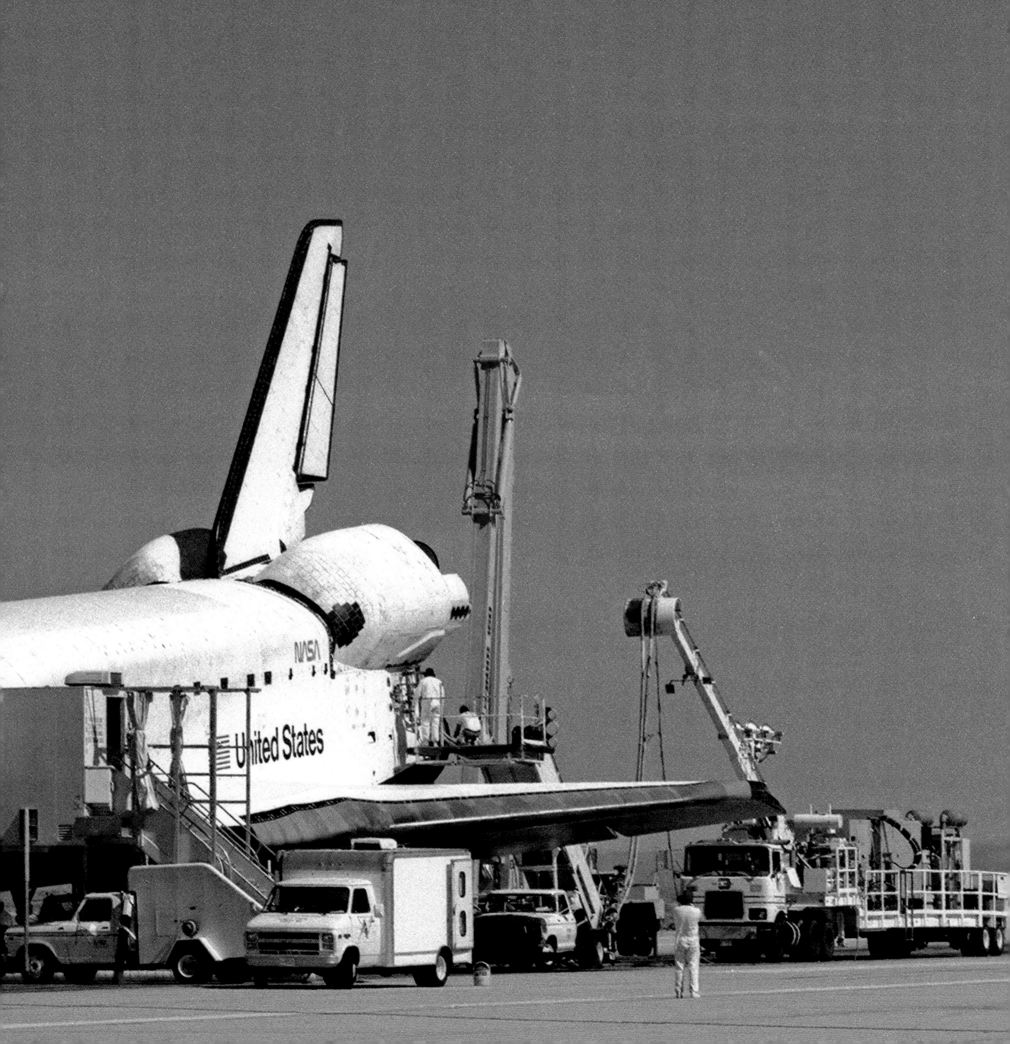

Left The STS-44 mission has landed safely at Edwards Air Force Base in California in December 1991, and space shuttle *Atlantis* is being returned to the Kennedy Space Center on the other side of the country in Florida where all shuttle missions originate. Until February 1984, when the Shuttle Landing Facility opened at Kennedy Space Center, most shuttle missions landed at Edwards, and some still do. When the space shuttle does land at Edwards, it is hoisted onto one of two NASA 747s for the return trip to Florida, using a gantry-like steel structure called the mate–de-mate device.

Overleaf All eyes are on space shuttle *Discovery* as it enters the vehicle assembly building (VAB) at the Kennedy Space Center in October 2006. It will be mated to its external tank and twin solid rocket boosters in preparation of the launch of mission STS-116 some six weeks later.

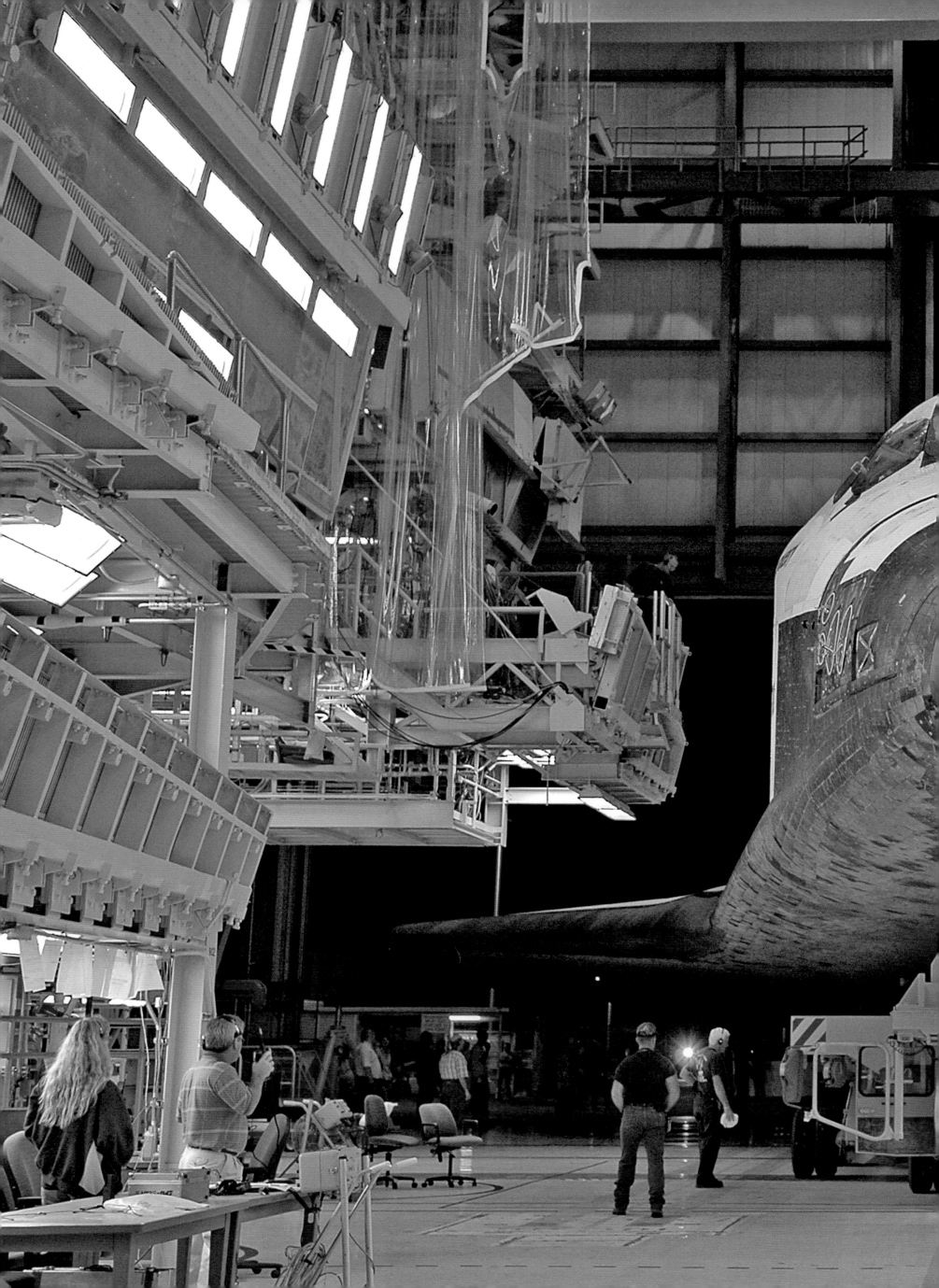

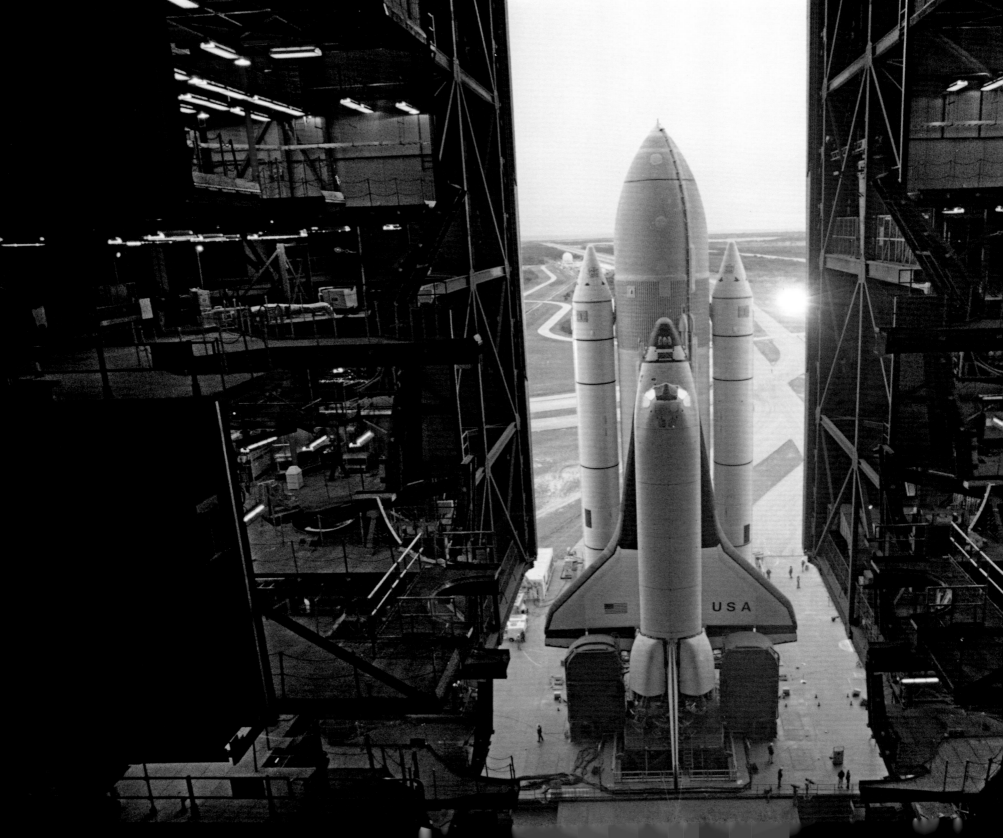

Inside the VAB, the approximately 171,000-pound orbiter is hoisted by crane and mated with the 184-foot-tall external tank/solid rocket booster stack. The space shuttle stack is then transported on a mobile launcher platform to the launch pad three-and-a-half miles away by the crawler-transporter, which is the world's largest self-powered tracked vehicle. The platform and transporter were built for the Saturn rockets of the Apollo program and adapted for the space shuttle.

Left Space shuttle *Atlantis* is being de-mated from the stack during preparations for the STS-79 mission, in a photograph taken from the thirty-fourth level of the VAB, August 1, 1996. **Below left** Space shuttle *Columbia* begins its first manned journey, STS-1, as it exits the 456-foot-high doors of the VAB, December 29, 1980. **Below** Readied for mission STS-79, *Atlantis* sits atop the stack directly outside the VAB, in a photograph taken from the roof 525 feet above the ground, August 20, 1996. **Far left** Space shuttle *Challenger* moves through the fog toward the gantry at Launch Pad 39A for its first flight on mission STS-6. The much-delayed launch took place on April 4, 1983.

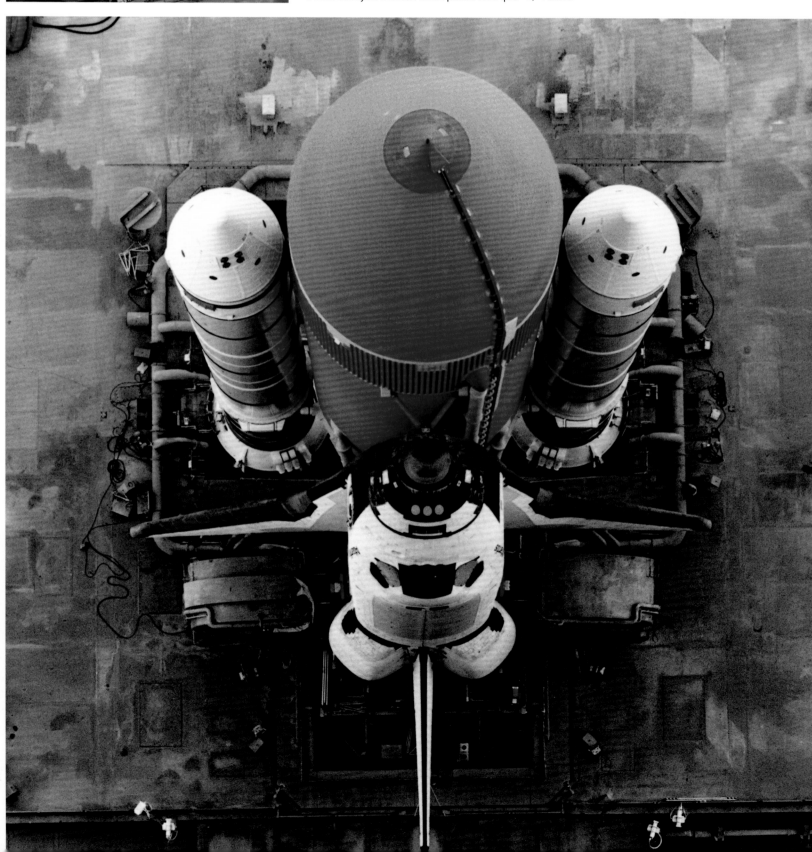

Right More than five years after the Apollo-Soyuz
Test Project of July 1975, the US manned space
program resumes with the launch of the first space
shuttle mission, designated STS-1. The date is April
12, 1981, and the crew of space shuttle *Columbia*
includes Commander John Young and Pilot Robert
Crippen, who will orbit the Earth thirty-six times over
fifty-four-and-a-half hours. One hundred and twenty-six
seconds into the launch, when the orbiter is traveling
at 3,438 mph, the boosters will be jettisoned, and
the main engines will take over all the work. Shortly
before the fuel runs out, the main engines will be shut
down and the external tank released. (After STS-2,
NASA stopped painting the external tank white to
save weight.)

Overleaf left The space shuttle *Columbia* lifts off
from Launch Pad 39B on June 5, 1991, with Mission
STS-40, carrying a crew of seven and the Spacelab
Life Sciences-1 laboratory. Eight-and-a-half minutes
after launch, the space shuttle will reach its orbital
speed of 17,500 mph.

Overleaf right The space shuttle *Discovery*
lands at night at Kennedy Space Center's Shuttle
Landing Facility on September 22, 1993. This is
the end of STS-51, whose five-man crew launched
an advanced communication satellite. The orbiter is
traveling at about 16,700 mph when it enters the
Earth's atmosphere at an altitude of 400,000 feet.
It touches down at about 220 mph, after a rapid
descent.

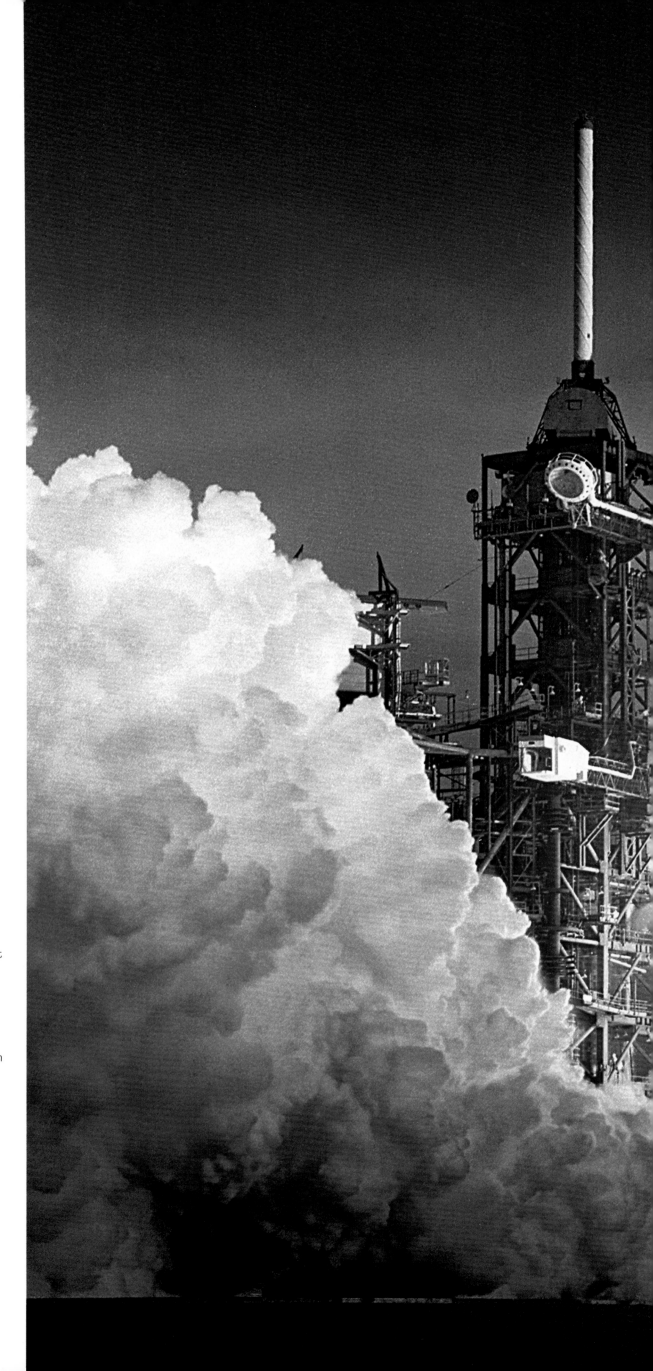

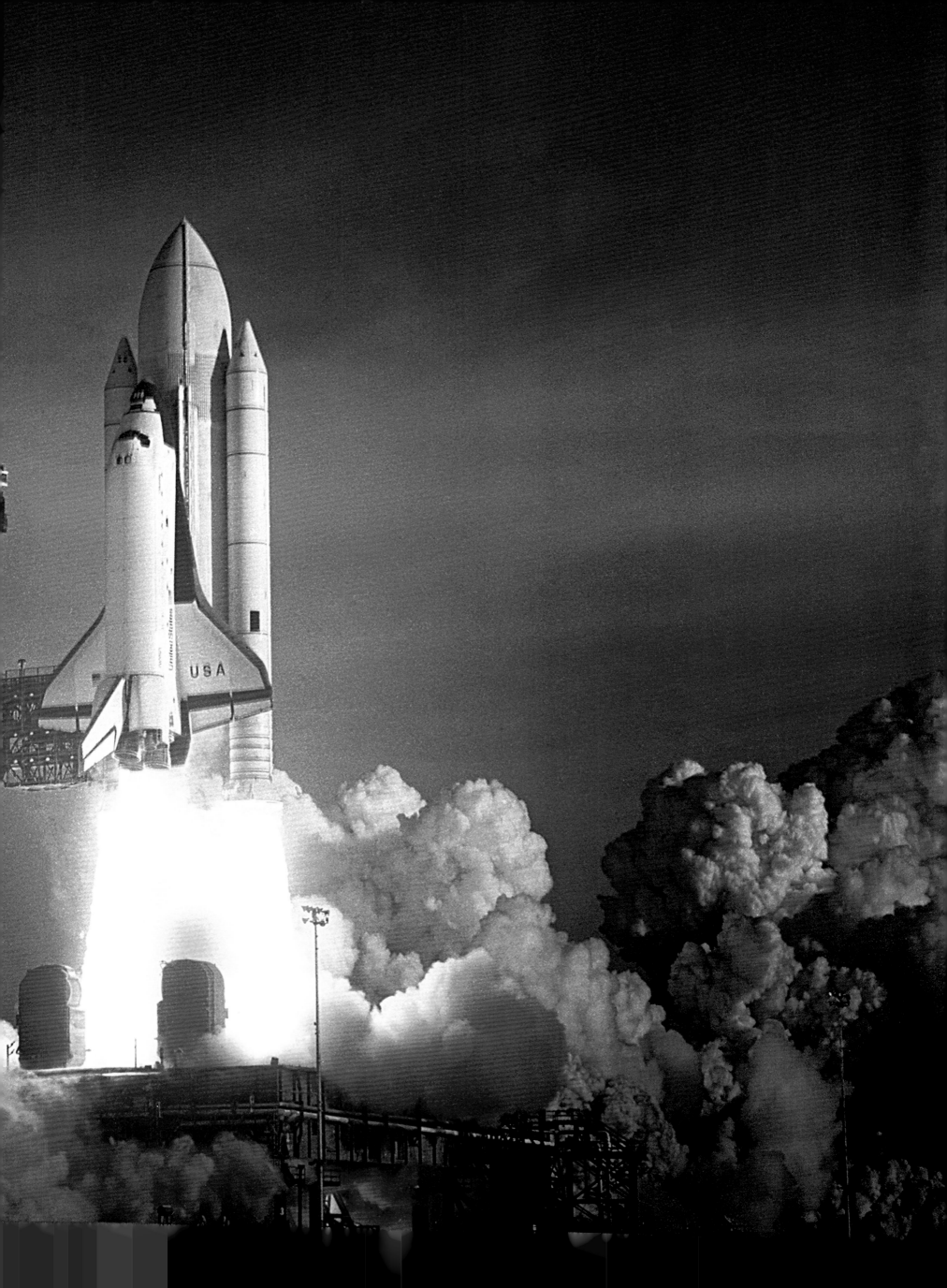

Right The space shuttle *Columbia* rests on Rogers Dry Lake at Edwards Air Force Base in California after completing mission STS-1 on April 14, 1981. The orbiter will be towed back to the Dryden Flight Research Center from the base for post-flight processing. The earliest space shuttle missions terminated here in California's Mojave Desert, the site of most of NASA's experimental aeronautic programs.

Overleaf President Ronald Reagan points out the space shuttle *Columbia* to his wife Nancy as it nears the runway at Edwards Air Force Base on July 4, 1982. Seen here (left to right) are NASA Administrator James Beggs, astronaut Robert Crippen, Nancy Reagan, President Reagan, and astronaut Joe Engle. Hundreds of people came to the desert with their RVs and campers to observe the landing of STS-4, which carried a crew of two and was the final research and development mission for the program.

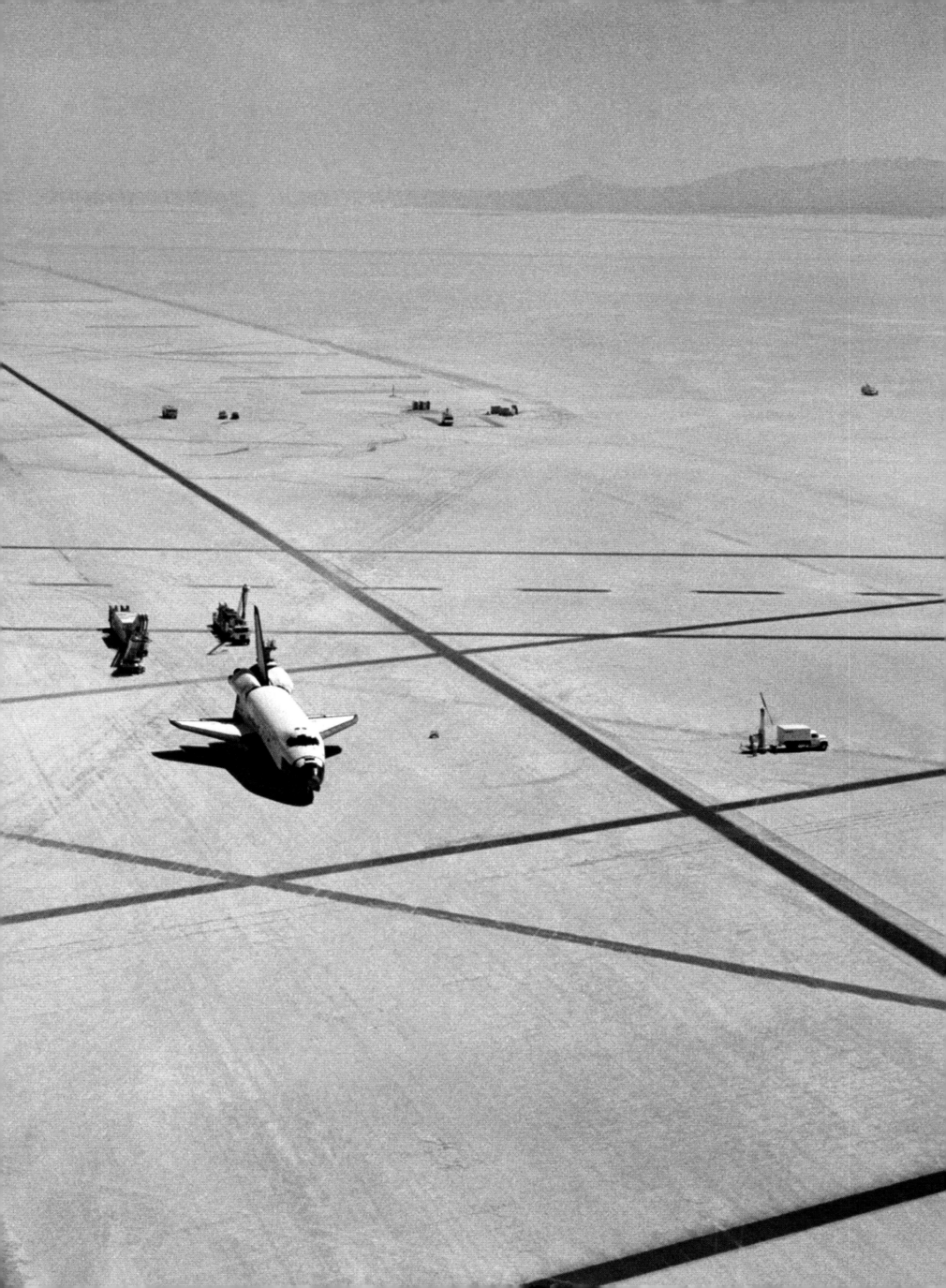

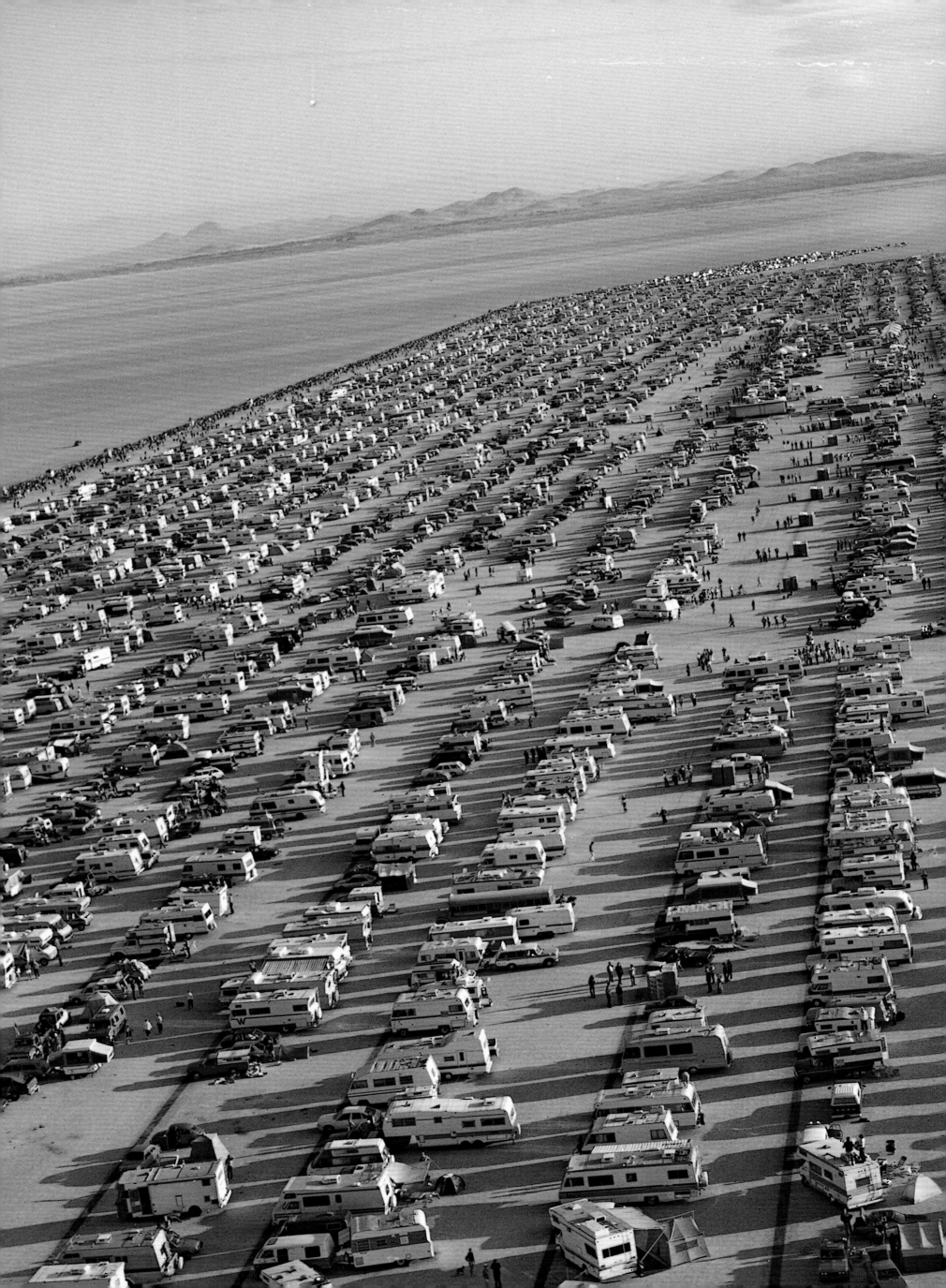

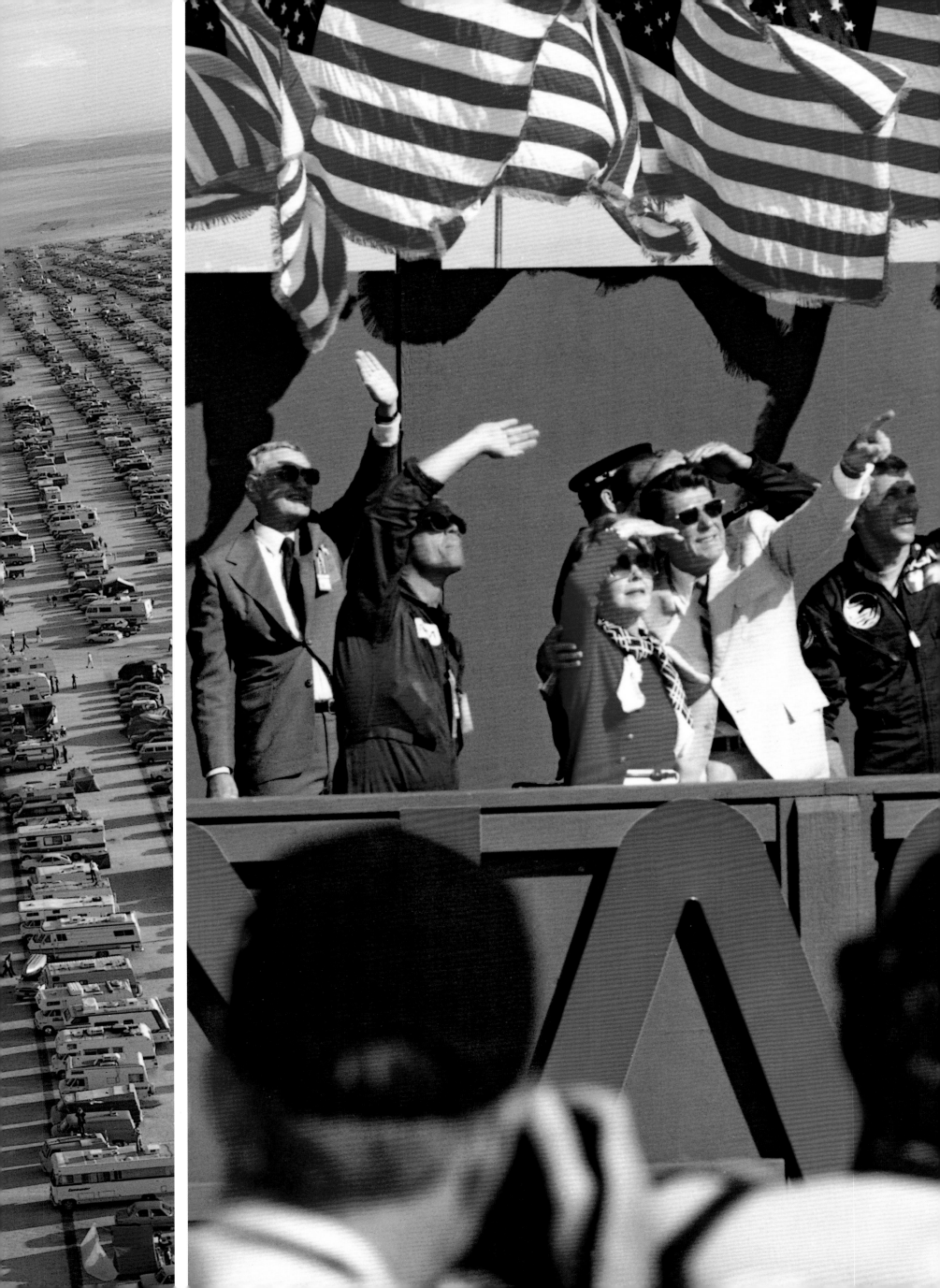

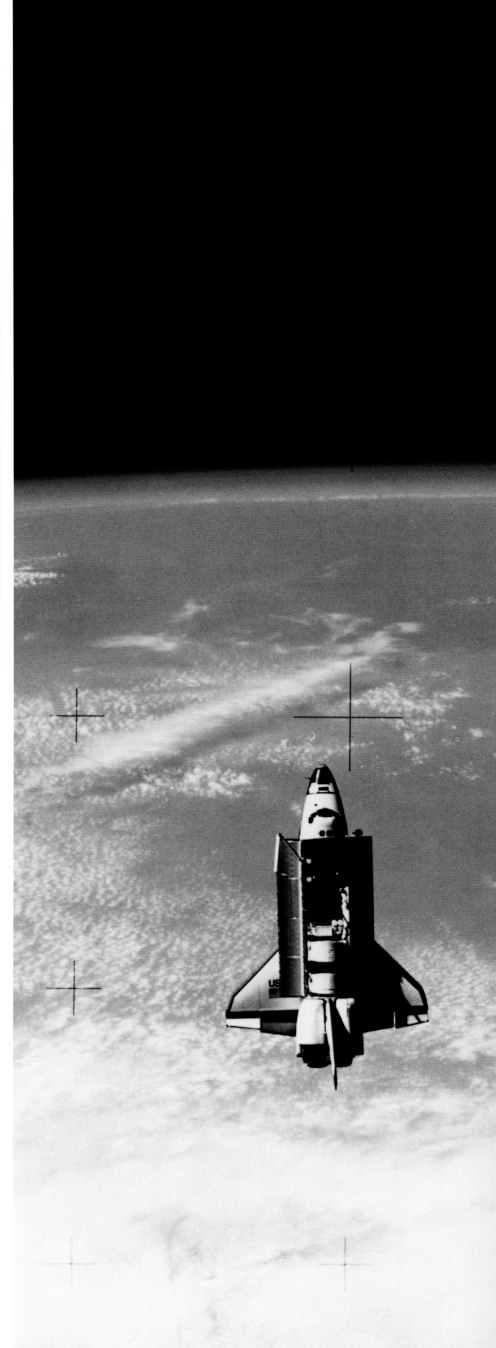

Right Space shuttle *Challenger*, with its cargo bay open, appears to drift lazily above the Earth as it is photographed by a 70mm camera on the Shuttle Pallet Satellite SPAS-01. Among the five-person crew of STS-7, June 22-24, 1983, commanded by Robert Crippen, is Mission Specialist Sally Ride, the first American woman in space. **Above** Ride, using a sleeping bag designed to keep astronauts from floating around the shuttle cabin and give them a familiar sense of support in weightless conditions, drifts off herself. **Far right** About two months later, again aboard *Challenger*, STS-8 Commander Richard Truly and Mission Specialist Guion Bluford take a brief rest without restraint. Bluford was the first African American astronaut in space.

Overleaf Christa McAuliffe and Barbara Morgan undergo weightlessness training on board NASA's KC-135 "zero-gravity" aircraft in January 1986. The Teacher in Space Project of 1984 was intended to inspire teachers and students in math, science, and space exploration. McAuliffe, a social studies teacher from Concord High School in Concord, New Hampshire, was selected to be the first teacher in space with Morgan as her alternate. After McAuliffe died in the *Challenger* disaster in 1986, NASA discontinued the program. Morgan was not slated to fly until STS-118, scheduled for 2007.

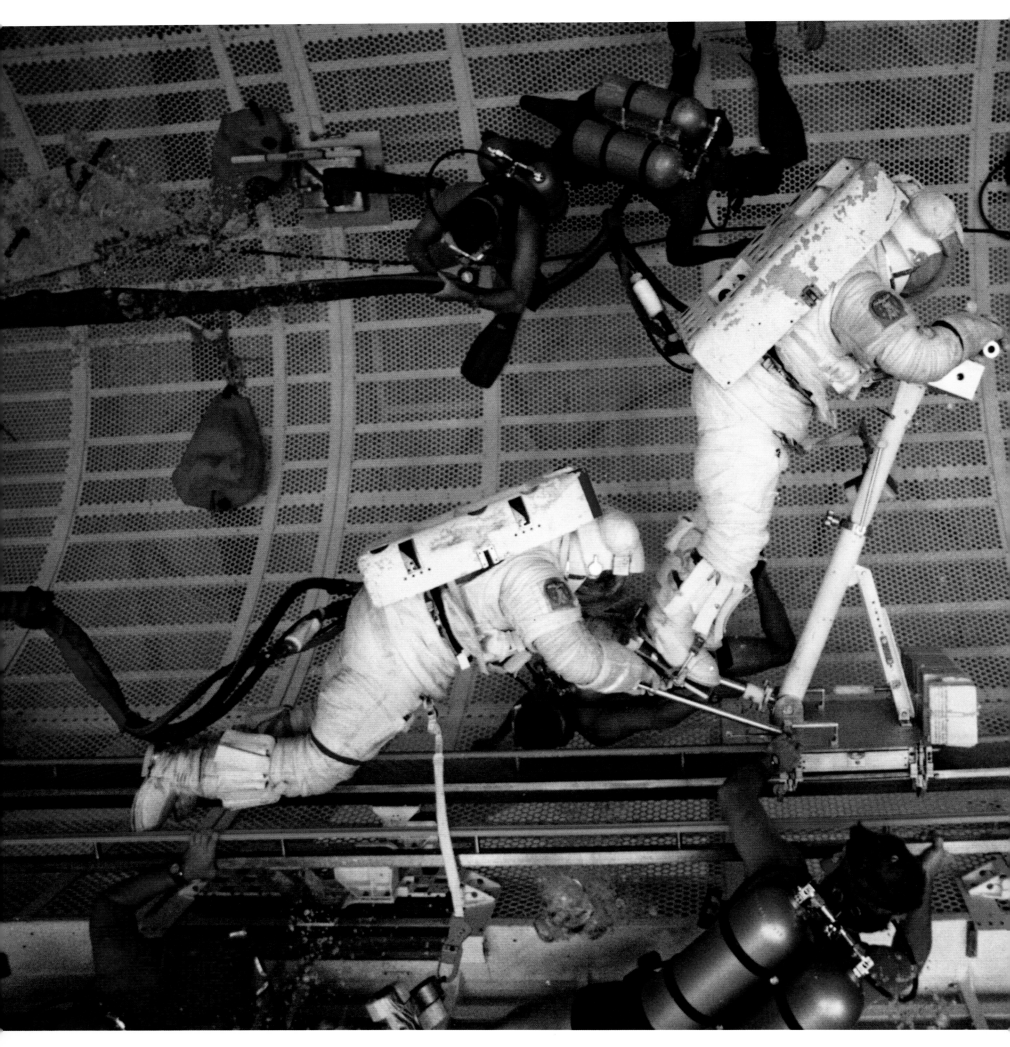

Above In the Johnson Space Center's Weightless Environment Training Facility pool, astronauts Jerry Ross and Jay Apt practice operating the electrical hand-pedal cart they will use during their six-hour spacewalk during mission STS-37, which launched on April 5, 1991. This was the third of seven missions for Ross, a US record he shared with Franklin Chang-Diaz. Apt is pulling Ross along to test the cart's ability to carry a person plus cargo in October 1989.

Below NASA's most dramatic EVAs involved the use of the Manned Maneuvering Unit (MMU), a pack with twenty-four nozzle thrusters that an astronaut could use for propulsion on untethered spacewalks. Here, Mission Specialist Bruce McCandless is stepping into the MMU in the Weightless Environment Training Facility pool in August 1981, six months before his mission.

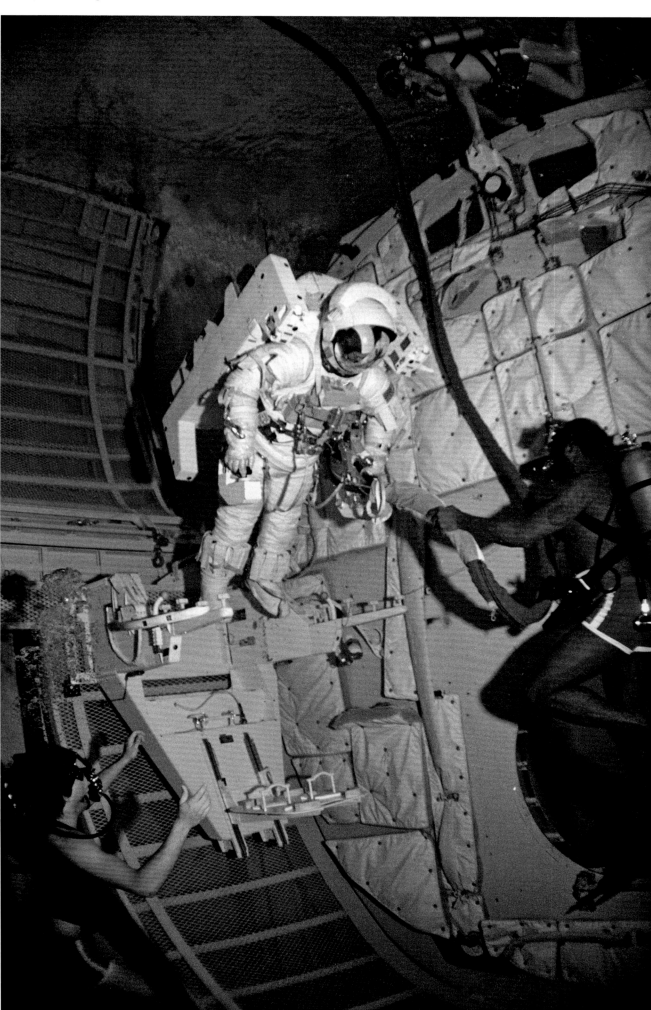

Overleaf In one of the most remarkable photographs ever taken of a human being, McCandless is seen further away from the confines and safety of his ship than any astronaut before or since. After a series of test maneuvers, the mission specialist aboard STS-41-B went "free-flying" to a distance of 320 feet away from the orbiter on February 7, 1984. The MMU was used on two more space shuttle missions and then retired after the *Challenger* disaster.

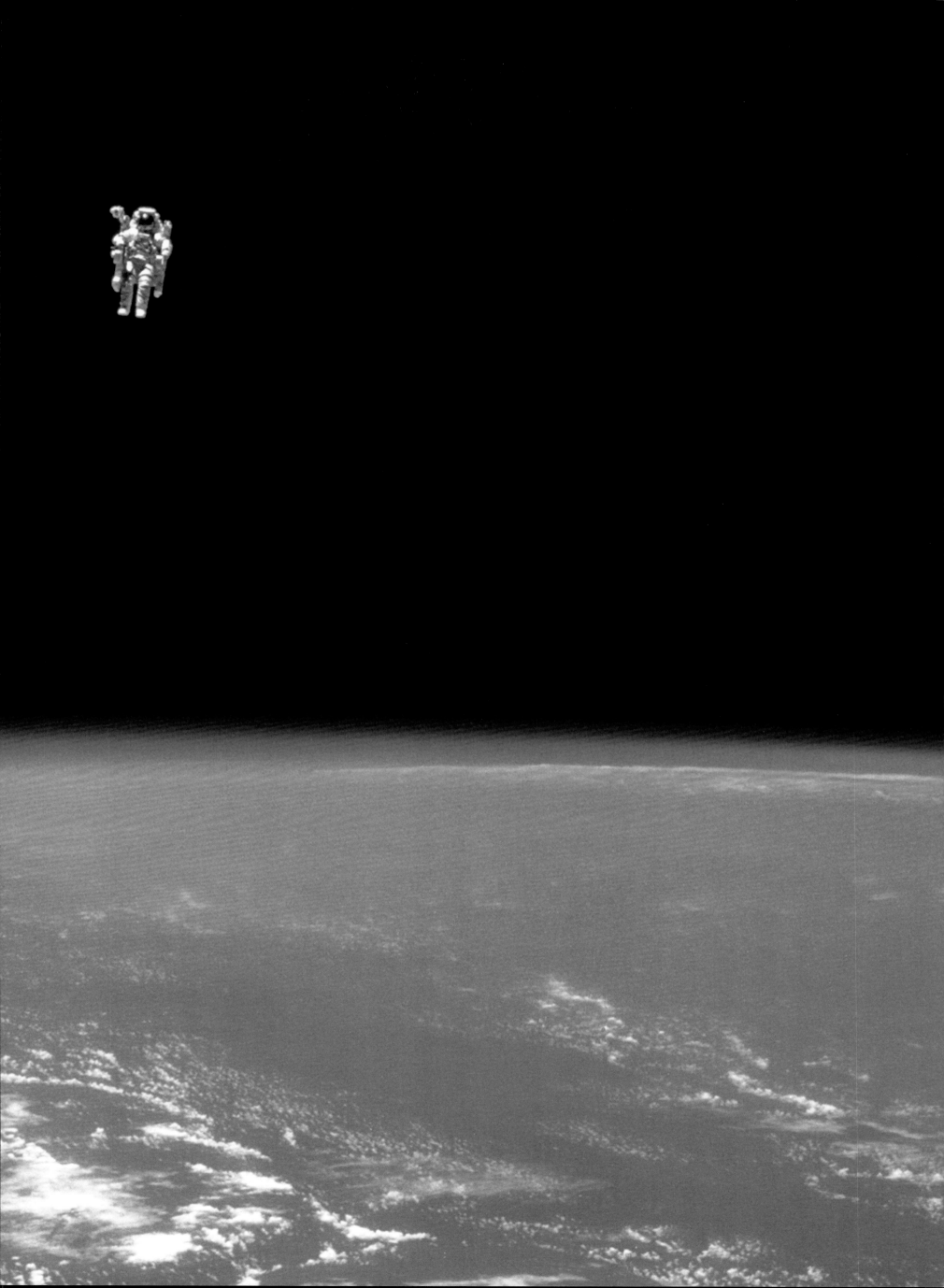

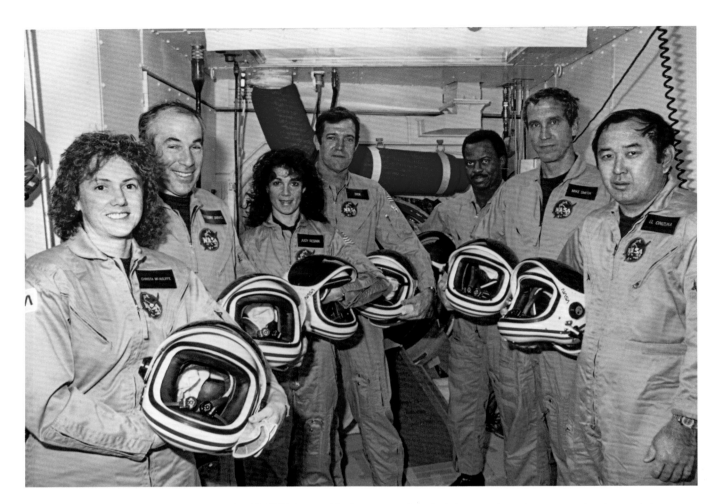

Opposite T+73.162 seconds, altitude 48,000 feet: with the external tank disintegrating, the space shuttle stack is torn apart on January 28, 1986, claiming the lives of the STS-51-L crew in *Challenger*. The main-engine exhaust, solid rocket-booster plume, and an expanding ball of gas from the external tank are visible seconds after the accident. Investigating the accident, a presidential commission that included astronauts Neil Armstrong and Sally Ride pointed to a design flaw in the solid rocket boosters as well as faulty decision-making within NASA. **Above** Three weeks earlier on January 9, the crew of STS-51-L stands in the white room at Pad 39B following a countdown demonstration test: Payload Specialists Christa McAuliffe and Gregory Jarvis, Mission Specialist Judith Resnik, Commander Francis Scobee, Mission Specialist Ronald McNair, Pilot Michael Smith, and Mission Specialist Ellison Onizuka. **Below** In April, NASA officials bid farewell to the crew's remains, as they are placed on board a transport plane at the Kennedy Space Center's Shuttle Landing Facility en route to Dover Air Force Base, Delaware. The astronauts were buried at Arlington National Cemetery.

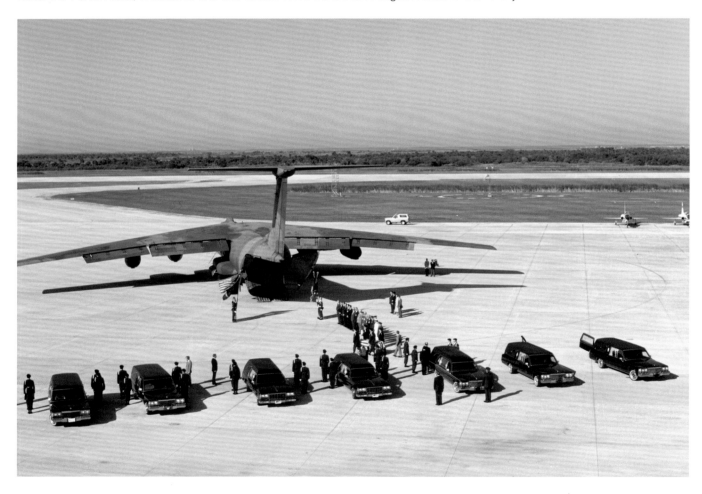

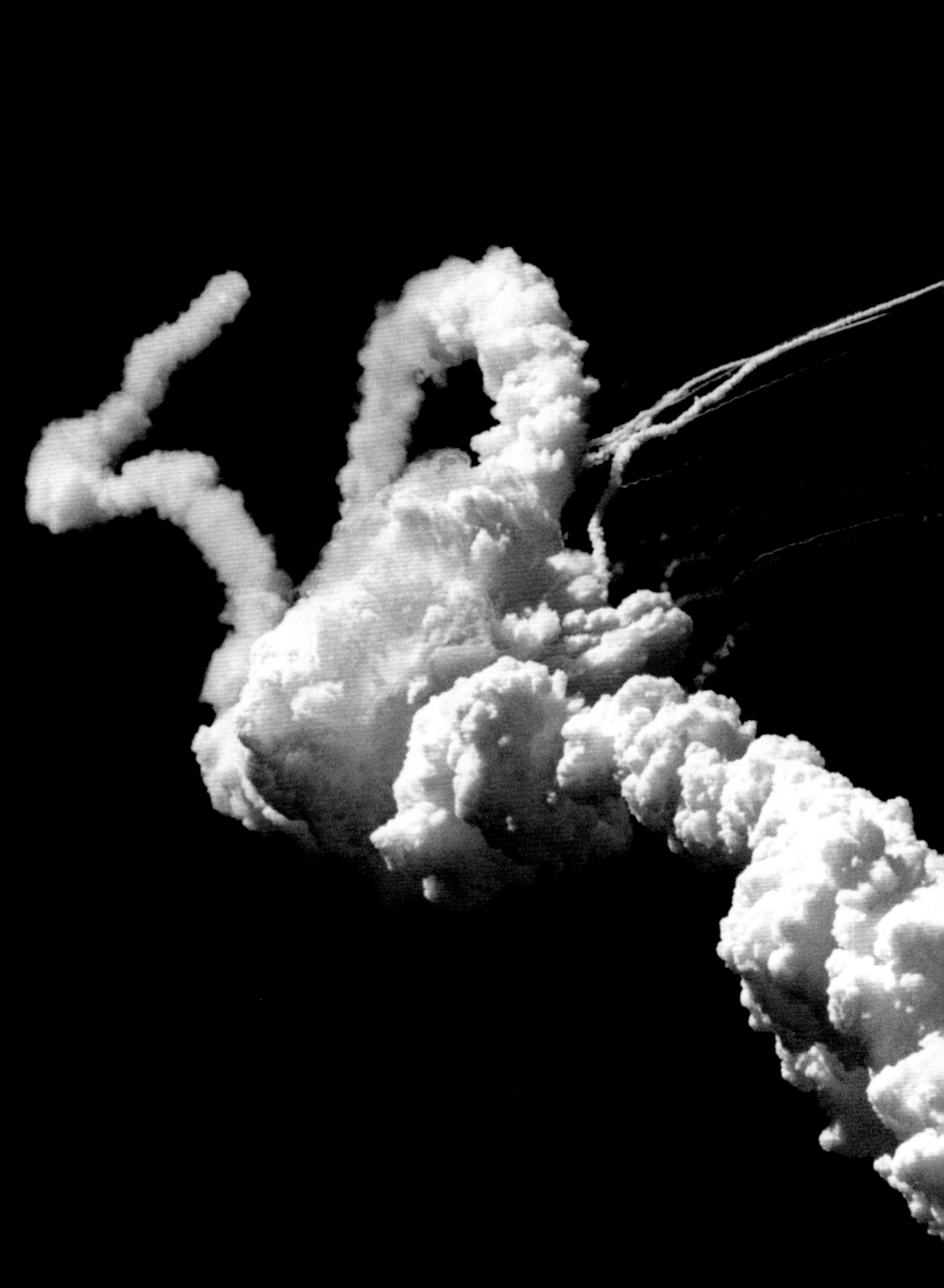

The idea of launching a telescope into space is almost as old as NASA itself: in 1962, a study group for the National Academy of Sciences proposed it as a long-range goal for the US space program. Congress funded it in 1977. It took almost a decade to build the telescope, named after astronomer Edwin Hubble, and the spacecraft was not completed until 1985. Delayed by the *Challenger* disaster, it was launched by the STS-31 mission in 1990.

Left At Johnson Space Center, where virtually all on-orbit duties are simulated, the stage is set in May 1986 for astronauts to train to launch the Hubble Space Telescope. The tall, gray cylinder to the right is a mock-up of the telescope. This high-angle view of Building 9A's training facilities also takes in the space shuttle full fuselage trainer and the Remote Manipulator System (RMS) mock-up—this mechanical arm is used to maneuver and deploy shuttle payloads and as a work station for astronauts on EVAs.

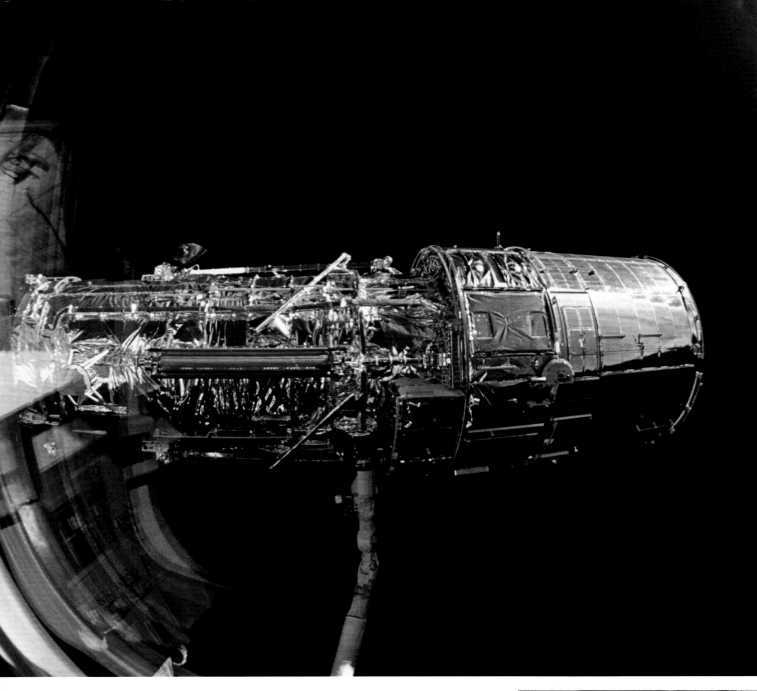

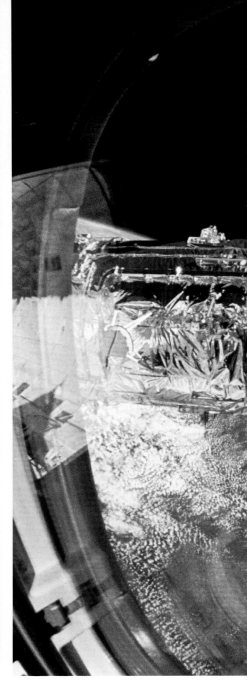

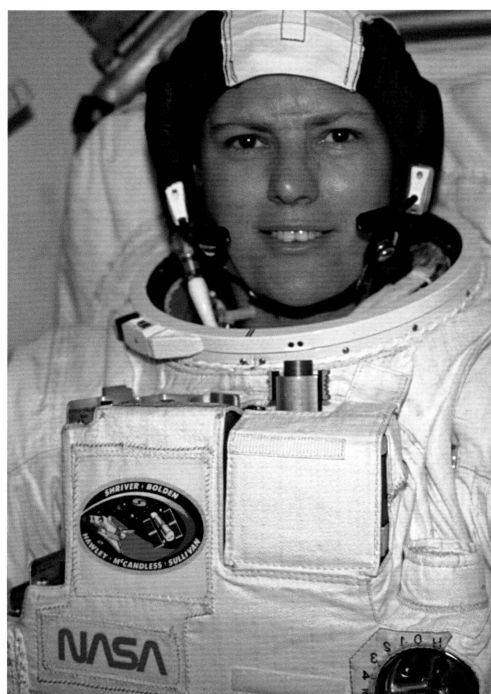

Above A series of three photographs records the deployment of the Hubble Space Telescope on April 29, 1990, using the RMS: the spacecraft extends its two gold solar-array wings and is released to soar above the Andes Mountains in the background.

Far right Three members of the STS-31 crew observe the procedure from the aft flight deck of *Discovery*. From front to back are Commander Loren Shriver, Mission Specialist Steven Hawley, and Mission Specialist Bruce McCandless. The ongoing scene outside the crew cabin is mirrored in the closed-circuit television screens on McCandless's right.

Right Mission Specialist Kathryn Sullivan prepares for contingency EVA in the event of problems with the deployment.

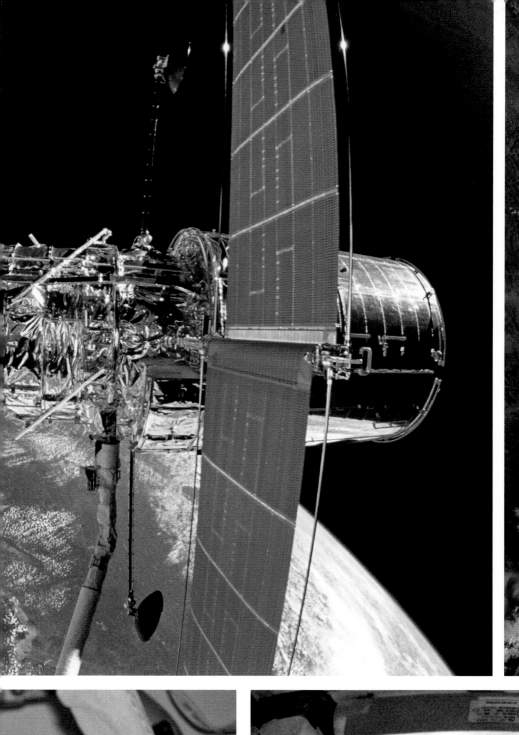

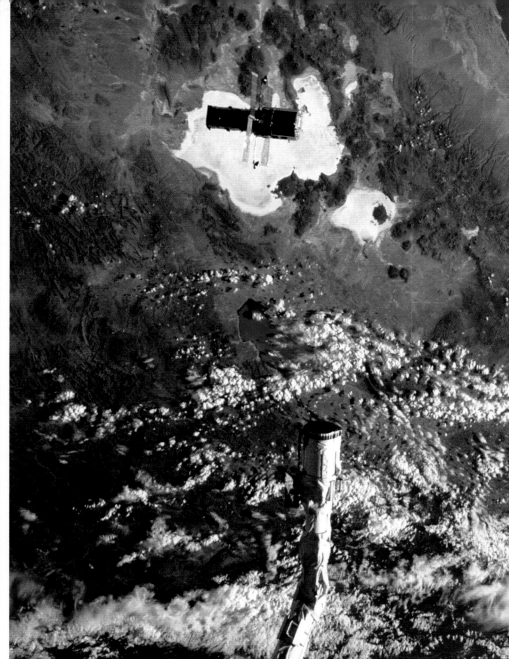

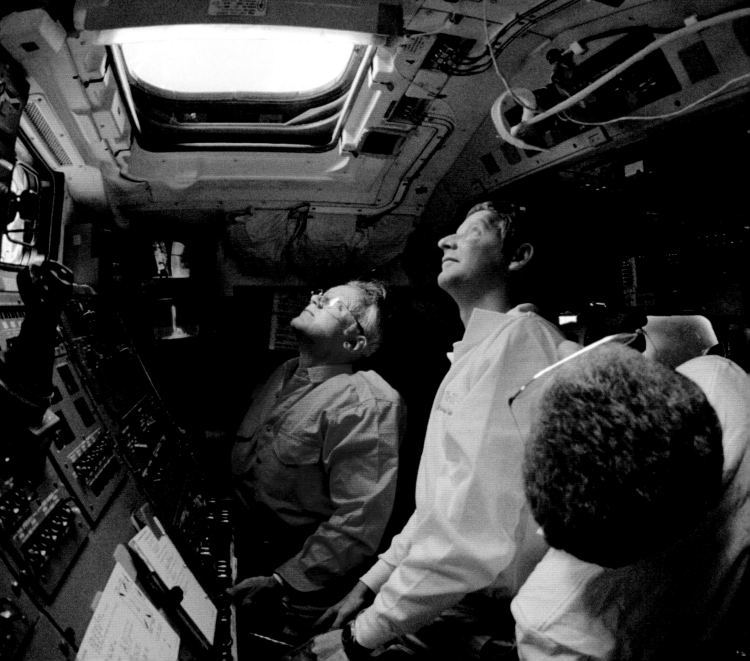

Right The seven-person crew of STS-49, the first for the new space shuttle *Endeavour*, set a record for the most EVA time to date: twenty-five hours and twenty-seven minutes. Most of those hours were spent trying to capture an INTELSAT VI communications satellite that had been stranded in an unusable orbit since it was launched in March 1990. The first two attempts failed to retrieve the spacecraft. The third, the first three-person EVA by a NASA crew, succeeded: the astronauts grabbed the four-and-a-half-ton satellite as Commander Daniel Brandenstein maneuvered the orbiter to within a few feet of it. In this photograph of the successful capture on May 16, 1992, Mission Specialist Rick Hieb is visible to the left, Mission Specialist Bruce Melnick has his back to the camera, and Mission Specialist Tom Akers uses the RMS, right. The satellite was repaired and released into geosynchronous orbit.

Overleaf left Spacelab was a reconfigurable laboratory developed by the European Space Agency and mounted in the space shuttle's cargo bay for microgravity experiments on space shuttle missions between 1983 and 1997. STS-47 Mission Specialist Mae Jemison appears to be clicking her heels as she floats in the mission's manned Spacelab-J (a collaboration with the Japanese space agency) in September 1992.

Overleaf right NASA's successor to the MMU was the Simplified Aid for EVA Rescue, or SAFER, a small propulsive backpack unit to be worn by all astronauts on tethered EVAs as a safety device. STS-64 Mission Specialist Mark Lee tests the SAFER system without a tether on September 16, 1994.

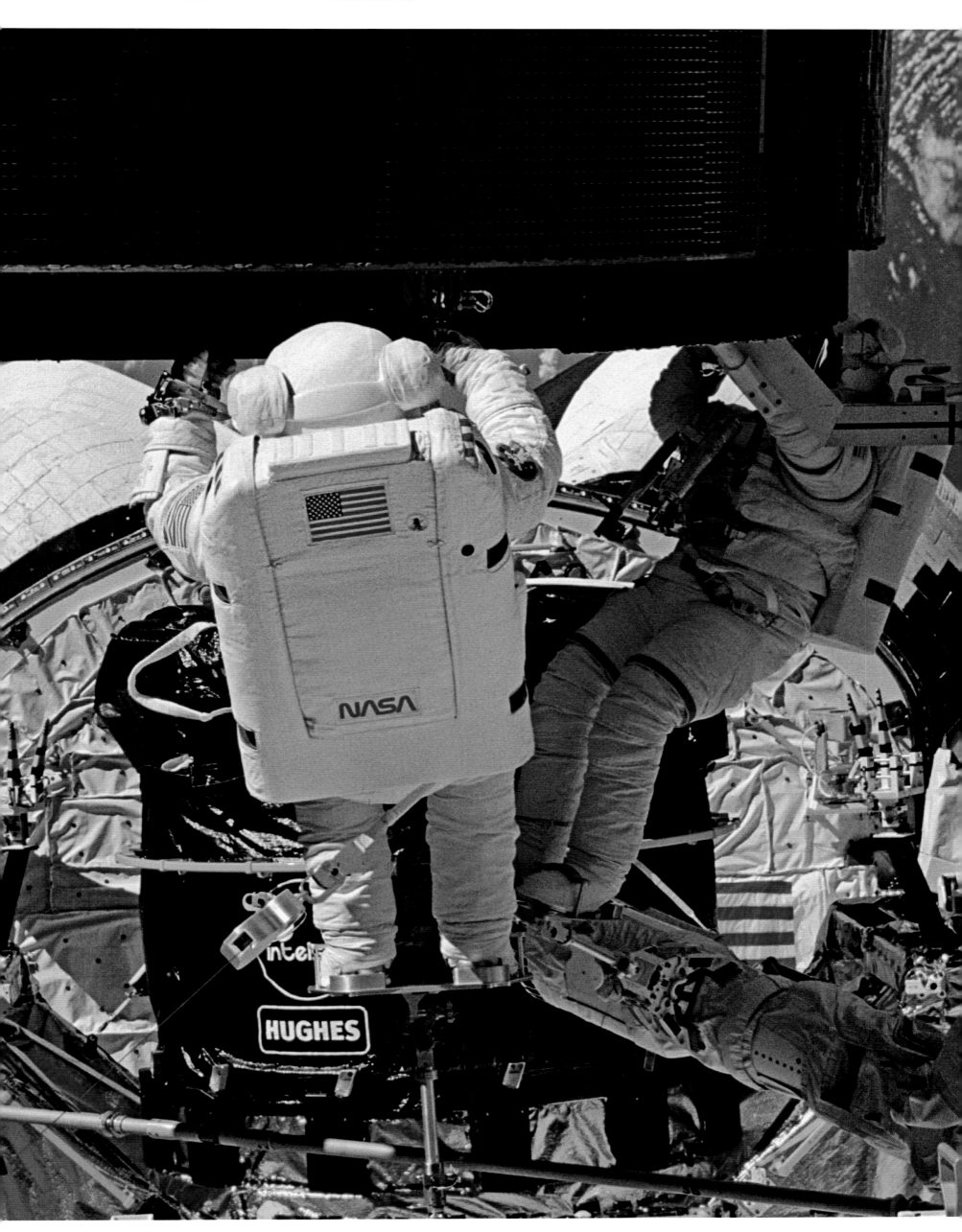

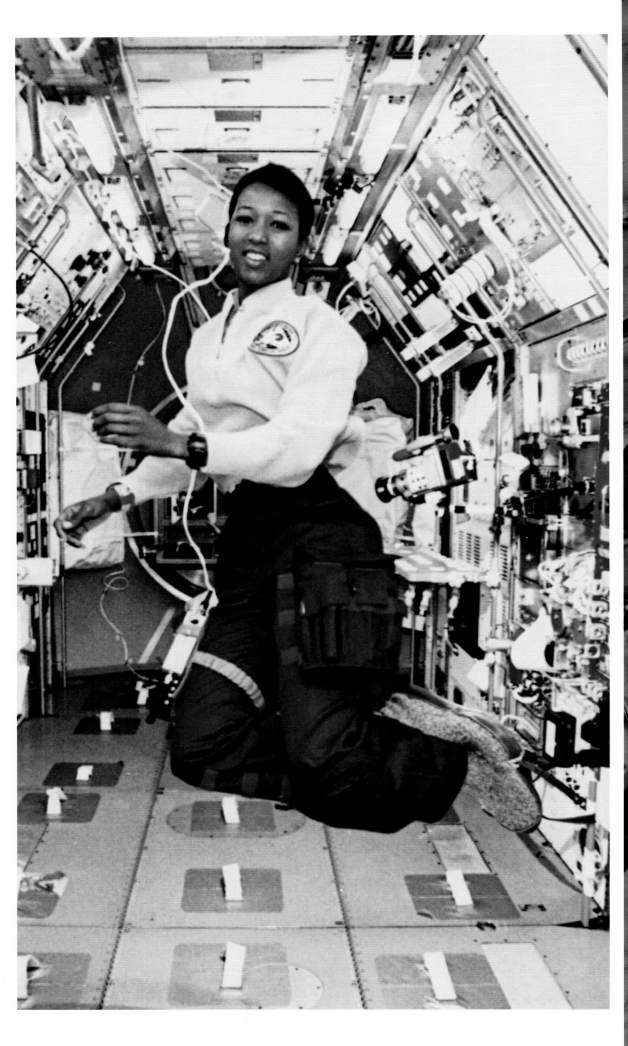

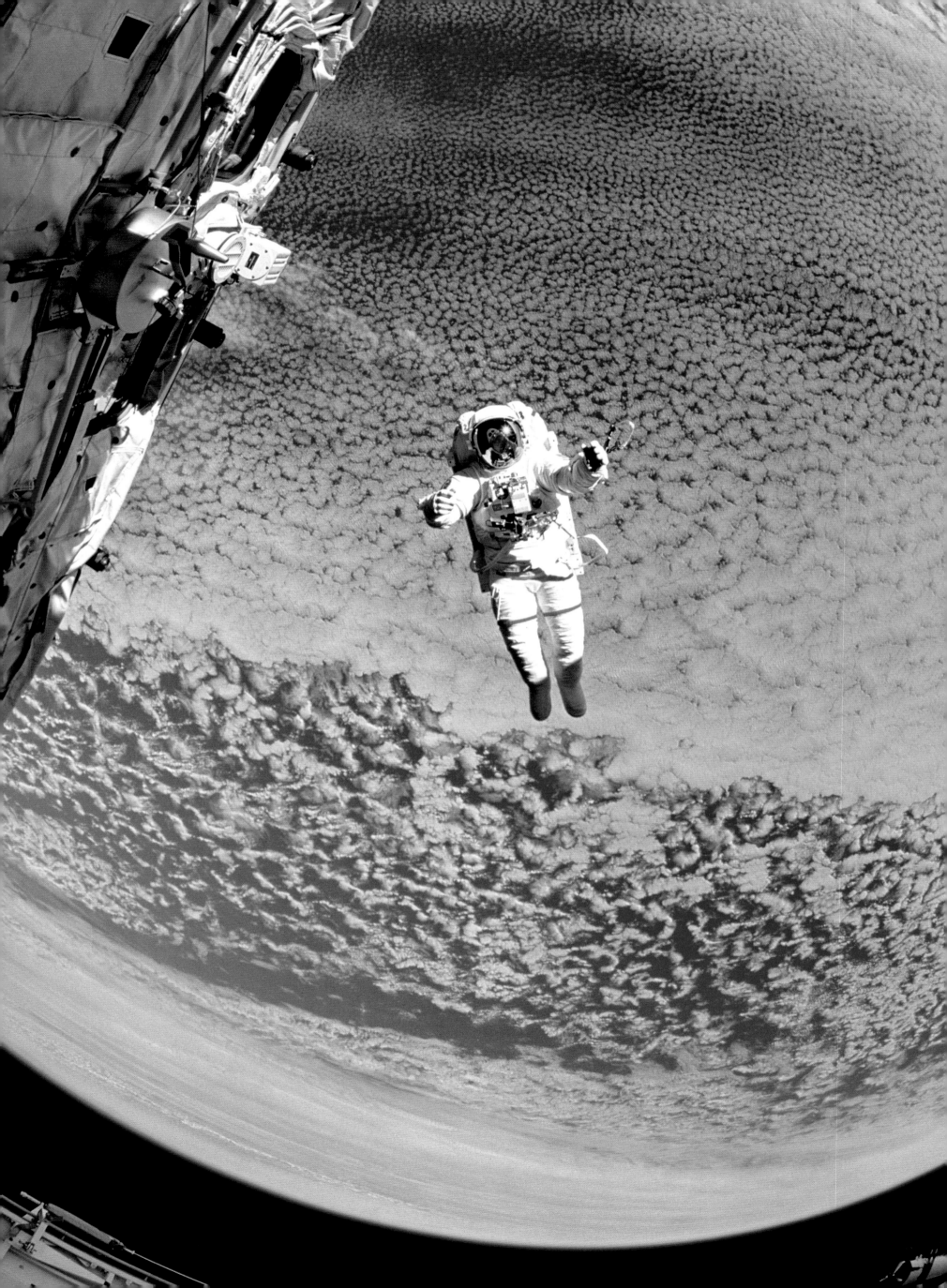

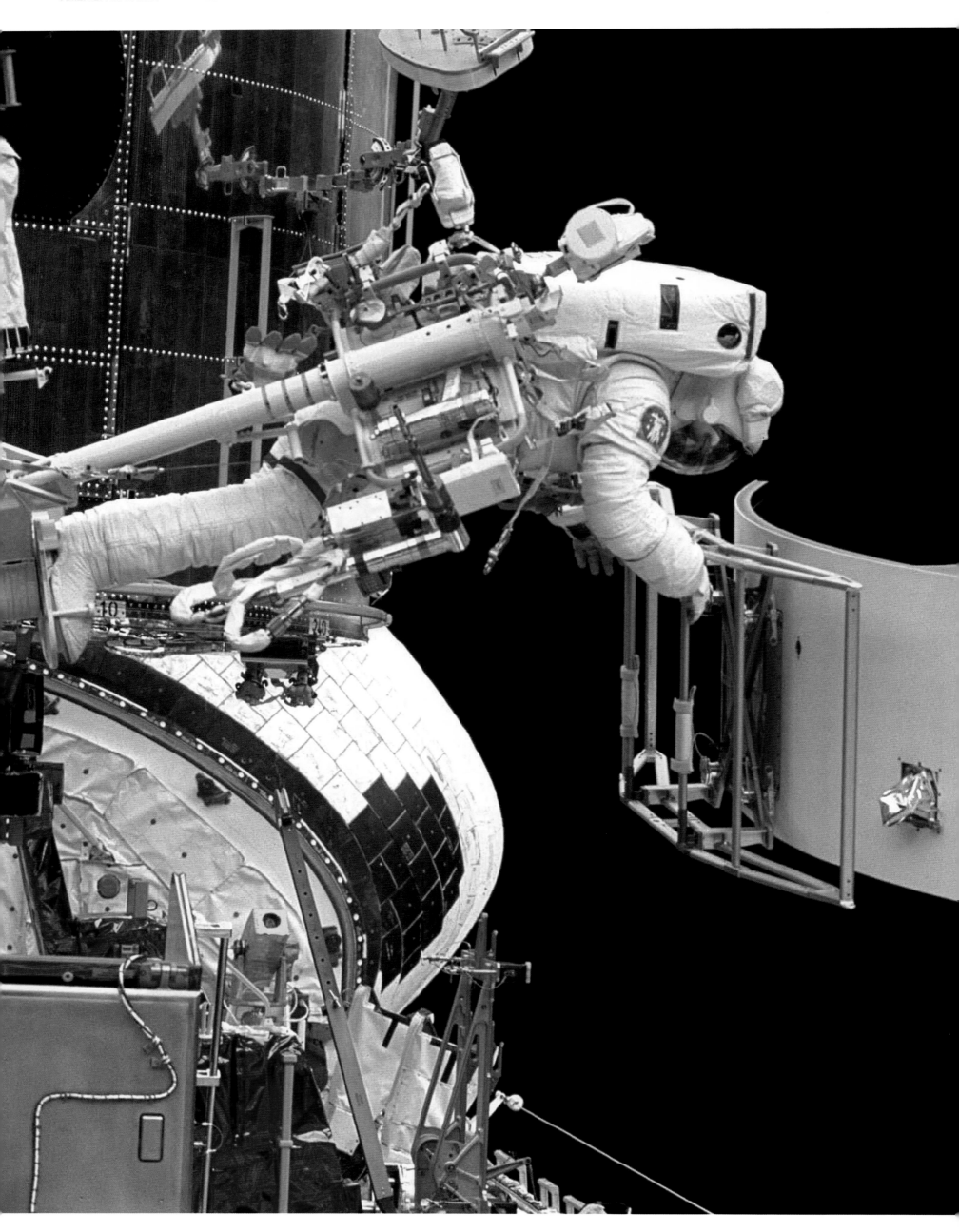

Pages 282-83 The fourteen-day STS-58 was dedicated to life-science research, especially human adaptation to weightlessness. Inside Spacelab Life Sciences, Payload Commander Rhea Seddon spins Payload Specialist Martin J. Fettman, who is wearing an instrument that records his eye movements on October 24, 1993. The purpose of the experiment is to investigate the effects of weightlessness on the human neuro-vestibular system, and particularly its impact on visual and spatial perception and the causes of space-motion sickness.

Left After Hubble's deployment in 1990, it was discovered that the telescope's primary mirror had a flaw. Because some of the light from the objects being studied was being scattered, Hubble's images were fuzzy. STS-61—the first of four Hubble-servicing missions (a fifth is projected for 2008)—installed instruments on the telescope to correct the problem, among them a replacement for the telescope's wide field/planetary camera with an improved one that has since taken most of Hubble's best-known photographs. This arduous eleven-day mission in December 1993 aboard space shuttle *Endeavour* with a crew of seven set a record for the most EVAs at five. Here, Mission Specialist Jeffrey Hoffman is about to stow the old camera, which has been removed from the satellite.

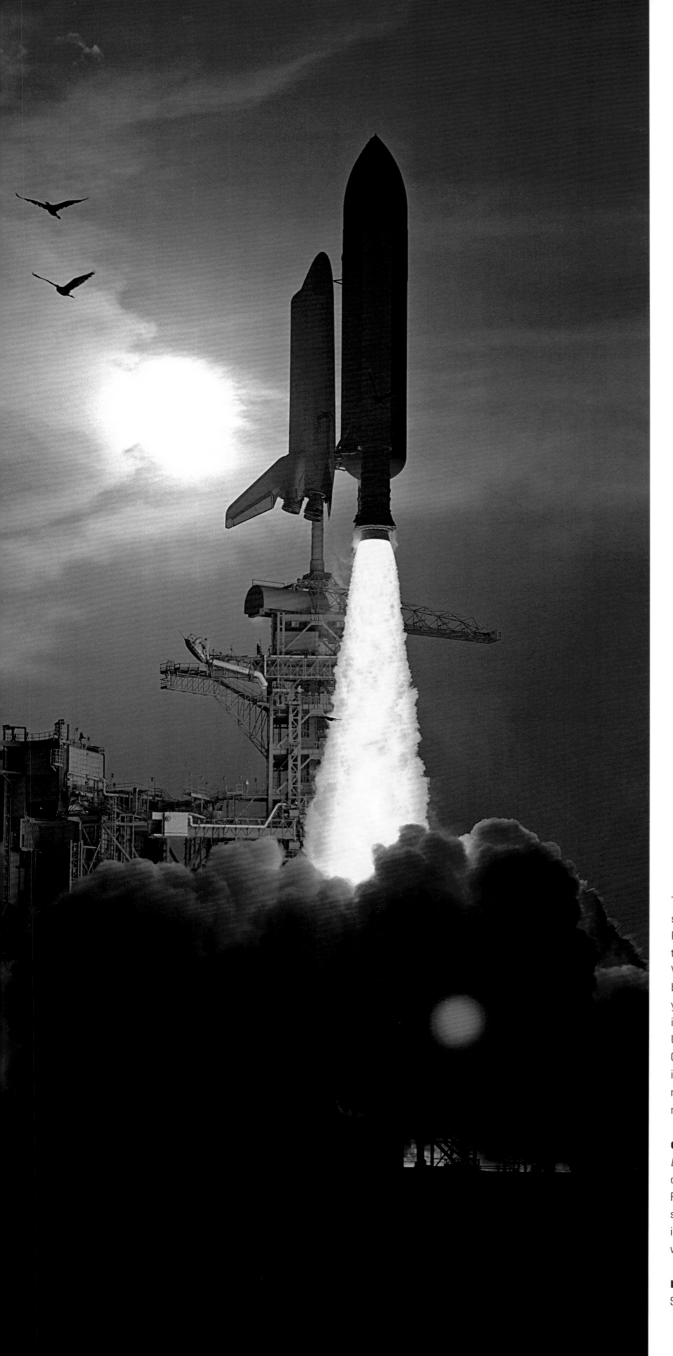

The first inhabited orbital research station in space, Mir was an initiative of the Soviet (and later Russian) space program. It was built from modules transported from Earth between 1986 and 1996. When the last crew departed in August 1999, it had been continuously inhabited for eight days short of ten years. On March 23, 2001, it was de-orbited, and it broke apart during atmospheric reentry. In 1992, United States and Russia signed a Joint Statement on Cooperation in Space that called for US participation in Mir. Eventually, the STS-63 mission was detailed to rendezvous with Mir, in preparation for a later docking mission.

Opposite A photographer on board space shuttle *Discovery* captures Cosmonaut Valeriy Polyakov, as he observes the rendezvous through a window on Mir on February 6, 1995. Polyakov was close to the end of a stay of fourteen months on the station. *Discovery* was in the hands of Pilot Eileen Collins, the first American woman to pilot a spacecraft.

Left The launch of mission STS-64 scatters gulls on September 9, 1994.

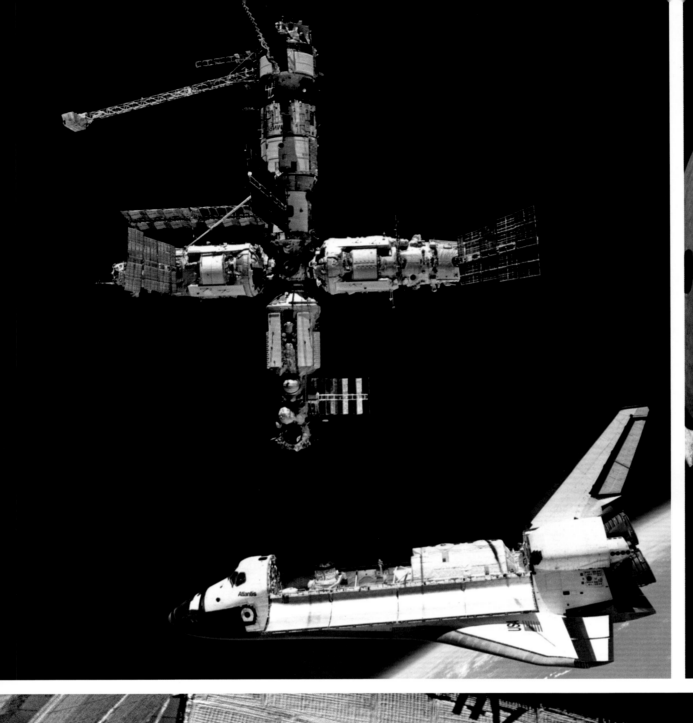

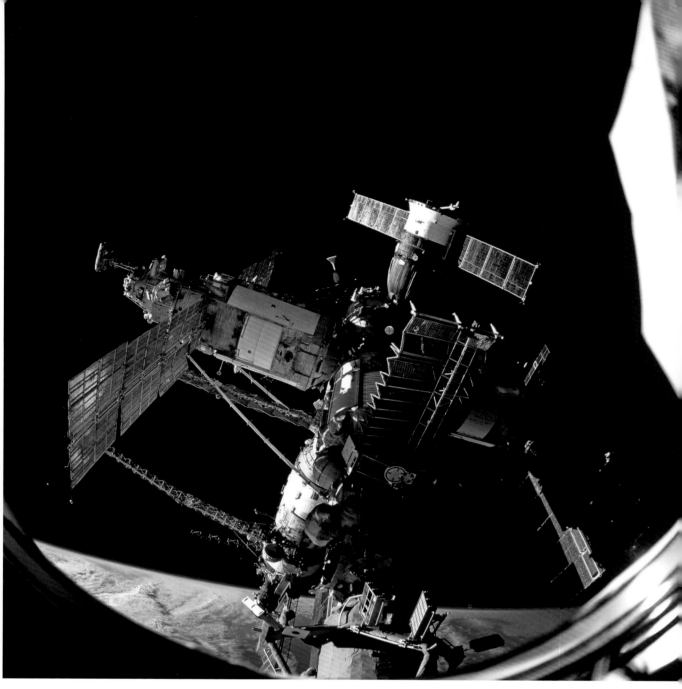

Above left Space shuttle *Atlantis* is seen returning to Earth at the end of STS-71, the first mission to dock with Mir, in a photograph taken by cosmonauts aboard their Soyuz TM transport vehicle, July 7, 1995.

Above center An iconic image of *Atlantis* taken from Mir with a fish-eye lens by an unidentified photographer during STS-71, June 29, 1995.

Above right The docked Mir station is partially visible through the Spacehab viewing port on board the space shuttle *Atlantis*, on the STS-79 mission, September 1996.

Left The crew of STS-74 crowds the windows on the aft flight deck of space shuttle *Atlantis* for a photograph taken by an astronaut on Mir on October 24, 1995. From the top they are Kenneth Cameron, Mission Commander; Jerry Ross, Mission Specialist; James Halsell Jr., Pilot; and William McArthur Jr. and Canadian astronaut Chris Hadfield, Mission Specialists. October 24, 1995.

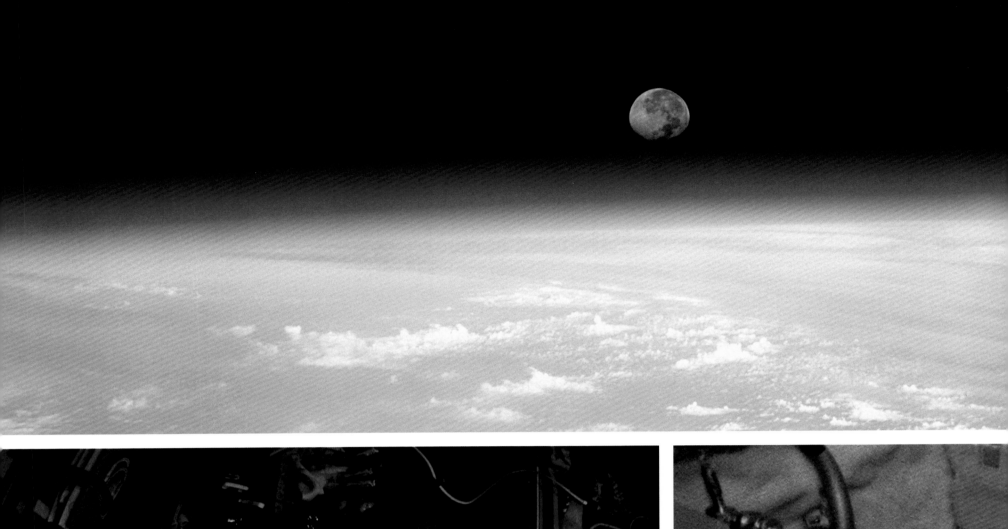

Left Astronauts in orbit must get used to dissociating everyday events like sunrise and sunset from their sense of time. For example, a space shuttle orbiter makes one complete orbit of the Earth approximately every ninety minutes, and the astronauts on board experience sixteen sunrises and sixteen sunsets every twenty-four hours. The Moon setting over the Earth's limb, taken from space shuttle *Discovery* during STS-70 in July 1995, does not signal the approach of "morning."

Below left In all, seven American astronauts were to live on Mir, some battling boredom and depression and others in relative contentment. The first to visit was Norm Thagard, who spent three-and-a-half months on the station. Thagard settles into his sleep station in Mir's core module in 1995. **Below** The longest American stay on Mir was astronaut Shannon Lucid's six months, which set an American record that was later surpassed by astronauts on the International Space Station. Lucid is posing with cosmonaut Aleksandr Kaleri as she prepares to join the crew of STS-79 for the trip to Earth in September 1996.

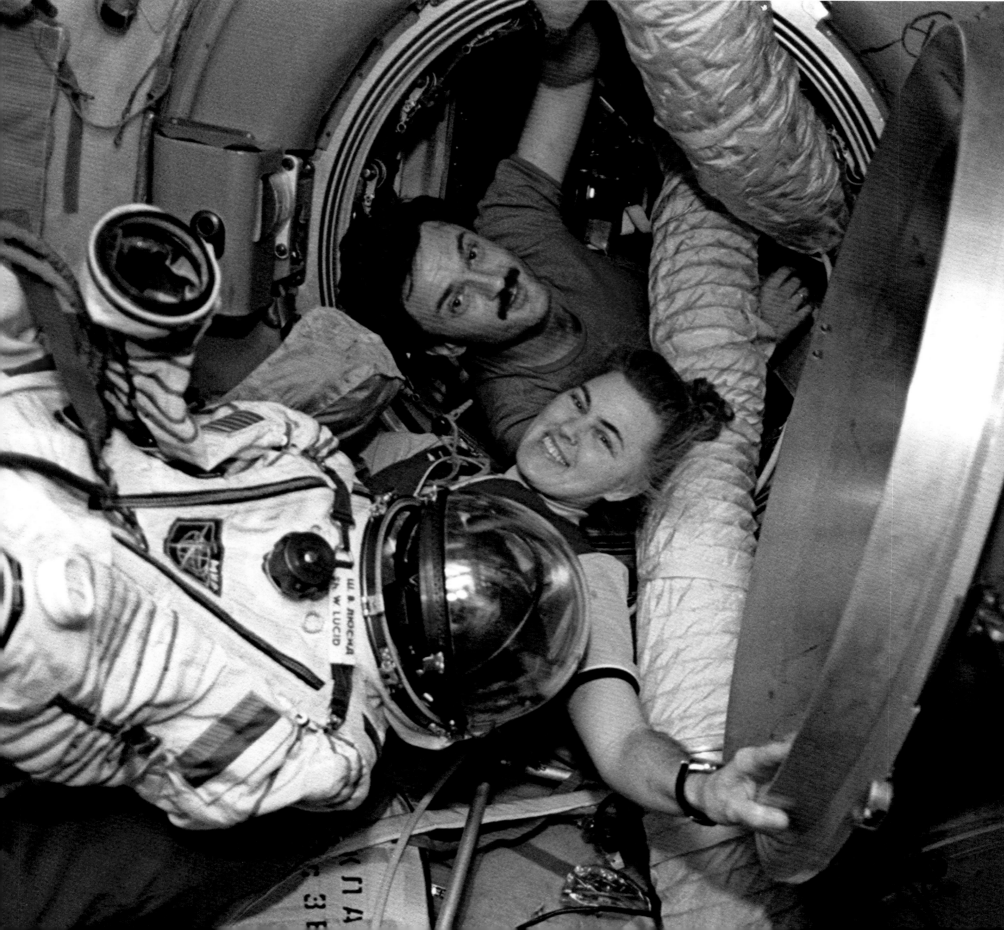

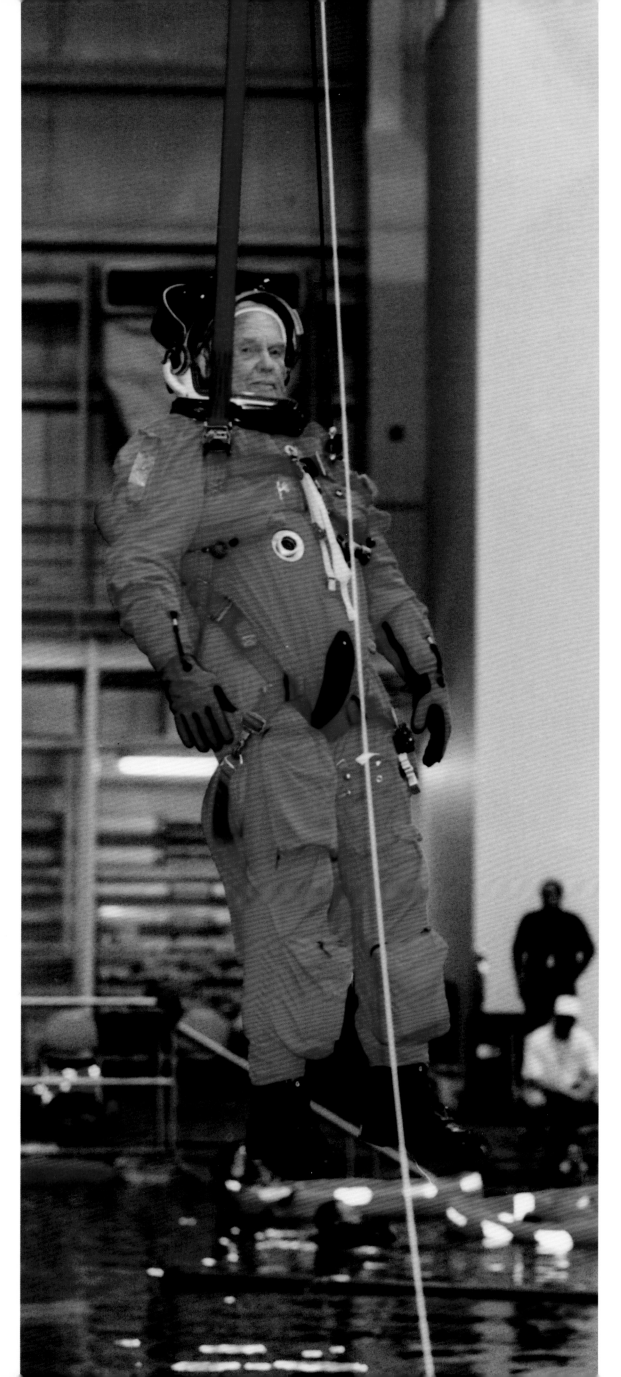

Left At age seventy-seven, former Mercury astronaut and US Senator John Glenn joined STS-95 as payload specialist. During the nine-day mission (October 29–November 7, 1998) Glenn pursued experiments on the aging process, but for many older Americans it was inspiring just to know that he could do it. Here, he simulates a parachute drop into water during emergency bailout training before the mission in June 1998.

Opposite top Pilot Rick Husband of STS-96 reads over the flight data file at the pilot's station on the starboard side of space shuttle *Discovery's* forward cabin. This was the first shuttle mission to dock with the International Space Station, May 27–June 6, 1999.

Opposite bottom On the third Hubble servicing mission, STS-103, in December 1999, Mission Specialist Steven Smith retrieves a power tool while standing on the RMS-mounted foot restraint/work station. One of the legacies of the space shuttle program has been the hard-won acquisition of experience and knowledge related to working in space.

Overleaf In 1993, the United States relinquished its long-standing plans to build Space Station Freedom, a proposed American response to Mir, and committed itself to supporting the International Space Station, along with Russia, Japan, Canada, and the European Space Agency. The first module of the new station, the Zarya control module, was launched by Russia on November 20, 1998. Two weeks later, on December 4, came the launch of STS-88, with space shuttle *Endeavour* carrying the thirty-five-ton Unity module in its cargo bay. Its mission was to rendezvous with Zarya and connect the two modules. Mission Specialists James Newman and Jerry Ross completed three EVAs to complete the job. Here, Newman holds one of the handrails on the Unity module near the beginning of a seven-hour, twenty-one-minute spacewalk on December 7, 1998, when the two men mated forty cables and connectors.

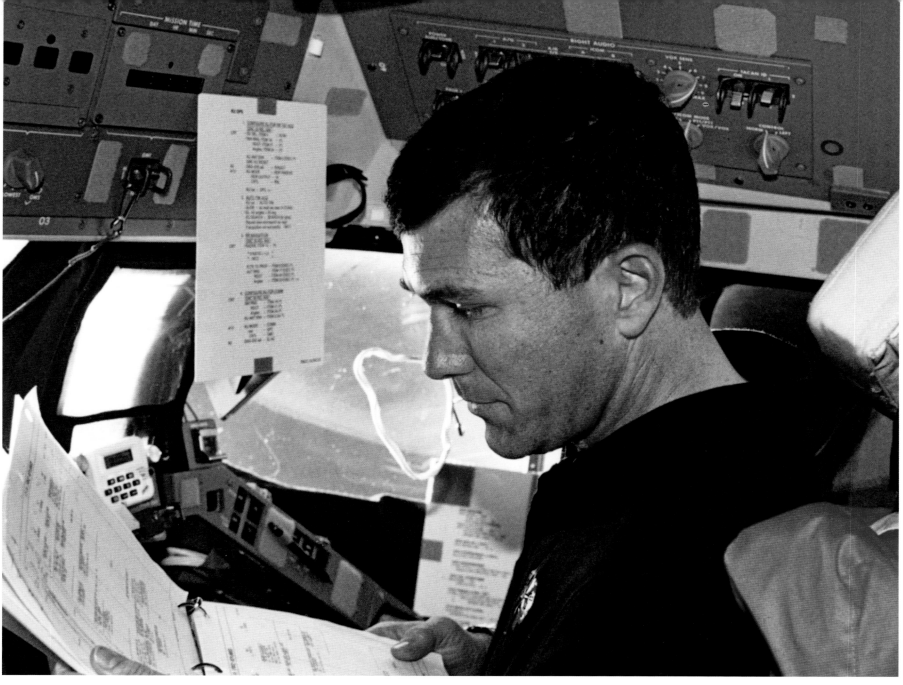

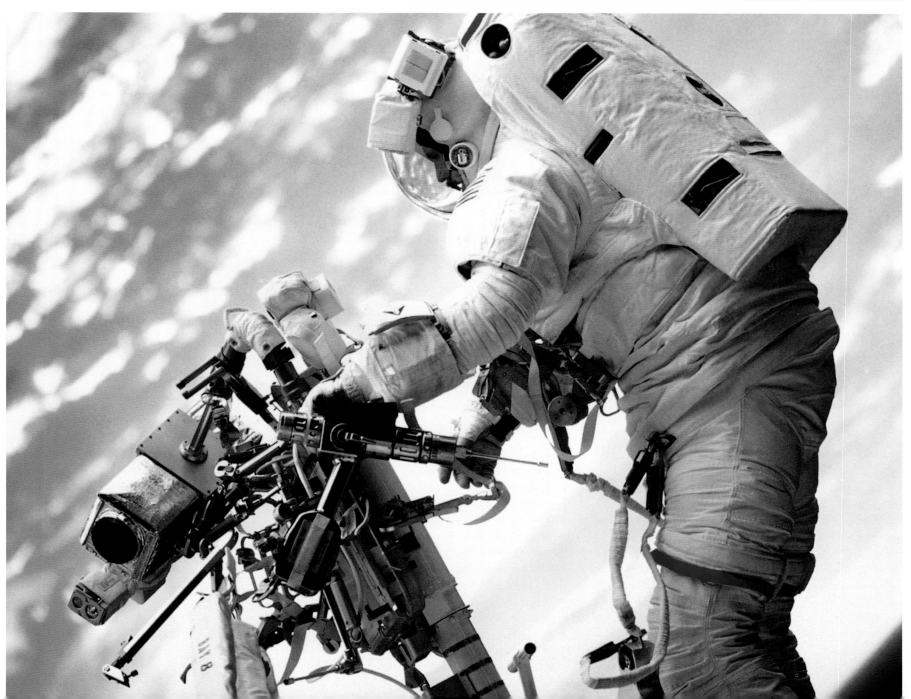

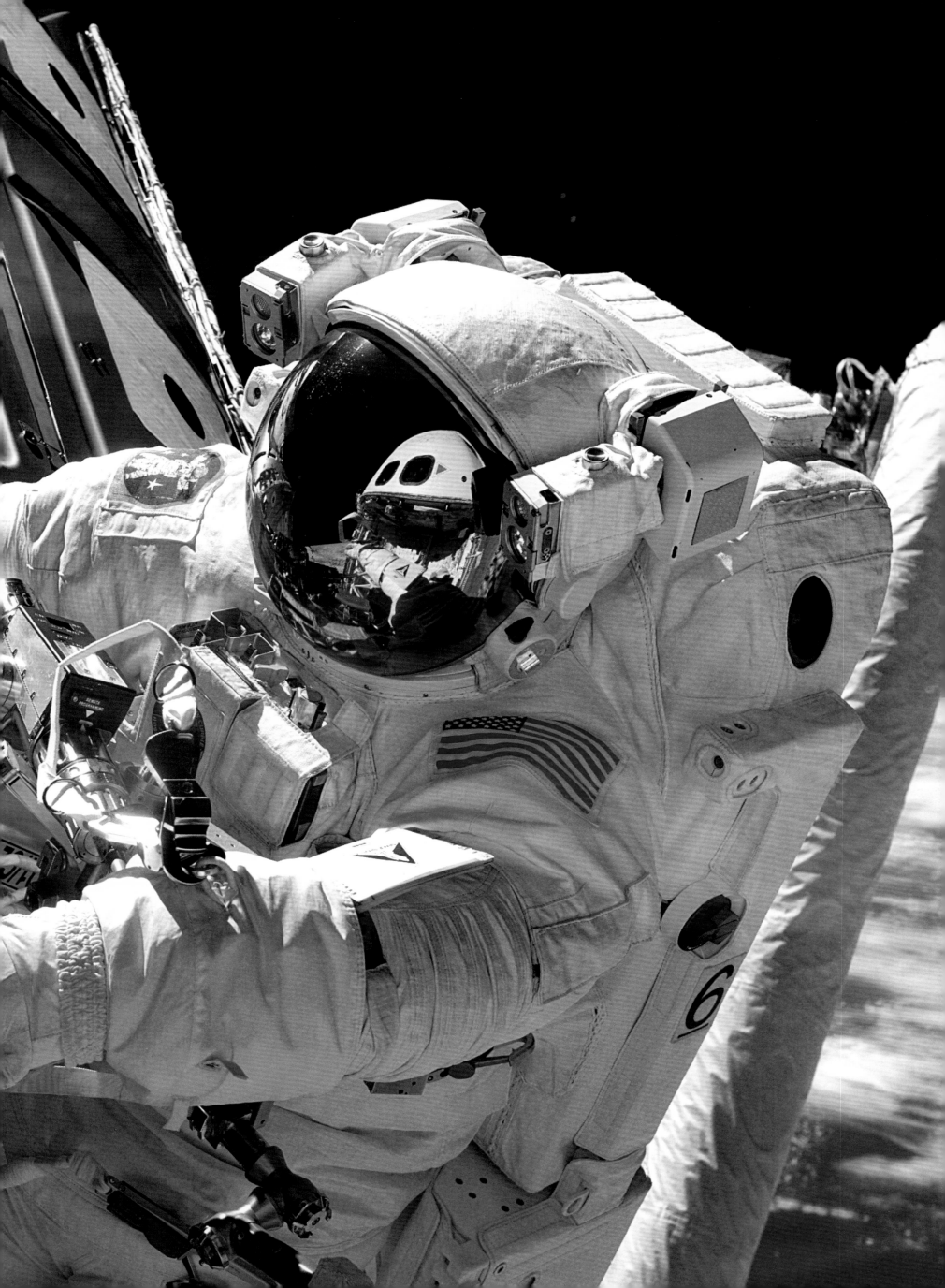

STS-93 Commander Eileen Collins floats on *Columbia's* middeck during a free moment. She is the first American woman to command a space mission, after piloting two previous space-shuttle missions. On this voyage in July 1999, the crew will launch the Chandra X-Ray Observatory.

The seven-member crew of STS-107 was killed when space shuttle *Columbia* disintegrated during reentry to the Earth's atmosphere on February 1, 2003. The cause was later found to be damage to the thermal protection system on the leading edge of the left wing, after it was struck by a piece of foam during launch. **Above** This picture of the crew striking a "flying" pose for their traditional in-flight crew portrait was on a roll of unprocessed film later recovered by searchers from the debris. In the bottom row, left to right, are Mission Specialist Kalpana Chawla, Mission Commander Rick Husband, Mission Specialist Laurel Clark, and Payload Specialist Ilan Ramon of the Israeli Space Agency. In the top row, left to right, are Mission Specialist David Brown, Pilot William McCool, and Payload Commander Michael Anderson. **Above right** In memory of the crew, people left memorials in front of the Johnson Space Center. **Right** During the investigation of the accident, teams scoured the approach path of *Columbia*, looking for debris that might help explain its cause: one of the larger pieces recovered was *Columbia's* nose gear, with tires still intact.

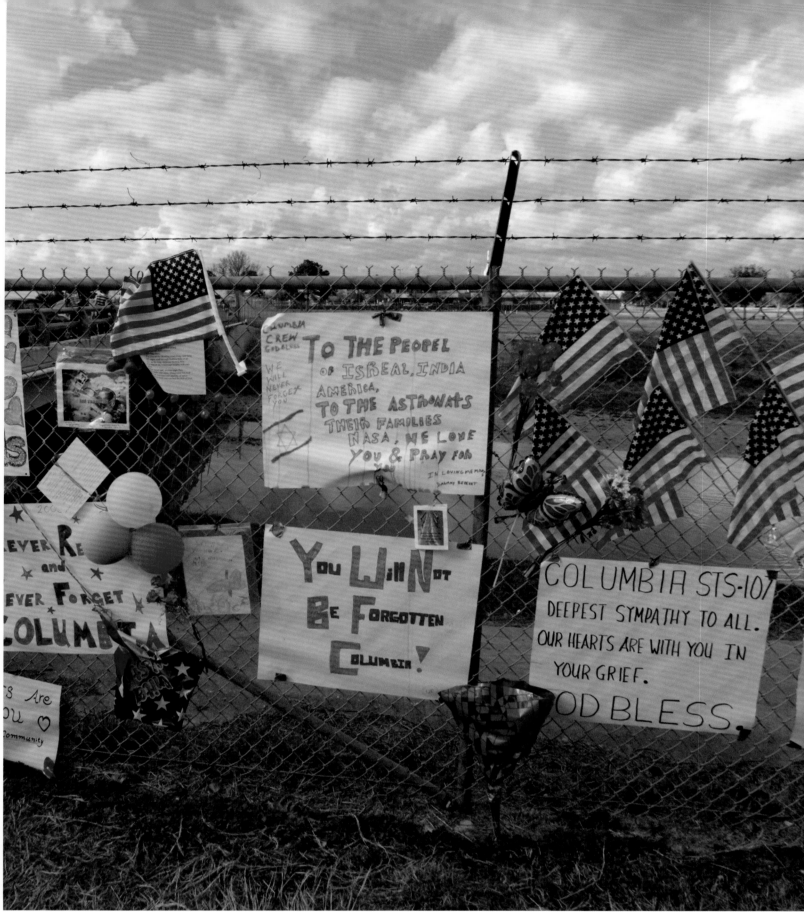

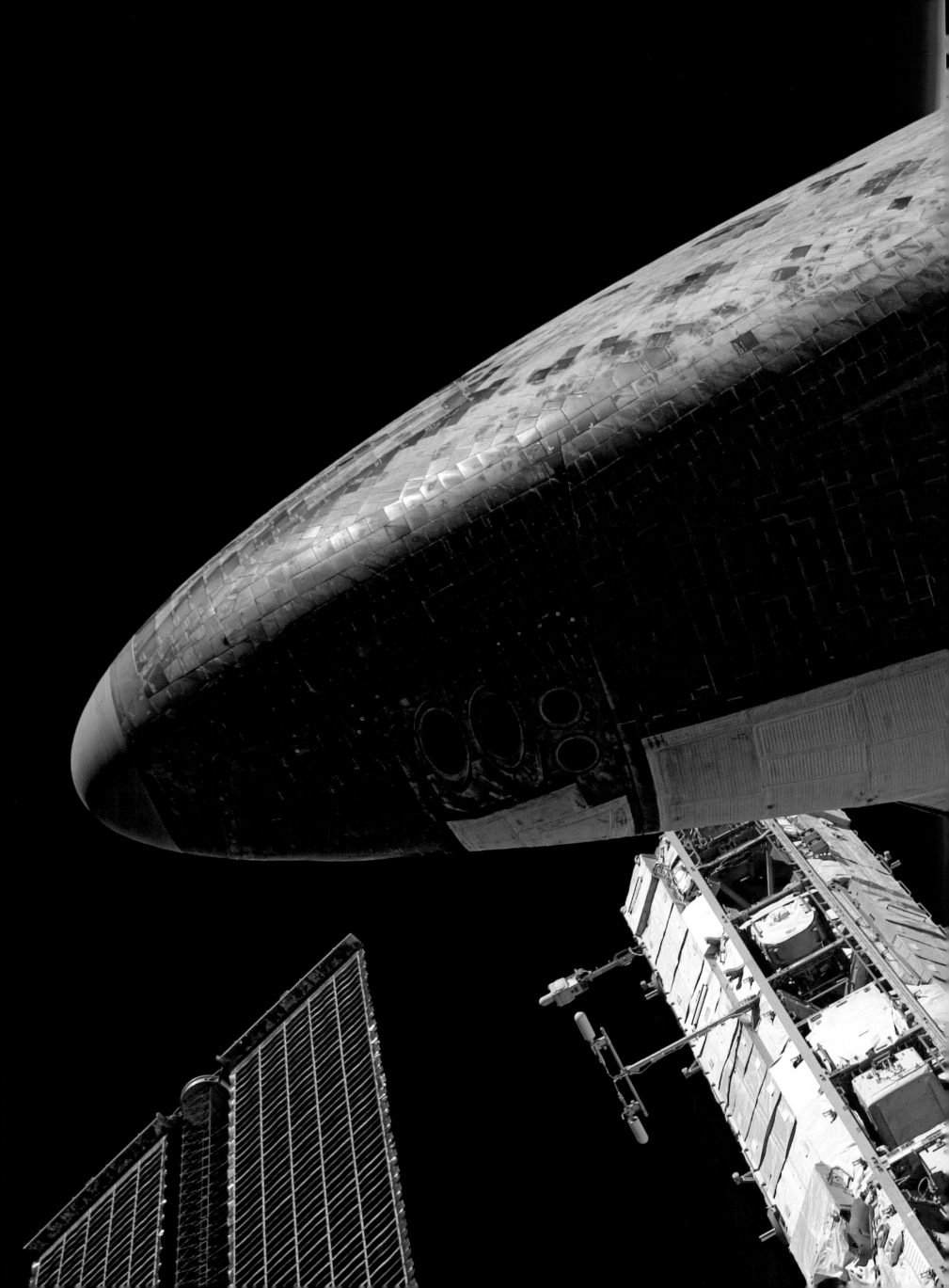

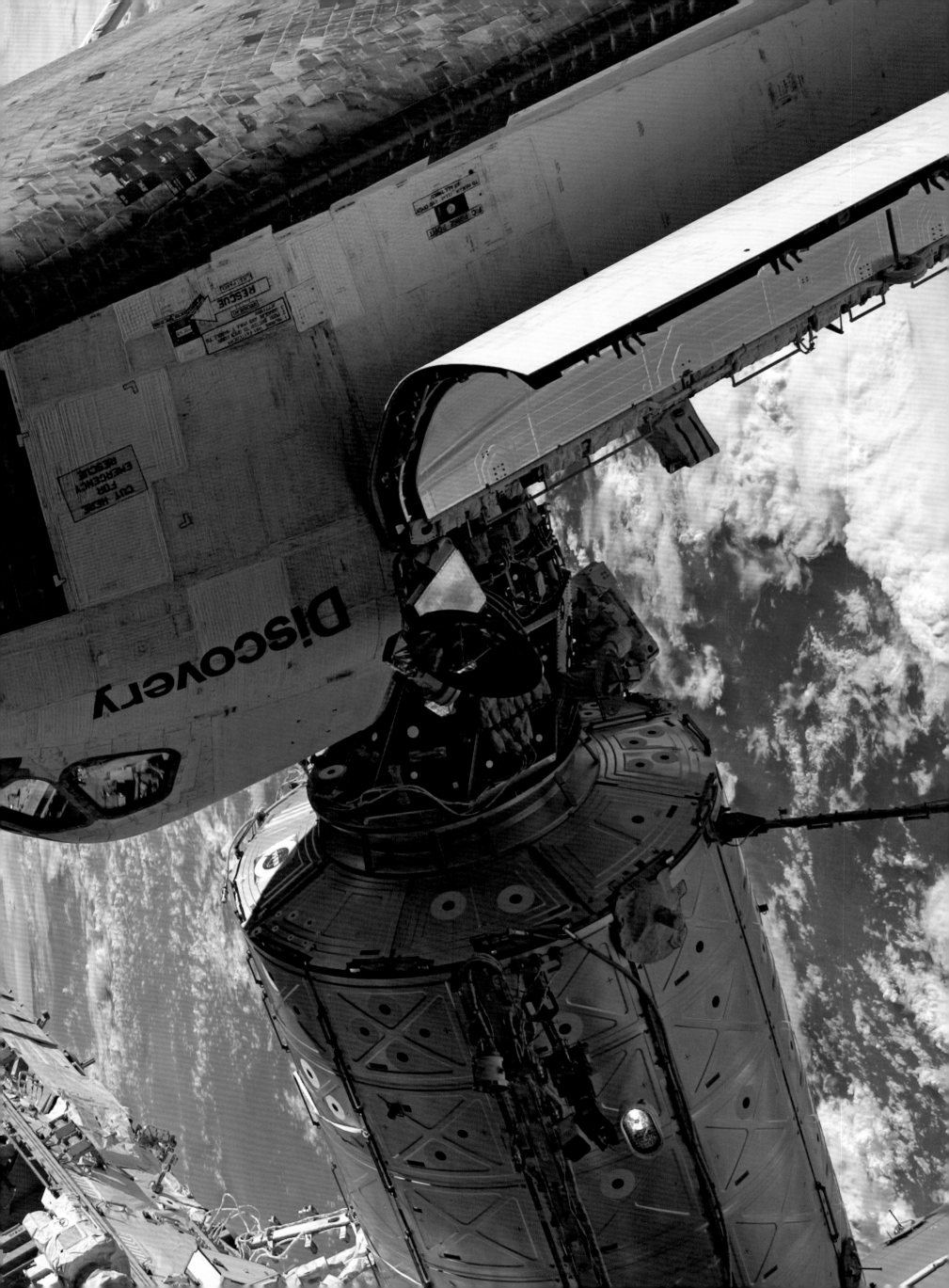

Previous spread STS-114, which launched on July 26, 2005, marked NASA's return to flight more than two years after the *Columbia* STS-107 tragedy. The space shuttle *Discovery* docks at the International Space Station. Mission Specialist Soichi Noguchi (Japan), is partially visible between *Discovery's* payload bay and the station's Destiny Laboratory in this photograph taken on August 3 by Mission Specialist Stephen Robinson.

Right Trips to the International Space Station also originate in Kazakhstan, from the same launch pad at the Baikonur Cosmodrome as Yuri Gagarin, on the first manned space flight of April 12, 1961. Missions to crew the International Space Station are designated "Expeditions." Here, Expedition 1 Commander William Shepherd (US, center), flanked by Soyuz Commander Yuri Gidzenko (Russia, bottom) and Flight Engineer Sergei Krikalev (Russia, top), pose on the stairway to their Soyuz spacecraft on October 31, 2000.

Below Russia's Federal Space Agency Deputy Director General Nikolai Moiseev (left) offers farewell to Expedition 8 Commander Michael Foale (US, rear), Soyuz Commander Aleksandr Kaleri (Russia, center), and Flight Engineer Pedro Duque (European Space Agency, foreground) on October 18, 2003. Combining his six-month tour on the International Space Station and his four months aboard Mir, Foale holds the record for an American astronaut in space: 374 days, 11 hours, 19 minutes.

A Soyuz rocket is rolled out of the assembly building and travels via rail to the pad at the Baikonur
Cosmodrome, in preparation for the launch of Expedition 7 on April 26, 2003.

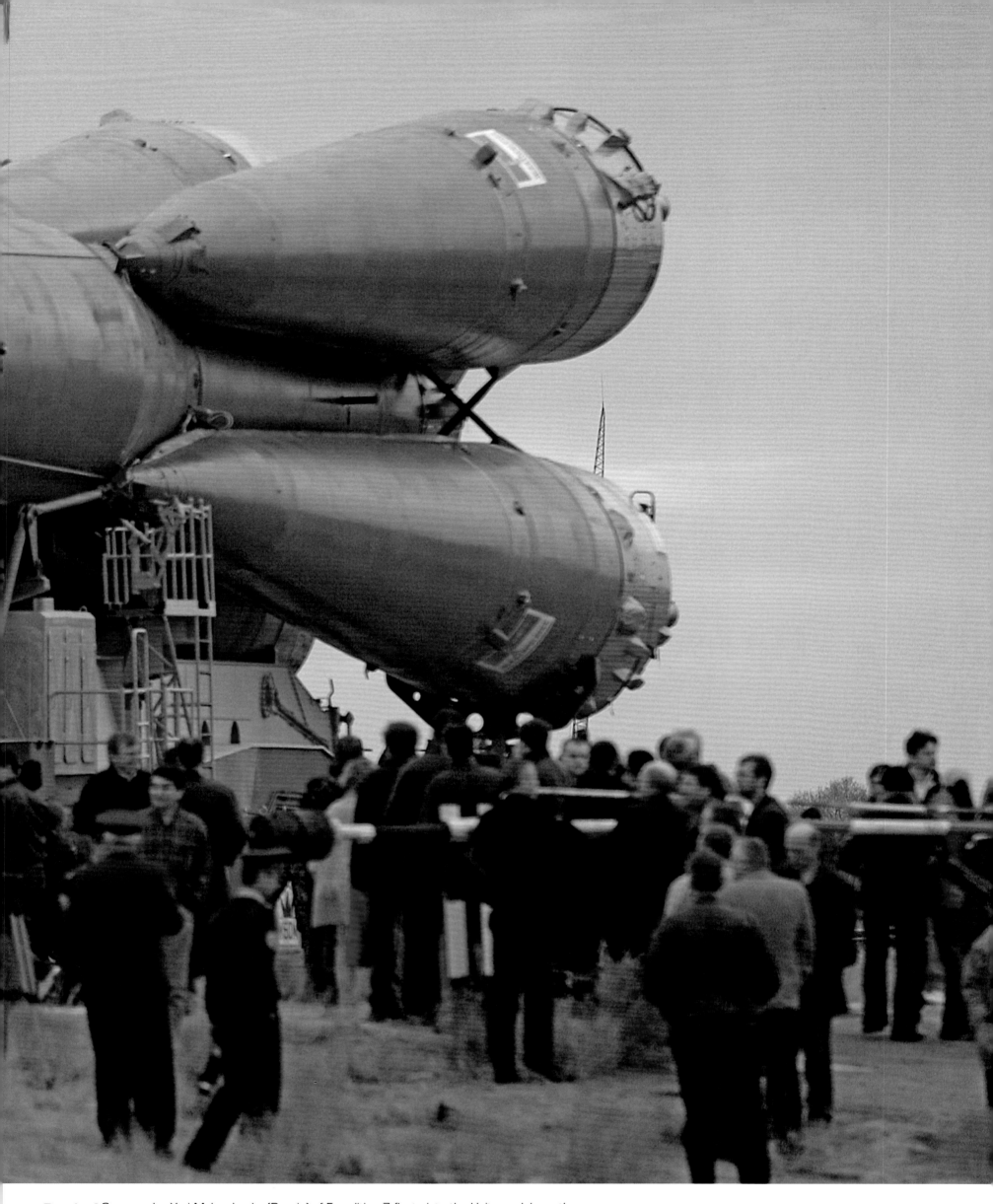

Overleaf Commander Yuri Malenchenko (Russia) of Expedition 7 floats into the Unity module on the International Space Station on August 3, 2003.

Pages 308-309 Flight Engineer Yuri Shargin (Russia) is wearing his launch and entry suit during a countdown test for the launch of Expedition 10 on October 14, 2004.

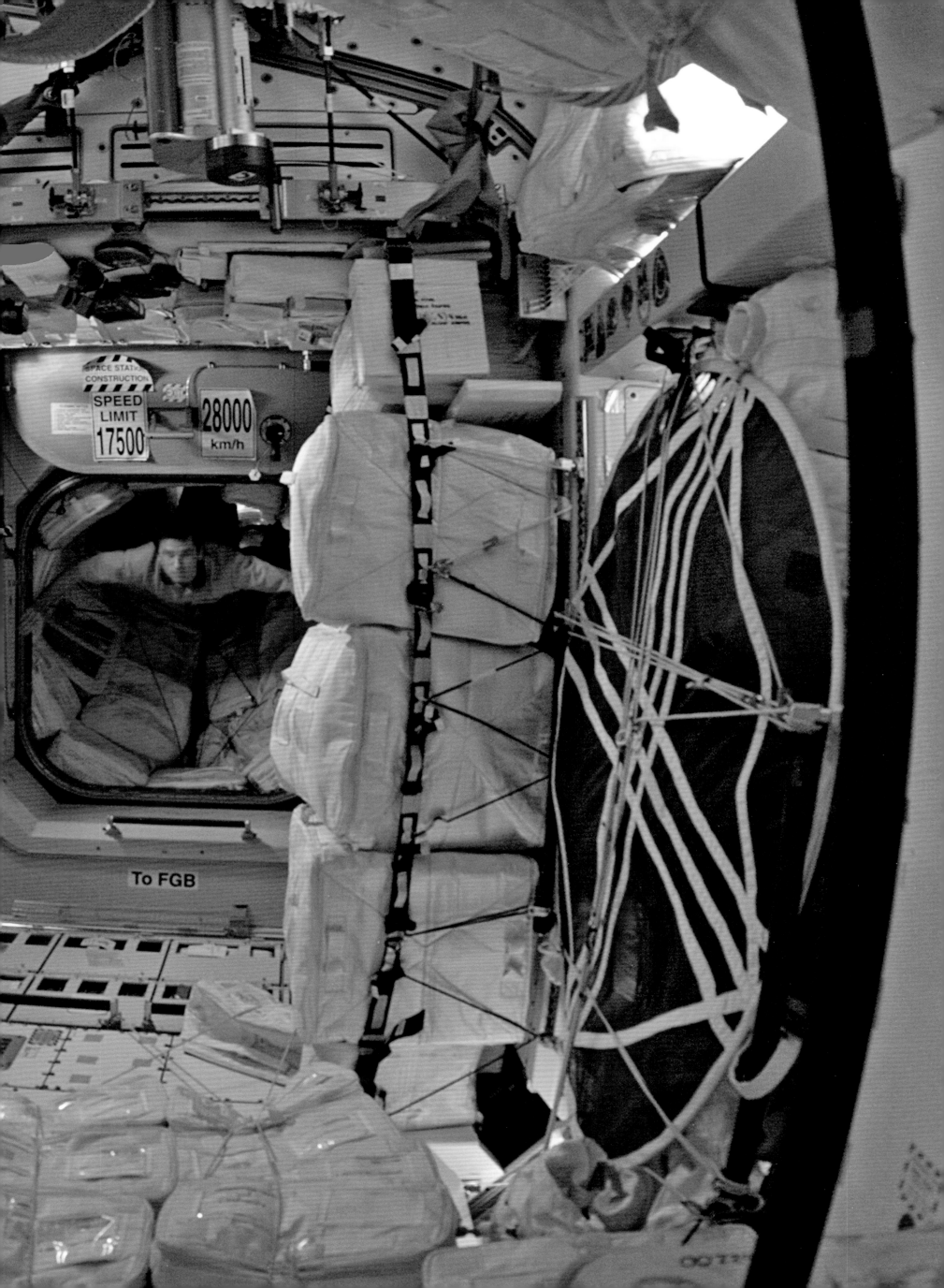

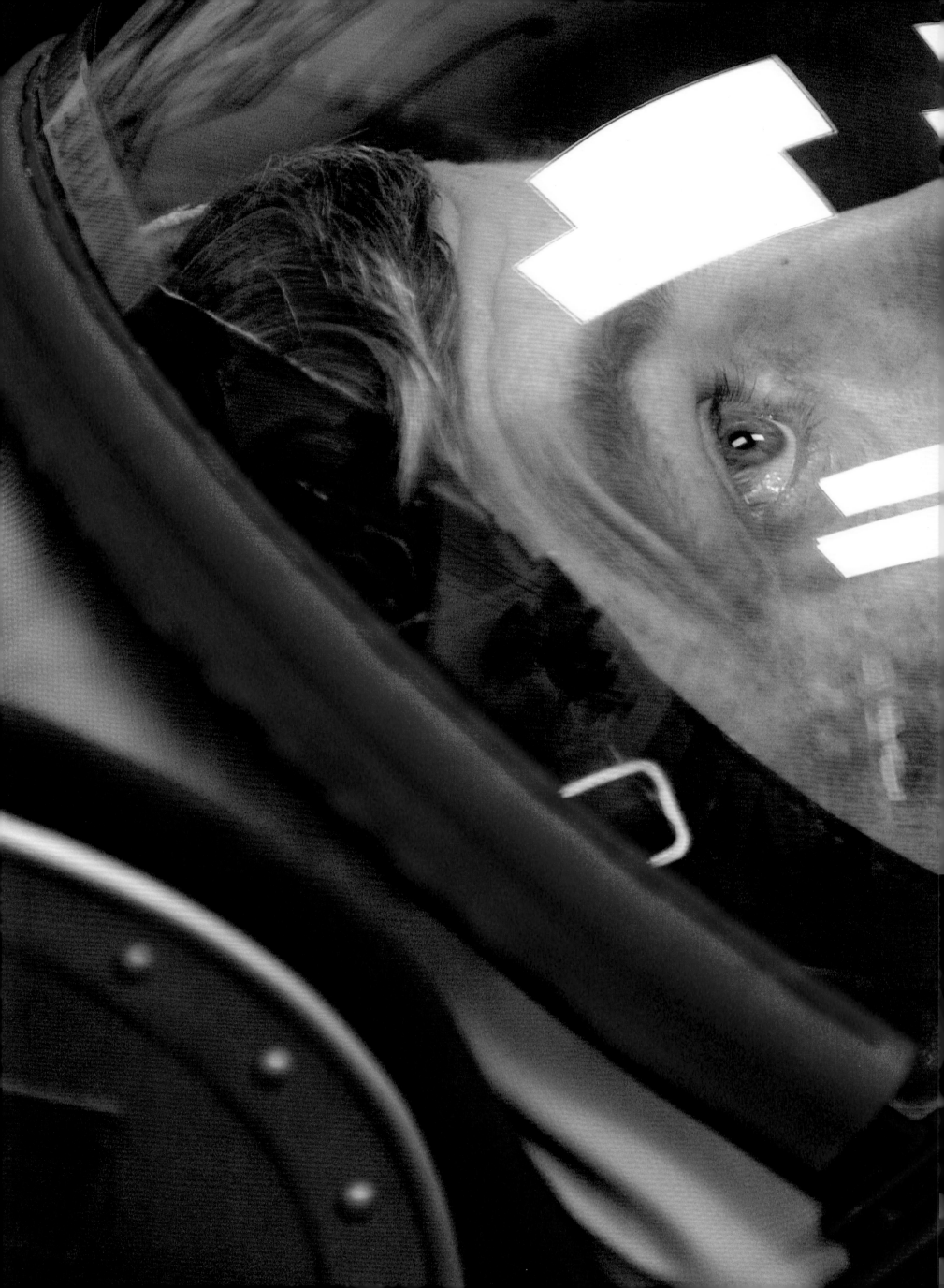

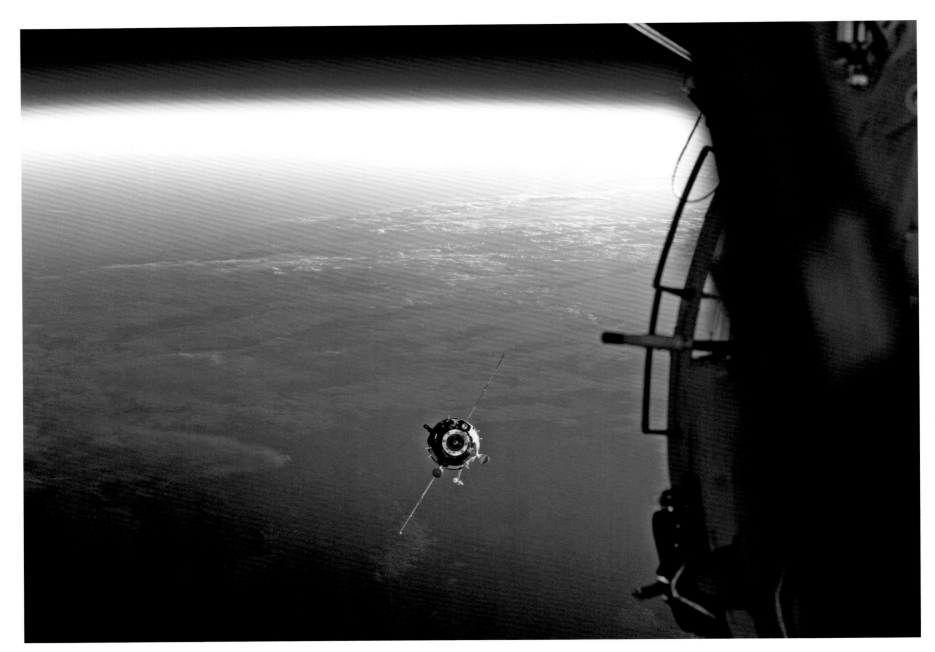

The Soyuz series dates back to the late 1960s and has carried more missions into space than any other spacecraft. The current Soyuz configuration consists of three connected units: an orbital module, a service module, and a reentry module. The spacecraft can transport three astronauts and provide life support for up to thirty days, and there is always one docked at the International Space Station in case a "lifeboat" is needed. Unlike NASA's capsules, which were designed for water landings, the Soyuz reentry module lands on solid ground: it fires breaking engines for a soft landing.

Above Expedition 14, on board a Soyuz TMA-9 spacecraft, approaches the International Space Station, September 20, 2006. **Opposite top** Commander Sergei Krikalev (Russia) of Expedition 11, smiles after the safe landing of his Soyuz TMA-6 spacecraft in a remote region of Kazakhstan, October 11, 2005. **Opposite bottom** Technicians remove cargo from the Soyuz TMA-7 module at sunrise on the steppes of Kazakhstan following the pre-dawn return of Expedition 12 from the International Space Station, April 9, 2006.

Overleaf This dramatic photograph of the International Space Station was taken by a crewmember of STS-114 on August 6, 2005, during a fly-around by space shuttle *Discovery*. Visible in the frame are the Zarya module, now used mostly for storage, and the Zvezda service module, living quarters for astronauts.

Pages 314–15 A year later on September 17, 2006, the International Space Station floats serenely in the shelter of the Earth, in a photograph taken shortly after the space shuttle *Atlantis* on mission STS-115 undocked from the orbital outpost.

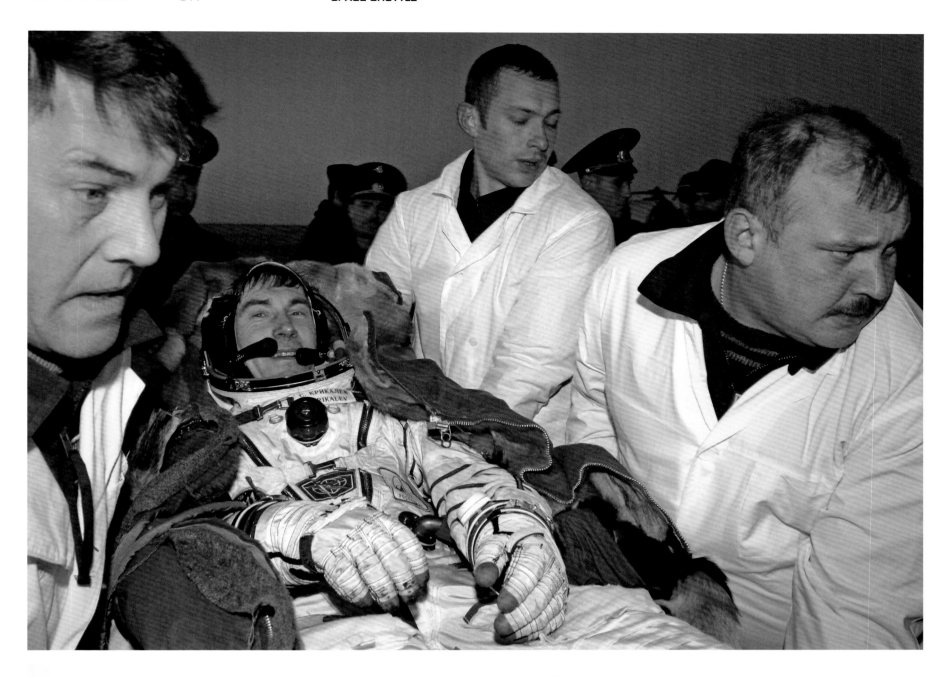

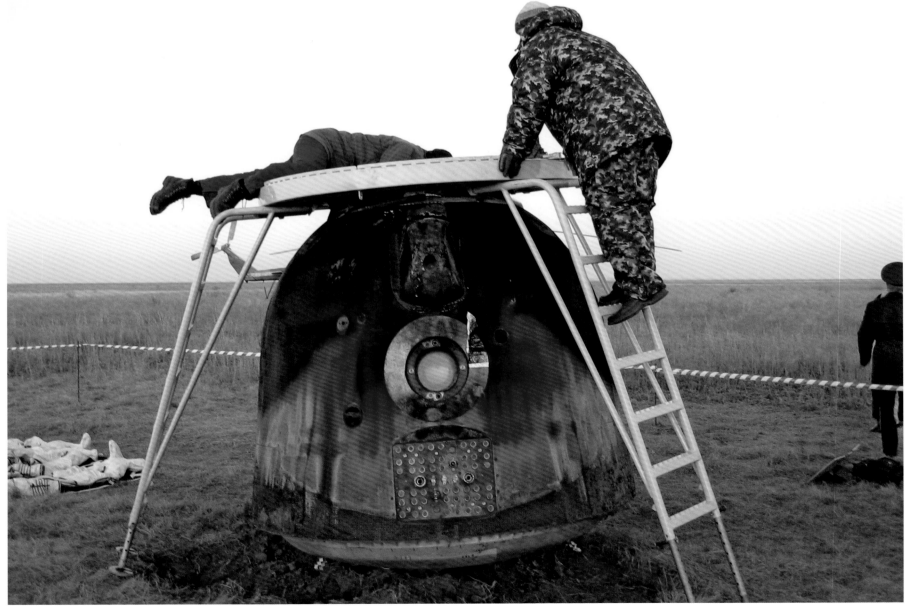

4

VOYAGES IN SPACE AND TIME

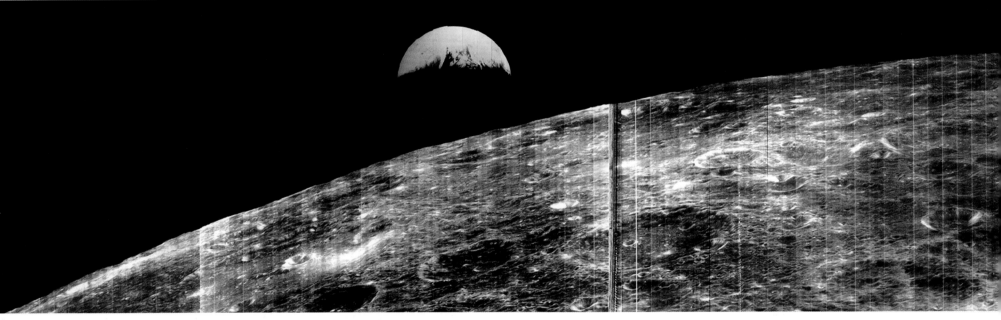

Page 316 Technicians at the Kennedy Space Center prepare the Spitzer Space Telescope for launch in August 2003. NASA's Great Observatories concept called for powerful space telescopes that would gather data across the electromagnetic spectrum. The four observatories are the Hubble Space Telescope (ultraviolet, visual, and near-infrared wavelengths); the Compton Gamma Ray Observatory; the Chandra X-Ray Observatory; and the Spitzer Space Telescope (thermal infrared wavelengths).

Previous spread Since the Mercury missions, manned spacecraft have been one of NASA's main platforms for Earth observation. **Left** On September 30, 1994, an astronaut on STS-68 photographed an eruption of the Kliuchevskoi Volcano on the Kamchatka Peninsula in Russia. **Right** Pilot Michael Baker and Mission Specialist Tamara Jernigan photograph the Earth from the aft flight deck of space shuttle *Columbia* during STS-52 in October 1992.

Opposite top left Unmanned exploration of the Moon was an obvious priority for NASA in the years leading up to the Apollo missions. *Ranger 4*—seen here being prepped at the Jet Propulsion Laboratory in Pasadena, California in March 1962—was the first US spacecraft to reach the Moon, albeit by crashing into it instead of landing as planned. **Opposite top right** Later Rangers were designed to crash into the lunar surface but not before transmitting photos of their descent: this image was taken by *Ranger 7* on July 13, 1964, from an altitude of 1,100 miles. *Ranger 7*'s photographs were one thousand times better than images taken from the Earth.

Opposite center The Lunar Orbiters (1966-67) accurately mapped the Moon's surface from orbit, helping Apollo planners select landing sites for missions. The first good image of the Earth taken from the vicinity of the Moon was captured by *Lunar Orbiter 1* on August 23, 1966.

Opposite bottom left The Surveyor series of spacecraft successfully soft-landed on the Moon, transmitting photographs and doing soil experiments. An engineering test model of *Surveyor 1*, launched in 1966 and the first to soft land on the Moon, is photographed on a California beach near Hughes Aircraft Company, where it was designed and built.
Opposite bottom right A *Surveyor 7* mosaic shows the rim area of Tycho Crater in January 1969. In November of that year, Apollo 12 landed within walking distance of *Surveyor 3* (see page 205).

Right The first humans to see the surface of the Moon with their own eyes were the crew of Apollo 8. On December 24, 1968, they took one of NASA's most impactful photographs, of the Earth as it came into view when their command module emerged from behind the Moon. "Earthrise" is visible from lunar orbit but not from the surface of the Moon. This reproduction of the famous image is oriented the way it was originally seen by the crew, rather than with the Moon at the bottom of the frame.

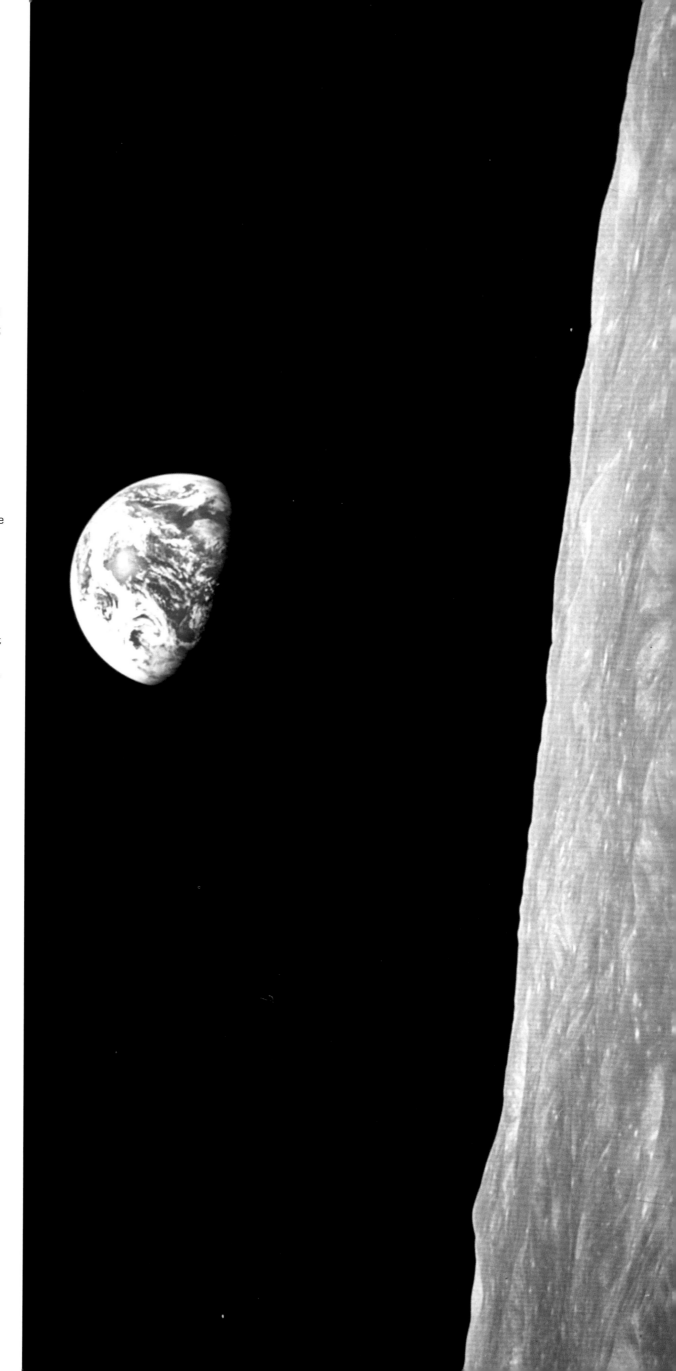

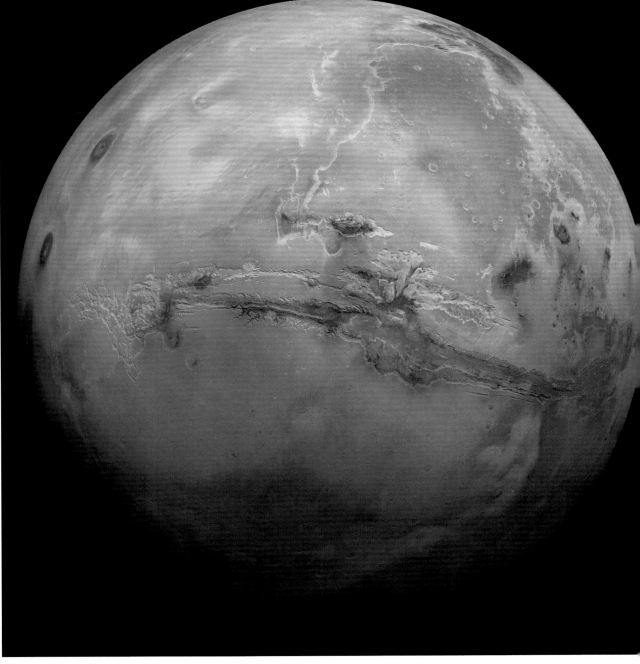

After the Moon, the most obvious destinations for unmanned exploration were Earth's nearest neighbors, Mars, Venus, and Mercury, objectives of the successful Mariner and Viking programs in the 1960s and 1970s. Mariner spacecraft eventually conducted flybys of all three planets. **Opposite far right** Technicians at JPL are working on *Mariner 4,* which made the first flyby of Mars on July 14–15, 1965, returning photographs of a seemingly dead environment that rattled scientists and enthusiasts of the Red Planet.

Two Viking spacecraft traveled to Mars in the mid-1970s. Each consisted of an orbiter and a lander; the former photographed the planet from orbit and the latter collected data on the surface. **Below** The first Viking spacecraft is being assembled at Martin Marietta Aerospace near Denver, Colorado, in May 1974. **Right** A mosaic of images captured by the *Viking 1* orbiter shows the planet's Valles Marineris canyon system, the largest known in the solar system. **Below right** A boulder-strewn field of red rocks stretches nearly two miles to the horizon in a photograph taken by the *Viking 2* lander on Mars's Utopia Planitia. The success of the Viking program was especially notable, given that about two-thirds of all unmanned missions to Mars have failed.

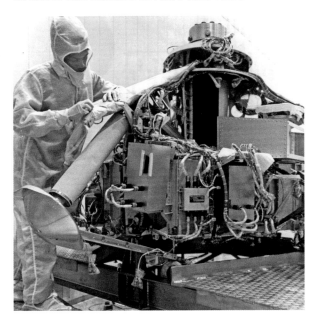

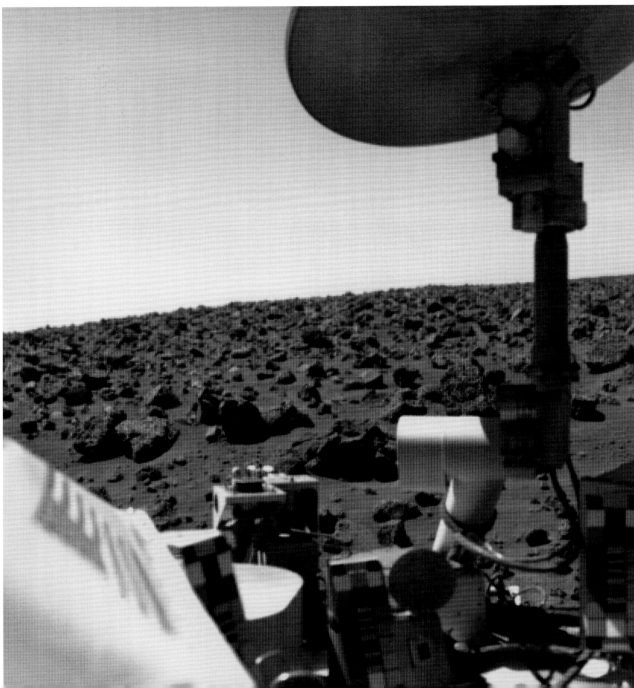

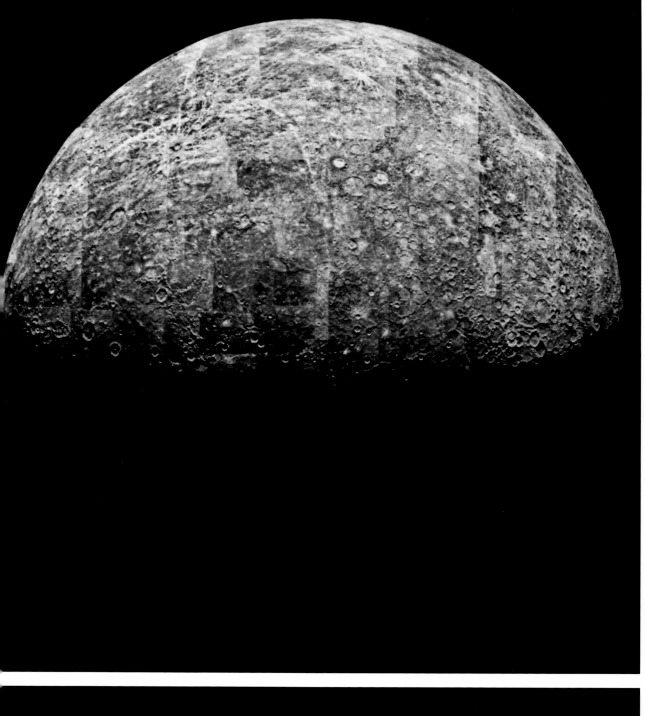

In charting a course for Mercury, *Mariner 10* was the first spacecraft to use a gravity assist trajectory, taking advantage of the gravitational pull of Venus. **Left** On March 29, 1974, it became the first and only spacecraft to reach Mercury; this mosaic was taken on the first and closest of three flybys.

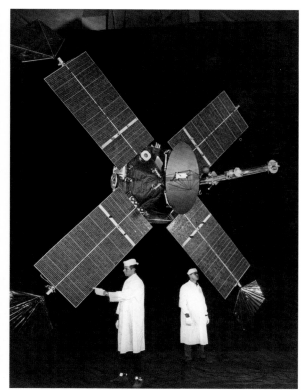

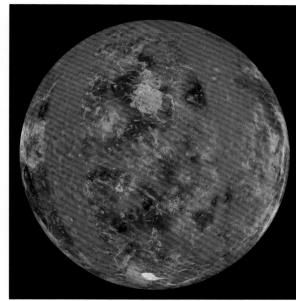

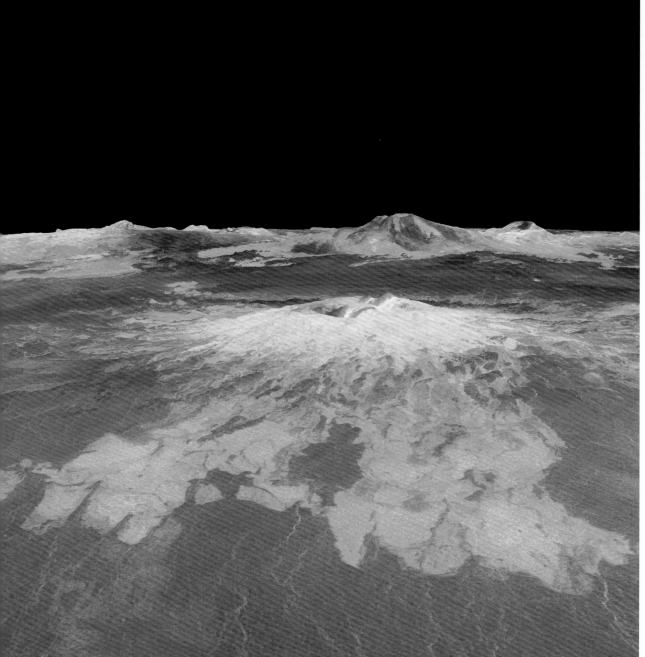

Mariner 2 became the first spacecraft to fly by another planet on December 14, 1962, when it completed its three-and-a-half-month journey to Venus. Accurate mapping of Venus had to await the launch of the *Magellan* spacecraft in 1989. *Magellan* remained in orbit around the planet for more than four years, beginning on August 10, 1990. It used high-resolution radar imaging to penetrate the planet's thick atmosphere. **Above** A false-color global view of Venus from *Magellan*; **Left** A 3-D false-color image of the mile-high Sapas Mons volcano on Venus.

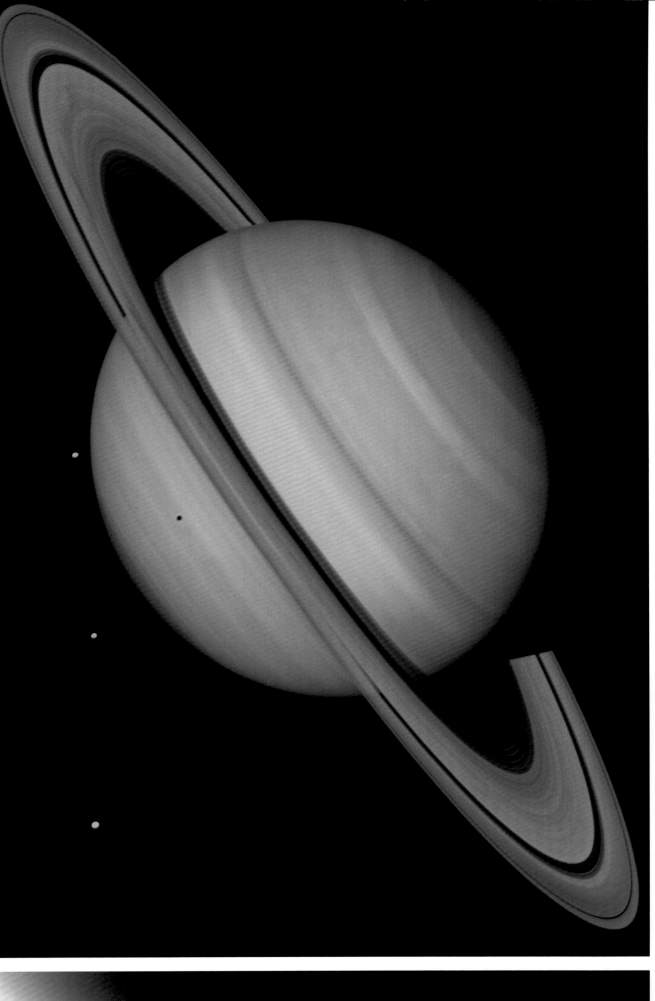

The Pioneer and Voyager spacecraft were the marathon runners of NASA's first quarter century. Two Pioneer spacecraft became the first to reach Jupiter and Saturn in the 1970s. The two Voyager craft began their epic journeys in 1977, and as they penetrated into the furthest reaches of the solar system, they captured the imagination of the millions who dream of interplanetary travel. On this spread are way stations on the itinerary of *Voyager 2* as it proceeded onward from Jupiter: **Left** Saturn (1981), in enhanced color, with four of its moons; **Below** Uranus (1986), in a picture processed to approximate the planet as the human eye would see it; **Bottom** Neptune (1989), from 4.4 million miles out; **Below left** Neptune with its moon Triton from 3 million miles away.

Opposite The most thought-provoking photo from the missions was one taken by *Voyager 1* on February 14, 1990, as it came to the edge of the solar system. At the urging of astronomer Carl Sagan, NASA commanded the spacecraft to turn around to photograph the planets it had visited. From a distance in excess of 4 billion miles, the blue Earth appeared, in the words of Sagan, as a "pale blue dot . . . That's here. That's home. That's us." The Earth, visible about two-thirds of the way down in the "shaft of light" on the right side of the image, has been enlarged slightly in this reproduction.

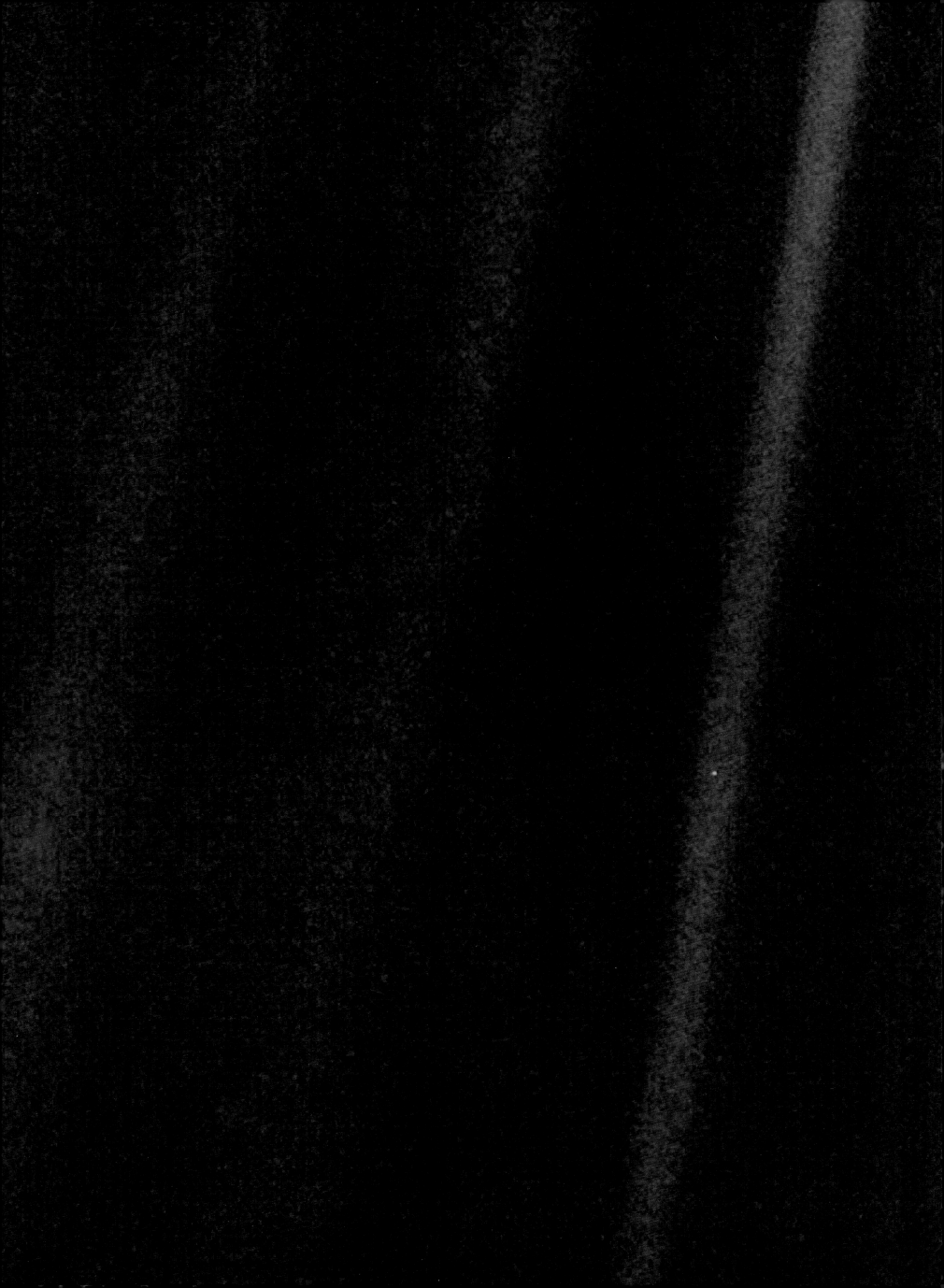

The *Galileo* and *Cassini-Huygens* spacecraft visited the scenes of Voyager's triumphs a decade later with more sophisticated imaging systems and the ability to hang around in orbit. *Galileo,* launched from the space shuttle on October 18, 1989, arrived at Jupiter in December 1995 and began eight years of orbiting the gas giant; in July 1995, it released a probe that endured extraordinary conditions of heat and pressure as it sped into Jupiter's atmosphere. **Top left** The spacecraft, which was built at JPL, is being readied for loading in the space shuttle at Kennedy Space Center: the structure at the top is an antenna that will open up like a flower in space; the probe is housed in the bottom.

Cassini-Huygens was sent on a similar mission to Saturn. Launched on October 15, 1997, it became the first spacecraft to orbit Saturn on July 1, 2004, after a flyby of Jupiter. Like *Galileo, Cassini-Huygens* consisted of an orbiter *(Cassini)* and a probe *(Huygens)*. The *Huygens* probe, built by the European Space Agency, landed on Saturn's moon Titan on January 14, 2005; Titan was selected because its environment appears to be similar to the Earth's before biological processes began putting oxygen into the atmosphere. **Left** The *Cassini-Huygens* spacecraft undergoes preflight testing at JPL, where it was assembled, in October 1996. *Huygens* is stored inside the round, gold-colored bay on the front of the craft.

Opposite A photo gallery from the explorations of *Cassini-Huygens.* **Top left** Jupiter's moon Io (with its shadow) in transit against the disk of Jupiter, December 2000. **Bottom left** Saturn with its rings, March 2004. **Top right** Jupiter with its moon Ganymede, November 2000. **Second down on right** Saturn's pale, icy moon Dione, with Saturn in the background and a side view of its rings, October 2005. **Third down on right** Io floating above the cloudtops of Jupiter, January 2001. **Bottom right** Saturn's moon Titan, July 2004.

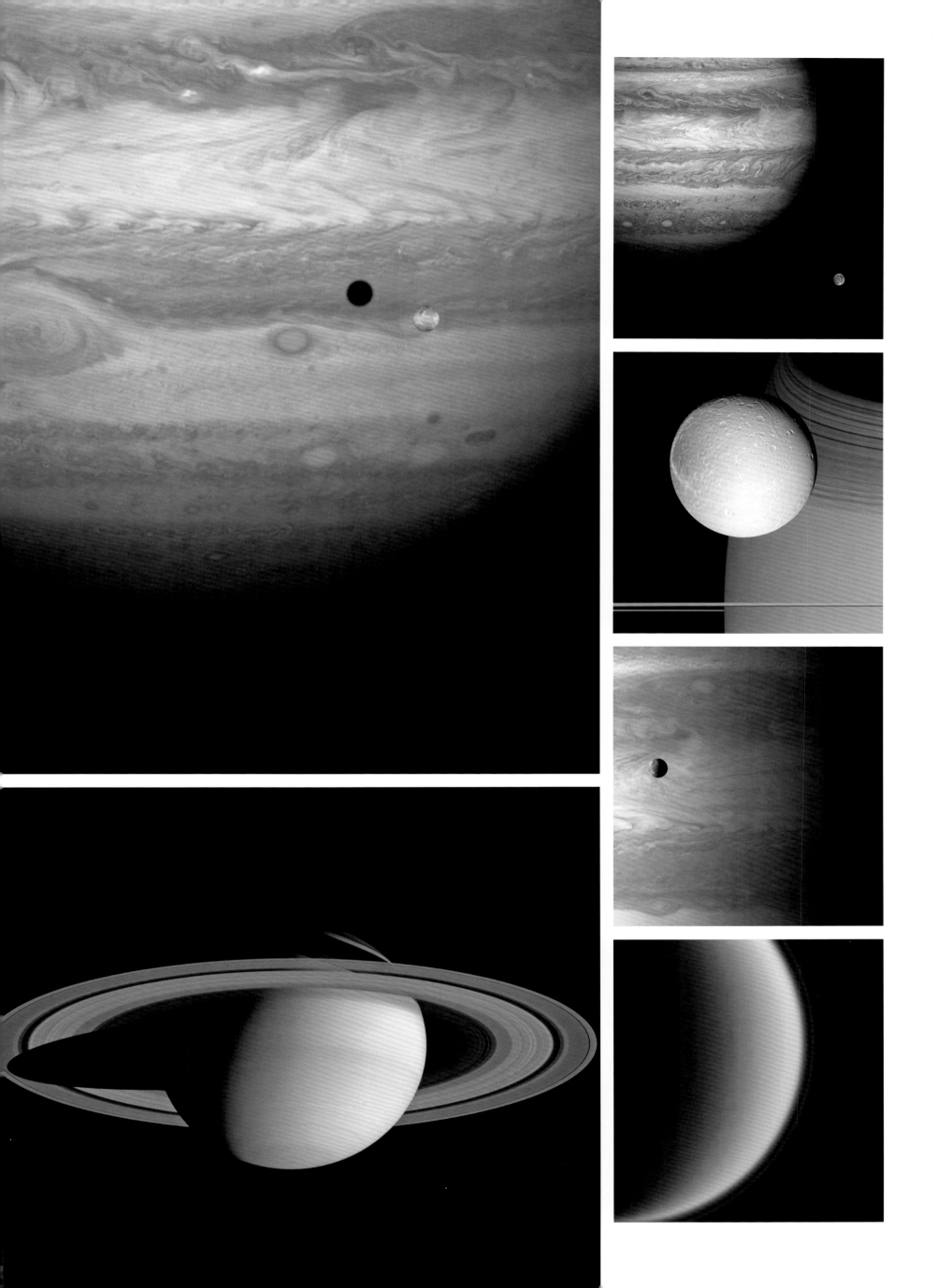

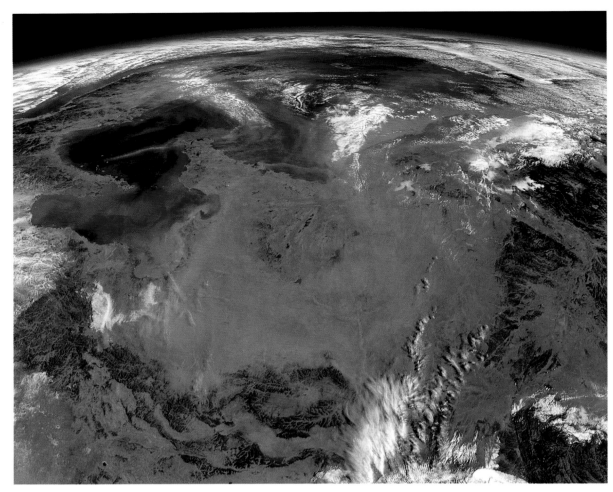

One of NASA's more familiar missions is Earth observation. The agency launched the first weather satellite in 1960, with spectacular long-term results. More recent orbital satellites are capable of extremely subtle observations. *SeaWiFS* (for Sea-viewing Wide Field-of-view Sensor), launched on August 1, 1997, can detect fine gradations of ocean color that signify types and quantities of marine phytoplankton, a key factor in the study of oceans. *SeaWiFS*'s superb sensors also capture detailed views of Earth's weather. **Left** A dense haze lingers over eastern China in January 2000; **Below** Hurricane Alberto churns the atmosphere east of Bermuda in August 2000.

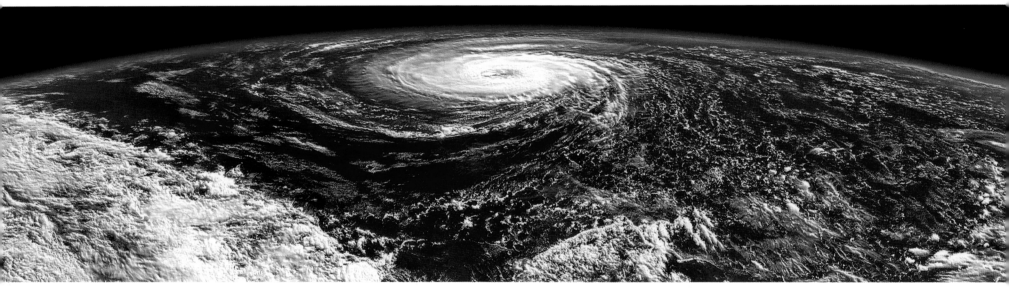

The Landsat program that studies land features from space has similarly transformed our view of Earth. *Landsat 1* launched on July 23, 1972, and before it was removed from service in January 1978, it had demonstrated the usefulness of "remote sensing" data for land surveys, land management, water resource planning, agricultural forecasting, forest management, sea ice movement, and cartography, among other things. **Left** A *Landsat 7* photograph of the coast of Greenland taken in September 2000.

Opposite Apollo 17's famous "blue marble" photograph of the full Earth (see page 6) has inspired recent images of the Earth compiled from satellite data. Much of the information contained in this extremely high-resolution, true-color image of the Earth came from a single remote-sensing device: MODIS (for Moderate Resolution Imaging Spectroradiometer), launched on the *Terra* spacecraft in 1999. The MODIS data, collected from June through September 2001, was supplemented with data from many other sources.

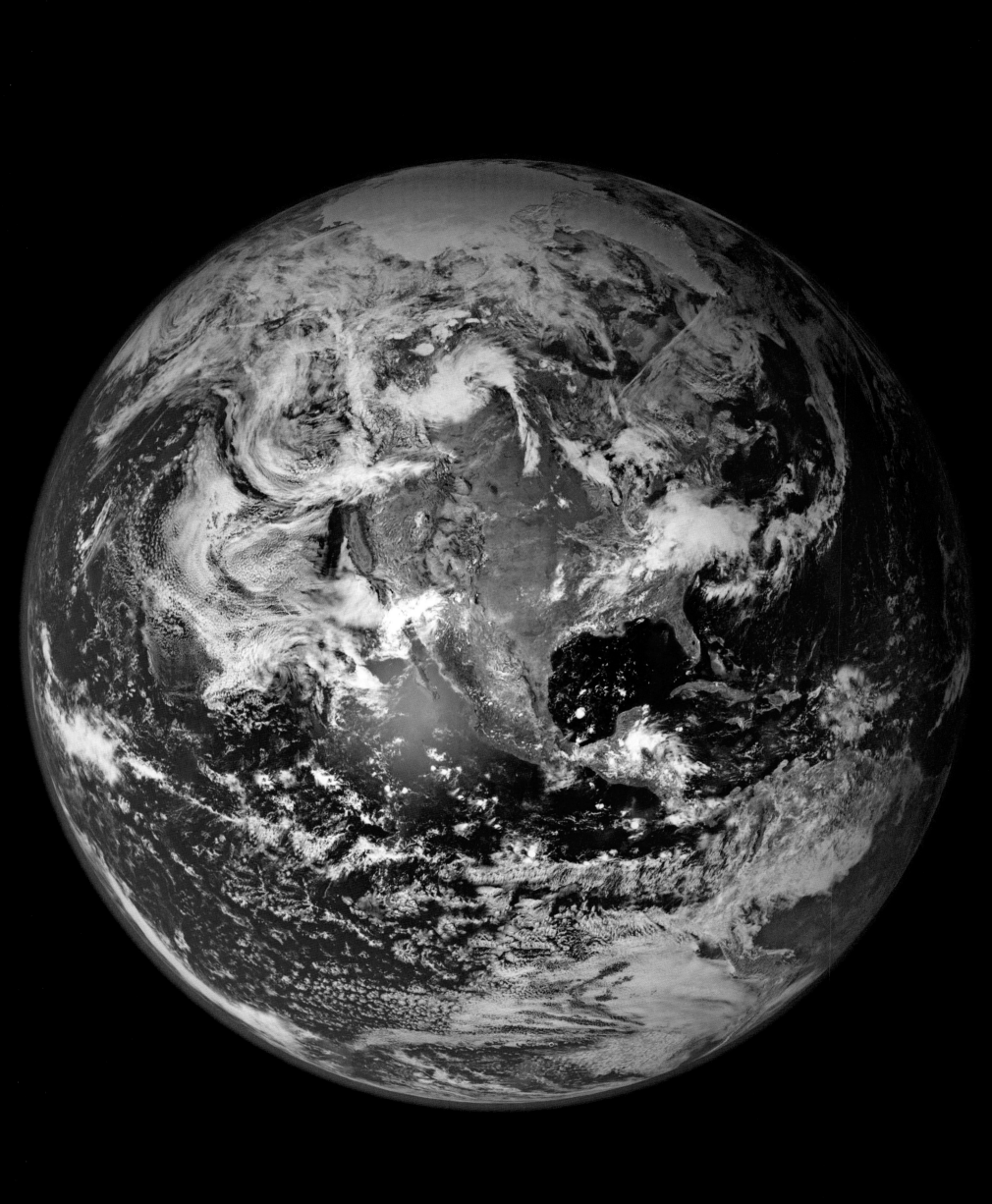

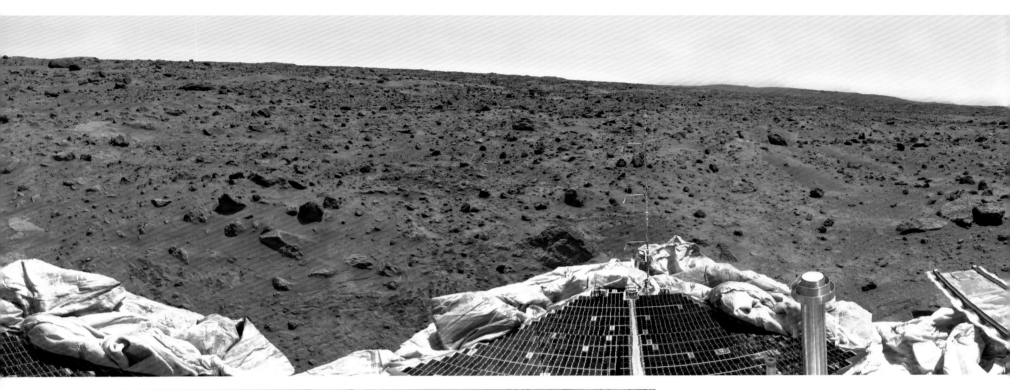

The late 1990s saw a triumphant return to Mars. *Mars Global Surveyor* entered Mars orbit on September 12, 1997. By the end of January 2001, the spacecraft had recorded more data—relating to the surface, atmosphere, and interior of the planet—than all other Mars missions combined. Virtually all contemporary Mars missions are at least partly designed to look for evidence of liquid water in the past or present of the Red Planet; *Mars Global Surveyor* did find evidence of liquid water near the surface, and more recent explorations have confirmed this. **Left** The Mare Australe in Martian midsummer is crisscrossed by dark streaks that are trails left behind by small dust devils. **Opposite left** Gullies on the walls of impact craters in Newton Basin in Sirenum Terra may have been formed by the release of groundwater to the Martian surface in geologically recent times.

Mars Pathfinder followed *Mars Global Surveyor* off the launch pad by a month. *Pathfinder* landed on July 4, 1997, and released a tiny remote-controlled rover called *Sojourner* that caused an international sensation, in part because the World Wide Web suddenly made the remote exploration of other worlds something that anyone could vicariously participate in. From this moment forward, millions of people would experience the daily discoveries of unmanned space exploration and imaging. **Above** In a magnificent panorama made from about one hundred frames stitched together, *Sojourner* is visible at right nosing around the surface, July 5, 1997.

The work of *Mars Global Surveyor* is being carried forward by the *Mars Reconnaissance Orbiter*, which entered Mars orbit on March 10, 2006. The name of this spacecraft alludes to one of its purposes: to scout landing sites for future manned Mars missions, much as the Lunar Orbiters did for Apollo. **Opposite right** Deposits at the North Pole alternate bright ice-rich layers with dark sandy layers.

Left As superb imagery of Mars accumulates, specific pictures stand out for their vast sweep and artistry; this view of the Chasma Boreale, a long valley that cuts into Mars' north polar icecap, made by *Mars Odyssey* in 2002, has all the authority of the great photographic images of such major Earthly landscape features as the Grand Canyon or the Sahara Desert.

The successors of tiny *Sojourner* are the two Mars Exploration Rovers: *Spirit,* which landed in Gusev Crater on January 3, 2004, and *Opportunity,* which landed in the Meridiani Planum on January 24, 2004. **Below** One of them sits atop the deployed lander with its solar arrays and wheels stowed at JPL in December 2002. **Bottom** An image mosaic from *Spirit's* panoramic camera in 2004 shows heights nicknamed the Columbia Hills, on the right, toward which the rover is heading. The rover's heatshield can be seen on the left as a tiny bright dot in the distance, just under the horizon. The rovers are well equipped to do geology on Mars.

With the Hubble Space Telescope, NASA reached for the stars. When the telescope was being planned and built, no one could have guessed at the impact its images would have on people around the world. **Below** Technicians study Hubble's main, eight-foot mirror before installation in 1982. This is the mirror whose spherical aberration needed to be corrected in space for the telescope to function properly. **Opposite bottom left** Lockheed technicians assemble the Hubble Space Telescope in March 1988. **Overleaf** The telescope, which was finally deployed in 1990 (see pages 276–277), serenely orbits the Earth in this photograph taken by one of the STS-109 crew members in 2002.

Opposite top left A tour de force of precise space navigation was achieved by the *Deep Impact* spacecraft on July 4, 2005. Launched by *Cassini*, *Deep Impact* rendezvoused with periodic comet Tempel 1, a rock believed to be about 8.7 by 2.5 miles in size, and separated into two parts, an impactor probe and a flyby probe. While the impactor smashed into the comet, a high-resolution camera on the flyby probe recorded the event (seen here sixty-seven seconds after impact). The purpose of the mission was to study the composition of comets for clues to their history.

There is of course one star that can be studied without leaving the solar system. SOHO (for Solar and Heliospheric Observatory) was launched on December 2, 1995, to study the Sun. Given its mission, SOHO can be stationed at a point of gravitational balance between the Earth and the Sun. **Opposite bottom right** SOHO was a joint project of NASA and the European Space Agency; the spacecraft is seen at the Matra Marconi Space facility in Europe, where it was built. **Opposite top right** Is an image of the Sun taken on September 14, 1999. A huge, erupting prominence can be seen in the upper right.

Perhaps Hubble's best-known image was given the inspirational name "Pillars of Creation"; it showed an area in the Eagle Nebula where new stars were being formed. The picture was taken on April 1, 1995, with the new wide field/planetary camera that was installed on the telescope at the end of 1993, and it soon became one of the most frequently viewed photographs on the World Wide Web: it spoke to people. This is a detail of the full image.

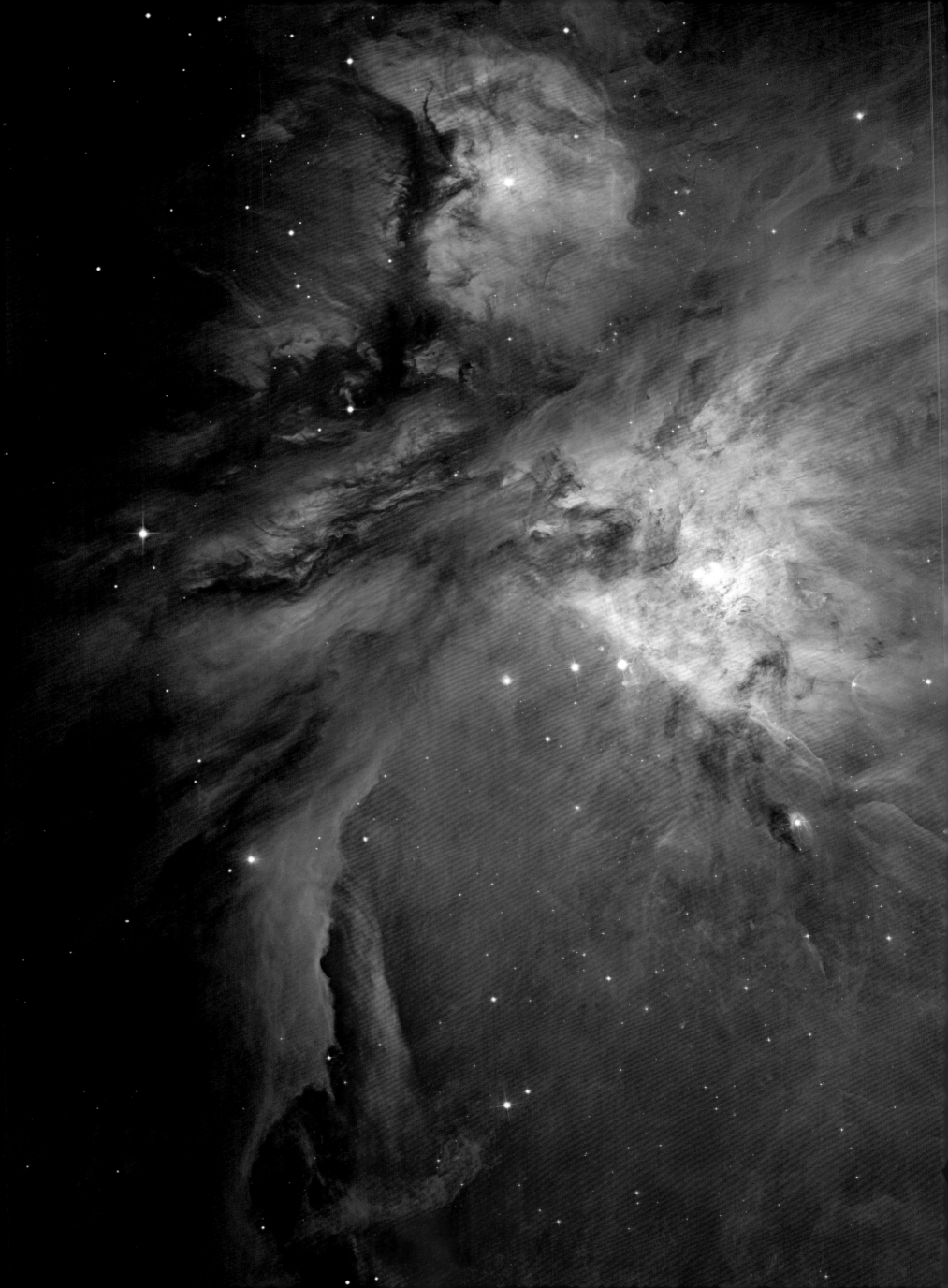

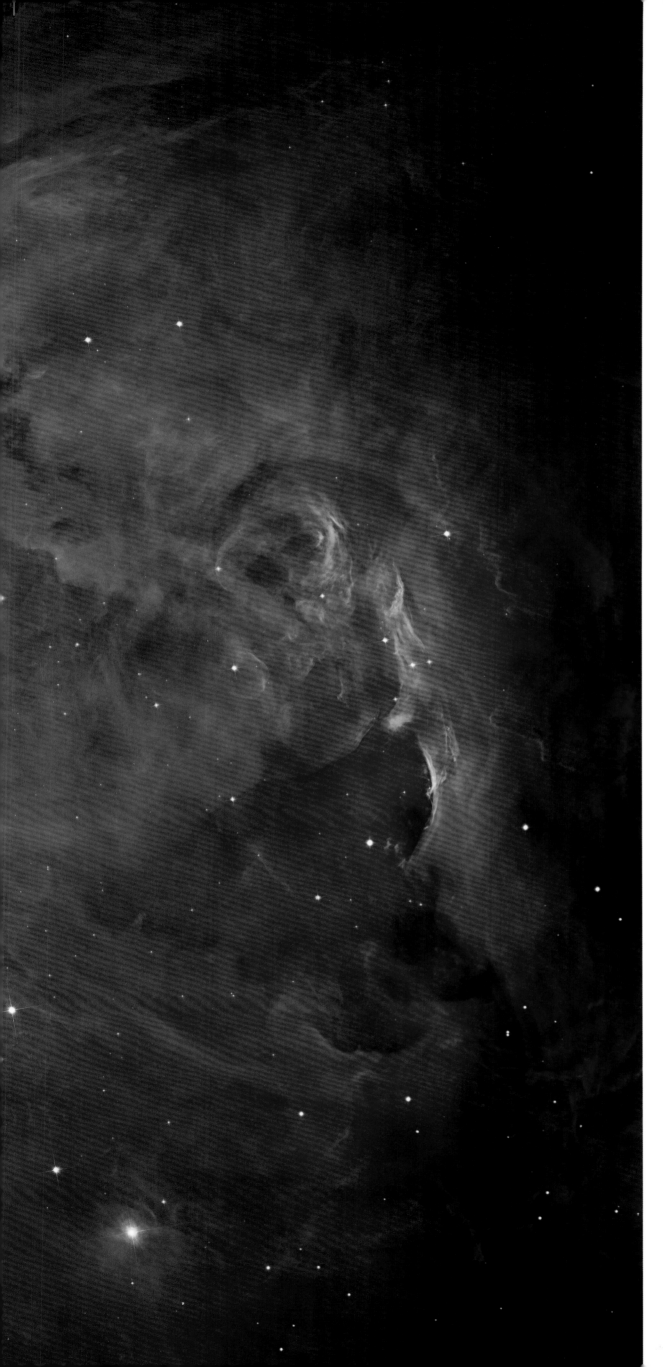

Previous spread The completion of the Great Observatories means that the same celestial object can be viewed by powerful space telescopes that "see" different wavelengths of the electromagnetic spectrum. **Left** Hubble (visible spectrum) and Spitzer (infrared spectrum) team up to capture the complex structure of the Helix Nebula, in a false-color image that uses data from both telescopes. **Right** Another view of the Helix Nebula, released in 2003, is a seamless blend of ultra-sharp images from Hubble combined with the wide view of the Mosaic Camera at Kitt Peak National Observatory near Tucson, Arizona.

Left In one of the most detailed astronomical images ever produced, released in 2006, Hubble captured the Orion Nebula, revealing thousands of stars never seen before in visible light. This extensive study took 105 Hubble orbits to complete. All imaging instruments aboard the telescope were used simultaneously to study the nebula.

Overleaf In 2004 astronomers released the deepest portrait of the visible universe ever achieved. Called the Hubble Ultra Deep Field (HUDF), the image included the first galaxies to emerge from the "dark ages," the time shortly after the big bang when the first stars reheated the cold, dark universe. The observations used to compile the image began on September 24, 2003, and continued through January 16, 2004. Light from the very faintest objects reached Hubble's detectors at a trickle of one photon per minute, compared with millions of photons per minute from nearer galaxies.

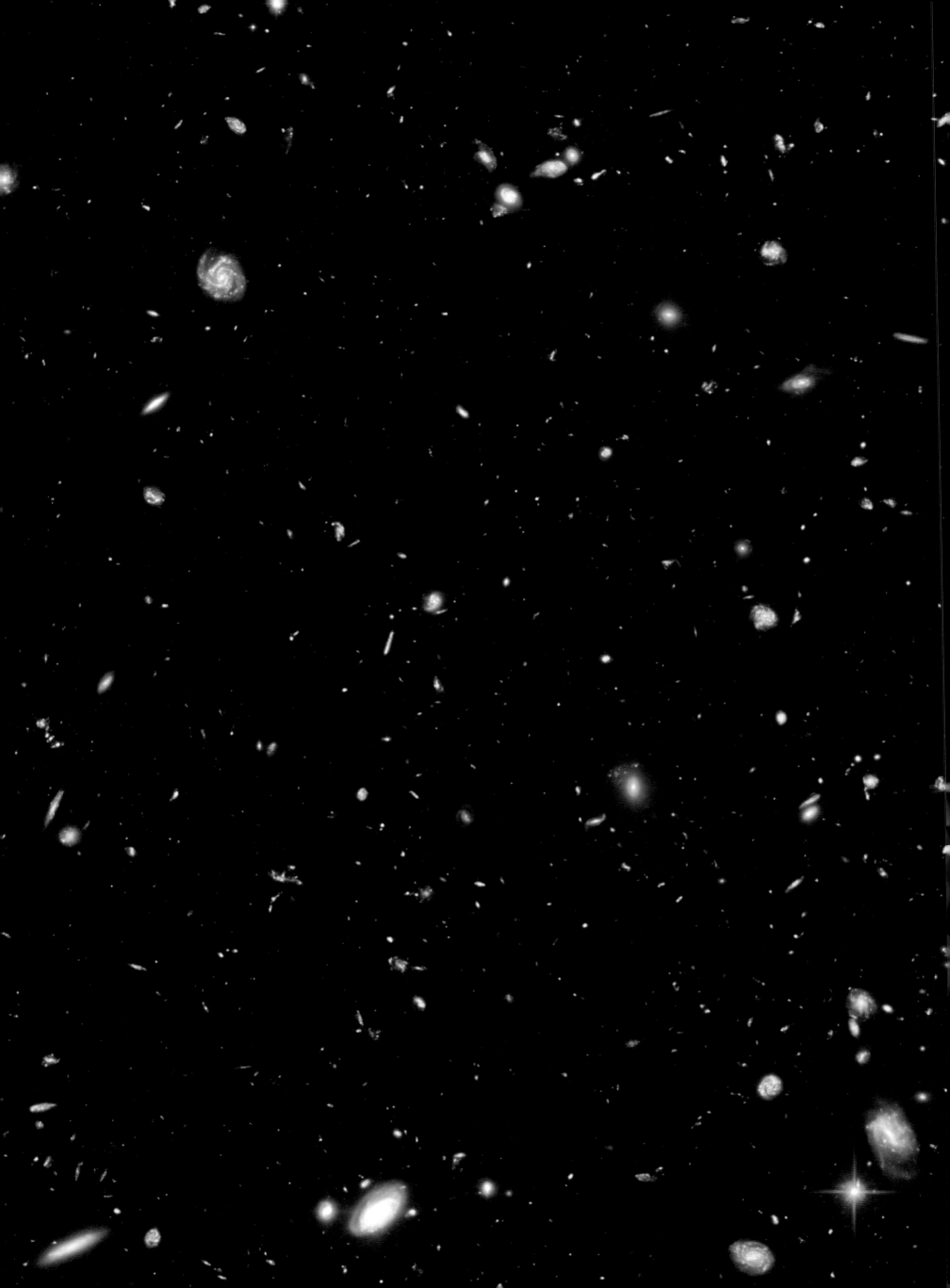

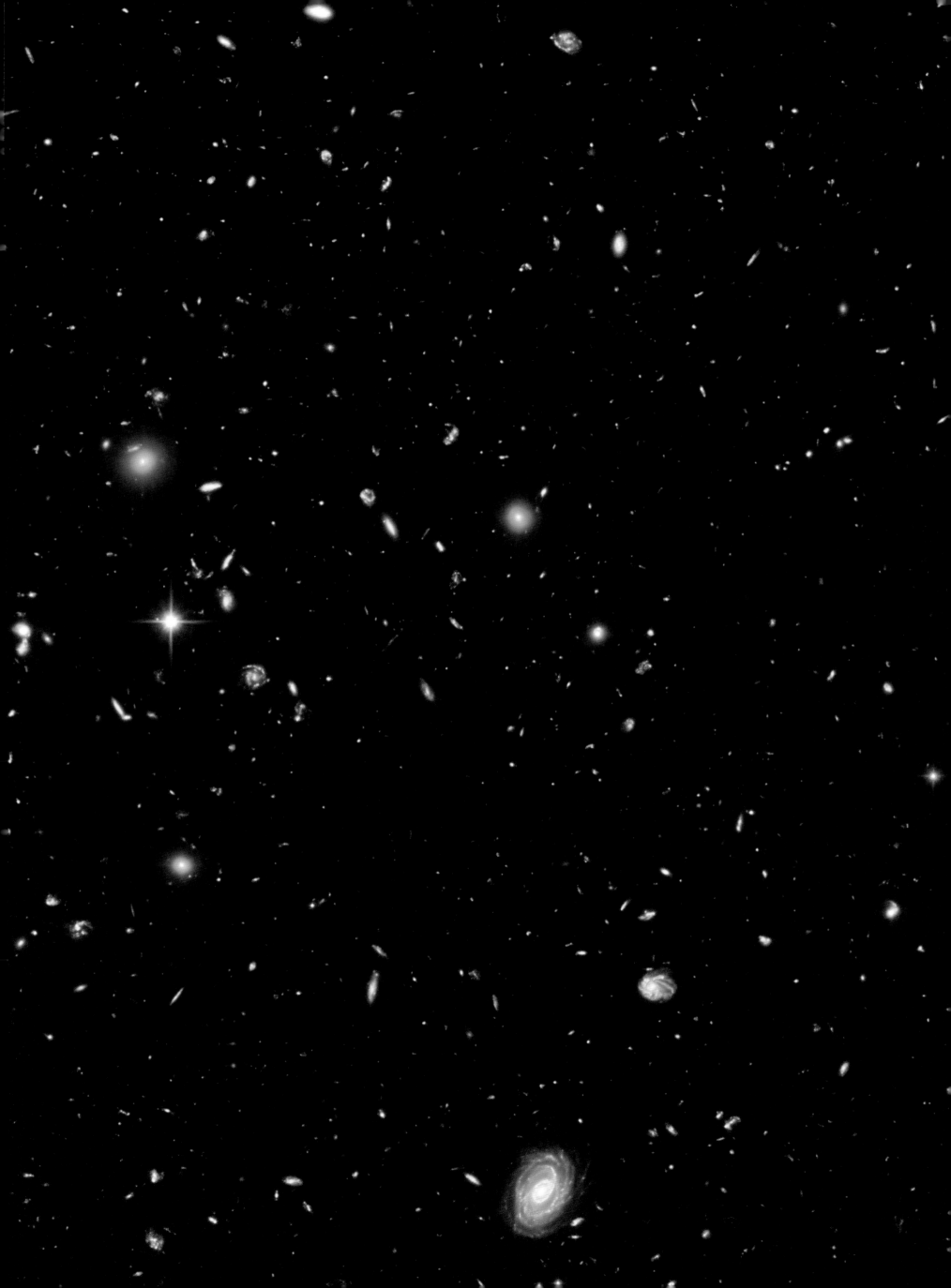

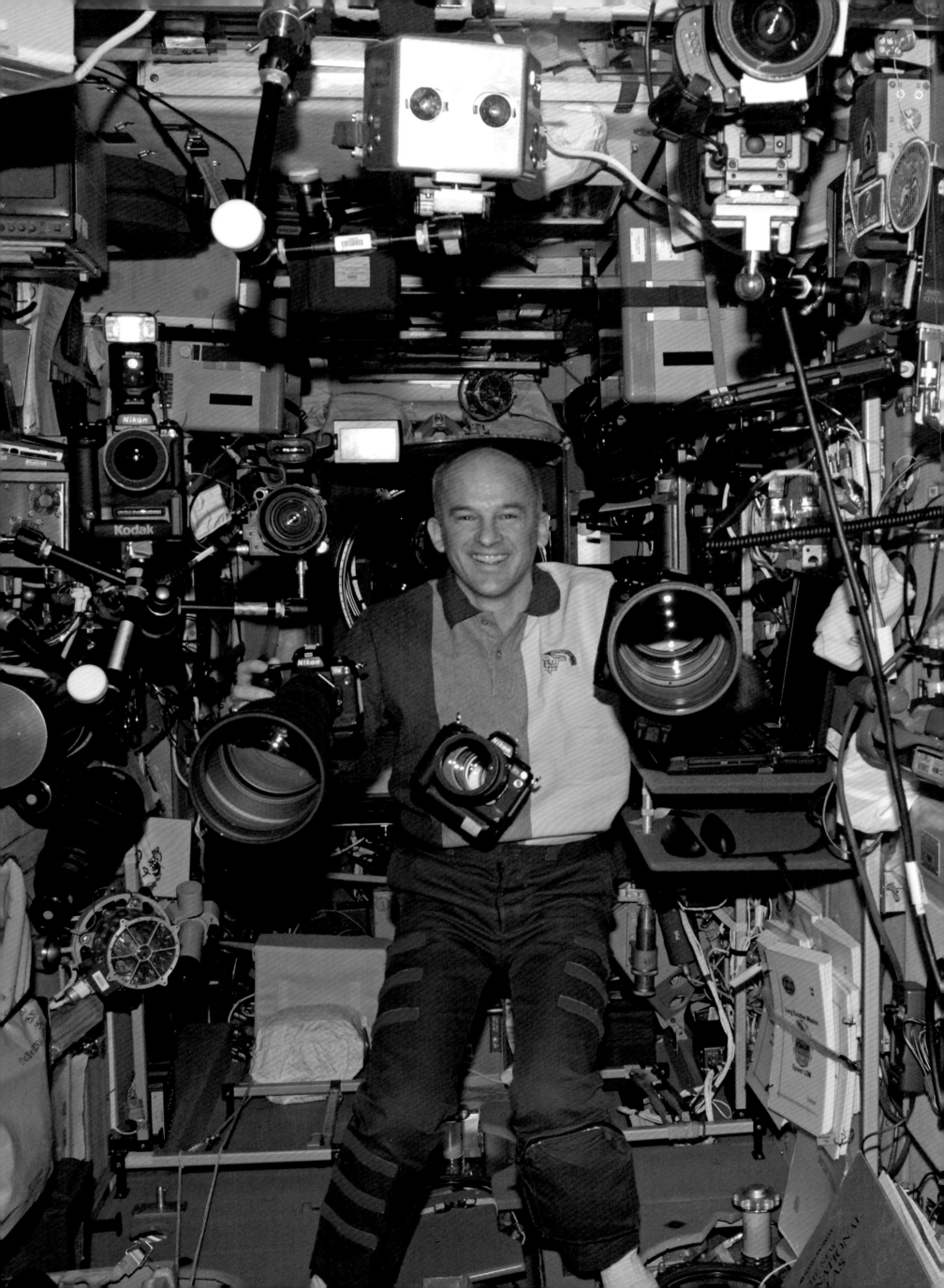

AFTERWORD

Two of NASA's most recognized and requested photographs are the Earth taken during Apollo 17 (page 6) and Neil Armstrong's famous man-on-the-Moon photograph of Buzz Aldrin from Apollo 11 (pages 188–189). The first looks back wistfully at the fragility of our planet, a blue marble floating in the darkness of space. The other is more forward-looking and celebrates the human quest to explore, and someday even possibly inhabit, a new lunar domain. These two photos coincidentally foretell a new chapter yet to be realized: NASA's return to the Moon, this time to stay.

Other images of NASA's future, almost as popular and equally prescient, are the rocky panoramas taken by the tiny rovers sent to the Martian terrain. In fact, when pictures from the Pathfinder mission were first released online on July 4, 1997, the burgeoning world of the Web took note (page 330). Millions logged on to their computers to look at the robot's snapshots of Mars. NASA's Web site had an unprecedented number of hits that day. Pathfinder images, along with images of the Mars Exploration Rovers and other Mars probes, have reached the general public and set the stage for an inevitable human mission to Mars. They portend the second goal of NASA's vision for space exploration, not only to send humans back to the Moon, but beyond to the red planet—a second giant leap from the neighboring Moon to distant Mars.

NASA photographs tell a powerful story. When taken as a whole, the vast archive of NASA photos conveys so much: human ingenuity, courage, tragedy, dangers, triumphs, and new worlds. It depicts the struggle of scientists, engineers, pilots, and astronauts to break barriers of velocity, distance, and human understanding. The images are humbling since they make us look at our own fragile selves in our own fragile world against a vastness of space yet to be explored. They share the story of brave superheroes. Normal humans don't wear silver suits and take off in capsules or shuttles to go explore the universe. NASA photos also expose a more humanly identifiable drama— ordinary fathers and mothers bidding heart-wrenching farewells to their families as they bravely risk life and limb to pioneer a new terrain; the public in rapt attention at a launch or landing; school children inspired by the latest images beamed down from distant places, whether by human or robotic photographers.

NASA's photographers have essentially acted as messengers to the public. With their behind-the-scenes access, they have photographed crews quietly suiting up for their journeys and have captured the majesty of launches with their beautiful plumes of billowing smoke. They have documented the sheer power of rockets and aircraft and those who have built and commanded them. Photographers have also included astronauts documenting their journeys from the heavens. Increasingly, intricate machines, controlled remotely by scientists, have become the photographic lens for the public as well. Rovers take pictures on Mars; space probes take pictures of Saturn; and space observatories such as Hubble, Chandra, and Spitzer open up visual worlds for us to behold.

NASA's beginnings in 1958 luckily coincided with the popularity of the picture magazines of the 1950s and 1960s, which took great advantage of the photographic medium. Magazines like *Colliers*, *Look*, and *Life* brought the human drama of space exploration to homes of millions of Americans in the 1960s and shaped America's impression of the astronauts, a concept which has lingered for decades. Today, the Web also takes advantage of the power of the image. When new pictures of the Hubble Space Telescope or the Cassini mission are posted, they grab the attention of millions around the world.

On a much more "far out" level, NASA photos have also been employed as the medium to reach out to life beyond our planet. In 1972, astronaut Charles Duke left behind a simple photograph of his family on the surface of the moon (page 226). Partly, this was to leave behind something for other human explorers to find on the lunar surface. However, on another and perhaps more poignant level, the picture is also a message to whatever life might be out there, perhaps long after our civilization is gone. The photo is simple—a father, mother, and children—essentially a photo of human life with different meanings for human and non-human viewers. Similarly, in 1977, the Voyager space probes carried a diplomatic package known as the "golden record." The record includes sounds and images of life on Earth on the small chance that other forms of life might understand what it is like to live on our home planet. After three decades, at NASA's fiftieth anniversary, the Voyager spacecraft are crossing the threshold of interstellar space and will continue forever as our silent sentinels into the universe. Even though their solar system mission is long over, these spacecraft continue to carry the images of Earth to worlds yet to be explored. The Voyager record leaves a profound legacy of human life at the frontier. So do the images of NASA represented here, which have inspired the public for fifty years and will continue to do so.

Opposite Surrounded by assorted camera gear floating freely, Science Officer Jeffrey Williams (US) smiles for the camera in the Zvezda service module of the International Space Station on September 20, 2006.

SELECTED READING

Chapter 1: In the Beginning

Hunley, J. D. *The Birth of NASA: The Diary of T. Keith Glennan* (NASA: Washington, DC, 1993).

Launius, Roger. *A History of the U.S. Civil Space* Program (Krieger Publishing: Malabar, Florida, 1994).

Legislative Origins of the National Aeronautics and Space Act of 1958, Monographs in Aerospace History Number 8 (NASA: Washington, DC, 1998).

Logsdon, John M. (ed.), *Exploring the Unknown: Selected Documents in the History of the U.S. Space Program*, vol. I: Organizing for Exploration (NASA SP 4407: Washington, DC, 1995).

McCurdy, Howard. *Inside NASA: High Technology and Organizational Change in the U.S. Space Program* (Johns Hopkins University Press: Baltimore and London, 1993).

McDougall, Walter. *The Heavens and the Earth: A Political History of the Space Age* (Basic Books: New York, 1985).

Chapter 2: The First "A" in NASA

Bilstein, Roger E. *Testing Aircraft, Exploring Space: An Illustrated History of NACA and NASA* (Johns Hopkins University Press: Baltimore and London, 1996).

Conway, Erik M. *High-Speed Dreams: NASA and the Technopolitics of Supersonic Transportation, 1945–1999* (Johns Hopkins University Press: Baltimore and London, 2005).

Gorn, Michael H. *Expanding the Envelope: Flight Research at NACA and NASA* (University Press of Kentucky: Lexington, 2001).

Jenkins, Dennis R. *Hypersonics Before the Shuttle: A Concise History of the X-15 Research Plane*, Monographs in Aerospace History Number 18 (NASA SP-4518: Washington, DC, 2000).

Schultz, James. *Winds of Change: Expanding the Frontiers of Flight. Langley Research Center's 75 Years of Accomplishment, 1917–1992* (NASA NP-130: Washington, DC, 1992).

Wallace, Lane E. *Flights of Discovery: 50 Years at the NASA Dryden Flight Research Center* (NASA SP-4309: Washington, DC, 1996).

Chapter 3: One Small Step . . .

Apollo Lunar Surface Journal, at http://history.nasa.gov/alsj/

Bilstein, Roger. *Stages to Saturn: A Technological History of the Apollo/Saturn Launch Vehicles* (NASA SP-4206: Washingon, DC, 1980 and 1996). Online at http://history.nasa.gov/SP-4206/sp4206.htm

Brooks, Courtney, James Grimwood and Loyd S. Swenson, Jr., *Chariots for Apollo: A History of Manned Lunar Spacecraft* (NASA SP-4205, Washington, DC, 1979). Online at http://www.hq.nasa.gov/office/pao/History/SP-4205/cover.html

Chaikin, Andrew, *A Man on the Moon: The Voyages of the Apollo Astronauts* (Penguin: New York, 1994). The basis for the HBO miniseries *From the Earth to the Moon.*

Compton, W. David. *Where No Man Has Gone Before: A History of Apollo Lunar Exploration Missions.* (NASA SP-4214: Washington, 1989). Online at http://history.nasa.gov/SP-4214/cover.html

Hacker, Barton C., and James M. Grimwood. *On the Shoulders of Titans: A History of Project Gemini* (NASA SP-4203: Washington, DC, 1977). Online at http://www.hq.nasa.gov/office/pao/History/SP-4203/cover.htm

Hansen, James R. *First Man: The Life of Neil A. Armstrong* (Simon and Schuster: New York, 1975).

Heppenheimer, T. A. *Development of the Shuttle, 1972–1981* (Smithsonian Institution Press: Washington and London, 2002).

———. *The Space Shuttle Decision: NASA's Search for a Reusable Space Vehicle.* (NASA SP-4221: Washington, DC, 1999). Online at http://history.nasa.gov/SP-4221/sp4221.htm

Johnson, Stephen B. *The Secret of Apollo: Systems Management in American and European Space Programs* (Johns Hopkins University Press: Baltimore and London, 2002).

Lambright, W. Henry. *Powering Apollo: James E. Webb of NASA* (Johns Hopkins University Press: Baltimore and London, 1995).

Logsdon, John M. *Together in Orbit: The Origins of International Participation in the Space Station,* Monographs in Aerospace History Number 11. Online at http://history.nasa.gov/monograph11.pdf

Seamans, Robert C., Jr. *Project Apollo: The Tough Decisions* (NASA SP-2005-4537: Washington, DC, 2005). Online at http://history.nasa.gov/monograph37.pdf

Siddiqi, Asif, *Challenge to Apollo: The Soviet Union and the Space Race, 1945–1974* (NASA SP-2000-4408: Washington, DC, 2000).

Swenson, Loyd S., Jr., James M. Grimwood, and Charles C. Alexander. *This New Ocean: A History of Project Mercury* (NASA SP-4201: Washington, DC, 1998). Online at http://history.nasa.gov/SP-4001/cover.htm

Chapter 4: Voyages in Space and Time

Burrows, William. *Exploring Space: Voyages in the Solar System and Beyond* (Random House: New York, 1990).

Kraemer, Robert S. *Beyond the Moon: A Golden Age of Planetary Exploration, 1971–1978* (Smithsonian Institution Press: Washington, DC, 2000).

Mack, Pamela. *Viewing the Earth: The Social Construction of the Landsat System* (MIT Press: Cambridge, Massachusetts, 1990).

Murray, Bruce. *Journey into Space: The First Three Decades of Space Exploration* (W.W. Norton: New York, 1989).

Schorn, Ronald A. *Planetary Astronomy from Ancient Times to the Third Millennium* (Texas A&M: College Station, 1998).

INDEX

Italics indicate photographs

ACKNOWLEDGMENTS

Many people have helped in the creation of this book and some deserve special mention. First, we thank the employees in NASA's photo offices throughout the agency, in particular Bill Ingalls, Heidi Fancher, and Gwen Pitman from NASA Headquarters; Mike Gentry, Susan Phipps, and Jody Russell from the Johnson Space Center; Margaret Persinger from the Kennedy Space Center; and Xaviant Ford from the Jet Propulsion Laboratory. Without their help, this book never would have happened.

From the Office of External Relations, we thank the Assistant Administrator, Michael F. O'Brien, and the Deputy Assistant Administrator, Al Condes. From the History Division, Colin Fries and John Hargenrader assisted with captions.

From Public Affairs, we thank Bob Jacobs, who helped envision the book, and David Mould for his support in allowing time to be devoted to the project. We also thank Gary Borda in the Office of the General Counsel.

We also appreciate Tony Springer's knowledge and help in pitching in at the last minute to edit the aeronautics section of this book.

We especially thank Neil Armstrong for contributing such a wonderful foreword and Wally Schirra for allowing us to use his smiling face on the cover.

Lastly, we thank Eric Himmel and his colleagues at Abrams, and designer Kayhan Tehranchi. This is their book as much as ours. Their perseverance, guidance, and talent have resulted in a book of precious photographs for NASA and the nation to be proud of for many years to come.

Steven Dick, NASA Chief Historian
Constance Moore, Head, Photo Researcher
Bertram Ulrich, Curator and Multimedia Manager

NASA Headquarters
Washington, DC

Editor Eric Himmel
Designer Kayhan Tehranchi
Production Manager Anet Sirna-Bruder

Overleaf Rocket pioneer Robert H. Goddard stands in front of a liquid oxygen gasoline rocket on March 16, 1926, in Auburn, Massachusetts. Goddard believed that rockets would take humans to the Moon.

Library of Congress Cataloging-in-Publication Data
America in space : NASA's first fifty years / foreword by Neil Armstrong ; edited by Steven J. Dick ... [et al.] ; with the assistance of the NASA Chief Historian's Office and the NASA Photo Departments.
 p. cm.
 Includes index.
 ISBN-13: 978-0-8109-9373-0 (hardcover)
 ISBN-10: 0-8109-9373-2 (hardcover)
 1. United States. National Aeronautics and Space Administration—History—20th century. 2. Astronautics—United States—History—20th century. I. Dick, Steven J. II. United States. National Aeronautics and Space Administration. History Office.

 TL521.312.A628 2007
 629.40973—dc22
 2007011247

Printed and bound in China
10 9 8 7 6 5 4 3 2 1

HNA ■■■■■
harry n. abrams, inc.
a subsidiary of La Martinière Groupe

115 West 18th Street
New York, NY 10011
www.hnabooks.com